BIRDS OF NORTH AMERICA *A Photographic Atlas*

Bruce M. Beehler

Photo Editor
Brian E. Small

Foreword by
Michael J. Parr

BIRDS OF NORTH AMERICA

A Photographic Atlas

Johns Hopkins University Press, Baltimore

Johns Hopkins University Press
2715 North Charles Street
Baltimore, Maryland 21218
www.press.jhu.edu

Library of Congress Control Number: 2023935928

A catalog record for this book is available from the
British Library.

ISBN 978-1-4214-4826-8 (hardcover)
ISBN 978-1-4214-4827-5 (ebook)

*Special discounts are available for bulk purchases
of this book. For more information, please contact
Special Sales at specialsales@jh.edu.*

Book design: Broad Street Books
Copyeditor: Carrie Love

Photographs by Brian E. Small
Front jacket/cover image: Male Painted Bunting
Back jacket/cover image (from top to bottom):
 Great Blue Heron, Wood Duck,
 Baltimore Oriole, Eastern Bluebird
Endsheets: Red-winged Blackbird flock
Title-page spread: Greater Prairie-Chickens in display
Dedication page: Allen's Hummingbird
Page 6: A birder at dawn scoping the Salton Sea

North American "regions" map in the Introduction
 (p. 29) by Bill Nelson.

American Bird Conservancy (ABC)
is the nonprofit sponsor of this book.
Learn more about ABC and its work
to conserve wild birds and their hab-
itats on the organization's website:
abcbirds.org

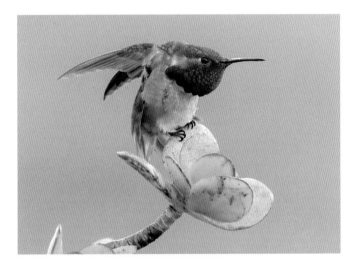

Bruce dedicates this book
to Carol Beehler,
for her unstinting support
and superb design sense.

Brian dedicates this book to
his father, Dr. Arnold Small,
a wonderful teacher, author,
birder, and the person who
inspired Brian's chosen career
path—"Thanks, Dad!"

And to the memory of
Tom Johnson.

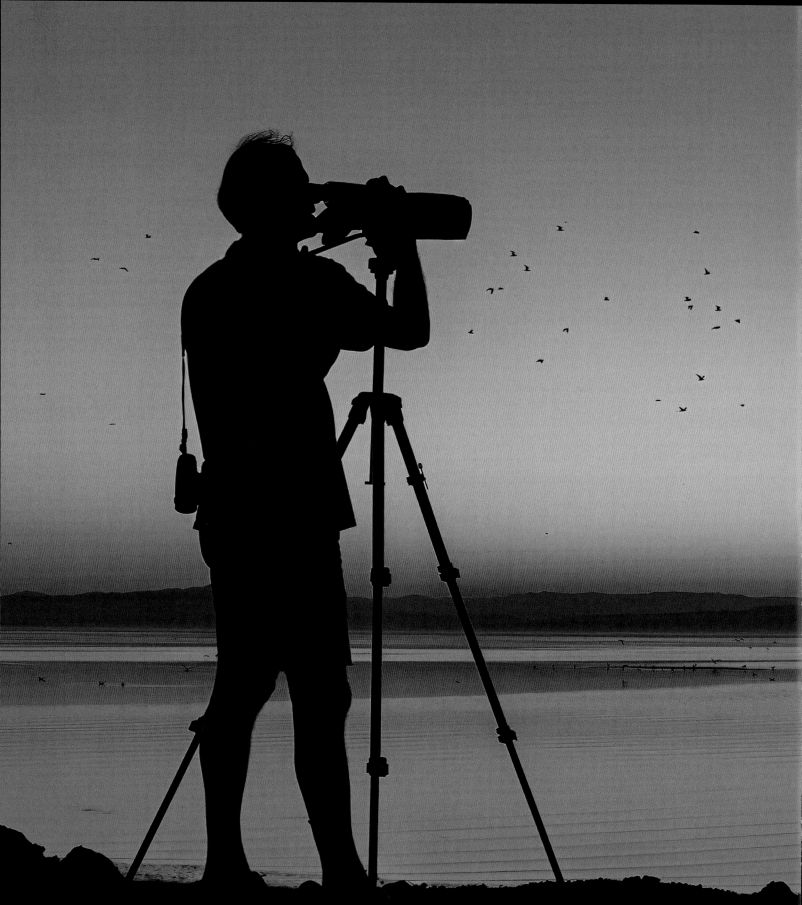

CONTENTS

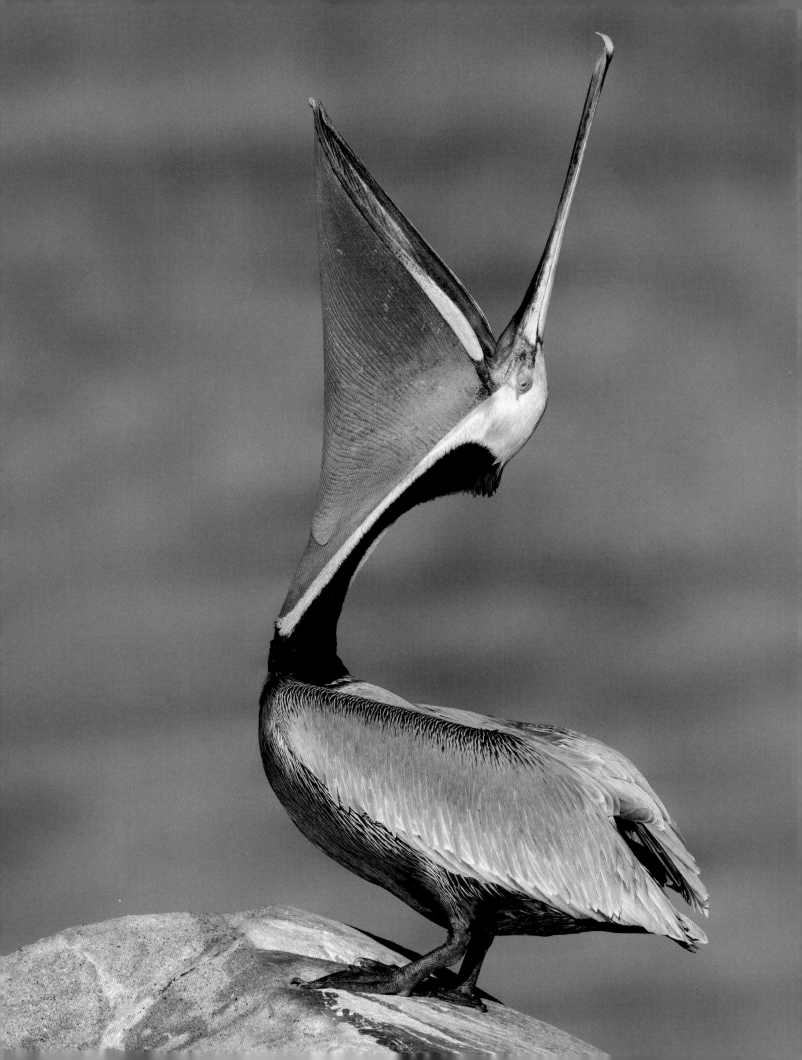

THE BRITISH ARE KNOWN around the world for a variety of things, but some of the most well-known include soccer (termed "football" by the Brits), being eccentric, Harry Potter, the Royal Family, and perhaps surprisingly, birdwatching. I grew up in Britain in the 1960s, and at quite an early age began taking an interest in the birds coming to our backyard feeder. My favorite was the Great Spotted Woodpecker, but once in a while we would also get some more unusual species in the yard such as siskins, Bramblings, Redwings, and once a Reed Bunting.

I still haven't figured out exactly why Brits are so connected to birdwatching—perhaps because there are so few mammals in the UK, or maybe it's because hunting opportunities are very limited for most people, but it could be just because we are eccentric! Whatever it is, I got the bug and began to dig into birds in a big way. One of the first books I got was Roger Tory Peterson's *Field Guide to the Birds of Britain and Europe*. I loved Roger's clear illustrations and the comprehensive nature of the book. It soon led me to purchase his eastern North American book, and wow! Those warblers! Having now progressed from Reed Buntings in the back yard to chasing rare birds around the country, I was already aware of American birds. I'd even seen a few transatlantic strays such as Pectoral Sandpiper. But Peterson's book most made me want to see North America's warblers in their fabulous spring plumage. Those waifs that occasionally made it across the Atlantic such as Blackpoll Warblers would usually be young birds in their drab (yet subtly beautiful!) fall plumages. As an impatient youngster I wanted to visit the candy store of spring warblers in person.

In my late teens, I had become part of a broader birding community and some friends suggested I get a job working on the construction of the Sullom Voe oil refinery in the Shetland Islands where I could make enough money to allow me travel the world birding. So that's what I did. My first job was fairly brutal, working as a cleaner high on scaffolding in the Scottish winter, but I saved up enough money to head to North America for a month. So I got my passport, bought a plane ticket, and off I went. I ended up spending a magical month at Point Pelee on the north side of Lake Erie, followed by a few days in Michigan chasing the then extremely rare Kirtland's Warbler and other northern birds like Boreal Chickadee. I was hooked! The very first warbler I saw was on an early May morning as I walked through Point Pelee National Park when a zebra-styled Black-and-white Warbler appeared, shimmying around the trunk of a tree. I was transfixed. It was like meeting a movie star in person—having seen so many illustrations and photos of this iconic North American warbler over the years.

Opposite: A Brown Pelican stretches, showing off its massive and colorful fish-holding gullet.

It didn't take me long to decide that I needed to go even further afield, and it was during a six-month expedition to India and Nepal that I first really realized that my mission needed to be not only seeing birds, but protecting them. The habitat loss that I witnessed sparked a new imperative for me—save the world's birds! I have been fortunate to find a career pursuing my passion for birds, first through BirdLife International, and now, some 40 years on from my first North American trip, as President of American Bird Conservancy—working on behalf of those birds I fell in love with back in the spring of 1982. And it all started with a bird feeder and a good bird book.

I hope that as you read through this magical volume, you will get a sense of the amazing diversity and splendor of North America's birds and wild places. Birds have led me on a spectacular journey throughout my life, and this wonderful book can be the beginning of your journey with birds, or, it can help to build your knowledge of birds you are already familiar with. Whichever it is, I'd like to congratulate the author Bruce Beehler, the photo editor Brian Small, and the entire production team for putting together a beautiful, informative, and inspiring work of art, that is sure to help the next generation of birders find the same passion and excitement that has made birds and birding such a joy for me.

I hope that if it does ignite a spark for you too, that you will consider also joining American Bird Conservancy and helping to conserve the birds that this book features so beautifully. Please visit us at abcbirds.org.

Thank you.

MICHAEL J. PARR
President, American Bird Conservancy

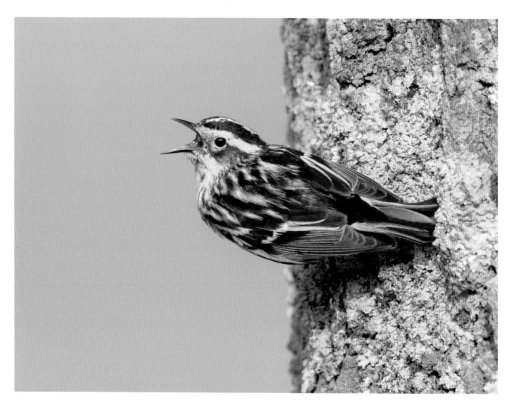

A subadult male Black-and-white Warbler sings while clinging to the bark of a tree in early spring.

THE IDEA FOR THIS PROJECT started with a conversation between the author and nature photographer Middleton Evans back in early 2017. At that time, we were finishing *Birds of Maryland, Delaware, and the District of Columbia*. Subsequently, for various reasons, Evans decided this project did not match his professional vision, and so he passed me on to Brian Small, on the West Coast, who had contributed his wonderful bird photographs to any number of books. I thank Middleton for his ideas and various early contributions. Luckily for me, Brian Small has proven a perfect partner in this enterprise. This book would not be what it is without Brian's amazing photographs and his finding additional superb images from a wide array of colleagues.

The next step to making this book a reality was to engage a nonprofit institutional partner, and that partner is American Bird Conservancy (ABC), where I have served as a board member in the 1990s and as a scientific affiliate more recently. It was ABC that served as my institutional partner for the long travels I took in search of migrating and breeding songbirds (especially wood warblers) pursuant to writing *North on the Wing: Travels with the Songbird Migration of Spring*.

With this atlas project, I wanted to create a North American handbook that would bring more people into the realm of birding, thus minting more future members of ABC! With ABC as a partner, I was able to raise the funds necessary from various friends, colleagues, and foundations to craft this big (and costly to produce) book. I thank Mike Parr, Erin Chen, Jack Morrison, and Betty Lopey for their guidance and assistance in putting the various pieces of this project together.

This book consists of three substantive components—beautiful images of birds, up-to-date and detailed species range maps, and concise text. Brian Small has contributed a huge body of his own images to this book. In addition, he has done the legwork to find images of the remaining species—an image for every bird species ever recorded from North America. That is, indeed, a big job. The sources of all the images are noted on p. 589. Brian Small provided the bulk of these, I provided a paltry few, and an additional 73 nature photographers and artists provided the remainder. I salute these contributors for their fine work. We could not have completed this project without their contributions.

Production and refinement of the more than 700 range maps constituted another big hurdle. Thanks to the wisdom, guidance, and artistic and technical expertise of cartographer Bill Nelson, we were able to produce these in a series of iterations aided by many sources (see p. 541) but especially the Cornell Lab of Ornithology. Our

cutting-edge maps could not have been completed without the various sources of geo-referenced range data and mapping synthesis provided by Cornell and eBird (see pp. 519, 520). We also tip our hat to the state breeding bird atlases that fed detailed range data into our range maps.

The text benefitted from incisive critical input from the late Tom Johnson and Luke Seitz, as well as David Wiedenfeld, Clive Harris, Dessi Sieburth, Holly Coates, Caleb Frome, Patsy and Tom Inglet, and two anonymous peer reviewers. I wish to thank Tiffany Gasbarrini, senior science editor for Johns Hopkins University Press, for her sage advice and Ezra Rodriguez for the abundant technical assistance provided.

Financial support for this project was provided by the following generous persons and entities.

Four foundational grants that made this book possible were provided by the Charles T. Bauer Charitable Foundation, the Shared Earth Foundation, John F. Swift, and John Friede.

Major gifts were provided by Lisa Anderson, Maria Semple, Rampa Hormel, Merrick Darley, Jeffrey Elliott, and Wendy Paulson.

Additional generous gifts were provided by John and Molly Beard, Patrick Eastman, Jonathan Kravetz, Carol and Bruce Hosford, the Doran family, Carol Sisler, Richard Levy, Amy Tan, and Thane Pratt. I thank all of these generous friends and colleagues. Simply put, this book was made possible by their philanthropy.

The beautiful design of the book is a product of the genius of my wife, Carol H. Beehler. She has designed five books for me, and I have never been disappointed. I also thank copyeditor Carrie Love, who fixed so many things that needed fixing with the manuscript. Her copyediting prowess is unparalleled. Needless to say, any remaining errors are solely my responsibility. I am happy to receive emails from readers suggesting corrections and improvements for the second edition. Email me at brucembeehler@gmail.com.

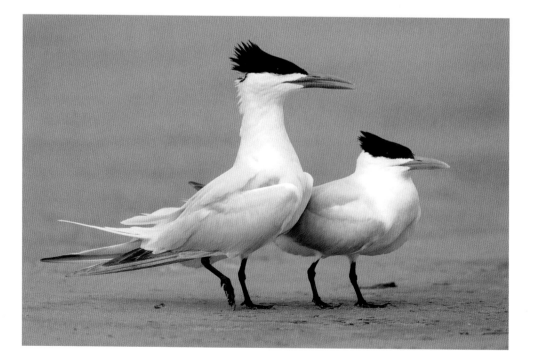

A Royal Tern pair loaf on a coastal sandflat. The red-billed male is wooing the orange-billed female.

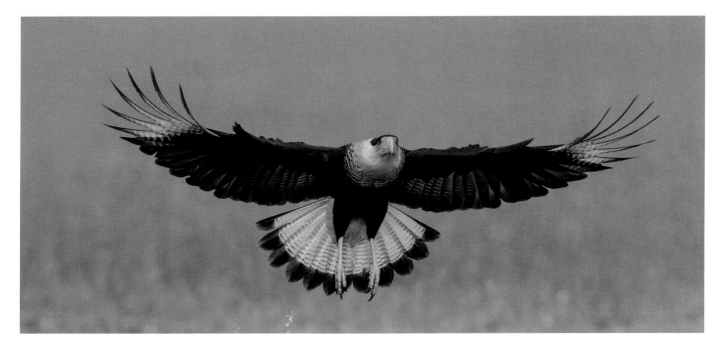

GEOGRAPHIC TERMS

Aleutian Islands. A long westward-arcing string of Alaskan islands that extend from the Alaska Peninsula to near Kamchatka, Russia, with the Bering Sea to the north and the North Pacific and Gulf of Alaska to the south.

Arid Southwest. Lowland arid lands from West Texas to interior Southern California.

Atlantic Canada. The Canadian Maritimes plus Newfoundland and Labrador (i.e., the easternmost part of Canada).

Atlantic Coast. The East Coast of North America from Newfoundland south to Miami, Florida.

Baja. Western peninsular Mexico just south of California (also known as Baja California).

Big Island of Hawaii. The island of Hawaii, which is the largest island in the state of Hawaii.

Border. The US-Mexican border, from South Texas to Southern California.

Borderlands. Those lands near to either side of the US-Mexico border.

boreal Canada. The swath of Canada that features conifer forest (taiga), ranging from New Brunswick northwest to the Yukon.

Canadian Maritimes. New Brunswick, Nova Scotia, and Prince Edward Island (facing the Atlantic Ocean and Gulf of Saint Lawrence).

Central America. The land from southernmost Mexico to easternmost Panama.

This Crested Caracara exhibits its beautifully patterned primaries and tail feathers.

Chukotka. Easternmost Russian Far East—adjacent to Alaska and its Seward Peninsula.

the Continent. North America. For purposes of this book, North America denotes the United States and Canada—the entire land area north of the Mexican border.

Deep South. The southern portions of Louisiana, Mississippi, Alabama, Georgia, and South Carolina, as well as the northern portions of Florida and East Texas.

the East. The eastern quarter of the Lower 48 and southern Canada.

East Coast. The Atlantic Coast of the Lower 48 and Canada.

Far North. From the sub-Arctic northward.

far southern seas. The southernmost oceanic waters that encircle Antarctica.

Far West. West of the Rocky Mountains.

Great Plains. The prairie lands east of the Rockies, from West Texas north to eastern Montana and North Dakota and on into western Manitoba, Saskatchewan, and Alberta.

Gulf Coast. The coastline of the Gulf of Mexico, from South Texas to southwestern Florida.

High Arctic. Portions of Canada and Alaska north of the Arctic Circle.

the Interior. The interior of North America, away from the coasts.

Interior Mountain West. The areas of the West dominated by mountains, lying east of the Sierras and Cascade Mountains.

Interior Southwest. Arid lands ranging from southern Nevada to West Texas.

Interior West. The western portions of the Lower 48 and Canada that lie east of the Sierras and Cascade Mountains.

the Keys. The Florida Keys, south and southwest of Miami.

Lower 48. The US states south of Canada (thus excluding Hawaii and Alaska).

lower Mississippi. The valley of the Mississippi south of its confluence with the Ohio.

Lower Rio Grande Valley. The lands near the Rio Grande (Río Bravo) River south of Laredo.

Middle America. Mexico plus Central America.

Midwest. States bordering the Mississippi and eastward to the western bank of the Ohio River.

Mountain West. The mountainous regions west of the Great Plains.

Neotropics. Mexico, Central America, the Caribbean, and tropical South America.

New World. The Americas.

the North. The northern third of the Lower 48 and all Canada.

North America. For purposes of this book, North America denotes the United States and Canada—the Continent north of the Mexican border.

North Atlantic. The Atlantic Ocean north of the Tropic of Cancer.

the Northeast. This region encompasses northern New York, New England, southern Ontario, southern Quebec, and Atlantic Canada.

northern US Borderlands. US territory near the border with Canada, from Washington state to Maine.

North Pacific. The Pacific Ocean north of the Tropic of Cancer.

the North Slope. The Arctic lowlands of Alaska, the Yukon, and the Northwest Territories that drain northward into the Arctic Ocean.

Northwestern Hawaiian Islands. The isolated old and low volcanic islands of the Hawaiian chain, starting with Nihoa Island, to the northwest of Kauai and Niihau, and stretching westward to Midway and Kure Atoll.

North Woods. The boreal forests of the US northern Borderlands from Minnesota to Maine and the boreal forests of central and eastern Canada.

Old World. Europe, Asia, and Africa.

Pacific Coast. North America's western coastline from Alaska south to Mexico.

the Pacific Northwest. The wet forested region from western Idaho and Oregon north to southwestern Alaska, featuring temperate rainforest.

Pampas. Lowland grasslands of Argentina, Uruguay, and southern Brazil.

Prairie Potholes. Prairie country dotted with glacial-remnant kettle ponds, ranging from central Alberta southeastward to northern Iowa, including the Dakotas.

This adult Horned Grebe in its lovely breeding plumage hunts for invertebrates in a northern slough.

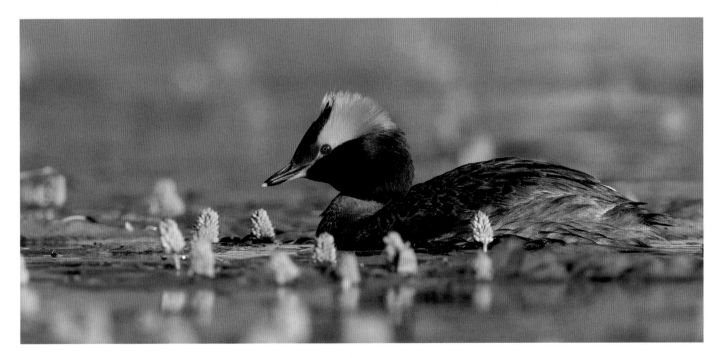

the South. The southern third of the Lower 48, southward from the northern east–west borders of North Carolina, Tennessee, Arkansas, and Oklahoma. Westward of this is the Southwest.

the Southeast. Virginia, North Carolina, South Carolina, Georgia, Alabama, and Florida.

South Florida. The southern quarter of Florida.

South Texas. Texas territory south of San Antonio.

the Southwest. West Texas, New Mexico, Arizona, Southern California, and southern Nevada.

Southwest Borderlands. Those lands adjacent to the US-Mexico border, from South Texas west to San Diego, California.

sub-Antarctic. Seas or lands just north of the Antarctic Circle.

sub-Arctic. Seas or lands just south of the Arctic Circle.

sub-Saharan Africa. Lands of Africa south of the desert zone of northern Africa.

the Tropics. Territory lying south of the Tropic of Cancer and north of the Tropic of Capricorn.

the West. The western half of North America. The US and Canadian territory west of longitude 100° west. The Great Plains westward to the West Coast.

the West Coast. The Pacific Coast of the Lower 48 and Canada.

Western Hemisphere. The New World. North America, Central America, the Caribbean, and South America.

West Texas. The western third of Texas.

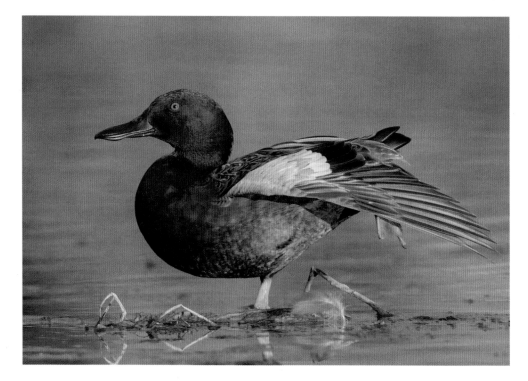

An adult male Cinnamon Teal stretches its wing, showing its pale blue shoulder-patch.

TECHNICAL TERMS

arid land. An environmental term denoting land that receives inadequate annual rainfall to maintain forest. Typically land dominated by desert or dry scrub and brushland.

arthropods. That large group of invertebrates that includes the insects, millipedes, centipedes, spiders, crustaceans, and more.

brackish. Waters that are a mix of fresh water and salt water.

brushland. Typically an arid landscape dominated by low scrub or shrubbery and lacking a tree canopy.

buteo. A broad-winged raptor of the genus *Buteo*.

chaparral. A thick evergreen broadleaf shrubland that is a type of Mediterranean scrub weathering a summer dry season and that is found along coastal California and interior California and Oregon.

confiding. Tame or allowing close approach.

conspecific. Of the same species. For example, the Mexican Duck was formerly considered conspecific with the Mallard but now is treated as a separate species.

covey. A small and cohesive family group (as in quail).

crepuscular. Active at dawn and dusk.

cryptic. Typically remaining hidden or difficult to see. Camouflaged.

decurved. Downward curving.

diurnal. Active during the daytime.

Douglas-fir. A lineage of five species of conifers in the genus *Pseudotsuga*. The genus ranges from Mexico and western North America to East Asia. The Common Douglas-fir is an important timber species in the Mountain West and Pacific Northwest.

extant. Currently existing (not extinct).

family. A higher taxonomic category denoting a recognized cluster of related species and/ or genera (plural of genus). For example, the family Turdidae (the thrushes) encompasses a number of related genera, which each encompasses one or more species.

genus (plural genera). The taxonomic category immediately above species. A genus will encompass one or more related species. The genus (or generic) name comes in front of the species name in the scientific name of a bird. Thus, the genus name for the American Robin, *Turdus migratorius*, is *Turdus*.

Gulf Stream. A warm-water current in the Atlantic that originates in the Gulf of Mexico and flows northward up the East Coast and then northeastward to Europe. The Gulf Stream influences the distribution of pelagic seabirds off the East Coast.

hybrid. A hybrid is a cross between two different forms. For instance, in the Great Plains, where the Baltimore Oriole comes into contact with the Bullock's Oriole, occasionally these two species mate, producing hybrid offspring exhibiting characteristics of both parent forms. Distinct subspecies can cross, and even members of different genera can cross.

insectivore. A species of bird or other animal that consumes insects.

irruption. An irregular and unpredictable population movement, typically southward and typically in winter, usually once every few years (not annually). Distinct from annual migration. For instance, Snowy Owls irrupt from the Arctic into the US every 5–7 years.

IUCN Red List. The International Union for Conservation of Nature (IUCN) Red List of Threatened Species, which classifies the plant and animal species of the world by level of extinction threat. See iucnredlist.org.

lek. A traditional display site for polygamous males of grouse and other lek-displaying species. Grouse leks are often called "booming grounds." This is where males and females meet and mate. Lek sites are typically used year after year.

live oak. A group of oak species, which includes the Southern Live Oak and the Texas Live Oak, two very important trees of the Deep South. Popular with foraging migrant wood-warblers.

mesquite. A genus of arid-loving bushes and trees—a mimosa-relative in the genus *Prosopis* (Fabaceae).

mixed forest. Forest with a mix of conifer and deciduous broadleaf tree species.

muskeg. A sub-Arctic bogland or peatland that occurs mainly in the taiga zone of Canada and Alaska. Usually includes open peat swamp with a scattering of Black Spruce and tamarack.

nest parasitism. In birds, when a female lays fertile eggs in the nest of another female; the host then raises the parasite's offspring. This happens within and between species.

nocturnal. Active at night.

non-passerine. The bird lineages that comprise the orders other than the Passeriformes, or perching birds. All the "lower orders" of birds, here the waterfowl to the parrots.

Nyjer. A popular seed for bird feeders—sometimes known as "thistle." Preferred by goldfinches, siskins, and other small seed-eaters.

passerine. Pertaining to the avian order Passeriformes—the perching birds. Perching birds include flycatchers, jays, crows, thrushes, sparrows and most of the small landbirds.

pectoral. Pertaining to the sides of the chest—at the bend of the wing.

pelagic. Pertaining to the open ocean, away from the coast.

recurved. Curving upward.

Red List. The IUCN Red List of Threatened Species, which classifies species of the world by level of extinction threat. See iucnredlist.org.

rictal bristles. Hair-like bristles that protrude from either side of the base of the bill.

sagittal. Pertaining to the midline of the crown. A sagittal crest is situated like the upright fringed adornment atop a Roman helmet.

Saguaro cactus. A large and distinctive species of cactus (*Carnegiea gigantea*) inhabiting the Sonoran Desert of southwestern Arizona and northwestern Mexico.

saltmarsh. A coastal marshland that receives tidal flows of salt water. Typically features marsh grasses such as *Sporobolus pumilus*, *Spartina alterniflora*, *Juncus* spp., and *Scirpus* spp.

species. The fundamental taxonomic category for delineating plants and animals, a species is a collection of closely related interbreeding populations that is recognized as unitary. Most species are well defined by plumage or behavior. But not all. For instance, the Willow Flycatcher and Alder Flycatcher are two closely related but distinct species. Even though the two look alike, their vocalizations are distinct and they do not interbreed regularly.

subspecies. This is the taxonomic category below the species level. A subspecies is a recognized and named population of a species that exhibits a distinct range and one or more distinct morphological or behavioral characteristics that make it unique. Not all species have recognized subspecies. Subspecies are only marginally treated in this work.

taiga. Taiga is the Russian name for boreal conifer forest. Taiga forests cloak interior southern Alaska and span Canada from the Yukon southeastward to Quebec and Labrador. These forests are dominated by spruce, fir, and tamarack (larch).

talon. Sharp claw of a falcon or raptor.

tamarack/larch. The tamarack is a genus of conifers (*Larix*) whose needles turn yellow and then drop from the tree in autumn. It inhabits boggy taiga and muskeg.

tundra. Arctic and sub-Arctic habitat where vegetation is low, mainly treeless, and dominated by dwarf shrubs, sedges, grasses, mosses, and lichens; often associated with permafrost and occurring north of the taiga. South of the Arctic, this includes some mountaintop habitat (e.g., atop Mt. Washington, in New Hampshire).

vagrant. A species that has wandered from its normal range. Birds, in general, are great wanderers. As this book demonstrates (especially the rare species sections) the North American list is littered with tropical, European, and Asian species that have wandered here from time to time. Wandering, or vagrancy, is distinct from migration, an annual, predictable phenomenon. Some bird families are very sedentary. Others like to wander.

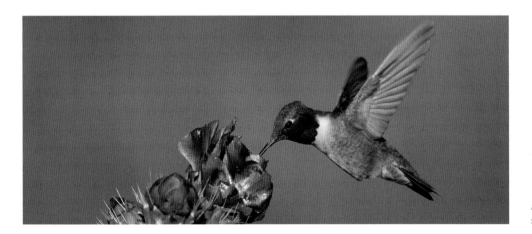

A male Black-chinned Hummingbird sips nectar from a cactus flower.

ABBREVIATIONS AND SYMBOLS

♂ male

♀ female

***CR** Critically Endangered (IUCN Red List category)

e.g., for example

***EN** Endangered, the category below CR (IUCN Red List category)

***EW** Extinct in the Wild (IUCN Red List category)

***EX** Extinct (IUCN Red List category)

L length

***NT** Near Threatened, the category below VU (IUCN Red List category)

***VU** Vulnerable, the category below EN (IUCN Red List category)

***WL** Watch List—the North American Bird Conservation Initiative (NABCI) list of North American birds deserving conservation attention

WS wing span

A pair of male Baltimore Orioles aggressively display to each other in a spring encounter.

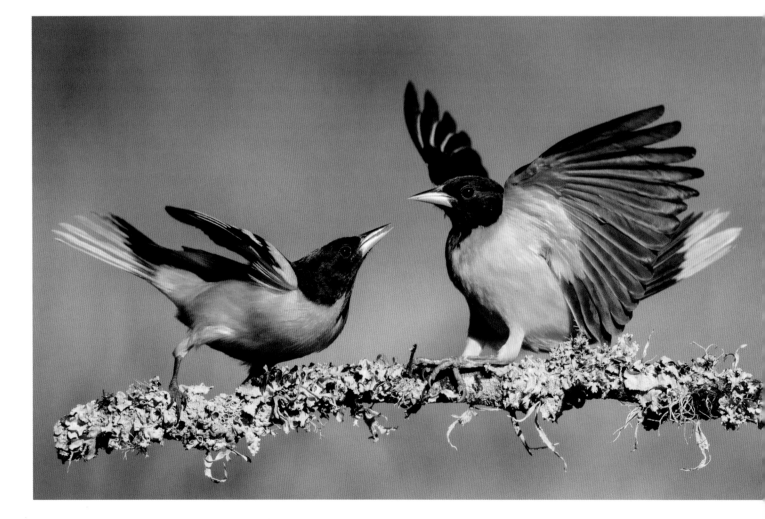

SOME PEOPLE PERHAPS take birds for granted. This book seeks to make those people think again and to start focusing on the wonder of birds, which are with us whether we are at home, at work, or on the road. Why should we *not* take birds for granted? For plenty of reasons. They are diverse, beautiful, and musical. They are abundant and easy to find. They bring us pleasure. And they provide the Earth with important ecological services. If we pay attention, focus, and open our hearts to them, we will all recognize that birds are important to our very existence. Birds are a source of simple joy that costs us nothing. Their value to humankind is nearly boundless.

In fact, birds are a great gift from nature. Thoughtful people benefit from and enjoy the presence of birds in our world. Some of us like seeing them in our backyards. Some like photographing or drawing them. Some enjoy carving waterfowl decoys or small wooden decorative songbirds. Some love hunting waterfowl or upland game birds. There are many ways birds enter our lives to help us enjoy the natural world around us. They are true ambassadors from nature.

Every human society in history has left behind evidence that it recognized birds as important to human well-being in everyday life. Ancient Egyptian wall friezes featured geese and ducks; ibises and falcons were the focus of painstaking mummification rituals in recognition of their deity status. Depictions of birds in Mughal art in India were so accurate that the species being depicted can be easily identified half a millennium after being painted.

Even traditional rainforest-dwelling societies of New Guinea commonly use birds for totemic identification of clans, much in the way that, today, avian imagery is artfully deployed to help us identify with local professional and amateur sports teams. An abundance of raven, oriole, eagle, cardinal, and falcon iconography appears on cars, flags, shirts, and hats across North America. Our curiosity about birds, our appreciation of their beauty, and our fascination with their behavior make bird-watching something that is practically hardwired in us. Who knows, maybe there is a bird-watching gene hidden in our DNA. It is no wonder that many of us do take notice of, and pleasure from, birds on a regular, even daily, basis.

Many of us took up the avocation of bird-watching at home, as children. Peering out the kitchen window, we saw, hanging on the suet feeder, a lovely feathered creature with a glossy red patch atop its head and black-and-white zebra-barring on the back. We immediately wanted to know the name of that beautiful bird. For those lucky ones with

enlightened parents, there was a field guide by Robbins or Peterson lying near the window for this express purpose. Aha!—a male Red-bellied Woodpecker.

The birders who start young are blessed with a recurrent source of joy that may last all their days. As youths, these bird-lovers got to train their brain while it was still fresh and efficient at data storage and retrieval—making the intricacies of identification of birds by sight and sound almost second nature. Others start the hobby at college with a course in ornithology, whereas some don't start until retirement, perhaps at the urging of a neighbor, family member, or friend. Today, the United States has a staggering 45 million bird-watchers. Most of them simply enjoy looking at birds in their yard, but 16 million of them travel to go birdwatching. These bird-lovers spend some $7 billion annually on their hobby. Bird-watching is big business and a part of the fabric of our recreational lifestyle.

Moreover, birds enter our lives through other avocations. Game hunting in North America is a widespread, popular pastime. Hunters target ducks, geese, Mourning Doves, Wild Turkey, Ruffed Grouse, Sandhill Cranes, American Woodcock, Wilson's Snipe, and

This Elf Owl peeks out from his nest hole set in a Saguaro cactus.

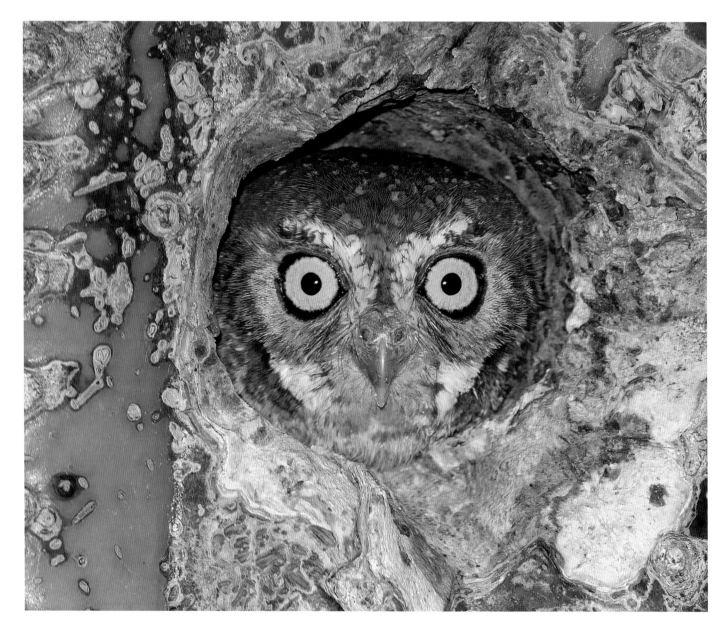

several rail species, among others. Bird-hunting seasons come in fall and winter as well as the spring. Hunters learn the game birds not only to make sure they are meeting all regulations on harvest but also because they fall in love with these beautiful birds.

Falconers practice their ancient sport across North America in small numbers. These lovers of raptors (hawks, eagles, and falcons) train their birds to hunt a variety of game birds. Commonly trained raptor species include the Red-tailed Hawk, Harris's Hawk, and Peregrine Falcon.

Today's news cycle regularly brings us stories about the decline of our native birdlife. In spite of these very real declines, birds remain the most abundant and readily accessible type of wildlife in North America. The United States and Canada today support more than 7 billion birds. This book features the 1,144 species of birds that have been recorded from North America north of the Mexican border, plus Hawaii. Some of these species, such as the Red-winged Blackbird and American Robin, are widespread and commonplace. By contrast, the Worthen's Sparrow is known from a single New Mexico record in 1884. The sleek and graceful Bat Falcon was first recorded from North America in December 2021 in the Lower Rio Grande Valley of southern Texas. As this book was being put together, additional avian novelties have been added to the North American list—this is because birds have wings and show a propensity to wander far and wide. Bird-watchers love seeing new species of birds, and each new North American record creates considerable excitement within the bird-watching community. Many bird-watchers love chasing after these notable and rare bird species. It is worth watching the movie *The Big Year* to get a sense of the extremes pursued by some birders in search of more species for their "life list" or their "year list"—a tally of how many bird species a birder has recorded in a long lifetime or a single calendar year.

Anyone with even a slight interest in birds who has visited the nature section of a local bookshop or done a search on Amazon will know that there are a lot of books on birds, especially on birds of North America. Why another book of this kind? Who is the audience and what does this book seek to accomplish? First, we see this book as a companion volume to a good North American field guide—we suggest the two *Sibley Field Guides* (to Eastern and Western North America) or the *National Geographic Field Guid to the Birds of North America*. Full details of these references can be found in the "Annotated Bibliography" at the back of this book (see p. 541). Field guides are compact and heavily illustrated; they are mainly used in the field to properly identify the species of birds seen.

This book is a desk reference, meant to be kept in a handy location in the den or kitchen, not for use in the field. It is targeted at beginning and intermediate bird enthusiasts. It leaves the particulars of field identification to the field guides; instead, it focuses on introducing readers to the stunning diversity of birds in North America—highlighting their beauty (with a single killer image of the most handsome plumage for each species) and including a focus on the geography of each species' annual range. For each species, we present a lovely image, a fact-filled thumbnail text account, and a large-format color map depicting where the species spends the summer, the winter, and the spring and autumn migratory seasons.

We treat the entries in the book in a simple and straightforward manner that will allow you to quickly get to know each species. The hope is that you will fall in love with a

selection of species, will study the concise text to learn about these species, and will closely examine the range map to learn where each species lives. The point of establishing these little love affairs with particular species is twofold. First, you will become a bird-lover. Second, you will start heading out into the field to see these birds firsthand and, in doing so, become an active field birder.

Why do we want this to happen? We believe that the more active birders there are, the better our world will become—especially if these birders become participating members of the American Bird Conservancy (ABC) and other local and national bird appreciation and conservation organizations. Many of the great accomplishments in nature conservation were carried out by naturalists who fell in love with birds. So, reader, keep this book in a convenient place. On those days when it is better to stay indoors, brew a cup of tea or coffee and browse this book looking for species that can help you determine your next field trip, whether to the next county or the next state. Before long, you may be planning trips to Alaska or Arizona! Birding trips to gorgeous green spaces in North America will become some of the most rewarding and memorable experiences in your life. This book can start you on the way to new and exciting discoveries about your world.

THE LIST

You might wonder who decides what birds live in North America. This book follows the most recent list of North American birds published by the American Birding Association (ABA)—version 8.11 (of August 2022). This list is updated annually. The ABA seeks to maintain an accurate list of the birds that have been proven to occur in North America. The list used by eBird (the Clements List) is similar but not identical. These are mainly native and naturally occurring species. But there are also non-native species that have been brought to North America as pets and cagebirds. Some of these have escaped and become established. The best known of these are the European Starling and House Sparrow, both introduced to New York City in the late 1800s. New exotic species (many of them parrots and finchlike birds) continue to make their way to North America with human assistance. The ABA determines when these new immigrants have become successfully established based on the species breeding and maintaining a viable local population. This book also includes several additional introduced species that have not yet made it onto the ABA list, but which are featured in the major field guides. These appear, with additional ABA-listed species, in the section entitled "Localized Mainland Exotics" (see p. 485).

In addition, the ABA recently decided to add Hawaii's birds to the North American list. In this book, the Hawaiian avifauna is treated in its own section, following the main species accounts section (see p. 465).

Professional ornithologists are partners in the annual updating of the ABA list. The North American Checklist Committee of the American Ornithological Society (AOS) annually updates its list of birds of North America (but the AOS's list also includes Mexico and Central America). The ABA list closely tracks the AOS list, which makes many updates based on scientific publications treating the systematics and nomenclature of the species in question. The AOS focuses on the evolutionary and scientific side of list-keeping. The ABA list is the "birders' list," whereas the AOS list is the "ornithologists' list."

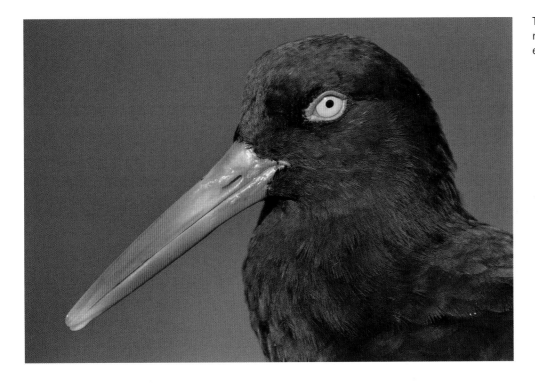

THE SPECIES ACCOUNTS

The bulk of the book comprises accounts of the species of birds of North America. The main accounts feature birds that are recognized as residents or regular visitors to the region. These are birds with full accounts in the Sibley and National Geographic field guides. The order presented in the book, for the most part, follows the order of the ABA list (but we have shifted some to put like species adjacent to each other). Below is a sample species account—one for the American Robin.

American Robin *Turdus migratorius*
L 10" WS 17" ♂ ≈ ♀ AMRO *LC

One of our most commonplace songbirds, ranging from coast to coast. Northern birds migrate southward in winter. Much of the United States has the species year-round. The Deep South and Southwest Borderlands mainly see the species during the winter. There are additional breeding populations that range south through Mexico. This common garden bird is also a forest-dweller that inhabits mixed and conifer forests to Labrador and Alaska. Forms foraging flocks in winter that can be quite large. Summer diet is mainly invertebrates; winter diet tends to be dominated by fruit. The substantial cup nest is situated in a small tree or shrub. Nest is constructed of grass, twigs, and bark held together with mud and lined with finer plant material. Lays four pale blue eggs.

The species account is headlined with the currently accepted English name, **American Robin**, followed by the scientific binomen (usually constructed of Latin and Greek roots), *Turdus migratorius*. The two-part technical name would have been given to

the species when it was first described to science. It combines a genus name ("*Turdus*") with a species name ("*migratorius*"). This two-part scientific name is sometimes "updated" for technical reasons, sometimes arcane, which are beyond the scope of this book.

The genus name is the group (or evolutionary lineage) of a particular family (in this case, Turdidae, the thrushes) that encompasses a particular species. The genus *Turdus* is a worldwide genus that includes more than a hundred species. The *Turdus* thrushes include the **Eurasian Blackbird** (*Turdus merula*), which is a familiar garden songbird in England.

The species name "*migratorius*" was given to the American Robin in 1766 by the Swedish systematist Carl von Linné in his great encyclopedia of animal life entitled *Systema Naturae*. He never saw a living American Robin but had access to museum specimens of the species as well as published natural history accounts of this North American bird. He gave it this particular species name because he had read that the bird was migratory.

The account headline continues with the bird's length in inches (L 10") and its wingspan in inches (WS 17"); these are measurements of the adult male, which is typically larger than the female. Next, the symbols ♂ ≈ ♀ indicate the plumage of the male (♂) is similar (but not identical) to (≈) that of the female (♀). In species where the male and female are identical, the symbols ♂ = ♀ appear, and in instances where the male and female are unlike, ♂ ≠ ♀.

The account headline includes the four-letter bird-banding code for the species. This code was created as a shorthand by bird-banders—people who trap birds and place aluminum numbered rings on their legs to study populations and movements. These four-digit codes are especially useful when taking field notes or entering sightings into the eBird mobile app (see p. 519). The American Robin's banding code is AMRO, based on the first two letters of the first word of the name and the first two letters of the second word of the name. Most of the codes were created using that method.

Where applicable, the account headline finishes with one or two conservation codes. The first is the IUCN Red List of Threatened Species classification, which is only included if the bird is under some sort of threat (or near threat). These codes are *NT = Near Threatened, *VU = Vulnerable, *EN = Endangered, *CR = Critically Endangered, *EW = Extinct in the Wild, and *EX = Extinct. If the species is treated as Least Concern (*LC), that is, not threatened, no code is presented (except in the example above)—most species are, in fact, Least Concern. An entry might also include the code *WL, which indicates the bird appears on the Watch List of the *North American Bird Conservation Initiative* (NABCI) and therefore merits conservation attention.

The narrative that follows the headline includes notes on the geography of the bird's range in summer and winter, including its range outside of North America. It discusses migration, habitat preference, diet, nest placement, the structure and components of the nest, and the number and color of eggs laid. Nest and egg information is *not* included for species that do not nest in North America.

The photograph provided depicts an adult bird in its most attractive plumage (in many instances an adult male). This is the plumage usually most easy to identify in the field. This book is *not* a field identification guide. It instead is an introduction to the birds of North America. We list identification guides in the back of the book (see p. 521).

THE RANGE MAPS

Each account's range map is color coded, and depicts the year-round range of the featured species within the scope of the map and is presented for the years 2012–2021. Note that the map's depicted range may be a bit more inclusive than the species' true range because of the specialized habitat requirements of the species and the patchiness of habitats across North America.

BRIGHT GREEN, a color associated with the breeding season in much of North America (green trees, green grass), indicates the **summer/breeding** range. Green regions depict where the species occurs during the summer or breeding season but not in autumn or winter. Thus, green is used for species that are migratory. Note that some species are migratory in some parts of their ranges and sedentary in other parts of their ranges.

BLUE indicates the normal or expected distribution in the **winter** months. Depicted is the typical seasonal distribution, with expected variation from year to year.

PURPLE shows areas where the species can be found the **year-round**. This refers to either sedentary resident populations or a place where there is mix of breeding and win-

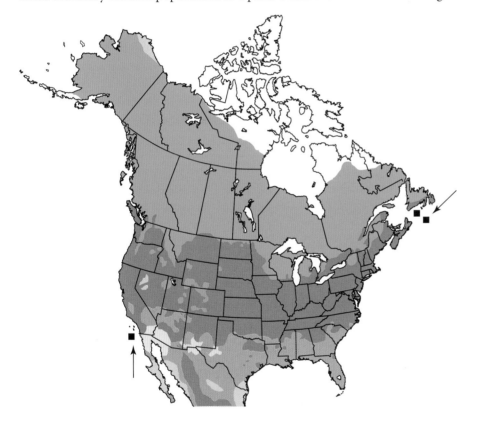

Sample range map. Note the five colors: green (breeding), purple (year-round), blue (winter), yellow (migration), and gray (rarely seen). Black squares pinpoint breeding colonies. Arrows highlight parts of range that might otherwise be overlooked.

tering bird populations. In other words, the species may be present there the year-round, even though differing populations are present in winter and summer.

YELLOW denotes **migratory pathways**—both spring and fall. Note that, in many cases, birds will also be migrating through areas shown in purple, green, or blue.

GRAY indicates where the species may be expected to stray on occasion—where the species is **rare or very rare** but not unheard of. An entire gray area may receive only a few records of the species per year, but over a decade, this area is visited widely by the species. Birders wishing to locate a target species certainly will not choose to hunt for it

in a gray-colored area (unless there is a well-known "stake-out" individual reported). A particular county that is depicted in gray may only record a single record of the species in a decade.

The small black squares found in the coastal seas indicate the site of a localized breeding colony—typically on an island.

The arrows on the map highlight localized, or very narrow distributions that might otherwise be overlooked.

RANGE MAP COLOR LEGEND

summer migration year-round winter rare

GEOGRAPHIC SHORTHAND TERMS

The large map of North America on the opposite page designates a number of useful terms that are deployed frequently in the species accounts to describe the range of species in a concise and user-friendly manner. When studying these range descriptions in the accounts, be sure to scrutinize the accompanying range map to learn the exact limits of the species range in question. This is a useful way of learning some of the nuances of North American geography.

COLOR-CODING OF BIRD FAMILIES

To save space and improve the design, we have streamlined the **species accounts**, which immediately follow this section. They are grouped by bird family, but the family accounts are in the back of the book (see p. 501). We note family affiliation using the footer at the bottom of the page, and we add a color coding in the lower corner of each page—each family has its own color. Thumb through the front of the species accounts and you will see that the waterfowl are all coded with the pale yellow swatch in the bottom page corner. You can quickly get to a family grouping by looking for the family's color swatch.

An adult Brandt's Cormorant conducting a mating display at his rough nest site on a cliff.

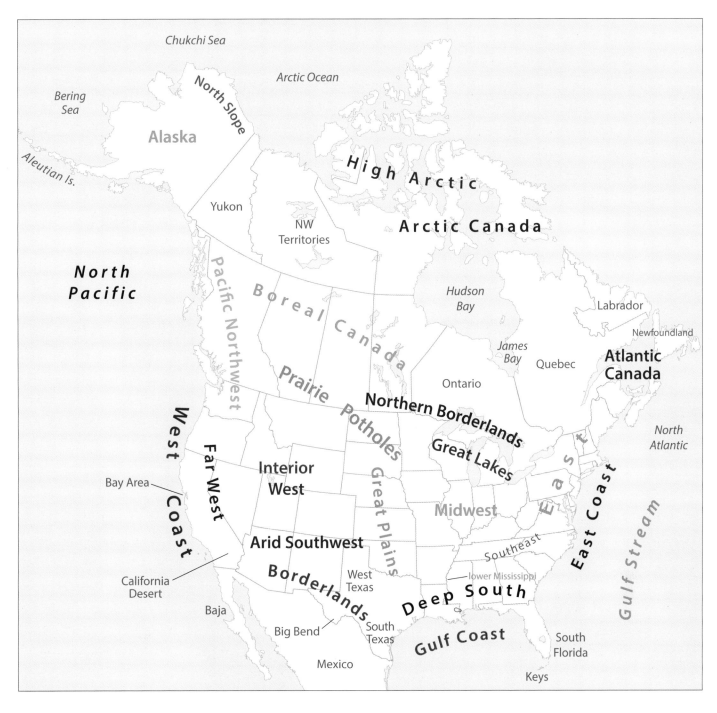

Frequently used geographic terms found in the species accounts that follow.

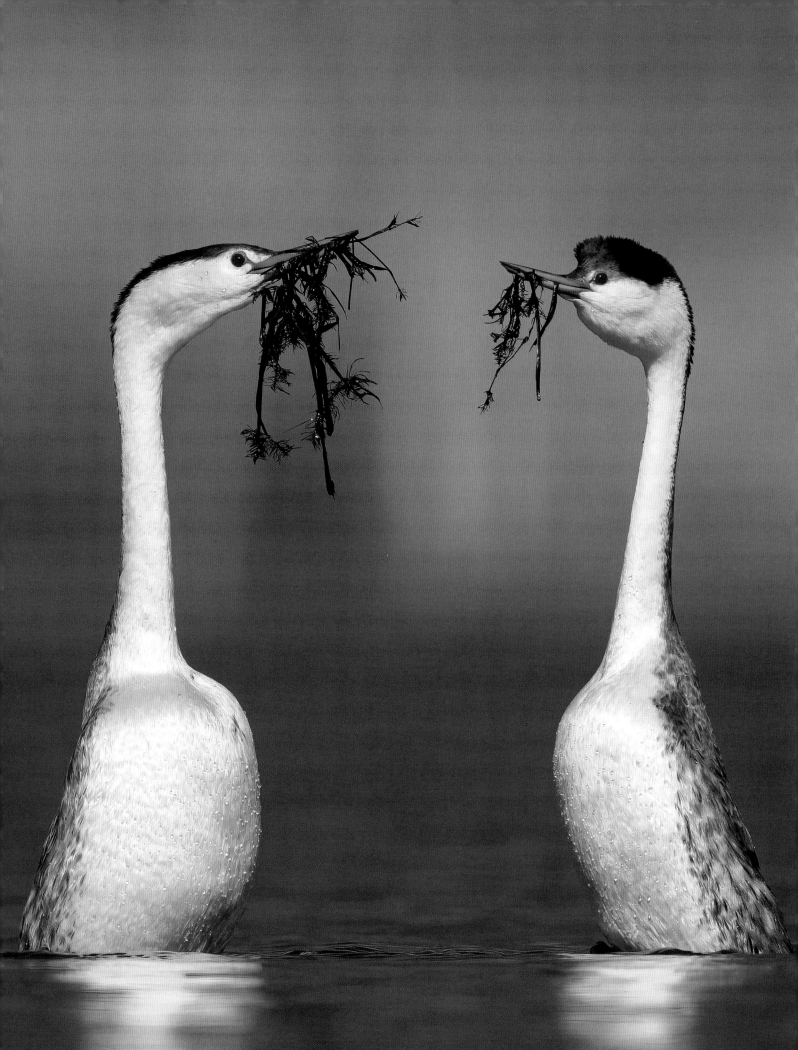

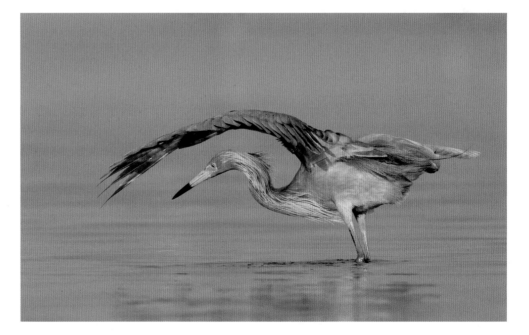

Opposite: A probable Western Grebe (right-hand bird) displays to a Clark's Grebe. These two very similar species occasionally hybridize. The right-hand grebe may, in fact, be a hybrid. Right: A Reddish Egret foraging in a saltwater lagoon.

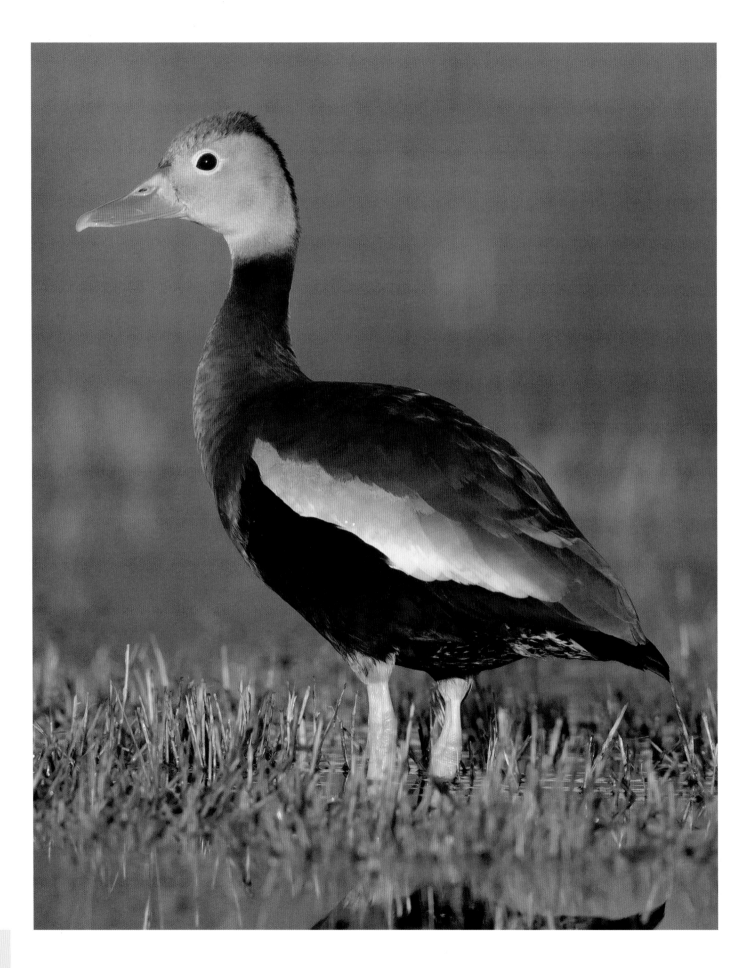

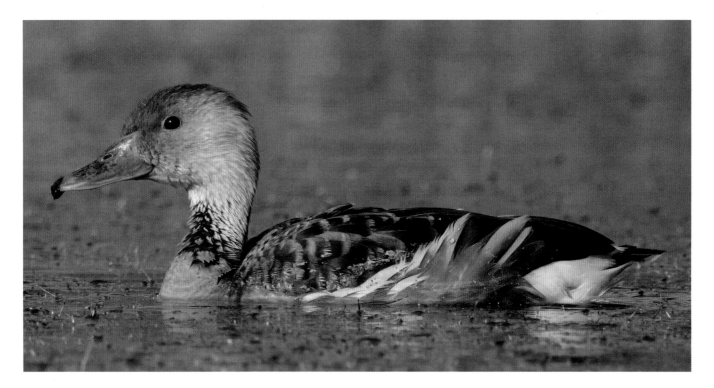

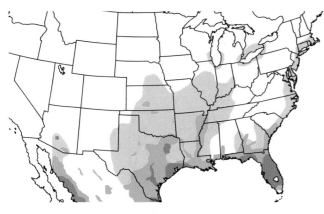

Black-bellied Whistling-Duck BBWD
Dendrocygna autumnalis L 21" WS 30" ♂ = ♀

In flight, this is a strikingly patterned flocking duck. Ranges from the Deep South and Borderlands southward to northern Argentina. Prefers tree-lined ponds and wetlands in open habitat. Perches in trees. Confiding and sociable. Forages mainly on land in day or night for seeds and vegetation. Nests mainly in tree cavities or nest boxes. Lays 12–16 whitish eggs. An increasingly frequent visitor northward and eastward. Now regularly seen in the Mid-Atlantic.

Fulvous Whistling-Duck *Dendrocygna bicolor*
L 19" WS 26" ♂ = ♀ FUWD

A vocal and sociable duck of rice fields of the Deep South, with other populations ranging to South America, South Asia, Africa, and Madagascar. Prefers freshwater wetlands. Active in daytime, at dusk, and at night. Forages in wet fields mainly for grains. This species also dives to forage and dabbles to harvest aquatic vegetation. Places grassy cup nest in marshland reeds. Lays 12–14 white eggs. Some North American populations appear to be decreasing. No longer breeds in California.

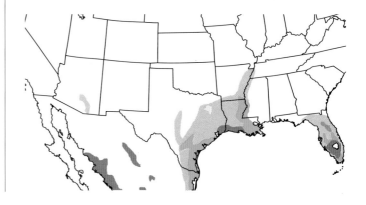

RANGE MAP COLOR LEGEND

summer migration year-round winter rare

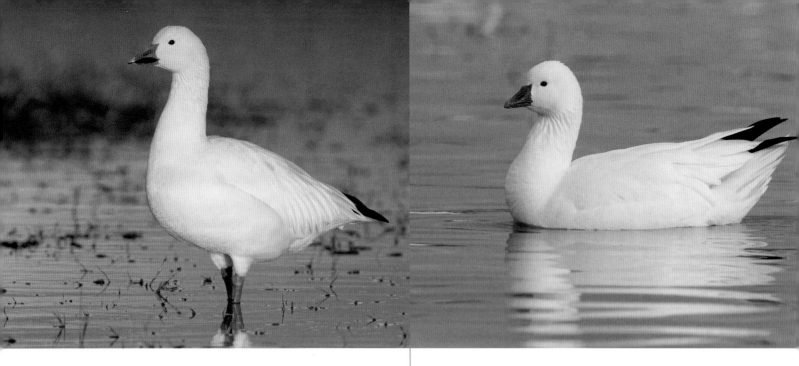

Snow Goose *Anser caerulescens*
L 30" WS 55" ♂ = ♀ SNGO

An abundant Arctic-breeding goose that summers in Canada, Alaska, and northeastern Siberia and winters across the United States. Breeds in Arctic tundra and winters in coastal bays and marshes and interior farm fields. Found in two color morphs—white and dark (the latter formerly known as the Blue Goose), which can be found in the same flock. The dark birds are typically uncommon in the East. Very sociable and vocal, moving about in noisy flocks that are popular with birders in winter. Feeds in stubble fields, coastal bays, and saltmarshes. Nests colonially; nest, sparsely lined with down, is placed on a low hummock in tundra. Lays three to five whitish eggs. In winter, spends the night on open water.

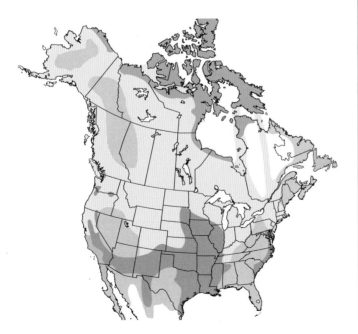

Ross's Goose *Anser rossii*
L 23" WS 45" ♂ = ♀ ROGO

This species is a diminutive and typically less common version of the Snow Goose. Both species exhibit a white morph and a "blue" or dark morph, but the latter is quite rare in Ross's Goose. Summers in Arctic Canada; winters patchily in the southern and central United States and Mexico. Breeds on tundra and winters in freshwater and salt marshes. Often associates with Snow Geese but also forms large monospecific flocks in central California. Feeds in stubble fields and shallow marshlands. Nests in loose colonies; down-lined nest is placed on ground on a small island in a tundra lake. Lays two to six off-white eggs. Occasionally hybridizes with Snow Goose. Ross's Goose populations have substantially increased since the 1950s. Remains on the wintering grounds longer into spring than the larger Snow Goose.

Canada Goose *Branta canadensis*

L 45" WS 60" ♂ = ♀ CANG

The common and widespread North American goose, with local resident populations ("golf course geese") and migrant wild Canadian breeding populations mixing in winter in the Lower 48. Seen overhead in V flocks that give a distinct honking call (hence the familiar name "honkers.") In Alaska, this species mainly breeds in the interior, whereas the similar Cackling Goose breeds along the coast. Nests in marshes and the edges of lakes and rivers. Loafs and feeds in grassy openings, parks, golf courses, stubble fields, lawns, and grasslands. Adults defending fledgling flocks can be aggressive. Nest is placed mainly on the ground on a grassy mound with a lining of down. Lays four to seven white eggs. The species is now naturalized and widespread in western Europe. Some northern populations are declining.

Cackling Goose *Branta hutchinsii*

L 25" WS 43" ♂ = ♀ CACG

A small, short-necked, and short-beaked version of the more widespread Canada Goose. Only recently considered to be a distinct species. Nests on Arctic tundra of Alaska and Canada. Winters mainly in farmland and interior marshes from Washington to Northern California, in the lower Great Plains, and on the Gulf Coast. Typically this species flocks with its own species but where it is rare it joins flocks of Canada Geese. Takes waste grain and vegetable matter from stubble fields and marshes. The nest of sedges, lichens, and mosses is situated on an elevated spot in tundra or on an island in a tundra pond. Lays two to eight white eggs. Given the variation among Canada and Cackling Geese, individuals can be difficult to identify. Use caution when identifying individuals out of range.

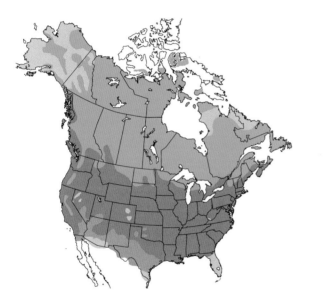

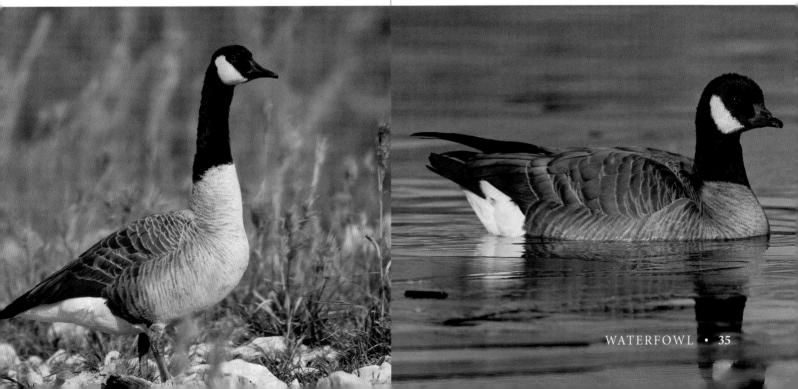

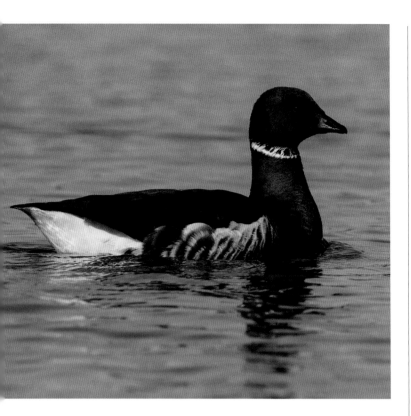

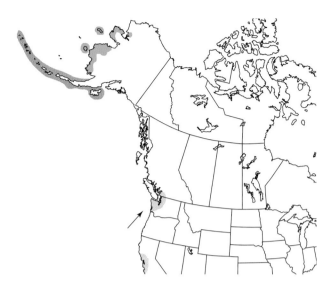

Emperor Goose *Anser canagicus*
L 26" WS 47" ♂ ≠ ♀ *NT *WL EMGO

A small and handsome Arctic-breeding goose of the northernmost Pacific Northwest that summers in Alaska and eastern Siberia. A species of the Bering Sea and Aleutian Islands. Nests in wet coastal tundra and winters in sheltered bays and lagoons along the coast of southwestern Alaska. Strays to coastal California and Washington. Takes primarily submerged vegetation but also consumes mollusks in winter. The down-lined ground nest is set on a small island in marshy coastal tundra. Lays four to six cream-colored eggs.

Brant *Branta bernicla*
L 25" WS 42" ♂ = ♀ BRAN

A small, dark goose that summers in the Arctic across the Northern Hemisphere. North American breeders winter in flocks along the East and West Coasts. Flies low in irregular ever-changing flocks. Breeds on the tundra and winters in salt marshes and estuaries near the sea. Very sociable and vocal. Feeds mainly on aquatic vegetation in shallow saltwater bays, occasionally on land. Mainly nests near or on Arctic coastlines; the bowl-shaped nest is lined with down and placed on a small island in a tundra pond. Lays three to five cream-colored or pale olive eggs.

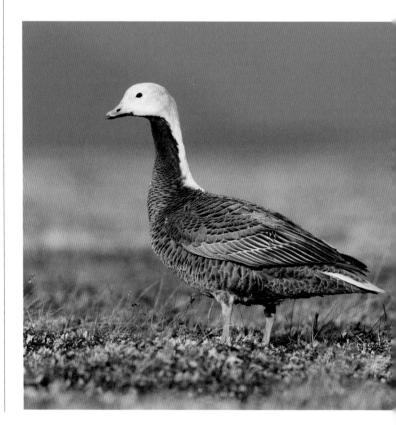

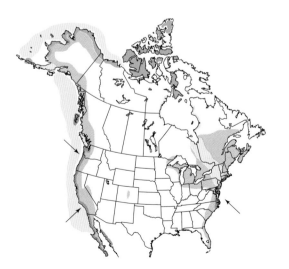

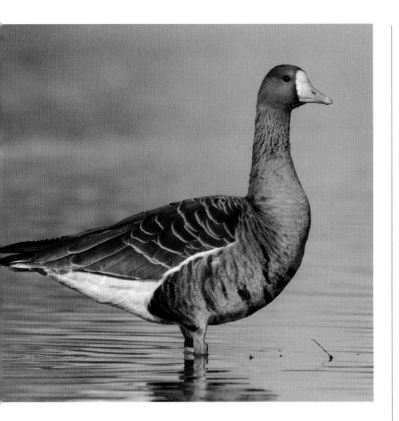

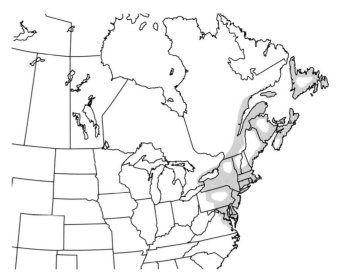

Pink-footed Goose *Anser brachyrhynchus*
L 28" WS 53" ♂ = ♀ PFGO

A dark European goose typically found in winter as a single-ton in a flock of another goose species (typically the Canada Goose). Has increased substantially in recent decades due to increases on the breeding range; now about a dozen North American records a year, ranging from Newfoundland to the Mid-Atlantic region. Summers in eastern Greenland, Iceland, and Svalbard. Could be confused for a young Greater White-front.

Greater White-fronted Goose *Anser albifrons*
L 28" WS 53" ♂ = ♀ GWFG

A sociable Arctic-breeding goose that migrates through the Far West and Great Plains, wintering in California's Central Valley, the lower Mississippi, and Mexico. More birds are wintering in the Mid-Atlantic of late. And Greenland breeders are showing up in our Northeast. Breeds in tundra marshes and wintering birds forage in marshes and stubble fields. Consumes plant material: roots and greenery in summer; seeds and waste grain in winter. Nests in a down-lined depression on the tundra. Lays three to six dull white eggs.

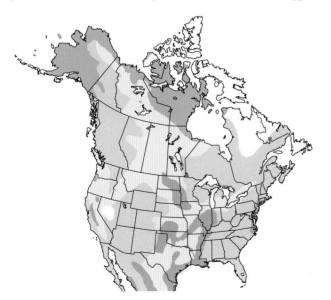

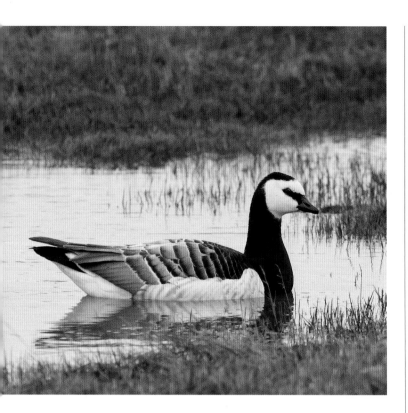

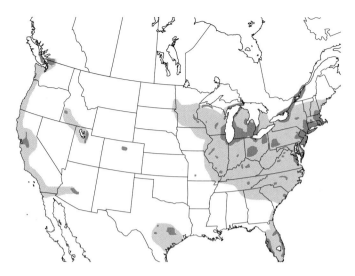

Mute Swan *Cygnus olor*
L 60" WS 75" ♂ = ♀ MUSW

A non-native, largely nonmigratory swan of the East and Midwest, though northern birds tend to move southward in winter. Some populations are now established on the West Coast. Native range is Eurasia. Frequents lakes and shallow ponds, often in urban parks; also bays and estuaries. Typically seen in pairs or small parties, but also in larger flocks during the nonbreeding season. Feeds mainly on aquatic plant material taken from shallow waters. Nest, set on a large waterside mound, is down- and feather-lined and is conspicuous. Lays five to seven pale green eggs. Adults guard their nest quite aggressively. Some state wildlife authorities consider this exotic invasive species to be a threat to local natural habitats and native wildlife populations.

Barnacle Goose *Branta leucopsis*
L 27" WS 50" ♂ = ♀ BARG

This very pretty white-faced goose is a rare visitor from eastern Greenland and northern Eurasia. The species is typically found in North America as a singleton or family group within a flock of Canada Geese. Migrants stray in autumn to Atlantic Canada and the Saint Lawrence valley. Rare individuals winter in East Coast marshlands or grasslands, and their occurrence in North America has increased in recent years, allied to the increase of Greenland's breeding population. The size of a Cackling Goose. Feeds in stubble fields with other geese. This is also a popular bird in captive waterfowl collections, so one must be cautious with individuals distant from typical coastal and northeastern wintering sites.

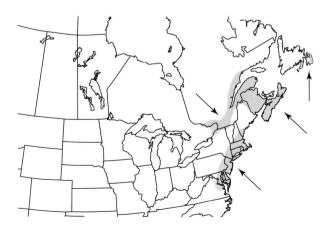

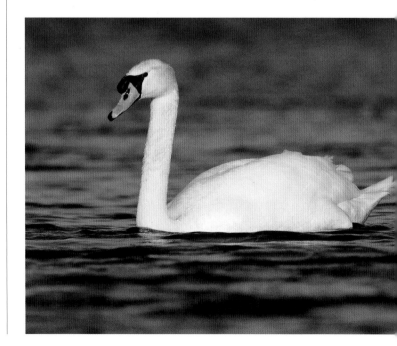

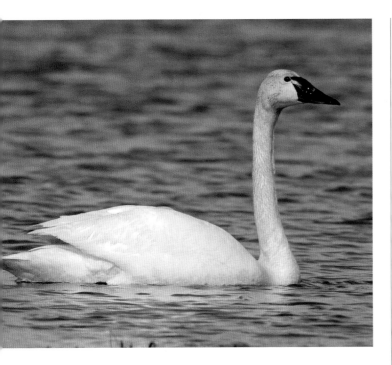

Trumpeter Swan *Cygnus buccinator*
L 60" WS 80" ♂ = ♀ TRUS

This is the largest of our waterfowl, now recovering from decimation of its population during the nineteenth century. Once bred widely from the Great Lakes to Montana and Alaska. Now a species of the Interior West and Pacific Northwest, most common in western Canada and Alaska. Recently, it has been successfully reintroduced to the Midwest. The southernmost breeding populations in the Lower 48 are nonmigratory. Inhabits lakes, ponds, marshes, and rivers. Typically seen in pairs or small family groups; winters in flocks in interior waters, the northern populations migrating southward. Harvests aquatic vegetation; in winter, will forage in stubble fields. Large mounded nest is situated atop a beaver lodge or on an island in a pond or lake. Lays four to six whitish eggs.

Tundra Swan *Cygnus columbianus*
L 49" WS 75" ♂ = ♀ TUSW

This widespread pan-boreal breeder summers in the Arctic of Alaska and Canada as well as Hudson Bay; also summers across northern Eurasia. North American breeders winter in large flocks on the West Coast and coastal Mid-Atlantic. In winter, feeds in shallow bays and agricultural fields. Diet is a mix of aquatic plant matter and seeds. Also consumes waste grain in winter fields. Feeds by tipping and dabbling. Nest is a large mounded basin, situated on an island or shore of a lake or pond in marshy tundra. Lays four to six whitish eggs.

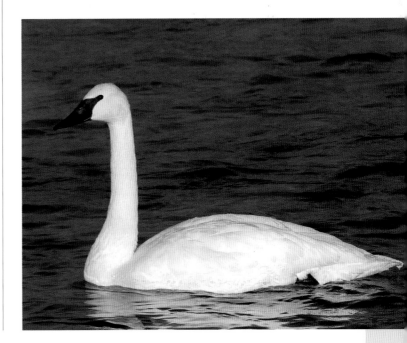

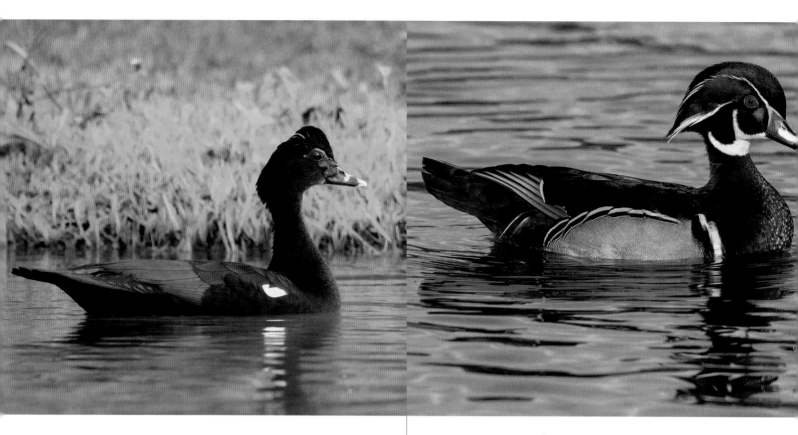

Muscovy Duck *Cairina moschata*
L 31" WS 48" ♂ ≠ ♀ MUDU *WL

This large and odd-looking species of South and Middle America is best known as a barnyard domestic (typically in a pied plumage) that might be found in a park pond anywhere in the Lower 48. A feral population inhabits South Florida. Wild individuals can be found infrequently in woodlands along the Lower Rio Grande of South Texas. Wild birds inhabit forested wetlands and spend considerable time roosting in trees. Fast-flying and wary. Feeds in small groups in tree-lined wetlands and riversides. Nests in a tree hollow or nest box. Lays 8–10 white eggs. The species in its native range is apparently on the decline. Ducks Unlimited Mexico has placed nest boxes in trees in appropriate habitat in Mexico to encourage nesting by wild populations of this species. The species is generally silent.

Wood Duck *Aix sponsa*
L 19" WS 30" ♂ ≠ ♀ WODU

The male of this species is a great beauty; the female is demure. The species is a widespread, common duck of wooded ponds and streams across the United States and southern Canada. The species has expanded its range into the northern Great Plains over the last half-century. The species population is stable. Very shy—it flushes with noisy alarm calls. Consumes aquatic plant material, especially seeds (even acorns), taken by dabbling in shallow water. Nests in tree cavities that overhang water as well as nest boxes placed over water. Young fledglings tumble from the nest into the water. Lays 9–14 whitish to pale buff eggs.

Canvasback *Aythya valisineria*
L 21" WS 29" ♂ ≠ ♀ CANV

A common breeder through the Prairie Potholes of the United States and Canada, ranging in small numbers northward into Alaska. Winters across the southern tier of states and along the three coasts. Wary and fast-flying. Nests in prairie and tundra marshlands. Winters in large flocks in coastal lakes and southern saltwater bays. Flocks of this species often can be found in association with other bay ducks, such as Redheads. Dives for aquatic plants. Down-lined nest is a bulky mass of marsh vegetation often over wet marshlands. Lays 7–12 olive-gray eggs.

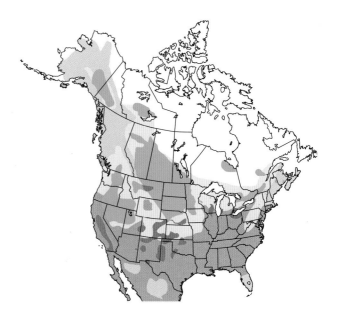

Redhead *Aythya americana*
L 19" WS 29" ♂ ≠ ♀ REDH

Another common Prairie Pothole nester, breeding from Alaska to New Mexico and Texas. It winters through the South, along the Atlantic, Pacific, and Gulf Coasts, and into Mexico. A marsh nester. Winters in flocks on bays and estuaries, often with other bay ducks such as scaup. Winter rafts of Redheads in popular coastal bays can be large. Dives for aquatic vegetation and invertebrates. Often feeds at night, resting during the day. The bulky down-lined nest is hidden in bulrushes in shallow water. Lays 9–14 whitish or olive-buff eggs. Females, on occasion, are known to lay eggs in the nests of other species. Declining in the East.

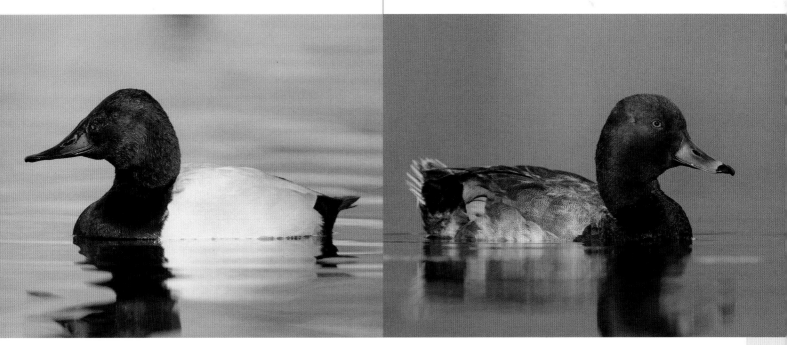

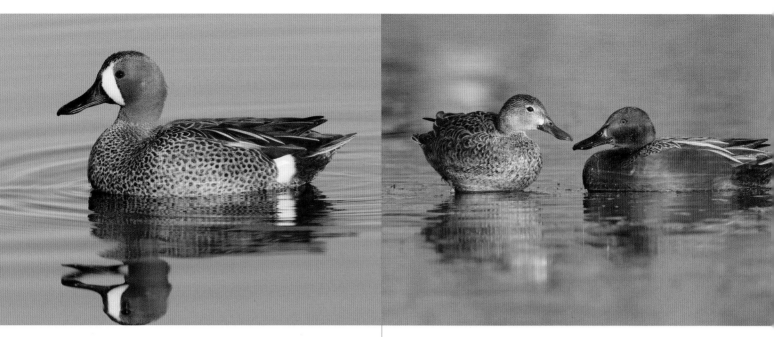

Blue-winged Teal *Spatula discors*
L 16" WS 23" ♂ ≠ ♀ BWTE

A small, fast-flying duck that breeds from coast to coast in the northern United States and Canada. The most abundant duck summering in the Prairie Potholes. Winters southward to the Atlantic, Pacific, and Gulf Coasts and to northern South America. Most members of this species winter south of the Border. Frequents freshwater ponds as well as fresh and brackish marshes. Typically occurs in small parties in shallow waters. Mainly takes aquatic vegetation from the surface of the water. Also takes some invertebrate prey. Nest is a shallow, down-lined depression of grass in the cover of taller grassy vegetation. Lays 9–13 dull white eggs with a greenish tinge. Migrates late in the spring and early in autumn. Population stable across the Continent.

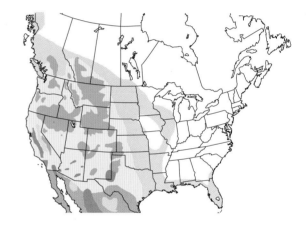

Cinnamon Teal *Spatula cyanoptera*
L 16" WS 22" ♂ ≠ ♀ CITE

The male is a very attractive western counterpart to the more widespread and abundant Blue-winged Teal. The females of these two are nearly identical. The Cinnamon inhabits ponds and marshes, as well as shallow alkaline lakes, but generally avoids the Prairie Potholes. Most frequently found in the Great Basin. North American breeders winter mainly in Mexico. Additional resident populations inhabit South America. A few stray to Florida in winter. Hybridizes with the Blue-winged Teal where the two breeding ranges overlap. Travels in small, fast-flying parties. Forages in shallow water for seeds of aquatic vegetation and some invertebrate prey. Nest is a down-lined shallow grassy depression hidden in marsh vegetation. Lays 9–12 whitish or pale buff eggs. Population appears to be stable, though much outnumbered by its close relative, the Blue-winged Teal. Not nearly as easy to find as the Blue-winged Teal.

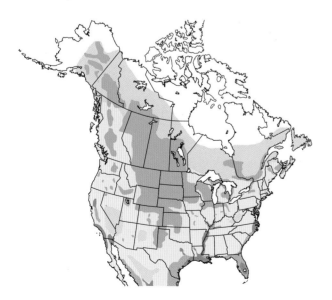

Green-winged Teal *Anas crecca*

L 14" WS 23" ♂ ≠ ♀ GWTE

The smallest of our dabbling ducks. This speedy little flier is widespread and common across northern and northwestern North America as well as Eurasia. Breeds in the Prairie Potholes and widely across Canada, in and around marshy bodies of fresh water. Winters in the interior as well as in coastal estuaries and bays. Notable for its rapid zigzagging flight in small flocks. Forages in shallow waters in small parties, dabbling for aquatic plant material and invertebrates. Down-lined nest is hidden in thick grasses, usually near water. Lays 6–11 pale buff eggs. The Eurasian subspecies overlaps with the American subspecies in the Bering Sea and is a rare visitor to the Atlantic and Pacific Coasts.

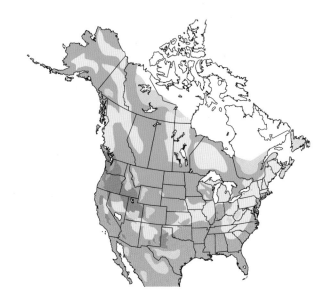

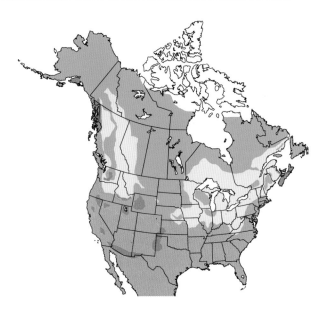

Northern Shoveler *Spatula clypeata*

L 19" WS 30" ♂ ≠ ♀ NSHO

This duck, which is superficially similar to the Mallard, has a large spatula-like bill that it uses to strain aquatic food from shallow waters. Summers from the northern and western Lower 48 north to Alaska, and also through northern Eurasia. North American birds winter into Mexico and as far south as Panama. Frequents marshes and shallow ponds and can be found wintering in flocks in estuaries and saltwater bays. An accomplished flier with a strong migratory habit. A surface-feeding specialist that targets invertebrates as well as plant material with its specialized bill. Nest is a down-lined grassy depression hidden in short grass and is situated near water. Lays 9–12 pale olive eggs.

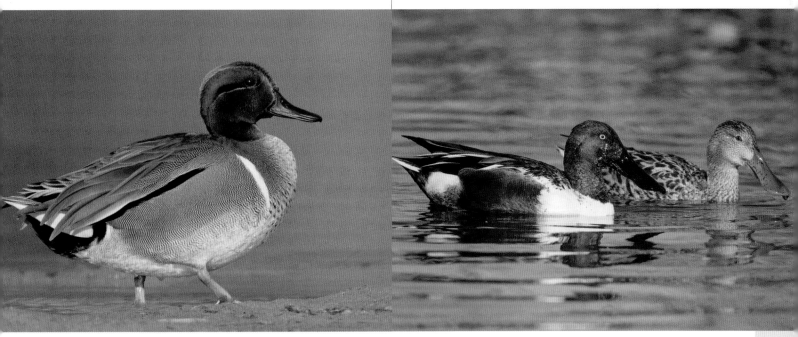

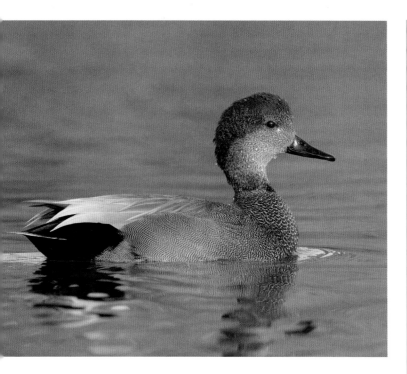

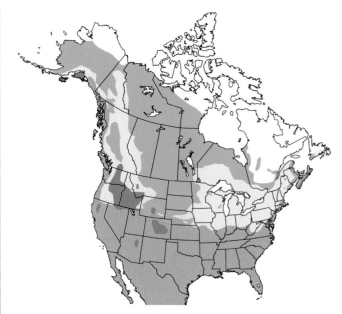

Gadwall *Mareca strepera*
L 20" WS 33" ♂ ≠ ♀ GADW

This demurely plumaged dabbler summers across much of North America and Eurasia. Winters southward, some birds reaching southern Mexico. Often overlooked because of lack of distinctive plumage features. Common and widespread in marshlands and prairie freshwater and brackish ecosystems of interior North America. Feeds on the move, taking items from the water surface or dabbling in shallow waters. Nests on the ground on dry land situated near water; nest is a grassy depression placed in a reedy thicket. Lays 8–11 white eggs. Concentrates in winter on the East and West Coasts. The species has been on the increase.

American Wigeon *Mareca americana*
L 20" WS 32" ♂ ≠ ♀ AMWI

This common and widespread duck flocks on lakes and ponds and is known to steal food from coots and diving ducks. Summers across Alaska, Canada, and parts of the western United States. Winters southward. Inhabits shallow lakes, ponds, and marshes in open habitats. Roosts at night in flocks on bays. Vocal and wary, flocks rise steeply in alarm when flushed. Forages in shallow waters and also grazes on land, taking shoots of grasses. Down-lined grassy nest is a depression placed on dry land near water and concealed by vegetation. Lays 8–11 whitish eggs. Population stable.

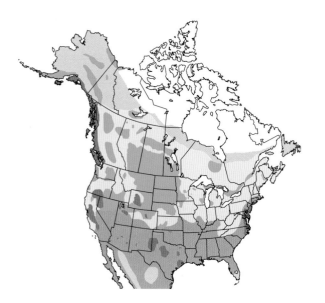

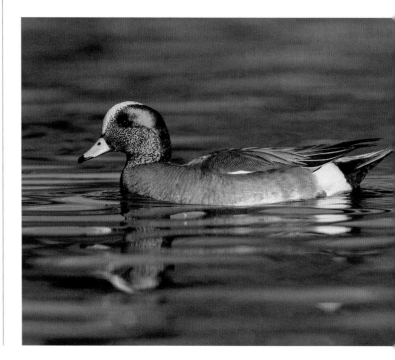

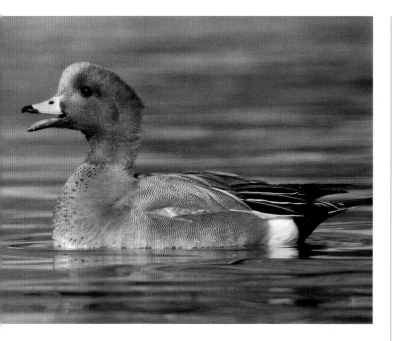

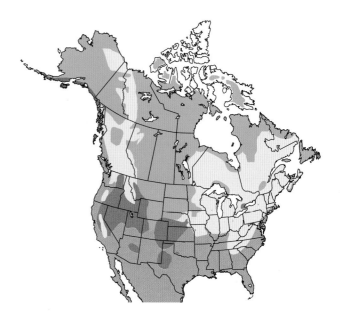

Eurasian Wigeon *Mareca penelope*

L 20" WS 32" ♂ ≠ ♀ EUWI

A widespread duck of the Old World that regularly strays to North America. Habits are much like its American cousin, with which it hybridizes regularly. Most commonplace in the Aleutians and western Alaska, but regular in small numbers along the West and East Coasts. Frequents lakes, ponds, and marshes in autumn, winter, and spring. Typically seen as a singleton in association with a flock of American Wigeons. Dabbles in shallow water, grazes on land, steals food from coots and geese, and is known to forage at night. Individuals often return to the same wintering site annually.

Northern Pintail *Anas acuta*

L 23" WS 34" ♂ ≠ ♀ NOPI

This graceful flier ranges across North America and Eurasia, making it one of the most abundant ducks on Earth, only outnumbered by the omnipresent Mallard. Summers in the Prairie Potholes, western marshes, shallow lakes, and brackish estuaries. Winters southward to shallow coastal embayments and flooded fields. Forages in shallow water for seeds of aquatic vegetation and invertebrates. Nest is a shallow down-lined basin of grass placed near water without much concealing vegetation. Lays 6–10 pale olive eggs. Largest wintering population is in California. North American populations show drought-induced fluxes.

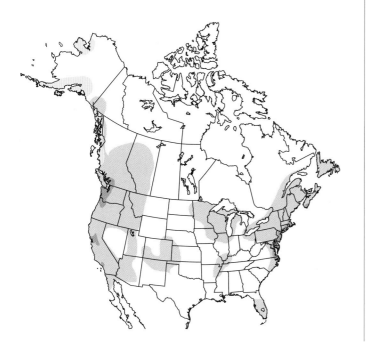

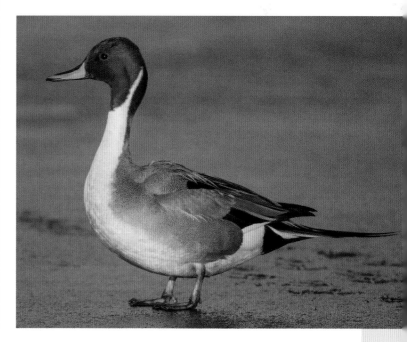

Mallard *Anas platyrhynchos*
L 23" WS 35" ♂ ≠ ♀ MALL

This is North America's most widespread, common, and familiar duck. It also ranges across northern Eurasia. Seen in parks, on virtually any body of water, and often breeding in cities in unlikely situations. Frequents lakes, ponds, marshes, wet ditches, riverine wetlands, and urban bodies of water of all sizes. Often seen in male-female pairs. Females produce large broods of ducklings, even in city centers. Dabbles for all manner of aquatic plant and animal material. Also forages on land by grazing. Northern breeders winter southward. The ground nest, a shallow bowl, is concealed in vegetation. Lays 7–10 whitish or olive-buff eggs.

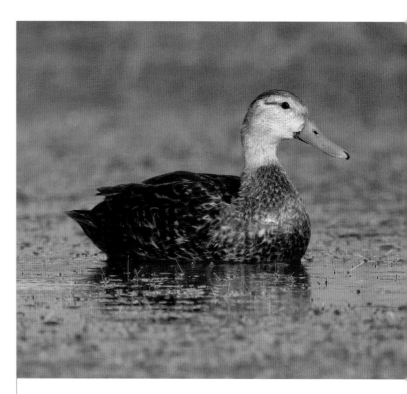

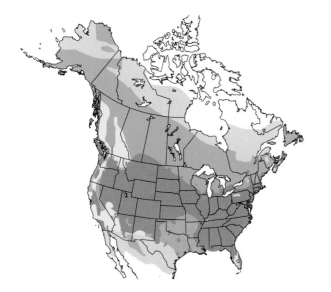

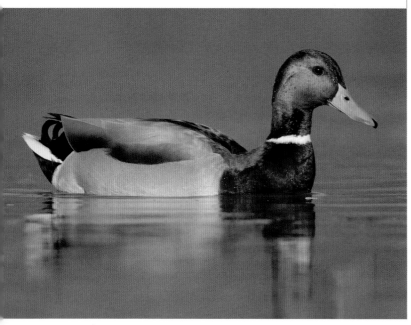

Mottled Duck *Anas fulvigula*
L 22" WS 30" ♂ = ♀ MODU

This close relative of the American Black Duck is an uncommon inhabitant of coastal and inland marshes of the Deep South. Very much a species of the Gulf Coast. Inhabits wet prairies, rice fields, and brackish marshes, typically back from the coast in open treeless expanses. Found in pairs and small parties. Forages in shallow water mainly by dabbling, taking invertebrates and aquatic vegetation. Nest, a shallow bowl of grasses, is hidden in thick marsh vegetation, usually close to water. Lays 8–12 whitish to pale olive eggs. Nonmigratory. Hybridizes with the Mallard and the Mexican Duck. Individuals stay in pairs year-round and generally do not join up in flocks. Introduced to South Carolina.

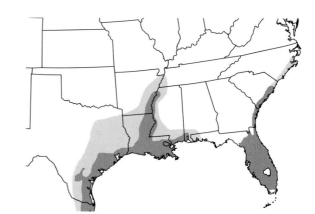

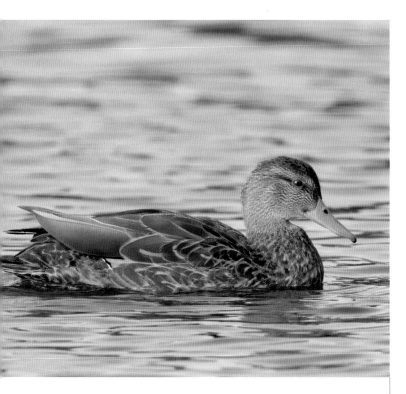

American Black Duck *Anas rubripes*
L 23" WS 35" ♂ ≈ ♀ ABDU *WL

An iconic duck of the northeastern marshes. Inhabits marshlands and woodland swamps of the East Coast and northeastern Interior, as well as other bodies of water, including estuaries. Shy and fast-flying. Usually found in pairs or small parties, in many cases in association with Mallards. Dabbles in shallow water for aquatic plants and invertebrates. The ground nest, a shallow grassy bowl, is typically hidden in thick marshy vegetation. Lays 7–11 creamy-white to greenish-buff eggs. Northern breeders winter southward. Possibly threatened by hybridization with Mallard.

Mexican Duck *Anas diazi*
L 22" WS 30" ♂ = ♀ MEDU

Quite similar to the Mottled Duck. And formerly treated as conspecific with the abundant and widespread Mallard. The Mexican Duck inhabits marshy ponds and rivers in the Arid Southwest, but most of its range is to the south in Mexico. Seen in pairs or small parties, at times mixing with (the paler-looking) Mallards, with which it hybridizes. Nest is lined with vegetation and down and placed in grassy or sedgy areas. Lays five to nine white eggs with a faint green tinge. The species probably has the smallest population of any of the Mallard-relatives.

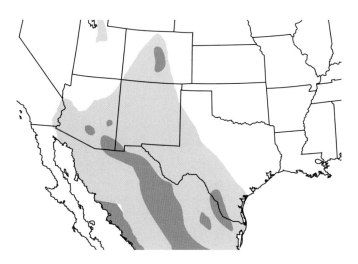

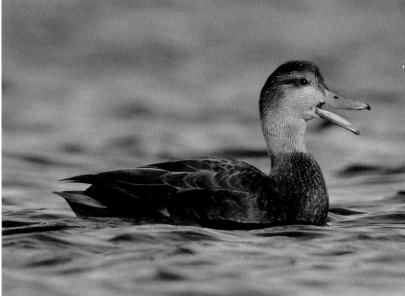

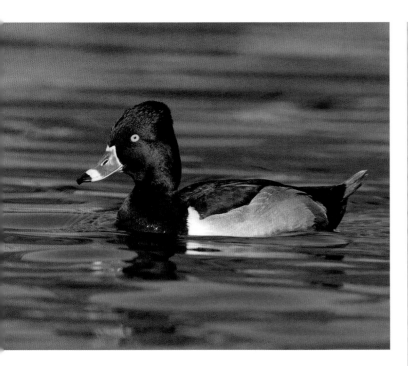

Tufted Duck *Aythya fuligula*
L 17" WS 26" ♂ ≠ ♀ TUDU

This is the Eurasian counterpart to our Ring-necked Duck. It is a rare but regular stray to North America. A visitor to the Atlantic and Pacific Coasts during the autumn, winter, and spring. Most regularly recorded in coastal western Alaska. Individuals are known to return to wintering locations year after year. Singletons are typically found in association with Ring-necks, scaup, or other diving ducks, and small flocks winter in Newfoundland. Behavior indistinguishable from that of the Ring-necked Duck. Dives for aquatic prey in association with large rafts of scaup and other bay ducks. Globally an abundant species—stable and widespread.

Ring-necked Duck *Aythya collaris*
L 17" WS 25" ♂ ≠ ♀ RNDU

This trimly patterned duck summers across Canada to Alaska south to the northern US Borderlands and Mountain West (south to Arizona). Winters in the southern United States and Mexico with some birds reaching Central America. Breeds on wooded ponds and lakes. Winters on fresh water, typically on waters protected by woodlands. Usually found in small and wary roosting or foraging parties. Takes aquatic vegetation and invertebrates by diving. Female places nest near water. Nest is a low, down-lined depression of grasses. Nests of several females may be placed near one another. Lays 8–10 buff to olive eggs.

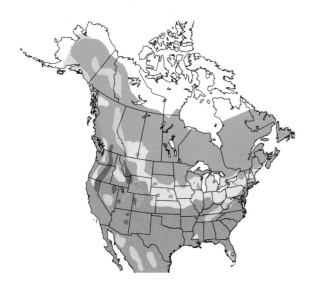

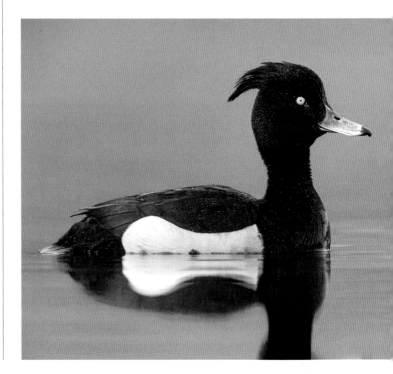

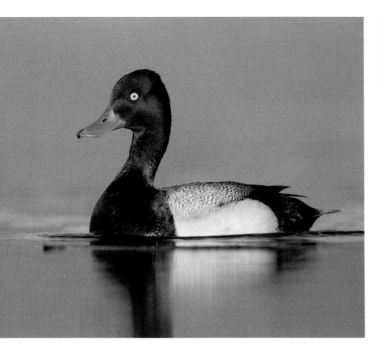

Lesser Scaup *Aythya affinis*
L 17" WS 25" ♂ ≠ ♀ LESC

A common and widespread diving duck across North America, forming large flocks in winter. Flocks of this species are often separate from Greater Scaup, but the two species regularly form mixed flocks. Breeds in the Prairie Potholes and in taiga and tundra ponds. Winters in large rafts on sheltered waters throughout the southern third of North America, including the Atlantic, Pacific, and Gulf Coasts. A very active feeder on the water. Forages primarily by diving, at times feeding at night. Takes mollusks, other invertebrates, and aquatic vegetation. Down-lined grassy nest is usually placed on dry ground adjacent to water and hidden in rushes. Lays 9–11 olive-buff eggs.

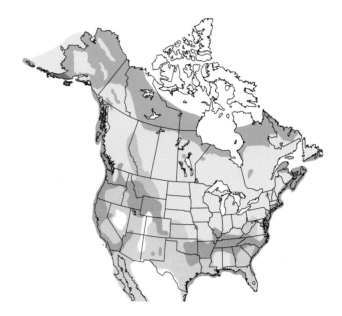

Greater Scaup *Aythya marila*
L 18" WS 28" ♂ ≠ ♀ GRSC

The more northerly of our scaup, nesting on taiga and tundra ponds and wintering in large estuaries and saltwater bays of the Atlantic, Pacific, and Gulf Coasts. In winter, it tends to prefer larger bodies of open water than the Lesser Scaup, though the two scaup species do form mixed flocks. Found in large flocks in winter. Dives for mollusks and aquatic vegetation. The down-lined low grassy nest is placed close to water on a small island in a pond or along the shoreline. Lays seven to nine olive-buff eggs. The population of this species is apparently stable.

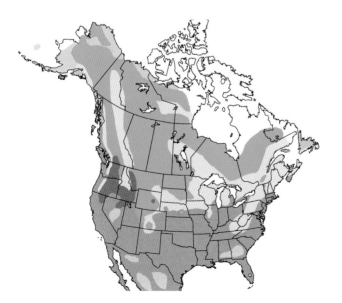

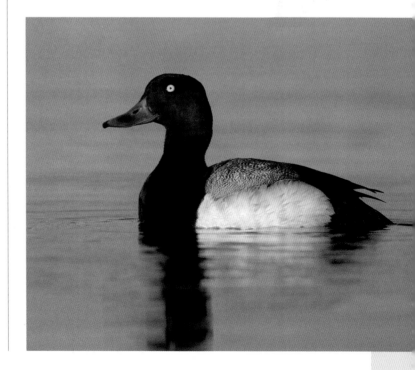

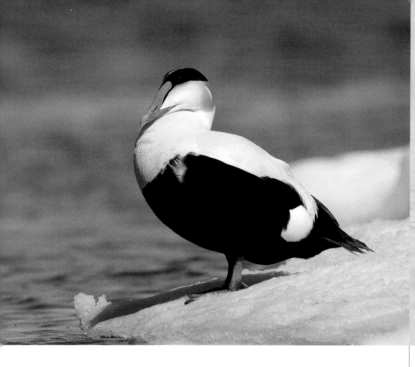
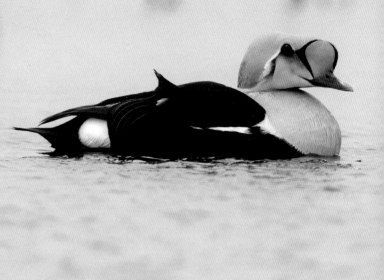

Common Eider *Somateria mollissima*
L 24" WS 38" ♂ ≠ ♀ COEI *NT *WL

This Northern Hemisphere sea duck is famous for the down produced by the nesting females. This down is harvested for pillows and cold-weather jackets and sleeping bags. A locally common duck of saltwater coasts in the Northeast and northern Europe, Alaska, and Northeast Asia. Frequently seen in flocks along the New England coast. Most common and widespread of the eider ducks. Very sociable and typically seen in coastal seas and estuaries. Feeds mainly on mollusks for most of the year, though takes other invertebrates during the breeding season. Nest is a low depression of plant material, abundantly lined with down, often situated near water. Lays three to five olive eggs. Northernmost breeders shift southward in winter. Atlantic Canada population is declining.

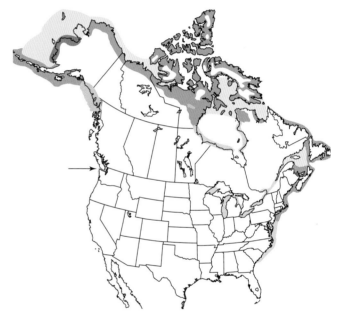

King Eider *Somateria spectabilis*
L 22" WS 35" ♂ ≠ ♀ KIEI *WL

A large sea duck of the Far North, inhabiting both the New and Old Worlds. The adult male in its breeding plumage is perhaps the most beautiful of the sea ducks. The females and young are dowdy by comparison. Breeds along rocky coasts of the Arctic. Carries out impressive coastal migrations in spring in the Far North. Winters primarily in cold oceanic waters. A rare winter visitor to coastal locations with rocky shores or rock jetties from New England to the Mid-Atlantic. Large flocks migrate in long lines off coastal shores. Forages for mollusks by diving, often in deep water. Down-laden nest is placed on dry ground near the water in coastal tundra. Lays four or five pale olive eggs.

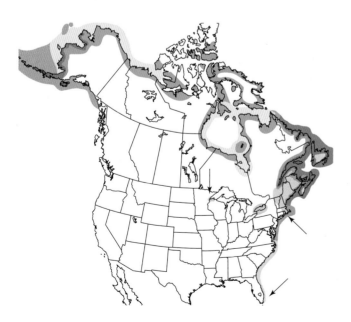

Spectacled Eider *Somateria fischeri*
L 21" WS 33" ♂ ≠ ♀ SPEI *NT *WL

A large, striking, and somewhat mysterious sea duck of the Bering Sea and Arctic Ocean. Breeds in wet low tundra of Alaska westward to central Siberia. Typically seen in pairs or small flocks, but winters in large flocks in openings in the sea ice of the Bering Sea. Forages for mollusks in winter when out at sea and for aquatic invertebrates and various types of plant material in summer when on land. The down-lined nest is a low grassy bowl placed at the edge of a tundra pond. Lays three to six olive-buff eggs. Alaskan breeding population has declined substantially over the last half century and is classified as Threatened by the US Fish & Wildlife Service. This is one of the most elusive of North America's waterfowl for birders, even in prime habitat.

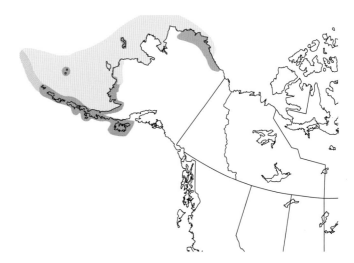

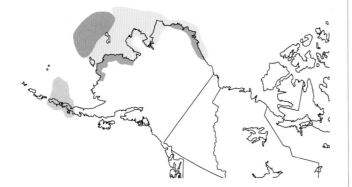

Steller's Eider *Polysticta stelleri*
L 17" WS 27" ♂ ≠ ♀ STEI *VU *WL

This small and atypical eider summers in northern coastal Alaska westward across the Arctic to central Siberia. North American birds winter along the Alaska Peninsula, Kodiak Island, and the Aleutian Islands. Summers in low tundra. Very sociable. In winter, it subsists on mollusks and other marine invertebrates. In summer, it takes aquatic arthropods and plant material. The down-lined nest is a low bowl placed in low tundra scrub near water. Lays seven or eight olive-buff eggs. Alaskan populations have declined substantially. Another very elusive duck for North American birders.

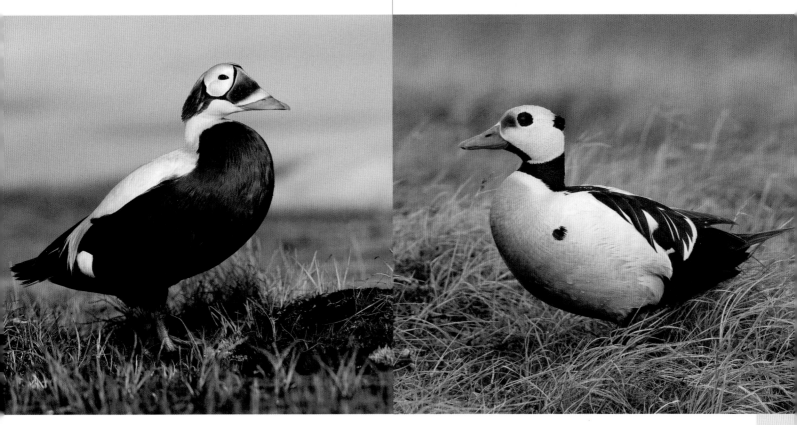

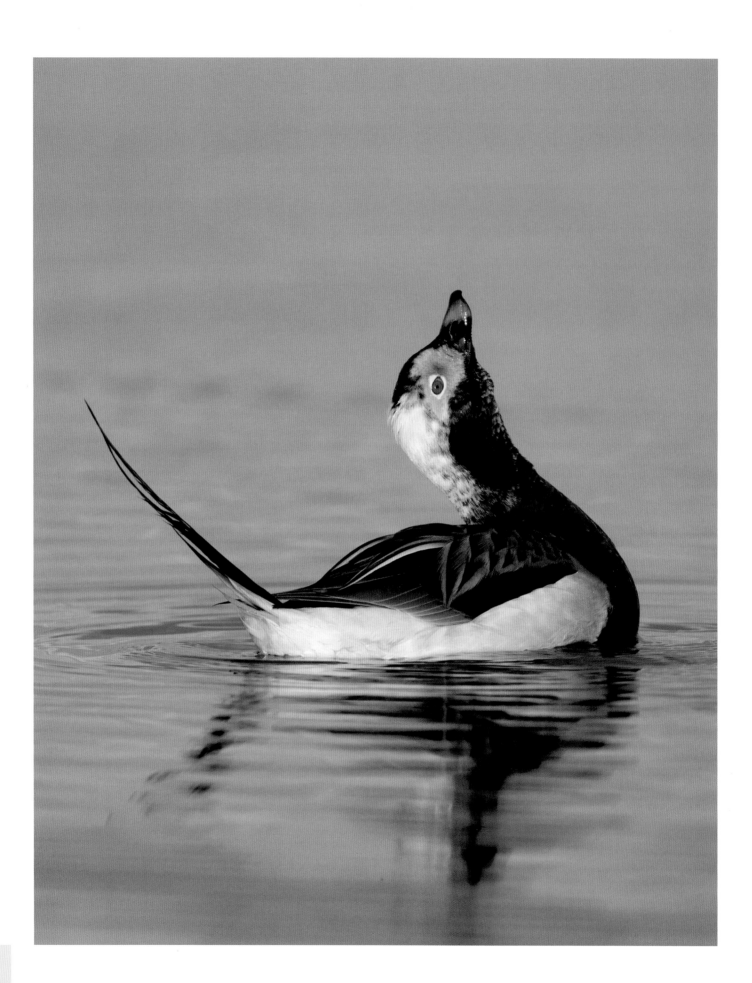

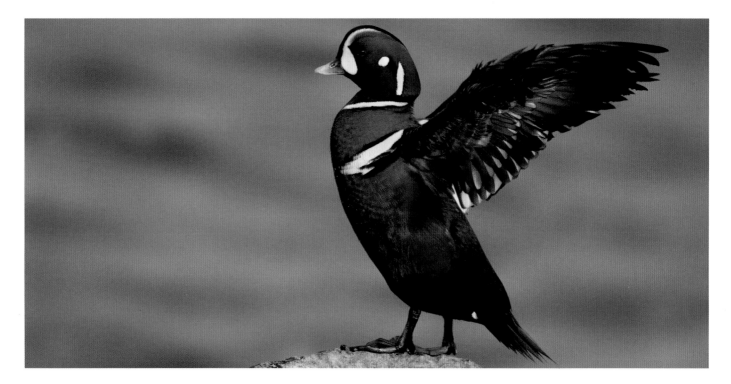

Harlequin Duck *Histrionicus histrionicus*
L 17" WS 26" ♂ ≠ ♀ HADU

The adult male is a favorite quarry of birders at northern coastal locations in winter. In summer, the species favors boreal and taiga-zone rocky torrents of Canada, the northern Rockies, Alaska, and eastern Asia. In winter, North American birds are found around rocky coastal sites in the Pacific Northwest, Atlantic Canada, New England, and the Great Lakes. Typically found in small parties in winter and male-female pairs in summer. In winter, feeds on mollusks and marine invertebrates; in summer, mainly aquatic invertebrates and aquatic plant material. The down-lined nest is a low bowl of vegetation set near water, well hidden by vegetation or rocks. Lays five to seven pale buff eggs.

Long-tailed Duck *Clangula hyemalis*
L 17" WS 28" ♂ ≠ ♀ LTDU *VU

An Arctic-breeding diving duck that features an extravagant male plumage. In North America, mainly seen in winter at sea or in large estuaries of the East or West Coast or in the Great Lakes. Breeds on tundra ponds. Winters in large vocalizing flocks, which can be heard from considerable distance. Often mixes with scoters and eiders in the winter, feeding mainly on mollusks and other marine invertebrates. In summer, consumes aquatic invertebrates, seeds, and plant material. The down-lined nest is usually placed on dry land near water and hidden under shrubbery. Lays six to eight olive-buff eggs.

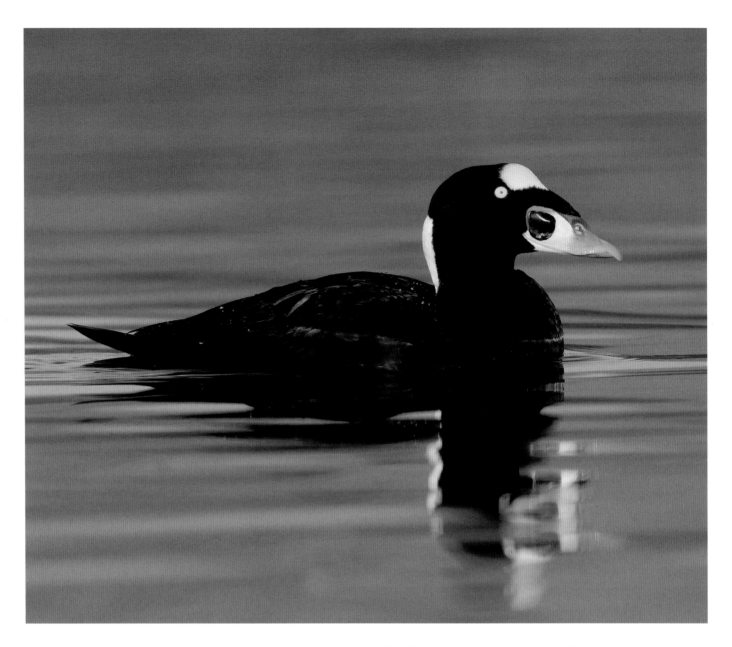

Surf Scoter *Melanitta perspicillata*
L 20" WS 30" ♂ ≠ ♀ SUSC *WL

A large and distinctive black sea duck of the New World. The males stand out prominently because of the distinctively patterned black, white, and orange head and bill. Breeds on lakes in northern Canada and Alaska; winters widely to the Atlantic and Pacific Coasts. Rare inland away from large lakes. Usually silent. Dives for mollusks and crustaceans. Nest is a down-lined depression on the ground by water in a spruce forest or tundra. Lays five to nine pale buff eggs. Seen migrating in large linear flocks low over coastal seas. The most common of our scoters, but the species is included on the Watch List because of recent declines.

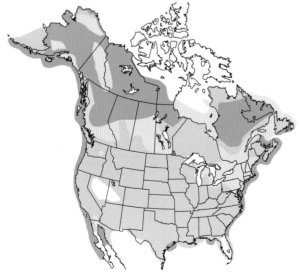

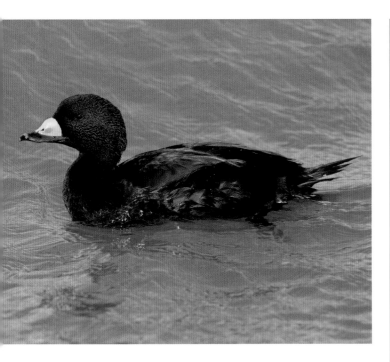

Black Scoter *Melanitta americana*
L 19" WS 28" ♂ ≠ ♀ BLSC *NT *WL

The smallest and most vocal of the scoters. Breeds in low wet tundra and in lakes and ponds in open taiga in Alaska, northeastern Canada, and eastern Siberia. Winters on the sea off the Atlantic and Pacific Coasts. Very sociable. During the autumn, seen in long lines flying low over the ocean, at times in association with other scoter species. In winter, takes mollusks and other marine invertebrates by diving. In summer, subsists on aquatic insects and plant material. The down-lined nest is a low basin of grass placed near water and hidden under thick shrubbery. Lays eight or nine pale buff eggs. In substantial decline.

White-winged Scoter *Melanitta deglandi*
L 21" WS 34" ♂ ≠ ♀ WWSC *WL

Largest of the scoters. Birds in flight show distinctive white secondary wing patches. Breeds in northwestern Canada and Alaska, wintering on the East and West Coasts and in the Great Lakes, favoring sandy shorelines. In autumn and winter, lines of birds fly low over the water. Flocks migrating over land tend to fly very high. Dives mainly for mollusks and crustaceans. The down-lined nest is a depression near water, hidden under brush. Lays 9 or 10 pale buff or pinkish eggs. North American populations are in decline.

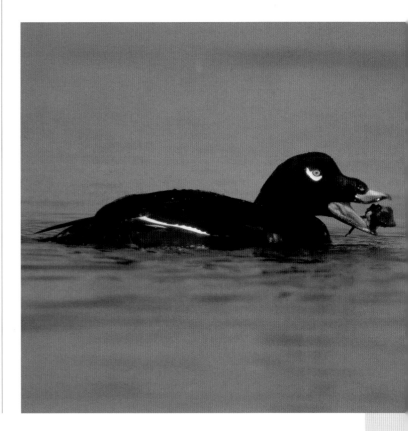

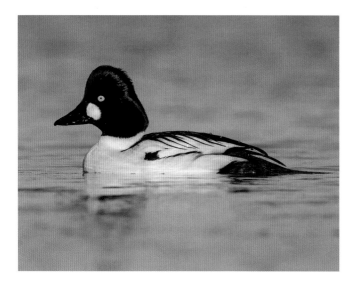

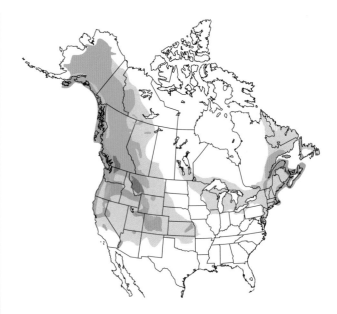

Common Goldeneye *Bucephala clangula*
L 19" WS 26" ♂ ≠ ♀ COGO

Male is a handsome diving duck of lakes and bays, breeding mainly in Canada and Alaska and wintering throughout southern Canada and the northern United States. Also summers across northern Eurasia. Summers on boreal ponds, lakes, and rivers in boreal conifer forest. Winters on open water of rivers, lakes, and bays. Usually outnumbered by Buffleheads and scaup. A rather shy diving duck. Considerably more common and much more widespread than Barrow's Goldeneye. Dives for aquatic insects in summer, pondweeds in autumn, and crustaceans and mollusks in winter. Does most of its foraging under water. Nests in the cavity of a large tree near a marshy lake. Lays 7–10 olive-green eggs. Population is apparently stable. Local populations have benefited where nest boxes have been provided.

Barrow's Goldeneye *Bucephala islandica*
L 18" WS 28" ♂ ≠ ♀ BAGO

This uncommon diving duck summers on taiga ponds and lakes in the Far North and on alpine lakes and rivers in the Rockies. Winters on ice-free lakes and bays. Summers in eastern Quebec, the Pacific Northwest, Alaska, and the northern Rockies. Also inhabits Iceland and southern Greenland. Retiring and fast-flying, typically found in small groups or pairs. Feeds on aquatic insects in summer and mollusks and crustaceans in winter, where it can be found in association with groups of Common Goldeneye. Female makes her nest in a tree hollow or on the ground—a down-lined depression. Lays 7–10 pale olive or blue-green eggs. This species is seen much less frequently than the Common Goldeneye, and thus is a prized addition to a day's bird list.

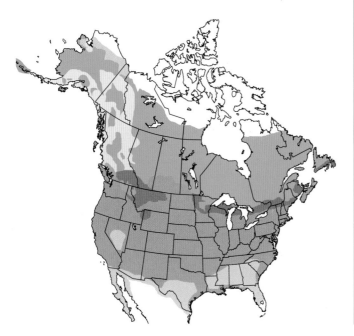

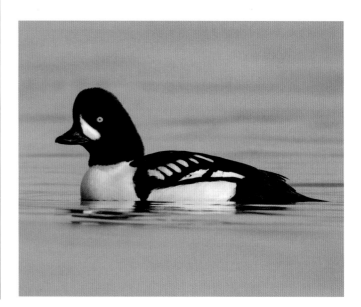

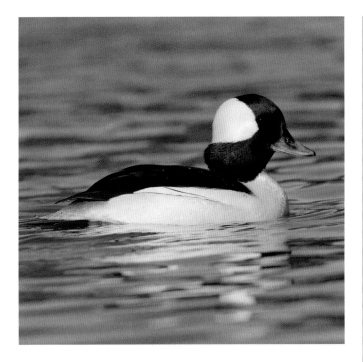

Bufflehead *Bucephala albeola*
L 14" WS 21" ♂ ≠ ♀ BUFF

A commonplace little diving duck. The male is distinctively pied and can be seen from a great distance on open water. Nests on boreal lakes and ponds; winters on open water of bays and large lakes. The drakes are very active in late winter, displaying to females. Dives for aquatic insects in summer and for crustaceans and mollusks in winter. Often nests in old woodpecker holes in boreal forest trees near water. Nest is down-lined. Lays 8–10 pale buff eggs. The population of this abundant little duck appears stable.

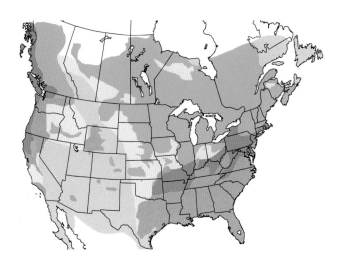

Hooded Merganser *Lophodytes cucullatus*
L 18" WS 24" ♂ ≠ ♀ HOME

This small freshwater duck summers in the northern Lower 48 and Canada and shifts southward in winter. The drake is strikingly patterned. Female is somewhat cryptic. A diving duck of wooded ponds, but also uses large lakes and estuaries in winter. Fast-flying. Male courtship display is energetic and varied. Dives for crustaceans, small fish, amphibians, and aquatic insects. Nest located in a tree cavity over water. Down-lined nest is of wood chips. Lays 10–12 white eggs. The species is less common in the West, more common in the East. Population appear stable. The smallest and handsomest of our three mergansers. Population is stable.

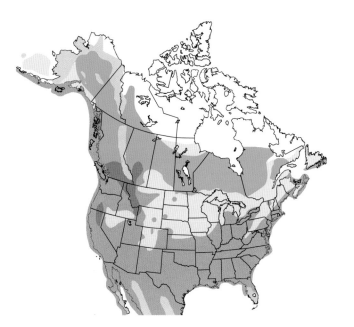

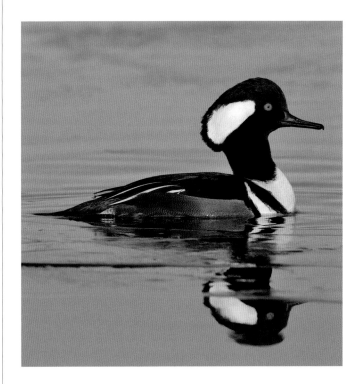

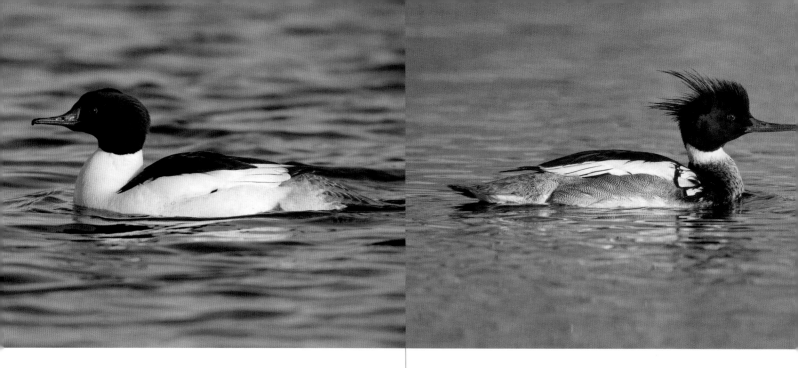

Common Merganser *Mergus merganser*
L 25" WS 34" ♂ ≠ ♀ COME

A large fish-eating duck that summers on northern and mid-continent rivers and lakes and winters on stretches of open fresh water across the United States and Canada. Generally a short-distance migrant. Northern extent of wintering depends on open water. Also summers across northern Eurasia. Haunts clear-water rivers and lakes mainly in the northern United States, Mountain West, and Canada to Alaska. Seen in pairs in early spring. During the summer, groups of female-plumaged birds are often seen loafing on rocks and logs. Actively dives for fish as well as other aquatic fare. The down-lined nest is placed in a tree hollow or other hidden location near water. Lays 8–11 pale buff eggs.

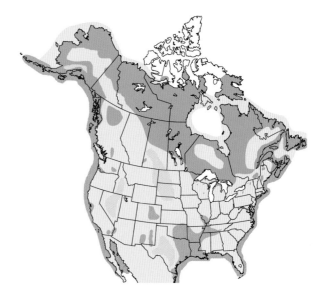

Red-breasted Merganser *Mergus serrator*
L 23" WS 30" ♂ ≠ ♀ RBME

A smaller and slimmer relative of the Common Merganser. The Red-breast has a more northerly breeding range and spends more time wintering on salt water. Summers on boreal lakes and rivers of Canada, Alaska, and the northeastern US Borderlands, as well as in Eurasia. Winters in estuaries, nearshore salt water, and large reservoirs. Dives for small fish and other aquatic life. Sometimes forages in groups to corral small fish. Places its down-lined nest on the ground, typically near water and hidden by vegetation. Nest is in some instances placed in a crevice or hollow. Lays 7–10 olive-buff eggs. Dintinguishing the females of this species and the Common Merganser requires care. The North American population is generally stable.

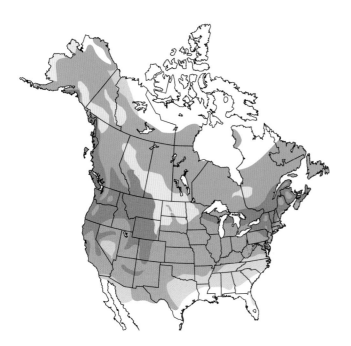

Masked Duck *Nomonyx dominicus*
L 14" WS 17" ♂ ≠ ♀ MADU

A rare Neotropical visitor from south of the Border to Texas and South Florida, with fewer than a dozen US records in the last decade. The species' range extends from the Caribbean and eastern Mexico south to northern Argentina. Typically a reclusive visitor to marshy ponds or aquatic impoundments; primarily active at night and spends most of the day loafing quietly. Does not usually associate with the similar Ruddy Duck. Apparently nomadic; movements unpredictable. Dives for aquatic vegetation. Has nested in Texas. Female constructs the reed nest in marshy wetlands. Lays 4–10 whitish or pale buff eggs. Exhibits periodic small-scale invasions of South Texas, then there will be years when it is not seen at all. Records also from the Midwest, the Mid-Atlantic, and New England.

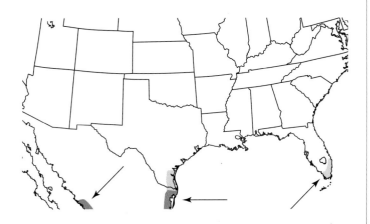

Ruddy Duck *Oxyura jamaicensis*
L 15" WS 19" ♂ ≠ ♀ RUDU

The drake is a compact and nattily patterned duck of open-water habitats. Summers in the western and north-central United States and Canada, and less commonly in the Northeast. Winters on the Atlantic, Pacific, and Gulf Coasts, as well as inland. Summers in ponds across the Prairie Potholes; winters in estuaries, bays, and reservoirs. Winters in monospecific flocks separate from other waterfowl. Dives mainly for aquatic vegetation and invertebrates. Additional populations are resident in the Caribbean and Mexico. Nest is a bowl of vegetation that is sometimes lined with down and is placed on the ground by the water, hidden in dense vegetation. Lays 5–10 whitish eggs.

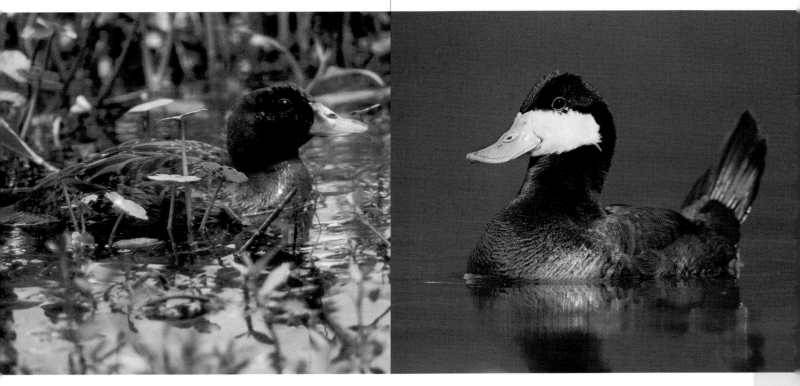

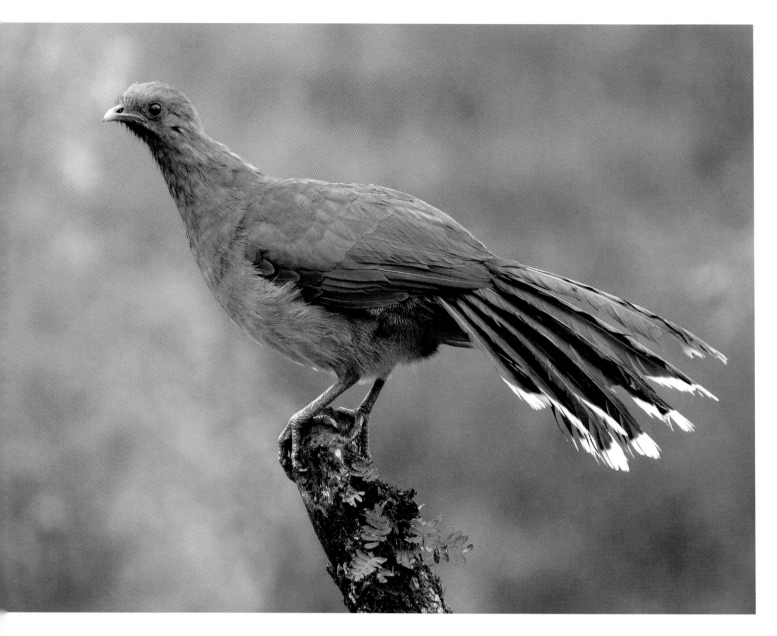

Plain Chachalaca *Ortalis vetula*
L 22" WS 26" ♂ = ♀ PLCH

A long-tailed and dull olive pheasant-like bird typically seen foraging on the ground in groups—the northernmost representative of the family that includes the guans and curassows. Inhabits South Texas brushland, especially in woodlands near a stream or river. The species ranges from South Texas to Costa Rica. Sociable and vocal, their loud raucous choruses traveling great distances. Mainly consumes plant material as well as a few invertebrates. Groups roost in trees. Nest is a stick platform placed up on a tree branch. Lays two or three creamy-white eggs. Typically nests near to water. An introduced population has become established on Sapelo Island, Georgia. The South Texas population appears stable. Can be quite confiding in some locations.

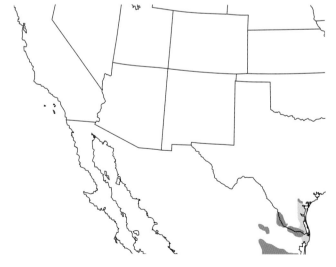

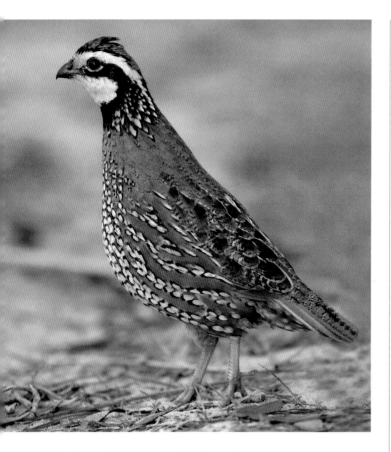

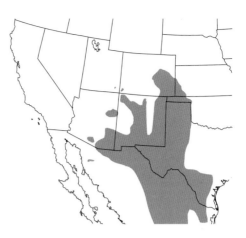

Scaled Quail *Callipepla squamata*
L 10" WS 14" ♂ ≈ ♀ SCQU

A crested quail resident across the Interior Southwest, ranging south into central Mexico. Inhabits grasslands, arid brushlands, and semi-desert. Generally inconspicuous except in spring when males are calling from exposed perches. Tends to run from danger rather than flying. Forages upon plant matter and invertebrates. The well-hidden ground nest is typically placed under a shrub; shallow depression is lined with leaves and grass. Lays 5–16 whitish eggs speckled with brown. Regularly visits water holes.

Northern Bobwhite *Colinus virginianus*
L 10" WS 13" ♂ ≠ ♀ NOBO *NT

Perhaps most distinctive is this species' loud and musical bob-WHITE song, given by the male. Has been declining in the East for decades, though still common in the Great Plains and Deep South. Long term decline tied to loss of habitat. Ranges from the northern US to southern Mexico and Cuba. Prefers weedy fields, old hedgerows, and brushy open country. In winter, the birds live in social groups of 10 or so, which break up during the breeding season. Subsists on plant matter and invertebrates harvested from rank grassland. The ground nest is a shallow depression hidden in dense undergrowth. Lays 12–16 white or pale buff eggs.

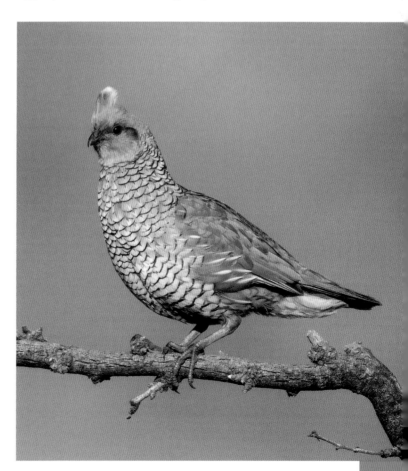

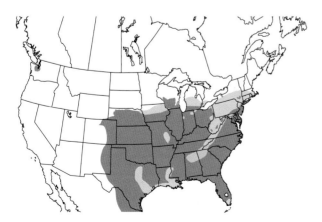

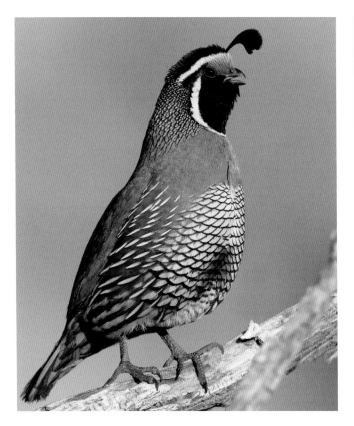

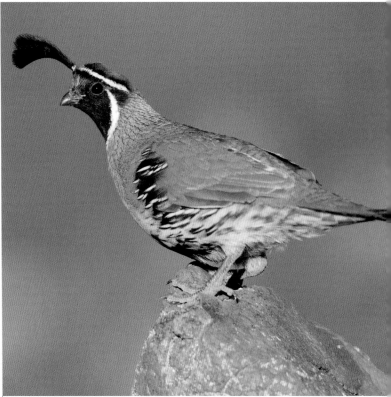

California Quail *Callipepla californica*
L 10" WS 14" ♂ ≠ ♀ CAQU

The strikingly handsome quail of the West Coast, ranging into southern Baja. Male's little topknot is like a large black comma. Female's is smaller and less obvious. Inhabits chaparral, scrub, parks, and suburbs. Travels in tight coveys that burst into flight with noisy wings when disturbed. The male sings his three-note chuckle from atop a fencepost. Forages for a variety of plant matter taken from the ground. The leaf-and-grass nest is usually hidden on the ground under brush. Lays 10–16 pale buff eggs. The range of the species has been enlarged by introductions in many locations including the Interior Northwest, the Pacific Northwest, Hawaii, Chile, and New Zealand.

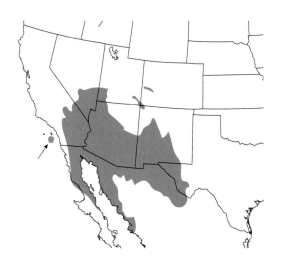

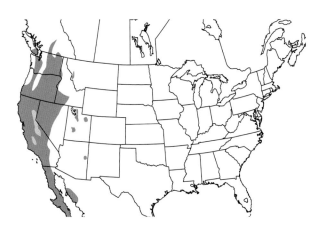

Gambel's Quail *Callipepla gambelii*
L 10" WS 14" ♂ ≠ ♀ GAQU

Very similar to the California Quail but inhabits interior arid country south and east of the range of that species. Ranges into western Mexico. Occupies semi-desert, dry shrublands, and associated agricultural lands. Also visits rural and suburban bird feeders offering seed on the ground. Sociable during the nonbreeding season, traveling in coveys. Diet is mainly plant matter. Nest is a shallow depression of grass placed on the ground under a shrub. Lays 10–12 pale buff eggs. Visits water holes to drink. The male's repeated chuckling is a part of the soundscape of the Arid Southwest.

Mountain Quail *Oreortyx pictus*

L 11" WS 16" ♂ ≈ ♀ MOUQ

The tall, black, twinned forehead plume is unique. A beautiful quail of chaparral, pine forest, and woodland in mountainous country. Ranges into northern Baja. Uncommon and unobtrusive. Difficult to see unless the male is singing from a prominent perch. Feeds upon plant material as well as some invertebrate life. Nest is a shallow depression of grass and leaves on the ground, hidden under dense vegetation. Lays 9 or 10 creamy-white or pale buff eggs. Moves to lower elevations in winter. Overall the species appears to be in decline.

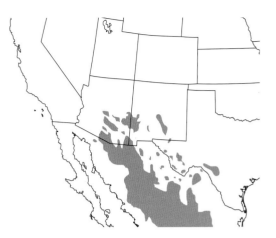

Montezuma Quail *Cyrtonyx montezumae*

L 9" WS 15" ♂ ≠ ♀ MONQ

The male, with his harlequin pattern, is a small and globular game bird of the Southwest Borderlands. The species ranges south into the mountains of southern Mexico. Frequents arid canyonlands, mountain slopes, grassy hills, and dry woodland—usually habitats including both oaks and grassy ground cover. Difficult to see. Crouches motionless when disturbed, waiting until the last moment before noisily flying off. Diet is a variety of plant material and invertebrates, including berries, acorns, and bulbs. Nest, constructed on the ground, is a grassy structure with a side entrance and a grassy dome. Lays 10–12 white eggs.

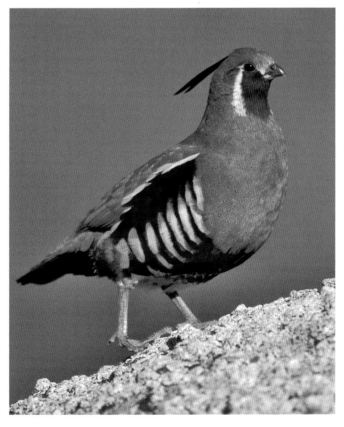

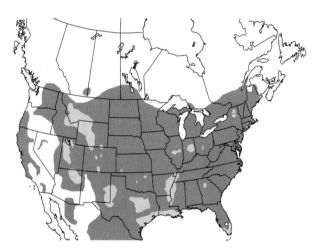

Wild Turkey *Meleagris gallopavo*
L 46" WS 64" ♂ ≠ ♀ WITU

At 16 pounds, the male Wild Turkey is North America's largest game bird. It ranges across most of the Lower 48 and much of Mexico. Inhabits forest and woodlands, but commonly forages in clearings. Typically seen in a flock at the edge of an agricultural field. Widespread and has been expanding its range; reintroductions have aided their recovery after being essentially exterminated from those sites by the 1890s. The adult male ("gobbler") is a massive and impressive game bird. Individual males can be quite territorial and aggressive, even in backyards. Forages mainly on the ground for plant matter (especially acorns), invertebrates, and small vertebrates. Ground nest is a shallow depression, lined with grass and leaves, situated near the base of a tree or some sort of concealing cover. Lays 10–15 white or buff eggs with red-brown dots.

Gray Partridge *Perdix perdix*
L 13" WS 19" ♂ ≠ ♀ GRAP

A Eurasian game bird introduced to North America more than a century ago—another species brought from overseas to enrich our hunters' bag. Native range extends from England to central Russia. In North America, found mainly resident in the northern prairies and northern Rockies. Also in spots in the northeastern Borderlands. Most prevalent in farm country—especially overgrown pastures, grassy meadows, and agricultural lands. Travels on the ground in groups, which flush as a cohesive flock. Often remains hidden in grass. Diet is mainly plant matter with a few invertebrates. The ground nest is a shallow depression lined with vegetation and sited under a hedgerow or other cover. Lays 10–20 olive eggs. This exotic species is apparently declining in many places in its adopted homeland in North America.

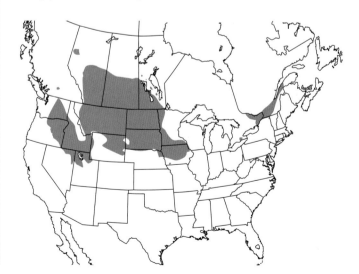

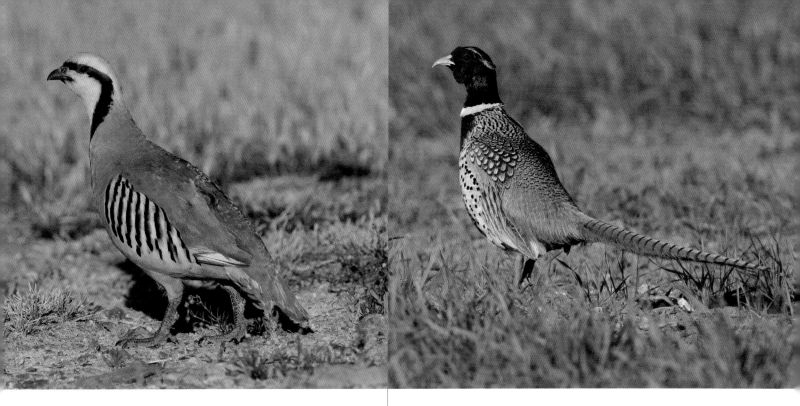

Chukar *Alectoris chukar*
L 14" WS 20" ♂ = ♀ CHUK

A widespread Asian game bird successfully introduced to western North America. Males are vocal and active in spring. Inhabits rocky and arid mountain country, especially canyon lands with access to water. Travels in flocks in the nonbreeding season. Nonmigratory. Forages mainly on the ground for plant matter and some insects. Ground nest is a depression of grass and leaves hidden under a shrub, thick grass, or a rock overhang. Lays 8–15 whitish eggs spotted with brown. Birds continue to be released for sport hunting in other parts of North America. Large coveys can be seen at water holes. Immediately recognizable, as its facial and flank plumage patterns are unlike that of any other game bird in North America.

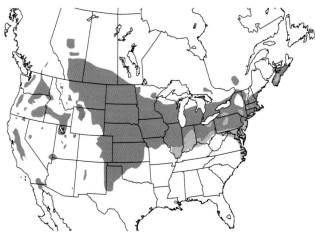

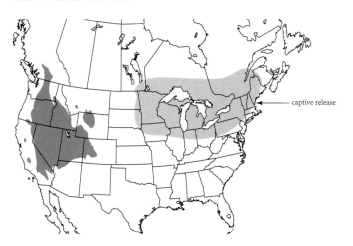

captive release

Ring-necked Pheasant *Phasianus colchicus*
L 35" WS 31" ♂ ≠ ♀ RNEP

An Asian pheasant that has been introduced to Europe and North America as a game bird. Native range is from the Caucasus to Korea. The cock is one of the most distinctive and ornamented birds in our avifauna. Prefers agricultural lands as well as open grasslands and marshlands. Solitary in the summer season. More sociable in the nonbreeding season, when birds form small sex-specific flocks. Nonmigratory. The polygamous male keeps a cohort of females in the breeding season. Diet includes plant matter, invertebrates, and small vertebrates. The ground nest is a shallow grassy depression placed under dense cover. Lays 6–15 buff-olive eggs. Abundant in the northern Great Plains. Declining in the East. Individuals of this species are still being released for hunting purposes.

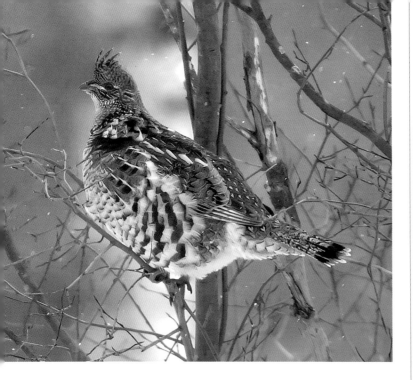

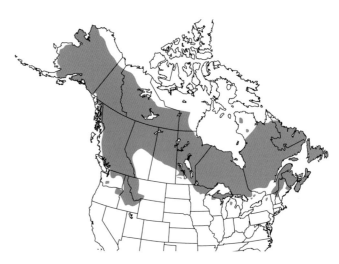

Spruce Grouse *Canachites canadensis*
L 16" WS 22" ♂ ≠ ♀ SPGR

A very tame but reclusive grouse of boreal conifer forests. Typically difficult to locate, but often does allow close approach if found. Inhabits forests of spruce and fir as well as those of Jack and Lodgepole Pine. Nonmigratory. Only frequents forest where the ground is covered with *Sphagnum* moss. Spends time on the ground dust-bathing in favored clearings. Feeds on buds and the fresh needles of conifers taken from tree branches, especially in winter. Also forages on other plant matter and invertebrates on the ground. The male conducts a short flight display in early spring. The nest, placed on the ground, is a shallow depression under dense cover. Lays 4–10 olive or buff eggs, typically blotched with brown.

Ruffed Grouse *Bonasa umbellus*
L 17" WS 22" ♂ = ♀ RUGR

The is the "partridge" favored by hunters across much of North America. Ranges from Alaska to northern Georgia. Populations rise and fall but most have shown long-term declines. Most commonly detected in spring by the low-pitched rhythmic "drumming" by the male when displaying in the woods. Prefers mixed forest broken by shrubby openings. Consumes plant material and invertebrates taken from the ground and in favored trees. The male's stunning spring courtship display is carried out from atop a fallen log in forest interior. The male fans his tail, erects his black neck-ruff into a circular collar, and drums the air with his wings. The ground nest, placed near a rock or log or hidden under vegetation, is a depression lined with various plant materials and a few feathers. Lays 9–12 buff eggs that are spotted brown.

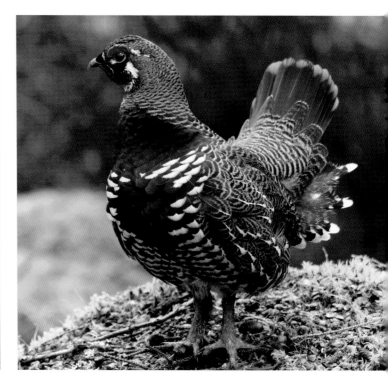

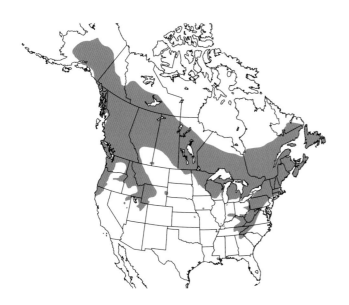

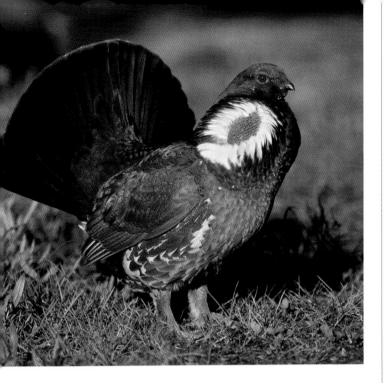

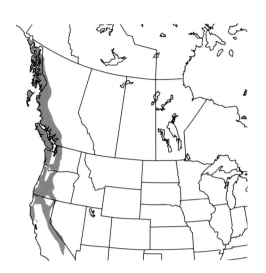

Dusky Grouse *Dendragapus obscurus*
L 20" WS 26" ♂ ≠ ♀ DUGR

Very similar to the Sooty Grouse, but it inhabits mountain forests of the Interior West. Prefers openings in montane conifer forest and scrubland adjacent to aspen stands. The male displays on the ground in a clearing by calling, fanning his tail, and exhibiting his two "fried egg" dark pink neck sacks. Voice low and heard only at close range. Diet in winter is mainly conifer needles; in summer, it takes a mix of animal and plant matter harvested from the ground. The ground nest is a bare shallow depression near a stump or rock. Lays 5–10 cream-colored eggs spotted with brown.

Sooty Grouse *Dendragapus fuliginosus*
L 20" WS 26" ♂ ≠ ♀ SOGR *WL

A large and dark grouse of open northwestern coastal conifer forests. Inhabits mature forests of Douglas-fir, hemlock, cedar, and true fir. In spring, the male displays by giving his owl-like hooting call from a well-hidden perch atop a tall conifer. Diet includes a mix of conifer needles (especially in winter), other plant material, and invertebrates. Ground nest is a shallow depression placed at the base of a large tree, hidden by some vegetation. Lays 5–10 beige eggs spotted with brown. Population in decline, especially in California.

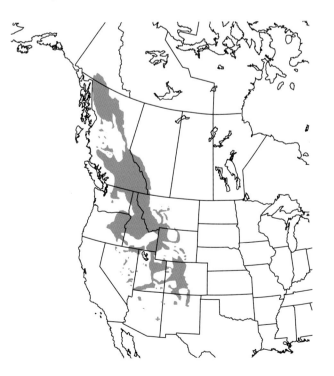

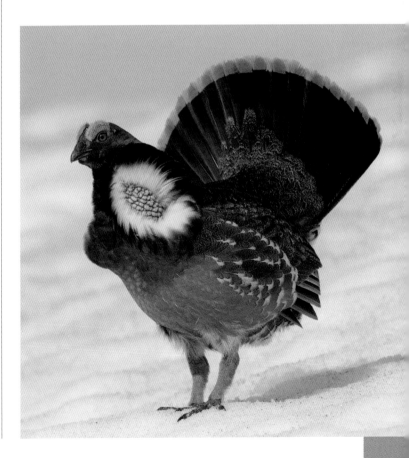

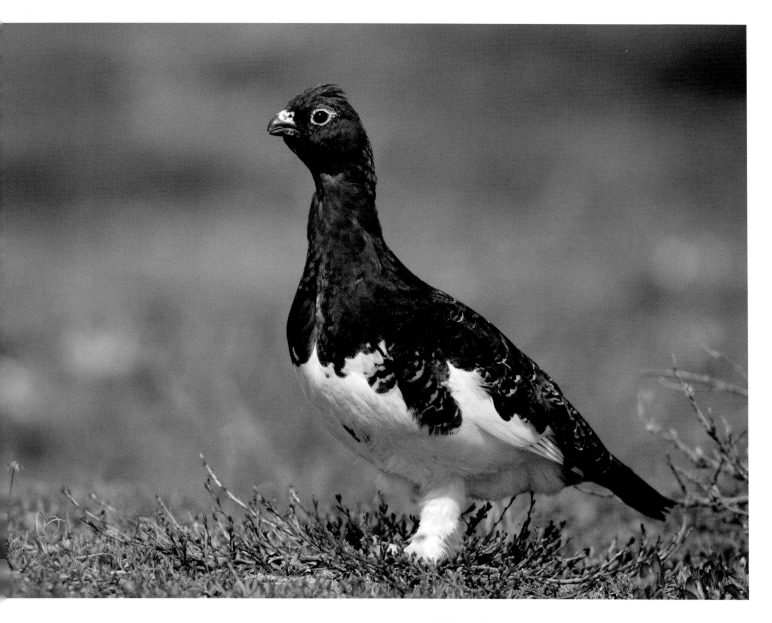

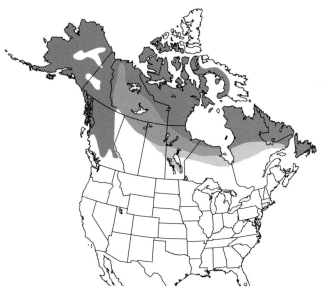

Willow Ptarmigan *Lagopus lagopus*
L 14" WS 23" ♂ ≈ ♀ WIPT

A common and tame resident of dwarf willow thickets in tundra across the Northern Hemisphere. The male, in spring, carries out circular display flights, giving its weird gurgling call. Inhabits low wet tundra and also muskeg. South of tundra areas, it is found in clearings in mountainous uplands. Very tame and confiding, especially displaying males in spring. A terrestrial feeder, taking mainly plant material. Ground nest is a shallow depression lined with grass and moss, sited in open tundra or under a willow thicket. Lays 5–15 blotchy blackish-brown eggs. The winter plumage of the Willow Ptarmigan, the Rock Ptarmigan, and the White-tailed Ptarmigan is nearly all white, to hide in the snowy landscape. Some ptarmigans migrate southward in groups in winter.

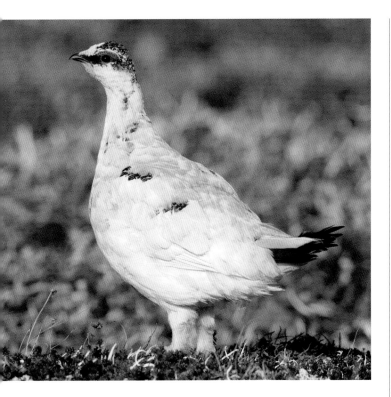

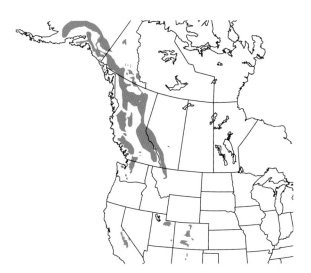

Rock Ptarmigan *Lagopus muta*
L 14" WS 23" ♂ ≈ ♀ ROPT

Less common than the better-known Willow Ptarmigan, and more difficult to find, inhabiting less accessible habitat. It, too, spans the Northern Hemisphere. In spring, males carry out display flights. Inhabits barren rocky upland tundra with a scattering of thickets. Birds pair up during the summer but travel in flocks in winter. Largely a consumer of terrestrial plant matter, though it also takes some invertebrate prey. The ground nest is a shallow depression lined with moss and lichen, protected by the proximity of a large rock. Lays 4–13 pale buff eggs with brown spotting. Some birds winter southward and to lower elevations. Populations fluctuate. Southernmost populations may be contracting northward.

White-tailed Ptarmigan *Lagopus leucura*
L 13" WS 22" ♂ ≈ ♀ WTPT

The White-tailed Ptarmigan, the smallest and most southerly of the ptarmigans, is easily overlooked and difficult to locate in its open grassy and rocky habitat. Inhabits alpine tundra in high mountains of the West, from Alaska to New Mexico. This is the only ptarmigan to be regularly found in the Lower 48. It associates in groups during the nonbreeding season. Forages for terrestrial plant matter and the occasional invertebrate. Ground nest, situated under low vegetation, is a shallow depression lined with grasses and a few feathers. Lays two to eight pale cinnamon eggs spotted with dark brown. Shifts to lower elevations in winter. Introduced to the Sierra Nevadas of California and the Uintas of Utah.

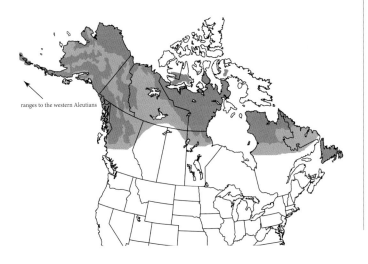

ranges to the western Aleutians

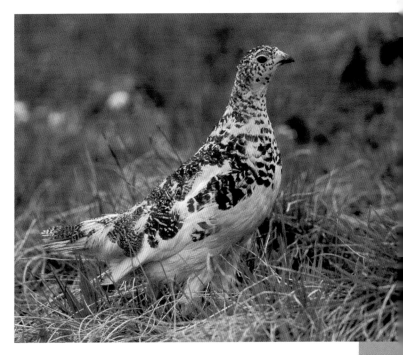

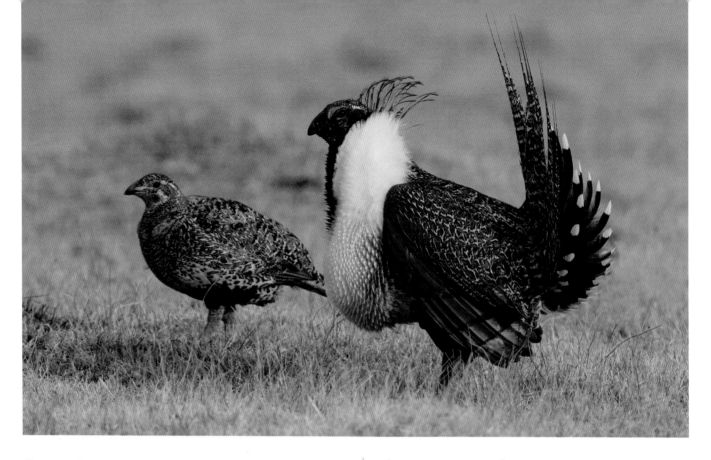

Greater Sage-Grouse *Centrocercus urophasianus*
L 28" WS 38" ♂ ≠ ♀ GRSG *NT *WL

A large grouse of sagebrush country, in decline because of widespread disturbance of its habitat from gas and oil exploration as well as overgrazing. Inhabits plains, foothills, and upland mesas where sagebrush predominates. Males congregate on a traditional display ground (a lek) in the manner of the other prairie grouse. Some leks may feature more than 50 displaying males. Diet includes sage buds, sage leaves, and arthropods. The ground nest, sited under a sagebrush or tussock of grass, is a shallow depression lined with grass. Lays seven to nine olive-buff eggs dotted with brown.

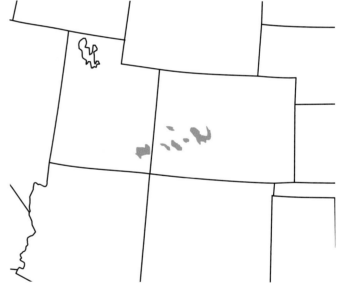

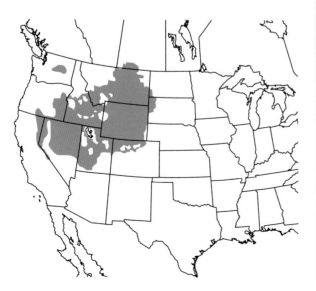

Gunnison Sage-Grouse *Centrocercus minimus*
L 22" WS 30" ♂ ≠ ♀ GUSG *EN *WL

A rare and declining species with a tiny range in western Colorado and eastern Utah. Like a small version of the Greater Sage-Grouse; males have bushier head filoplumes than the Greater. World population is but a few thousand. Found in sagebrush plains above 7,000 feet elevation. Males display in a lek with a dance distinct from that of the Greater Sage-Grouse. The ground nest, sited under a sagebrush or tussock of grass, is a shallow depression lined with grass. Lays 6–10 olive-buff eggs dotted with brown.

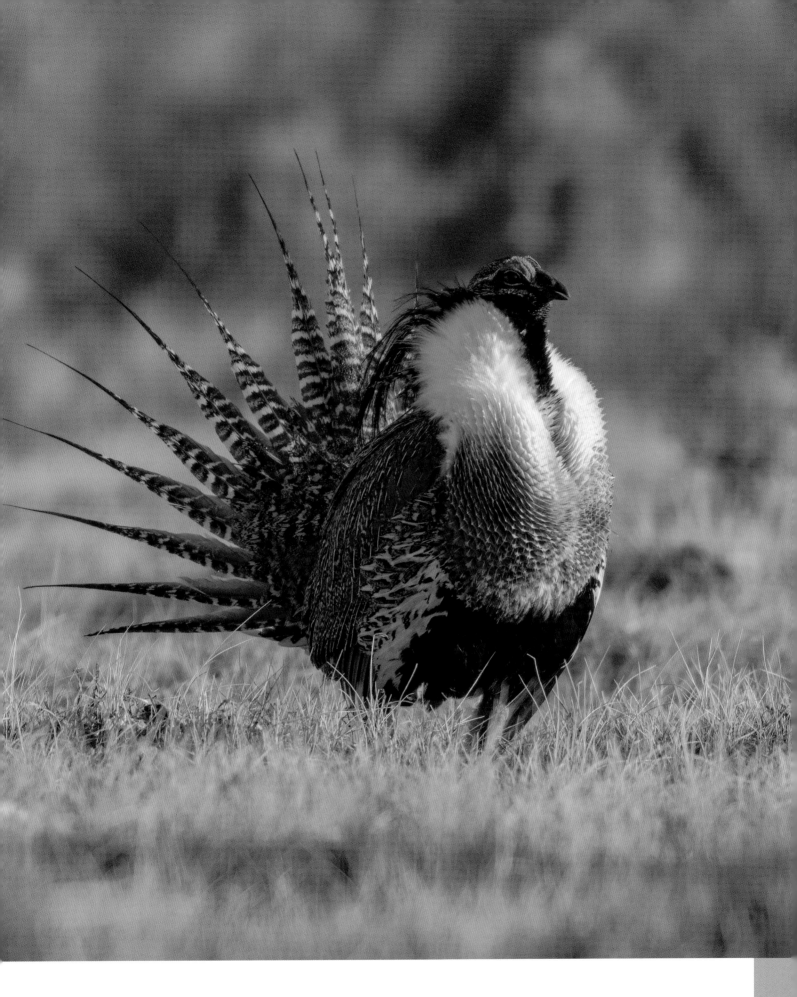

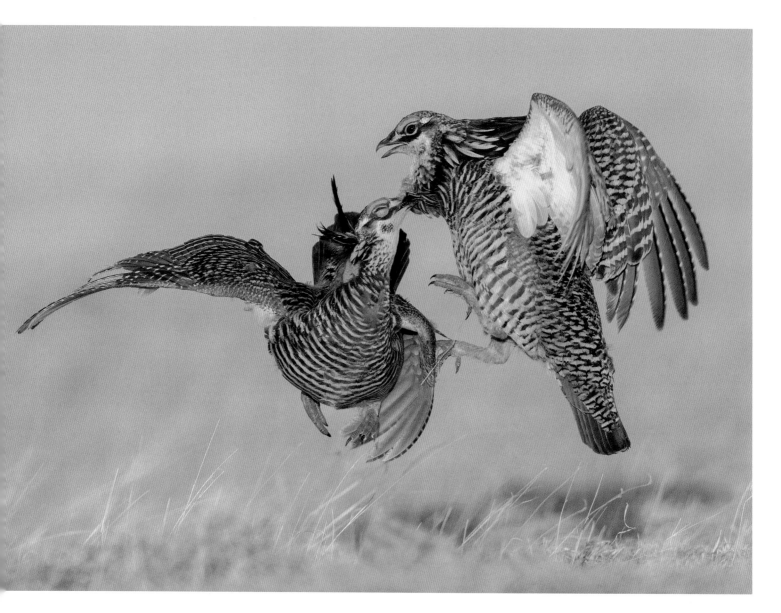

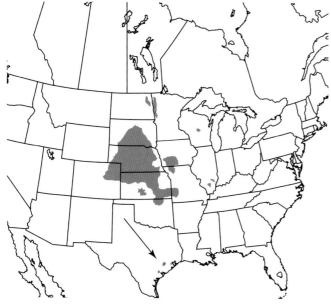

Greater Prairie-Chicken *Tympanuchus cupido*
L 17" WS 28" ♂ ≈ ♀ GRPC *VU *WL

This declining species is best located by the low moaning sounds given by displaying males at a traditional lek. Prefers native tallgrass prairie. The species forages mainly on the ground for a wide variety of plant matter and invertebrates. Also ascends into oaks to forage on buds and fresh leaves. Males display communally on their booming grounds situated on a low grassy hill. A displaying male vocalizes, raises its tail, inflates its orange neck sacs (called "tympana"), and stamps its feet. The ground nest is hidden under a clump of tall grass—a shallow depression lined with grass and other vegetation. Lays 8–12 olive eggs marked with brown. An eastern population, known as the Heath Hen, became extinct in 1932. Attwater's Prairie-Chicken, a subspecies of the Texas coastal prairie, is being kept alive by annual reintroduction of captive stock.

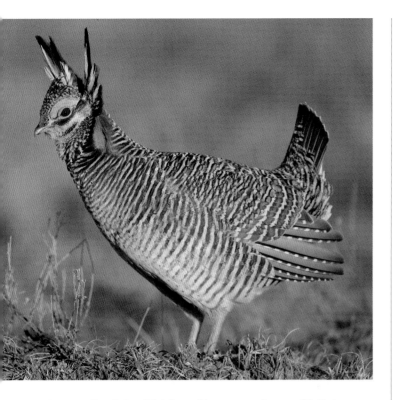

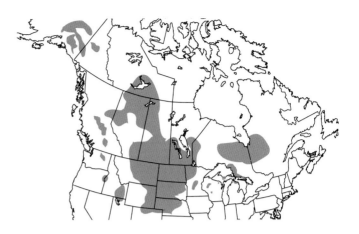

Sharp-tailed Grouse *Tympanuchus phasianellus*
L 17" WS 25" ♂ ≠ ♀ STGR

A grouse of the Interior North and Northwest of North America, inhabiting openings in deciduous woodlands and boreal conifer forests and ranging from Colorado, Michigan, and Quebec northwest to Alaska. Also inhabits prairies, grassland clearings in burned areas, and bogs. Forages for a variety of plant matter on the ground in grassland. In snowy winters, will feed in shrubs and trees for dormant buds. Males display in spring at traditional leks in open grassland. The adult male droops his wings, raises his tail, and rapidly stamps his feet at other males and to visiting females. Ground nest is a shallow depression of grass and ferns hidden under vegetation. Lays 8–12 olive eggs marked with brown.

Lesser Prairie-Chicken *Tympanuchus pallidicinctus*
L 16" WS 25" ♂ ≈ ♀ LEPC *VU *WL

A rare species in decline. Found in a dwindling mosaic across western Kansas, southeastern Colorado, western Oklahoma, eastern New Mexico, and northern and western Texas. Inhabits sandy shortgrass prairie with a scattering of dwarfed oaks. Will forage in agricultural fields but only when adjacent to native prairie. In season, the males gather to display on a traditional booming ground (a lek)—typically atop a low hill in grasslands. Males vocalize, stamp their feet, erect their neck plumes, expand their burnt-orange-colored neck sacs (tympana), and occasionally hop into the air. The ground nest is a shallow depression that is lined with grass and hidden under a tussock of grass or low shrub. Lays 11–13 cream-colored eggs.

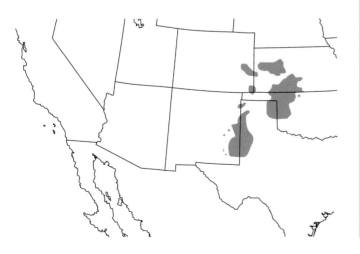

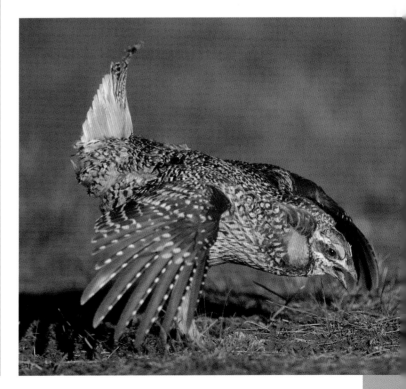

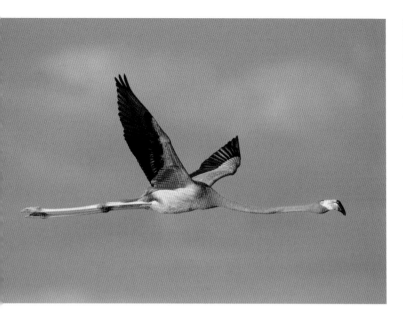

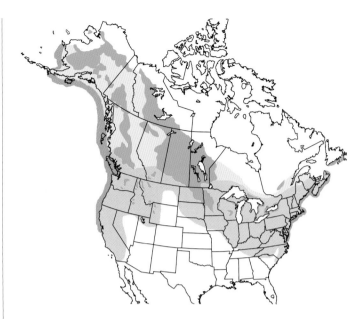

American Flamingo *Phoenicopterus ruber*
L 46" WS 60" ♂ = ♀ AMFL

Everybody is familiar with flamingoes, but in North America wild individuals are few and far between, much outnumbered by escapes from captive populations. Resident native populations range across northern South America, the Galápagos, the Caribbean, and the Yucatán. Strays show up regularly in South Florida and rarely along the Gulf of Mexico coast. Birds found in other states are often thought to have escaped captivity. The species inhabits coastal lagoons and flats. In its native habitat, the species typically forages in large flocks; in North America, the species is usually seen as singletons. Diet is mainly aquatic invertebrates, sifted from the water with its weirdly shaped bill. Most often seen in Florida Bay of Everglades National Park in South Florida.

Red-necked Grebe *Podiceps grisegena*
L 18" WS 24" ♂ = ♀ RNGR

A large and attractively-plumaged grebe. Summers on ponds and lakes with fringing marshlands in Alaska, central and northwestern Canada, the north-central US Borderlands, and Eurasia. Winters along the East and West Coasts and on the Great Lakes, where found on estuaries, bays, and large lakes. Forages for fish, crustaceans, and other aquatic invertebrates. In spring, the male and female perform a series of picturesque and vocal joint courtship displays. Floating nest is a mound of soggy vegetation, usually anchored to marsh grass. Lays four or five bluish-white eggs. The prettily striped young ride on the back of a parent.

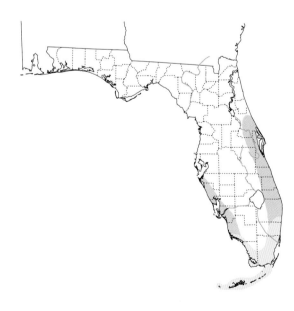

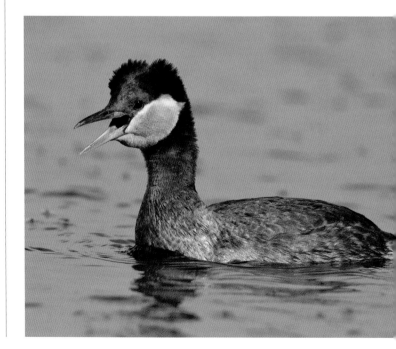

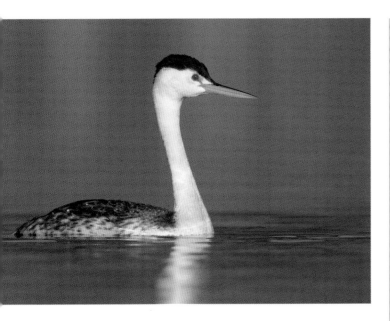

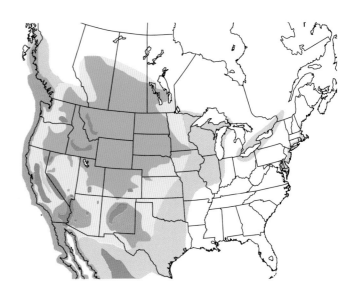

Clark's Grebe *Aechmophorus clarkii*
L 25" WS 24" ♂ = ♀ CLGR

A twin of the Western Grebe (see next), inhabiting a similar range in the Interior West. Some nonbreeding individuals are impossible to distinguish from the Western Grebe; the nearly identical morphology, summer and winter range, and behavior make this species-pair a bit of a biological mystery. Summers on marshy lakes of the West and winters along the West Coast and in the Southwest Borderlands. Dives mainly for fish. The male and female conduct a striking courtship display. Floating nest is a mound of soggy vegetation, usually anchored to marsh reeds. Lays three or four bluish-white eggs.

Western Grebe *Aechmophorus occidentalis*
L 25" WS 24" ♂ = ♀ WEGR

A large pied grebe that is very similar to Clark's Grebe. Summers in marshy lakes of the West and winters off the West Coast and also in the Southwest Borderlands. Gregarious year-round. Dives mainly for fish. The male and female, in their paired courtship, conduct striking side-by-side displays across the water's surface. Breeds in colonies. Floating nest is a mound of soggy vegetation, usually anchored to marsh grass. Lays three or four bluish-white eggs. Birds migrate in flocks at night. Bill color, amount of black in the face, width of hindneck strip, and extent of white in the flanks all help separate the Western Grebe from its close relative, the less common and less widespread Clark's Grebe. These two species can be found in the breeding season on the same body of water and are known to hybridize where populations mix. Populations of these two species reduced from those of the 20th century.

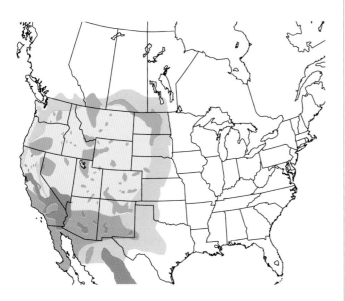

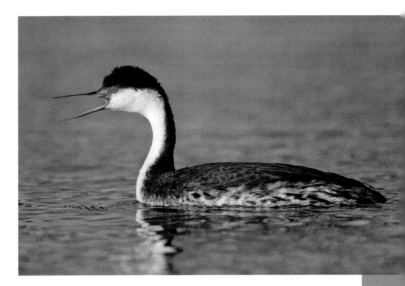

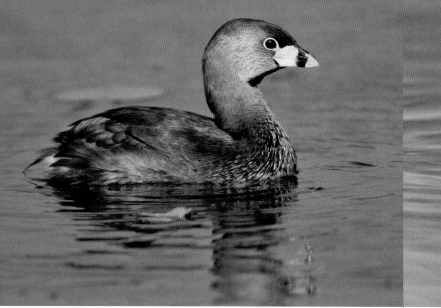

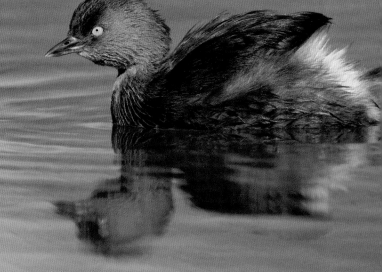

Least Grebe *Tachybaptus dominicus*
L 10" WS 11" ♂ = ♀ LEGR

This is the smallest of our grebes. This widespread Neotropical species is seen commonly in North America only in South Texas and along our border with Mexico, where it inhabits marshes, shallow ponds, and water-filled ditches. When approached, it commonly retreats to hide in marshy vegetation. Commonly seen in pairs. Diet is mainly aquatic invertebrates, with a lesser component of small fish and crustaceans. Nest is a mound of wet vegetation either floating in shallow water or firmly anchored to marsh grass. Lays three to six bluish-white eggs. Will nest year-round in South Texas. The only North American grebe with a bright yellow iris. Occasionally strays to other states along the Southwest Border and South Florida. Also records from California, Oklahoma, and Arkansas. This species may take to flight with greater frequency than other grebes, and this diminutive grebe readily colonizes ephemeral bodies of water. Pairs are quite vocal. This aids in locating the birds. Nonmigratory, but prone to wandering in search of water. Local populations seem to vary based on rainfall and, in winter, extreme cold. The species is under no threat.

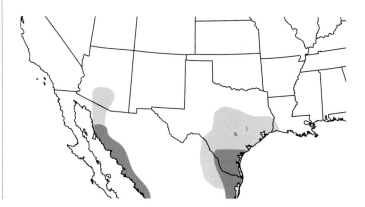

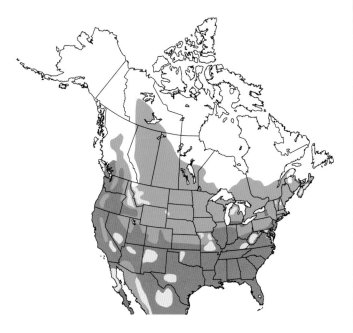

Pied-billed Grebe *Podilymbus podiceps*
L 13" WS 16" ♂ = ♀ PBGR

Our most widespread grebe, also the one most frequently seen in the East. Summers across the Lower 48, northward to Atlantic Canada and the Northwest Territories. Northern breeders winter in the southern half of the Lower 48. Breeds on marshy ponds and lakes; winters on lakes, ponds, estuaries, and bays fringed with marshland. During summer, this species is reclusive, often vocalizing while hidden within the protection of the marsh. Dives for small fish as well as aquatic invertebrates. Nest is a heap of marsh vegetation either floating or anchored in the shallow water, with ready access to open water. Lays four to seven whitish eggs. When threatened, often retreats from view by sinking deeper into the water until only the head and neck are visible.

Horned Grebe *Podiceps auritus*
L 14" WS 18" ♂ = ♀ HOGR

A very handsome small grebe with a wide distribution in the Northern Hemisphere. Summers in northern North America; winters on the Atlantic, Pacific, and Gulf Coasts and in the Deep South. Breeds on ponds and lakes with surrounding marshy habitat. Not as sociable as the Eared Grebe. Winters on coastal oceanic waters, estuaries, bays, and large reservoirs. In spring, male-female pairs carry out side-by-side displays, rushing across the surface of the water. Dives for small fish, crustaceans, and aquatic arthropods. Floating nest of waterweeds and cattails is anchored in the marsh vegetation. Lays four to seven bluish-white eggs.

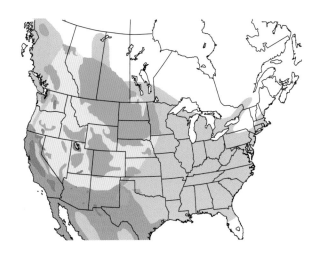

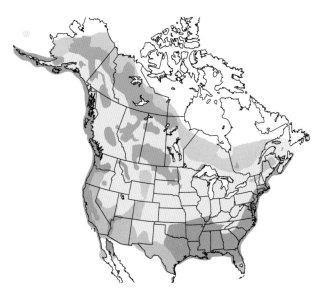

Eared Grebe *Podiceps nigricollis*
L 13" WS 13" ♂ = ♀ EAGR

A small and gregarious grebe that summers widely through the Interior West. Winters mainly on the West Coast and the Southwest Borderlands on bays and on freshwater and alkaline lakes. Also inhabits Eurasia. Sometimes seen in large flocks during migration at favored stopover lakes in the West. Breeds through the Prairie Potholes and other interior lakes and ponds with marshy verges. Dives for aquatic invertebrates and crustaceans. Male-female pairs carry out striking side-by-side courtship displays on the water. Nests in colonies. Nest is a floating mound of vegetation and algae in shallow water. Lays three to five bluish-white eggs. In autumn, thousands of individuals flock to Mono Lake in California and Great Salt Lake in Utah. Population stable.

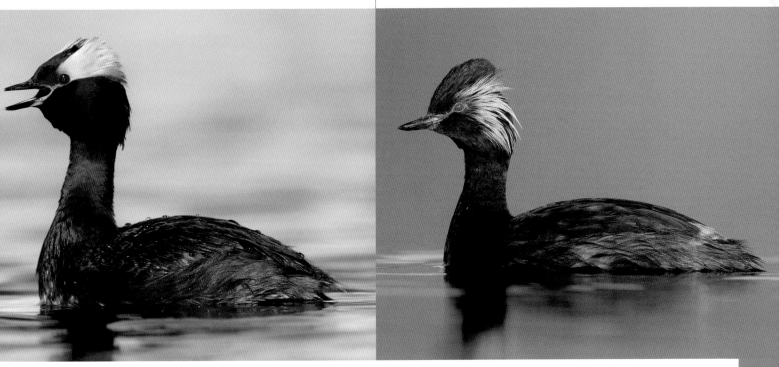

Rock Pigeon *Columba livia*
L 13" WS 28" ♂ = ♀ ROPI

This species, introduced from Europe, now inhabits the entire Lower 48, southern Canada, parts of Alaska, and Mexico. This is our "domestic pigeon." Native throughout Eurasia and parts of northern Africa. Today, found in most large cities of the world. In North America, it is a permanent resident found in cities and on farms. Nests on cliffs, in barns, and under large highway bridges. Travels and forages in flocks. Diet is seeds and waste grain. The nest is a platform of twigs set on a ledge. Lays one or two white eggs. Pigeon fanciers have bred many color varieties of this species, and these can be seen free-flying in local populations.

White-crowned Pigeon *Patagioenas leucocephala*
L 14" WS 24" ♂ = ♀ WCPI *WL

This species of the Caribbean and Yucatán ranges into the Florida Keys, the Everglades, and coastal South Florida. Nests in mangroves and travels about in small flocks in search of fruiting trees, sometimes traveling considerable distances into the interior. Shy and reclusive. Usually seen in flight. Diet is various fruits. The nest, set in a mangrove, is a loose platform of twigs. Lays one or two white eggs.

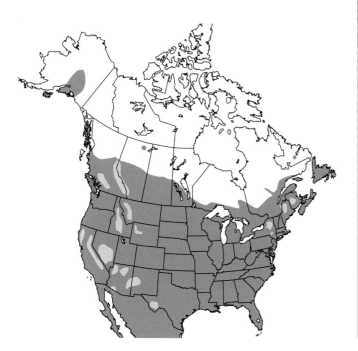

Red-billed Pigeon *Patagioenas flavirostris*
L 15" WS 24" ♂ = ♀ RBPI

This Central American and Mexican resident ranges north-ward into the Lower Rio Grande Valley of South Texas mainly in the summer. Inhabits riverine woodland. Travels in small flocks in search of fruiting trees. Forages in tree canopies. Often seen perched conspicuously in treetops. Diet is fruit and nuts, including acorns. The nest, set in a tree or shrub, is a flimsy platform of twigs lined with finer plant material. Lays one or two white eggs. Observation of this species along the Lower Rio Grande has declined in recent decades. Reduction of gallery forest cover along the Rio Grande is certainly one reason for the decline of this species along the Border.

Band-tailed Pigeon *Patagioenas fasciata*
L 16" WS 26" ♂ = ♀ BTPI *WL

This big flocking pigeon summers in the Southwest and along the West Coast. Winters mainly along the West Coast and in Mexico. Its range extends south into the Andes of South America. Breeds in oak woodlands and pine-oak and fir forests in mountains. Winters in wooded habitats. Nomadic. Travels widely in flocks in search of fruits, seeds, acorns, and other mast. The nest, set on a branch of a tree, is a bulky platform of sticks. Lays one or two white eggs. Seen overhead in fast-flying flocks.

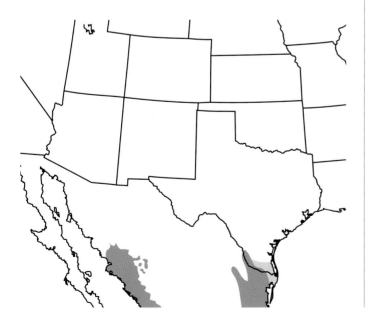

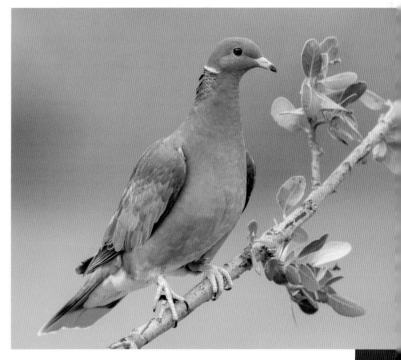

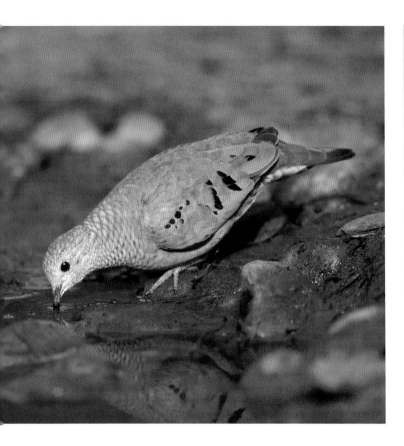

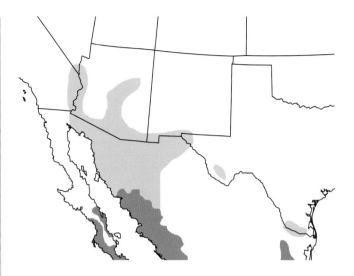

Ruddy Ground Dove *Columbina talpacoti*
L 7" WS 11" ♂ ≈ ♀ RUGD

This widespread Neotropical species ranges from northern Argentina to northern Mexico. It strays across the Border into the United States, from South Texas to Southern California, where it has bred on occasion. Individuals that stray to North America mainly frequent lawns, ranchland, and desert oases. Often in small groups associated with Inca Doves. Diet is mainly seeds taken on the ground. Known to use old nests of other species, usually in a shrub or small tree. Lays two white eggs. Most North American records come from autumn and winter.

Common Ground Dove *Columbina passerina*
L 7" WS 11" ♂ ≈ ♀ COGD

This short-tailed and unobtrusive ground-dweller inhabits the Deep South and Southwest Borderlands. Most birds are resident, but some populations shift southward in winter. The species' range extends south to Brazil. Inhabits roadsides, woodland edges, orchards, and farmland. Diet is mainly seeds and waste grain. The nest, set in a shrub, is a flimsy platform of sticks. Lays two to three white eggs. In flight, the wings make a distinctive fluttering sound.

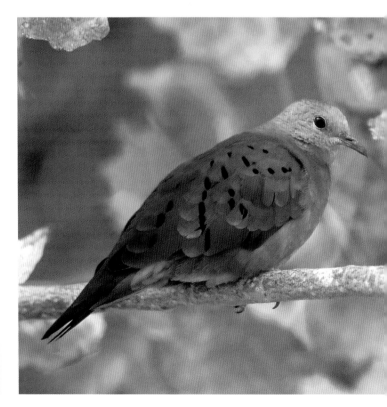

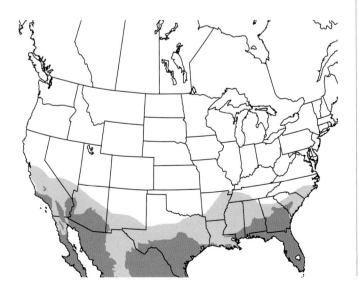

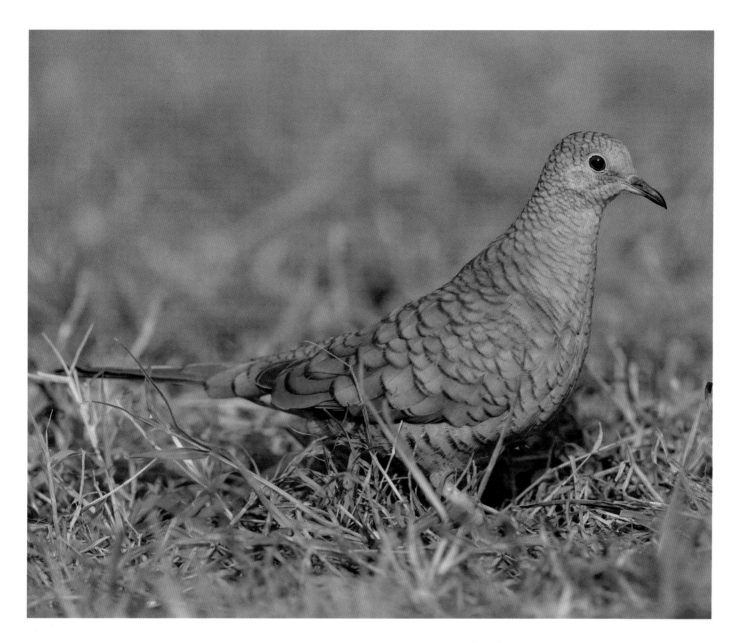

Inca Dove *Columbina inca*
L 8" WS 11" ♂ ≈ ♀ INDO

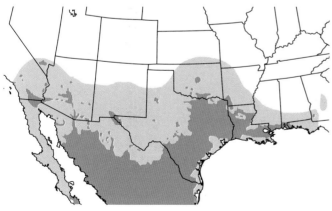

This scaly plumaged ground-living dove is a permanent resident of the Arid Southwest, but it is apparently continuing to expand its range in North America (but see below). The species occurs throughout Central America and Mexico. Inhabits farms, towns, and parks, usually in association with human habitation. Forages on the ground, usually in small groups, for seeds. The nest, set in a tree or shrub, is a small platform of twigs lined with grass. Lays two white eggs. Most recently, some urban populations in the Arid Southwest have declined and the species has withdrawn from some northern outposts. Presumably, this widespread Neotropical species is otherwise in good shape. Confiding and easy to observe.

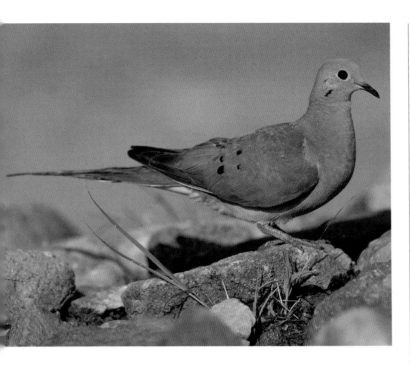

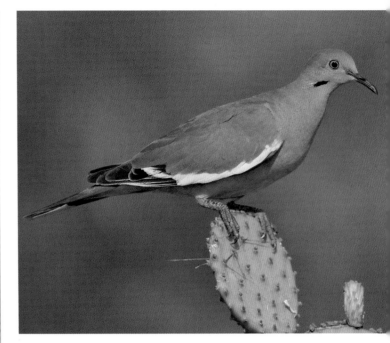

Mourning Dove *Zenaida macroura*
L 12" WS 18" ♂ = ♀ MODO

This is the most common, widespread, and familiar dove of the Lower 48. The species ranges from southern Canada to the Caribbean and Central America. It inhabits suburbs, parks, and agricultural lands. Forms flocks in autumn. Northernmost birds shift southward in winter. Forages mainly on the ground and will cluster under bird feeders to take spilled seed. The nest, set in a shrub or tree, is a flimsy platform of twigs. Lays two white eggs. Individual birds migrate, though the species is present year-round over much of its range. Avoids forest interior. The population is large and stable. The species name is presumably a reference to the rather sad cooing song the bird gives, especially early in the breeding season.

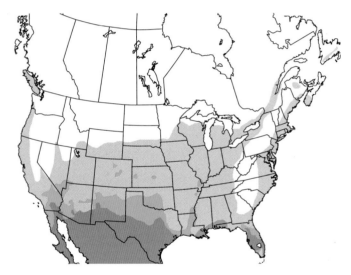

White-winged Dove *Zenaida asiatica*
L 12" WS 19" ♂ = ♀ WWDO

This dove of the Caribbean, Mexico, and Central America historically ranged north to the Deep South and the Southwest Borderlands. Recently, populations have expanded northward and now include birds summering north to northern Colorado. Northern-breeding birds winter southward. Strays can now be found in most suburban areas of the Lower 48 and southern Canada. Inhabits suburban and agricultural areas as well as open country with woodland and shrubland. A prominent vocalist. Heard through many residential neighborhoods. Will mix in flocks with Mourning Doves. Diet is mainly seeds and sometimes nectar in the deserts of the Southwest. The nest, set in a shrub or low tree, is a flimsy platform of twigs. Lays one to four white or pale buff eggs.

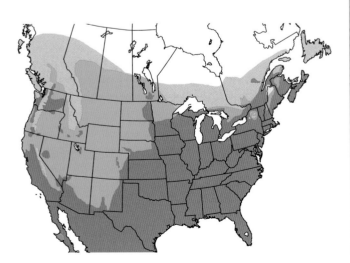

White-tipped Dove *Leptotila verreauxi*
L 12" WS 18" ♂ = ♀ WTDO

A Neotropical species that ranges from northern Argentina to the southernmost United States. Resident in South Texas, especially the Lower Rio Grande Valley. Inhabits shady woodland thickets and edge, especially near rivers. Will visit feeders. Forages quietly on the ground for seeds. Generally solitary. The nest, set in a shrub, is a flimsy platform of twigs and other plant material. Lays two pale buff eggs. In flight, the wings whistle. In South Texas, the species has expanded its range in recent years. Less sociable than other dove species.

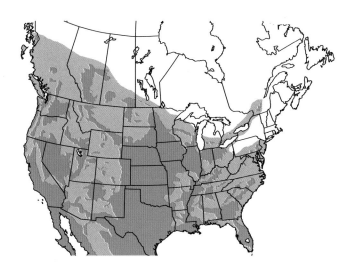

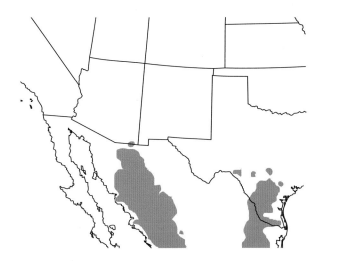

Eurasian Collared-Dove *Streptopelia decaocto*
L 13" WS 22" ♂ = ♀ EUCD

This Eurasian species has colonized much of the Lower 48 and parts of southern Canada. The species' range continues to expand (except in the Northeast and Mid-Atlantic). North American birds apparently originated from birds introduced to the Bahamas in 1974. They arrived in Florida from the Bahamas shortly thereafter (without human assistance). Settles in farmland as well as suburban and open habitats. Typically seen perched on utility lines. Diet is mainly seeds and waste grain. The nest, set in a tree or shrub, is a flimsy platform of twigs. Lays one or two white eggs.

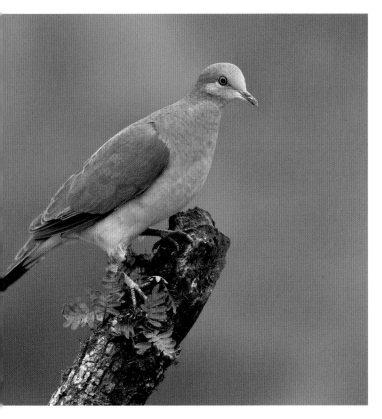

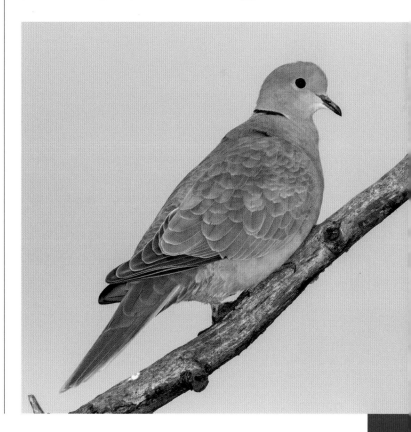

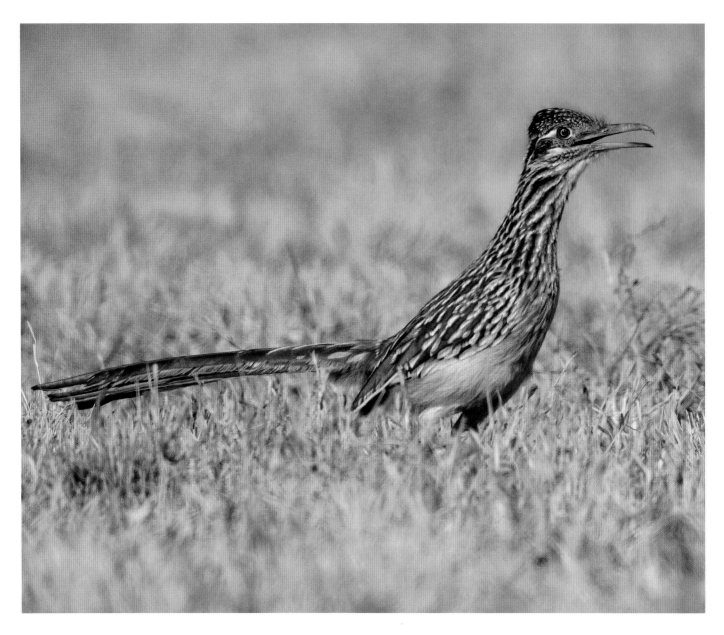

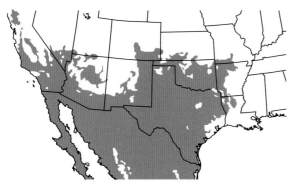

Greater Roadrunner *Geococcyx californianus*
L 23" WS 22" ♂ = ♀ GRRO

This large, crested, ground-dwelling cuckoo is widespread in the Southwest, from southern Missouri to California, as well as northern and central Mexico. Inhabits open arid lands, brushlands, chaparral, and dry grasslands. Hunts on the ground, often dashing speedily after prey. Diet is a mix of arthropods, small vertebrates, and some fruit. Will hunt lizards and snakes as well as many large arthropods. Appears to be a sedentary resident, defending a year-round territory. The nest, set in a shrub or cactus, is a platform of sticks lined with other plant matter and feathers. Lays three to five white or pale yellowish eggs. Will occasionally fly a short distance, gliding back to the ground. Famous because of the long-running Loony Tunes character "Beep Beep."

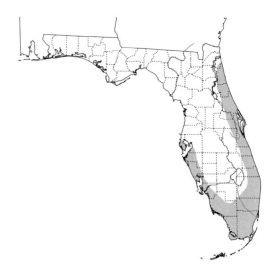

Smooth-billed Ani *Crotophaga ani*
L 15" WS 19" ♂ = ♀ SBAN

This widespread South American and Caribbean cuckoo, once common in Florida, is now very rare there, perhaps known only from individuals straying from the Bahamas. Found in farmland and scrub, often found in association with cattle. The species is omnivorous. The communal nest, set in a low shrub by several mated pairs, is a bulky bowl of twigs and other plant material. Several females may lay as many as 20 blue eggs in the single group nest.

Groove-billed Ani *Crotophaga sulcirostris*
L 14" WS 17" ♂ = ♀ GBAN

This strange and very sociable black cuckoo, looking much like the Smooth-billed Ani (see next), is widespread in Central and northern South America. A small population summers in South Texas. This population wanders eastward along the coast to Florida. Mexican strays also appear across the Arid Southwest. Inhabits scrubby pastures and brushland. Sociable and flocking. Groups of 4–10 seen roosting together in a bush or low tree. Diet is mainly arthropods, as well as fruit and small vertebrates. The communal nest, shared by several females and attended by their mates, is set in a shrub. It is a bulky bowl of twigs and other plant matter. Each female lays three or four pale blue eggs into the communal nest. Males and females take turns incubating. There are recent records from Wyoming, North Dakota, and Ontario. The Texas population is stable.

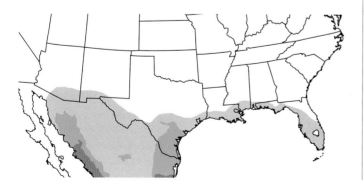

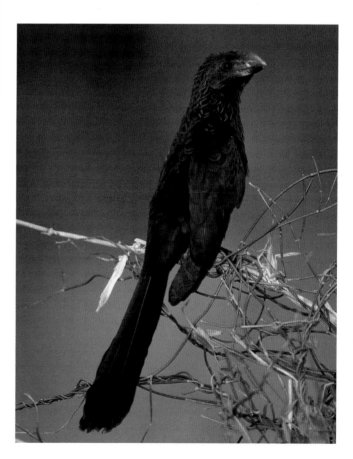

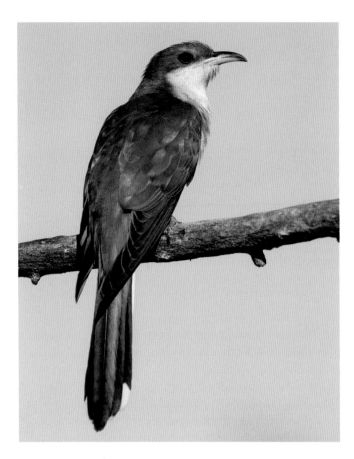

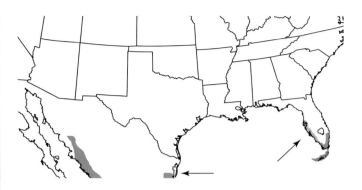

Mangrove Cuckoo *Coccyzus minor*
L 11.5" WS 17" ♂ = ♀ MACU *WL

This cuckoo of the Caribbean, Mexico, and Central America ranges into coastal South Florida, where it is an elusive resident. In Florida, inhabits mangroves and tropical hardwood forest. Forages slowly and deliberately in the interior of mangrove forest. Diet is primarily arthropods, probably mainly caterpillars. The nest, set in a mangrove thicket, is a thin platform of sticks. Lays two or three pale blue-green eggs. Northernmost breeders shift southward in winter.

Yellow-billed Cuckoo *Coccyzus americanus*
L 12" WS 18" ♂ = ♀ YBCU

Traditionally known as the "rain crow," this cuckoo summers widely in the central and eastern United States, and sparingly in the Southwest. Winters from the Yucatán and Hispaniola south to northern Argentina. Breeds in dense deciduous thickets and woodland edge. In the West, it is found in riparian corridors along streams and rivers. Vocal but retiring. Diet is mainly caterpillars and other arthropods. Also takes some small vertebrates and fruit. The nest, set in a thicket or shrub, is a loose platform of twigs, lined with finer materials. Lays three or four pale blue-green eggs. Known to act as a brood parasite by occasionally laying eggs in the nests of other cuckoos and other species of birds.

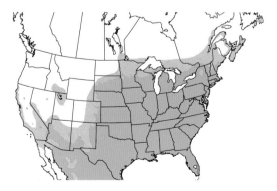

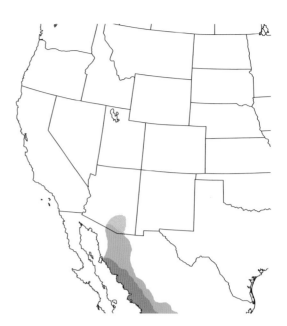

Buff-collared Nightjar *Antrostomus ridgwayi*
L 9" WS 18" ♂ ≈ ♀ BCNI

This resident of Central America and Mexico edges north-ward across the US Border in southeastern Arizona in summer. The northernmost breeders probably retreat to the south in winter. Breeds in thornscrub and rocky desert canyons with heavy brush. Forages for flying insects by sallying out from a bush or by making an aerial patrol. The one or two pale buff eggs are laid on the ground in a spot protected by overhanging vegetation. The loud and staccato vocalization is distinctive. No recent records from New Mexico.

Black-billed Cuckoo *Coccyzus erythropthalmus*
L 12" WS 18" ♂ = ♀ BBCU *WL

Summers in the central and eastern United States and southern Canada. Winters in northern South America where it becomes a phantom and is rarely encountered. Breeds in thicket edges of deciduous and mixed forests. A retiring skulker. Heard more than seen. Diet is mainly caterpillars, as well as other arthropods and some fruit. The nest, set in a thicket, is a loose platform of sticks lined with finer materials. Lays two or three blue-green eggs.

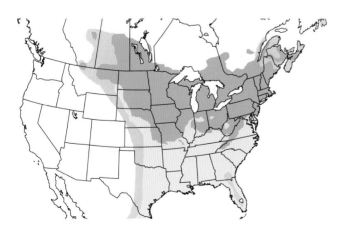

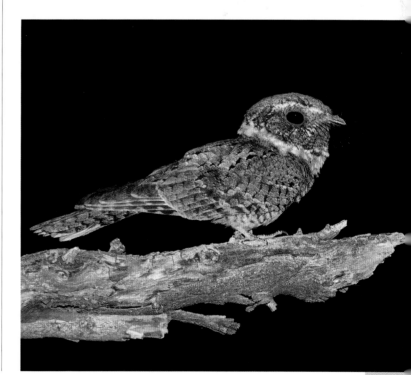

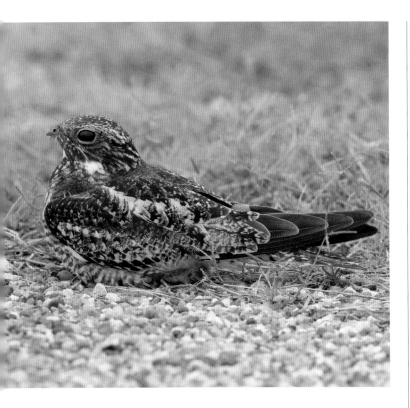

Common Nighthawk *Chordeiles minor*
L 10" WS 24" ♂ ≈ ♀ CONI

This familiar aerial insectivore summers across North America and winters in South America. Breeds in open country, farmland, urban areas, and towns. In spring and fall, often seen migrating in flocks in the daytime. Forages by aerial hawking of flying insects (mainly at night). Diet is exclusively arthropods. The two or three whitish eggs are laid on a bare patch on the ground or on a flat roof. This species has been exhibiting a substantial decline, along with many of the aerial insectivores.

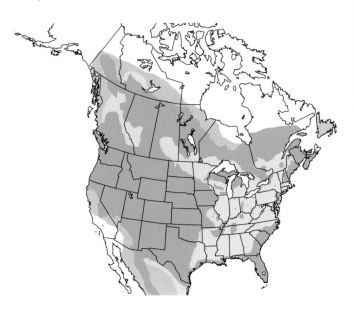

Lesser Nighthawk *Chordeiles acutipennis*
L 9" WS 22" ♂ ≈ ♀ LENI

This desert-loving species breeds from Brazil to the US Southwest and north to Northern California. US breeding populations winter in Mexico and Central America. Breeds in dry grasslands, desert, and arid scrub. Takes flying insects while in flight, and also hawks insects from a ground perch. Diet is mainly flying arthropods, especially swarming ants. The nest is a scrape on bare ground. Lays two whitish eggs. Sometimes seen foraging in groups.

Antillean Nighthawk *Chordeiles gundlachi*
L 9" WS 21" ♂ ≈ ♀ ANNI

This Caribbean species, a close relative of the Common Nighthawk, summers in the Florida Keys and apparently winters in South America. Very similar to the Common Nighthawk. Breeds in openings—open lots, airport runways, and fields. The nest is a scrape on the ground where the two whitish to pale olive eggs are laid. After nesting, birds, on occasion, wander northward into the mainland of South Florida. This species began to colonize the Florida Keys in the 1940s. When that happened, it was found that the Antillean and Common Nighthawks had different vocalizations and defended breeding territories against each other—demonstrating the two were distinct species.

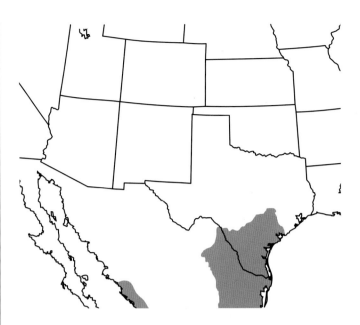

Common Pauraque *Nyctidromus albicollis*
L 11" WS 24" ♂ = ♀ COPA

This wide-ranging species of South and Central America and Mexico edges north into South Texas, where it is locally common. Breeds in woodlands and thickets with openings, and also forages at night in these locations. Forages by launching out from a perch on the ground or from a branch to hawk passing insects. The two buff eggs are laid on dried leaves on the ground. Often encountered at night settled onto the surface of a back road. In a spotlight the eyes glow reddish. Can be quite confiding. This common species is most easily detected by its distinctive voice, a repeated *puwEEEo*. Nonmigratory. The population of this widespread species in South Texas population appears stable.

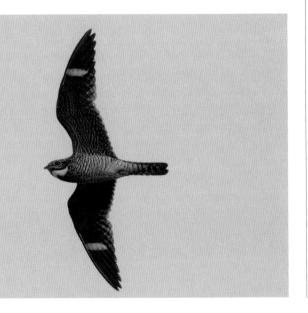

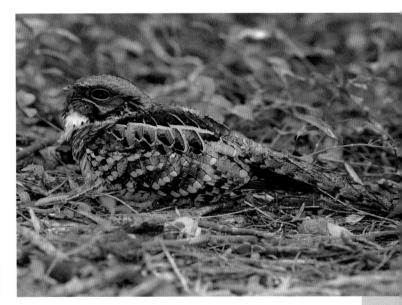

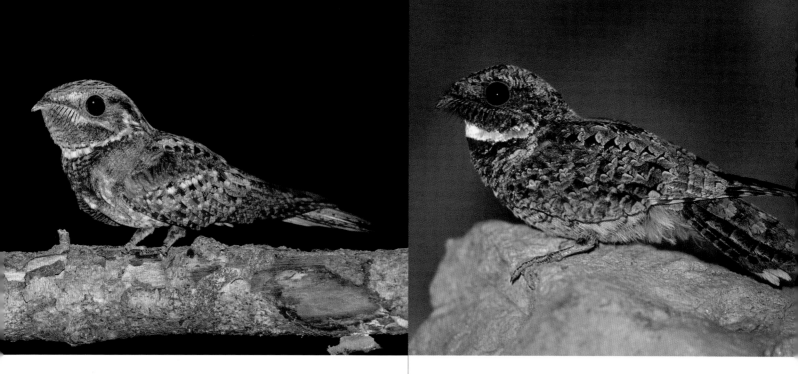

Chuck-will's-widow *Antrostomus carolinensis*
L 12" WS 26" ♂ ≈ ♀ CWWI *NT

This vocal nightbird summers across the central and eastern United States, from Texas and Florida to eastern Massachusetts. Best known in the Deep South, where this is one of the cherished night sounds in spring and summer. Winters in South Florida and widely south of the Border as far as northern South America. Breeds in pine and decid-uous forests. Forages from the ground, from a branch, or in flight, hawking flying insects. Diet is mainly large arthro-pods and, remarkably, small birds on occasion. No nest is constructed. The two cream-colored eggs are laid on leaves or pine needles on flat ground in a woodland clearing. Rarely seen. All of our goatsuckers/nightjars are faring poorly, along with the other aerial insectivores. This may be a result of globally declining arthropod populations. The Chuck-will's-widow is Near Threatened. Our largest nightjar.

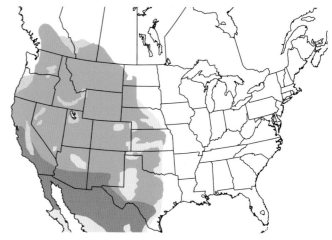

Common Poorwill *Phalaenoptilus nuttallii*
L 8" WS 17" ♂ ≈ ♀ COPO

Our most diminutive goatsucker, one of the common western nightbirds, summers across the Interior West. It winters from the Southwest Borderlands southward to northern Mexico. Breeds in dry hills and open brushlands. After dark, it perches on open ground and flies up to catch passing insects. Best detected at night during the breeding season by its repeated song *pur-wil-up*, the last note heard only at close range. The nest is a scrape on the ground, sometimes located under a shrub or overhanging rock. Lays two white eggs. Northern breeders winter southward to the Borderlands and beyond. Southern populations move downslope. On cold nights, this species goes into a torpid state, lowering its body temperature to save energy. The US population of this species appears stable.

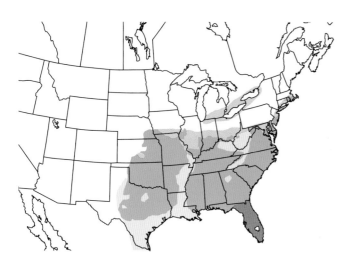

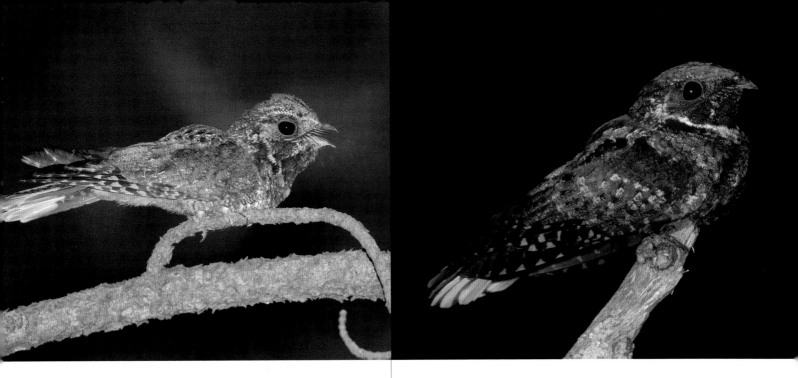

Mexican Whip-poor-will *Antrostomus arizonae*
L 10" WS 19" ♂ ≈ ♀ MWPW *WL

This Central American and Mexican species, a close relative of the Eastern Whip-poor-will, summers north into the Arid Southwest. It breeds in mountainous territory in open pine-oak woodlands. Habits are the same as the Eastern Whip-poor-will, and it is nearly identical in appearance. Diet is flying arthropods. The two white eggs are laid upon dead leaves on the ground. Long considered to be a subspecies of the Eastern Whip-poor-will. Best distinguished by its rougher, slower, and lower-pitched song *wir-pir-wir*. Note also that the ranges of these two species do not overlap. In winter, most US-breeding birds retreat south into Mexico for the winter. Population of this little-known species appears stable, and the range of the species in the US appears to be expanding northward. This species tends to occupy inaccessible mountainous country, making the bird a difficult "get" for birders seeking to add the species to their life lists.

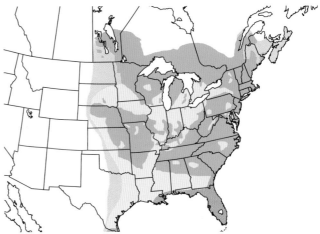

Eastern Whip-poor-will *Antrostomus vociferus*
L 10" WS 19" ♂ ≈ ♀ EWPW *WL *NT

This vocal nightbird of rural eastern woodlands summers in the central and eastern United States and southern Canada. It winters in Florida, eastern Mexico, and Central America. Breeds in openings in deciduous and mixed woodlands. Hawks flying insects from a perch on the ground or from a branch or during an aerial patrol. The two white eggs are laid on leaves on the flat ground. Heard often but rarely seen. This is a species in decline. The voice of this species was once a familiar night sound in rural woodlands of the East. Many local populations are decreasing and there is evidence of range contraction in recent years. Red List treats the species as Near Threatened. The lovely song of this species (*wir-wor-will!*), a night sound that was once synonymous with the rural wooded countryside of the East is now heard in fewer places than it once was. This may be a product of the overall decrease in our nocturnal arthropod fauna.

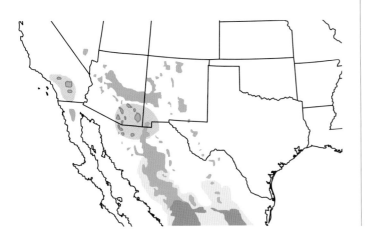

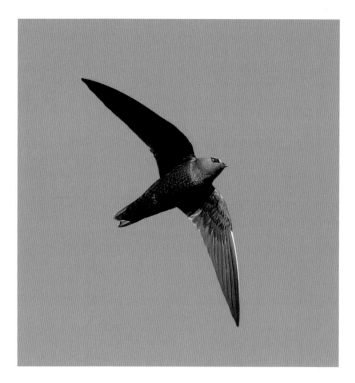

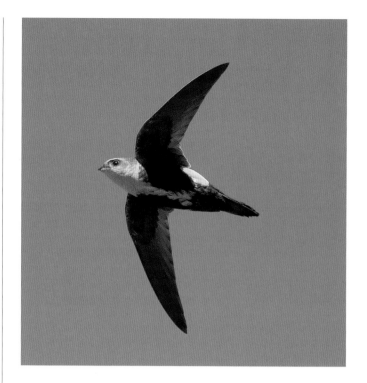

Black Swift *Cypseloides niger*
L 7" WS 18" ♂ = ♀ BLSW *VU *WL

This bird, the largest swift in the United States and Canada, summers sparingly in a few enclaves in the Mountain West and Pacific Northwest. The species also breeds in Mexico, Central America, and the Caribbean. The wintering home for these birds was recently discovered to be the Brazilian Amazon. Breeds on rocky coastal cliffs and along waterfalls in mountain canyons. Forages high in the sky, ranging widely from nest sites in small flocks or singly. Diet is flying arthropods. The nest, set on a protected and inaccessible ledge, is a small saucer of mud, moss, and ferns lined with finer material. Lays one white egg. Its breeding range may be limited by availability of its remote and inaccessible nesting sites.

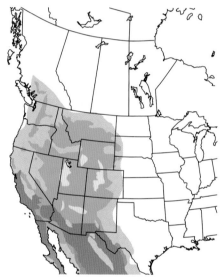

White-throated Swift *Aeronautes saxatalis*
L 7" WS 15" ♂ = ♀ WTSW

This pied western swift summers across the Interior West. Northern breeders winter to Southern California, the Southwest Borderlands, and southward. The species also breeds in Mexico and Guatemala. This is the only swift to be seen commonly in the United States in the winter. The species breeds in mountain canyons and rocky cliffs, and it forages widely from its nesting site. It is a speedy aerial forager. Diet is flying arthropods. The nest, set in an inaccessible vertical crevice of a cliff or building, is a shallow half-saucer of plant material and feathers glued together with saliva. Lays four or five white eggs. The species mates in flight.

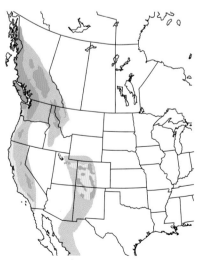

Vaux's Swift *Chaetura vauxi*
L 5" WS 12" ♂ = ♀ VASW

This western counterpart to the Chimney Swift summers in the Pacific Northwest. North American breeders winter in western Mexico and sparsely in Southern California. Other populations breed in Central America and Mexico. Breeds in conifer forest and mixed forest, mainly in old growth where there are suitable old hollow trunks for nest sites. Forages over large openings, such as lakes and rivers, either high up or low down, depending on the weather and the location of insect prey. Diet is flying arthropods. The nest, set in a tree hollow or occasionally in a chimney, is a shallow half-cup of twigs glued together with saliva. Lays three to seven white eggs. The spine-tipped feathers of the tail aid the bird in roosting on a vertical surface. Vaux's Swifts gather in chimneys in massive communal roosts during migration, sometimes numbering 10,000 or more birds at a time.

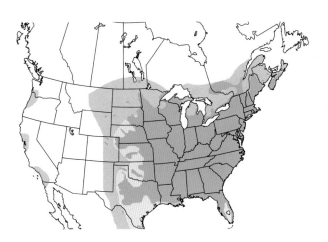

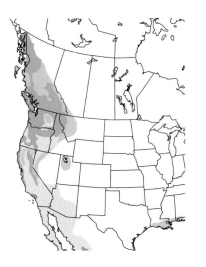

Chimney Swift *Chaetura pelagica*
L 5" WS 14" ♂ = ♀ CHSW *NT

The Chimney Swift, our most familiar swift, summers across the central and eastern United States and southernmost Canada. Winters in Amazonia. Breeds mainly near cities and towns, where suitable chimneys for nesting are available. In autumn, large flocks form prior to southward migration, and hundreds or thousands can be seen at dusk "funneling" into chimneys to roost. Diet is flying arthropods. The nest, plastered to the vertical wall of a chimney interior or in a hollow tree trunk, is a half-saucer of twigs glued together by the bird's saliva. Lays four or five white eggs. This species, along with many aerial insect-feeders, has shown substantial declines of late. Local conservation groups are now putting out swift "towers" to provide nesting and roosting sites for these admired birds. The spine-tipped feathers of the tail aid the bird in roosting on a vertical surface.

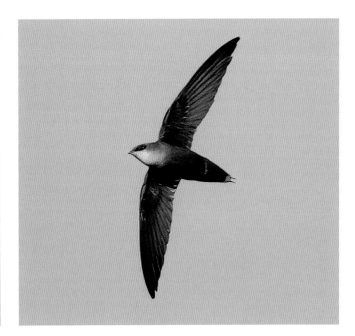

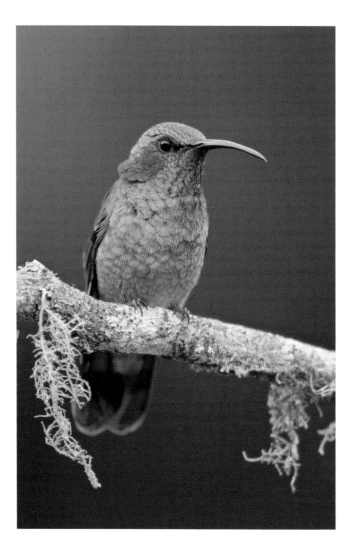

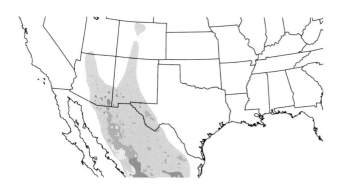

Rivoli's Hummingbird *Eugenes fulgens*
L5" WS 8" ♂ ≠ ♀ RIHU

This large and all-dark iridescent hummer summers patchily along the Southwest Borderlands, wintering in southeastern Arizona and Mexico. Wanders widely in the Southwest. The species ranges south to Honduras. Breeds in pine-oak glades in mountain canyons, also in maples and sycamores along streams. Pugnaciously defends nectar resources. Diet is nectar and lots of insects. The nest is a tiny, compact cup of plant fibers and spider silk saddled on a horizontal branch. Lays two white eggs. Formerly known as the Magnificent Hummingbird.

Mexican Violetear *Colibri thalassinus*
L 5" WS 7" ♂ = ♀ MEVI

This beautiful iridescent green, blue, and purple hummingbird is resident in Mexico and Central America. North American records are mainly strays to the hill country of Texas (late spring and summer), but others come from the Midwest, Great Lakes, and New England, as well as Alberta, California, Ontario, and New Jersey. North American sightings typically are at hummingbird feeders and flower gardens. Formerly known as the Green Violetear.

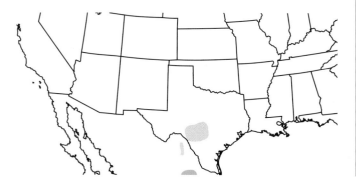

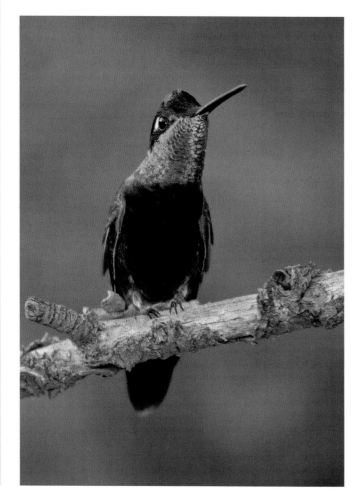

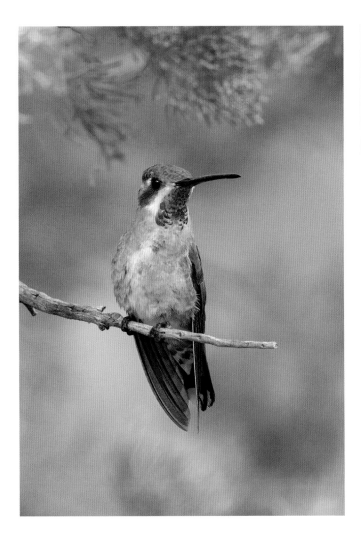

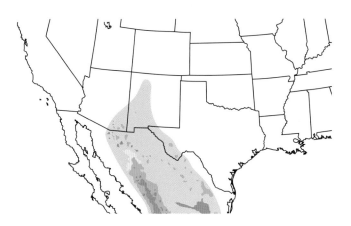

Blue-throated Mountain-gem *Lampornis clemenciae*

L 5" WS 8" ♂ ≠ ♀ BTMG

This blue-throated Mexican hummer summers patchily along the Southwest Borderlands. Winters in Mexico, where the species is a widespread resident. Breeds in mountain canyons with permanent water. This large hummingbird is very aggressive. Diet is nectar and arthropods. The nest, set on a twig or protected ledge, is a small cup of plant materials that is covered in green moss bound with spider silk and is lined with fine plant fibers. Lays one or two white eggs. Formerly named Blue-throated Hummingbird. A regular at nectar feeders in the Huachuca and Chiricahua Mountains of Arizona.

Plain-capped Starthroat *Heliomaster constantii*

L 5" WS 7" ♂ = ♀ PCST

This large, long-billed hummingbird ranges from western Costa Rica to northern and western Mexico, straying north to southeastern Arizona on a regular basis (mainly in summer and early autumn). Northern birds withdraw to the south in winter. Seen mainly in summer at feeding stations at canyon mouths in lowlands. Spends much time perched on the highest branches of isolated trees in search of insects. Diet is nectar and arthropods. Plumage has a washed-out appearance, but the twin white face-stripes are distinctive.

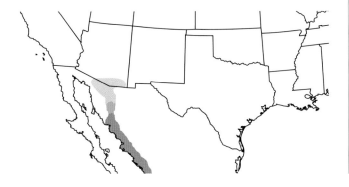

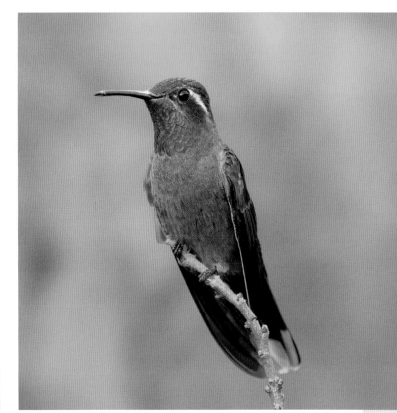

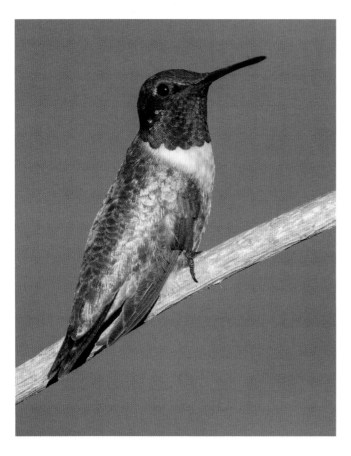

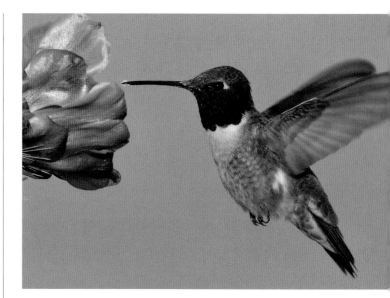

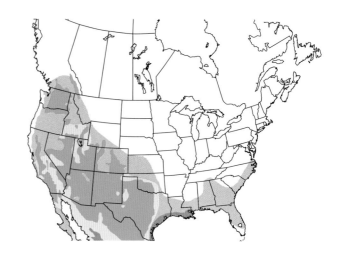

Ruby-throated Hummingbird *Archilochus colubris*
L 4" WS 5" ♂ ≠ ♀ RTHU

This is the hummingbird known to many North Americans living east of the Great Plains. Summers across the eastern and central United States and southern Canada. Winters in the Deep South, Mexico, and Central America. Breeds in open woodlands, forest edge, gardens, city parks, and suburban backyards. A faithful visitor to garden flowers and nectar feeders, especially from July through early September. Diet is nectar and small arthropods. The tiny cup nest, plastered atop a horizontal branch, bound together with spider silk, and decorated with lichens, is made of plant down and fibers. Lays two white eggs.

Black-chinned Hummingbird
Archilochus alexandri
L 4" WS 5" ♂ ≠ ♀ BCHU

This is the western counterpart to the familiar Ruby-throated Hummingbird of the East, summering from Texas to British Columbia and Southern California. Winters in western Mexico and sparingly along our Gulf Coast. Breeds through semi-open country, chaparral, riverine scrub, and suburbs. Males perform a "pendulum" display with whirring wings. A regular visitor to nectar feeders. Diet is nectar and arthropods. The tiny nest, set atop a horizontal branch, is a tidy cup of plant fibers bound with spider silk and encrusted with lichens. Lays one to three white eggs. Unlike the Rubythroat, this species pumps its tail when feeding on nectar. This is perhaps the most familiar of the western hummingbirds. As the sister species to the Rubythroat, its range complements that of the eastern species. A commonplace species whose population appears stable.

Lucifer Hummingbird *Calothorax lucifer*

L 4" WS 4" ♂ ≠ ♀ LUHU *WL

This primarily Mexican species summers to various spots along the Southwest Borderlands. Winters in southern Mexico. Breeds on arid hillsides in desert. Also wanders to adjacent habitats. Forages especially at the Century Plant (*Agave americana*), cacti, ocotillos, and other flowering shrubs. Diet is mainly nectar and small insects. The nest, set in a cactus or similar succulent, is a small cup of plant fibers wrapped in spider silk and decorated with lichens. Lays two white eggs.

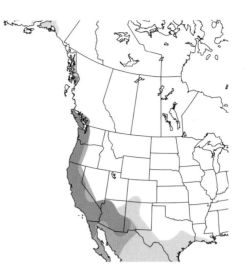

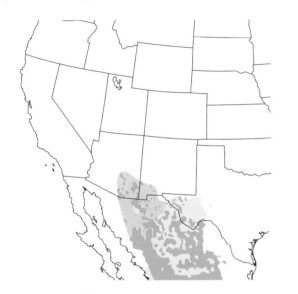

Anna's Hummingbird *Calypte anna*

L 4" WS 5" ♂ ≠ ♀ ANHU

This magenta-faced hummer is resident along the Pacific Coast from southeastern Alaska south to Baja. Also summers in the Sierras; these birds winter to the Southwest Borderlands. Breeds in woodland openings, chaparral, and backyard gardens. Ranges into mountains in late summer. The male produces many sounds by voice and wings. Diet is nectar and arthropods. The largish nest, set atop of a branch of a shrub, is a tidy cup of plant fibers bound with spider silk and encrusted with lichens. Lays one to three white eggs.

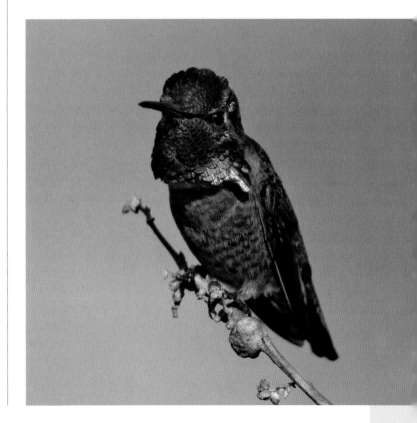

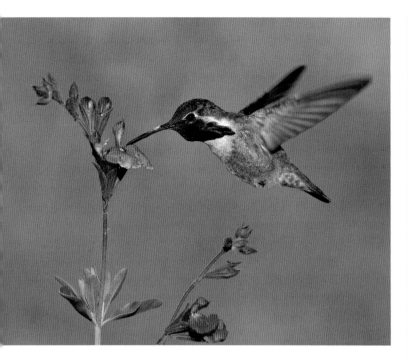

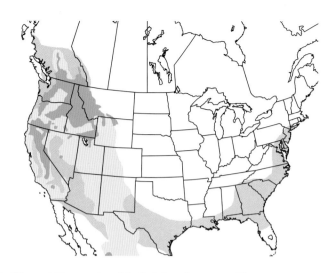

Calliope Hummingbird *Selasphorus calliope*
L 3" WS 4" ♂ ≠ ♀ CAHU

The smallest bird in North America, the Calliope Hummingbird summers in the Interior West and winters in Mexico in pine-oak woods. Breeds in mountain meadow openings near streams. Diet is nectar and arthropods. The nest, set on a pine branch, is a compact cup of plant matter that is wrapped in spider silk and encrusted with bark and lichens. Lays two white eggs. The species is typically quiet and inconspicuous. This common and widespread western species appears to be doing well, with a stable population. Note the short and squared-off tail.

Costa's Hummingbird *Calypte costae*
L 4" WS 5" ♂ ≠ ♀ COHU

The male sports a purple crown and flared throat patches. The species breeds from central California to southeastern Arizona and into western Mexico and Baja. This tiny hummer winters from the Southern California southward into western Mexico. Breeds in desert washes, sage scrub, and hillsides. Male gives a very high-pitched zinging whistle in display. Diet is nectar and arthropods. The nest, set upon a horizontal branch in the open, is a cup of plant fibers, wrapped in spider silk, with a grayish cast. Lays two white eggs.

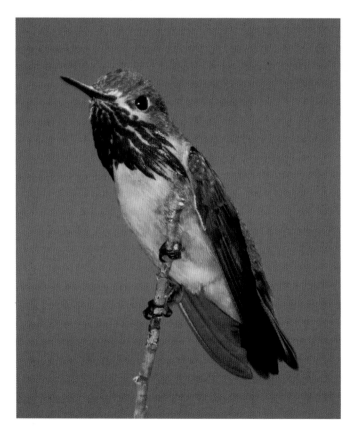

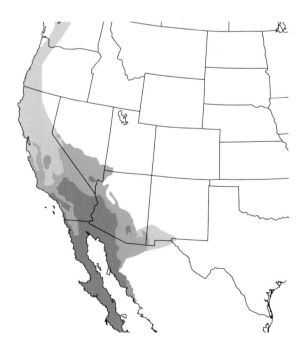

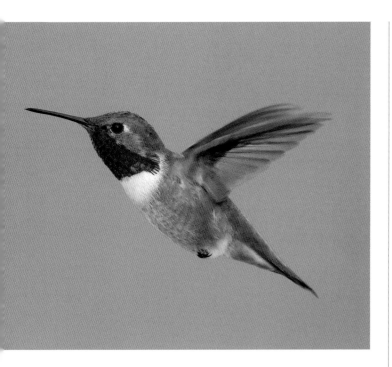

Rufous Hummingbird *Selasphorus rufus*
L 4" WS 5" ♂ ≠ ♀ RUHU *WL

This rusty-highlighted hummer summers in the Pacific Northwest, north to south-central Alaska. Winters from the Deep South to Mexico; its wintering range has expanded with the widespread winter availability of flowers and feeders. Breeds in open conifer forest and riparian woodland. Male is pugnacious in defense of a feeder or flower patch. Diet is nectar and arthropods. The nest, set on a low conifer branch, is a compact cup of plant matter that is wrapped in spider silk and encrusted with bark and moss. Lays one or two white eggs.

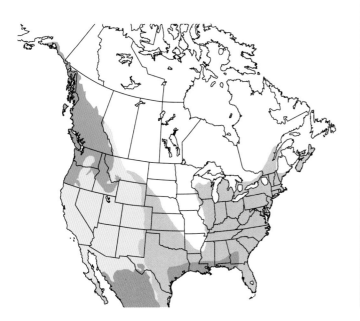

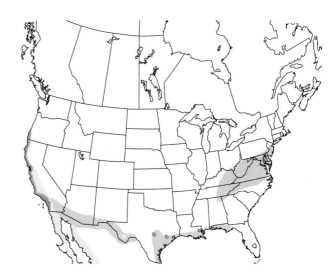

Allen's Hummingbird *Selasphorus sasin*
L 4" WS 4" ♂ ≠ ♀ ALHU *WL

This sister species to the Rufous Hummingbird summers along the coast of California. Winters in Southern California (where some are year-round residents) and central Mexico. Breeds in coastal chaparral and low riparian woodlands. Male is pugnacious in defense of a feeder or flowers. Diet is nectar and arthropods. The nest, set on a low shrub, is a tidy cup of plant matter and green mosses that is wrapped in spider silk and encrusted with lichen. Lays two white eggs. Often impossible to distinguish in the field from the more northerly-breeding Rufous Hummingbird, with which it interbreeds in an overlap zone.

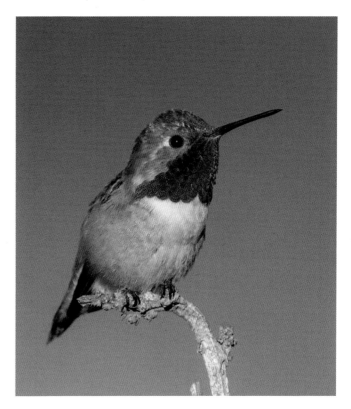

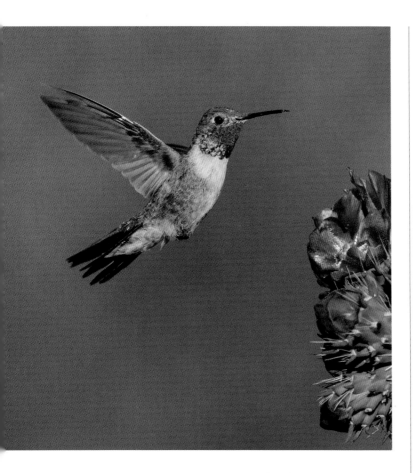

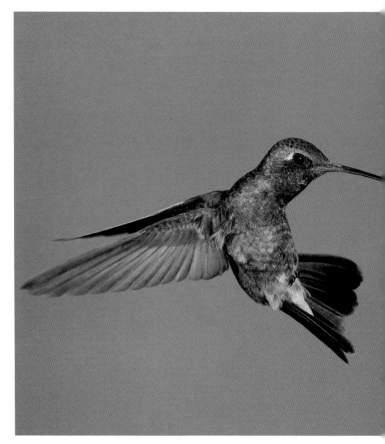

Broad-tailed Hummingbird *Selasphorus platycercus*
L 4" WS 5" ♂ ≠ ♀ BTHU

This crimson-throated hummer summers in the Interior West and southward into Mexico. It winters in Mexico. Breeds in mountain forests and alpine meadows. The wings of the male in flight make a distinctive high trill. Diet is nectar and arthropods. The nest, set on a low conifer branch, is a neat cup of plant matter that is wrapped in spider silk and encrusted with lichen, moss, and bark. Lays one or two white eggs. This species is often confused for the Rufous Hummingbird. Varies from uncommon to common across its range. The species population may be in decline.

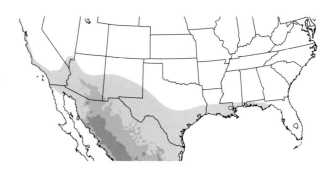

Broad-billed Hummingbird *Cynanthus latirostris*
L 4" WS 6" ♂ ≠ ♀ BBIH

This iridescent-blue-and-green hummer is a widespread Mexican species that summers in southeastern Arizona. Many of the US birds retreat to Mexico for the winter, but some overwinter in Arizona. Breeds in riverine vegetation near streams, in desert canyons, and in oak foothills, mainly in the uplands above 3,000 feet elevation. Common in its limited range in the United States. Diet is nectar and arthropods. The nest, set in a shrub, is a loose cup of grasses bound with spider silk. Nest is camouflaged with pieces of bark and leaves. Lays two white eggs. The male wags its tail and makes a distinctive chattering call.

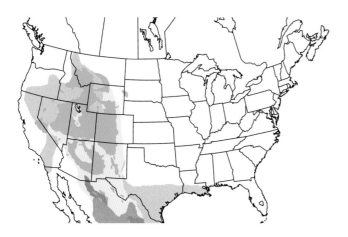

White-eared Hummingbird *Basilinna leucotis*
L 4" WS 6" ♂ ≠ ♀ WEHU

This handsome Mexican and Central American species strays north in summer regularly to southeastern Arizona and rarely to West Texas. Winters in Mexico. Occasionally breeds north of the Border in montane pine-oak forest near stream corridors. Most regularly seen at nectar feeders. Diet is nectar and arthropods. The nest, set on a twig in a shrub, is a cup of plant fibers and pine needles wrapped in spider silk and lined with fine plant down. The cup is camouflaged with lichens and moss. Lays two white eggs.

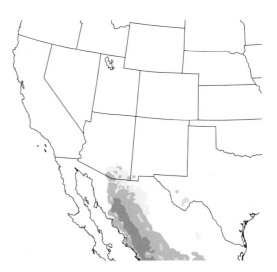

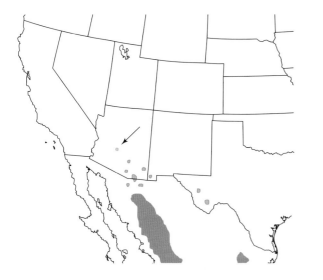

Violet-crowned Hummingbird
Ramosomyia violiceps
L 5" WS 6" ♂ = ♀ VCHU

This Mexican hummer, distinctive because of its entirely white underparts, summers north into southeastern Arizona. It winters mainly in Mexico. Breeds in lower canyons in groves of tall sycamores and cottonwoods along a flowing stream. Diet is nectar and arthropods. The nest, set on the branch of a deciduous tree or shrub, is a cup of cottony plant down wrapped in spider silk. Nest is encrusted with lichens. Lays two white eggs. Population appears stable.

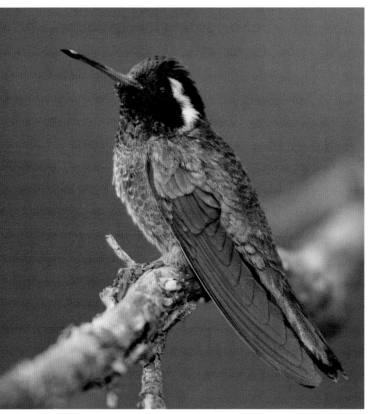

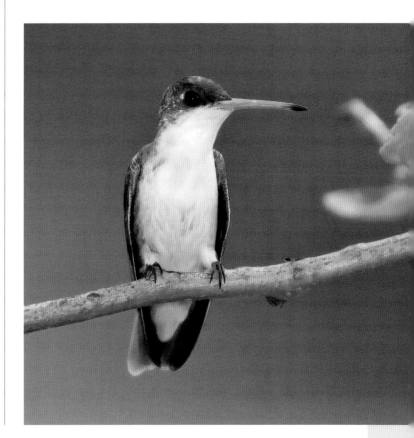

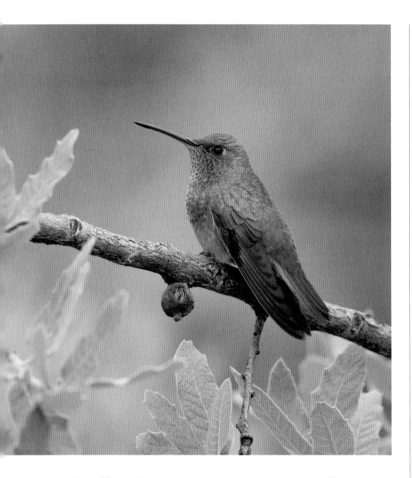

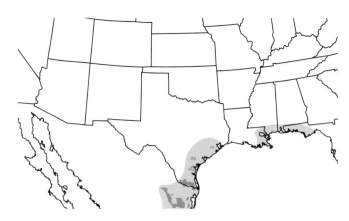

Buff-bellied Hummingbird *Amazilia yucatanensis*
L 4" WS 6" ♂ ≈ ♀ BBEH

This eastern Mexican and northern Central American species ranges north into South Texas, where it is a permanent resident. Winters sparingly along the Gulf Coast, south to the Yucatán. Breeds in gardens, clearings in thickets, woodland edge, and citrus groves. Diet is nectar and arthropods. Has a penchant for red tubular flowers. The nest, set in a shrub or low tree (3–10 feet up), is a cup of plant fibers bound with spider silk and lined with plant down with the exterior of the cup encrusted with lichens. Lays two white eggs. Wanders up the Gulf Coast on occasion as far as the Panhandle of Florida. The population in Texas appears stable.

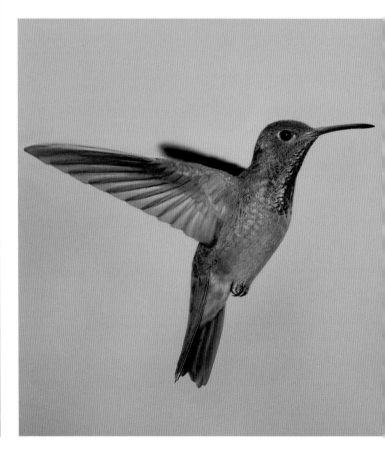

Berylline Hummingbird *Saucerottia beryllina*
L 4" WS 6" ♂ ≈ ♀ BEHU

This widespread and common Mexican species summers sparingly in southeastern Arizona, where it has nested on occasion, but it is mainly a cross-Border stray. Winters in Mexico. The species ranges south to Honduras. Breeds in upland canyons and montane forest, mainly above 5,000 feet above sea level. Diet is nectar and arthropods. The nest, set in a deciduous tree or shrub, is a cup of plant fibers wrapped in spider silk and encrusted with green lichens. Lays two white eggs. May shift to lower elevations during winter. Most similar to the Buff-bellied Hummingbird.

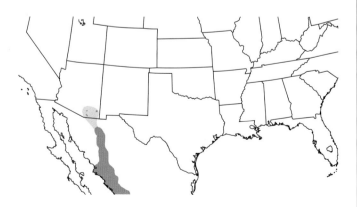

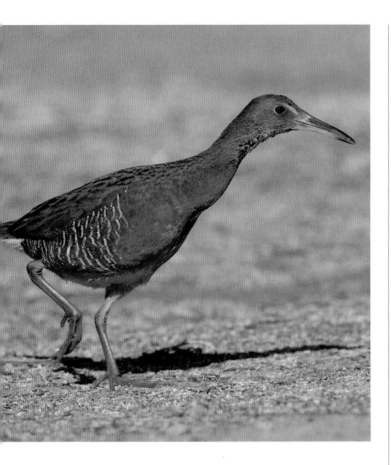

Clapper Rail *Rallus crepitans*
L 15" WS 19" ♂ = ♀ CLRA

A permanent resident that ranges along the Atlantic and Gulf Coasts southward to the Yucatán and the islands of the Caribbean. Breeds in saltmarshes. Generally shy, but can also be confiding. Typically seen when tide exposes mud next to saltmarsh or when floodwaters push the birds out of cover. Diet is fish, arthropods, and crustaceans. The nest, often domed, is a bowl of dead marsh grasses hidden at the base of tall saltmarsh vegetation. Lays 9–21 buff eggs marked with brown. Northernmost breeders retreat southward in winter. This species is known to hybridize with the King Rail where their breeding ranges meet.

Ridgway's Rail *Rallus obsoletus*
L 16" WS 20" ♂ = ♀ RIRA *NT *WL

A species of western Mexico that ranges patchily northward up the West Coast to the San Francisco Bay area of California. Breeds in coastal and bay saltmarshes and a few freshwater marshes of the arid Interior Southwest. Until recently, considered conspecific with the Clapper Rail. Diet is fish, arthropods, and crustaceans. The nest, often a domed bowl of dead marsh grasses, is hidden on the ground within marsh vegetation. Lays 9–12 buff eggs spotted with brown.

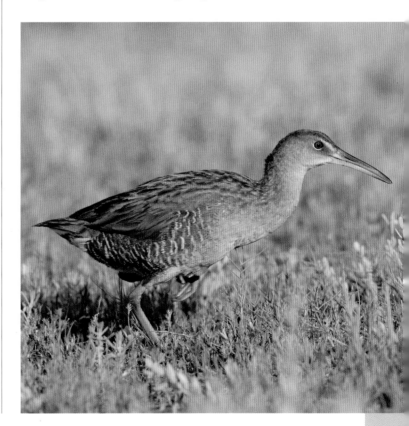

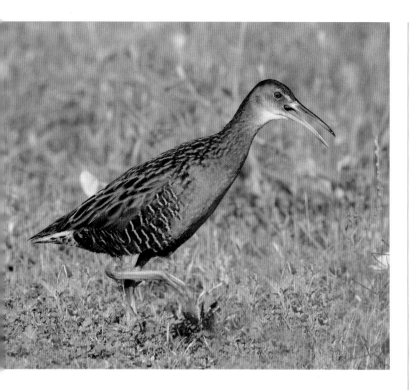

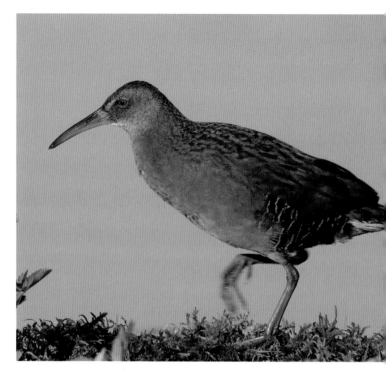

King Rail *Rallus elegans*
L 15" WS 20" ♂ = ♀ KIRA *NT *WL

Inhabits freshwater and brackish marshes of the central and eastern United States. A permanent resident in the marshlands of the Deep South. Northern birds migrate southward in the winter. Sometimes can be found in the same brackish marsh habitat as the Clapper Rail. The two species do hybridize from time to time. Diet is crustaceans, arthropods, and small vertebrates. The nest, set in thick marsh grasses, is a platform of dead marsh vegetation covered over with more vegetation. Lays 10–12 pale buff eggs lightly marked with brown. Appears to be a species in decline.

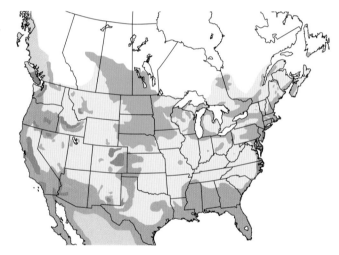

Virginia Rail *Rallus limicola*
L 10" WS 13" ♂ = ♀ VIRA

Summers patchily across the Lower 48 and southern Canada. There are some permanent resident populations on the West Coast and Interior West but most populations are migratory. Winters in the Deep South and Southwest Borderlands, southward into Mexico. Breeds in freshwater and brackish marshes. Winters also in saltmarshes. Elusive—heard but rarely seen. Diet is mainly arthropods and crustaceans. The nest, sited in a dense clump of marsh vegetation, is a platform of dead marsh grass with a canopy of living vegetation overhead. Lays 5–13 pale buff eggs lightly marked with brown and gray. This species and the Sora are our two most widespread rails.

Sora *Porzana carolina*
L 9" WS 14" ♂ = ♀ SORA

This distinctive short-billed rail breeds across most of North America except for the Southeast. Winters southward, into the Deep South, Southwest Borderlands, Mexico, the Caribbean, and northern South America. Breeds in freshwater marshes and wet meadows. Shy and elusive, typically heard but not seen. A buoyant swimmer. Diet is seeds, arthropods, and snails. The nest, set in dense marsh vegetation, is a cup made of plant matter with a runway and a covering arched over the nest. Lays 10–12 rich buff eggs spotted brown. Can be found in saltmarshes in winter. This is a game bird in the East. Species is generally faring well.

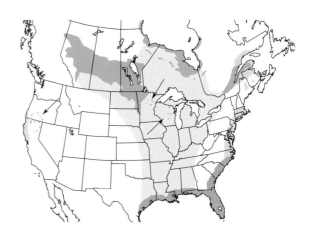

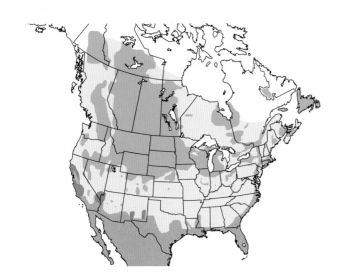

Yellow Rail *Coturnicops noveboracensis*
L 7" WS 11" ♂ = ♀ YERA *WL

Summers sparingly in the northern US Borderlands, central Canada, and sporadically in Northern California and southern Oregon. Winters in the Deep South. Breeds in wet sedge meadows and grassy marshes. Winters in salt and brackish marshes and rice fields. Exceedingly secretive. Rarely observed unless flushed, but its clicking call is heard at night during the breeding season. Diet is arthropods, snails, and seeds. The nest, set in wet marsh vegetation, is a shallow cup of plant matter with a concealing canopy of dead plant matter. Lays 8–10 buffy-white eggs with red-brown spotting. Tends to vary in abundance on the breeding grounds—perhaps in relation to annual water levels in the marshy habitat. Very difficult to locate on wintering range.

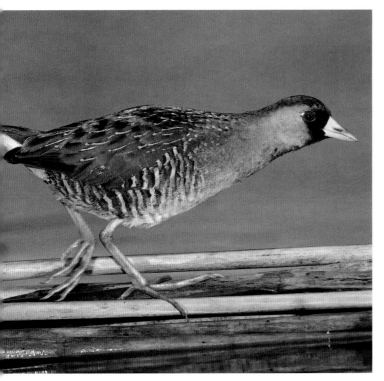

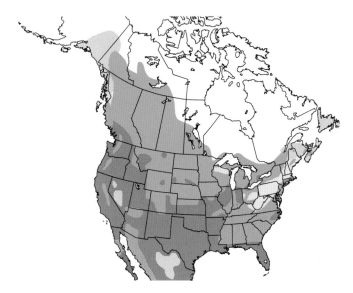

American Coot *Fulica americana*
L 16" WS 24" ♂ = ♀ AMCO

This blackish waterbird with a white bill summers across the central and western United States and Canada, wintering along the Atlantic, Pacific, and Gulf Coasts. A permanent resident in much of the West and Southwest. Breeds in ponds, lakes, and marshes. Winters in most open waters, both fresh and salt. Duck-like in behavior, paddling about in flocks. Frequents city parks and urban reservoirs with ducks. Diet is a wide mix of plant and animal matter. The nest is a floating platform of dead recumbent marsh vegetation, anchored to living marsh plants. Lays 6–11 buff or gray eggs with brown spots.

Black Rail *Laterallus jamaicensis*
L 6" WS 9" ♂ = ♀ BLRA *NT *WL

A rare and declining species with small breeding populations on the Atlantic, Pacific, and Gulf Coasts and in a few sites in the Interior. Breeds in marshland. Very secretive and elusive; heard vocalizing at night and occasionally in the daytime during the breeding season. Northern populations winter in the coastal Deep South. Diet is arthropods, snails, and seeds. The nest, hidden in thick marsh grass, is a domed cup of marsh vegetation. Lays 3–13 white or buff eggs dotted with brown. East Coast populations appear in steep decline. Arizona population declared endangered.

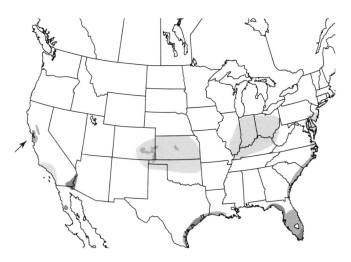

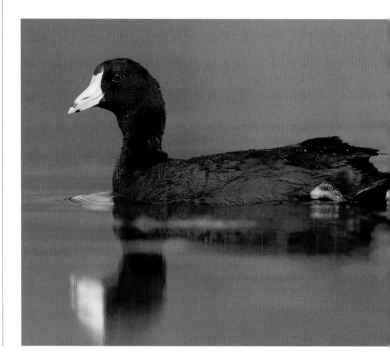

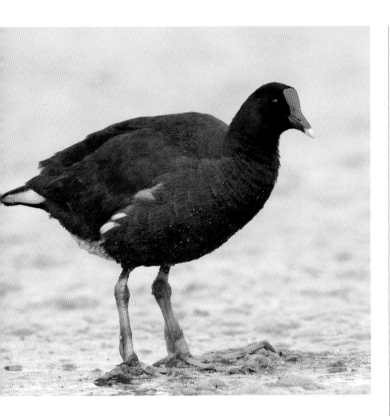

Common Gallinule *Gallinula galeata*

L 14" WS 21" ♂ = ♀ COGA

This dark marsh hen summers patchily in the eastern and central United States (and in southernmost Quebec). Wintering birds and permanent residents inhabit the Deep South, Southwest Borderlands, parts of California, and Mexico. The species ranges through Central and South America and the Caribbean. Breeds in freshwater marshes and reedy ponds. Tends to hide in marsh grass or lurk at the marsh edge, but it can also be found swimming in the open. Diverse diet is a mix of plant and animal matter. The nest is a substantial platform of vegetation with an access ramp of plant matter. Lays 8–11 buff eggs spotted with brown. Some local populations appear to be declining.

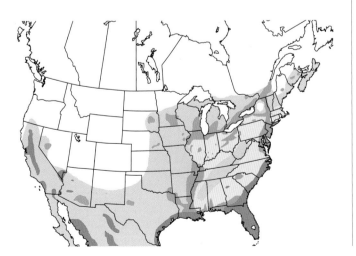

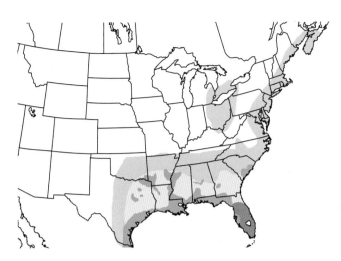

Purple Gallinule *Porphyrio martinicus*

L 13" WS 22" ♂ = ♀ PUGA

This colorful marsh hen summers in the Deep South, wintering in Florida and Mexico. The species ranges through eastern Mexico and the Caribbean and southward to northern Argentina. Breeds in freshwater swamps, marshes, and reedy ponds. Very vocal. Clambers over marsh vegetation with its huge feet. Rather shy. Diet is a wide array of plant and animal matter. The nest, set over water in dense marsh vegetation, is a platform of recumbent dead plant material anchored to living growth. Lays six to eight buff eggs spotted brown. Northernmost breeders retreat southward.

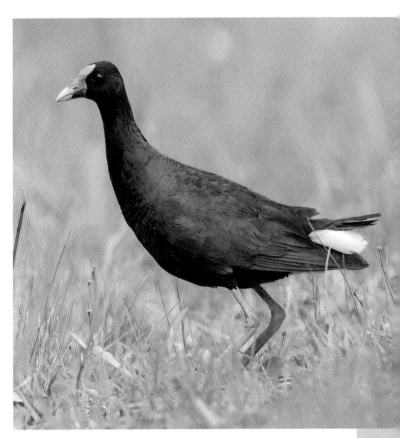

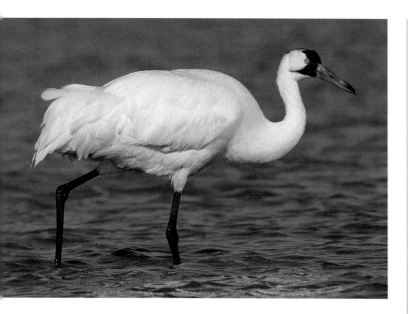

Whooping Crane *Grus americana*
L 52" WS 87" ♂ = ♀ WHCR *EN *WL

This very rare species is one of North America's most striking—and tallest—bird species. The extant wild population breeds in west-central Canada in muskeg or boggy marshland. Experimental breeding groups have been introduced in the Lower 48. Most migratory birds currently winter in Texas, while those in Louisiana and Florida are part of resident reintroduced populations. In migration, birds travel in pairs or paired adults with one or two offspring. Pairs carry out a distinctive display dance in spring. Diet is a wide range of plant and animal matter. The nest is a large mounded cup of dead marsh vegetation and mud. Lays one to three olive-buff eggs spotted dark brown. Formerly nested in the northern prairies southward to Illinois. The species population dropped to 21 birds in 1941, and was subsequently rescued by intensive captive-breeding efforts. As of 2021, the species was represented in the wild by some 600 individuals.

Sandhill Crane *Antigone canadensis*
L 46" WS 77" ♂ = ♀ SACR

This grand, long-legged wading bird summers widely from Alaska to the northern United States. Winters across the southern United States. A permanent resident population inhabits peninsular Florida and southern Mississippi. Huge flocks congregate on the Platte River of Nebraska in late March. Breeds in prairies, marshes, bogs, and tundra. Winters in farm fields and river valleys in prairie country. Birds form flocks during the nonbreeding season. Pairs carry out a dancing display in spring. Diet is a wide range of plant and animal matter. Takes waste grain when available. The nest is a mounded cup of dead plant material set in the water or on dry ground. Lays one to three olive or buff eggs marked with brown spots. Alaska breeders are the smallest.

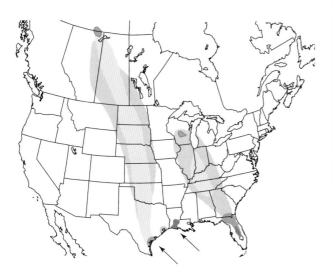

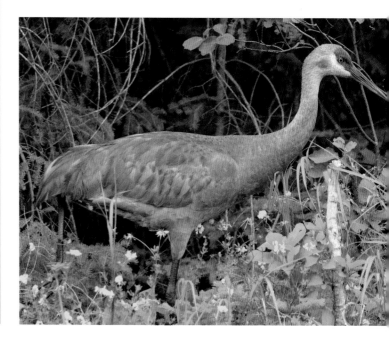

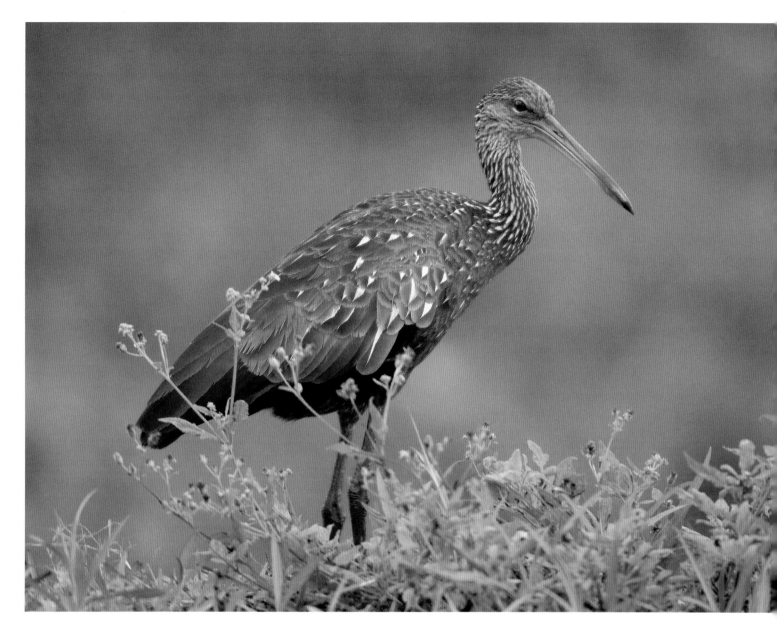

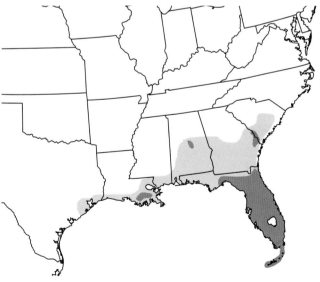

Limpkin *Aramus guarauna*
L 26" WS 40" ♂ = ♀ LIMP

Looking like a much-oversized rail, the Limpkin is an uncommon and shy permanent resident of peninsular Florida, though its range has recently begun expanding into the southeastern United States. The species also inhabits the Caribbean and Central and South America. Breeds in brushy and wooded freshwater swamps. Gives a loud wailing call, especially at night, when it seems to be most active. Diet is mainly large aquatic snails, as well as other invertebrates and small vertebrates. The nest is a platform of reeds and grass lined with finer plant material. Lays four to eight buff or olive eggs marked with darker colors. Early in the 20th century was hunted nearly to extirpation from its Florida haunts. Now population appears safe and stable.

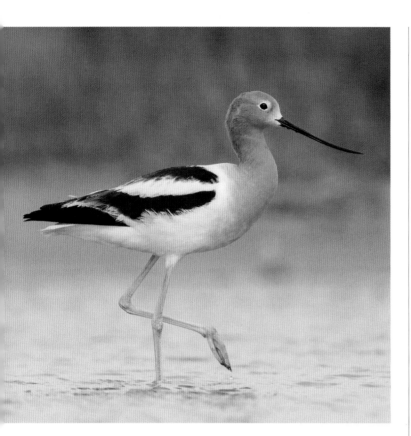

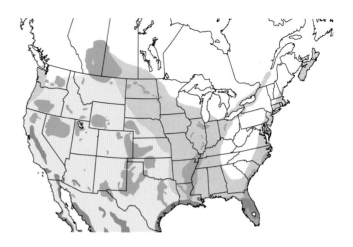

Black-necked Stilt *Himantopus mexicanus*
L 14" WS 29" ♂ ≈ ♀ BNST

This conspicuous pied wader of shallow water lagoons summers patchily across the United States. Winters in the Deep South and Southwest. Breeds in grassy marshes and shallow lakes where bare open ground is available. Moves to the Atlantic, Pacific, and Gulf Coasts in winter. Additional populations are resident south to Chile and Argentina. Diet is mainly arthropods and crustaceans. The nest is a scrape lined with pebbles on bare ground. Lays two or three pale buff or olive eggs marked with brown and black. Vocal on the breeding ground. Species population is on upswing.

American Avocet *Recurvirostra americana*
L 18" WS 31" ♂ ≈ ♀ AMAV

The breeding adult is one of our most beautiful waders. It summers widely in the Interior West (and central Mexico) and winters on the Atlantic, Pacific, and Gulf Coasts and in Mexico. Breeds in shallow alkaline lakes and ponds with fringing vegetation. Typically forages in flocks, with birds moving in unison through shallow water with their dipped bills waving side to side. Diet is mainly small crustaceans and arthropods. The nest, set on open ground, is a scrape lined with pebbles or a mounded cup of plant detritus. Lays three to five olive-buff eggs blotched with brown and black.

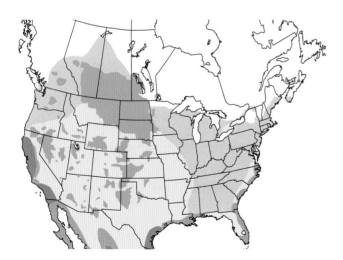

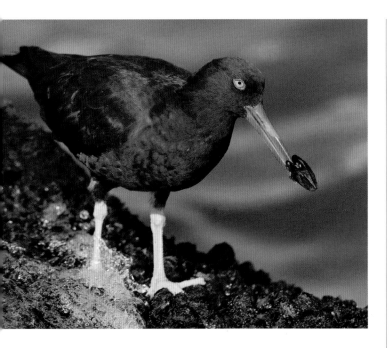

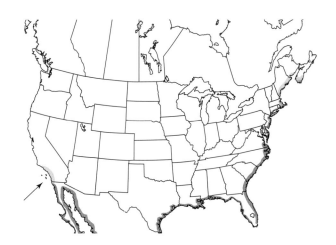

Black Oystercatcher *Haematopus bachmani*

L 18" WS 32" ♂ = ♀ BLOY *WL

A coastal resident from the Aleutian Islands and southern mainland Alaska south to Baja. Summers in the rocky coastal intertidal zone, especially on offshore islands. Spends more time on mudflats in winter. Wary and vocal. Diet is mainly shellfish, as well as crustaceans. The nest is a slight scrape with a lining of pebbles along the rocky shore. Lays two or three olive eggs marked with brown and black.

American Oystercatcher *Haematopus palliatus*

L 18" WS 32" ♂ = ♀ AMOY *WL

This striking wader summers along the coasts of the Atlantic and Gulf, wintering southward. Additional populations inhabit the coasts of Mexico and Central and South America. Breeds on coastal beaches where there are nearby tidal flats and salt marshes, especially where there are oyster beds and clam flats. Typically found in pairs or family parties in summer and in flocks in winter. Diet is a mix of shellfish and marine worms, as well as other invertebrates. The nest is a scrape in the sand lined with pebbles or shell fragments. Lays one to four buffy-gray eggs speckled with dark brown. Recent conservation interventions to protect nesting beaches has aided recovery of this species along the Atlantic Coast. Range has extended to Nova Scotia.

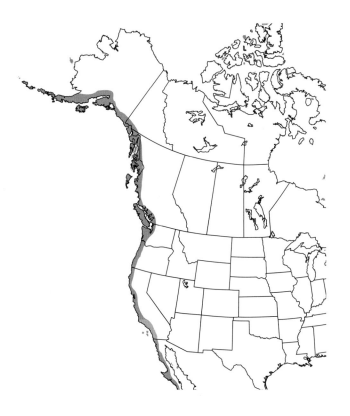

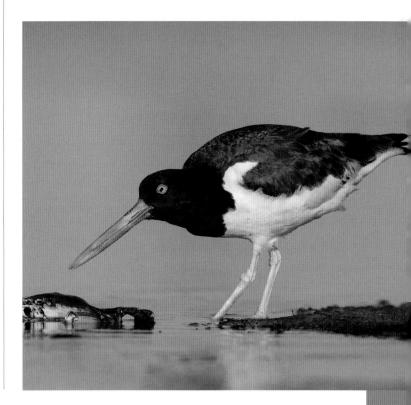

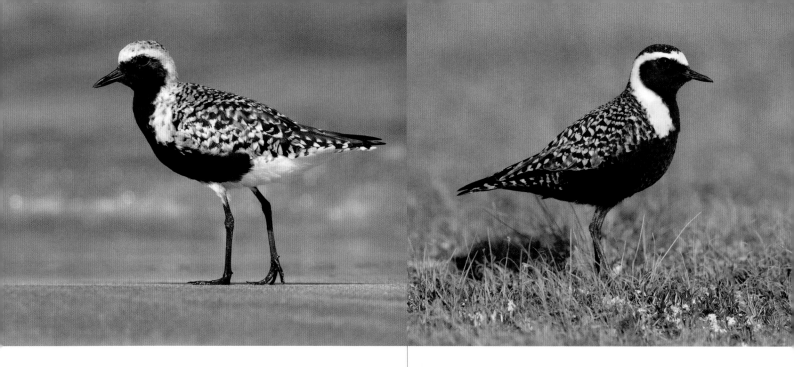

Black-bellied Plover *Pluvialis squatarola*
L 12" WS 29" ♂ ≠ ♀ BBPL

This handsome plover summers in the High Arctic of Canada, Alaska, and Siberia, and it winters on our Atlantic, Pacific, and Gulf Coasts and southward. Breeds on dry tundra uplands. This and other plovers exhibit a distinctive run-and-stop foraging gait. Diet is a wide range of invertebrates—including arthropods, crustaceans, and mollusks. The nest is a shallow scrape lined with pebbles and detritus set atop of a tundra ridge. Lays three to five buff eggs blotched with dark markings. Globally, this is one of the most widespread and common of the larger plovers. In Europe known as the Grey Plover. Population stable.

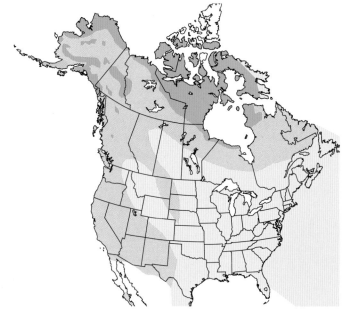

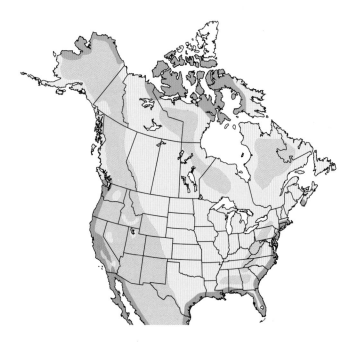

American Golden-Plover *Pluvialis dominica*
L 11" WS 26" ♂ ≈ ♀ AMGP

This elegantly plumaged plover summers on tundra from Baffin Island and Hudson Bay west to Alaska. Winters in southern South America. Breeds on well-drained rocky tundra slopes. Flocks of breeding-plumaged migrants stop over in plowed fields in the Great Plains in spring. In autumn, some southbound birds fly east to Atlantic Canada and then fly out over the Atlantic nonstop to South America. Diet is arthropods, crustaceans, mollusks, and some plant material. The nest, set in low dry tundra, is a shallow depression lined with lichens and moss. Lays three or four pale buff eggs boldly blotched with brown and black. Considerably less common than the Black-bellied Plover.

Pacific Golden-Plover *Pluvialis fulva*
L 11" WS 24" ♂ ≠ ♀ PAGP

Summers in Siberia and western Alaska. Winters into the South Pacific and Australia. Many birds stop over or winter in Hawaii. Breeds in low-elevation wet tundra with higher vegetation than that of the the American Golden-Plover. The American Golden-Plover and Pacific Golden-Plover can both be found nesting in northwestern Alaska. Carries out long overwater migrations from Alaska and Siberia to islands in the Pacific. There are many autumn and winter records of the species from the West Coast, but but few from the East Coast. Diet is arthropods, crustaceans, and mollusks. The nest is a depression in the tundra lined with lichens. Lays three or four buff eggs spotted with brown.

Northern Lapwing *Vanellus vanellus*
L 13" WS 33" ♂ = ♀ NOLA *NT

A widespread dark-crested Eurasian plover that strays to the East Coast on occasion, with records from Atlantic Canada south to Florida. Mainly found in plowed fields in late autumn and winter. Typically solitary birds are found. Diet is arthropods and other invertebrates. The species is declining in Europe. Note the long rounded wings with white tipping. This is our only shorebird with a crest. Could not be mistaken for any other bird. The breeding range of the species extends from Spain and England to northern China and easternmost Russia. Most North American records come from Atlantic Canada—mainly storm-driven birds.

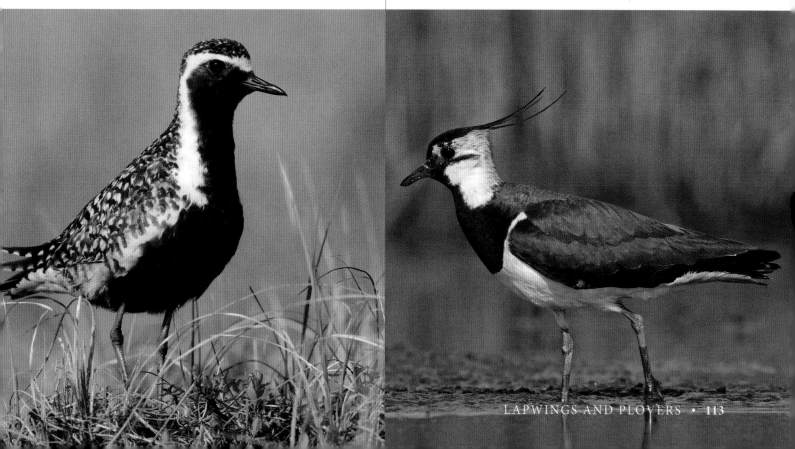

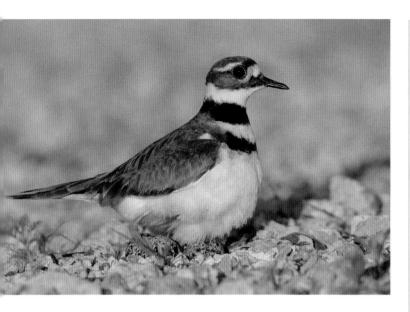

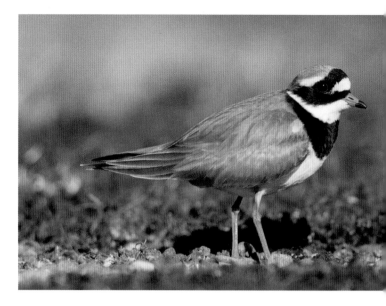

Killdeer *Charadrius vociferus*
L 11" WS 24" ♂ = ♀ KILL

This bird—our most familiar, vocal, and commonplace plover—summers across North America. Northern populations winter southward, as far as the Deep South and Mexico. The species is also resident in the Caribbean, Mexico, and western South America. Breeds in open country, including heavily grazed pastures, plowed fields, golf courses, and shortgrass prairies. Diet is arthropods and other invertebrates. Adults at the nest carry out the "broken wing" display that lures predators away from nestlings. The nest is a shallow scrape in soil or gravel, sometimes lined with bits of debris. Lays three to five buff eggs blotched with darker colors. This is a plover of the Interior and generally not abundant on beach shores, where the other plovers predominate. Typically heard before seen. The only plover to be expected in suburbia. Population stable.

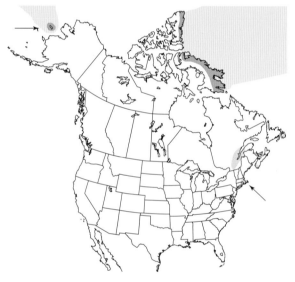

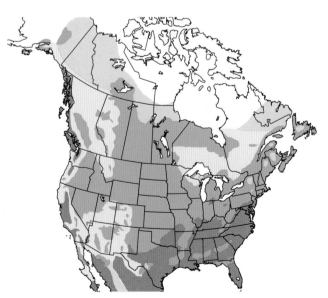

Common Ringed Plover *Charadrius hiaticula*
L 7" WS 19" ♂ ≠ ♀ CRPL

Summers on Baffin and Ellesmere Islands of High Arctic Canada and Saint Lawrence Island, Alaska, as well as Greenland and across northern Eurasia. Winters to the Old World Tropics and Subtropics. Breeds on tundra. Very similar to the Semipalmated Plover, which is presumably a close relative. The species periodically strays to the Northeast, the West Coast, the Aleutians, and coastal Alaska. Diet is various marine invertebrates and arthropods. The nest is a scrape lined with shell fragments on a sandy beach. Lays four buff eggs spotted with brown and black. This is Eurasia's version of our familiar Semipalmated Plover. Population appears stable.

Semipalmated Plover *Charadrius semipalmatus*
L 7" WS 19" ♂ ≈ ♀ SEPL

This little ring-necked plover summers on tundra and shingle beaches of northern Canada and Alaska. Winters on the Atlantic, Pacific, and Gulf Coasts and southward to South America. Mainly seen on beaches of coastal shores and tidal flats. Common in migration, found where shorebirds habitually stop over—water treatment plants, lakeshores, and other open ground near water. Usually in flocks in the nonbreeding seasons. Diet is arthropods and marine and aquatic invertebrates. The nest is a shallow depression in low tundra or beach gravel. Lays three or four olive-buff eggs blotched with darker colors.

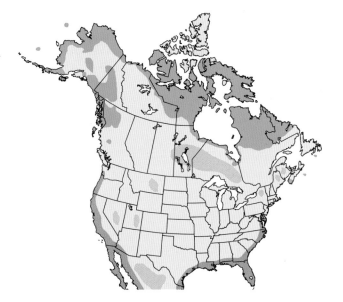

Piping Plover *Charadrius melodus*
L 7" WS 19" ♂ ≠ ♀ PIPL *NT *WL

This pale little plover summers along beaches of the East Coast and the Great Lakes, as well as along river sandbars and lakes of the northern and western Great Plains. Winters on the coastlines of the Deep South, Mexico, and the Caribbean. Breeds on sandy beaches. Winters on coastal beaches and tidal flats but rarely seen in migration. Shy and elusive. Difficult to locate on expansive stretches of beach where the birds hide among shore detritus high above the tide line. Diet is various arthropods and marine and aquatic invertebrates. The nest is a shallow scrape in the sand, in some cases lined with shell fragments or pebbles. Lays two to five pale buff eggs marked with darker colors.

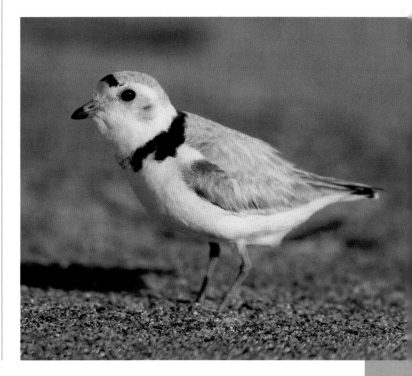

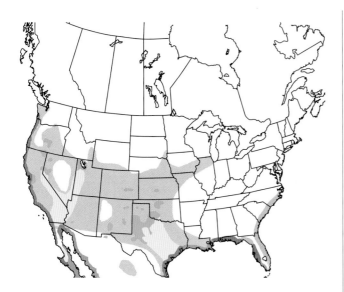

Snowy Plover *Charadrius nivosus*

L 6" WS 17" ♂ ≠ ♀ SNPL *NT *WL

A permanent resident along the Gulf and Pacific coasts. Summers patchily in the Interior West. Also breeds in the Caribbean, Mexico, and western South America. North American breeders winter to the West Coast, Baja, the Gulf Coast, and Central America. Breeds on beaches and sandy interior salt flats. Inconspicuous and easily overlooked. Diet is a range of small invertebrates. The nest is a shallow scrape, lined with pebbles and shell bits, on open bare ground. Lays two or three pale buff eggs dotted with black.

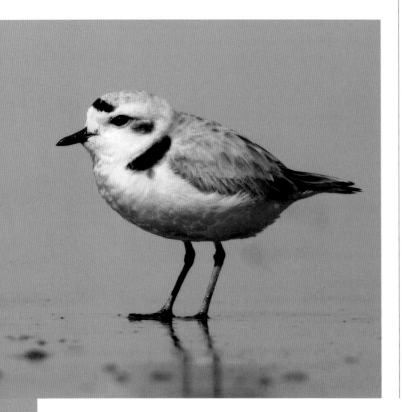

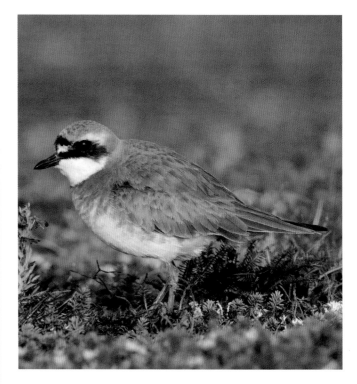

Lesser Sand-Plover *Charadrius mongolus*

L 8" WS 18" ♂ ≠ ♀ LSAP

Summers in central and East Asia, to Kamchatka and Chukotka, Russia. Has bred in northwestern Alaska. Winters in East Africa, South Asia, Southeast Asia, and Australasia. An annual visitor to Alaska: the western Aleutian Islands, Pribilof Islands, Saint Lawrence Island, and along the coast of the mainland. Additional records up and down the West Coast. A few records from the Atlantic and Gulf Coasts. Various records from the Interior (e.g., Ontario, Indiana, Virginia, and Arizona). Most records come from late summer. The nest, situated on tundra or shingle, is a sandy scrape lined with pebbles and detritus. Lays two or three buff eggs marked with darker colors.

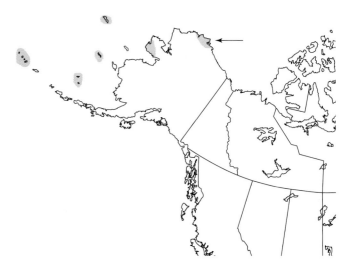

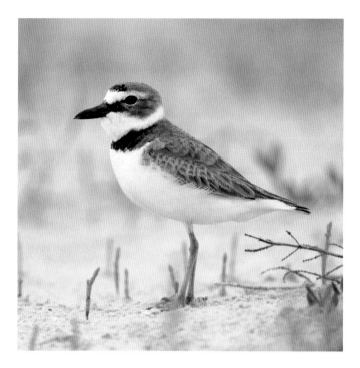

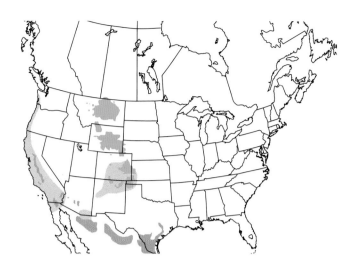

Wilson's Plover *Charadrius wilsonia*
L 8" WS 19" ♂ ≠ ♀ WIPL *WL

Summers along the Atlantic and Gulf Coasts of the Deep South. The species also breeds in Mexico, the Caribbean, and northern South America. Winters southward. Breeds only on coastal beaches, especially on coastal islands protected from vertebrate predators. May share beach habitat with breeding Snowy Plovers. Diet is crustaceans, worms, and small mollusks. Summering birds will forage at night. The nest is a shallow scrape in the sand with a sparse lining of pebbles. Often set near a piece of driftwood. Lays two to four buff eggs blotched with darker colors. A species in decline.

Mountain Plover *Charadrius montanus*
L 9" WS 23" ♂ = ♀ MOPL *NT *WL

This elusive and plain-plumaged plover summers sparingly up and down the Great Plains, from Montana to New Mexico and northernmost Texas. Winters through the Southwest Borderlands and into northern Mexico. Breeds in dry shortgrass prairie, overgrazed pastureland, and arid plains. Winters in flocks. Diet is mainly arthropods, as well as other invertebrates. The nest is a shallow scrape in soil or gravel on open ground, usually placed next to some natural feature. Lays three to five olive eggs blotched with darker colors. The name of the species should be changed to "Great Plains Plover." A species in decline from habitat loss.

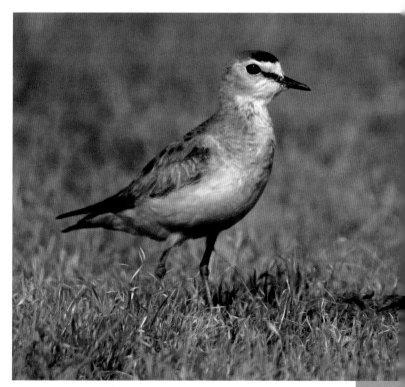

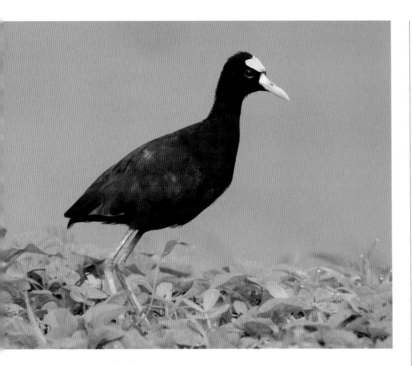

Northern Jacana *Jacana spinosa*
L 10" WS 20" ♂ = ♀ NOJA

This permanent resident of Mexico, Central America, and the Caribbean occasionally strays north across the Border into Texas and Arizona. It has bred in South Texas and has also been reported from Florida. Inhabits ponds with dense emergent vegetation. Walks with its oversized feet on emergent vegetation in search of prey. Diet is mainly arthropods; also takes some small fish. The nest is a flimsy cup of plant matter laid down atop marsh vegetation in shallow water. Lays three to five brown eggs scrawled with black lines. Most North American records come from coastal South Texas. There was a small breeding colony in Brazoria County, Texas, in the 1960s and 1970s.

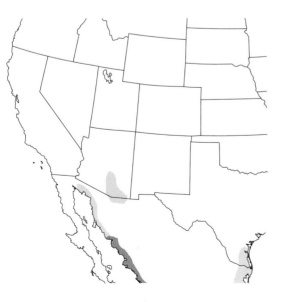

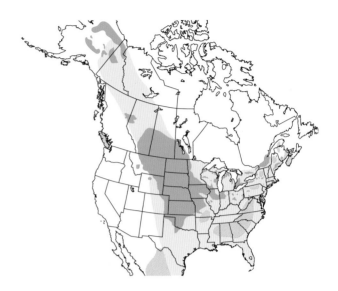

Upland Sandpiper *Bartramia longicauda*
L 12" WS 26" ♂ = ♀ UPSA

This grassland-breeding shorebird summers in the northern United States, parts of Canada, and Alaska. Winters on the Pampas of southern South America. Breeds in shortgrass fields, meadows, and prairie grasslands. Shy and elusive. When it lands upon a wooden fencepost in a rural field, it often holds its wings up for a second or two before closing them. Best located by voice. Diet is mainly arthropods, some seeds. The nest, hidden in thick grass, is a shallow scrape on ground lined with dry grass. Nest is usually hidden by a canopy of covering grass. Lays four pale buff eggs spotted with reddish brown. Populations in the East are sparse and declining. Strange flight song is bubbling and musical.

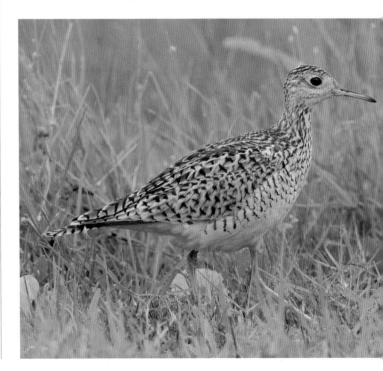

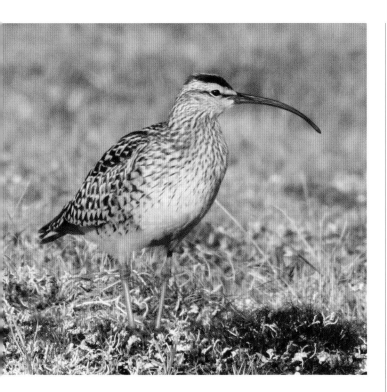

Bristle-thighed Curlew *Numenius tahitiensis*
L 17" WS 32" ♂ = ♀ BTCU *VU *WL

This rare Whimbrel look-alike summers in the interior of western Alaska and winters on islands of the tropical Pacific. It breeds in hilly upland grassy tundra with some shrubs. Its Alaskan breeding ground was not discovered until 1948. The species is most easily seen when migrant or wintering birds stop over on grassy fields in Hawaii. Diet is arthropods, crustaceans, and berries. The nest, hidden under a dwarf willow, is a shallow depression in tundra vegetation lined with a variety of plant parts. Lays four olive-buff eggs blotched with brown. This is the only shorebird known to have a flightless molt, which takes place during its winter sojourn in the South Pacific.

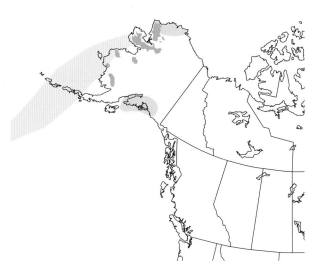

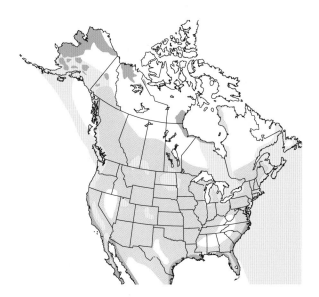

Whimbrel *Numenius phaeopus*
L 18" WS 32" ♂ = ♀ WHIM

This comely curlew summers in Alaska, the Yukon, the Northwest Territories, and the western shore of Hudson Bay. North American birds breed on open mossy tundra. Nonbreeders frequent coastal flats and interior shortgrass pastures, wintering in our southern coastlines and southward to South America. Other populations breed across northern Eurasia and winter south to Africa and Australasia. Migrates in flocks. In autumn, many southbound migrants in the East fly over the open Atlantic from New England south to South America. Diet is arthropods, crustaceans, and berries. The nest, situated on a dry rise in open tundra, is a depression lined with bits of plant matter. Lays three or four olive eggs blotched with brown.

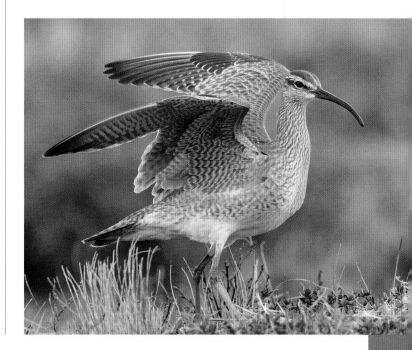

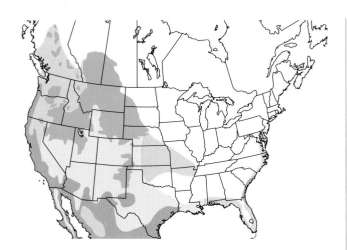

Long-billed Curlew *Numenius americanus*
L 23" WS 35" ♂ = ♀ LBCU *WL

North America's most magnificent shorebird, the Long-billed Curlew summers in thin numbers across the high plains of the Interior West. Winters on the Atlantic, Pacific, and Gulf Coasts, the Southwest Borderlands, and in Mexico south to Honduras. Breeds in dry shortgrass and sagebrush prairies of high interior plains. Most easily found where birds winter along the coasts. Diet is mainly arthropods; also takes some crustaceans, small vertebrates, and berries. The nest, set on the ground in open prairie, is a shallow scrape that is sparsely lined and has a rim of materials around the perimeter. Nest usually placed next to some feature such as a rock or shrub. Lays three to five pale buff eggs spotted with darker colors. A species in substantial decline.

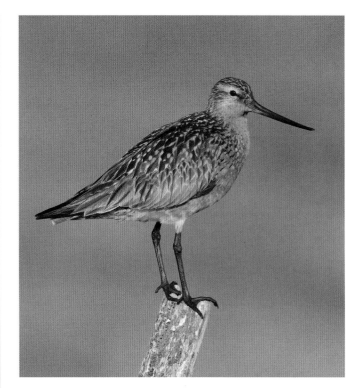

Bar-tailed Godwit *Limosa lapponica*
L 16" WS 30" ♂ ≠ ♀ BTGO *NT

This attractive godwit summers in northwestern Alaska and Siberia, westward to Scandinavia. Alaska-breeding birds winter to the Southwest Pacific and Australia. Breeds in hilly tundra with patchy shrubs. Nonbreeding birds are mainly found on tidal mudflats. Alaskan migrants travel long distances nonstop over the open Pacific to their Southern Hemisphere wintering grounds. Strays appear on both the West Coast (in autumn) and East Coast (in spring and fall), with East Coast vagrants coming from both Alaska and Europe. Diet is arthropods, crustaceans, and mollusks. The nest, set on a raised hummock, is a shallow depression lined with grass and lichens. Lays four olive eggs marked with brown.

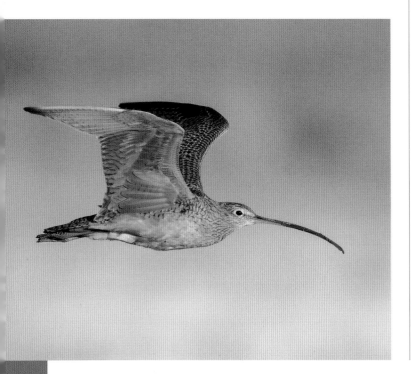

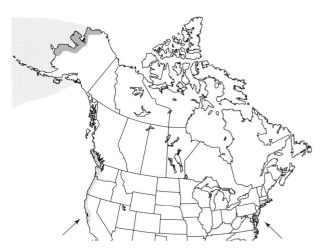

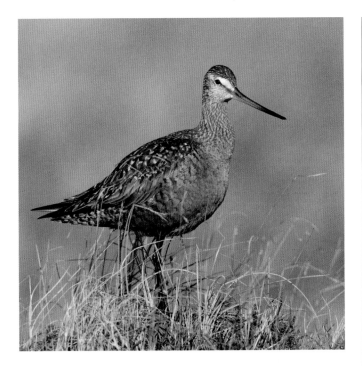

Hudsonian Godwit *Limosa haemastica*
L 16" WS 29" ♂ ≠ ♀ HUGO *WL

This gorgeous long-billed shorebird summers in Alaska, the Northwest Territories, and western Hudson Bay. It winters in Chile and Argentina. Breeds in boggy tundra surrounded by spruce forest. Birds in spring migrate north through the Great Plains, stopping over in flooded fields. Autumn migration sees flocks depart New England and fly nonstop out over the Atlantic to South America. Diet is arthropods, mollusks, marine worms, and crustaceans. The nest, placed on a small rise in wet boggy tundra, is a depression placed near a fallen branch or shrub. Lays three or four olive eggs blotched with dark brown.

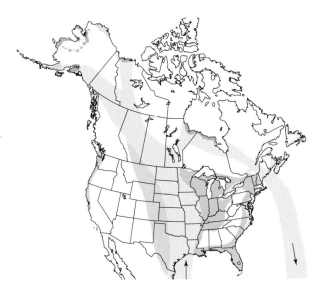

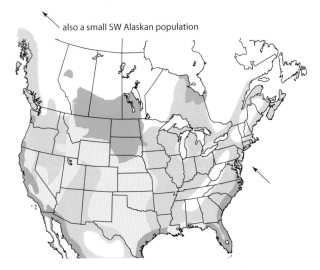

also a small SW Alaskan population

Marbled Godwit *Limosa fedoa*
L 18" WS 30" ♂ = ♀ MAGO *WL

This large godwit summers on the northern Great Plains and locally on boglands at James Bay and in southwestern Alaska. Winters on the Atlantic, Pacific, and Gulf Coasts and southward to northern South America. Breeds in wet grasslands near prairie ponds and also in grassy boglands in Alaska. Nonbreeders favor extensive coastal mudflats. Forms large flocks in wintering sites. Diet is arthropods, crustaceans, and mollusks. The nest, hidden in short grass, is a shallow depression lined with dry grass and set on dry ground near water. Lays three to five olive eggs spotted brown. A species in decline due to loss of prime nesting habitat.

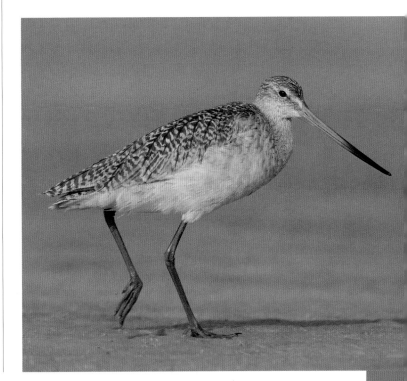

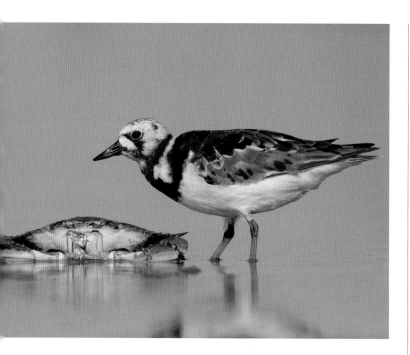

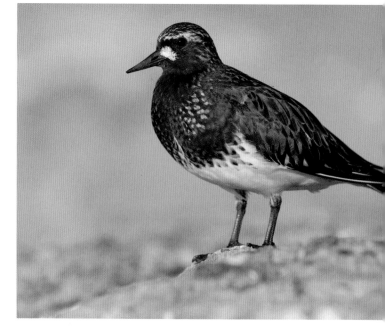

Ruddy Turnstone *Arenaria interpres*

L 10" WS 21" ♂ ≠ ♀ RUTU

This distinctive-looking and compact shorebird summers in the Arctic of Canada and Alaska. Winters on the Atlantic, Pacific, and Gulf Coasts and southward into Central and South America. Other populations summer through Eurasia and winter to Africa and throughout the coasts of the Old World and Australasia. Breeds on open ground—rocky ridges and sparsely vegetated tundra near water. Winters along coastlines. Associates with other shorebirds in winter. Diet is a mix of arthropods, mollusks, and crustaceans. The nest, set on ground, is a shallow depression lined with sparse vegetation. Lays two or three olive-green eggs blotched with dark brown. Widespread population in decline.

Black Turnstone *Arenaria melanocephala*

L 9" WS 21" ♂ = ♀ BLTU

This blackish version of the Ruddy Turnstone summers in coastal Alaska and winters up and down the West Coast, south into Baja. Breeds in marshy coastal tundra. Winters in the rocky intertidal zone of coastlines, foraging on wave-washed rocks of the West Coast. Diet is arthropods, mollusks, and other invertebrates. The nest, set on the ground close to water and hidden in grasses, is a shallow depression lined with grass. Lays two to four olive eggs blotched brown. Whereas the Ruddy Turnstone has a very broad Arctic breeding range, the Black Turnstone breeds only in coastal Alaska, and its breeding range is similarly restricted to the West Coast. Population stable.

Surfbird *Calidris virgata*
L 10" WS 26" ♂ = ♀ SURF

This strange, turnstone-like shorebird summers in Alaska and the Yukon and winters the length of the West Coast, with some birds traveling as far as Chile. It breeds in barren, rocky upland tundra far from salt water, but it spends most of its year in the rocky intertidal zone of the West Coast. Diet is mainly a range of terrestrial and marine invertebrates. The nest, situated on the ground of a high dry ridge, is a shallow depression lined with plant material. Lays four buff eggs spotted reddish brown.

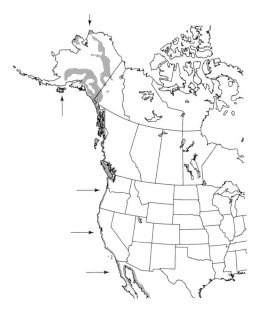

Red Knot *Calidris canutus*
L 11" WS 23" ♂ = ♀ REKN *NT

This pudgy and ruddy-breasted shorebird summers in the High Arctic of Canada and northern Alaska, wintering on the Atlantic, Pacific, and Gulf Coasts and southward as far as southern South America. Other populations breed in Eurasia and winter in Africa and Australia. Breeds in barren upland tundra, typically near a pond or stream. The eastern Canadian subspecies, which famously stops over in late May in Delaware Bay to feed on the eggs of Horseshoe Crabs, is in steep decline. Diet is arthropods, mollusks, other invertebrates, and some plant matter. The nest, set on the ground, is a shallow scrape lined with plant matter. Lays three or four pale olive-green eggs marked with brown.

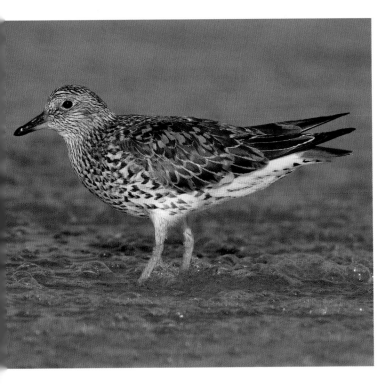

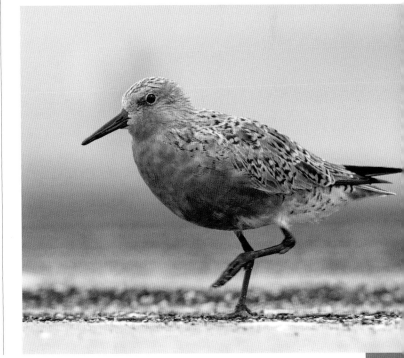

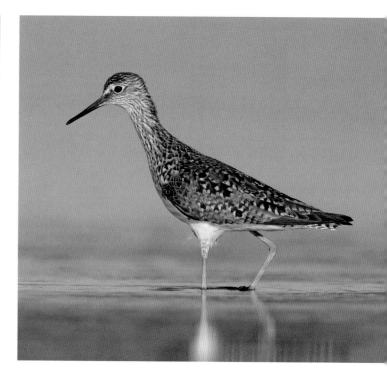

Greater Yellowlegs *Tringa melanoleuca*

L 14" WS 28" ♂ = ♀ GRYE

This larger yellowlegs summers across Canada to south-western Alaska. Winters on the Atlantic, Pacific, and Gulf Coasts, in the Deep South, and southward. Breeds in open spruce forest, muskeg, and boglands with conifers. Nonbreeding birds frequent shallow waters in marshlands in small groups. Bobs its head and gives alarm notes when approached. A very active forager, taking arthropods and small fish. The nest, placed on the ground in a boreal opening, is a shallow depression lined with plant material and often placed near a stump or other feature. Lays four buff eggs blotched with gray and dark brown.

Lesser Yellowlegs *Tringa flavipes*

L 11" WS 24" ♂ = ♀ LEYE *WL

This slender and yellow-legged sandpiper summers in northern Canada and Alaska. It winters on our Atlantic, Pacific, and Gulf Coasts and southward. Breeds in openings in boreal forest and muskeg. Nonbreeding birds frequent shallow ponds in marshland. Often seen in small flocks in migration and in winter. Diet is a mix of arthropods, crustaceans, and tiny fish. The nest, placed on the ground in a boreal opening, is a shallow depression lined with plant material; often placed near a stump or other feature. Lays three or four buff or gray eggs blotched with brown. The species is apparently in substantial decline. This species also bobs its head when watching an approaching human.

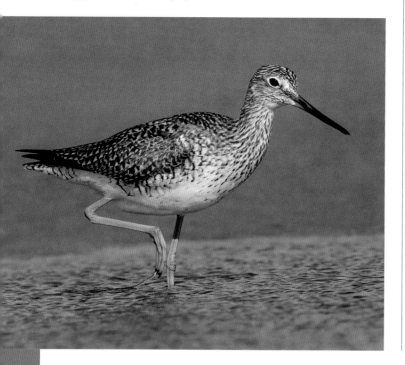

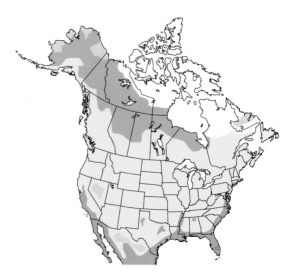

Curlew Sandpiper *Calidris ferruginea*
L 9" WS 18" ♂ ≠ ♀ CUSA

This handsome Eurasian sandpiper summers across northern Siberia. It winters widely to the Southern Hemisphere of the Old World and Australasia. Individuals stray to North America in small numbers annually, with most records from the East and West Coasts. Has nested in northern Alaska. Found in tidal flats, freshwater mudflats, and shallow ponds. The wandering singletons often are found in association with Dunlins. Diet is various invertebrate prey. The nest, set in a dry ridge in wet grassy tundra, is a depression lined with moss and lichens. Lays four cream-colored eggs blotched with brown.

Stilt Sandpiper *Calidris himantopus*
L 9" WS 18" ♂ = ♀ STSA

This tall and trimly plumaged sandpiper summers in northeastern Alaska, High Arctic Canada, and the western shore of Hudson Bay, wintering from Florida and coastal Texas to South America. Breeds in sedge meadows in tundra. Migrants frequent shallow pools and shallows, often with yellowlegs and dowitchers. Often seen foraging in water up to their bellies. Typically seen in small flocks. Diet is arthropods, mollusks, and some plant matter. The nest, set atop of a dry ridge surrounded by water, is a shallow depression in the tundra vegetation. Lays four buff or olive eggs spotted with brown. In both spring and fall, most birds migrate through the Interior.

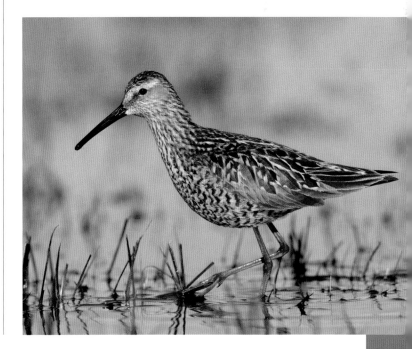

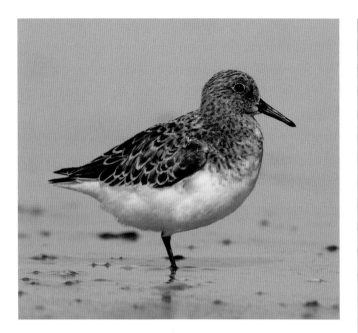

Purple Sandpiper *Calidris maritima*
L 9" WS 17" ♂ = ♀ PUSA

This shorebird winters along the East Coast and breeds in the High Arctic of Canada, Greenland, and Eurasia. Breeds in northern and barren low mossy tundra in stony clearings and low ridges. Winters on rocky shorelines and breakwaters along the Atlantic Coast, foraging on wave-washed rocks in association with Ruddy Turnstones and Sanderlings. Diet is a mix of arthropods, marine invertebrates, and plant matter. The nest, set in open tundra, is a shallow depression in lichens and mosses; sometimes lined with plant fragments. Lays three or four olive or buff eggs blotched with brown.

Sanderling *Calidris alba*
L 8" WS 17" ♂ ≠ ♀ SAND

This adorable species—for most beach-lovers the prototypical sandpiper—summers in High Arctic Canada, Greenland, and northern Siberia. North American birds winter southward to the Atlantic, Pacific, and Gulf Coasts. The species winters widely into the Southern Hemisphere. Migrants and wintering birds favor sandy beaches and coastal tidal flats. Most of the year, it is very sociable and found in foraging flocks that move up and down the sandy shoreline "chasing the waves." Diet mainly consists of mole crabs, other crustaceans, and additional invertebrates. The nest, set in gravel ridges in tundra, is a shallow scrape lined with bits of vegetation. Lays three or four olive to pale brown eggs sparsely marked with brown and black.

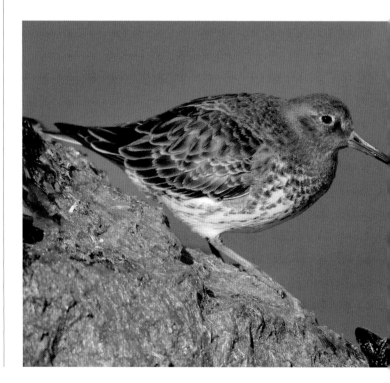

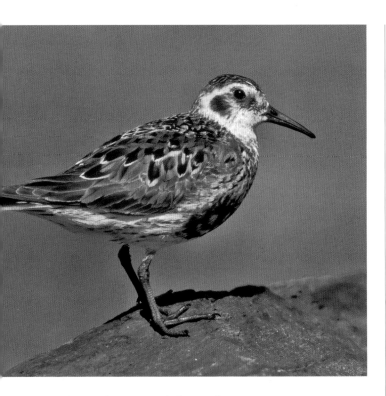

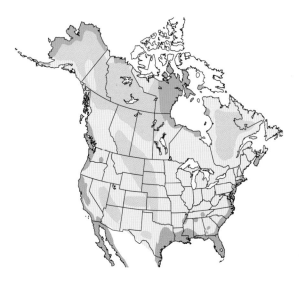

Rock Sandpiper *Calidris ptilocnemis*
L 9" WS 17" ♂ = ♀ ROSA

This bird, the western counterpart to the Purple Sandpiper, summers in western Alaska and easternmost Siberia. Some North American birds winter down the West Coast as far as Northern California; others remain in Alaska year-round. Breeds on mossy tundra. Winters on rocky coastal shorelines and rock jetties. Forages in the rocky intertidal zone along with Black Turnstones and Surfbirds. Diet is arthropods and various marine invertebrates. The nest, set in open and dry tundra, is a deep scrape lined with lichens and moss. Lays four olive or buff eggs blotched with brown.

Dunlin *Calidris alpina*
L 9" WS 17" ♂ = ♀ DUNL

This black-bellied sandpiper with the drooping bill summers in western and northern Alaska, Arctic Canada, and Arctic Eurasia. Winters southward to all three Coasts and into Mexico. Breeds atop low ridges in wet tundra. Migrants and wintering birds favor muddy pools, mudflats, and tidal waters, where birds feed with their bellies in the water. Very sociable and seen in large flocks in winter and on migration. Diet is arthropods and small invertebrates. The nest, hidden under tundra vegetation on a low hummock, is a shallow scrape lined with bits of vegetation. Lays two or three olive eggs with brown blotches.

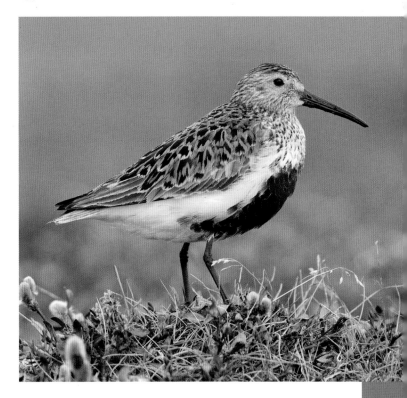

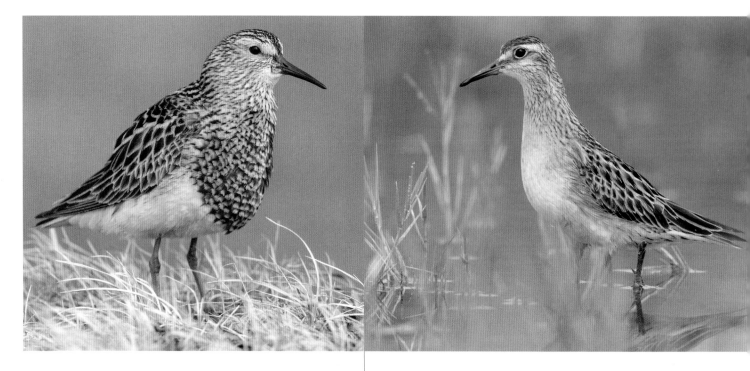

Pectoral Sandpiper *Calidris melanotos*
L 9" WS 18" ♂ = ♀ PESA *WL

A large and trimly plumaged peep that summers in High
Arctic Canada, Alaska, and central and eastern Siberia.
Winters in southern South America and Australia. Breeds in
wet grassy lowland tundra. Migrants favor grassy or muddy
freshwater shallows. On the nesting ground, the larger male
conducts a striking breeding display for the smaller female,
consisting of a slow flight low over the ground with the chest
distended, accented by a booming series of notes. Diet is
mainly arthropods but also some crustaceans and plant
matter. The nest, set on a hill in grassy tundra, is a shallow
depression with a lining of plant bits. Lays four white eggs
marked dark brown.

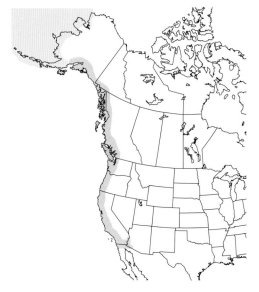

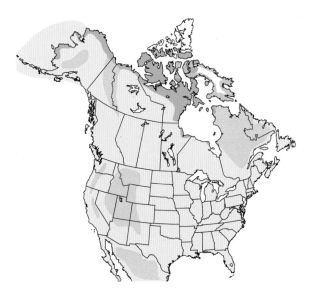

Sharp-tailed Sandpiper *Calidris acuminata*
L 9" WS 18" ♂ = ♀ SPTS

This Asian species, reminiscent of our Pectoral Sandpiper,
summers in northeastern Siberia and winters in Australasia.
A few stray to the Lower 48 every year. Many young birds
pass through Alaska after the breeding season. Most of
the birds that are encountered in North America are juve-
niles. Young birds are found in association with Pectoral
Sandpipers in muddy and grassy freshwater shallows. The
population of this species is stable.

Red-necked Stint *Calidris ruficollis*

L 6" WS 14" ♂ ≈ ♀ RNST

This peep summers in northeastern Siberia, but is also a rare nester in northwestern Alaska. It winters from India to Australia. Also a regular stray to western Alaska and a less frequent visitor to the West Coast, even less so to the East Coast. To be found on mudflats with other peeps. Shows a preference for the more muddy and grassy edges of flats. Most birds found in the Lower 48 are encountered in mid-summer; these are typically adults in their bright summer plumage, making identification straightforward. Diet is arthropods and crustaceans. Nest is a shallow depression in the tundra lined with willow leaves. Lays four buff eggs marked with brown.

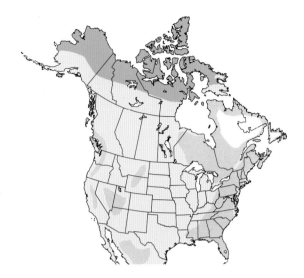

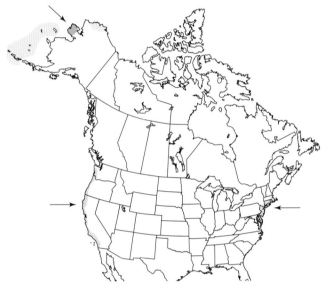

Baird's Sandpiper *Calidris bairdii*

L 8" WS 17" ♂ = ♀ BASA

This long-winged and buffy-brown peep summers in the High Arctic of Canada, Alaska, and eastern Siberia, wintering in southern South America. Breeds on upland tundra. Migrants frequent grassy shallows, edges of mudflats, and shortgrass fields. Mainly migrates through the Great Plains in spring and fall. Diet is mainly arthropods, also some crustaceans. The nest, set in dry tundra with low ground cover, is a shallow scrape lined with various bits of plant matter, including lichens. Lays four pinkish-buff eggs blotched with dark brown. Rather uncommon in autumn migration along the East Coast. This is a species many West and East Coast birders eagerly hunt for in August and September.

Least Sandpiper *Calidris minutilla*
L 6" WS 13" ♂ = ♀ LESA

This tiny and commonplace peep summers from Atlantic Canada to Alaska. It winters in the southern Lower 48 and also as far south as northern South America. Breeds in northern boreal bogs, sedge meadows, and tundra. Migrants frequent muddy flats and grassy freshwater pools. Diet is arthropods, small crustaceans, and tiny snails. The nest, set on a low grassy hummock near water, is a shallow depression lined with plant matter. Lays three or four pale buff eggs blotched with brown. This is the smallest of our "peep" sandpipers (which are termed "stints" in Europe). Migrants are usually found in small flocks, which may or may not be associated with other sandpiper species. This is the only peep to be expected in winter in the cold interior of the Lower 48. The population appears stable.

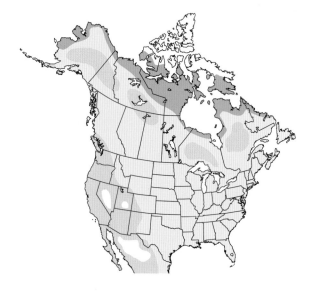

Semipalmated Sandpiper *Calidris pusilla*
L 6" WS 14" ♂ = ♀ SESA *NT *WL

This plain-plumaged and very common peep summers from northern Alaska to Hudson Bay and northern Labrador. It winters in coastal northern South America. Breeds on low Arctic tundra near water. Migrates in large flocks, with large groups staging in autumn on mudflats in Atlantic Canada. Some southbound flocks depart New England and travel nonstop out over the Atlantic to South America. Diet is mainly arthropods and crustaceans. The nest, set on a low hummock in wet tundra, is a depression hidden under a shrub and lined with moss and other plant bits. Lays three or four white or olive eggs blotched with brown and gray. A common species that is in decline. Rare in migration in the Interior West. This species and the Least Sandpiper are the two "peeps" most familiar to East Coast birders.

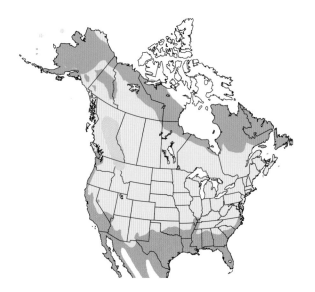

White-rumped Sandpiper *Calidris fuscicollis*
L 8" WS 17" ♂ = ♀ WRSA

This long-winged and white-rumped peep summers in Arctic Canada and northeastern Alaska. Winters in southern South America. Breeds on wet tundra. Migrants frequent freshwater marshes, flooded fields, and shallow ponds. Often found in large flocks. A long-distance migrant. In spring, mainly seen in the Interior. In autumn, migrates eastward to Atlantic Canada and then out over the Atlantic to South America. Diet is arthropods, marine and aquatic invertebrates, and some plant matter. The nest, hidden down in low tundra vegetation, is a depression lined with lichens and other plant material. Lays three or four olive eggs blotched with browns. Distinguished from the more common peeps by its larger size, long wingtip projection, and white rump patch visible in flight. The species is faring well.

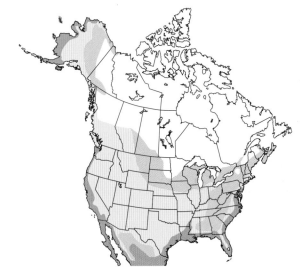

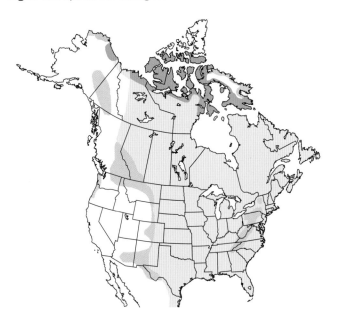

Western Sandpiper *Calidris mauri*
L 7" WS 14" ♂ = ♀ WESA

Tinged rusty in its breeding plumage, this small peep summers in Alaska and eastern Siberia and winters on the Atlantic, Pacific, and Gulf Coasts and southward to northern South America. A majority of birds winter along the West Coast. Breeds on tundra slopes near marshland. Migrates and winters on coastal flats and wetlands. Diet is arthropods and various small invertebrates. Tends to feed in deeper water than the other peeps. The nest, set in tundra under cover of vegetation, is a shallow depression with sparse plant lining. Lays three or four whitish to buff eggs with dark brown spotting. This seems to be the western counterpart to the Semipalmated Sandpiper. This abundant species is faring well and under no threat.

Spotted Sandpiper *Actitis macularius*
L 8" WS 15" ♂ = ♀ SPSA

This species, our most widespread-breeding sandpiper, summers across the northern two-thirds of North America. Winters in the Deep South, the Southwest Borderlands, and southward as far as Argentina. Breeds on fresh water—lakeshores, riverbanks, and ponds. Winters widely near water features of various kinds. Solitary and with a very distinctive fluttering flight, its wings held low. Diet is arthropods, crustaceans, and other aquatic invertebrates. When foraging, it bobs the back end of its body up and down. The nest, often near water and hidden under a shrub, is a shallow depression lined with plant material and feathers. Lays three to five buff eggs blotched with brown. Population stable.

Solitary Sandpiper *Tringa solitaria*
L 9" WS 22" ♂ = ♀ SOSA

This small sandpiper of interior wooded wetlands summers in Canada and winters in the Deep South, Southwest Borderlands, and southward into South America. Breeds near ponds in boreal forest. Winters at stream sides, wooded swamps, and freshwater marshes. Often solitary and walks with a teetering gait. Diet is arthropods and aquatic invertebrates. For its nest, it adopts the discarded nest of a boreal songbird up in a conifer. Lays four or five olive or buff eggs marked with brown.

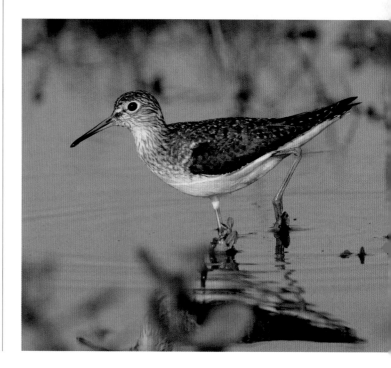

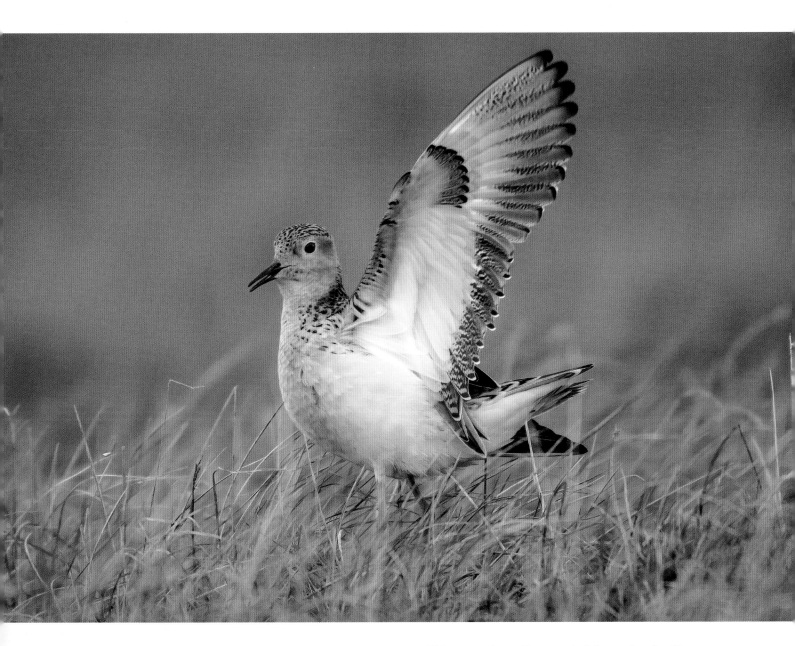

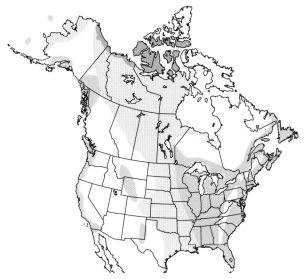

Buff-breasted Sandpiper *Calidris subruficollis*
L 8" WS 18" ♂ = ♀ BBSA *NT *WL

This rarely seen and very comely sandpiper summers in the High Arctic of north-central Canada and northeastern Alaska. Migrates through the Great Plains in flocks. Winters on the Pampas of Argentina. Breeds on tundra slopes and uplands near water. Migrant flocks to be looked for in short-grass or plowed fields—not in association with water. Diet is mainly arthropods. The nest, set on a hummock of moss in tundra, is a shallow depression lined with plant matter. Lays two to four buff or olive eggs marked with brown toward the larger end. A polygamous lek-breeding species, the males display but do not provide any assistance in raising off-spring. The global population of this species is tiny and the species is considered to be Near Threatened.

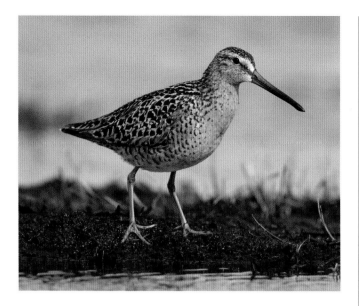

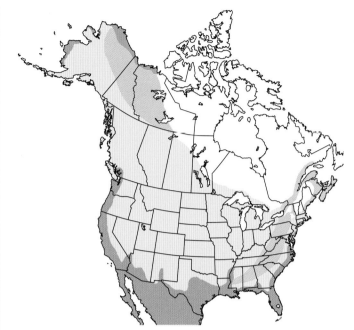

Short-billed Dowitcher *Limnodromus griseus*
L 11" WS 19" ♂ = ♀ SBDO *WL

This dumpy, long-billed sandpiper summers patchily across central Canada and western Alaska, wintering on the Atlantic, Pacific, and Gulf Coasts and southward. Breeds in northern boglands and muskeg in open taiga. Migrants and wintering birds frequent coastal mudflats, tidal marshes, and wetland edges—with a greater propensity for salt water than the Long-billed Dowitcher. Flocks forage in deep water up to their bellies, probing the mud with their long bills. Diet is small aquatic invertebrates. The nest, hidden in low in muskeg vegetation, in a shallow depression lined with plant matter. Lays three or four olive or buff-brown eggs marked with darker brown. Because of plumage variation, distinguishing this species from the Long-billed Dowitcher is very difficult, but the distinct flight calls are helpful.

Long-billed Dowitcher *Limnodromus scolopaceus*
L 12" WS 19" ♂ = ♀ LBDO

This near-twin of the Short-billed Dowitcher summers on the North Slope of Canada and northern and western Alaska, as well as northeastern Siberia. Winters on the Atlantic, Pacific, and Gulf Coasts and southward to Central America. Migrates mainly through the West and Great Plains. Breeds in wet hummocky tundra. Winters mainly in freshwater wetlands and mudflats. Less common on the East Coast than its sister species and migrates through there later in autumn. Diet is small aquatic invertebrates. The nest, hidden in wet tundra, is a depression sparingly lined with plant matter. Lays three or four olive eggs marked with darker brown.

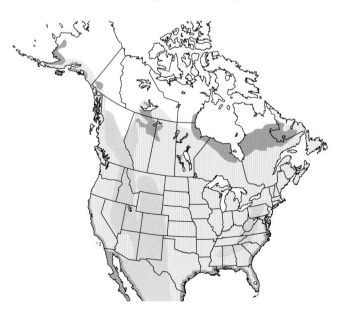

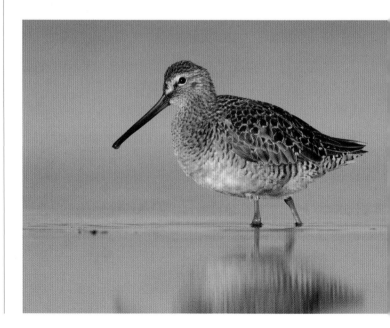

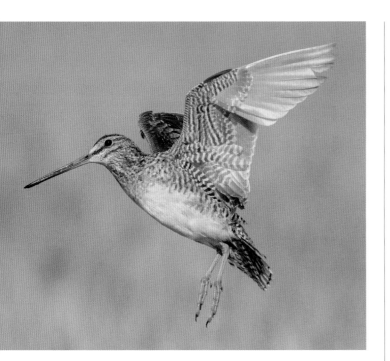

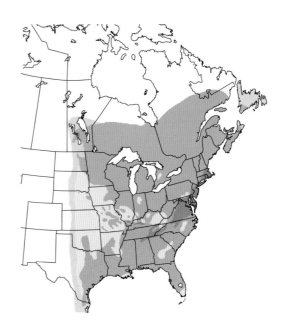

American Woodcock *Scolopax minor*
L 11" WS 18" ♂ = ♀ AMWO *WL

This elusive, secretive, and popular game bird summers across the eastern and central United States and Canada, wintering in the Deep South. Inhabits bottomland woods, brushy swampland, and a mix of early successional woods and openings. This shorebird is never found on a mudflat with other sandpipers (unlike the snipe). Forages on the ground in woodlands. In early spring, the male carries out a remarkable aerial display flight high over open fields. Diet is mainly earthworms and arthropods. The nest, set on the ground in damp woods, is a scrape lined with leaves. Lays one to five pinkish-buff eggs blotched with brown and gray.

Wilson's Snipe *Gallinago delicata*
L 11" WS 18" ♂ = ♀ WISN

This elusive shorebird summers in openings in boreal forest of the northern United States and Canada. Winters across the southern United States and south into northern South America. Breeds in bogs, wet meadows, and tundra. Winters in wet pastures and fields. In spring, the male carries out a display flight high in the sky in which its tail feathers produce a weird and ghostly pulsing sound. Diet is arthropods and earthworms. The nest, hidden on the ground in boggy vegetation, is a depression lined with plant matter. Lays three or four brownish or olive eggs marked with dark brown. Population is stable. Perches on fenceposts.

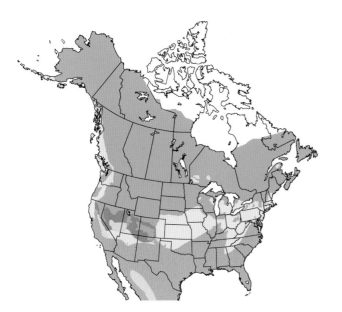

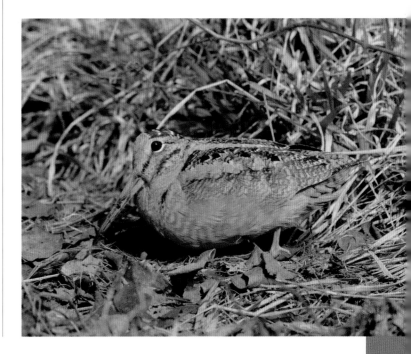

Willet *Tringa semipalmata*
L 15" WS 26" ♂ = ♀ WILL *WL

This large, plain sandpiper summers in two distinct popula-
tions—one in salt marshes along the Atlantic and Gulf coast-
lines and the other in the northern Great Plains and Interior
West. The western population winters on the Atlantic,
Pacific, and Gulf Coasts. The eastern bird entirely departs
the US for the winter. Noisy on the breeding grounds. In
flight, the bird exhibits its distinctive black-and-white wings.
Diet is arthropods, crustaceans, and other small inverte-
brates. The nest, set on the ground in thick marsh grass,
is a shallow depression lined with living and dead grass.
Lays four or five gray to olive-buff eggs blotched with brown.
Some authorities suggest that the interior and coastal popu-
lations should be treated as separate species.

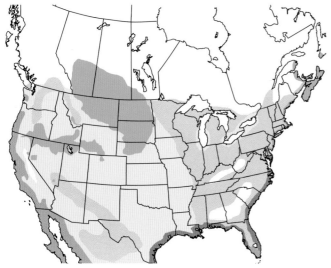

Wandering Tattler *Tringa incana*

L 11" WS 26" ♂ = ♀ WATA

This two-toned sandpiper summers in the Yukon, Northwest Territories, Alaska, and eastern Siberia; it winters on the West Coast and also southwestward to Hawaii and Australia. Breeds along rocky streams in Arctic and sub-Arctic mountains. Most often seen on rocky Pacific shores. Diet is a mix of arthropods, crustaceans, and mollusks. The nest, set in gravel along a mountain stream, is a depression often lined with plant material. Lays four olive eggs heavily blotched with brown. Global population small but probably safe.

Ruff *Calidris pugnax*

L 12" WS 23" ♂ ≠ ♀ RUFF (the female is called Reeve)

This large and distinctive sandpiper summers across northern Eurasia, wintering in Africa and southern Asia. Has nested once in Alaska. A few birds stray every year to North America, with most records along the Atlantic and Pacific Coasts, and some records from the Great Lakes and Mississippi drainage. Frequents flooded fields, grassy marshland, and mudflats. The lek-breeding adult males exhibit a striking head- and neck-ruff of display plumage that varies from white to rusty to black. Diet is various invertebrates and some small vertebrates. The ground nest is a shallow depression lined with grass and hidden by vegetation. Lays two or three olive eggs blotched with brown.

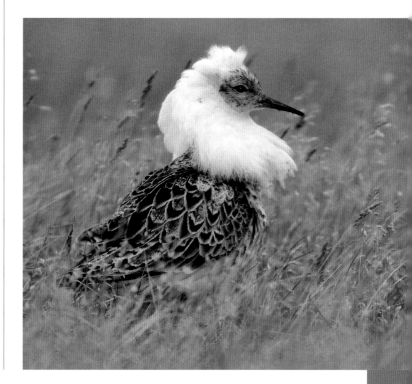

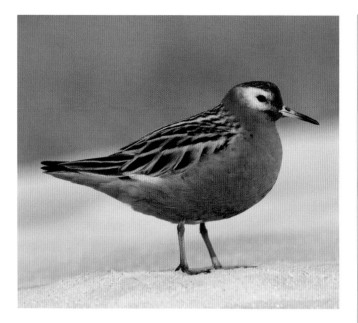

Red Phalarope *Phalaropus fulicarius*
L 9" WS 17" ♂ ≠ ♀ REPH

This ocean-going sandpiper summers in the High Arctic of Canada, northern Alaska, and northern Siberia and winters on the open ocean off our West and East Coasts, western South America, and southwestern Africa. Breeds in low wet tundra. Rarely seen inland during migration. Diet is arthropods, mollusks, and crustaceans. The nest, set on the ground in low tundra near water, is a shallow scrape lined with plant material. Lays two to four olive or buff eggs marked with black or dark brown. The brightly plumaged breeding-season female is quite striking but seen only in a few selected locales in the spring before arriving on the breeding grounds. Population stable.

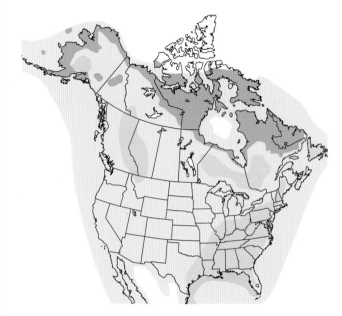

Red-necked Phalarope *Phalaropus lobatus*
L 8" WS 15" ♂ ≠ ♀ RNPH

This atypical shorebird summers across northern Canada, Alaska, and northern Eurasia. North American breeders winter mainly in the tropical eastern Pacific. Other populations winter in the waters off Australasia and in the Arabian Sea. Breeds on tundra ponds and lakes. Winters on open ocean. Large flocks appear on lakes of the Interior West in autumn. Foraging birds spin about to stir up prey. The polyandrous female is brighter than the male, as with all phalaropes. This is called sex-role reversal. Diet is arthropods, crustaceans, and mollusks. The nest, set on the ground in tundra, is a shallow scrape lined with plant matter. Lays three or four olive or buff eggs blotched with dark brown.

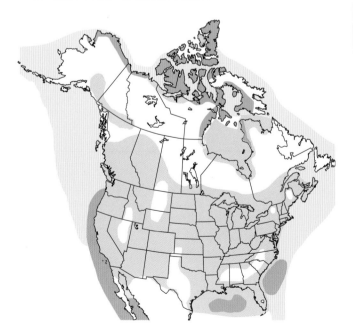

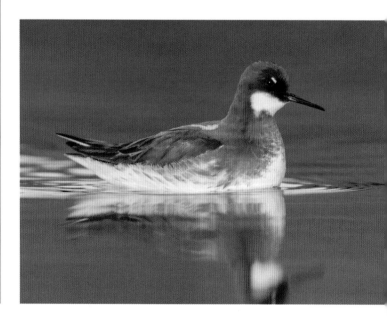

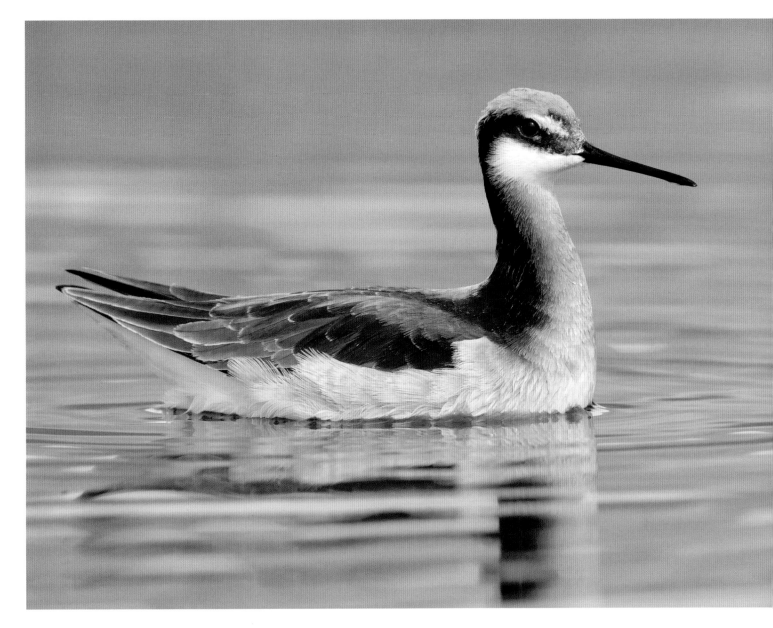

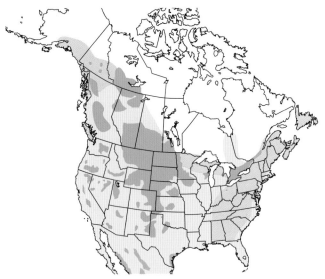

Wilson's Phalarope *Phalaropus tricolor*
L 9" WS 17" ♂ ≠ ♀ WIPH

This attractive wader summers across the Interior West, ranging eastward patchily to the Great Lakes. Winters mainly on lakes high in the Andes of South America. Breeds in shallow and marshy freshwater or alkaline lakes. Quite sociable. Individuals often twirl about in shallows to stir up aquatic prey. Diet is aquatic insects and crustaceans. The nest, set on open ground near water, is a shallow depression with a sparse lining of grass. Lays three or four buff eggs blotched with brown. During autumn migration, flocks gather in lakes of the Interior West, preparing for the long flight to the Tropics. The brighter-plumaged female competes for multiple males, which care for the nest and raise the offspring. Appears to be declining due to drought and habitat loss.

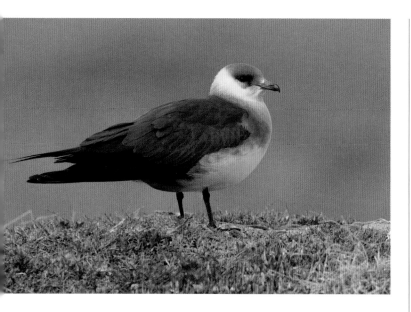

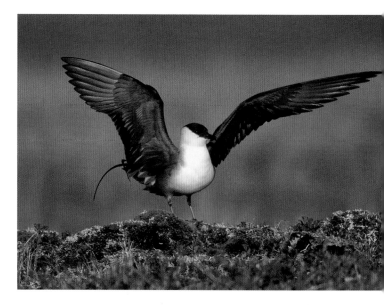

Parasitic Jaeger *Stercorarius parasiticus*
L 20" WS 46" ♂ = ♀ PAJA

This predator, the most familiar of the jaegers, summers in Arctic and sub-Arctic Canada, Alaska, and Eurasia, and winters southward into open ocean habitats, ranging into the Southern Hemisphere. Regular in migration in the pelagic zone of the Atlantic, Pacific, and Gulf of Mexico. Breeds in tundra, muskeg, and coastal marshlands. Steals fish from terns and gulls at sea. On the breeding grounds, will take lemmings, nestling birds, and eggs. The nest, set on the ground on a slight rise in open tundra, is a slight depression sparsely lined with plant matter. Lays one to three olive or buff eggs spotted with brown. Can be seen from the shore during autumn when individuals steal fish from foraging gulls and terns in tidal rips.

Long-tailed Jaeger *Stercorarius longicaudus*
L 23" WS 43" ♂ = ♀ LTJA

This graceful and diminutive jaeger summers in Arctic Canada, Alaska, and Eurasia, wintering in Southern Hemisphere seas. Breeds on dry interior tundra. Migrates and winters at sea. Will steal fish from terns at sea but is less prone to this behavior than the other two jaegers. Diet includes fish, other vertebrates, and berries. The nest, set on the ground in dry upland tundra, is a shallow depression sparsely lined with plant matter. Lays one to three olive or brownish eggs blotched with darker colors. Rarely seen from shore. Population apparently stable. The species winters at sea, mainly off South America and South Africa. Quite common on its Arctic breeding habitat.

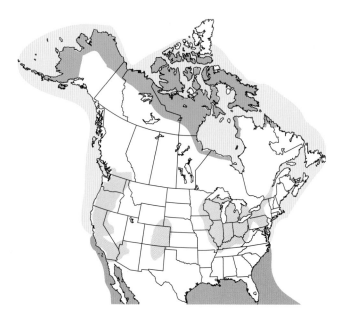

Pomarine Jaeger *Stercorarius pomarinus*
L 23" WS 52" ♂ = ♀ POJA

This powerful-looking jaeger summers in the High Arctic of Canada, Alaska, and Eurasia, wintering south to the oceans of the world. Breeds on low-lying tundra near the coast. Winters in the pelagic zone of the Atlantic, Pacific, and Gulf of Mexico, typically farther from land than the Parasitic Jaeger. A solitary hunter, stealing fish from terns and gulls. Takes many lemmings and nestling birds on the tundra in summer. The nest, placed on the ground in tundra, is a shallow depression lined with plant material. Lays one to three olive eggs blotched with dark brown. Populations fluctuate.

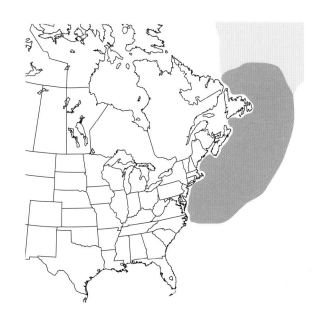

Great Skua *Stercorarius skua*
L 23" WS 55" ♂ = ♀ GRSK *WL

This solitary and bulky dark predator summers in far northern Europe, wintering in the Atlantic pelagic zone. Nearest breeding population is on Iceland. Seen on the open Atlantic when on migration and off Atlantic Canada south to North Carolina during winter. A solitary hunter on the open ocean, stealing fish from other seabirds. Diet is mainly fish (at sea) and other vertebrates and eggs (on the breeding ground). Encountered as a solitary individual at sea far from land. In our waters, seen less frequently than the South Polar Skua.

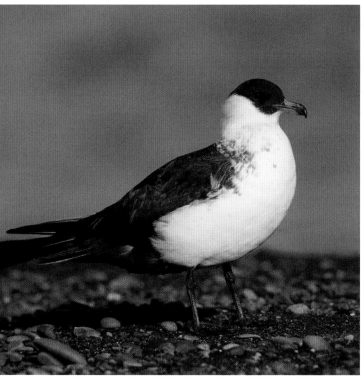

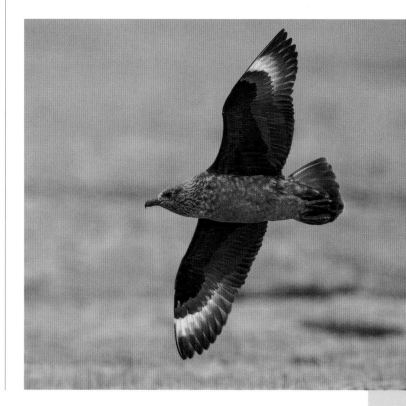

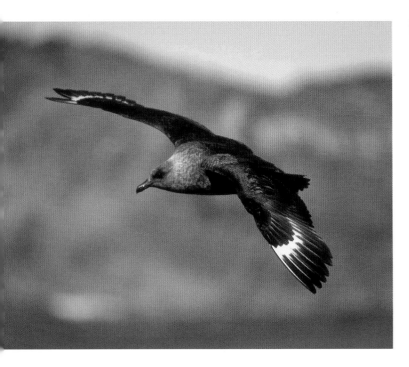

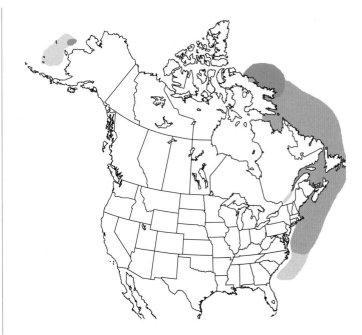

South Polar Skua *Stercorarius maccormicki*
L 21" WS 52" ♂ = ♀ SPSK

This skua summers along the Antarctic coast and winters north to northern Temperate Zone oceans far out at sea. Seen in the Atlantic and Pacific in migration between May and October. A solitary hunter on the open ocean, stealing fish from other seabirds. Diet is mainly fish, other vertebrates, and eggs (on the breeding ground). Can be difficult to distinguish from other skua species. Note that skuas are polymorphic, with pale and dark plumage morphs, making species identification all the more difficult. Breeds as far south as any bird species. Population stable.

Dovekie *Alle alle*
L 8" WS 15" ♂ = ♀ DOVE

This tiny pied and short-necked alcid summers in the Arctic, wintering on cold-water seas of the Northern Hemisphere. Breeds on rocky cliffs on Arctic islands. Bering Sea population is tiny. Winters on open ocean as far north as the pack ice. Often found on the sea in large flocks. Diet is small crustaceans and small fish. The nest, set on a cliff or among rocks, is a flat spot adorned with pebbles and some plant matter. Lays one pale egg, sometimes marked with brown spotting. North American populations apparently declining.

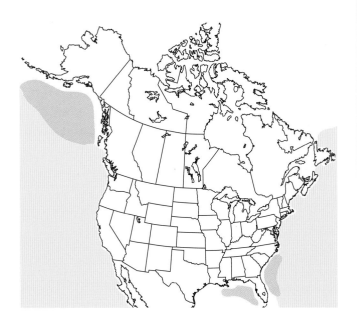

Common Murre *Uria aalge*
L 18" WS 26" ♂ = ♀ COMU

This large pied alcid summers on rocky islands along the West Coast and in Atlantic Canada. Also breeds in easternmost Maine, northern Europe, and coastal East Asia. Winters widely in the pelagic Pacific and North Atlantic. Breeds mainly on rocky cliffs on coastal islands. Often in flocks. Dives deep to capture prey. Diet is mainly fish with some crustaceans. The nest is an unadorned spot on a flat cliff ledge. Lays one egg of variable color and patterning. Elongated egg shape keeps it from rolling off its cliff-ledge nest.

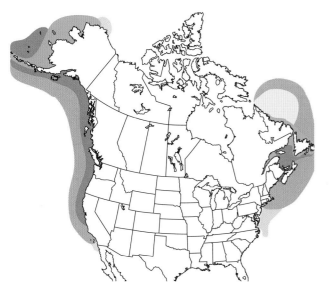

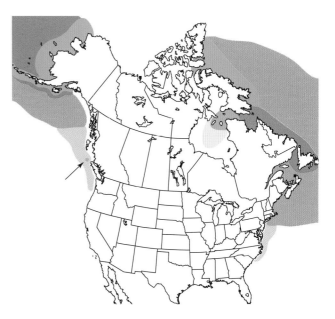

Thick-billed Murre *Uria lomvia*
L 18" WS 28" ♂ = ♀ TBMU

This large pied alcid, very similar to the Common Murre, summers on northern rocky islands from Canada and Alaska to Eurasia. Winters on cold Arctic and northern temperate seas as far north as the pack ice. Breeds on cliffs of rocky coasts and islands. Winters on the open ocean. Nests colonially. Seen in flocks on the water. Diet is mainly fish, also a range of marine invertebrates. Like its close relative, it dives as deep as 500 feet for prey. The single whitish egg, marked with brown and black, is laid on bare rock of a cliff ledge. The breeding adult exhibits a diagnostic white line on the cutting edge of the upper mandible. The species population is large but declining. Climate change may be impacting marine prey species.

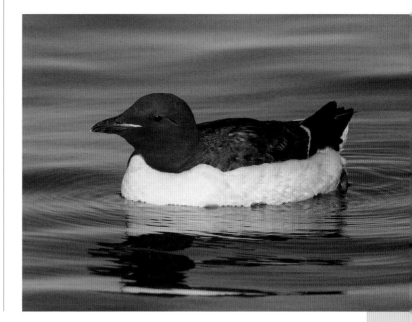

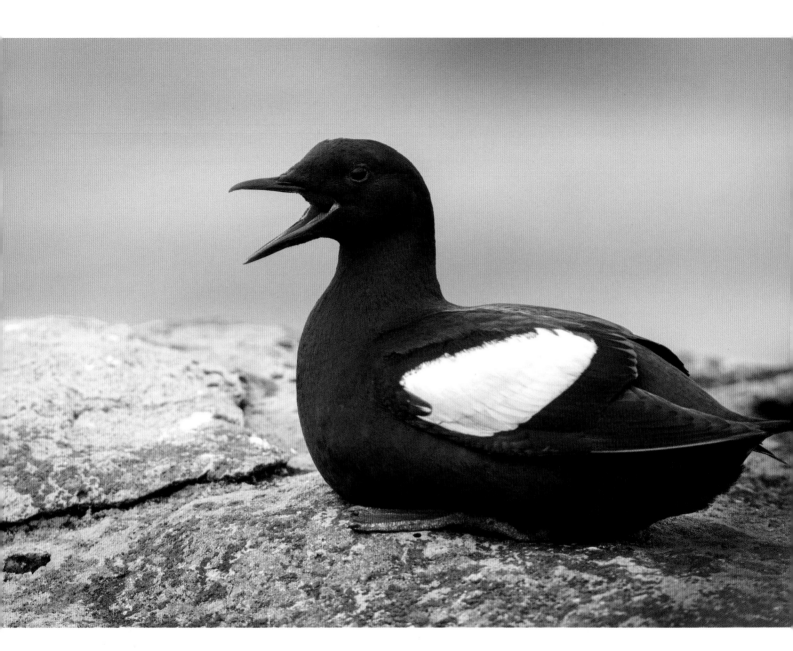

Black Guillemot *Cepphus grylle*
L 13" WS 21" ♂ = ♀ BLGU

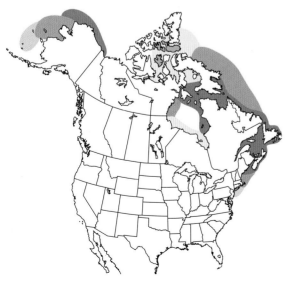

This sleek black alcid with a large white shoulder-patch and bright red feet summers across the Far North of North America and Eurasia, breeding on rocky islands. Winters mainly on inshore northern seas. Often seen in pairs bobbing just off rocky coastlines. Not as sociable as the murres. Diet is fish, crustaceans, and other marine invertebrates. The nest is hidden in a rock crevice or under driftwood. Nest is a thin gathering of pebbles. Lays one or two whitish or pale blue-green eggs marked with darker colors. Commonly seen near shore year-round in coastal Maine. Populations are apparently on the increase in North America. This species, more than other alcids, prefers inshore waters, making it easier to locate from land.

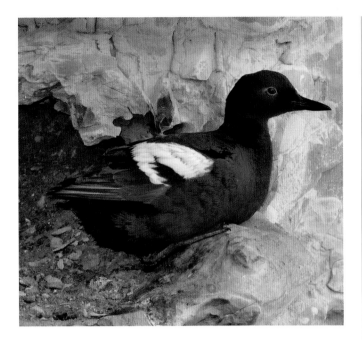

Pigeon Guillemot *Cepphus columba*
L 14" WS 23" ♂ = ♀ PIGU

This western counterpart to the Black Guillemot summers on islands of the West Coast, the Bering Sea, Aleutian Islands, and islands of the Asian Far East. It winters on open ocean of the Pacific and Bering Sea. Breeds on rocky islands and coastal cliffs. Winters mainly on inshore waters near nesting sites, but some frequent the edges of the pack ice on the Bering Sea. Typically seen in pairs or small parties. Diet is fish and marine invertebrates. The nest, set among driftwood or in a burrow, is sparingly adorned with pebbles and bits of debris. Lays one or two whitish or pale blue-green eggs blotched with gray and brown colors.

Razorbill *Alca torda*
L 17" WS 26" ♂ = ♀ RAZO

This stout-billed auk summers on islands in northern waters of North America and Europe, wintering through the cold waters of the Atlantic, concentrating near offshore shoals. Breeds on sea cliffs. Often nests on islands with other auk species. Sociable. Diet is mainly fish, for which it dives to 60 feet. The nest, set in a rock crevice on a cliff, is minimally adorned with pebbles. Lays one or two tan or greenish-white eggs marked with brown. Population levels low, but perhaps on the rebound. Currently of Least Concern on the Red List.

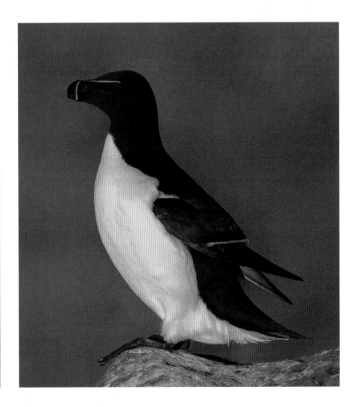

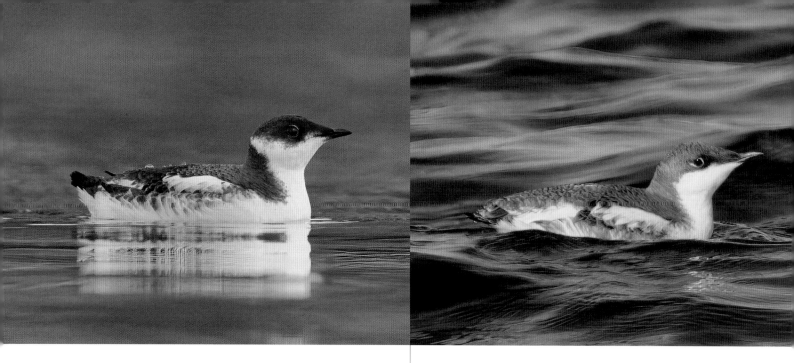

Marbled Murrelet *Brachyramphus marmoratus*
L 10" WS 16" ♂ = ♀ MAMU *EN *WL

A permanent resident along the West Coast from Northern California to the Aleutian Islands. Breeds in old-growth conifer forest and on rocky ground in the northern part of its breeding range. Winters on sheltered inshore waters near breeding areas. Usually seen in skittish pairs on the water. Diet is small fish and crustaceans. The nest, set atop a horizontal branch high in the forest canopy, is a depression in the moss of the branch. Lays one variably colored egg with darker markings. This species is classified as Endangered, with a declining population.

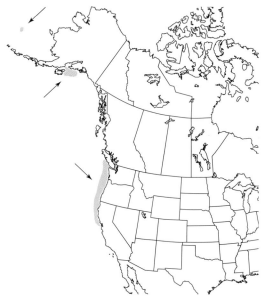

Long-billed Murrelet *Brachyramphus perdix*
L 10" WS 17" ♂ = ♀ LBMU *NT

This small alcid, nearly identical to the Marbled Murrelet, summers along coastal Northeast Asia. Most remarkably, strays of this enigmatic species have been recorded widely across North America, including inland bodies of water, and even to the East Coast. A few birds may be breeding along the Pacific Coast of Alaska suggested by nearshore summer records of singles and pairs. Mainly found in autumn in nearshore waters along the Pacific coast. Diet is small fish and crustaceans. Until 1997 this species was treated as a subspecies of the Marbled Murrelet. This Near-Threatened species is presumably in decline because of impacts of logging of its old growth breeding habitat.

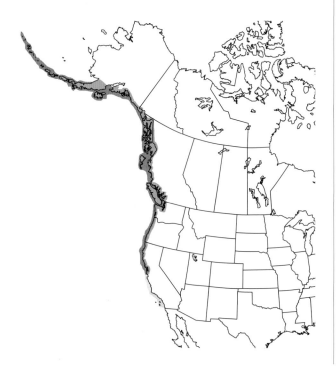

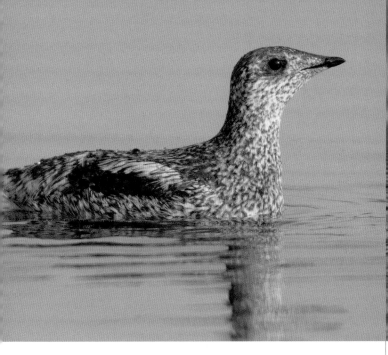

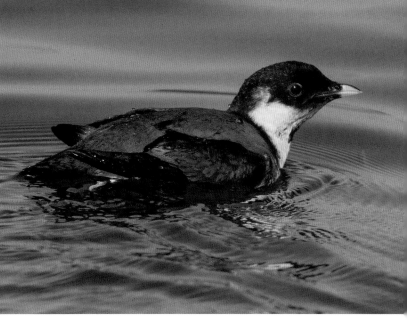

Kittlitz's Murrelet *Brachyramphus brevirostris*
L 10" WS 17" ♂ = ♀ KIMU *NT *WL

A small and short-billed seabird that summers in the Aleutian Islands, coastal mainland Alaska, and coastal eastern Siberia. Winters on the North Pacific, Bering Sea, and Chukchi Sea. Breeds on barren mountainsides including alongside glaciers. Winters on coastal ocean and in glacial fjords. Usually seen on water in pairs or small flocks. Diet is invertebrates and small fish. The single pale olive egg, spotted with gray and brown, is laid on bare ground in steep rocky uplands and hidden by a rock or other feature. This species is very similar to the Marbled Murrelet, with which it shares geography in Alaska. This Near-Threatened species is in substantial decline in Alaska. Apparently the species was heavily impacted by the massive oil spill of the *Exxon Valdez*.

Ancient Murrelet *Synthliboramphus antiquus*
L 10" WS 17" ♂ = ♀ ANMU *WL

This handsomely-patterned and agile little seabird nests on coastal Pacific islands from Northeast Asia and the Aleutian Islands to British Columbia. Winters out in pelagic waters adjacent to breeding habitats. The male displays by vocalizing from trees above its nesting habitat. Diet is crustaceans and small fish. The nest is a burrow on sloping ground near the sea. Lays two pale buff or olive eggs spotted brown. Tends to stray inland with greater frequency than other alcids. There have been quite a few records of wandering birds from across the United States, especially around the Great Lakes. The species is very sociable and active. Visits its breeding colony only at night. In serious decline because of the introduction of mammalian predators (foxes, Raccoons, and rats) to the species' breeding islands.

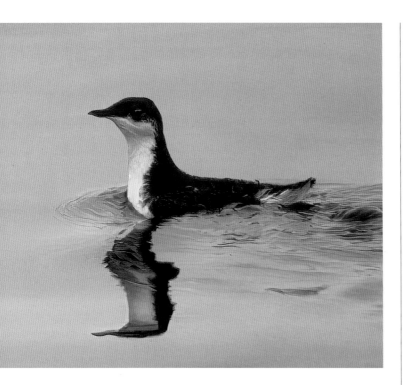

Scripps's Murrelet *Synthliboramphus scrippsi*
L 10" WS 15" ♂ = ♀ SCMU *VU *WL

A permanent resident of the waters off the islands of Southern California and northern Baja. Wanders northward after nesting. Winters offshore; rarely seen from shore. Seen in pairs. Diet is small fish and marine invertebrates. The one or two buff eggs with brown markings are laid on the ground in a crevice or among boulders back from the shore of an island. California population in decline.

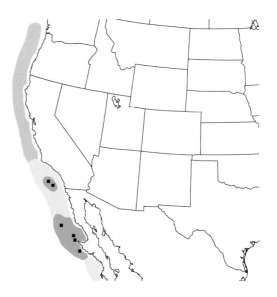

Guadalupe Murrelet *Synthliboramphus hypoleucus*
L 10" WS 15" ♂ = ♀ GUMU *EN *WL

This look-alike to the preceding species nests on islands off northern Baja and recently on islands off Southern California. When not breeding, found in the offshore Pacific Ocean far to the north of these breeding islands. Often seen in pairs. Diet is small fish and crustaceans. The one or two buff eggs with brown markings are laid on the ground in a crevice or among boulders back from the shore of an island. This recently-recognized species is a product of the split of "Xantus's Murrelet" into two novel species—Scripps's Murrelet and Guadalupe Murrelet. Nests only on a few predator-free islands. An Endangered Species.

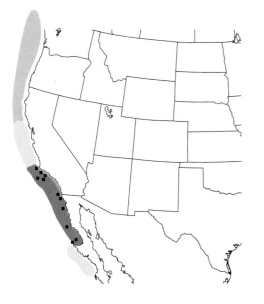

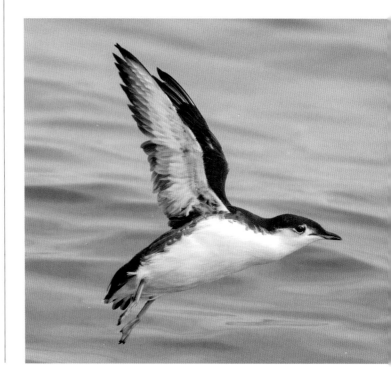

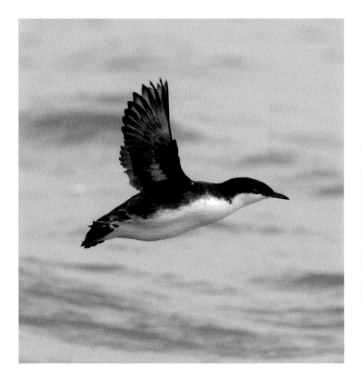

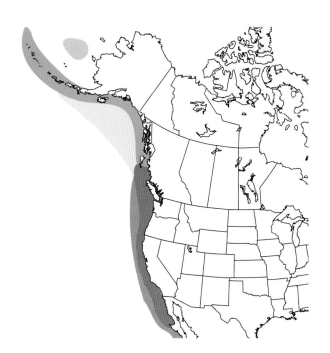

Craveri's Murrelet *Synthliboramphus craveri*
L 10" WS 15" ♂ = ♀ CRMU *VU *WL

Nests off both coasts of Baja (in the Gulf of California and in the Pacific), south of the Border. In the nonbreeding season, found sporadically northward into the waters off Southern California. Found on open ocean in relatively warm waters far offshore in late summer. Diet is small fish and marine invertebrates. The Craveri's Murrelet, the Scripps's Murrelet, and the Guadalupe Murrelet are all threatened by predation at their island nests by introduced mammalian predators (cats, foxes, rats, and mice). Craveri's, Scripps's, and Guadalupe Murrelets are all very similar and pose a challenge to identifcation in a moving boat at sea.

Cassin's Auklet *Ptychoramphus aleuticus*
L 9" WS 15" ♂ = ♀ CAAU *NT

This small gray alcid nests along the West Coast from the Aleutian Islands south to Baja. Breeds in colonies on coastal islands that are free of predators. Winters offshore. Northernmost breeders winter southward. Usually found foraging in flocks. Diet is small crustaceans. The island nest is a burrow in the ground. Lays one creamy-white egg. Does not wander inland. In the past was seriously threatened by nest predation by foxes and other mammals (now removed).

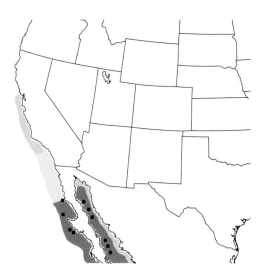

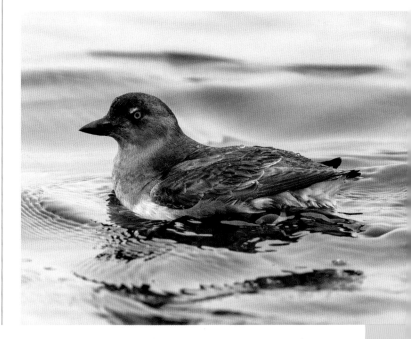

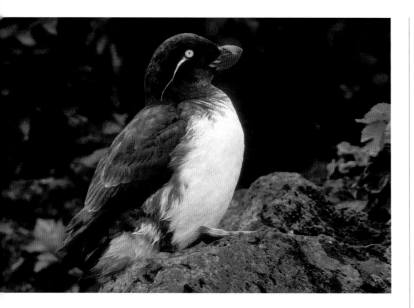

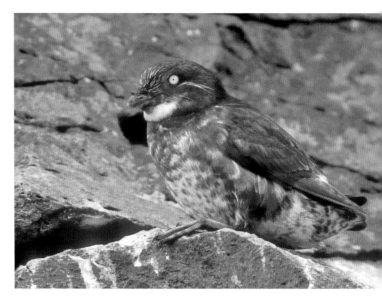

Parakeet Auklet *Aethia psittacula*
L 10" WS 18" ♂ = ♀ PAAU

This small, dark alcid with the orange-red parrot beak summers from southern Alaska through the Aleutian Islands, Bering Sea, and coastal eastern Siberia. Some birds winter near their breeding sites, whereas others wander widely across the northern Pacific, from Japan to California. Diet includes jellyfish, crustaceans, and other marine invertebrates. Forages by diving. Nests in loose aggregations in rocky outcrops. Nest is placed in a crevice without any adornment. Egg is laid on bare soil or gravel. Lays one whitish or pale blue egg. Strays have been recorded from the Northwestern Hawaiian Islands. Population stable.

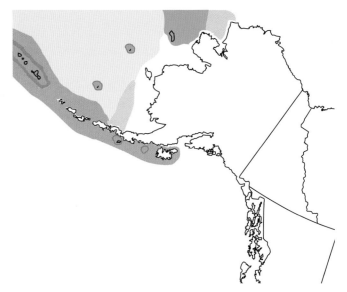

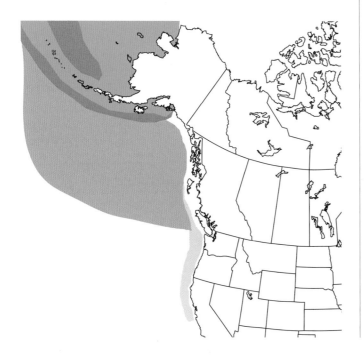

Least Auklet *Aethia pusilla*
L 6" WS 12" ♂ = ♀ LEAU

This tiny and stubby-billed alcid summers from East Asia to the Aleutian Islands and islands in the Bering Sea. Winters on the North Pacific and Bering Sea. Breeds in boulder fields in a relatively few very large nesting colonies in the Aleutians, Bering Sea Islands, and coastal Siberia. Winters on open ocean. Often seen in large flocks. Diet is small marine invertebrates, which it captures under the water. The single white egg is laid on bare ground in a crevice between boulders. Some island breeding colonies number more than a million birds. The breeding adults are variable, some quite dark and some with pale undersides. Easily identified by its tiny size. It is locally abundant in the Bering Sea. Introduced rats threaten the largest colony.

Whiskered Auklet *Aethia pygmaea*

L 8" WS 14" ♂ = ♀ WHAU *WL

This blackish alcid with fantastic black-and-white head plumes summers in the Aleutian Islands west to the Commander and Kuril Islands. Winters at sea near its nesting islands, where it breeds on rocks and cliffs. Often found in roiling water in areas with a strong current. Dives for prey. Diet is small crustaceans. The single dull white egg is laid on bare ground in a crevice between boulders on the nesting island. A rare species with a very restricted range. Island breeding populations have recovered once introduced predators were removed. Red List classifies it as Least Concern.

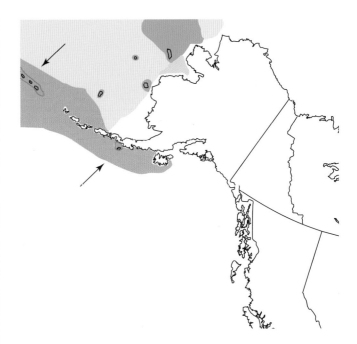

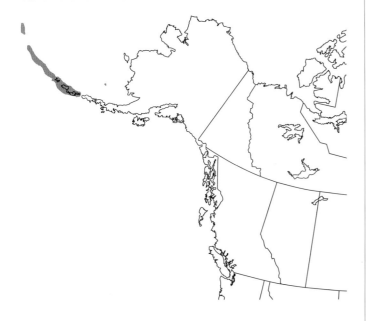

Crested Auklet *Aethia cristatella*

L 11" WS 17" ♂ = ♀ CRAU

This orange-billed auklet with a curving black forehead crest summers from the Kuril and Aleutian Islands to islands in the Bering Sea. Winters on the Bering Sea and North Pacific, from Japan to Kodiak Island, Alaska. Nests on sea cliffs of rocky islands. Winters on open ocean. Very gregarious. Often seen in large flocks in flight to foraging grounds. Diet is mainly small crustaceans. The nest, set in a crevice or rock pile, is a shallow scrape. Lays one white egg.

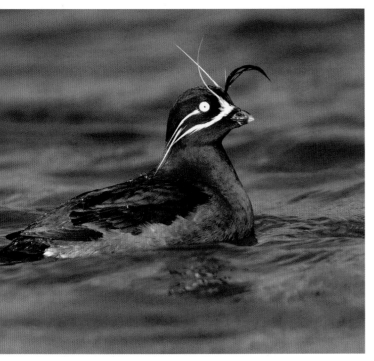

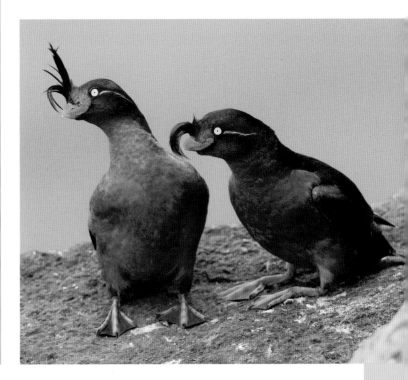

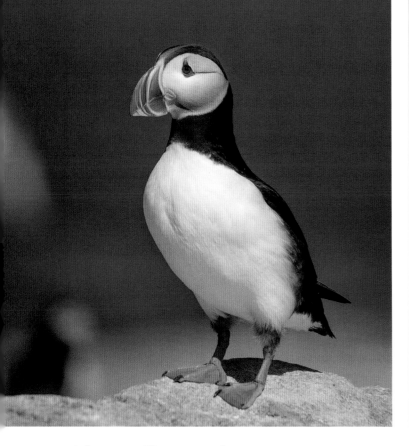

Atlantic Puffin *Fratercula arctica*
L 13" WS 21" ♂ = ♀ ATPU *VU

This most iconic of the alcids nests colonially on islands and protected headlands from Maine and northeastern Canada to Greenland and northern Europe. Winters widely in the North Atlantic to the edge of the pack ice and southward to the Mid-Atlantic. Dives for fish and crustaceans. The nest, set in a burrow or among rocks, is a sparse scrape lined with grass and feathers. Lays one white egg, in some instances with some faint dark markings. Population declines rate species as Vulnerable.

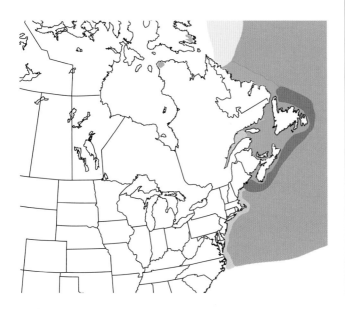

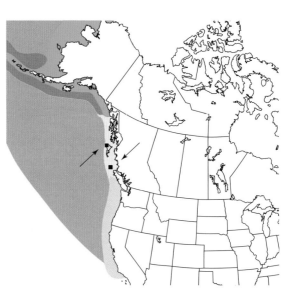

Horned Puffin *Fratercula corniculata*
L 15" WS 23" ♂ = ♀ HOPU

This western counterpart to the more familiar Atlantic Puffin summers widely on nesting islands on either side of the North Pacific. It sports a fleshy "horn" rising above each eye. Winters on the Bering Sea and North Pacific, south regularly to Washington and sparingly to California. Breeds on rocky islands and headlands. Winters on open ocean. Diet is mainly fish and marine invertebrates. The nest is placed in an earthen burrow or in a rock crevice and is sparsely adorned. Lays one dull white egg, lightly marked.

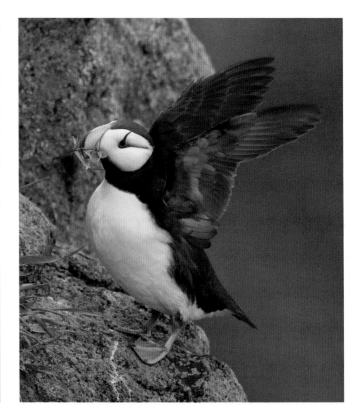

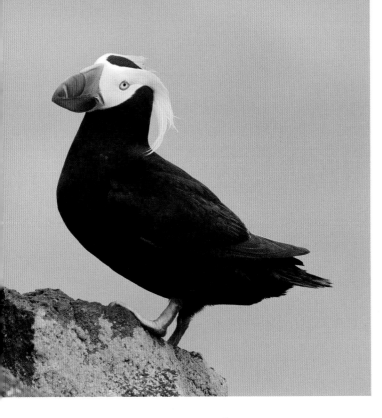

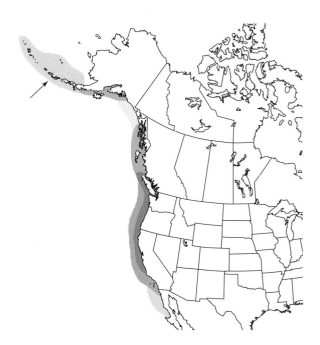

Tufted Puffin *Fratercula cirrhata*
L 15" WS 25" ♂ = ♀ TUPU

This most beautiful of the alcids summers along the Pacific Coast from northern Japan and the Aleutian Islands to Northern California. Breeds widely in the Bering and Chukchi Seas. Winters widely on the open Pacific. Breeds colonially on sea cliffs. Prefers to nest on treeless islands. Diet is mainly fish. The nest, set in a deep earthen burrow or natural rock crevice, is a sparsely lined cup. Lays one whitish egg, often with darker markings. In decline in California.

Rhinoceros Auklet *Cerorhinca monocerata*
L 15" WS 22" ♂ = ♀ RHAU

This puffin-relative summers along the North Pacific coasts, from Japan and Korea to central California. Breeds on predator-free coastal islands. Northern breeders in North America winter south into California and Baja. Winters on the open ocean. Forages by diving for prey. Diet is fish and crustaceans. The nest is placed in a long burrow made into the ground on a grassy island slope. Nest, situated in a burrow chamber, is a slight cup of twigs and moss. Lays one white egg, spotted with gray and brown. The horn atop its beak is regrown fresh every spring. Population stable.

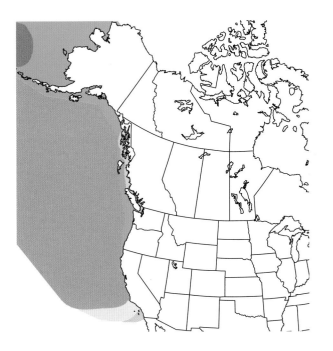

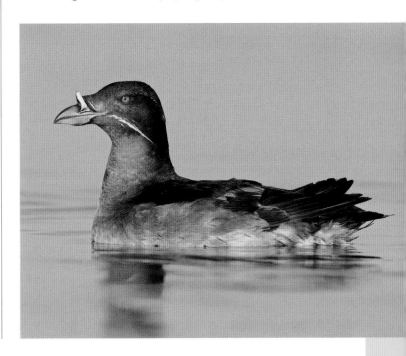

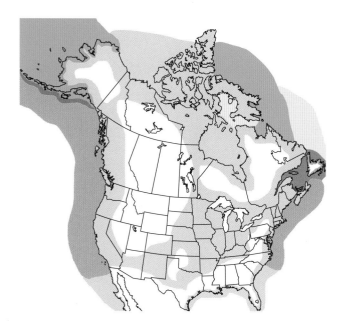

Black-legged Kittiwake *Rissa tridactyla*
L 17" WS 36" ♂ = ♀ BLKI

This mid-sized and trim white-headed gull summers on northern islands of Alaska, Canada, Greenland, and Eurasia, but it spends most of the year at sea. It breeds colonially on rocky cliffs and migrates and winters in flocks out over the open ocean. Diet is mainly fish, also crustaceans and other marine invertebrates. It dives and swims underwater to capture prey, unlike other gulls. The nest, set on a cliff ledge, is a cup of mud and vegetation. Lays one to three olive or pale blue eggs speckled with darker colors.

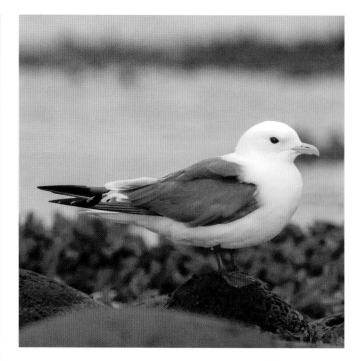

Red-legged Kittiwake *Rissa brevirostris*
L 15" WS 33" ♂ = ♀ RLKI *VU *WL

This small, short-billed gull summers only on the Commander, Pribilof, and Aleutian Islands, wintering near pack ice on the Bering Sea and in small numbers in the North Pacific. Breeds on ledges on sea cliffs of sub-Arctic islands. Often forages in flocks, in some cases in association with the much more common Black-legged Kittiwake. Diet is fish, squid, and crustaceans. The nest, set on a cliff ledge, is a shallow cup of mud, grass, and kelp. Lays one or two variably colored eggs. Much outnumbered by the very widespread Black-legged Kittiwake. The Red-legged Kittiwake is a species in apparent decline. The species is listed as Vulnerable.

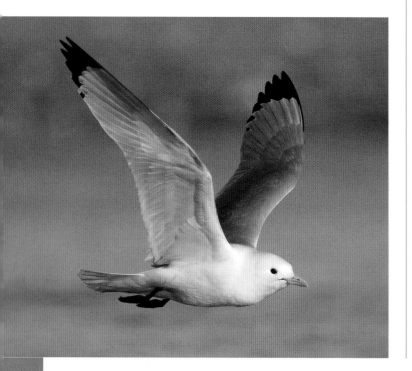

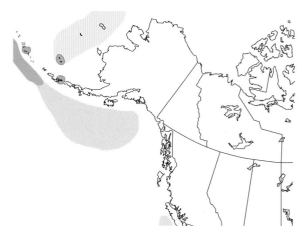

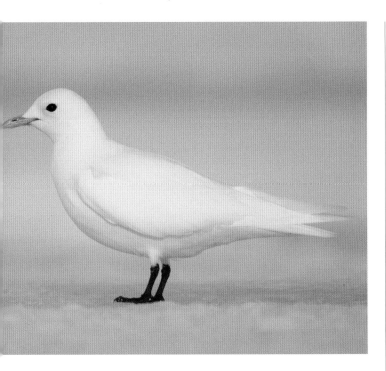

Ivory Gull *Pagophila eburnea*

L 17" WS 37" ♂ = ♀ IVGU *NT *WL

The all-white adult of this gull summers on islands of High Arctic Canada, Greenland, and Eurasia, wintering mainly on the seas of the Far North in the pack ice. Strays occasionally appear in Atlantic Canada and the Lower 48—especially around the Great Lakes and the Saint Lawrence. Breeds on barren northern island coasts. Diet is carrion, marine invertebrates, and small vertebrates; frequently scavenges dead animals with Glaucous Gulls. The nest, set on a cliff ledge or bare rocky ground, is a bulky mounded cup of seaweed and other debris. Lays one to three buff or olive eggs blotched with darker colors. In decline.

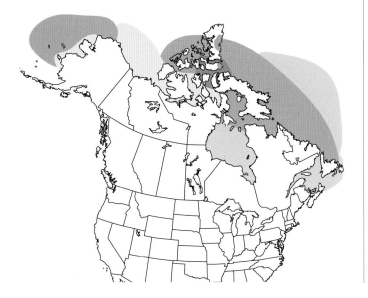

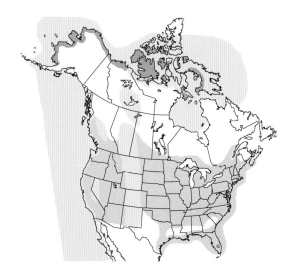

Sabine's Gull *Xema sabini*

L 14" WS 33" ♂ = ♀ SAGU

This very handsome gull summers in the High Arctic of Canada, Greenland, Alaska, and Eurasia, wintering mainly in the Southern Hemisphere, in seas west of southern South America and off southern Africa. In the Lower 48, it is mainly seen in migration at sea off the West Coast and in fall on large inland lakes and reservoirs. Breeds on low marshy tundra near the coast. Winters mainly on the open ocean. Diet is arthropods, fish, and crustaceans. The nest, set in open tundra, is a shallow depression, either lined with plant matter or unlined. Often nests in small colonies in association with nesting Arctic Terns. Lays one to three olive eggs with darker spotting. Population status unknown.

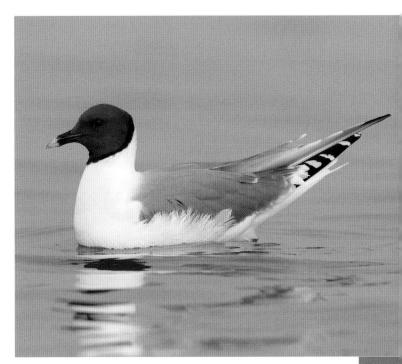

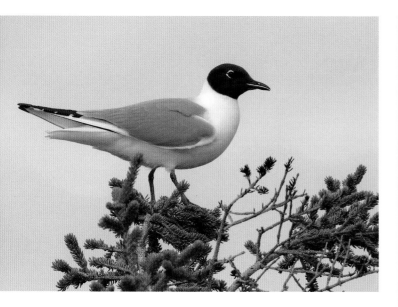

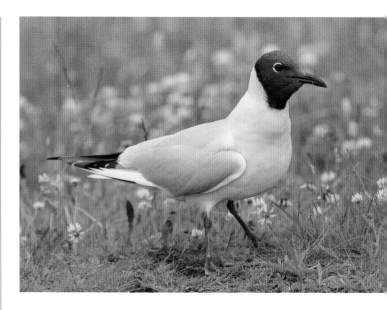

Bonaparte's Gull *Chroicocephalus philadelphia*
L 14" WS 33" ♂ = ♀ BOGU

This small and nicely-patterned gull summers in Canada and Alaska, wintering mainly our coastlines and offshore waters and in the lower Mississippi. Breeds in muskeg and open boggy spruce forest. Forms large flocks in migration and in winter. Diet is arthropods, crustaceans, and small fish. The nest, situated up in a spruce, is an open cup of sticks lined with finer materials. Lays two to four olive or buff eggs blotched with brown. This is the only North American gull that habitually nests in trees. Large nonbreeding flocks of Bonaparte's Gulls are good places to look for other rare gull species, especially the Little Gull and Black-headed Gull. Substantial declines in the size of winter flocks on both coasts indicates a possible threat to Bonaparte's Gull.

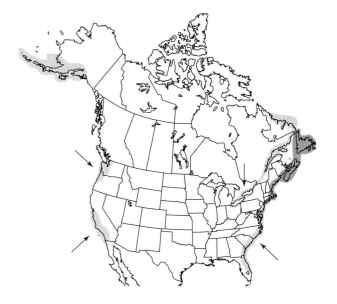

Black-headed Gull *Chroicocephalus ridibundus*
L 16" WS 40" ♂ = ♀ BHGU

This widespread Eurasian breeder winters southward to Africa and Asia. Aside from a few birds that breed in Newfoundland, the nearest breeding population is in Greenland. Individuals annually stray across the Atlantic to the East Coast and Atlantic Canada. Found typically as a singleton in large flocks of gulls in coastal locations or on the Great Lakes. In North America, most commonly associated with Bonaparte's and Ring-billed Gulls. Diet is diverse—arthropods, small fish, marine invertebrates, and carrion. The nest, set on the ground, often under low vegetation, is a scrape lined with plant matter. Lays one to four greenish or tan eggs blotched with brown. The species has been breeding in Greenland since the 1960s.

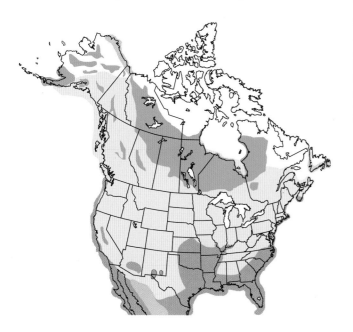

Little Gull *Hydrocoloeus minutus*
L 11" WS 24" ♂ = ♀ LIGU

This tiny and elegant Eurasian species typically winters in the Mediterranean. A few breed on the Great Lakes, and perhaps a larger number nest in the Hudson Bay lowlands. Winters in association with Bonaparte's Gulls. Diet is mainly arthropods and marine and aquatic invertebrates. Breeds colonially on interior marshes. The nest, set on the ground near water, is a shallow depression lined with plant matter. May be built up to avoid inundation. Lays two or three olive or buff eggs marked with brown and gray. This is the smallest of the world's gulls and one of the most desired target gulls by birders. Records of sightings have declined in US.

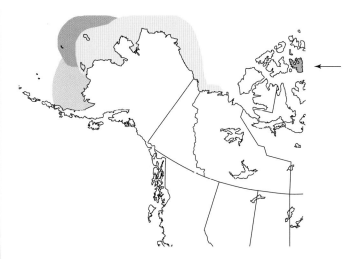

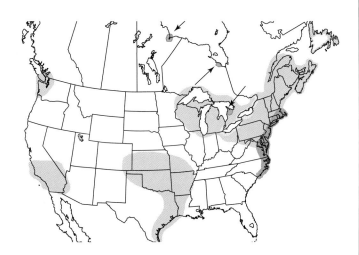

Ross's Gull *Rhodostethia rosea*
L 14" WS 33" ♂ = ♀ ROGU *WL

A small, ring-necked gull of the Far North. Summers in the Arctic of northeastern Siberia, High Arctic Canada, and Greenland. Winters mainly among the pack ice of the Arctic Ocean. Encountered in the Lower 48 about once a year, mainly in the Northeast or the Northwest. Breeds on wet boggy tundra. Seen in numbers annually in autumn, migrating past Utqiagvik (Point Barrow), Alaska. Diet is arthropods, fish, and crustaceans. The nest, set on a small island or a hummock near water, is a shallow depression lined with plant material. Lays two or three olive eggs blotched brown.

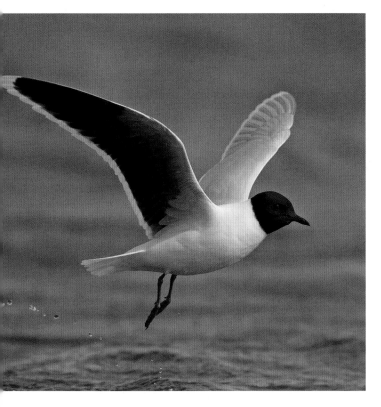

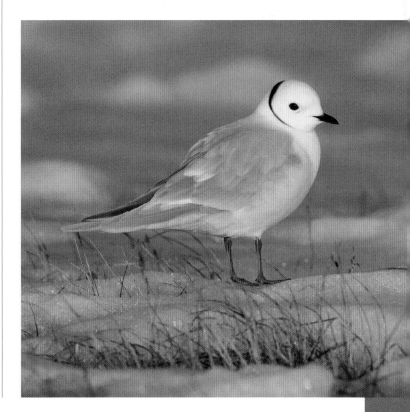

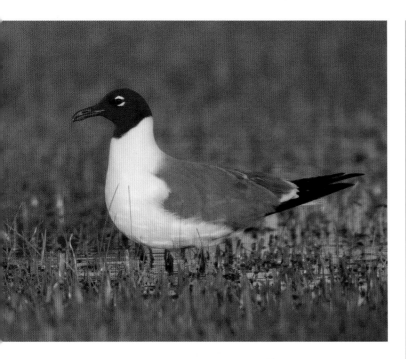

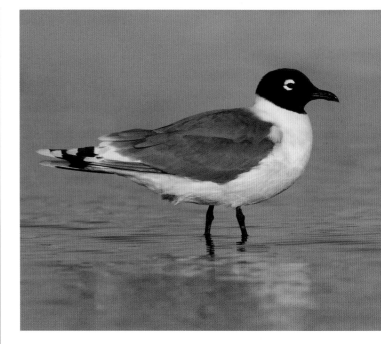

Laughing Gull *Leucophaeus atricilla*

L 17" WS 40" ♂ = ♀ LAGU

This familiar gull of beaches of the East summers on the Atlantic and Gulf Coasts, the Caribbean, and the coasts of Mexico. Winters on the Gulf Coast, the Salton Sea, Baja, and on the Atlantic mainly south of the Chesapeake Bay. Southernmost wintering birds reach the coasts of northern South America. Breeds in saltmarsh and coastal bays. Very sociable and vocal. Nests in colonies. Diet is a mix of fish and marine and terrestrial invertebrates. The nest, set on the ground in saltmarsh or on a low coastal island, is a scrape on the ground or shallow cup of detritus. Lays two to four olive or buff eggs blotched with brown. This is the commonplace summer gull of coastal marshes and bays of the Atlantic and Gulf regions.

Franklin's Gull *Leucophaeus pipixcan*

L 15" WS 36" ♂ = ♀ FRGU

This strongly migratory gull summers in the northern Great Plains and patchily in the Interior West. Winters on the western coasts of Central and South America. Avoids our Pacific and Atlantic Coasts in migration. Breeds in prairie marshes. Very sociable and travels in flocks. Nests in colonies. Diet is arthropods and fish. The nest, set on water in marshland, is a floating mass of rushes anchored to live vegetation. Lays two or three buff or olive eggs blotched with brown or black.

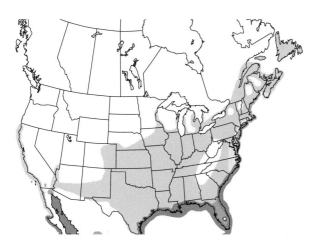

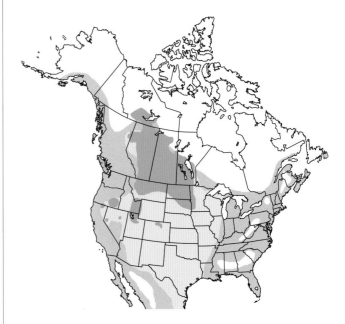

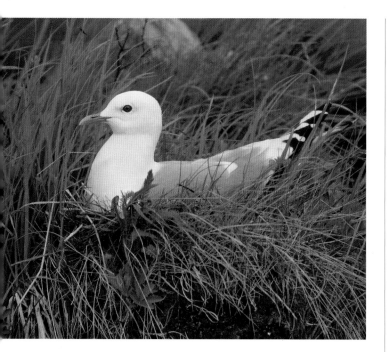

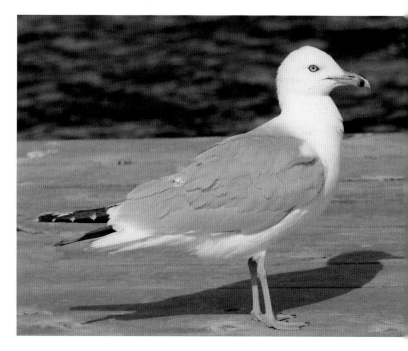

Short-billed Gull *Larus brachyrhynchus*

L 16" WS 43" ♂ = ♀ SBIG

This small and trimly plumaged gull summers from the Pacific Northwest to Alaska and northwestern Canada, wintering on the West Coast. Breeds on ponds, marshes, and rivers in boreal forest openings. Winters on beaches and coastal waters. Diet includes small fish, arthropods, crustaceans, and mollusks. The nest, set in a low spruce or on the ground near water, is a shallow scrape lined with plant material. Lays two or three olive or buff eggs marked with brown. Formerly known as the Mew Gull, which has now been split into the Short-billed Gull (North America) and the Common Gull (Eurasia).

Ring-billed Gull *Larus delawarensis*

L 18" WS 48" ♂ = ♀ RBGU

This commonplace mid-sized gull summers in the interior of northern North America and in Atlantic Canada, wintering southward (especially to the Atlantic, Pacific, and Gulf Coasts), rarely to the Caribbean and Central America. Nests in colonies mainly on islands in Interior lakes, sometimes in association with Caspian Terns and larger species of gulls. This is the familiar "parking-lot gull" of many urban areas. Omnivorous. The nest, set on the ground near water, is a shallow cup of plant material. Lays two to four gray or olive eggs blotched with brown.

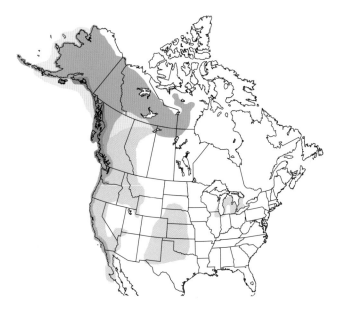

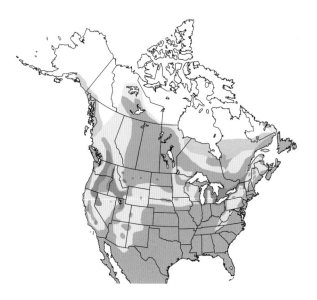

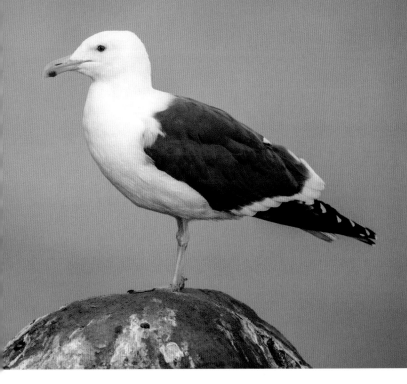

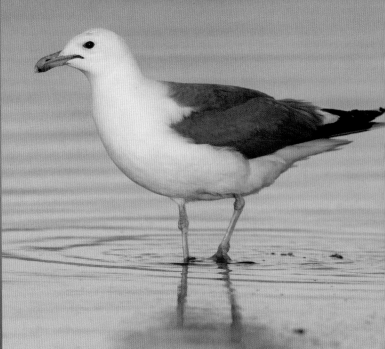

Western Gull *Larus occidentalis*
L 25" WS 58" ♂ = ♀ WEGU

This large, dark-mantled gull is a year-round breeding resident of the West Coast south into Baja. This gull is a coastal specialist—rarely moving inland. Breeds on coastal islands and cliffs. Hybridizes with Glaucous-winged Gull in Washington. Omnivorous. The nest, set on the ground or on a cliff ledge, is a shallow depression lined with plant material. Lays one to five buff or olive eggs blotched with dark brown. In recent decades the species has become more common in the interior, along the coastal slope of southern California. The species is abundant and probably still on the increase. In winter can be found in small numbers at the Salton Sea.

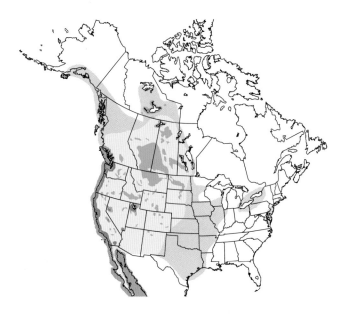

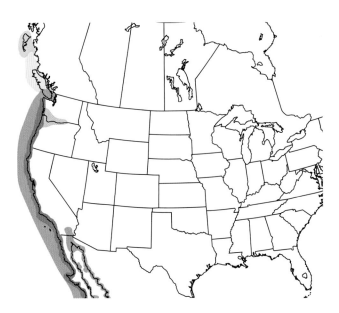

California Gull *Larus californicus*
L 21" WS 54" ♂ = ♀ CAGU

This white-headed gull summers patchily in the Interior West from Southern California north to the Northwest Territories. It winters along the West Coast from Vancouver south to western Mexico. Breeds colonially on lakes and marshes of the Interior West. And loafing nonbreeders can be found along the West Coast year-round. An omnivore. The nest, set on the ground near water, is a shallow depression lined with plant material and feathers. Lays two or three olive or gray eggs blotched with dark brown and gray. This is the gull that rescued the Mormons threatened by a plague of grasshoppers in Utah in 1848. Today, there is a seagull monument standing in Salt Lake City, a tribute to this species.

Yellow-footed Gull *Larus livens*

L 27" WS 60" ♂ = ♀ YFGU *WL

This close relative of the Western Gull is a year-round resident of the Gulf of California in western Mexico. It strays to the Salton Sea annually, mainly from June to October. Found on the barren shorelines of the Salton Sea and occasionally in nearby flooded fields. Diet is mainly fish and other marine life. Distinguished from the very similar Western Gull by the thicker bill and yellow legs and feet. This uncommon species breeds only in western Mexico. The species population appears stable. Observations of individuals at the Salton Sea increased steadily in the late 20th century and then declined after the 1990s. Red List treats species as of Least Concern.

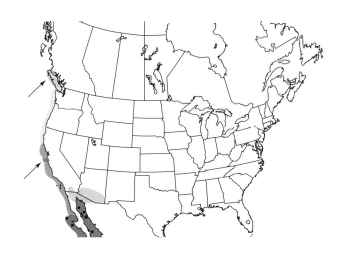

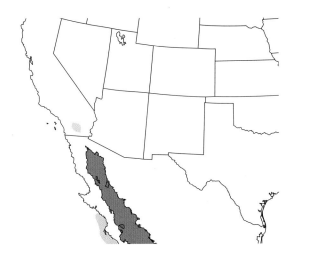

Heermann's Gull *Larus heermanni*

L 19" WS 51" ♂ = ♀ HEEG *NT *WL

This distinctive, gray-bodied gull nests along the coast of Baja and western mainland Mexico, and patchily in California, wintering northward up the Pacific Coast to southern British Columbia. Common in season along the California shore. Ranges far offshore. Rare inland. Very aggressive. Sometimes steals prey from other seabirds. Diet is fish and marine invertebrates. Most common in the United States between June and January. Most members of this species breed on Isla Rasa in the Gulf of California, making the species vulnerable to local and global threats due to its concentrated breeding population. The species suffers high mortality during strong El Niño years.

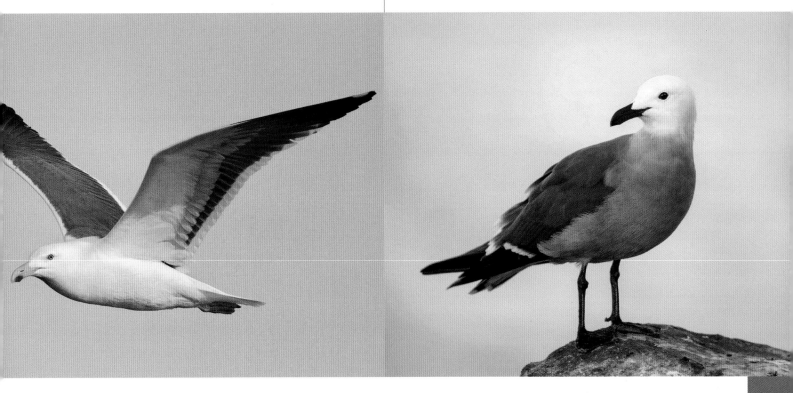

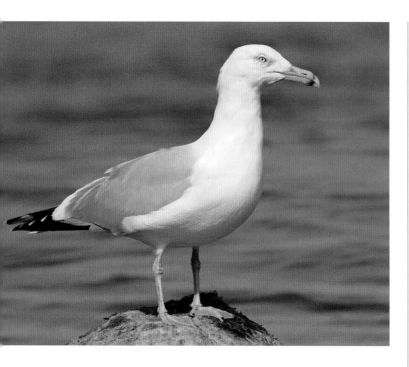

Herring Gull *Larus argentatus*
L 25" WS 58" ♂ = ♀ HERG

This big and wide-ranging gull summers across much of
Canada, the Northeast, and much of the East Coast. Winters
on the West, East, and Gulf Coasts, and in the interior East
and the South. Most common in the East. Other populations
range across northern Europe, Central Asia, and Siberia.
Hybridizes with the Glaucous-winged Gull in southwest-
ern Alaska. Breeds colonially on lakes, rivers, coasts, and
wetlands. An omnivore. The nest, set on the ground next to
some feature, is a shallow scrape lined with plant and other
matter. Lays one to four olive eggs blotched with dark.

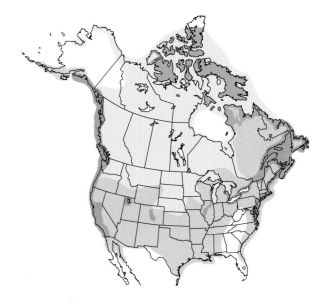

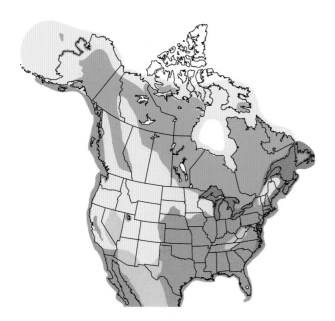

Iceland Gull *Larus glaucoides*
L 22" WS 54" ♂ = ♀ ICGU

This smaller white-winged gull summers in Arctic Canada
and Greenland, wintering on the coasts of the North Atlantic
and Pacific as well as the Saint Lawrence and Great Lakes.
Breeds on rocky coasts, cliffs, and fjordlands. Diet is mainly
fish. The nest, set on a cliff ledge or rocky northern shore-
line, is a bulky mound of debris with a depression on top.
Lays two or three buff or olive eggs marked with dark brown.
Thayer's Gull and Kumlien's Gull are both treated as subspe-
cies of the Iceland Gull. Population stable.

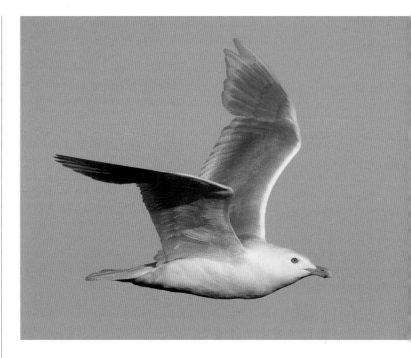

Glaucous-winged Gull *Larus glaucescens*
L 26" WS 58" ♂ = ♀ GWGU

This large pale-mantled gull is a year-round resident from western Alaska south to Washington state, wintering coastally south to Baja. It nests mainly on coastal islands or headlands. Hybridizes with Western, Herring, and Glaucous Gulls where breeding populations overlap. An omnivore. The nest, set on the ground, a cliff ledge, or a flat rooftop, is a shallow scrape lined with plant and other debris. Lays two or three olive eggs marked with brown and gray. This is a species that has been on the increase in recent decades.

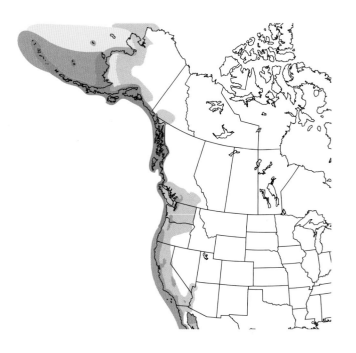

Glaucous Gull *Larus hyperboreus*
L 27" WS 60" ♂ = ♀ GLGU

This large white-winged gull summers in the Arctic of Canada, Alaska, Greenland, and Eurasia. American populations winter southward along the East and West Coasts as well as in the Great Lakes and Saint Lawrence. Breeds on Arctic cliffs, islands, and beaches. Winters mainly along coasts and offshore. Omnivorous. The nest, set on a ledge or flat rocky ground, is a mound of plant material and other debris with a depression for the eggs at the top. Lays two to four olive or buff eggs marked with dark brown. In the Lower 48 typically found as a singleton within flocks of other gull species.

Lesser Black-backed Gull *Larus fuscus*
L 21" WS 54" ♂ = ♀ LBBG

This European species has been actively invading North America. Now it is a regular year-round resident of the Atlantic and Gulf Coasts. The species has not been found breeding in North America yet but has paired with Herring Gulls in Maine and Alaska. Frequents coastal beaches. Typically seen in association with other gull species. Habits are similar to the Herring Gull. The ground nest, usually in a mixed gull colony, is a sparsely lined circle of grass and debris. Lays three pale green eggs marked with brown. The increase of this species along East Coast beaches is one of the most remarkable stories of avian population increase of the 21st century. In this instance, there is no assistance via human intervention (as with the East Coast colonization of the House Finch). Increase is expected to continue.

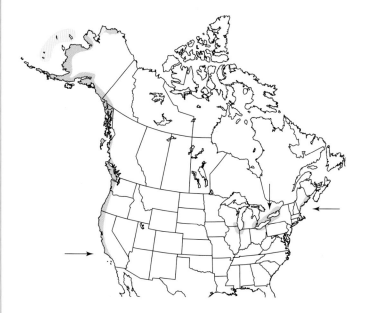

Slaty-backed Gull *Larus schistisagus*
L 25" WS 58" ♂ = ♀ SBAG

This dark-backed East Asian species strays regularly to Alaska, and less regularly to the West Coast—also very sparsely to the Great Lakes and Northeast. Habits and habitat choice are similar to that of Herring Gull. Very much a marine species associated with northern coasts. This little-known species is reported to be on the decline.

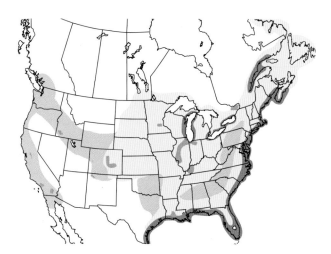

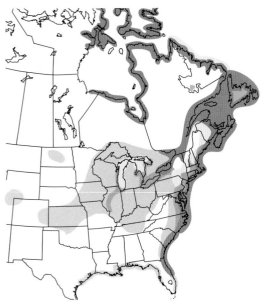

Great Black-backed Gull *Larus marinus*
L 30" WS 65" ♂ = ♀ GBBG

This bird, the world's largest gull, summers in northern Labrador, Greenland, and northern Europe. Also a permanent resident of eastern Arctic Canada, Atlantic Canada, and down the East Coast to Florida. Northern birds winter to the Great Lakes, Illinois, and Florida. Breeds on coastal features—rocky cliffs, island beaches, and marsh edges. Like the Glaucous Gull, this big bird is a predator and an omnivore. The nest, set on the ground or rocky outcrop, is a mound of plant material and debris with a depression sitting atop it. Lays two or three olive or buff eggs with brown blotches. In the East often seen perched in numbers on convenient resting places high on the superstructure of large bridges crossing coastal rivers or bays. This species has been on the increase for a half-century or more.

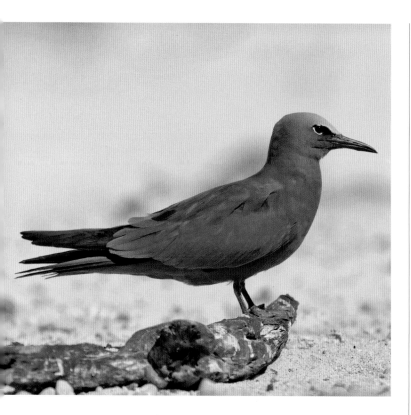

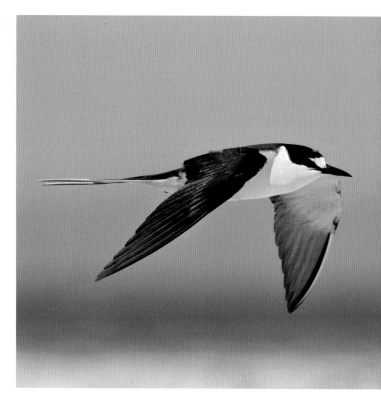

Brown Noddy *Anous stolidus*
L 16" WS 32" ♂ = ♀ BRNO

This globally widespread tropical tern nests on the Dry Tortugas of the Florida Keys as well as in Hawaii. The species spends most of the year in tropical and subtropical seas. This tern breeds in colonies, often with other tropical tern species. Diet is small fish. The nest, set in a shrub or tree, is a platform of sticks and seaweed, lined with bits of coral. Lays one pale buff egg lightly spotted with reddish brown and pale lavender. This, the White Tern, and the Black Noddy, are the only tree-nesting terns. The North American population is apparently stable.

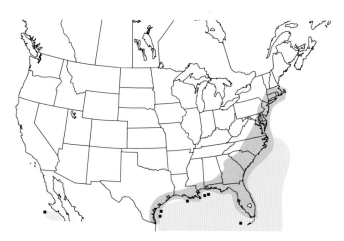

Sooty Tern *Onychoprion fuscatus*
L 16" WS 32" ♂ = ♀ SOTE

Within the United States, this pied, sea-dwelling tern nests on the Dry Tortugas of the Florida Keys as well as in Hawaii. Otherwise, a wanderer of tropical and subtropical seas. Birds periodically get blown ashore by strong tropical storms in the Gulf of Mexico and the Atlantic. Spends most time out of sight of land. Diet is small fish and squid. The nest, set on the open ground, is a shallow scrape lined with a few leaves. Lays one whitish egg marked with various other colors. Terns raised in the Dry Tortugas travel across the Atlantic to the waters off West Africa, where they spend the first three years of their lives at sea. Shares its Dry Tortugas breeding colony with Brown Noddies. Population stable.

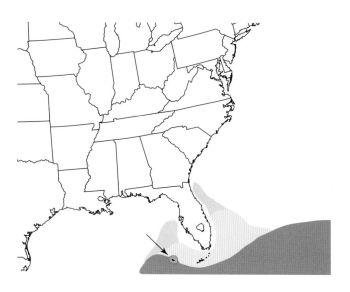

Bridled Tern *Onychoprion anaethetus*
L 15" WS 30" ♂ = ♀ BRTE

Another pantropical sea-faring tern seen in the warm Gulf Stream waters of the Deep South. This West Indian breeder is mainly seen perched on floating debris at sea. Also breeds on tropical islands in the Old World. Diet is mainly fish. A few birds nest on the Dry Tortugas in Florida, typically segregating themselves from the many nesting Sooty Terns and Brown Noddies. The nest, set on the ground in a protected location, is a shallow scrape with minimal lining. Lays one pale buff egg spotted with brown. Ranges to New England in summer by riding the Gulf Stream northward. This species has a large global population, breeding in tropical seas of the New and Old World. Population presumably stable.

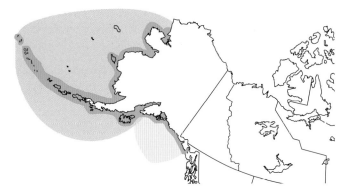

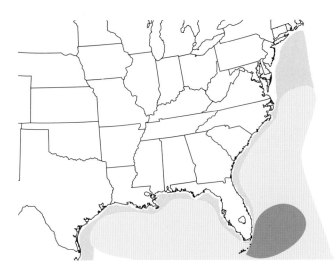

Aleutian Tern *Onychoprion aleuticus*
L 12" WS 29" ♂ = ♀ ALTE *VU *WL

This rarely seen gray-breasted tern summers from Northeast Asia to the Aleutian Islands and isolated parts of coastal Alaska. Winters south to the waters off Southeast Asia and even Australia. Presumably spends much of the year at sea far from land. Breeds on Alaskan coastlines, often in association with Arctic Terns. Diet is crustaceans and fish. The nest, set on the ground near water and hidden among low vegetation, is a shallow depression in moss and other plant material. Lays one to three buff or olive eggs marked with dark brown. Alaskan breeding colonies have shown declines, leading species to be Red Listed as Vulnerable.

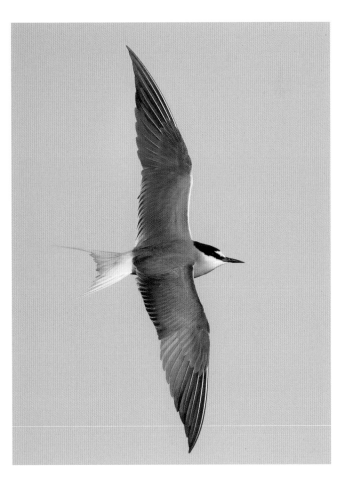

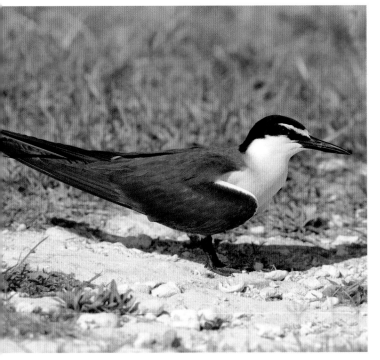

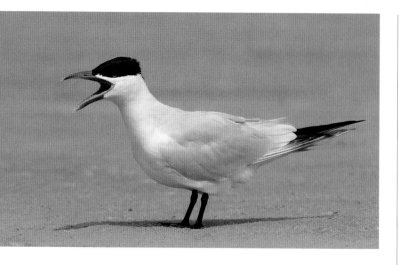

Caspian Tern *Hydroprogne caspia*
L 21" WS 50" ♂ = ♀ CATE

This cosmopolitan tern (and the largest tern) summers patchily across North America—mainly on the coastlines of the Deep South, the Pacific Northwest, Great Lakes, and northern sectors of the Interior. Winters on our Atlantic, Pacific, and Gulf Coasts. Breeds on islands and coastal flats. Winters on coastal bays and lagoons. Diet is mainly fish. The nest, set on flat ground and hidden among driftwood or debris, is a shallow depression sparingly lined with bits of debris. Lays one to three pale buff eggs spotted with darker colors. Some North American birds winter southward as far as northern South America. The species appears to be doing well in recent decades.

Royal Tern *Thalasseus maximus*
L 20" WS 41" ♂ = ♀ ROYT

Resident along the southern sector of the East Coast and in Baja and Southern California. Also breeds in the Caribbean and northern South America. Many North American breeders winter to South America. Nests on low-lying sandy islands. Winters on coastal beaches and lagoons. Diet is mainly fish and crustaceans. The nest, set on sandy ground, is a shallow depression with a sparse lining of debris. Lays one or two whitish or buff eggs with red-brown blotches. The species appears to be holding stable as a North American breeder. Nests in dense colonies, often with a smaller number of Sandwich Terns. After breeding, this beautiful long-winged species is commonly seen patrolling sandy Atlantic and Southern California shorelines.

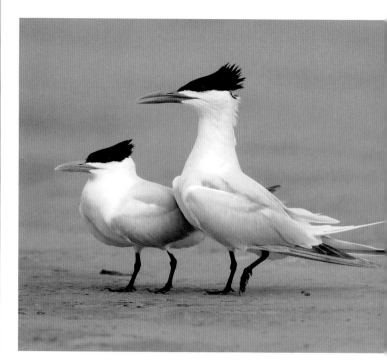

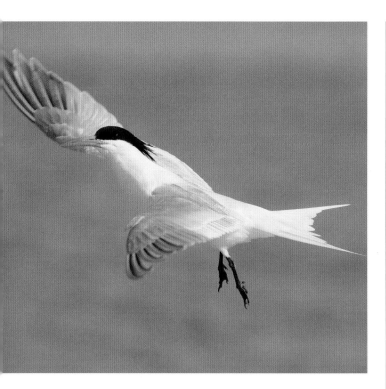

Sandwich Tern *Thalasseus sandvicensis*
L 15" WS 34" ♂ = ♀ SATE

This graceful tern with the two-toned bill summers along the coasts of the Southeast and Deep South. It winters to Florida, South Texas, and the Caribbean. Other populations inhabit western Eurasia and South America. Breeds on sandy coastal islands and protected beaches, often in association with the Royal Tern. Winters in coastal lagoons and estuaries. Diet is mainly fish. The nest, set on the ground in the sand, is a shallow scrape sparsely lined with found materials. Lays one to three pale cream eggs blotched dark. Called Cabot's Tern by some authorities.

Elegant Tern *Thalasseus elegans*
L 17" WS 34" ♂ = ♀ ELTE *NT *WL

A slightly smaller western counterpart to the Royal Tern, the Elegant Tern summers along coastlines of southern-most California and Baja. Winters along the Pacific Coast from central California to northern Chile. Breeds on coastal islands. Winters along coastlines near bays and estuaries. Wanders northward up the West Coast after breeding. Diet is small fish. The nest, set on open bare ground, is a shallow scrape. Lays one or two white or buff eggs spotted dark brown. Recent records of strays to the Gulf and East Coasts. Appears to be continuing its increase on the Pacific coast.

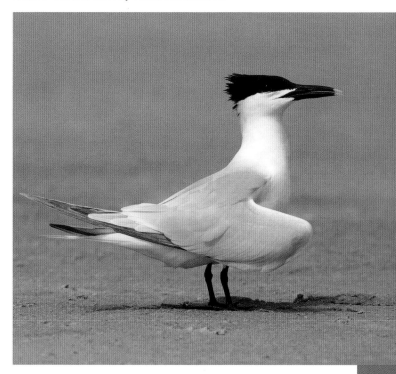

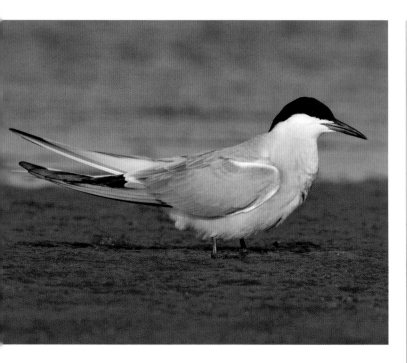

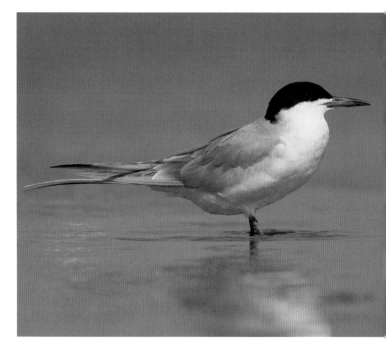

Common Tern *Sterna hirundo*

L 12" WS 30" ♂ = ♀ COTE

This species breeds across the Northern Hemisphere, wintering in the Tropics and Southern Hemisphere. North American birds summer in Canada, the Northeast, and the East Coast. These winter to Central and South America. Breeds on small islands and protected sandy beaches. Migrates along the East and West Coasts. Outnumbered by the similar Forster's Tern in the Interior. Diet is mainly small fish. Nests in colonies. The nest, set on bare ground, is a shallow scrape lined with bits of plant material or other debris. Lays one to three eggs of variable background color marked with black and brown.

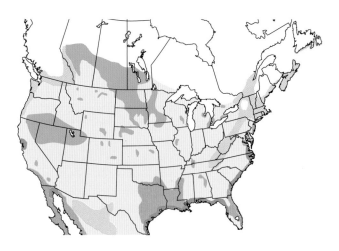

Forster's Tern *Sterna forsteri*

L 13" WS 31" ♂ = ♀ FOTE

This pale-winged tern of the New World summers patchily across the northern United States and the prairies of western Canada. Winters on the Atlantic, Pacific, and Gulf Coasts and southward to Central America and the Caribbean. Breeds on freshwater lakes, marshlands, and tidal creeks. Winters in coastal marshes and bays. Diet is arthropods, fish, and marine invertebrates. The nest, set in a marsh and lined with fine materials, is a platform of marsh grasses with a deep depression on top. Lays one to four olive or buff eggs marked with brown. Very similar to the widespread Common Tern but distinguishable by the very pale upper surface of the wings in flight. Species population is apparently stable.

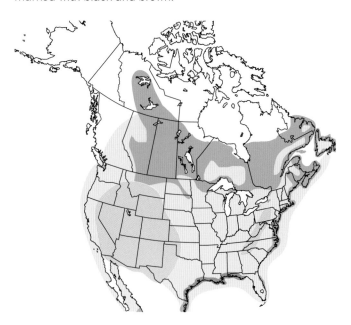

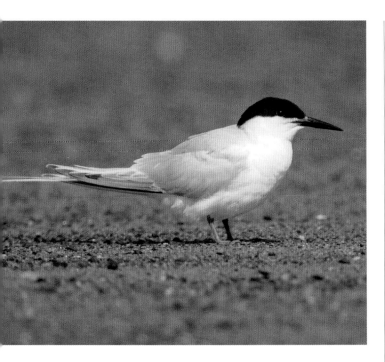

Arctic Tern *Sterna paradisaea*
L 12" WS 31" ♂ = ♀ ARTE

This gray-toned tern with the blood-red bill summers across northern Canada, Alaska, Eurasia, and Greenland, wintering in the far Southern Hemisphere and migrating far offshore. Breeds in small colonies in marshes, boglands, and coastal tundra. Spends much of the year at sea. Reputed to be the long-distance champion of migration, ranging from the High Arctic at latitude 84° North to Antarctic pack ice at latitude 78° South, a round trip of 31,000 miles. Diet is fish, crustaceans, and arthropods. The nest, set on the ground, is a shallow depression lined with plant matter. Lays one to three buff or pale olive eggs blotched black and brown.

Roseate Tern *Sterna dougallii*
L 13" WS 29" ♂ = ♀ ROTE *WL

Another cosmopolitan tern species. North American populations breed on small coastal islands from Long Island to Nova Scotia. A few birds also breed in the Florida Keys. Our birds winter to South America. Northeastern breeders gather for migration in August and September on Cape Cod, Massachusetts. Diet is mainly fish. The nest, set on the ground under some low vegetation is a shallow scrape lined with bits of debris. Lays one to three whitish or pale olive eggs blotched with dark brown. Listed by the US Fish & Wildlife Service as Endangered in the United States. Presumably in ongoing decline.

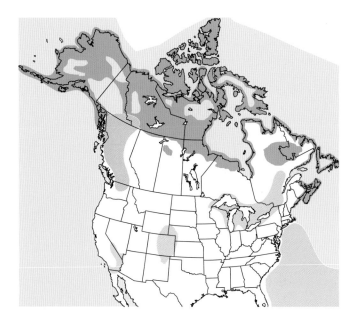

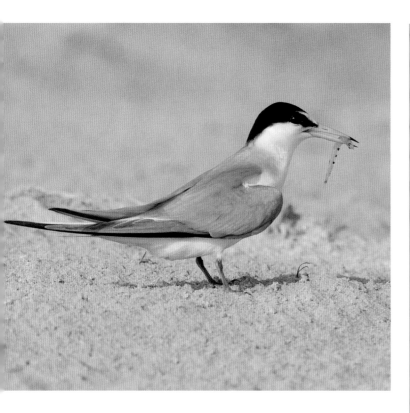

Least Tern *Sternula antillarum*

L 9" WS 20" ♂ = ♀ LETE *WL

This diminutive tern breeds along the Atlantic and Gulf Coasts, sparingly along the coast of Southern California, along major interior rivers, in the Caribbean, in coastal Mexico, and in northern South America. Winters south of the Border, as far as Brazil. This small tern forages over water, plunge-diving for small fish. Colonial nesting sites have been threatened by human activity. Sometimes it nests atop gravel rooftops. Nest is a shallow scrape, sometimes lined with grass, debris, and small stones. Lays one to three buff or pale green eggs blotched with darker colors.

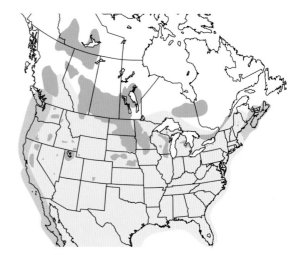

Black Tern *Chlidonias niger*

L 10" WS 24" ♂ = ♀ BLTE

This elegant little dark tern summers patchily through our northern Interior. Winters in the Caribbean and in the seas off Central and northern South America. Other populations inhabit Eurasia and winter to Africa. Breeds on freshwater marshes and lakes of the Interior. Diet is arthropods and fish. The nest, set in a marsh, is a platform of plant material or shallow depression with minimal lining. Lays two to four pale buff or olive eggs marked with brown and black. This is a species in widespread decline.

Gull-billed Tern *Gelochelidon nilotica*
L 14" WS 34" ♂ = ♀ GBTE

This rather stockily built but elegantly plumaged tern is a globally widespread species that summers on coastlines of our Mid-Atlantic and Southeast, as well as the Caribbean, western Mexico, and patchily through Eurasia. Winters southward, often into the Southern Hemisphere. Breeds in coastal bays and saltmarshes. Often forages over plowed fields. Diet is mainly arthropods. The nest, set on open sandy ground, is a shallow depression often rimmed with earth or bits of debris. Usually in small nesting colonies, sometimes at the edge of a Common Tern colony. Lays two or three pale buff eggs spotted with brown.

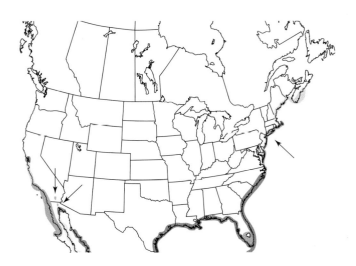

Black Skimmer *Rynchops niger*
L 18" WS 44" ♂ = ♀ BLSK

A mainly tropical species with breeding populations that range from South America northward to our Atlantic, Gulf, and California coastlines. North American birds winter southward to the Deep South and south of the Border. The species nests colonially on protected beaches, sandy islands, and shell banks. Winters in tight flocks. Diet is mainly small fish. The nest, set on the sand, is a shallow scrape. Lays four or five whitish or buff or blue-green eggs marked with brown. Forages by dipping lower mandible into water surface to catch bait fish at surface. North American breeding populations fluctuate.

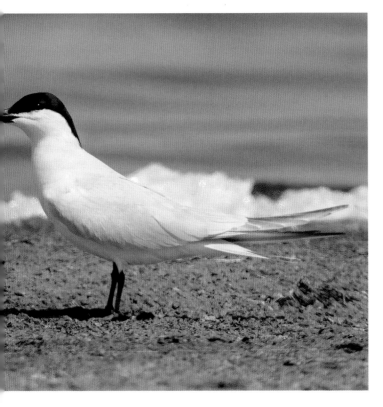

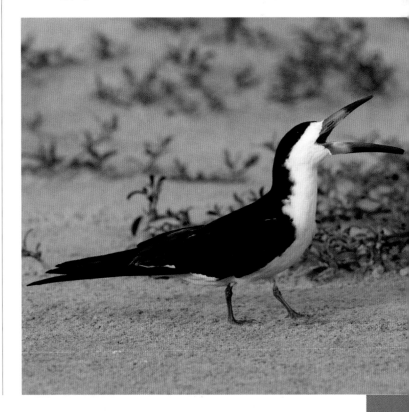

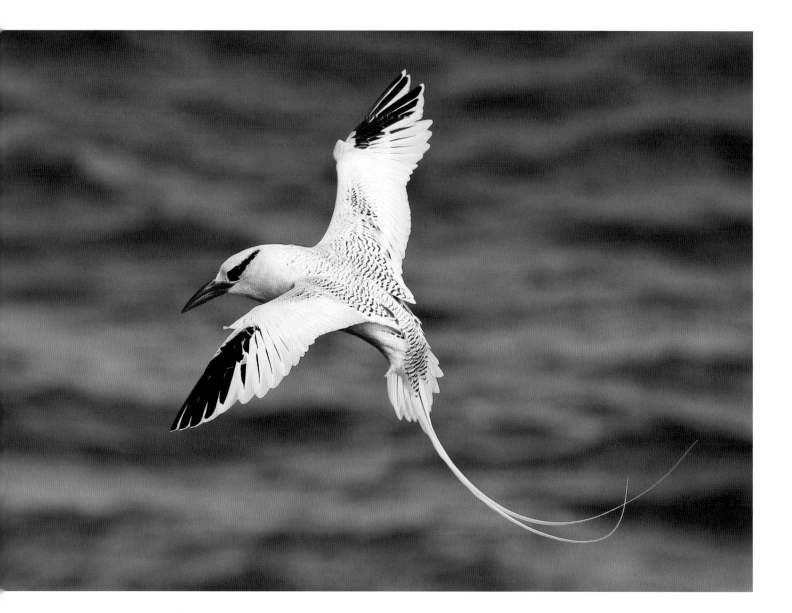

Red-billed Tropicbird *Phaethon aethereus*
L 34" WS 44" ♂ = ♀ RBTR *WL

This is a beautiful and long-tailed seabird that patchily inhabits tropical seas the world-round. Nests off both coasts of Baja and strays to the waters off Southern California. Also a rare visitor to warm waters off the southern sector of the East Coast (even to New England Gulf Stream waters). Usually found far offshore. Solitary, not mixing with other seabirds. Diet is mainly small fish. Most often seen well off the coast of southern California. Good numbers breed on islands of the Lesser Antilles in the southern West Indies. It is a Watch List species. White-tailed Tropicbird distinguished by its orange (not red) bill and the black streak on the upper-wing. Globally, this is the least numerous of the tropicbirds. Tropicbirds are certainly among the most desired seabirds to be seen on pelagic birding trips.

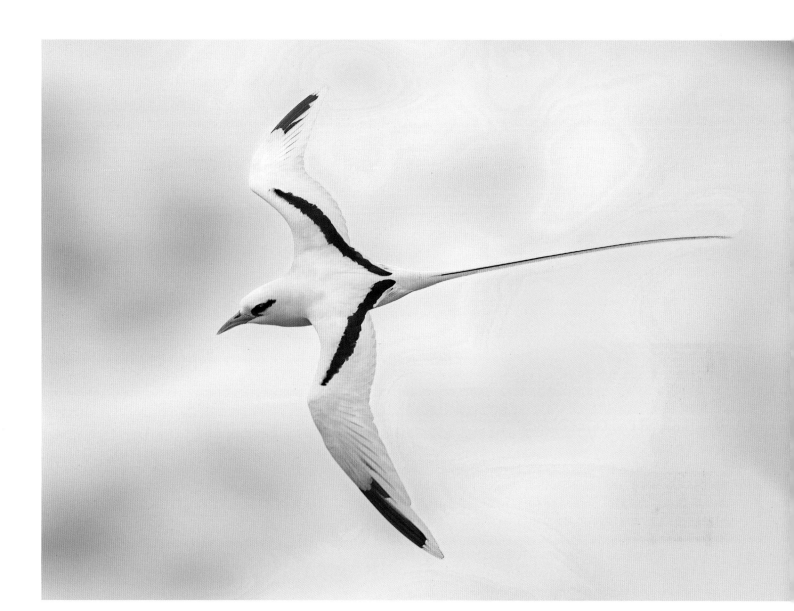

White-tailed Tropicbird *Phaethon lepturus*

L 29" WS 37" ♂ = ♀ WTTR

This beautiful long-tailed seabird species nests and wanders through tropical seas of the world. Nearest nesting sites are in the Bahamas and Bermuda. Also nests in Hawaii. Found regularly in warm Gulf Stream waters off our East Coast in mid- to late summer. Occasionally blown onshore by strong tropical storms. Diet is mainly fish. The nest, set in a rock crevice, is an unadorned bare scrape. Lays one pale buff egg marked with darker colors. The species population appears stable. Most easily seen in Hawaii. Globally, the species spends most of its time far offshore, coming to land only to nest. Flying fish are a favorite of this graceful seabird.

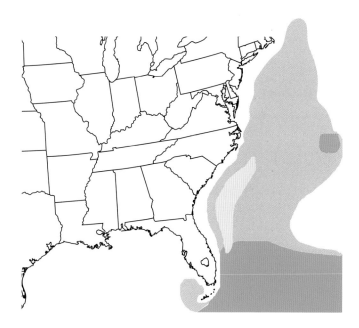

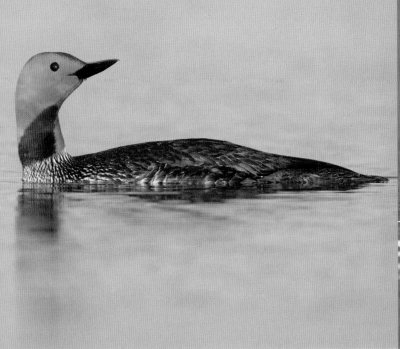

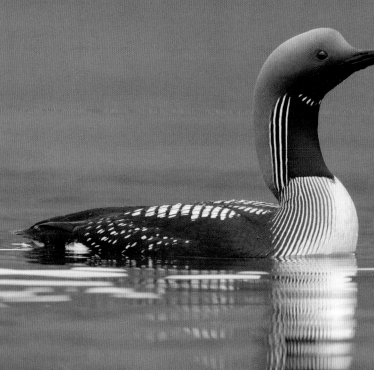

Red-throated Loon *Gavia stellata*

L 25" WS 36" ♂ = ♀ RTLO

A widespread Arctic-breeding species. North American breeders winter on the coastal waters of the Atlantic and Pacific. Small and slim. Breeds on small tundra lakes. In migration, found on bays and estuaries, as well as in the Great Lakes. Diet is mainly fish but also crustaceans, mollusks, and other small invertebrates. The lake nest is a heap of decaying vegetation in shallow water or on the shore. Lays one to three olive eggs with blackish spots. Regionally in decline.

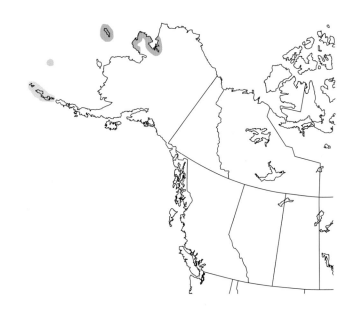

Arctic Loon *Gavia arctica*

L 27" WS 40" ♂ = ♀ ARLO

This is the larger Eurasian counterpart to the Pacific Loon. Formerly, these two very similar species were lumped together as one. In North America, this species is only regularly seen in northwestern Alaska (where it breeds); there it is greatly outnumbered by the Pacific Loon. Summers on large tundra lakes or coastal lagoons; winters on nearshore oceanic waters. In summer, it forages for small fish, crustaceans, and mollusks. In winter, takes mainly fish. Nest is a mound of vegetation floating in shallows or right on the shore. Lays one to three olive eggs with blackish spotting.

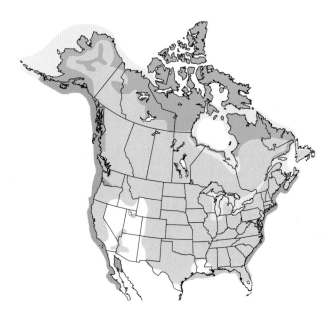

Pacific Loon *Gavia pacifica*
L 25" WS 36" ♂ = ♀ PALO

A widespread breeder in the North American Arctic and sub-Arctic, wintering primarily along the waters of the West Coast. Smaller and vastly more common than the Arctic Loon in Alaska. Breeds on tundra lakes and winters on the ocean along the coast, often farther from shore than the other loons. Gives loud, mournful yodeling calls on the breeding grounds. Dives for fish, crustaceans, and aquatic invertebrates. Nest is a mound of decaying vegetation placed by the edge of a lake or on an island. Lays one to three olive eggs marked with brownish-black spots. In winter often found in flocks of varying size. Some of these birds oversummer along the Pacific coast. The species population is apparently in good shape.

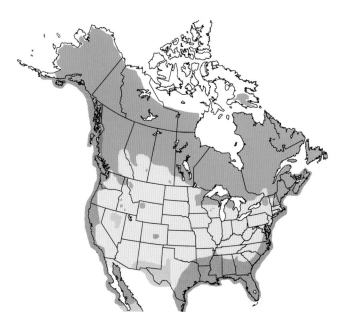

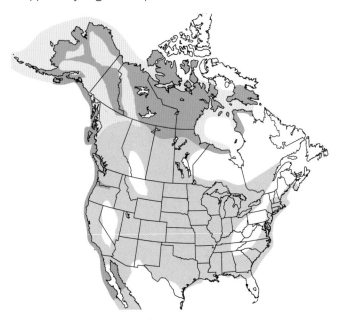

Common Loon *Gavia immer*
L 32" WS 46" ♂ = ♀ COLO

This most common of the loons rides low in the water. Very distinctive in flight, with narrow wings and long legs trailing the slim body. Summers on wilderness lakes in the northern half of North America. Winters mainly in the Atlantic, Pacific, and Gulf, but also can be found on larger clear-water lakes that remain ice-free. Summering birds give demonic yodeling vocalizations at dawn and after dark. Adults carry their small young on their backs. A powerful diver that consumes various fish as well as crustaceans, mollusks, and larger invertebrates. Nest is a low mound of marsh vegetation placed at the edge of a lakeshore. Lays one or two olive eggs spotted with darker colors. This is the most widespread of our loons. Recovering in the Northeast.

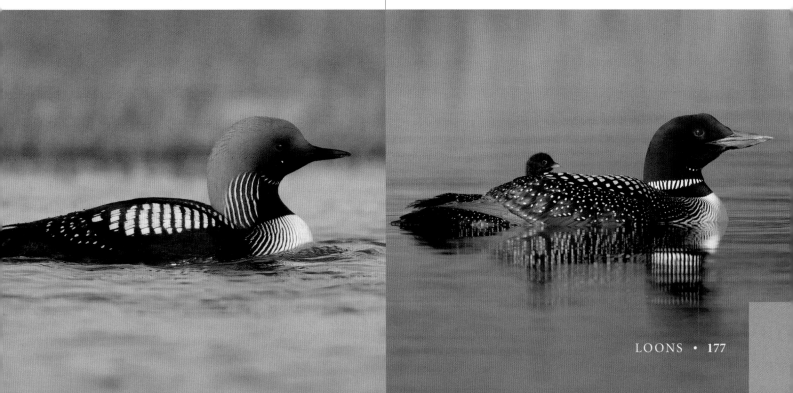

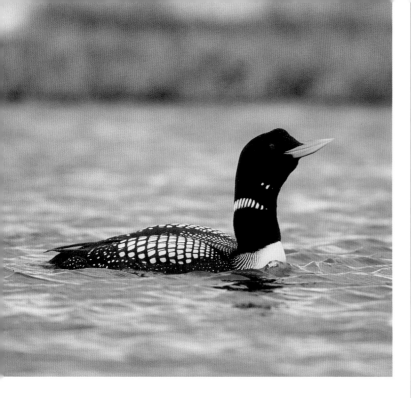

Yellow-billed Loon *Gavia adamsii*

L 35" WS 49" ♂ = ♀ YBLO *NT *WL

The largest of the loons. A little-known and rarely seen Arctic breeder that summers on tundra lakes of the Far North, from Nunavut to Alaska. Winters on the open North Pacific of Canada and Alaska, less commonly in estuaries and large reservoirs. Dives for small fish, crustaceans, and mollusks. Ground nest is a mounded heap of tundra vegetation placed at a lake edge, hidden by surrounding vegetation. Lays two beige or olive eggs spotted with dark brown. This is a species in substantial decline. It is a close relative of the more familiar Common Loon.

Laysan Albatross *Phoebastria immutabilis*

L 30" WS 79" ♂ = ♀ LAAL *NT *WL

This medium-sized albatross forages across the Pacific, especially in cold Alaskan waters. Nests in Hawaii in numbers. Has recently started nesting on islands off western Mexico. Spends most of the year on the open ocean. Uncommon off the West Coast. Forages across open ocean far from land. Diet is mainly squid. The elaborate courtship display between Laysan pairs in their first season together takes place near the nest site. Nest is a minimalist depression set in grass or bare sand in a colony with many others of the species. Lays one whitish egg spotted with brown. Species faces threats on the nesting ground and at sea from commerical fishing operations.

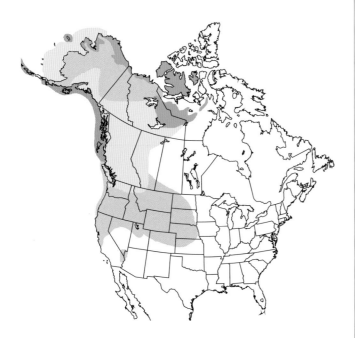

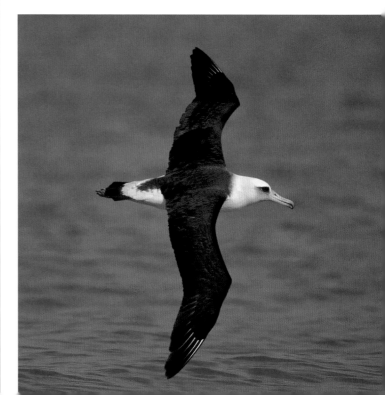

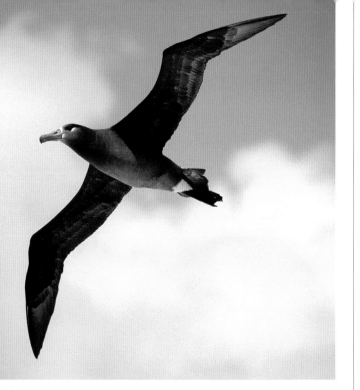

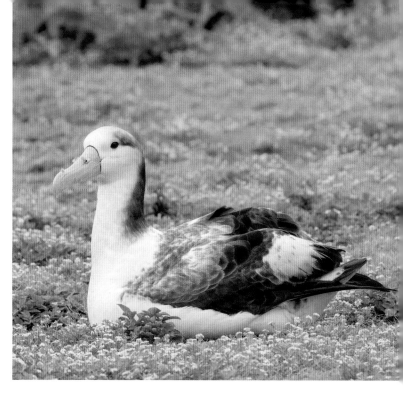

Black-footed Albatross *Phoebastria nigripes*
L 31" WS 83" ♂ = ♀ BFAL *NT *WL

A dark albatross of the North Pacific. The size of a Brown Pelican. Spends most of the year on the open ocean. Common off the West Coast from June to August, though it can be found in offshore waters year round. Takes mainly squid picked from the surface of the sea at night, but also follows fishing boats to feed on scraps and bait. Breeds in the Hawaiian Islands and on islands off southern Japan. Courtship display between pairs takes place near the nest site. The terrestrial nest is a shallow depression in the grass. Lays one cream-white egg spotted brown. Breeding population in the Hawaiian Islands is in serious decline.

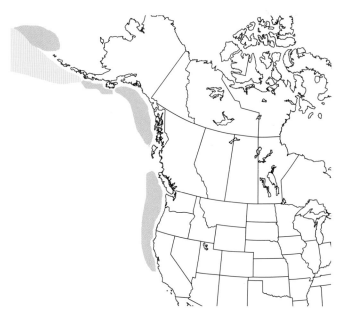

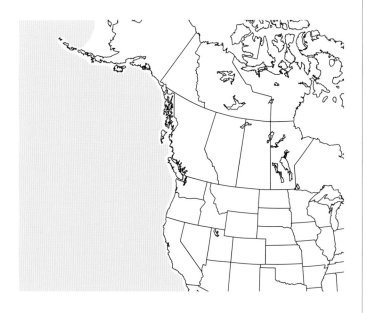

Short-tailed Albatross *Phoebastria albatrus*
L 34" WS 89" ♂ = ♀ STAL *VU *WL

This large pied albatross mainly breeds on a few islands off Japan and wanders the colder waters of the Pacific. Nearly hunted to extinction on its breeding grounds in the twentieth century. A few have recently bred in the Northwestern Hawaiian Islands. Spends most of the year in the open Pacific, especially in more northerly cold waters off Alaska. Has increased dramatically in recent decades. The terrestrial nest is fashioned of bare earth. Lays one white egg. The species exhibits considerable age-related variation in plumage pattern. In the mid-20th century it was thought to be extinct.

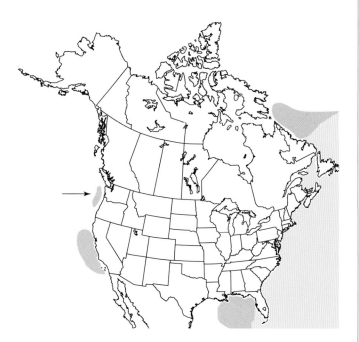

Wilson's Storm-Petrel *Oceanites oceanicus*
L 7" WS 16" ♂ = ♀ WISP

The most common storm-petrel of the nearshore western North Atlantic, where it is a nonbreeding visitor seen in the warmer months. A rare visitor to the West Coast. Summers on islands in the Antarctic and sub-Antarctic seas. Mainly inhabits pelagic-zone open ocean. Occasionally found within sight of shore. Forages solitarily or in groups. Patters across the sea surface in search of invertebrate prey. Along the Atlantic Coast, this is the species of storm-petrel pelagic birders first encounter.

White-faced Storm-Petrel *Pelagodroma marina*
L 8" WS 17" ♂ = ♀ WFSP

Breeds on islands off northwestern Africa and ranges westward through the Atlantic. Also found in the Indian Ocean and tropical Pacific. Spends most of the year on the open ocean. This distinctive species glides over water with stiff wings, propelled by powerful kangaroo-like hops delivered by its long legs. Typically solitary or in small groups and can be attracted to boat with chum. A rare late-summer visitor off our Atlantic Coast.

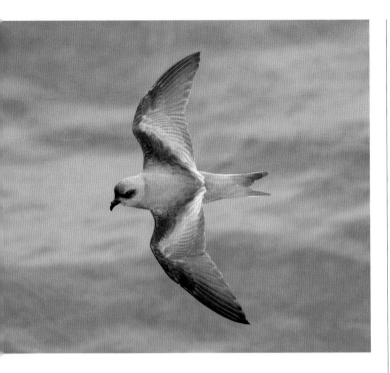

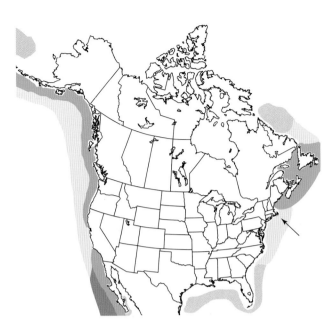

Fork-tailed Storm-Petrel *Hydrobates furcatus*
L 9" WS 18" ♂ = ♀ FTSP

The largely gray plumage is distinctive. Note heavily forked tail and dark underwing coverts. Inhabits cold waters of the Pacific. Breeds from the Kuril Islands north and west to Alaska, the Pacific Northwest, and islands off Northern California. Flies with shallow and rapid wingbeats. Takes marine invertebrates, small fish, and detritus from sea surface. Nests on islands in colonies. Nest is a subterranean burrow. Lays one off-white egg spotted with black.

Leach's Storm-Petrel *Hydrobates leucorhous*
L 8" WS 18" ♂ = ♀ LESP

A long-winged and fork-tailed dark storm-petrel that summers on islands of northern seas. Forages over open ocean in both the Atlantic and the Pacific. Note bounding and erratic flight as well as deep wing strokes, distinct from those of Wilson's Storm-Petrel. Takes mainly marine invertebrates harvested from the sea surface. Nests in burrows dug on coastal islands. Lays one whitish egg, some with purplish dots. Vocal birds come to their nests after dark.

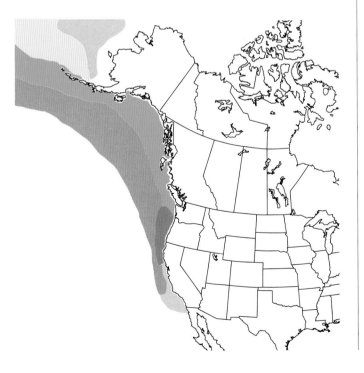

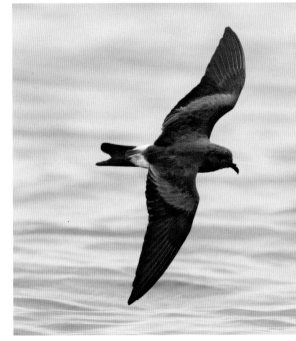

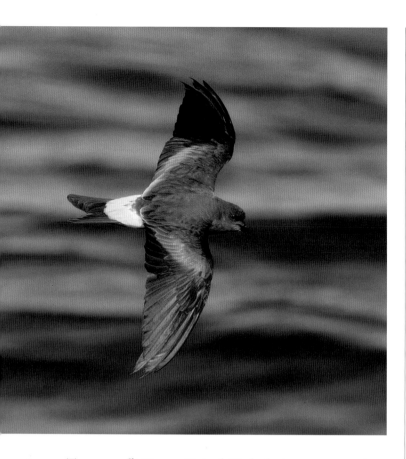

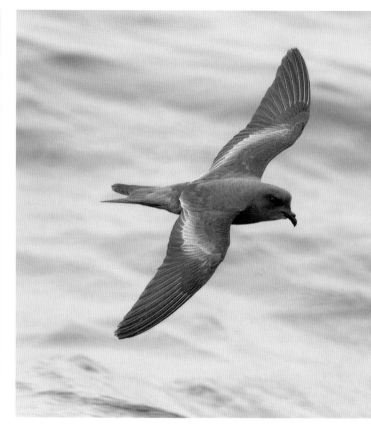

Townsend's Storm-Petrel *Hydrobates socorroensis*
L 7" WS 17" ♂ = ♀ TOSP *EN

Formerly thought to be a subspecies of Leach's Storm-Petrel. A small, dark storm-petrel that breeds off Baja. Wings shorter and tail less forked than those of Leach's. Forages over open ocean far from the Pacific Coast. Visits southern California waters in summer and autumn, being found mainly at or beyond the continental shelf edge. Flight steady and less erratic than that of Leach's Storm-Petrel, with clipped and deep wingbeats. Breeding confined to islets fringing Guadalupe Island, off western Baja. Global population is tiny. Probably under threat from nest predators. Red-Listed as Endangered. Distinguishing Townsend's from Leach's Storm-Petrel in the field can be difficult or impossible, depending on conditions (some individuals of both species exhibit a dark rump).

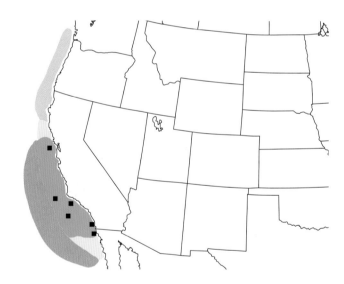

Ashy Storm-Petrel *Hydrobates homochroa*
L 8" WS 17" ♂ = ♀ ASSP *EN *WL

This endangered all-dark storm-petrel breeds on islands off California and northernmost Baja. Winters far offshore but does not depart the region. The range of this species is nearly entirely confined to the waters off California and northern Baja. Note fluttering wingbeats with a direct flight. Takes invertebrate prey from sea surface. Nests in a rock cavity or burrow. Lays one white egg, in some instances marked with buffy dots.

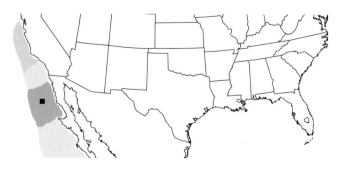

Band-rumped Storm-Petrel *Hydrobates castro*

L 9" WS 17" ♂ = ♀ BSTP *WL

This storm-petrel breeds on Atlantic islands off Africa as well as in the tropical and subtropical Pacific (including Hawaii), though several cryptic species are likely involved. Regularly seen in deep oceanic waters off the East Coast and in the Gulf of Mexico in the warmer months. Feeds by picking food from the ocean surface, though less adept at pattering than Wilson's Storm-Petrel. Forages solitarily or in small groups.

Black Storm-Petrel *Hydrobates melania*

L 9" WS 19" ♂ = ♀ BLSP *WL

Largest of the all-dark storm-petrels in North America. Not uncommon off the coast of Southern California, and sometimes can be seen from shore. Breeds on islands off Southern California and Baja. A graceful forager with deep and languid wing strokes. Hovers and flutters to take marine invertebrates from the surface. Nests in a crevice or burrow on an offshore island. Lays one white egg, in some cases with red-brown spotting. Distinguishing this species from other Pacific dark-rumped storm-petrels can be difficult. After nesting, individuals wander up the California coast to the Bay Area and beyond. World population exceeds half a million, but invasive predators threaten island breeding populations.

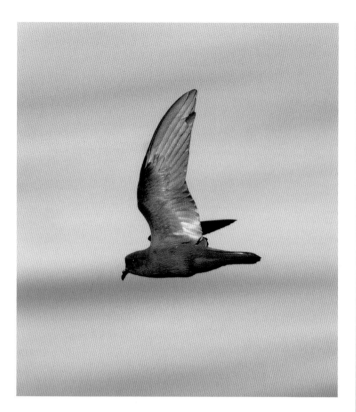

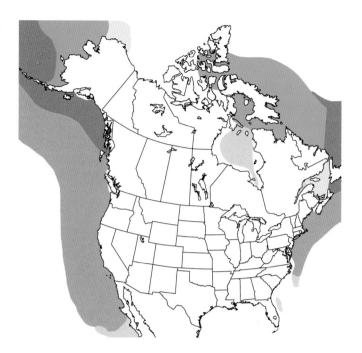

Northern Fulmar *Fulmarus glacialis*
L 18" WS 42" ♂ = ♀ NOFU

Individuals of this bulky seabird can be found in pale, intermediate, and dark color morphs. It summers in breeding colonies in the Far North. Winters on cold waters off the Atlantic and Pacific Coasts. Looks like a gull but flies rapidly like a shearwater on stiff wings. Forages over open ocean. At times, West Coast birds can be seen from shore. Follows fishing boats to feed on discarded offal. Diet is broad, including fish, squid, and crustaceans. Nest is a shallow scrape set on a narrow ledge of a cliff. Lays one white egg.

Least Storm-Petrel *Hydrobates microsoma*
L 6" WS 15" ♂ = ♀ LSTP *WL

A tiny all-dark storm-petrel with a wedge-shaped tail. This, the smallest of the storm-petrels, has a bat-like look in flight. Breeds on islands off western Mexico and wanders north to Southern California in late summer and early autumn. Note swift indirect flight with deep wingbeats, low over sea surface. Favors warm water. Presumably subsists on marine invertebrates harvested from the sea surface. The species is threatened by limited island breeding habitat as well as nest predation by invasive mammals such as rats and cats. This is a Watch List species. Sometimes carried into the interior of the Arid Southwest by strong Pacific storms. Varies in abundance in California waters from year to year.

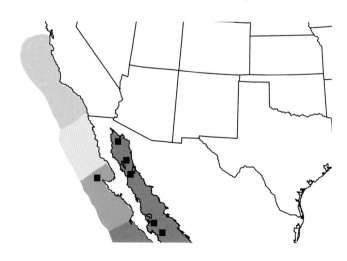

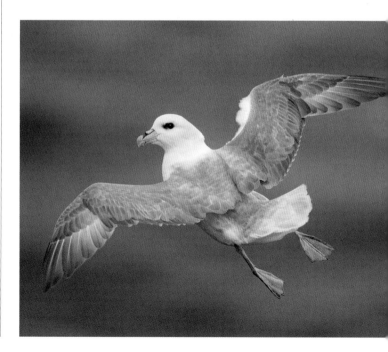

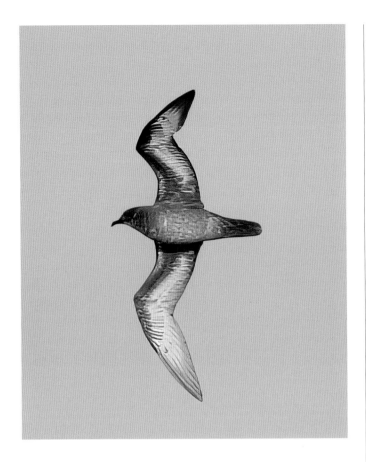

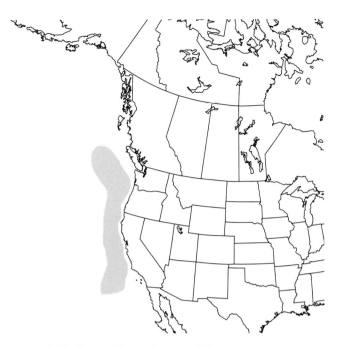

Trindade Petrel *Pterodroma arminjoniana*
L 16" WS 38" ♂ = ♀ TRPE *VU

A medium-large blackish or pied petrel that breeds on islands off Brazil and off Mauritius, with an inadequately known nonbreeding range. Of late, annually observed off the Mid-Atlantic sector of the East Coast in warm Gulf Stream waters. Frequents open pelagic-zone ocean. Flight is buoyant under calm winds, but in high winds, flies in steep and soaring arcs. Solitary. Seems curious about boats and is often attracted by chumming.

Murphy's Petrel *Pterodroma ultima*
L 15" WS 36" ♂ = ♀ MUPE *NT

Breeds on islands in the South Pacific and wanders northward to the seas off the West Coast in the nonbreeding season (mainly April–May). Found foraging on open ocean far offshore. Note the fast, buoyant flight. Solitary. Generally does not follow ships. This is the dark *Pterodroma* petrel most likely to be seen along the West Coast. The population of the species is large but is in decline. Mainly seen over deep water.

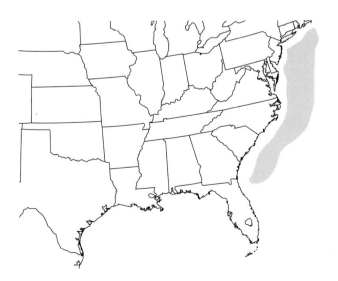

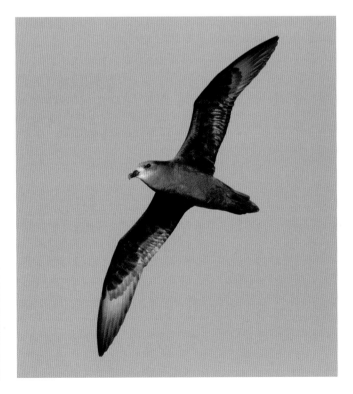

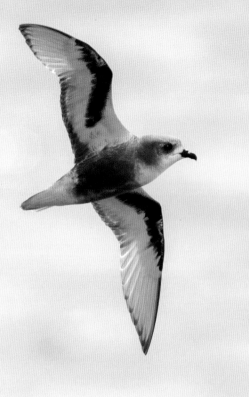

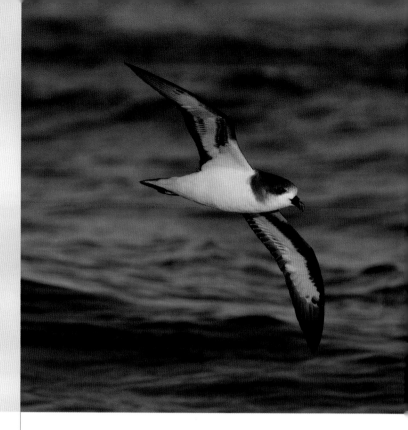

Mottled Petrel *Pterodroma inexpectata*
L 14" WS 34" ♂ = ♀ MOPE *NT

This strikingly patterned "gadfly" petrel breeds on islands off New Zealand and wanders north and east to the Aleutian Islands, southwestern Alaska, and the seas off the northern sector of the West Coast. Also seen in waters around Hawaii. Found in open ocean far from land. Note fast and direct flight. Occasionally follows boats. Diet is small fish and squid. The large New Zealand breeding population is apparently in decline, probably from changes in ocean temperature and the impact of El Niño events.

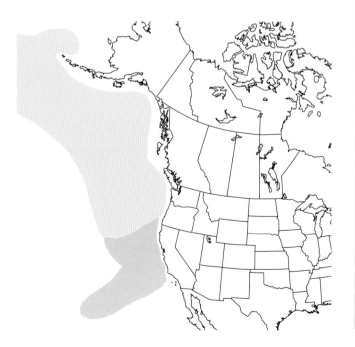

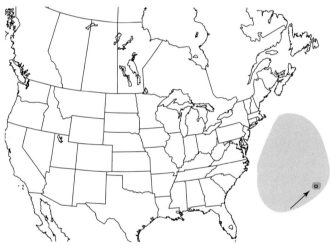

Bermuda Petrel *Pterodroma cahow*
L 14" WS 35" ♂ = ♀ BEPE *EN *WL

Today, just a few hundred individuals of this endangered species breed on islets off Bermuda. The species frequents open pelagic-zone ocean. Visits warm waters off the East Coast, but very rarely encountered at sea away from North Carolina offshore waters. Readily joins feeding flocks of shearwaters and petrels, and will investigate chum slicks. Dynamic flight typical of the genus. Known locally as "the Cahow." Once thought to be extinct, the breeding habitat of the species was rediscovered in 1951. The work of David Wingate and colleagues brought the critically endangered population back from the brink of extinction. This is one of the great seabird conservation stories of the 20th century.

Black-capped Petrel *Pterodroma hasitata*
L 16" WS 37" ♂ = ♀ BCPE *EN *WL

This Caribbean island breeder travels to loaf and forage in the waters off the southern sector of the East Coast, most commonly off the Carolinas but also north to Nova Scotia. Prefers warm Gulf Stream waters far off the Coast. Seen singly or in small parties. Will associate with other seabird species. Diet includes squid and fish. Serious decline of breeding populations probably a result of nest predation by mammalian predators. Main breeding populations are found on Hispaniola, with the majority in Haiti. Recent field research indicates the species may also breed in Cuba and other Caribbean islands. Various threats to breeding birds at the nest are causing ongoing population decline.

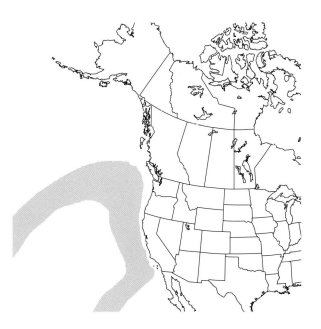

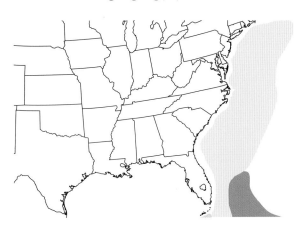

Hawaiian Petrel *Pterodroma sandwichensis*
L 16" W 39"♂ = ♀ HAPE *VU

A handsome and large pied petrel with very long and pointed wings. Breeds in the Hawaiian Islands and ranges out through the Pacific in the nonbreeding season. Regularly reported along the West Coast, from San Diego to southern British Columbia. Also seen in the waters off the main Hawaiian Islands. Tiny breeding population under threat.

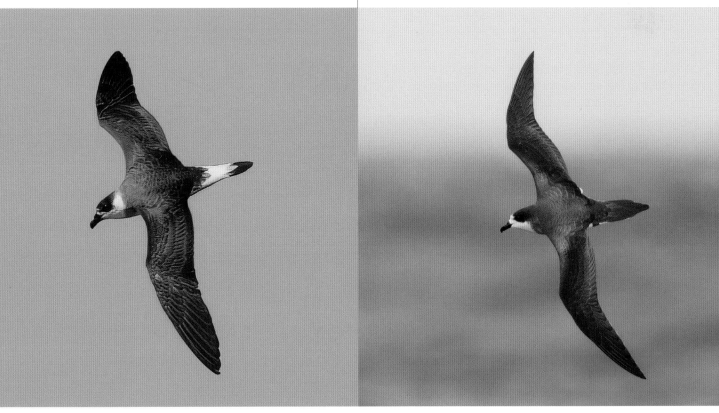

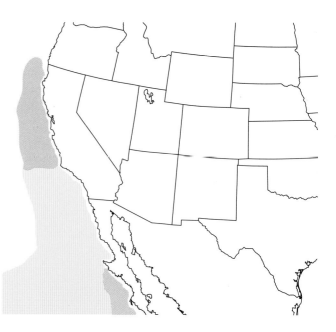

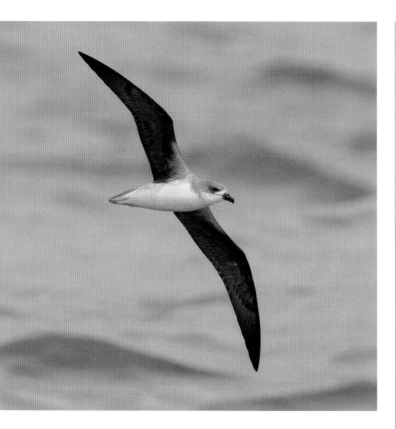

Fea's Petrel *Pterodroma feae*
L 15" WS 35" ♂ = ♀ FEPE *NT *WL

This small, heavy-bodied petrel with a wedge-shaped tail breeds on islands off the coast of West Africa. It ranges across the North Atlantic. Recorded annually from deep water off the East Coast. This is a small "gadfly" petrel that exhibits a distinctive dark "M" pattern atop the wings and back. Confusingly similar to Zino's Petrel. Estimates of the population of this species total fewer than 1,000 birds. Island nesting birds suffer various human and nonhuman threats. Typically, singletons are seen in warm Gulf Stream waters of North Carolina between May and September.

Cook's Petrel *Pterodroma cookii*
L 13" WS 31" ♂ = ♀ COPE *VU

Breeds off New Zealand and wanders widely across the Pacific, with records off the West Coast and around Hawaii. At times can be the most common petrel at sea. Inhabits open pelagic-zone ocean far from land. Feeds mainly on squid. Small and acrobatic. Flies in high arcs followed by bursts of rapid wingbeats. Generally solitary but can be found in large flocks. Distinctively plumaged.

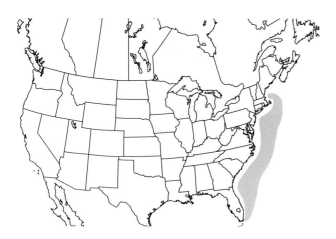

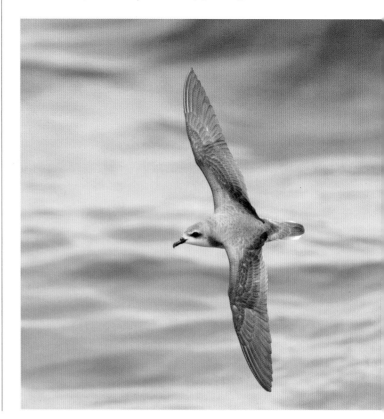

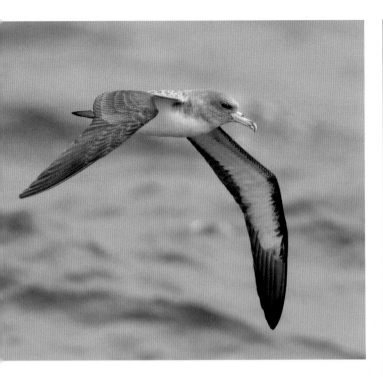

Cory's Shearwater *Calonectris diomedea*
L 19" WS 46" ♂ = ♀ COSH *WL

This, the largest of the world's shearwaters, is common-place in the Atlantic and Gulf of Mexico. Nests in the eastern Atlantic off Africa and in the western Mediterranean Sea. The Mediterranean population, known as Scopoli's Shearwater, is now treated by some authorities as a distinct species (and visits East Coast pelagic waters). Cory's Shearwater is regularly seen from land from the New England coast. Solitary or gregarious. Flight is slow and heavy with several wingbeats followed by a glide. Wings distinctively crooked at elbow. Feeds mainly on fish and squid. Along with the Great Shearwater, Cory's is the shearwater most commonly seen on pelagic trips off the US East Coast. Paler, larger, and slower flying than the Great.

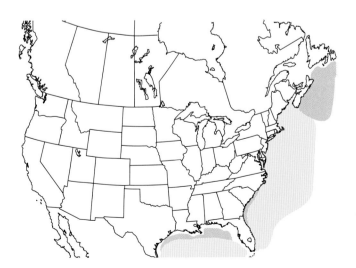

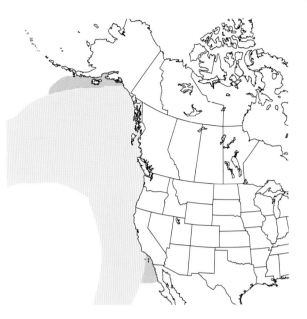

Buller's Shearwater *Ardenna bulleri*
L 16" WS 40" ♂ = ♀ BULS *VU *WL

Breeds off the North Island of New Zealand and wanders widely through the Pacific. Present in varying numbers along the West Coast in autumn. Prefers open ocean, especially near upwellings. Flight is buoyant and graceful, featuring periods of gliding; often flies together in tight, wheeling flocks. Takes crustaceans, squid, and fish.

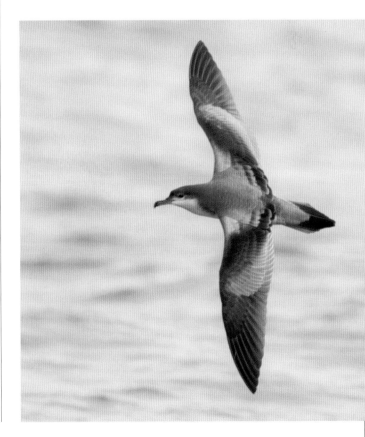

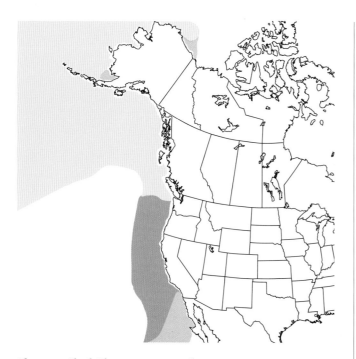

Short-tailed Shearwater *Ardenna tenuirostris*

L 17" WS 38" ♂ = ♀ SRTS

Breeds in the Australian region and wanders the Pacific and the far southern seas. Spends the northern summer in Alaskan waters. Found sparingly off the West Coast from October to March. Inhabits open ocean, especially near the continental shelf. Plunge dives for its prey. Flight is almost petrel-like, barely distinct from the Sooty Shearwater, which is seen more frequently and in larger numbers in US waters. Feeds on squid and fish.

Sooty Shearwater *Ardenna grisea*

L 18" WS 40" ♂ = ♀ SOSH *NT

Perhaps the most widespread of the shearwaters. A breeder on islands in the far southern seas, this species can be the most common seabird off the West Coast. Can be seen from the shore, migrating in large numbers where coastal waters are deep and cool. Also seen in the Atlantic in the summer months. Inhabits open ocean, especially around upwellings. Often mixes with other shearwaters. Has strong flexible wingbeats. Mainly feeds on fish and crustaceans, taken by diving below the surface. Has shown a substantial decline in recent years, leading to its Near-Threatened status.

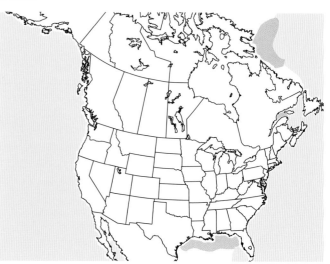

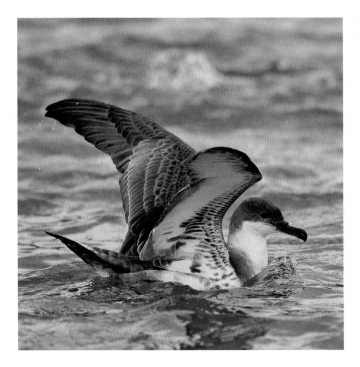

Great Shearwater *Ardenna gravis*
L 18" WS 44" ♂ = ♀ GRSH

The Great Shearwater is a large two-toned shearwater that is quite dark dorsally, found commonly in the North Atlantic during the warm-weather months. Breeds on Gough Island and islands in the Tristan da Cunha group in the South Atlantic. Inhabits open ocean and is occasionally seen from land in the Northeast. Found singly or in groups. At times flocks are seen resting on the sea surface. Feeds on squid and fish. Regularly approaches fishing boats for scraps. Plumage is much more distinctively patterned than the larger and slower-moving Cory's Shearwater. Superficially similar to the Black-capped Petrel, which is much rarer and distinct in its high-arcing flight. The Great Shearwater has a large population that appears stable.

Pink-footed Shearwater *Ardenna creatopus*
L 18" WS 44" ♂ = ♀ PFSH *VU *WL

A common warm-season visitor to the waters off the West Coast from its breeding islands off Chile. Inhabits open ocean with a preference for cold waters. This is a large shearwater with slow wingbeats. Forages for squid and fish caught mainly by diving from sea surface.

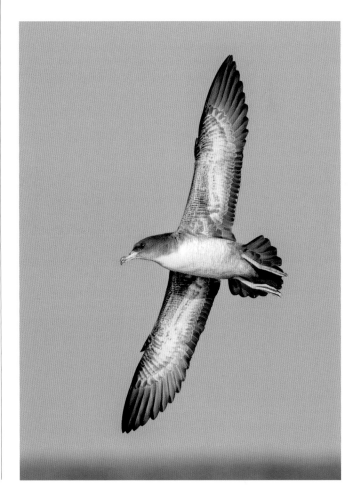

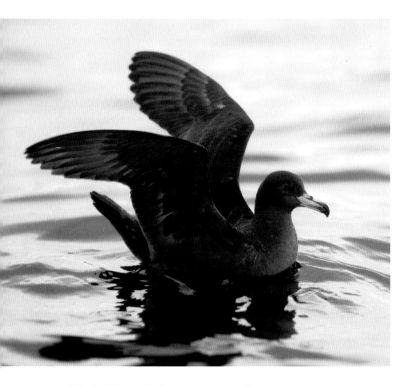

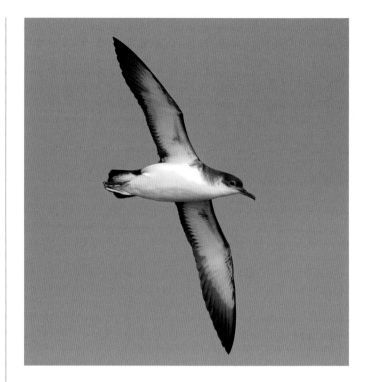

Flesh-footed Shearwater *Ardenna carneipes*
L 18" WS 44" ♂ = ♀ FFSH *WL

This Australasian breeder is a rare but regular autumn visitor to the West Coast. Prefers cold waters of the open ocean. Generally seen as singletons within groups of other shearwaters. Forages for squid and fish by diving, sometimes to depth. Breeds in the Southern Hemisphere on islands off New Zealand, Australia, and in the Indian Ocean. The species' population is threatened by loss of habitat as well as introduced mammalian predators to nesting islands. A species in decline.

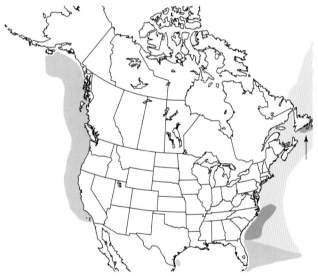

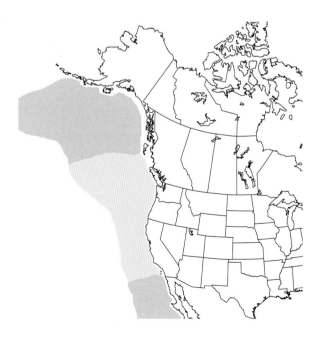

Manx Shearwater *Puffinus puffinus*
L 14" WS 32" ♂ = ♀ MASH

A small pied shearwater that is a regular visitor to the waters off the East Coast. Breeds on islands off Great Britain and Newfoundland. Prefers cold offshore waters of the Atlantic. Rare along the West Coast; may breed in Alaska. Note fast flight and stiff, rapid wingbeats low over sea. Forages mainly for fish. Nests in burrows on grassy slopes on offshore islands. There is a breeding record from Penikese Island, Massachusetts, from 1973. Breeding confirmed on islands off the coast of Maine in 2010. Breeding burrows should be looked for on islands of the Northeast and Atlantic Canada. May also breed in the Pacific Northwest.

Black-vented Shearwater *Puffinus opisthomelas*
L 15" WS 32" ♂ = ♀ BVSH *NT *WL

A common visitor to the waters off Southern California from its breeding islands off northwestern Mexico. Ranges from California to Costa Rica, through warm ocean waters often in sight of land. Note rapid wingbeats and low, direct flight. Diet is mainly squid and fish. A species in decline.

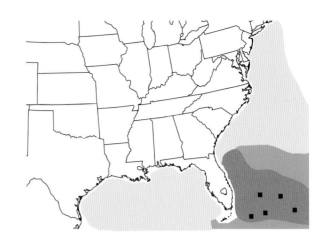

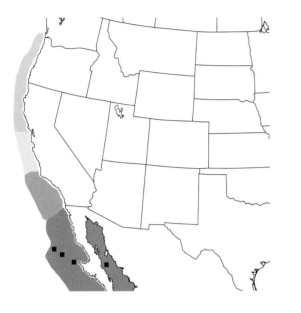

Audubon's Shearwater *Puffinus lherminieri*
L 13" WS 27" ♂ = ♀ AUSH *WL

One of our smallest shearwaters, which breeds in the Caribbean and visits the Gulf of Mexico and southern sector of the East Coast in the nonbreeding season. Prefers warm pelagic waters. Moves northward following Gulf Stream in late summer. Typically solitary with rapid, low flight but readily joins mixed-species feeding flocks. Feeds mainly on fish and squid. Most similar to the Manx Shearwater, which is distinct in its more northerly distribution, larger size, and dark undertail coverts.

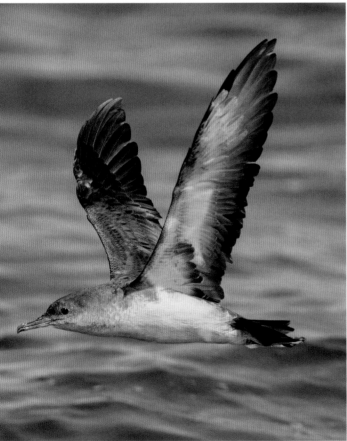

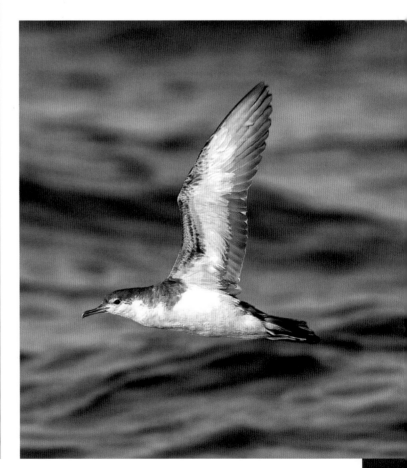

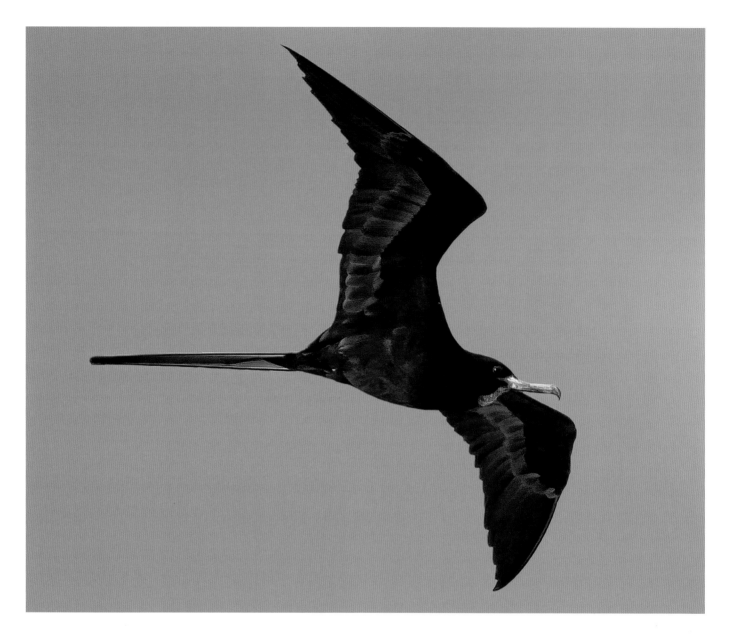

Magnificent Frigatebird *Fregata magnificens*
L 40" WS 90" ♂ ≠ ♀ MAFR *WL

This great black tropical soaring bird is all points—pointed beak, pointed wings, and twin-pointed forked tail. Breeds in colonies in the Caribbean and the American Tropics, also on islands off Africa. The Dry Tortugas of Florida hosts the only breeding colony in the Lower 48. Seen soaring lazily in circles in coastal settings in the Deep South—mainly Florida and South Texas. Diet includes small fish, crustaceans, and squid, either taken from the surface of the sea or forcibly taken from another bird in the air. Nest is a flimsy platform of sticks placed atop a mangrove or large bush. Lays one white egg. Individuals wander the Gulf of Mexico the year-round. This is a Watch List species. A few hundred nest on the Dry Tortugas; more nest in Mexico.

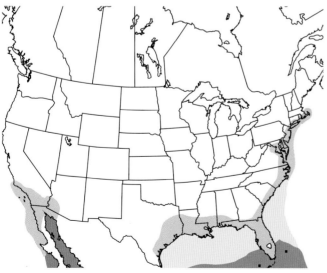

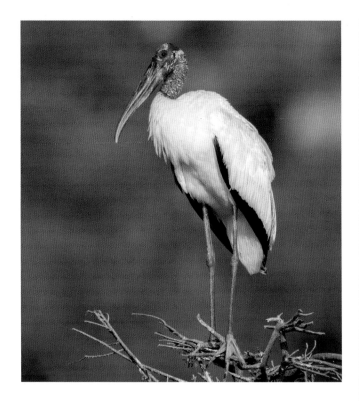

Wood Stork *Mycteria americana*
L 40" WS 61" ♂ = ♀ WOST

A very large, long-legged, heavy-billed, and pied waterbird of the Deep South. The species ranges southward to Argentina. Inhabits cypress swamps, marshlands, wet meadows, coastal waters, and ponds. Often seen soaring high overhead in small groups. Forages by wading with bill in water, taking fish, crustaceans, and small vertebrates. A colonial nester. Nest is a flimsy platform of sticks placed in a mangrove or cypress. Lays three or four whitish eggs. Birds tend to wander northward in late summer.

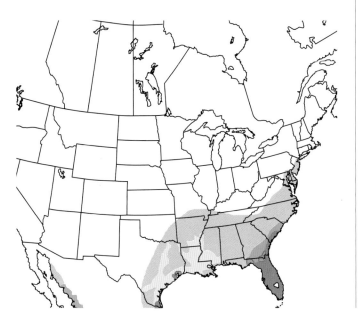

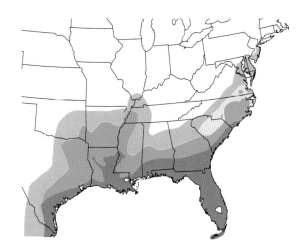

Anhinga *Anhinga anhinga*
L 35" WS 45" ♂ ≠ ♀ ANHI

Sometimes called "Snakebird," this cormorant-like waterbird of the Deep South soars high overhead in circles, with its long neck and long broad tail prominent. The species ranges southward to the Caribbean and South America. Inhabits wooded swamps and other swampy wetlands. Roosts in trees over water, often with its wings held open to dry them. Floats on water surface and dives for prey—fish, crustaceans, and small aquatic vertebrates. Often found nesting in colonies of herons; nest is a platform of sticks lined with green leaves and placed atop a shrub or tree branch. Lays two to four whitish or pale blue eggs.

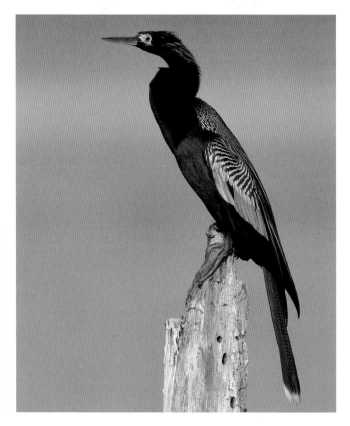

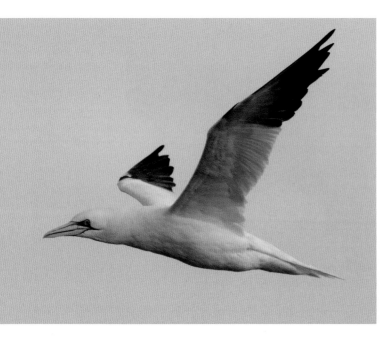

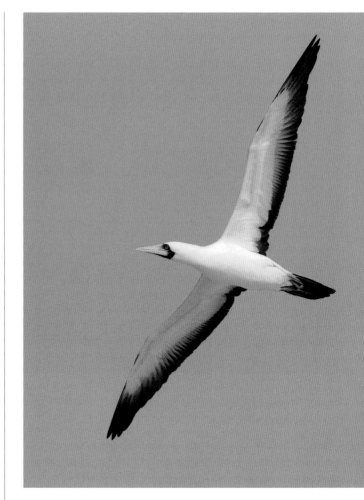

Northern Gannet *Morus bassanus*
L 37" WS 72" ♂ = ♀ NOGA

A large, pied seabird that breeds colonially in Atlantic Canada and wanders the rest of the year offshore of the East Coast and into the Gulf of Mexico. Other populations breed in northern Europe. Often seen from shore in winter and during seasonal migration. Forages over the open ocean, entering estuaries during inclement weather and strong easterly winds. Seen singly or in flocks over the sea. Like other sulids, it does rest on the water. Plunge dives for fish. Sometimes forms large foraging groups over fish schools. Nest is a low mound of vegetation and droppings that is used (and grows in size) year after year. Lays one pale blue or white egg.

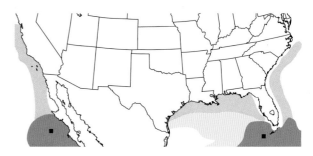

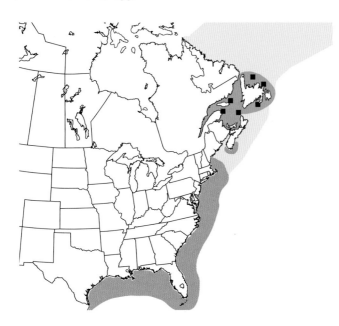

Masked Booby *Sula dactylatra*
L 32" WS 62" ♂ = ♀ MABO *WL

A large, pied, and long-winged seabird of warm tropical waters. It breeds on tropical islands and wanders to the Gulf Coast and southern sectors of our Atlantic and Pacific Coasts. Also common in Hawaii. Now nests in the Dry Tortugas, Florida. Seen foraging over open ocean or resting on the sea surface. Forages mainly for fish, which it captures by plunge-diving. The ground nest is a shallow depression surrounded by pebbles and rip-rap. Lays one or two pale blue or whitish eggs. The closely related Nazca Booby has recently begun to appear in small numbers off the Pacific Coast.

Blue-footed Booby *Sula nebouxii*

L 32" WS 62" ♂ = ♀ BFBO *WL

Nests in western Mexico and wanders northward to the Salton Sea as well as waters off Southern California in late summer and early autumn; has nested recently in California's Channel Islands. Inhabits warm tropical and subtropical waters of the eastern Pacific. Occurrence in our region varies from year to year. Roosts in groups on coastline rocks. Forages for fish by plunge-diving.

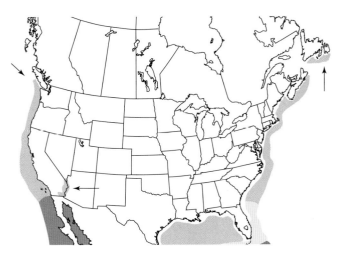

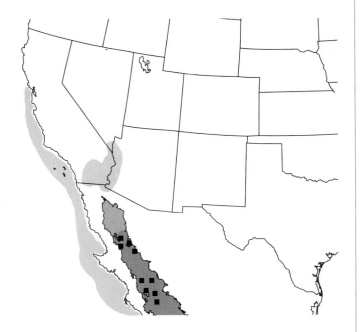

Brown Booby *Sula leucogaster*

L 30" WS 57" ♂ = ♀ BRBO

The most common booby to visit North American waters, found on the Atlantic and Pacific Coasts and in the Gulf of Mexico. Breeds throughout the Tropics. Nests in Hawaii and in California's Channel Islands. Loafs in warm subtropical waters. Solitary out in the pelagic zone. Inshore, this booby roosts on buoys or other similar structures. Forages for small fish by shallow plunge-diving. Ground nest is a shallow depression, often with sticks, grass, and other local items. Lays one to three whitish or pale blue-green eggs. The species has a large global population and its population appears stable. Records increasing up the East Coast.

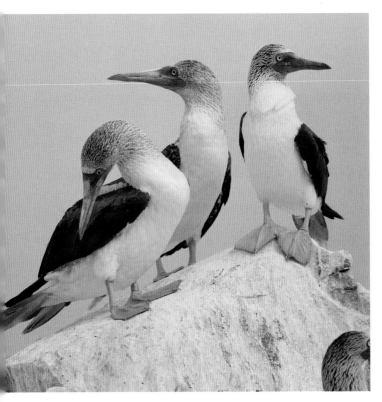

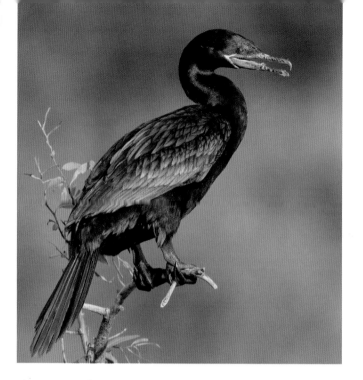

Double-crested Cormorant *Nannopterum auritum*
L 33" WS 52" ♂ = ♀ DCCO

This is the most widespread of our cormorants and the species most likely to be seen in most of the Interior. Inhabits coastal seas, estuaries, lakes, and open marsh waters. The species summers across the northern United States and Canada and winters in the lower Mississippi and Gulf Coast. Additional populations inhabit Mexico and the Caribbean. Rather loon-like on the water, but holds its head cocked slightly upward. Dives from the water surface for fish and other aquatic prey. Nests colonially, often with other wading birds. Nest is placed on a cliff, in a tree, or on the ground on an island. Nest is a platform of sticks lined with grass or leaves. Lays three or four bluish-white eggs. This species has seen substantial increases in population over the last several decades.

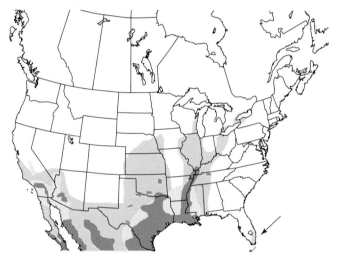

Neotropic Cormorant *Nannopterum brasilianum*
L 25" WS 40" ♂ = ♀ NECO

This widespread Neotropical species is common in southern and eastern Texas and has expanded northward into the interior of the southern United States. Most common on shallow freshwater bodies of the interior and some protected estuaries. Outnumbered by the larger Double-crested Cormorant in coastal locations and offshore. This species will mix in with Double-crested Cormorants. Smaller and lankier than that species. Dives from water surface for small fish and other aquatic prey. Colonial. Places nest in a bush or tree. Nest is a platform of sticks lined with twigs and grass. Lays three or four bluish-white eggs. Immatures of the Neotropic and Double-crested Cormorants are nearly identical in plumage. This species suffered serious declines in the 1960s but now has recovered. That said, the species exhibits considerable year-to-year ups and downs.

Brandt's Cormorant *Urile penicillatus*
L 34" WS 48" ♂ = ♀ BRAC *WL

A commonplace blackish waterbird resident on the rocky shores and offshore waters of the West Coast. Inhabits open ocean and coastal saltwater habitats, roosting on rocks. Not found in freshwater habitats. Sociable. Associates with other water birds. Forages by diving for fish and some crustaceans. May dive deep for prey. Nests colonially; nest is a mound of kelp and other vegetation cemented by droppings and placed on a flat site on a rock. Lays three to six whitish or pale blue eggs.

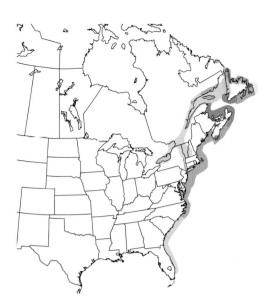

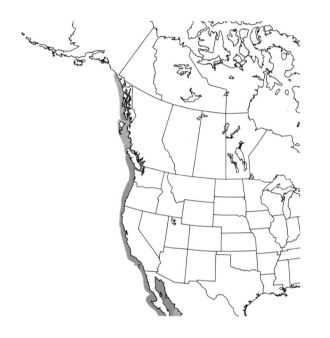

Great Cormorant *Phalacrocorax carbo*
L 36" WS 63" ♂ = ♀ GRCO

Our largest cormorant. Prefers rocky, cold-water coasts. In North America, it is confined to the Northeast, but widespread through the Old World and Australasia. Typically found roosting on a prominent high perch on a buoy or jetty light structure. Dives from the water surface to hunt fish. Stick nest is placed on a sheltered ledge on a cliff. Lays three to five pale blue-green eggs. Overall, the North American population continues to increase, its range expanding southward. Considerably larger and bulkier than the more familiar Double-crested Cormorant.

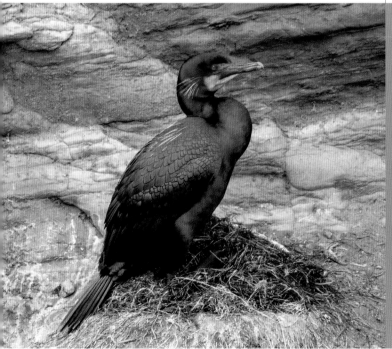

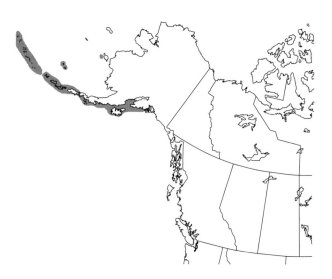

Pelagic Cormorant *Urile pelagicus*
L 28" WS 39" ♂ = ♀ PECO

This blackish, slim-necked, and small cormorant is wide-spread along the salt waters of the West Coast north to the Bering Sea, with some additional populations in Northeast Asia. Inhabits rocky coastlines, almost never offshore (the name "Pelagic" is a misnomer). Usually seen singly or in small groups. Dives from the surface for fish and crustaceans. A colonial nester. The nest, placed on a cliff ledge, is made of seaweed and other vegetation, and sometimes sticks. Lays three to five bluish-white eggs. Can dive to considerable depths in pursuit of prey.

Red-faced Cormorant *Urile urile*
L 29" WS 46" ♂ = ♀ RFCO *WL

An Alaskan specialty, inhabiting cold-water islands. Inhabits rocky bays and inlets near deep water. Does not migrate. Summer populations extend from southern Alaska to Kamchatka, Russia, and northern Japan. Remains near nesting sites through year. Diet is fish and crustaceans. Nests in mixed colonies on rocky sea cliffs; nest is a low mound of vegetation on a flat spot at the edge of a rocky ledge. Lays three or four bluish-white eggs.

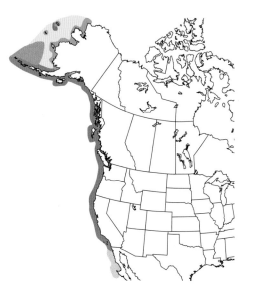

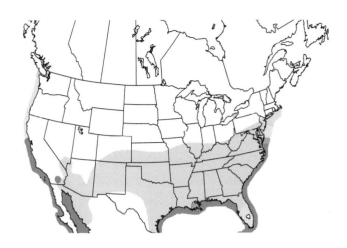

Brown Pelican *Pelecanus occidentalis*
L 51" WS 79" ♂ = ♀ BRPE

A very large and dark, long-winged waterbird often seen cruising in lines along the shore. Found along the Atlantic, Pacific, and Gulf Coasts. The species ranges to the Caribbean and northern South America. The species made a remarkable recovery from a decline in the 1960s brought on by pesticide poisoning. A coastal species, inhabiting seashore, bays, and estuaries. Loafs in water off beaches and sits on pilings at wharfs. Feeds by plunge-diving for fish. A colonial nester. Nest situated on ground, a cliff, or in a tree or bush; nest is a scrape on ground or heap of sticks up on a branch. Lays two to four white eggs.

American White Pelican *Pelecanus erythrorhynchos*
L 62" WS 108" ♂ = ♀ AWPE

Our largest waterbird; some males can weigh more than 16 pounds. A huge, white waterbird with distinctive black wing patches seen in flight. Mainly summers on large lakes of the Interior. Northern breeders winter to the Gulf Coast, Southwest Borderlands, and Mexico. Inhabits lakes, marshes, and saltwater estuaries. Mainly seen floating on the water in small flocks or soaring high in the sky in groups. Groups often fish cooperatively by floating side-by-side in a row and dipping bills in the water to harvest fish. Nest, placed on the bare ground, is a rough circle of plant matter, stones, and dirt. Breeds colonially. Lays two dull white eggs. In recent decades the species appears to be increasing and its range expanding.

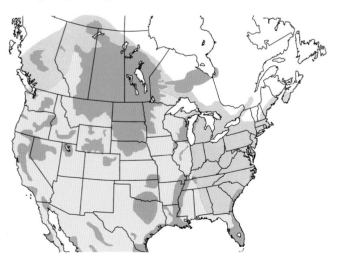

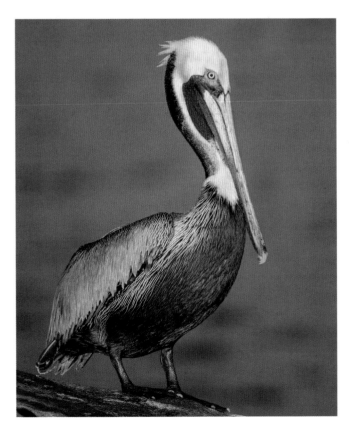

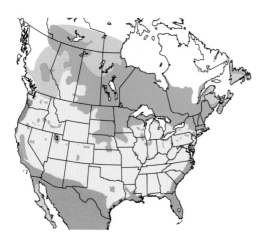

American Bittern *Botaurus lentiginosus*
L 28" WS 42" ♂ = ♀ AMBI

A widespread but uncommon and solitary heron of reeds and marshes. Breeds mainly in the Interior in freshwater marshes made up of sedges, cattails, and tall grasses. Winters mainly in coastal marshlands southward to the Yucatán. Very shy and rarely seen except in flight. Feeds by still-hunting—spearing fish, frogs, and other aquatic creatures that approach the motionless bittern. The nest, a well-hidden platform of reeds and grass, is set in marshland of tall vegetation, and sometimes above shallow water. Lays three to five buff or olive eggs. In the breeding season, this bird makes a distinctive, low three-note call (*oonk-a-lunk*) from the depths of a marsh, heard at dusk or dawn.

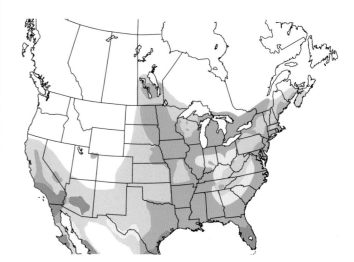

Least Bittern *Ixobrychus exilis*
L 13" WS 17" ♂ ≈ ♀ LEBI

Our tiniest heron, also the most reclusive. Summers patchily across the Lower 48 and southern Canada, most of these birds wintering south of the Border. Breeding most prevalent in the eastern and central United States. The species' range extends to southern Brazil. Seen mainly when in flight or heard calling at dawn or dusk (*coo-coo-coo*). Forages for fish and aquatic insects within dense reeds or cattails of freshwater or brackish marshes. Rarely seen wading in open water. Nest of reeds and other vegetation is well concealed within tall marsh vegetation. Lays four or five pale green or blue eggs.

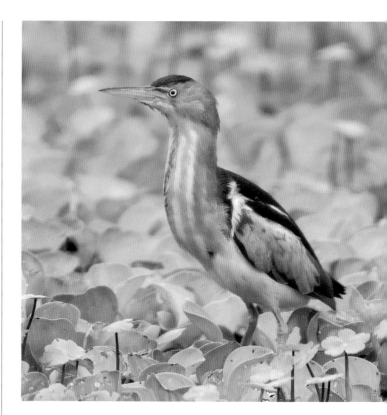

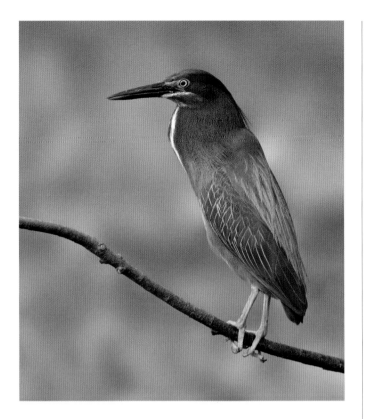

Green Heron *Butorides virescens*
L 18" WS 26" ♂ = ♀ GRHE

A small, dark, shy, and solitary heron of stream sides, wooded swamps, and thick marshes. Summers across the East, Midwest, and West Coast, wintering southward to the Gulf Coast and Borderlands. Perhaps most often seen in flight. Its wing stroke is deep and snappy. Not very active. Often stands or perches for long periods in the same spot by the water, waiting for an unwary prey item. Forages for small fish in shaded nooks and thus is easily overlooked. Nests solitarily in streamside woods. Nest is a platform of sticks placed in a shrub or tree (or rarely on the ground). Lays three to five pale green or blue-green eggs. The species ranges into the Caribbean and Central America. Species population appears stable.

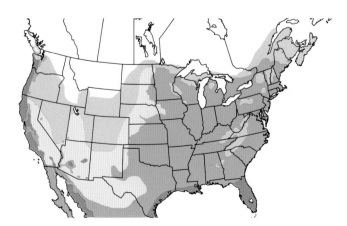

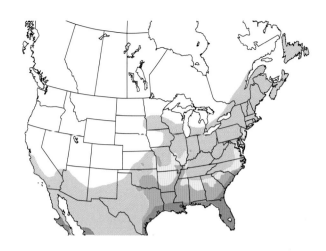

Little Blue Heron *Egretta caerulea*
L 24" WS 40" ♂ = ♀ LBHE *WL

This small heron summers along the East and Gulf Coasts and winters locally and southward into Mexico and Central America. Also shows up in Southern California. Other populations are found in South America and the Caribbean. Usually seen as a singleton, sometimes in association with white egrets. The juvenile plumage is all white and similar to that of a Snowy Egret, to which it is closely related. Frequents coastal flats, swamps, marshes, rice fields, and other habitats with shallow water. Mainly inhabits freshwater sites. Forages by standing or slowly pacing shallow water, flats, or grass. Diet includes fish, crustaceans, and various arthropods. Nests on the verges of heronries. Nest is a platform of sticks situated in a tree or shrub. Lays three to five pale blue-green eggs. This and other related species tend to disperse after nesting, sometimes moving northward in late summer.

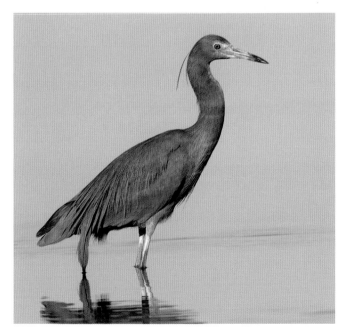

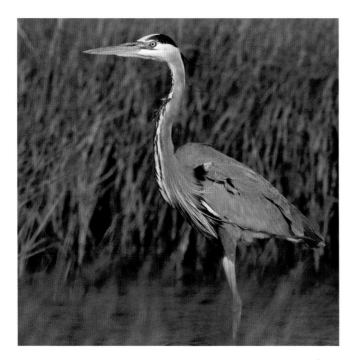

Great Blue Heron *Ardea herodias*
L 54" WS 72" ♂ = ♀ GBHE

This large waterbird is the most widespread and common-place large heron in North America. The northerly breeding populations winter southward as far as northern South America. Nests colonially in wooded swamps. Forages in all sorts of wetlands and water bodies—lakes, rivers, marshes, mudflats, and shallow coastal bays. Hunts by standing and watching or slowly wading in shallow water, spearing fish or other aquatic vertebrates of all sorts. Nest is a large plat-form of sticks situated in a tree close to the nests of others of this species. Lays three to five pale blue eggs. An all-white morph of this species is found in South Florida and the Keys (the "Great White Heron"), sometimes treated as distinct.

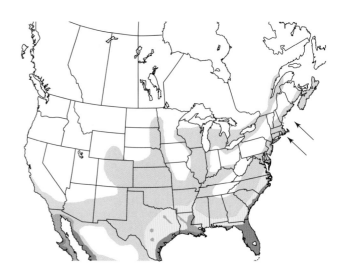

Tricolored Heron *Egretta tricolor*
L 26" WS 36" ♂ = ♀ TRHE

A very slim, long-necked, and long-billed heron of the Southeast. The species ranges southward to Peru and Brazil. North American breeders winter southward. Mainly inhabits coastal saltwater habitats—flats, estuaries, salt-marshes, and coastlines. Generally seen as a singleton. Prefers quiet and protected waters. Maintains an exclusive foraging zone when feeding. Forages for fish, crustaceans, and arthropods. Nest is a platform of sticks lined with grass and twigs situated atop woody vegetation in a heronry with a mix of species. Lays three or four pale blue-green eggs. The species appears to be in decline in the northeastern edge of its range as well as in Florida.

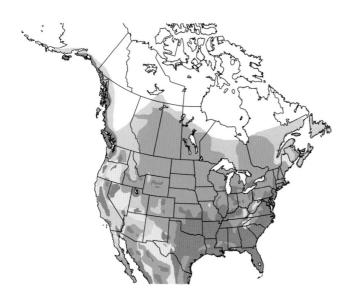

Black-crowned Night-Heron *Nycticorax nycticorax*
L 25" WS 44" ♂ = ♀ BCNH

A chunky, broad-winged heron, often seen flying at dusk or after dark. During the day it is often retiring, inactive, and easily overlooked. Summers across the Lower 48, wintering southward to the Atlantic, Pacific, and Gulf Coasts and south of the Border. Also found in South America, Africa, and Eurasia. Immature plumage is very distinctive—cryptically streaked and spotted. More common in urban waters than most herons; found in just about any aquatic setting where it can find fish or other aquatic prey. Lethargic and stolid. Feeds mainly at night. Often seen perched at the verge of a pond or slow-moving stream (a habit also shown by the Green Heron). Nests in colonies of its own kind or with other species. Nest, a platform of sticks, is situated low or high in a tree. Lays three or four pale green eggs.

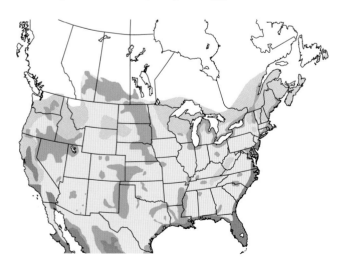

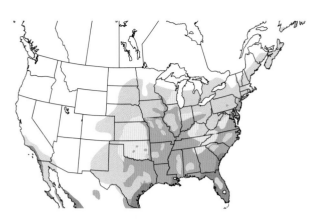

Yellow-crowned Night-Heron *Nyctanassa violacea*
L 24" WS 42" ♂ = ♀ YCNH

A species of the Deep South, Mississippi drainage, and the East Coast. Also now seen regularly in Southern California. Winters mainly south of the Border. Other populations are resident in coastal Mexico, Central America, and northern South America. Longer-necked and longer-legged than the Black-crowned Night-Heron; also more solitary and secretive. Seen foraging at stream sides, wooded swamps, mangroves, and other protected sites. Quiet and often overlooked, but a bit more diurnal than the Black-crowned Night-Heron. Uses its heavy bill to take crustaceans of various kinds, as well as other aquatic life. Nests solitarily or with other herons; nest, a platform of sticks, is hidden in shrubbery. Lays four or five pale blue-green eggs. Population stable.

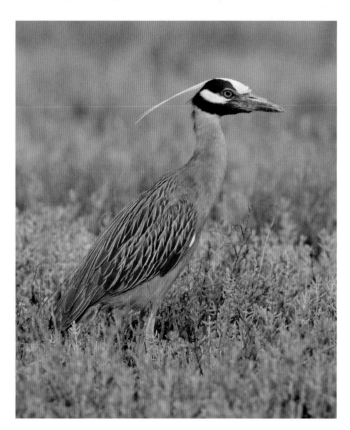

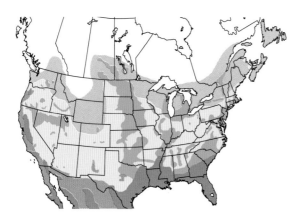

Great Egret *Ardea alba*
L 39" WS 51" ♂ = ♀ GREG

Our most common and widespread white egret. The species also breeds in South America, Africa, Eurasia, and Australasia. Inhabits open shallow waters of lakes, marshlands, or estuaries. Often seen as a solitary forager standing at the edge of a lake or marsh. A stately and slow-moving big waterbird. Forages by standing or slowly walking in water and spearing fish. Nest is a substantial platform of sticks placed atop a shrub or up on a tree branch, usually in association with others of the species as well as other herons and other waterbirds. Courtship display is a cascade of white plumes. Lays three or four pale blue-green eggs.

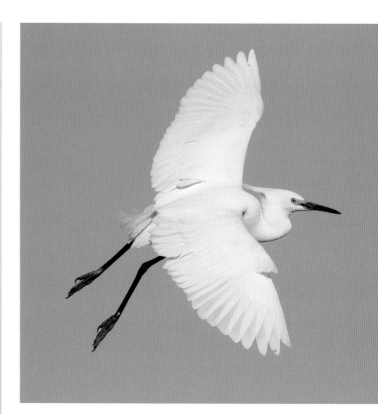

Snowy Egret *Egretta thula*
L 24" WS 41" ♂ = ♀ SNEG

A small, active, and beautiful egret with shaggy plumes, dark legs, and golden "slippers." Commonly found in fresh and saltwater habitats, including marshes, salt flats, mangroves, and shallow ponds. Breeding populations range from the northern United States to northern Argentina. North American birds winter southward. Often gregarious, in flocks of this species and with other herons. Feeds on fish, crustaceans, and aquatic arthropods. Nests in heronries in association with various other species. Nest is a platform of sticks placed in a tree or shrub. Lays three to five pale blue-green eggs.

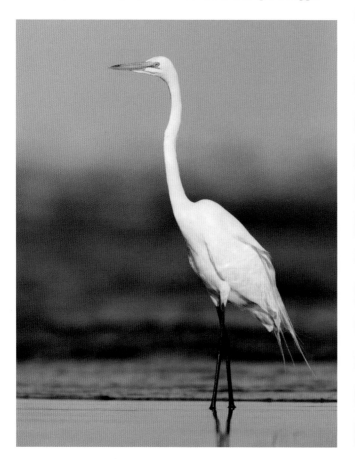

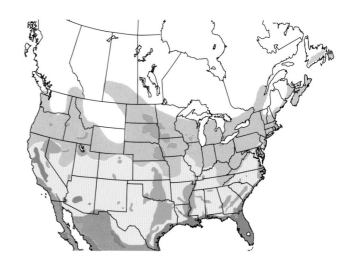

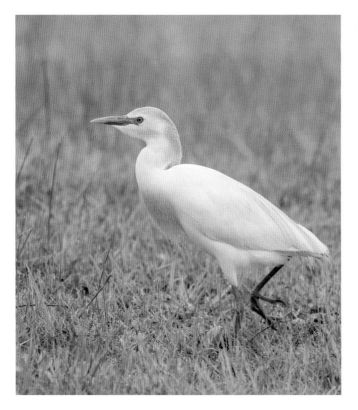

Cattle Egret *Bubulcus ibis*
L 20" WS 36" ♂ = ♀ CAEG

A small, compact, and flocking egret typically seen in pastures with cattle. Arrived in North America from South America in the 1950s as a natural colonization. South American birds apparently originated from Africa. Now widespread in North America. The species' range extends to Australia. Forages around ranches, farms, roadsides, and shortgrass fields. Groups of birds follow cattle or tractors in fields to capture insects that are flushed. Diet is mainly arthropods as well as some crustaceans and aquatic invertebrates. Nest is a platform of sticks placed atop woody vegetation in association with other herons. Lays three or four pale blue eggs.

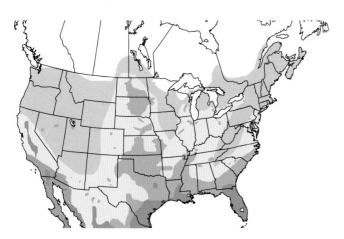

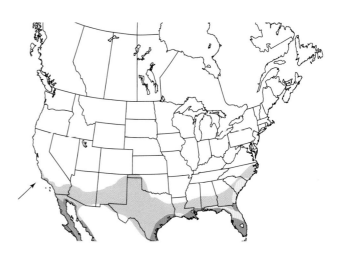

Reddish Egret *Egretta rufescens*
L 30" WS 46" ♂ = ♀ REEG *NT *WL

A handsome and very active forager, using all sorts of antics to capture its prey. Found in two morphs—rufescent and white. The North American range of this uncommon species is restricted mainly to the Deep South. It also inhabits the Caribbean, and the species ranges from Mexico to northern South America. Individuals also show up in Southern California. Mainly seen in open tidal flats along the coast. The most active of the herons. Prances about and flashes wings to corral fish in shallow water. Nests in mixed colonies on islands; nest, a platform of sticks or grass, is placed on the ground (Texas) or atop a mangrove (Florida). Lays three or four pale blue-green eggs.

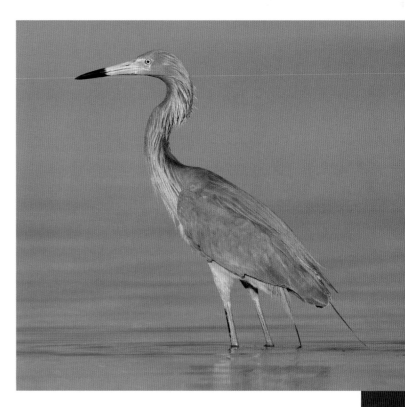

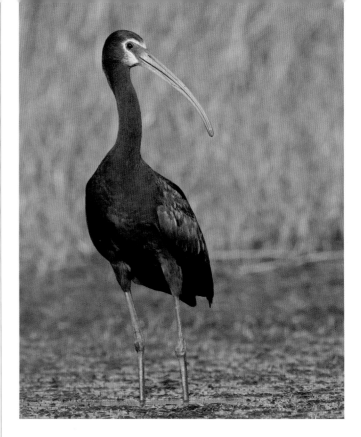

Glossy Ibis *Plegadis falcinellus*
L 23" WS 36" ♂ = ♀ GLIB

A dark, long-necked wading bird of the Southeast, usually seen in flocks. Inhabits marshes, swamps, and rice fields, usually near the coast. It winters southward. Its range has expanded since the 1940s. Probably a recent invader from Africa, in the manner of the Cattle Egret (additional populations nest in the Caribbean, Eurasia, Africa, and Australia). Picks up prey while walking about, taking arthropods and crustaceans, as well as some small vertebrates such as frogs and small fish. Colonial. Nest, a bulky stick platform lined with vegetation, is placed atop a shrub or low tree over water or land. When nesting on a protected island, may place the nest on the ground. Lays three or four pale blue-green eggs. Populations are stable or increasing.

White-faced Ibis *Plegadis chihi*
L 23" WS 36" ♂ = ♀ WFIB

The western counterpart to the Glossy Ibis. Found largely west of the Mississippi. Also inhabits South America. In North America, northern breeders winter south of the Border. Forages mainly in freshwater wetlands—marshes, flooded fields, and irrigated lands. Behaves much like the Glossy Ibis and the two will hybridize where ranges meet. Diet is mainly arthropods, earthworms, and crustaceans picked from the mud or water. Also takes frogs and small fish. Bulky nest of rushes is placed atop thick marsh growth or shrubbery. Lays three or four pale blue-green eggs.

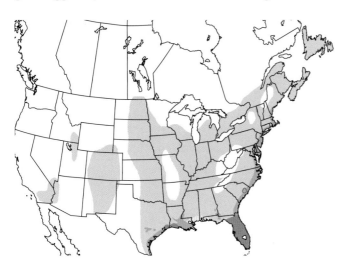

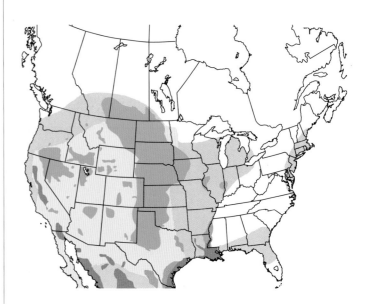

White Ibis *Eudocimus albus*
L 24" WS 42" ♂ = ♀ WHIB

A distinctive white wading bird with a long and decurved reddish bill and red legs. Summers mainly in the Deep South, but has expanded its breeding range north to New Jersey. Some birds wander northward in late summer. The range of the species extends to Ecuador. Some North American birds winter south of the Border. Found foraging in virtually any shallow water environment in the Deep South—marshes, rice fields, flooded pastures, mangroves, lake edges, wooded swamps, and mudflats. Roosts and feeds in flocks that sometimes number in the hundreds. In flight, note the distinctive trailing legs and black-tipped wings. Diet includes crustaceans, other aquatic invertebrates, and small vertebrates. Nests colonially, often in association with other wading birds. Nest is a platform of sticks or of reeds placed atop a mangrove, shrub, or tree near other nests. Lays two or three pale blue-green or white eggs. Species is prospering.

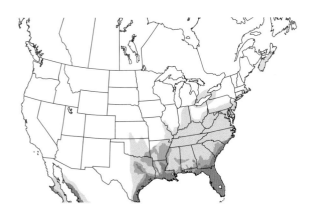

Roseate Spoonbill *Platalea ajaja*
L 32" WS 50" ♂ = ♀ ROSP

A weird, pink-washed wading bird of the Deep South with a strange-looking bill. The species' range extends southward to Argentina. Birds in northern part of the breeding range winter south into Mexico. Some individuals wander northward in the late summer. Prefers coastal waters—mangroves, mudflats, lagoons, and marshy shallows. Beautiful in flight. Rather comical at close range when perched. Uses its spoon-shaped bill to filter marine invertebrates, crustaceans, and tiny fish from murky waters. The bulky stick nest is placed in a mangrove, atop a shrub, or in a low tree in a mixed colony of wading birds. Lays two or three white eggs spotted with brown. Population is stable or increasing.

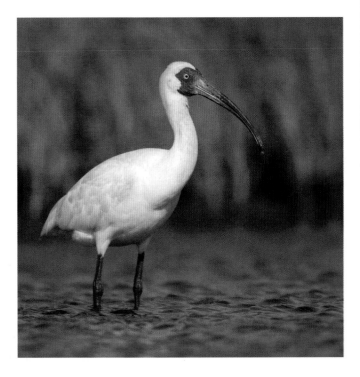

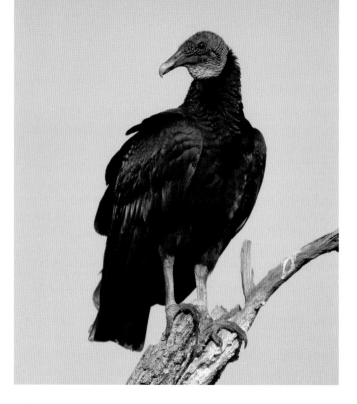

California Condor *Gymnogyps californianus*
L 46" WS 109" ♂ = ♀ CACO *CR *WL

Our largest flying bird. In 1987, it was perched at the precipice of extinction, and now, because of a courageous captive-breeding program, it is being introduced to open habitats in the Arid Southwest and Pacific Coast. Frequents coastal hills and dry interior valleys and mountains of the southern half of California as well as Utah and Arizona. Soars during the warm part of the day over arid hills in search of carrion. Apparently formerly a specialist on marine mammals found dead along the coast, but now feeds upon dead mammal carcasses found in the Interior—mainly cattle and deer. Lead bullet fragments in the condor's diet continues to cause a blood-toxicity problem for the species. The nest is placed on a cliff or in a cave high in the rocks or in the cavity of a burned-out Redwood. Nest is nothing more than a scrape with some assembled debris and gravel. Lays one whitish egg. In 1987, there were only 27 condors alive on Earth—all in captivity. In December 2022, there were more than 500 free-flying and captive condors.

Black Vulture *Coragyps atratus*
L 25" WS 67" ♂ = ♀ BLVU

This is a vulture of the South and the Mid-Atlantic that is on the move northward. Also ranges throughout the Neotropics and barely into the Arid Southwest. More aggressive than the longer-winged Turkey Vulture. Small groups soar high in search of carrion. Searches from high in the sky for activity of other vultures in order to track down available carrion on the ground. Consumes mainly roadkill; preys upon small vertebrates and will at times pick through garbage. Nests in an available hiding place—hollow log, barn, tree cavity, or cave. No nest constructed. Lays one to three pale gray-green eggs. The species is not a regular migrant.

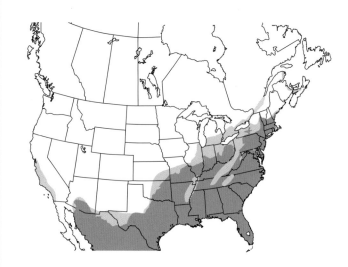

Turkey Vulture *Cathartes aura*
L 26" WS 67" ♂ = ♀ TUVU

The commonplace vulture of North America. Soars with wings slightly raised and tilted back and forth. Found virtually everywhere in the Lower 48 and southern Canada, especially where there is a mix of open and wooded country. Also ranges throughout the Neotropics. Northernmost breeders migrate south for the winter. Commonly seen soaring over suburbs and cities. Looks quite like a hawk or eagle. In general, vultures are more common than hawks and are more commonly seen in small soaring parties. This species is able to locate carrion by scent. It is one of the few birds with an excellent sense of smell. Takes mainly fresh roadkill. Nest is located in some hidden crevice—a cave, hollow tree, or under a jumble of large rocks. Eggs are laid on the ground with minimal nest material. Lays one to three whitish eggs blotched with brown and lavender.

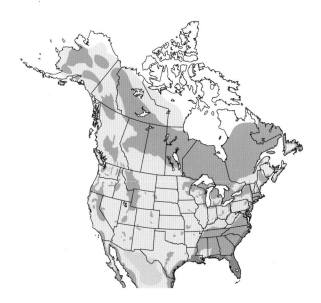

Osprey *Pandion haliaetus*
L 23" WS 63" ♂ = ♀ OSPR

This is our "fish hawk"—the long-winged raptor that frequents coastlines and other waters where prey fish are abundant. The species also exhibits a nearly worldwide distribution. Probably most common in coastal southern Florida and in eastern estuaries such as the Chesapeake Bay. During spring, members of this migratory raptor are seen following river valleys northward to their breeding destinations. Distinctive in flight with narrow, crooked wings and chocolate and white plumage. Cruises over water and drops feet first to capture prey fish, some quite large. The large stick nest, used year after year, is placed in a tall dead tree or atop a nesting platform. Lays two to four whitish eggs blotched with brown. The species has rebounded after having been decimated by pesticides in the 1960s.

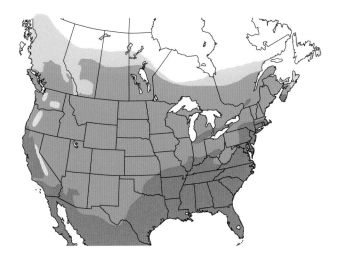

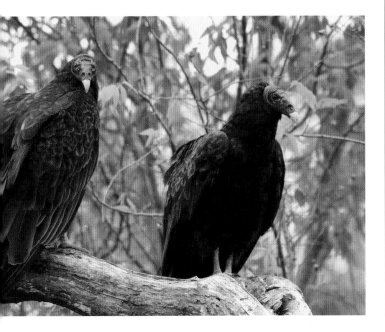

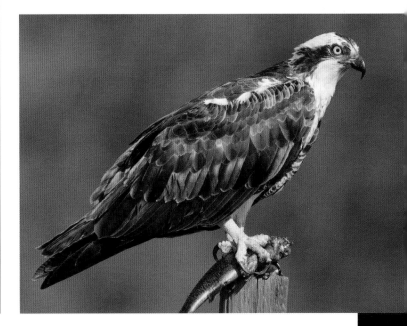

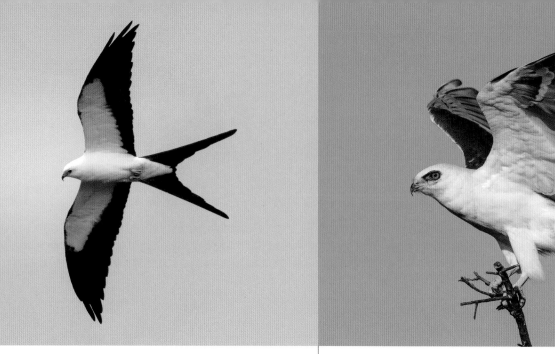

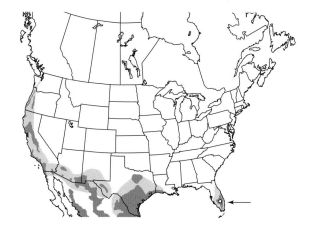

Swallow-tailed Kite *Elanoides forficatus*
L 27" WS 51" ♂ = ♀ STKI

Our most beautiful and graceful raptor is an uncommon denizen of the Deep South, typically seen soaring over a swampy stream course or an opening in the piney woods. The species ranges southward into South America. North American birds winter in the Tropics. Inhabits wooded bottomland swamps and other woodlands with access to marsh or prairie. Soars over forest canopy in search of flying insects and other small prey creatures, which it sometimes consumes on the wing. Diet includes arthropods, frogs, lizards, and birds. Nest is a platform of small sticks situated high in a tall pine or other canopy tree. Lays one to three whitish eggs marked with brown. Does not hover. Many birds pass through the Florida Keys in migration. The breeding population in the US is small but stable. The species is appearing north of its recent breeding range with increasing frequency, with records from Manitoba, Ontario, and Quebec. This migrant is not under threat.

White-tailed Kite *Elanus leucurus*
L 15" WS 39" ♂ = ♀ WTKI

A small and slim raptor with a prominent white tail and the habit of hovering over open ground in search of small rodents. The species has been on the increase in North America over the last 80 years, expanding its range into Northern California and southern Florida from its strongholds in Texas and Southern California. Also ranges through Mexico southward to Argentina and Chile. Found in open habitats with a scattering of shade trees—roadsides, farmlands, woodland clearings, prairies, and marshlands. Cruises over grassland, stopping to hover and locate a rodent, which it drops upon with its talons. The nest, sited atop a tree such as a live oak, is a substantial platform of sticks lined with vegetation, such as Spanish Moss. Lays four or five whitish eggs blotched with brown. Recently the Pacific Coast populations appear in decline, whereas those in Florida appear to be on the increase. Individuals have been recorded wandering north to British Columbia, Minnesota, and Wisconsin. US range may still be expanding.

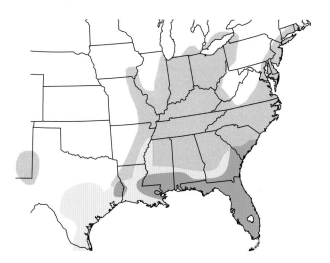

Hook-billed Kite *Chondrohierax uncinatus*
L 18" WS 36" ♂ ≠ ♀ HBKI

This Neotropical species, found in the United States only along the Lower Rio Grande Valley of South Texas, ranges from Mexico to South America. The species inhabits deciduous woodland along river courses. It moves through the canopy of woodland in search of tree snails. Sometimes seen soaring above the canopy but spends much of its time perched. Aside from tree snails, it will take small vertebrates and arthropods. Nest is a flimsy platform of sticks placed up in a woodland tree. Lays two to four white eggs marked with dark brown.

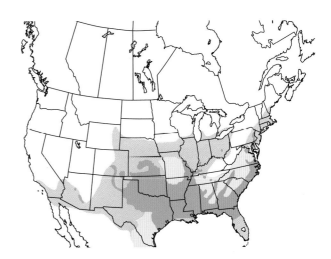

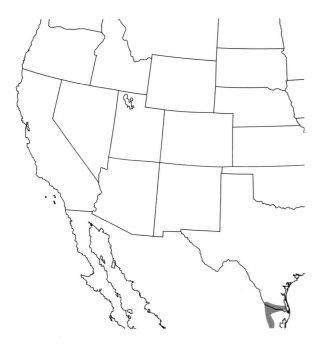

Mississippi Kite *Ictinia mississippiensis*
L 14" WS 31" ♂ = ♀ MIKI

This long-winged and graceful raptor, formerly confined to the Deep South and southern Great Plains, has been expanding its summer range northward and eastward over the last two decades. Winters in South America. Prefers woodlands near streams, wooded groves in open country, and other open habitats with trees to nest in. Fairly sociable. Migrates in loose flocks, sometimes large. Passing autumn flocks over the Texas coast can be huge in late September and early October. Hunts insects, often in the air; will also take small birds and other small vertebrates. Nests in loose colonies. The nest is a flimsy platform of stick lined with greenery situated in a tree. Lays one or two white eggs. Recently birds have been found wandering to the northern US states and into Manitoba, Ontario, and Quebec. Population appears to be on the increase.

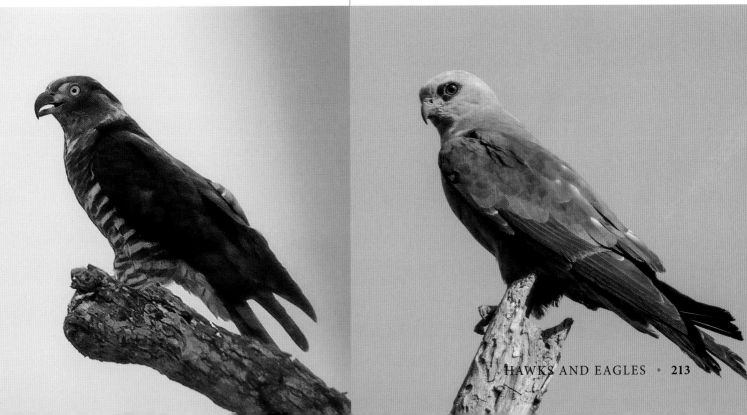

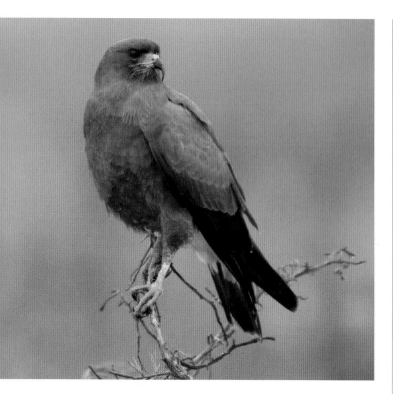

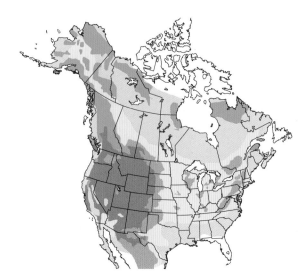

Golden Eagle *Aquila chrysaetos*
L 30" WS 79" ♂ = ♀ GOEA

A huge, dark raptor with long and broad wings, held out flat (or with a very slight uptilt) during its steady flight. Ranges across the Northern Hemisphere. Breeds in open country of the West and patchily across Canada into the Arctic. Winters widely in the interior West, in the Appalachians, and some East Coast marshes. A raptor of open country, where it hunts for small mammals. Most often seen soaring over open country or migrating in late autumn along the ridges of the Appalachians. Hunts for prey either high up or low to the ground. Favorite prey include rabbits, ground squirrels, prairie dogs, and marmots. The large stick nest, expanded year after year, is situated on a rocky cliff or in a tall tree. Lays one to three whitish eggs marked with brown. A juvenile bird, which exhibits the most striking plumage, is shown.

Snail Kite *Rostrhamus sociabilis*
L 17" WS 42" ♂ ≠ ♀ SNKI

In the United States, this snail specialist is confined to sawgrass marshes in southern and central Florida. Also inhabits the Caribbean and ranges southward into South America. Resident in interior marshlands of Florida, where it hunts for several species of apple snails. A gregarious species, associating in family groups. Cruises low over marshland searching for snails. Nest, placed in a shrub or low tree over water, is a bulky platform of sticks with a finer lining of vines and greenery. Lays two or three white eggs marked with brown.

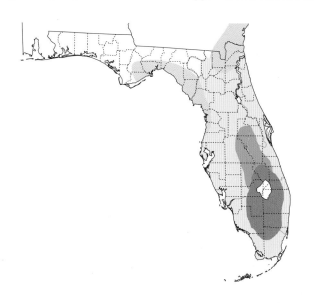

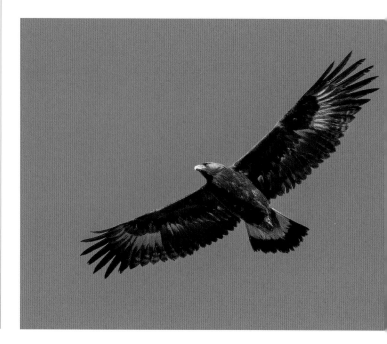

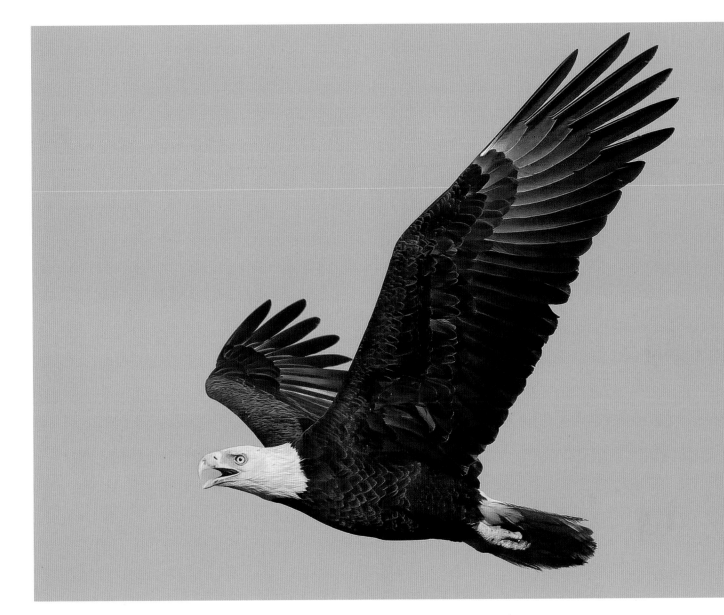

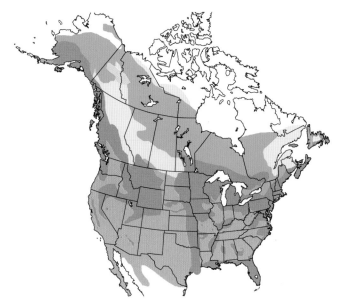

Bald Eagle *Haliaeetus leucocephalus*
L 31" WS 80" ♂ = ♀ BAEA

A giant raptor that frequents rivers, estuaries, and coastlines. America's national symbol is now fairly common across the Continent, having recovered from a major decline back in the 1960s. This is a fish eagle, found in many of the same places as our Osprey, and, in fact, the Bald Eagle not uncommonly steals fish from the Osprey. Inhabits coasts, rivers, and large lakes where fish are plentiful. In migration, might be seen anywhere. An opportunistic predator and scavenger. Attracted to rural dumps in winter. Hunts for fish but also takes a variety of small vertebrates. Winter concentrations of this species occur annually at favored points along major rivers across the Lower 48. The huge stick nest, used year after year, is typically situated high in a great waterside tree. Lays one to three white eggs.

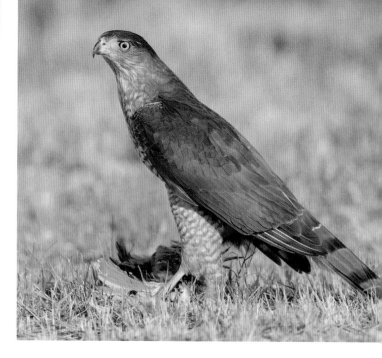

Northern Harrier *Circus hudsonius*

L 18" WS 43" ♂ ≠ ♀ NOHA

This slim and long-tailed raptor (the female brown, the male pale gray) is our "marsh hawk." It summers in marshes and grasslands across North America. It winters in similar habitats from the southern United States and Mexico south to Colombia. Typically seen cruising low over grasslands and marshes, its wings tilting back and forth. Flight distinctive. Main diet is voles and other small rodents; also takes arthropods, birds, and other small vertebrates. The nest, constructed of grass or rushes, is hidden on the ground among taller herbaceous vegetation. Lays four to six pale bluish-white eggs. Breeding populations of this species have declined in the southern portion of its range.

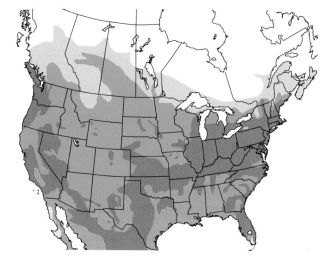

Cooper's Hawk *Accipiter cooperii*

L 17" WS 31" ♂ = ♀ COHA

A larger version of the Sharp-shinned Hawk, with a more southerly range, breeding into the Deep South. This is the raptor our grandparents knew as the "chicken hawk." It was formerly hunted relentlessly because of its tendency to prey on backyard poultry. Some birds winter south to Central America, but in much of the Lower 48, this species is seen year-round. Widespread in woodlands of all kinds, even in suburban and urban areas. In winter, it commonly haunts backyard bird feeders, hunting the birds and squirrels that visit. The bulky nest of sticks, lined with finer materials, is sited in a tall tree in a woodland. Lays three to five pale bluish-white eggs. As with other accipiters, in this species the female is larger and bulkier than the male. Today the Cooper's Hawk is our most abundant accipiter. The North American population has been on the rebound for a number of decades now that hunting has been halted.

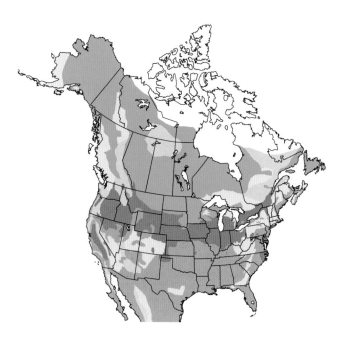

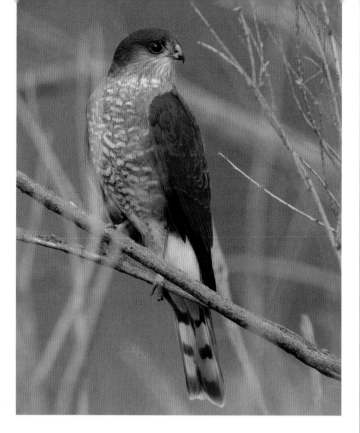

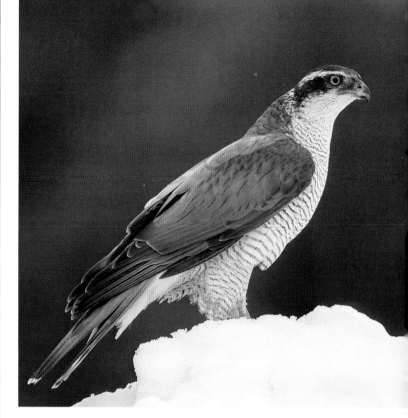

Sharp-shinned Hawk *Accipiter striatus*
L 11" WS 23" ♂ = ♀ SSHA

This diminutive hawk nests across northern North America, wintering southward as far as Panama. Additional resident populations inhabit the Appalachians, the Caribbean and Central and South America. North American birds breed in mixed conifer-deciduous forest and winter in woodlands and along woodland edges. An inveterate bird hunter. Smaller and more shy than the very similar Cooper's Hawk. Diet is small birds and the occasional mammal or other small vertebrate. The nest is a platform of sticks hidden in a tall conifer. Lays four or five bluish-white eggs blotched brown. This is a species seen in abundance at autumn hawk-watches.

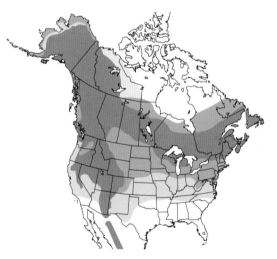

Northern Goshawk *Accipiter gentilis*
L 21" WS 41" ♂ ≈ ♀ NOGO

A large, powerful, and rare forest predator, breeding in northern and western North America and wintering southward in small numbers. Breeds in mixed forests of the Northeast and in mountains of the West and Northwest; winters in any woodland type. Southward incursions in winter occur periodically, primarily involving immature birds. A fierce attack hunter that typically haunts woodlands and edge. Only seen soaring when over nest site or in migration. Diet includes game birds, squirrels, and rabbits. Also ranges across Eurasia. Nest is a large stick structure lined with finer materials and green foliage and situated in the crotch of a large branch high in a deciduous tree within a stand of mixed forest. Lays two to four bluish-white eggs.

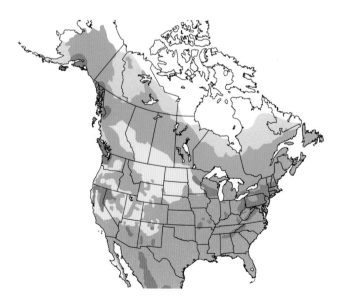

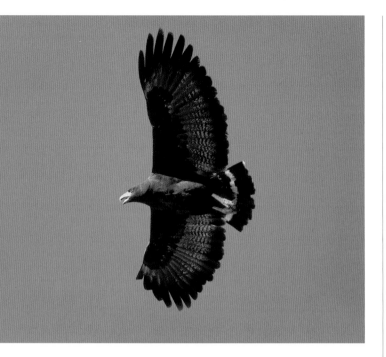

Common Black Hawk *Buteogallus anthracinus*
L 21" WS 46" ♂ = ♀ COBH

A distinctive Neotropical raptor that summers in the Borderlands of the Arid Southwest and that winters in Mexico. Additional resident populations are distributed from Mexico to Ecuador and the Guianas. Note broad wings and very short tail. Inhabits trees along desert watercourses. Hunts along stream corridors for fish, frogs, and lizards. Often seen perched on a cottonwood branch that hangs over a stream. A summer visitor to the United States, arriving in March and disappearing in the early autumn. The nest, placed in a large tree by a stream course, is a bulky platform of sticks lined with green leaves. Lays one to three white or greenish-white eggs.

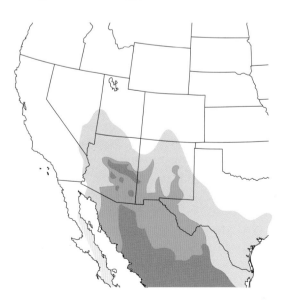

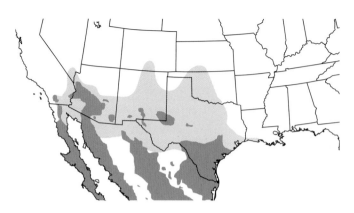

Harris's Hawk *Parabuteo unicinctus*
L 20" WS 42" ♂ = ♀ HAHA

This handsome and sociable raptor of the Arid Southwest is found mainly in the southern portions of Texas, New Mexico, and Arizona. Inhabits desert, brushlands, and riverine woodland. Often seen in small parties perched or hunting together. Diet includes small mammals, birds, lizards, and large insects. Additional resident populations inhabit Central and South America. The nest, sited in a small tree or cactus, is a bulky platform that is lined with twigs and grass; green leaves are added during the nesting cycle. Lays three or four pale bluish-white eggs, in some cases with sparse brown spotting.

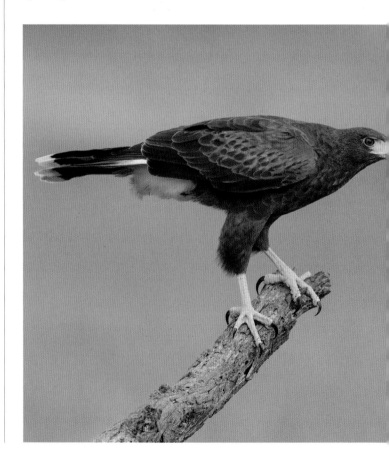

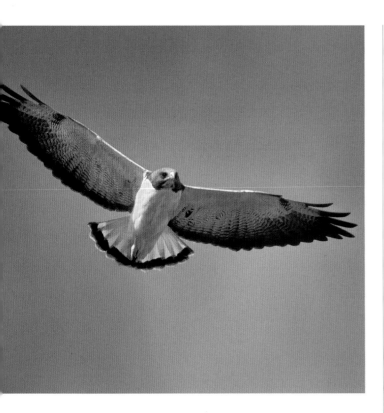

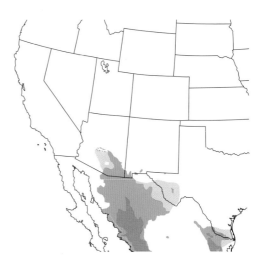

Gray Hawk *Buteo plagiatus*
L 17" WS 34" ♂ = ♀ GRHA

This small and vocally conspicuous Neotropical raptor is generally found in woods along stream valleys in arid country along the US Borderlands. It also ranges southward to Costa Rica. In the Southwest, the wailing calls of the Gray Hawk can be heard in cottonwood and mesquite woodlands along permanent streams. This hawk races through woodlands in search of canopy-dwelling lizards and other prey. Nest is a small platform of sticks with a lining of leafy green twigs, well hidden in a tree in a wooded grove. Lays two or three pale bluish-white eggs.

White-tailed Hawk *Geranoaetus albicaudatus*
L 20" WS 51" ♂ = ♀ WTHA

This boldly-patterned tropical species ranges from northern Argentina northward to southeastern Texas, where it inhabits dry grassland and remnant coastal prairie. In flight, its wings form an upward-tilted shallow V. Soars, kites, and hovers over grasslands in search of its small vertebrate prey. Takes mainly small mammals, lizards, snakes, and insects. Nest is a bulky platform of sticks lined with finer material and hidden atop a low tree or shrub in open country. Lays two or three white eggs, in some cases with brown spotting. Attracted to controlled burns of fields and crops, where it takes small vertebrates driven out from the fire line. The species is apparently unthreatened across its broad range. The very small Texas population is of limited geographic range but stable. This is one of those South Texas species of great interest to North American birders.

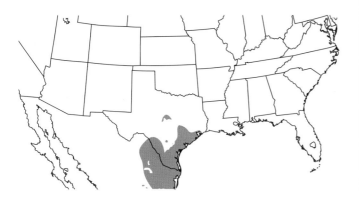

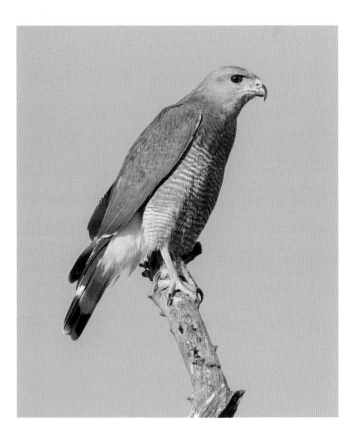

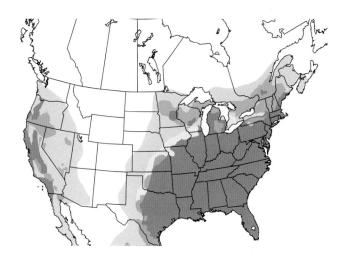

Red-shouldered Hawk *Buteo lineatus*

L 17" WS 40" ♂ = ♀ RSHA

A common woodland raptor of the East, Midwest, and West Coast. Northern-breeding birds winter southward as far as Mexico. In spring, commonly seen circling high over a woodland, calling out. Inhabits bottomland woods, stream woodlands, and wooded swamps; also found in other wooded habitats in California and Florida. The distinctive keening call of the Red-shouldered is commonly imitated by local Blue Jays. Mainly a perch-and-wait predator, dropping on small mammals, frogs, snakes, or birds. Nest is a well-lined bulky platform of sticks placed in the crotch of a large tree in woods. Lays three or four pale bluish-white eggs blotched with darker colors. Population stable.

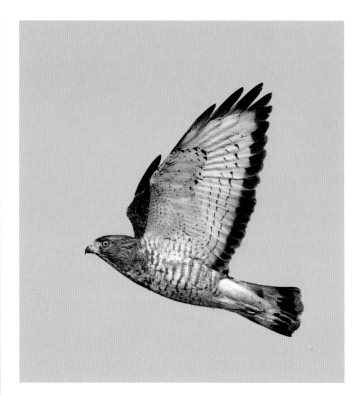

Broad-winged Hawk *Buteo platypterus*

L 15" WS 34" ♂ = ♀ BWHA

A small raptor of northern and eastern woodlands. Reclusive in summer, but found in large and high-flying migrant flocks in autumn, riding thermals along the Appalachian ridges. Winters in Central and South America. Southbound birds follow the coast of the Gulf of Mexico rather than cross over the salt water. Breeds in mixed woods of the East, ranging north and west to Alberta. In summer, mainly seen when it is soaring over the canopy and giving its two-note whistle. Another perch-and-wait predator that drops down from its woodland perch to capture a small vertebrate. Nest is a small platform of sticks lined with finer material and situated in the middle of a large tree in the forest. Lays two or three whitish eggs spotted brown.

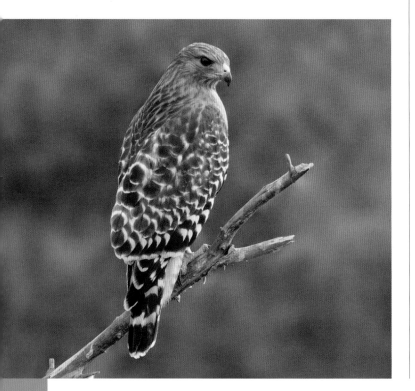

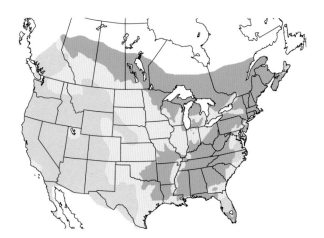

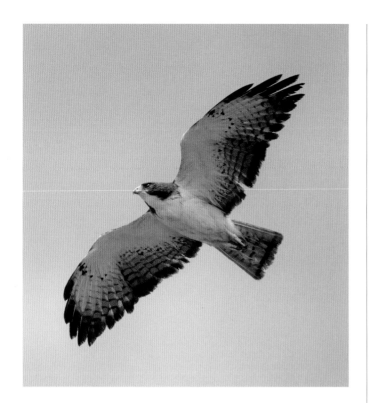

Short-tailed Hawk *Buteo brachyurus*
L 16" WS 37" ♂ = ♀ STHA

A small and uncommon bird-eating raptor of the woodlands of peninsular Florida. Can be found in a pale morph and a dark morph. The species also ranges from Mexico south into South America. Mexican birds sometimes stray into South Texas and southeastern Arizona, where they have bred on occasion. Breeding birds inhabit Florida woodlands that are mixed with open country. Commonly soars high above woodlands, circling and kiting in search of prey. Aside from small birds, this raptor takes reptiles, rodents, and arthropods. Nest is a bulky platform of sticks, twigs, and Spanish Moss, with green leaves added as lining. Situated high in a pine or cypress. Lays one to three pale bluish-white eggs. In the United States, this long-winged buteo is rarely seen perched. The species is apparently unthreatened across its broad range. The Florida population is small but stable.

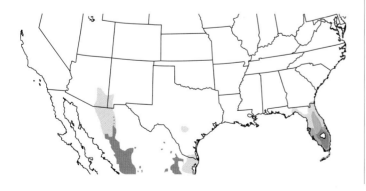

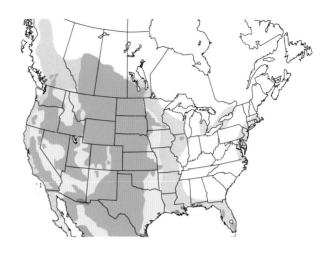

Swainson's Hawk *Buteo swainsoni*
L 19" WS 51" ♂ = ♀ SWHA

This long-winged, slim buteo summers on western farmland and prairies of the Great Plains and Interior West. Most individuals migrate to South America every autumn. Breeds in prairie lands where there is a scattering of large trees for nesting. Hunts either by soaring or by perching and scanning. Feeds on insects during the nonbreeding seasons and takes mainly mammals and reptiles while breeding. Nest is a platform of sticks with finer lining material situated in a tree and typically well hidden. Lays two or three pale bluish-white eggs. In spring migration, numbers of birds can be seen in the early morning, perched in plowed fields.

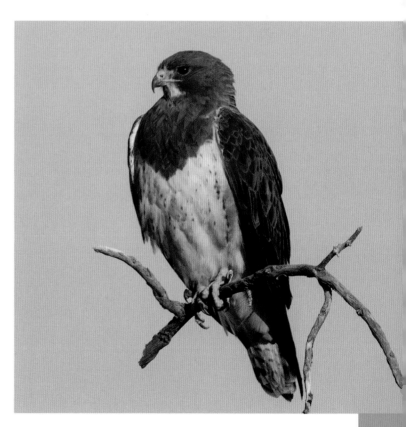

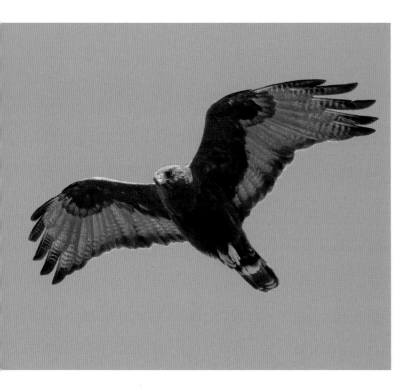

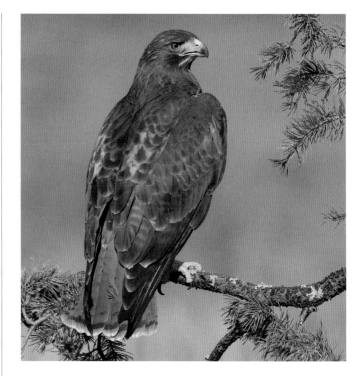

Zone-tailed Hawk *Buteo albonotatus*

L 20" WS 51" ♂ = ♀ ZTHA

This dark and long-winged raptor that summers in the Arid Southwest looks much like a Turkey Vulture when soaring high in the sky. Inhabits riverine woods, mountainous arid lands, and canyon country, but winters primarily south of the Border. When perched, it resembles a Common Black Hawk. Hunts by soaring and spotting terrestrial prey. Diet includes lizards, small mammals, and birds. Additional resident populations inhabit Central and South America. Nest is usually placed in a tall and isolated tree in a canyon or near a cliff. Nest is a bulky platform of stick lined with greenery. Lays one to three white eggs. Possible nesting pair in Oklahoma in 2021. Wanders to the East and West Coasts.

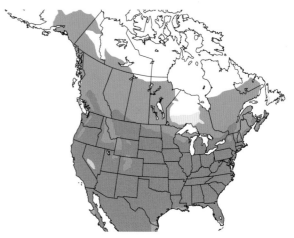

Red-tailed Hawk *Buteo jamaicensis*

L 19" WS 49" ♂ = ♀ RTHA

This is our most common and widespread large hawk, inhabiting all but the most northern climes. Northern breeders migrate southward in autumn. Additional resident populations inhabit the Caribbean, Mexico, and Central and South America. Quite variable in plumage across its range. Most common in open country or at the edges of woodlands near farmland. Especially common along roadsides. Hunts prey by scanning from a fixed perch or in flight over prime habitat. Diet is mainly small rodents but also includes a range of small vertebrates. Nest is a large platform of sticks lined with finer materials and situated in a tree or on a cliff or artificial structure (such as a building ledge in the city). Lays two or three whitish eggs blotched brown.

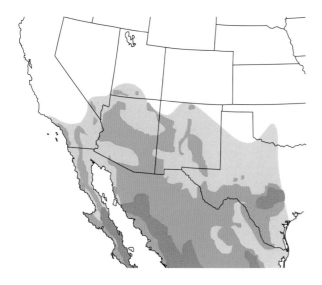

Rough-legged Hawk *Buteo lagopus*
L 21" WS 53" ♂ ≈ ♀ RLHA

A large raptor of open country summering on Arctic tundra lands across the Northern Hemisphere. Summers in northern Canada and Alaska, and winters in the northern half of the Lower 48 and southern Canada. Wintering populations in the United States vary from year to year. Year-round it prefers open country—tundra, marshlands, prairies, plains, and open fields. This is the only buteo that regularly hovers in search of prey. Diet is mainly small rodents, especially lemmings in summer. Nest, sited on the ground, cliff, or tree, is a bulky platform of sticks and debris lined with grasses and twigs. Lays two to seven pale bluish-white eggs. Lays larger clutches in years when lemmings are abundant.

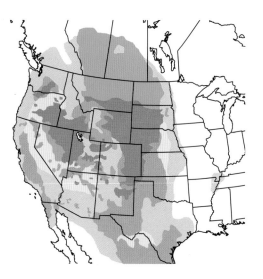

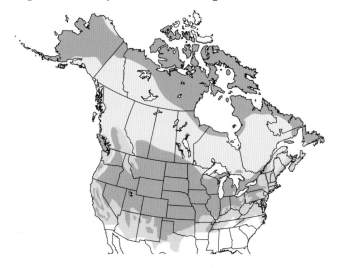

Ferruginous Hawk *Buteo regalis*
L 23" WS 56" ♂ = ♀ FEHA

This very large, pale hawk summers in the northern Great Plains and Great Basin and winters in the Arid Southwest and Mexico. Also occurs in a rather rare dark morph. Inhabits prairies and plains in the dry Interior. In winter, can be found foraging over agricultural fields. This mammal-specialist hunts on the wing, while perched in a tree, or on the ground. Takes mainly ground squirrels, rabbits, and mice, also some birds, snakes, and large insects. Nest is a bulky platform of sticks and other materials that is lined with finer materials, and is sited in a tree. Lays two to four pale bluish-white eggs.

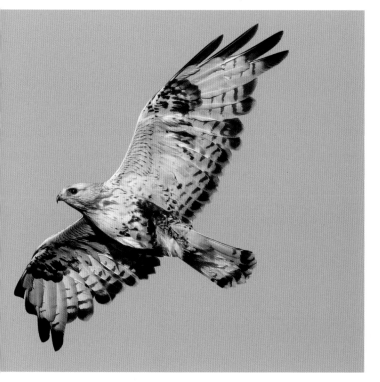

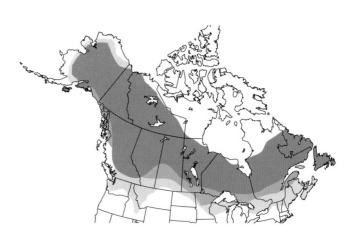

Northern Hawk Owl *Surnia ulula*
L 16" WS 28" ♂ = ♀ NHOW

A rare, long-tailed, diurnal owl of the taiga zone of Canada, Alaska, and Eurasia. North American breeders sporadically appear in winter in the northern Lower 48 away from breeding areas in small numbers. Summers in open taiga habitats—Black Spruce bogs, muskeg, open conifer forests, birch scrub, or a burned over area. Needs openings for hunting. A perch-and-search hunter, sitting atop a tall, exposed perch and watching intently for the movement of a vole or lemming. Takes a range of small vertebrates and even arthropods. Nest is situated in a large tree cavity, a broken-off hollow tree trunk, or a discarded stick nest of a crow or raptor. Lays three to seven white eggs. Not under threat.

Barn Owl *Tyto alba*
L 16" WS 42" ♂ = ♀ BANO

This pale and ghostly nocturnal predator is widespread but uncommon across the Lower 48; it is absent from the northern Interior. The species also occurs across much of the rest of the world. Inhabits a wide range of open habitats, from towns and farms to marshlands and prairies—wherever there is plenty of prey and good nesting sites. Its rasping shrieks are an unsettling night sound. Hunts at night by cruising over open ground or by perching and pouncing on prey moving on the ground, detected by its excellent hearing. Nest is usually sited in a hollow tree, barn loft, church steeple, dry well, or crevice under a bridge. Nest is minimal—usually a ring of debris on the surface of the nesting site. Lays three to eight whitish eggs.

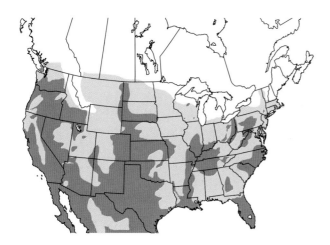

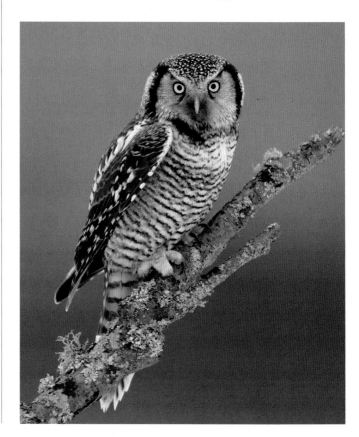

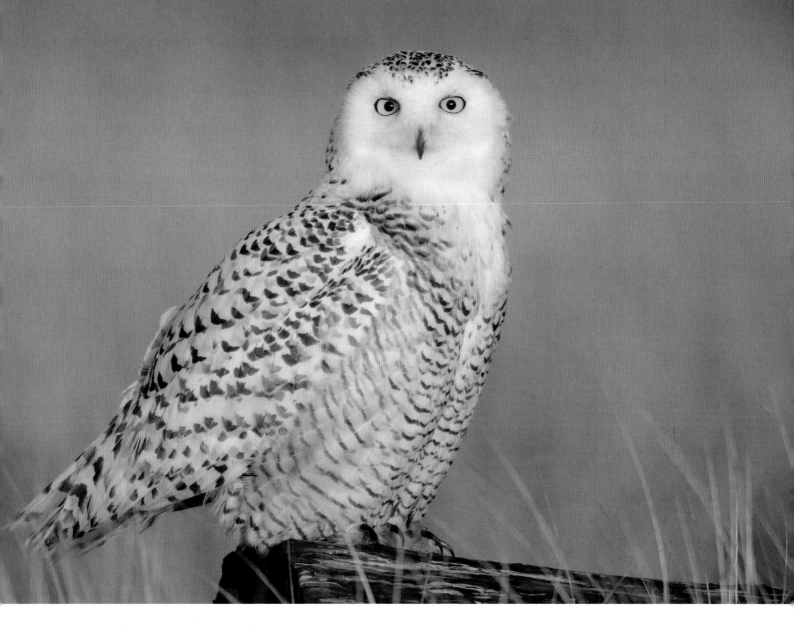

Snowy Owl *Bubo scandiacus*

L 23" WS 52" ♂ ≠ ♀ SNOW *VU *WL

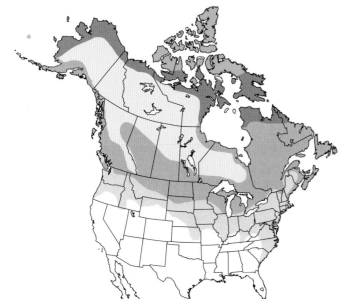

Our heaviest owl, the Snowy Owl breeds in the Arctic tundra of the Northern Hemisphere, wintering southward. During invasion years, when young birds are abundant, these owls appear throughout the northern United States, especially in habitats that mimic tundra—marshlands and expanses of low open grasslands. Breeds on hilly open tundra. Hunts by day and night. In winter, hunts for sea ducks out over the sea in the late dusk. Most often seen perched on a grassy tussock, looking out across marshlands in the daytime. Winter invasions from the North occur roughly every five to seven years. Diet includes lemmings, other rodents, and a variety of small and medium-sized vertebrates. The nest, placed on a rise overlooking a broad expanse, is a shallow depression in the tundra vegetation. Lays 3–11 whitish eggs. The species population appears to be in decline.

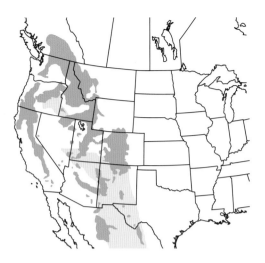

Flammulated Owl *Psiloscops flammeolus*
L 7" WS 16" ♂ = ♀ FLOW *WL

A small and reclusive owl of mountain forests of the Interior West. Best located at night by its repeated calling from a tall pine. Summers in open forests of Ponderosa Pine; also found in aspens and oaks. Winters south of the Border. During migration, it is found in dense thickets. A perch-and-snatch predator, flying out to capture passing arthropods. Nest is usually placed in an abandoned woodpecker hole in a pine. Will also use a nest box. Lays two or three white eggs. The Canadian population appears to be in decline.

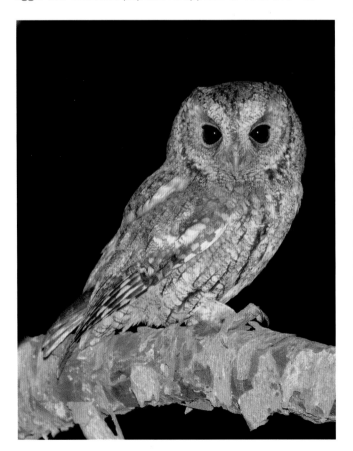

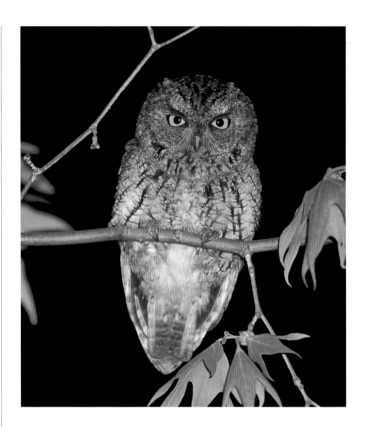

Whiskered Screech-Owl *Megascops trichopsis*
L 7" WS 18" ♂ = ♀ WHSO *WL

A small and common owl of the Borderlands of southeastern Arizona and westernmost New Mexico. The species ranges to Central America. Identified at night by its distinctive voice. Favors montane oak woodlands, pine-oak woods, sycamores, and canyons. Hunts from a perch, flying out to grasp prey on leaves or on ground. Diet is mainly large arthropods and the occasional rodent. Nests in a tree hole in an oak or a sycamore. Lays three or four white eggs. A year-round resident.

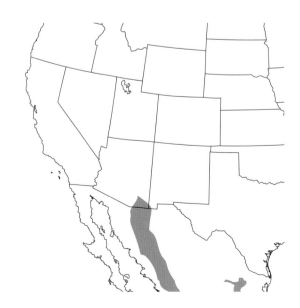

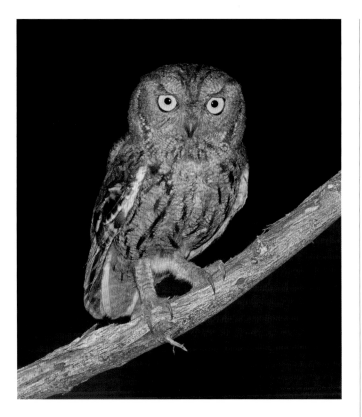

Western Screech-Owl *Megascops kennicottii*
L 9" WS 20" ♂ = ♀ WESO

A common and widespread little owl of the West and Pacific Northwest. Found in most open wooded habitats except high mountains and desert. Forages by perching and launching out to capture prey on the ground, in vegetation, or in the air. Diet includes small mammals and large insects. Nests in a small tree cavity, typically a disused woodpecker hole. Lays two to five white eggs. A year-round resident. Does not migrate.

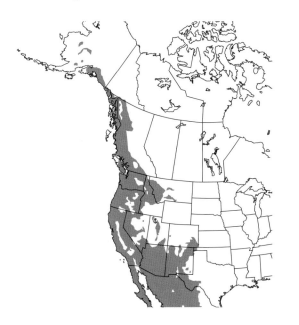

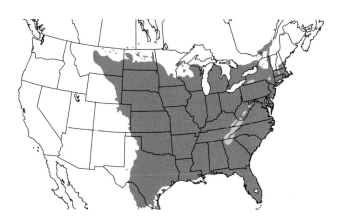

Eastern Screech-Owl *Megascops asio*
L 9" WS 20" ♂ = ♀ EASO

A widespread small owl of the eastern and central United States and southern Canada. Common but easily over-looked. Best located by hearing it calling at night. Strictly nocturnal. Spends the day roosting in a cavity or a thicket. Inhabits most all wooded habitats within its range—parks, suburbs, woodlots, edges, and shade trees where there are suitable nesting cavities. A perch-and-snatch predator, sitting on a tree branch and launching out to take prey on the ground or in flight. Nonmigratory. Diet includes small mammals, insects, and the occasional bird and other small vertebrate. Nests and roosts in a tree cavity as well as a nest box. Lays four or five white eggs. Found in two color morphs—rufous and gray.

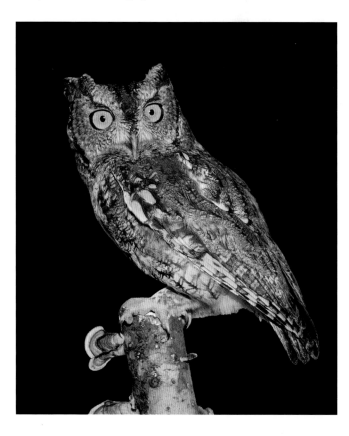

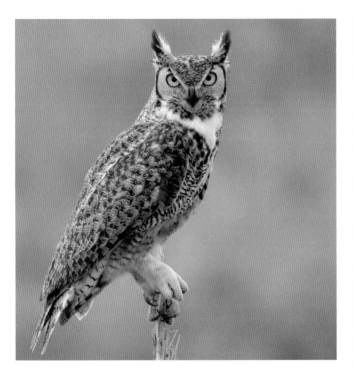

Great Horned Owl *Bubo virginianus*
L 22" WS 44" ♂ = ♀ GHOW

North America's most widespread and commonplace large owl. Most easily located by its nocturnal low-pitched, cadenced series of five to seven *hoo* notes. Found in most every habitat in North America, though absent from open habitats lacking trees or scrub where the owl can roost and nest. Perhaps also less common in expanses of closed forest. Hunts by perching from a vantage point and swooping down on prey on the ground, which it grasps in its talons. Diet includes rabbits, snakes, skunks, porcupines, squirrels, opossums, and other small vertebrates. Most commonly takes over an old stick nest of a raven or raptor. Also may nest on a cliff ledge or in a broken-off tree stump. Lays two or three whitish eggs in late winter.

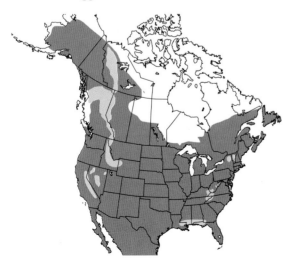

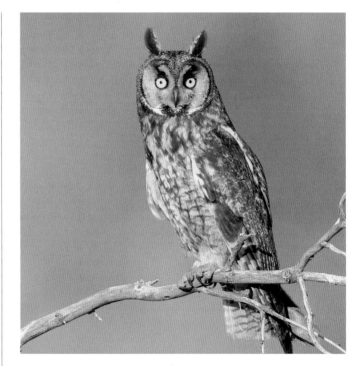

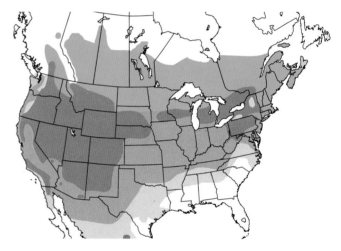

Long-eared Owl *Asio otus*
L 15" WS 36" ♂ = ♀ LEOW ★WL

A widespread but uncommon and reclusive owl summering across southern Canada and the northern United States; also widespread through Eurasia. Prefers a mix of open country for hunting and thick tree stands (conifer or broadleaf) for roosting and nesting. Forages for small mammals by cruising low over openings, capturing its prey on the ground. Difficult to locate when hidden within its daytime winter roosts in cedar thickets. Nests in an abandoned stick nest of another large bird, such as a raptor or magpie. Lays 4–6 white eggs. In winter, groups sometimes roost together in a thicket. Northern breeders winter southward. Not commonly heard calling.

Short-eared Owl *Asio flammeus*
L 15" WS 38" ♂ = ♀ SEOW

A crepuscular owl of expansive marshes and grasslands. Summers from Alaska and Labrador southward sporadically to Oklahoma, Missouri, and Kentucky. Winters across the Lower 48. Also inhabits the Caribbean, South America, Eurasia, and Hawaii. Nests in Alaskan and Canadian tundra; also coastal dunes, prairies, and marshlands. Winters in similar open habitats. Northern breeders winter southward into the United States. Forages mainly for small mammals by cruising low over open lands and dropping deftly on located prey. Also takes birds. Nest is a depression on the ground lined with grass and feathers and hidden by tall marsh grasses or similar vegetation. Lays six to eight white eggs. To see several of these birds winging gracefully over a marsh at dusk in winter is a special treat for the birder.

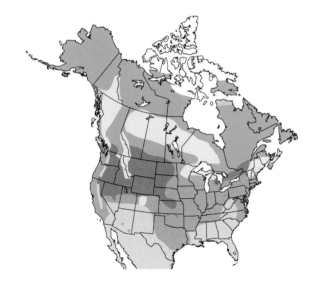

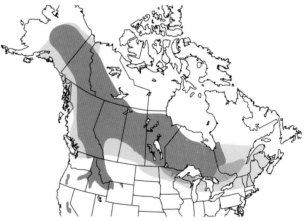

Great Gray Owl *Strix nebulosa*
L 27" WS 52" ♂ = ♀ GGOW

A huge gray owl with pale yellow eyes and rather confiding crepuscular habits. This bird of the boreal North inhabits openings adjacent to mature conifer forest—spruce bogs, burns, and other clearings in boreal habitat; also in mountain glades in the West. Often seen perched at forest edge on a cloudy day. Every few years, this species irrupts southward from Canada into the northern Lower 48, especially around the Great Lakes and Northeast. Diet is mainly small mammals. Pounces on its prey from a perch sited at the verge of an opening in the forest. Nest is typically placed atop an abandoned raptor nest, or sometimes in the cavity created by a broken-off stump. Lays two to five white eggs.

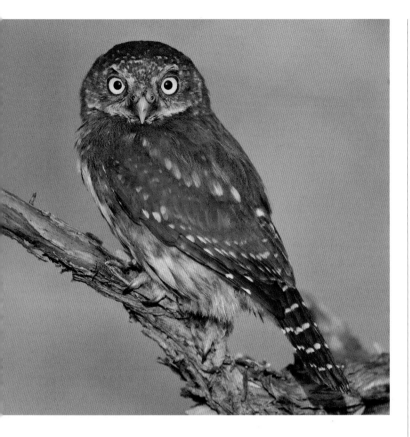

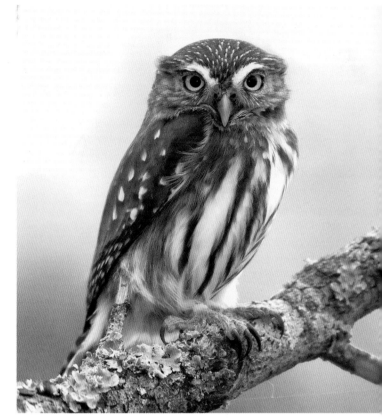

Northern Pygmy-Owl *Glaucidium gnoma*
L 7" WS 12" ♂ = ♀ NOPO

This small western owl is most active at dawn and dusk, hunting in open stands of conifers and deciduous trees. Ranges from southern Alaska south to Nicaragua. Prefers openings in conifer, mixed, or deciduous forest. Often found when the owl is mobbed by a flock of chickadees or other songbirds. Searches for prey from a perch at edge of a clearing, taking mainly small rodents, birds, lizards, and arthropods. Typically nests in an old woodpecker hole in a woodland. Lays three or four white eggs. Nonmigratory, but some birds wander in winter, either downslope or across the landscape.

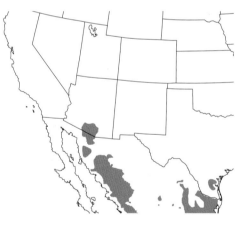

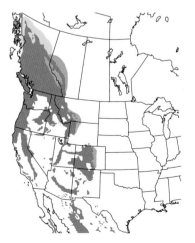

Ferruginous Pygmy-Owl *Glaucidium brasilianum*
L 7" WS 12" ♂ = ♀ FEPO

This tropical species ranges north from Argentina to southernmost Arizona and the Lower Rio Grande Valley of Texas. A rare species in the United States. Inhabits mesquite thickets, arid land riverine woodlands, Saguaro cacti, and stands of live oak. Typically found when a songbird flock mobs the owl at its perch during daylight hours. Hunts from a prominent perch, from which it darts out to grab its prey— small birds, arthropods, small rodents, and lizards. May be active during daylight. Nests in an old woodpecker hole in a Saguaro cactus or in a hollow of a deciduous tree. Lays three or four white eggs. In decline in the US.

Northern Saw-whet Owl *Aegolius acadicus*

L 8" WS 17" ♂ = ♀ NSWO

An adorable small owl of mixed forests of the Northeast and West. A common nocturnal migrant in late autumn. Winters widely, but difficult to locate roosting individuals. Some populations breed in Mexico. North American birds summer in mixed northern forests and winter southward in dense thickets. In mountains of the West, it can be found in oaks or riverine thickets in arid lands. Swoops down on small rodents from an elevated perch at the edge of a forest clearing; also consumes birds and arthropods. Nest is typically in a disused woodpecker hole in an aspen or other softwood; will also use nest boxes. Lays five or six white eggs.

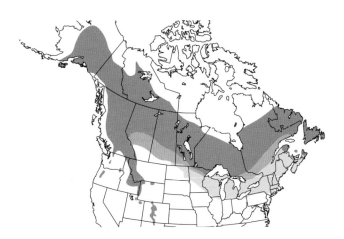

Boreal Owl *Aegolius funereus*

L 10" WS 21" ♂ = ♀ BOOW

A rarely seen small owl of the boreal forests of Canada. Isolated breeding populations also inhabit northeasternmost Minnesota, the mountain conifer forests of the Rockies, and the Northern Cascades. Lurks in conifer and mixed forests of the boreal zone. Nests in places where aspens and other softwood trees feature nest holes (often constructed by woodpeckers). Mainly found by listening for calling birds nocturnally in early spring when snow still blankets the ground. Moves about in the forest, from perch to perch, and drops down on prey moving on the ground or in the snow. Diet is mainly small rodents; will also take small birds. Typically nests in a tree hollow, but will also use a next box. Lays three or four white eggs. In some winters, northern birds move southward into the US northern Borderlands. Presumably common where it nests.

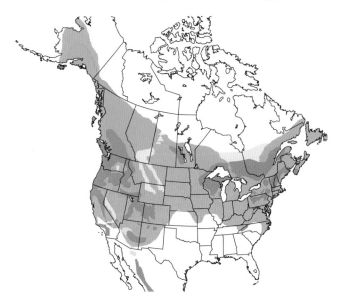

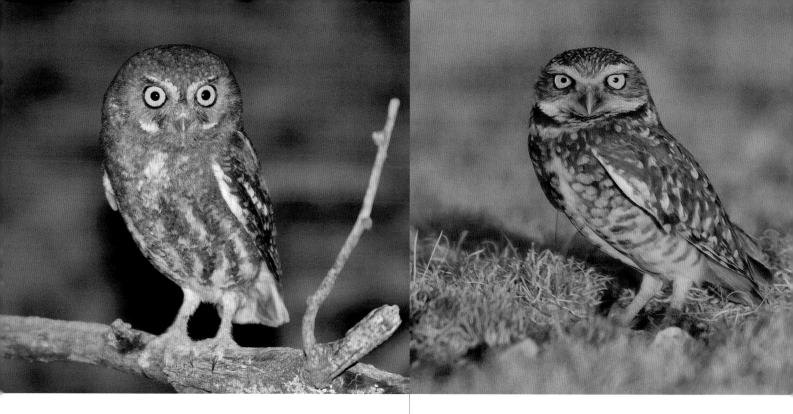

Elf Owl *Micrathene whitneyi*
L 6" WS 15" ♂ = ♀ ELOW

The Elf Owl is perhaps the smallest owl on Earth—smaller than a Northern Cardinal. It is a summer breeding visitor to the Southwest Borderlands and winters in Mexico. Found in desert groves of Saguaro cacti, canyon woodlands, and mesquite thickets. Usually solitary. Very vocal on early spring nights. Hunts from a perch, from which it swoops out to capture terrestrial or flying arthropods. Nest is typically in an old woodpecker hole, commonly in a Saguaro cactus in Arizona. Lays two to four white eggs.

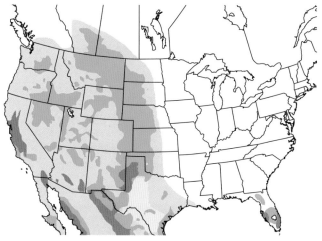

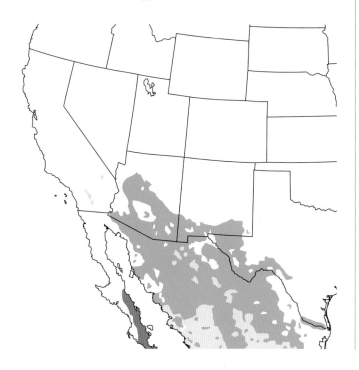

Burrowing Owl *Athene cunicularia*
L 10" WS 21" ♂ = ♀ BUOW

This curious species is widespread through the Western Hemisphere. In North America, it is a terrestrial owl of prairie-dog towns and other shortgrass clearings in arid settings. This long-legged owl is often active during the daytime but hunts mainly at night. Inhabits dry open grasslands, agricultural lands, prairies, waste land, and expanses of short grass found around airports. Hunts on the ground, from a perch, and on the wing. During the summer, it forages mainly on arthropods; in other seasons, it takes mainly small rodents. Nests within a burrow, either borrowed from a mammal or (in Florida) a Gopher Tortoise. May line the burrow nest site with cow manure. Lays 3–12 white eggs. The northern-breeding birds shift southward for the winter. In substantial decline, especially in the Great Plains.

Spotted Owl *Strix occidentalis*

L 18" WS 40" ♂ = ♀ SPOW *NT *WL

This uncommon and declining species of western forest ranges from southern British Columbia south into Mexico. Heard more often than seen. This bird's habitat in the Pacific Northwest is being invaded by the aggressive Barred Owl, which is hybridizing with the rarer species. In the Pacific Northwest, inhabits old-growth conifer forest. In the Southwest, inhabits mainly forested canyonlands, especially in association with rock walls and cliffs. Hunts from a perch, from which it launches out to take small mammals on the ground or in vegetation; also takes bats in the air. Nest is sited in a tree cavity, on a ledge, or atop an abandoned stick nest of a bird or squirrel. Lays one to four whitish eggs. Widespread logging of old-growth forest in the Pacific Northwest has heavily impacted populations of this species.

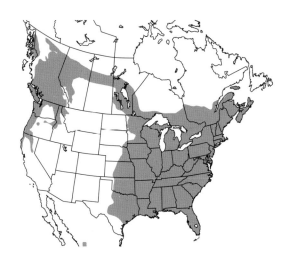

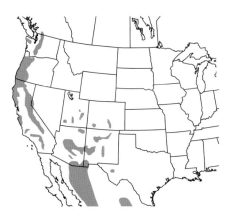

Barred Owl *Strix varia*

L 21" WS 42" ♂ = ♀ BADO

A commonplace and vocal owl of forests of the East, Midwest, Deep South, and Pacific Northwest. Especially common in deciduous bottomland forests. Also inhabits conifer and mixed forests. A bird of forest interior. Most often noted because of its loud and strident hooting call, given at night and on cloudy days. Diet is a variety of mammals and other small vertebrates. Hunts from a perch or by cruising low through the forest. Nest is situated in a natural tree cavity or an abandoned raptor nest. Lays two or three white eggs. Generally nonmigratory but occasionally will shift southward in winter from the northern edge of the range. Generally on the increase in North America.

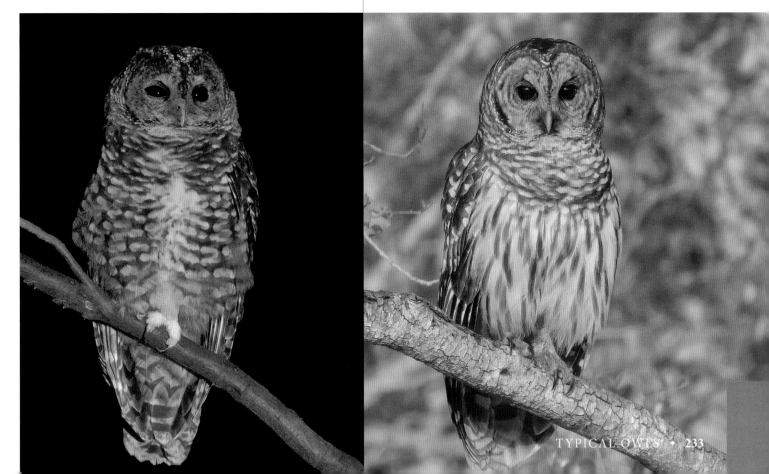

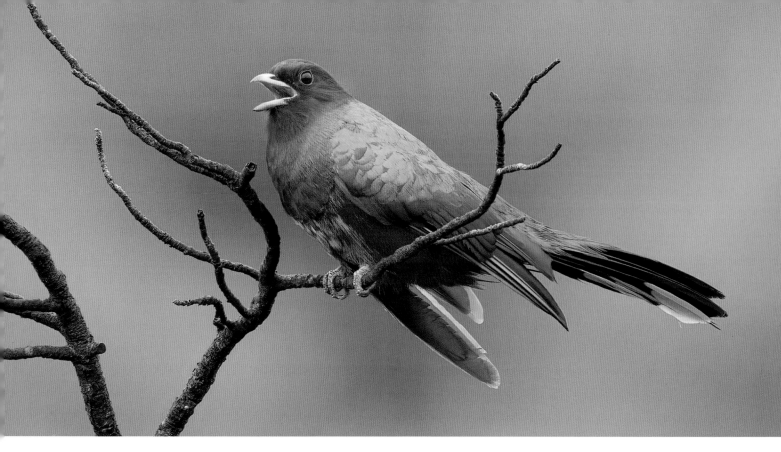

Eared Quetzal *Euptilotis neoxenus*
L 14" WS 24" ♂ ≠ ♀ EAQU *NT *WL

This showy but shy quetzal is resident through western Mexico. It is a very rare late-summer and autumn visitor to the mountains of Arizona, where it has attempted to breed. Inhabits mountain pine forests in deep canyons. Less closely associated with stream habitats than the Elegant Trogon and prefers higher elevations . Diet comprises large arthropods and fruit. Nests mainly in old flicker holes in trees well up on canyon slopes. Lays two pale blue eggs. Though the species is widespread in western Mexico, it may be under threat from habitat loss and loss of nesting cavities.

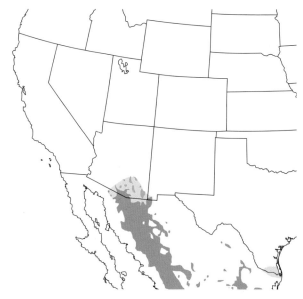

Elegant Trogon *Trogon elegans*
L 13" WS 16" ♂ ≠ ♀ ELTR *WL

This exotic-looking tropical species ranges from Costa Rica north to southeastern Arizona and southwestern New Mexico. It summers along wooded canyon streams, nesting in tree cavities, mainly of sycamores. Vocal in spring and summer when defending a nesting territory. Feeds upon fruit, arthropods, and the occasional small lizard. Nest is often placed in an old flicker nest. Eggs are laid on the debris at the bottom of the cavity. Lays two to four white eggs. US breeders winter in Mexico.

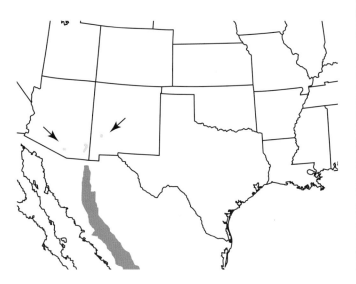

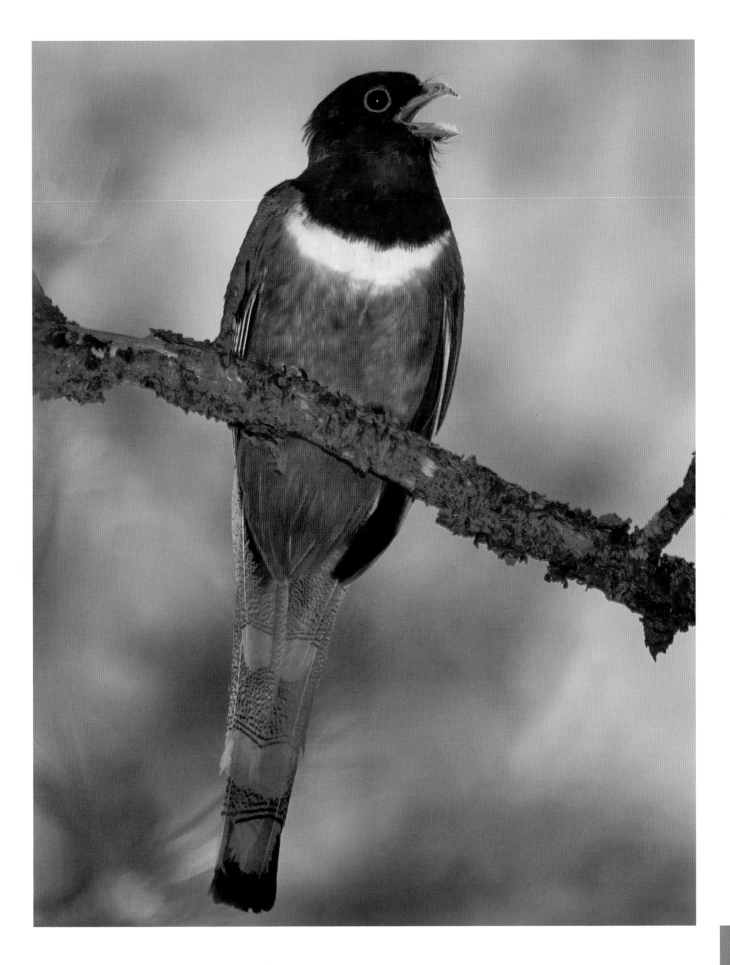

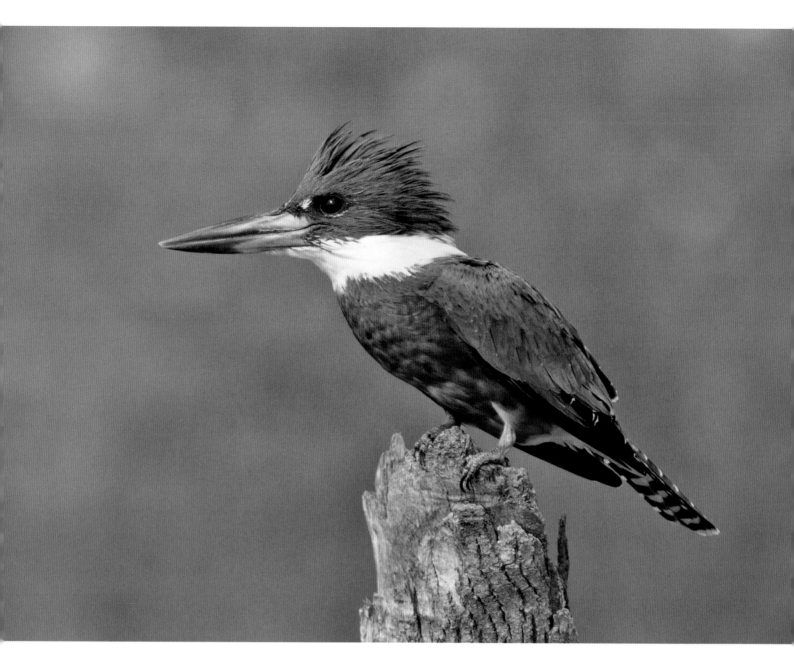

Ringed Kingfisher *Megaceryle torquata*
L 16" WS 25" ♂ ≠ ♀ RIKI

A large and bulky tropical kingfisher that ranges from southern South America north to South Texas. This is the largest kingfisher in the New World. Has increased in abundance in Texas since the 1960s. Found around rivers, streams, lakes, and impoundments where there are suitable fish prey. Easily located by voice and its active overflights. Hunts from a prominent high perch over water, from which it dives head first to take its quarry, typically a small fish. The nest is placed in a burrow in a steep bank of earth. Lays four or five white eggs. Nonmigratory, but does wander in winter.

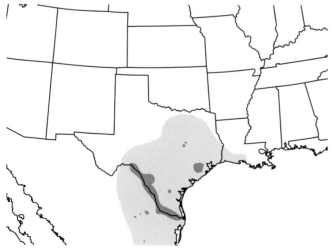

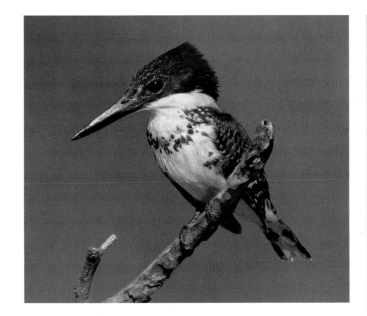

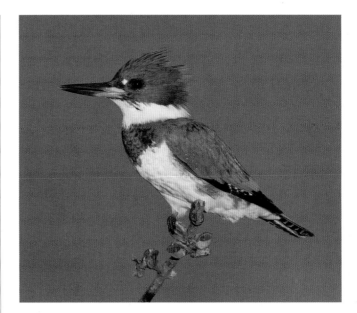

Green Kingfisher *Chloroceryle americana*
L 9" WS 11" ♂ ≠ ♀ GKIN

A small tropical kingfisher that ranges from Argentina north to southern Texas and southeastern Arizona. Nonmigratory. Inhabits streams, rivers, and other water bodies where there is low vegetation overhanging the water. More retiring than larger American kingfishers. Often seen flying low over the water. Will cock its tail. Hunts for small fish from a low perch over the water. Nest is a burrow dug in an earthen bank near water. Lays three to six white eggs.

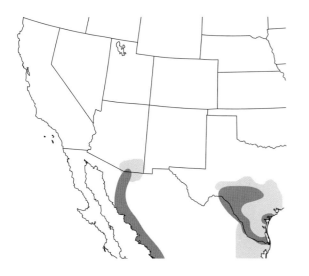

Belted Kingfisher *Megaceryle alcyon*
L 13" WS 30" ♂ ≠ ♀ BEKI

The common and widespread kingfisher of North America. Some birds winter into Central America and northern South America. Summers widely through Alaska, Canada, and the Lower 48, wherever there are waters that support a stock of small prey fish—streams, rivers, lakes, ponds, estuaries, and even rocky coastlines. Summer range also depends on availability of earthen cliff nesting sites. Noisy and active in spring. Birds make display flights high overhead, where they make a rattling call. Hunts from an exposed perch over water, from which it plunges to capture prey fish. Nests in a burrow dug into an earthen cliff. Lays five to eight white eggs. Northern-breeding birds migrate southward in winter, whereas more southern birds remain resident.

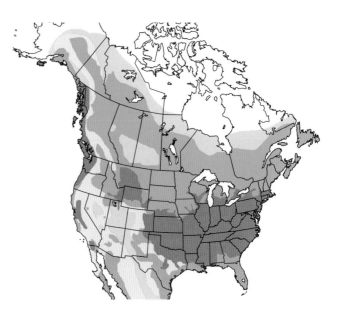

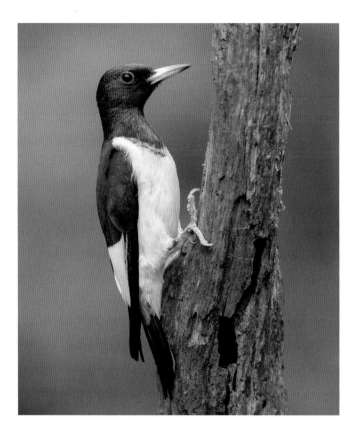

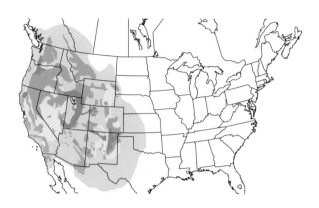

Lewis's Woodpecker *Melanerpes lewis*
L 11" WS 21" ♂ = ♀ LEWO *WL

A large, dark, peculiar-looking woodpecker of the arid Interior West. The only pink-breasted woodpecker. Found in dry woodland openings, cottonwood groves along rivers, and oak foothills. Shows a particular predilection for recently burned woodlands. Spends considerable time chasing winged arthropods, which it captures on the wing. Also caches acorns and other nuts. During some winters, many individuals migrate to interior lowlands of the Southwest. Pairs may form long bonds, nesting repeatedly in the same place. Somewhat colonial; nest is excavated in a dead trunk or limb. Lays six or seven white eggs.

Red-headed Woodpecker *Melanerpes erythrocephalus*
L 9" WS 17" ♂ = ♀ RHWO *NT *WL

This elegant red, white, and black woodpecker is widespread in the Midwest and the East, but it is most abundant in the Interior and Deep South. Northern birds move southward in the winter. Uncommon along much of the East Coast. Prefers open country with groves of large trees—agricultural countryside, swamps with standing dead oaks, and open pine woods. This vocal and active species at times will fly out repeatedly from a perch on a telephone pole to catch winged insects. In winter, collects acorns and other nuts, which it stores for later consumption. Diet is broad. Nest is excavated in a dead tree—in the trunk or major limb. Lays four or five white eggs.

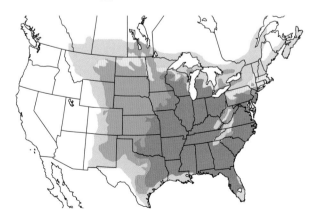

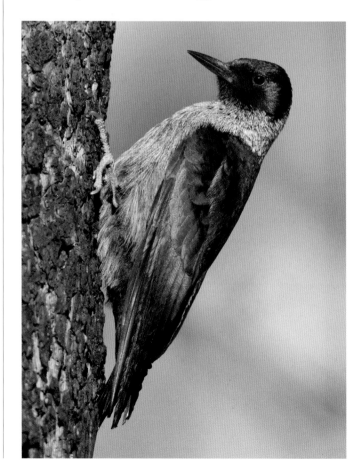

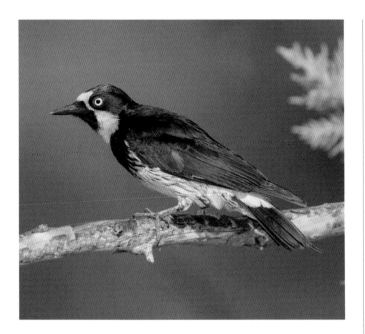

Acorn Woodpecker *Melanerpes formicivorus*
L 9" WS 18" ♂ ≈ ♀ ACWO

A harlequin-patterned and sociable species of the Far West and Southwest. Birds live in small colonies. Most closely associated with dry oak foothills and pine woodlands associated with oak groves. This acorn specialist stores acorns in holes drilled in large old trees. These granaries can be used year after year for storage of acorns and other nuts. Diet is varied and includes acorns, other nuts, arthropods caught on the wing, and even the eggs of other bird species. The species ranges southward to Colombia. Nest is excavated in a dead tree—in the trunk or major limb. Nest is managed by a senior pair, aided by male and female helpers. Lays three to seven white eggs.

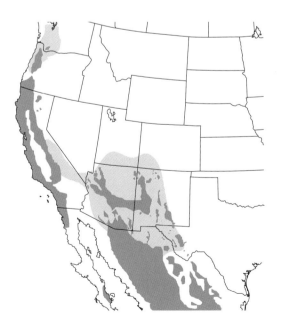

White-headed Woodpecker *Dryobates albolarvatus*
L 9" WS 16" ♂ ≠ ♀ WHWO

An attractive but inconspicuous two-toned woodpecker of mountain pine forests of the Pacific Coast, ranging from Washington to Southern California. Prefers mountain forests dominated by pines that produce large cones or those producing many pine seeds. Also found in montane habitat dominated by the Subalpine Fir. When foraging for bark insects, this bird is quiet and unobtrusive, easily overlooked. Diet is a mix of pine seeds and arthropods. Nest is a hole drilled in a dead tree stub, usually fairly low to the ground. Lays four or five white eggs. Some birds may move to lower elevations in winter, but mainly a permanent resident.

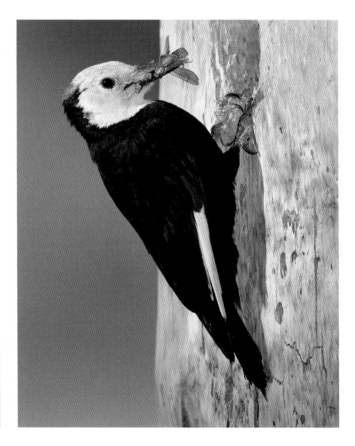

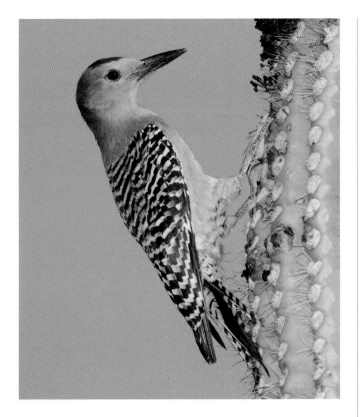

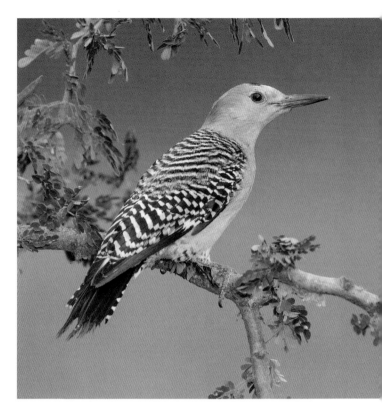

Gila Woodpecker *Melanerpes uropygialis*
L 9" WS 16" ♂ ≠ ♀ GIWO

A handsome and vocal woodpecker of arid lands of the Southwest—southeastern California, southern Arizona, and southwestern New Mexico. The species' range also extends into western Mexico. Inhabits stands of Saguaro cactus, desert washes, cottonwoods, and town yards. Confined to places where there are sufficient nesting sites, which are limited in desert country. In season, quite vocal and also a conspicuous drummer. Diet includes arthropods, other invertebrates, fruit, flower nectar, and even small lizards. Nest hole is drilled into a Saguaro, a cottonwood, or a palm trunk. Lays three or four white eggs.

Golden-fronted Woodpecker *Melanerpes aurifrons*
L 10" WS 17" ♂ ≠ ♀ GFWO

A common woodland woodpecker, very similar to its eastern relative, the Red-bellied. The Golden-fronted ranges from Nicaragua north to central Texas, inhabiting open woodlands near stream courses and dry mesquite brushland. The two species hybridize from time to time where their ranges meet. Diet is fruit, arthropods, and acorns. The nest is excavated in a tree or telephone pole, usually relatively low to the ground. Lays four or five white eggs. Nonmigratory.

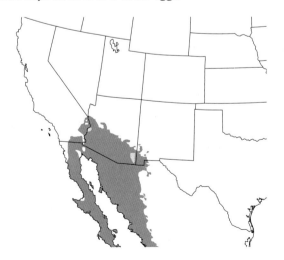

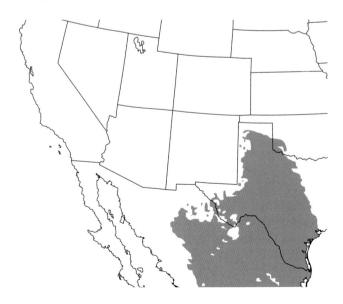

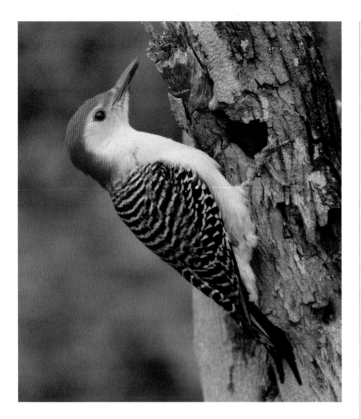

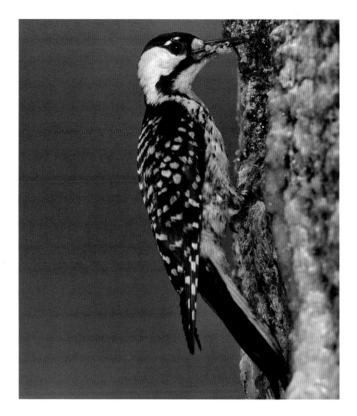

Red-bellied Woodpecker *Melanerpes carolinus*
L 9" WS 16" ♂ ≠ ♀ RBWO

A common woodland woodpecker of the East and Midwest. A regular visitor to backyard suet feeders. Inhabits deciduous forest, forest edge, suburban woodlands, and open mixed forest. The weak reddish wash on the belly is often difficult to detect in the free-ranging bird (and it is not as eye-catching as the male's red cowl). Forages for arthropods as well as fruit and seeds, even acorns. An omnivore. Nest is excavated in dead wood—a tree trunk, large branch, or telephone pole. Lays four or five white eggs. Largely resident, but in some years, many migrate south.

Red-cockaded Woodpecker *Dryobates borealis*
L 9" WS 14" ♂ ≠ ♀ RCWO *NT *WL

A rare woodpecker of the southeast. Inhabits open mature pine forest, especially where some pines exhibit the red heart fungus, which allows the birds to drill a nest cavity in the tree trunk. Favored pines are Longleaf and Loblolly. Nests in loose colonies. Breeding success has been improved by colony translocation and installation of artificial cavity nests in standing tree trunks. Drills a small nest hole in the trunk of a large pine, and scars the bark around the nest hole to encourage sap exudate that marks the nest and perhaps protects the young from nest predation. Forages by flaking bark on pine trunks and harvesting a variety of arthropod prey species; also consumes pine seeds and some fruit. Lays three or four white eggs. Nesting parents are aided by helpers, usually young from the preceding year.

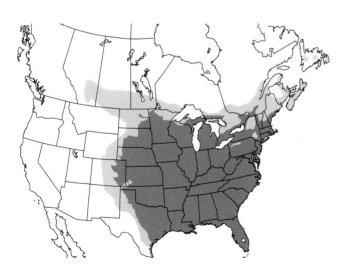

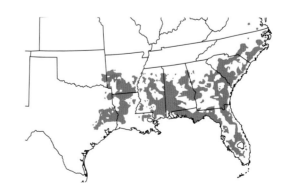

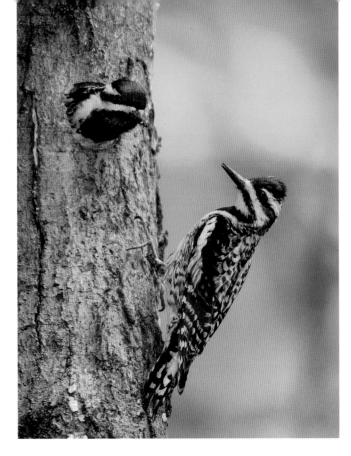

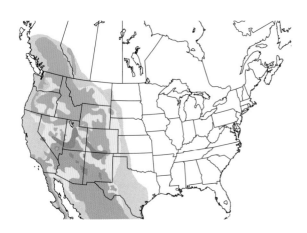

Red-naped Sapsucker *Sphyrapicus nuchalis*
L 9" WS 16" ♂ ≠ ♀ RNSA

Another sapsucker, this one of the Interior Mountain West. Very similar to the Yellow-bellied Sapsucker. Favors aspen groves in the mountains as well as mixed forest with conifers and aspens. Migrates to the Southwest Borderlands and Mexico for the winter. As with all sapsuckers, it drills sap wells in selected trees and feeds upon sap as well as arthropods attracted to the sap. Diet includes fruit and arthropods—especially ants. The male drills a nest hole in an aspen or in a dead conifer. Lays four to six white eggs.

Yellow-bellied Sapsucker *Sphyrapicus varius*
L 9" WS 16" ♂ ≠ ♀ YBSA

The sapsucker of boreal Canada and the Northeast, summering in mixed forests and wintering mainly in the Southeast. Prefers to nest in aspens in mixed conifer forest. One of the few common woodpeckers that is strongly migratory, with summering birds entirely departing their breeding range. As with all sapsuckers, it drills sap wells in selected trees and feeds upon sap as well as arthropods attracted to the sap—especially ants. The species winters into Mexico and the Caribbean. The male excavates a nest hole in an aspen, poplar, or birch. Lays five or six white eggs. Spring drumming is a distinctive ++ staccato tattoo.

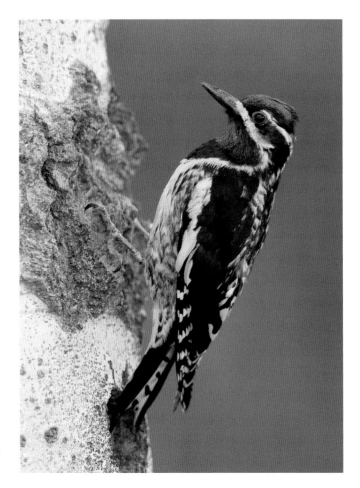

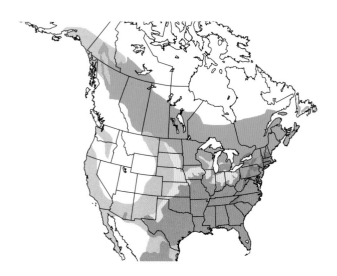

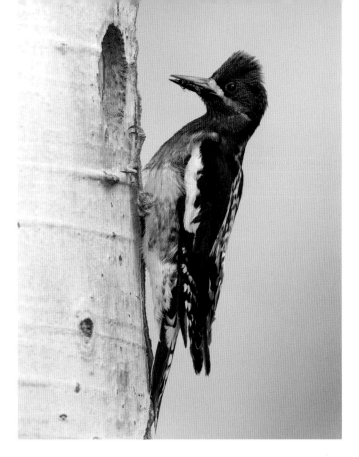

Red-breasted Sapsucker *Sphyrapicus ruber*
L 9" WS 16" ♂ ≠ ♀ RBSA

A sapsucker of the Pacific Coast mountains, from south-eastern Alaska and British Columbia south to northern Baja. Summers in conifer forests with a mix of aspens. Winters in a variety of wooded habitats, both deciduous and conifer-ous. Migrates to the West Coast or southward into California for the winter. As with all sapsuckers, it drills sap wells in selected trees and feeds upon sap as well as arthropods attracted to the sap. Diet includes sap, fruit, and arthro-pods—especially ants. The male drills a nest hole into an aspen, cottonwood, or a conifer. Lays four to six white eggs.

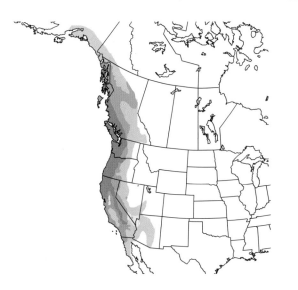

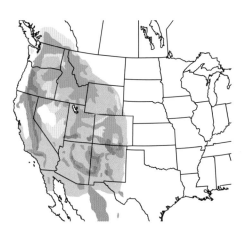

Williamson's Sapsucker *Sphyrapicus thyroideus*
L 9" WS 17" ♂ ≠ ♀ WISA

Male is a pretty sapsucker, patterned in black, yellow, and white, which summers in conifer forests of the Mountain West. Winters in pine-oak woodlands in the mountains. Some drop to lower elevations in winter. Others migrate southward, ranging into the mountains of Mexico. Year-round, it is found in association with conifers. As with all sapsuckers, it drills sap wells in selected trees and feeds upon sap as well as the arthropods attracted to the sap. Diet includes sap, fruit, and arthropods—especially ants. The male excavates a nest hole in a live tree with dead heart-wood—aspen, pine, or fir. Lays four or five white eggs.

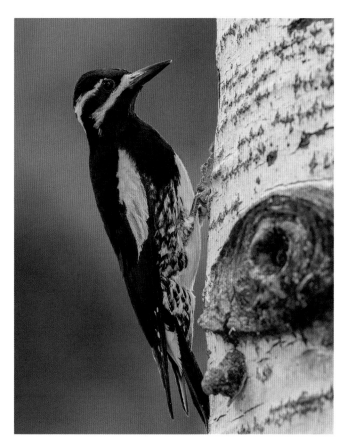

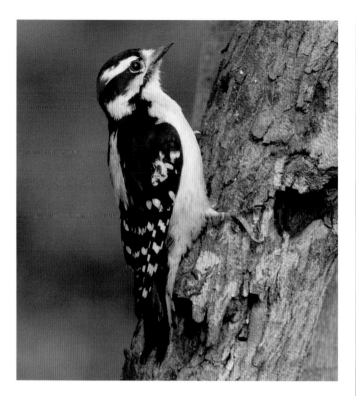

Downy Woodpecker *Dryobates pubescens*
L 7" WS 12" ♂ ≠ ♀ DOWO

A very small, pied woodpecker commonplace across much of North America (but largely absent from the Arid Southwest). Inhabits virtually any woodland habitat, especially sites where there is regrowth of shrubbery and smaller trees. A common backyard bird that favors suet. Forages on twigs and weed stems as well as on larger limbs and trunks. Diet is mainly arthropods, but also takes seeds and berries. The small nest hole is drilled in a limb or small trunk at medium height above the ground. Lays three to six white eggs. Mainly nonmigratory, but some individuals wander (or migrate?) in fall and winter.

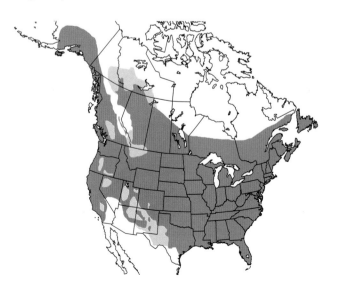

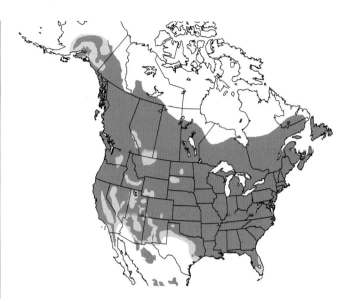

Hairy Woodpecker *Dryobates villosus*
L 9" WS 15" ♂ ≠ ♀ HAWO

A larger version of the Downy Woodpecker. Resident across North America. Usually nonmigratory, but some birds move considerable distances in autumn. Inhabits woodland and forest of all kinds. Widespread and common or uncommon from place to place. Diet is mainly arthropods, but also some seeds and berries. The species' drumming pattern is distinctively rapid. The species ranges southward to Panama. The nest hole is in a dead limb or tree trunk. Lays four or five white eggs. Note the oversized bill.

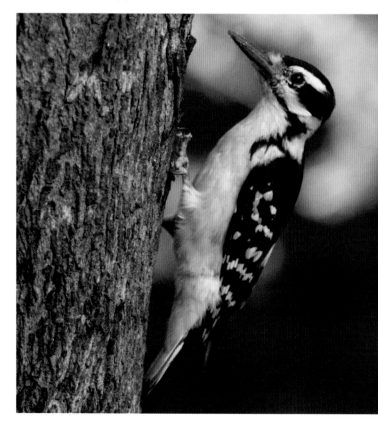

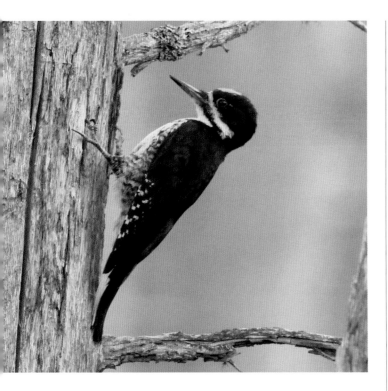

Black-backed Woodpecker *Picoides arcticus*
L 10" WS 16" ♂ ≠ ♀ BBWO

The larger, longer-billed, and glossier of the three-toed wood-peckers in North America. More common across the boreal forest of Northeast, the Sierras, and Alaska; less common in the Rockies. Prefers spruce-fir forests or mixed conifer forests. Found in forests of pine and Douglas-fir in the West. Most common in areas with recently killed conifer stands—from fire or insect infestation. Best found by listening for diagnostic drumming. Uses its larger bill to drill into trees for wood-boring beetles. Nest is a cavity excavated most commonly in a dead conifer. Lays three or four white eggs. A permanent resident of its favored conifer forests, but individ-uals wander in search of recent burns or conifer die-offs.

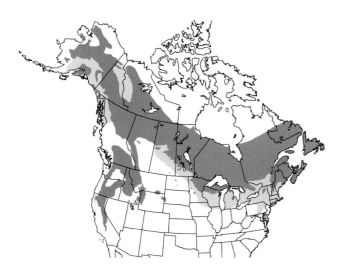

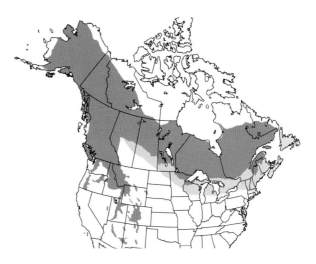

American Three-toed Woodpecker
Picoides dorsalis L 9" WS 15" ♂ ≠ ♀ ATTW

A quiet and inconspicuous inhabitant of boreal conifer forests of Canada and Alaska, as well as of the Interior Mountain West. Always found in association with conifer forests, especially spruce and fir. In the West also found in mountain pine forests. Most common in forests that have been disturbed by fire or that have wood-boring-insect infes-tations. Scales bark off conifers to get at insect larvae. Nest is excavated in a dead conifer or aspen, usually low to the ground. Lays three to six white eggs. Mainly sedentary, but birds do wander in search of patches of dead conifers.

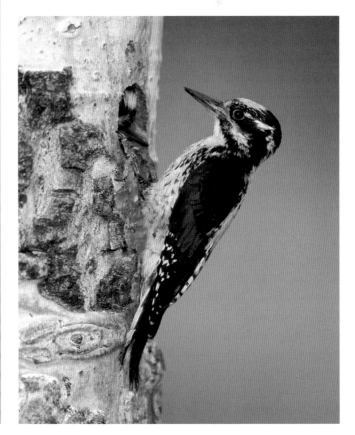

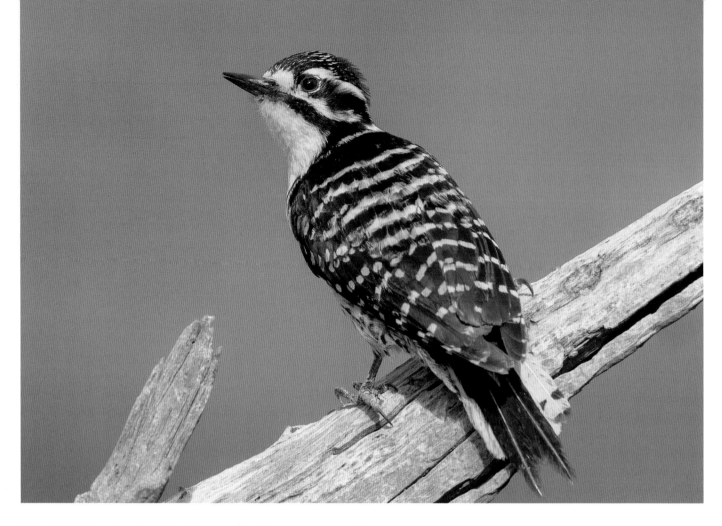

Nuttall's Woodpecker *Dryobates nuttallii*
L 8" WS 13" ♂ ≠ ♀ NUWO

A diminutive pied woodpecker of California oak woodlands. Inhabits riverine woodlands, canyons, and oak foothills in California and northern Baja. Near the Mexican border it is found in riverine woodlands of cottonwood, sycamores, willows, and mesquite. Diet is mainly arthropods, with some fruits and seeds. Nest is drilled into a tree or utility pole, low or high above the ground. Favored trees include sycamore, cottonwood, and willow. Lays three or four white eggs.

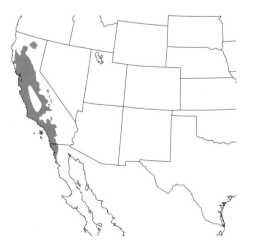

Pileated Woodpecker *Dryocopus pileatus*
L 17" WS 29" ♂ ≠ ♀ PIWO

This is our largest extant woodpecker. Widespread but absent from the Interior West. Frequents forests and wood-lots, ranging from wilderness to suburban areas in Florida and the Mid-Atlantic. The low and cadenced drumming on a hollow log carries a great distance. Also quite vocal. Works through rotting wood in search of carpenter ants and other prey, often leaving distinctive, large rectangular excavations. Also takes fruit of Poison Ivy and other berries. Commonly seen feeding on the ground. Large nest hole is drilled in dead wood of a tree trunk or large dead branch. Lays three to five white eggs.

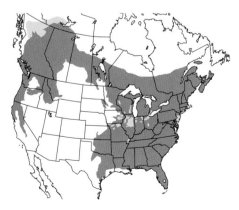

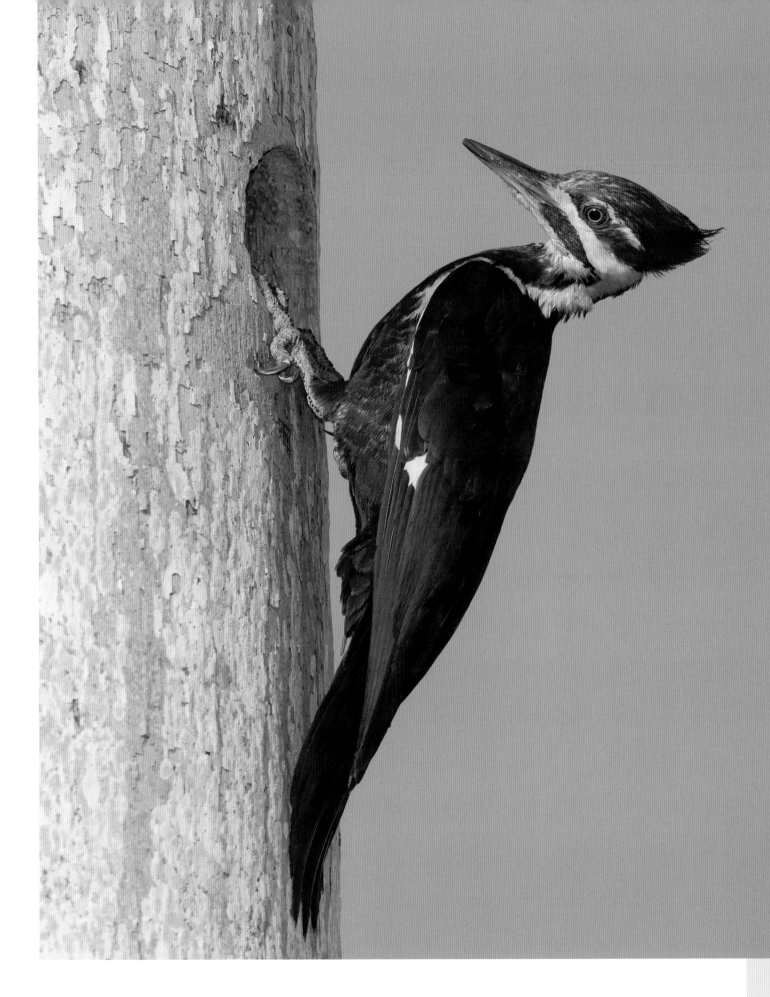

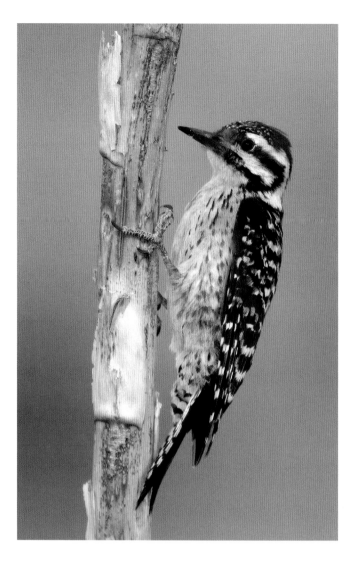

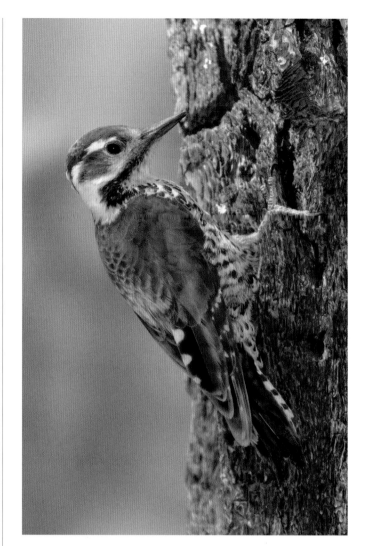

Ladder-backed Woodpecker *Dryobates scalaris*
L 7" WS 13" ♂ ≠ ♀ LBWO

A small, common, and widespread woodpecker from the Arid Southwest to the Texas coast. Nonmigratory. Inhabits a wide range of dry woodland habitats as well as dry brush-lands and desert scrub. Forages for insects and fruit in all available woody growth as well as weedy growth. Sometimes feeds on the ground. The species' range extends southward to Central America. Nest is a cavity excavated in a tree, cac-tus, or fencepost. Lays three or four white eggs.

Arizona Woodpecker *Dryobates arizonae*
L 8" WS 14" ♂ ≠ ♀ ARWO *WL

A small, brown-backed woodpecker of oak forests of the hill country of southeastern Arizona and southwesternmost New Mexico, ranging southward into central Mexico. Inhabits mountains of the Southwest Borderlands where oak and pine-oak forests predominate. It is a quiet bird that forages relatively low in the vegetation. Diet is mainly arthropods, but also some fruit and the occasional acorn. Nest is drilled in the dead stub of a large tree, often a walnut; sometimes nests in an agave. Lays three or four white eggs.

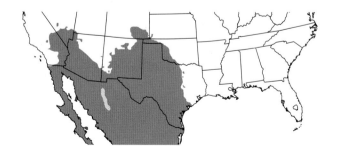

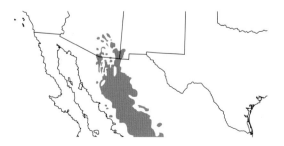

Gilded Flicker *Colaptes chrysoides*
L 11" WS 18" ♂ ≠ ♀ GIFL *WL

A bird of the Southwest desert country, ranging southward into Baja and northwest mainland Mexico. Frequents wooded canyon country and Saguaro desert. Occasionally hybridizes with the Northern Flicker where the two populations meet. Diet presumably similar to that of the Northern Flicker. Drills a nest hole in a giant Saguaro cactus. Lays six to eight white eggs.

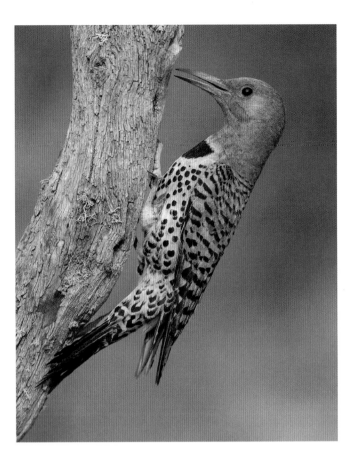

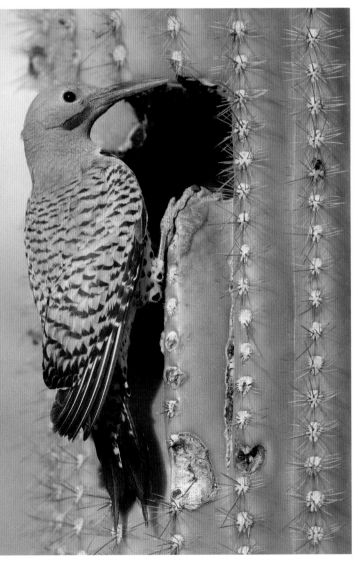

Northern Flicker *Colaptes auratus*
L 13" WS 20" ♂ ≠ ♀ NOFL

A large and atypical woodpecker, which regularly feeds on the ground for ants. Ranges across most of North America. The species also breeds in Mexico, Central America, and Cuba. Canadian populations migrate south into the United States for the winter. Prefers openings in woodlands and forest where it can forage on the ground. Birds in the East exhibit a yellow wash to their wing and tail feathers; those of the West show a reddish wash. Consumes arthropods, fruits, and seeds. Nest is a hole drilled in a dead tree trunk, relatively low to the ground. Lays five to eight white eggs.

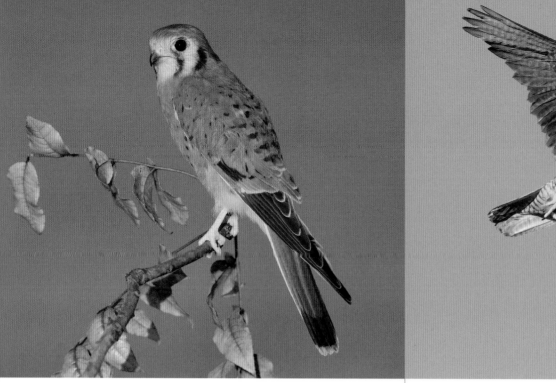

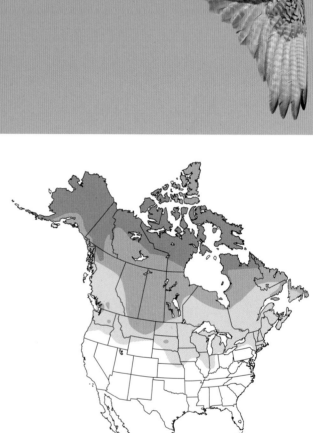

American Kestrel *Falco sparverius*
L 9" WS 22" ♂ ≠ ♀ AMKE

A small, strongly patterned falcon that ranges from Alaska and northern Canada to southern South America. Inhabits open country of all sorts—farmland, desert, prairie, forest edge, suburbs, and even cities. Northern populations migrate southward in autumn. It is typically encountered perched on a telephone wire along a rural roadside. Hunts by scanning the ground from a high perch and dropping on prey; also hovers over fields in search of small rodents. Usually places its nest in a cavity, typically in a dead tree. Lays four to six white or pale brown eggs, in some cases spotted with brown and gray. Has declined in East.

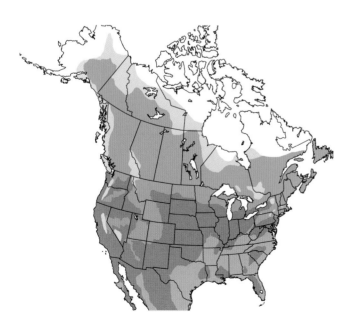

Gyrfalcon *Falco rusticolus*
L 22" WS 47" ♂ = ♀ GYRF

Our largest falcon. A rare visitor to the Lower 48 from its breeding habitat in the far northern tundra of Canada and Alaska. Most often seen in the northern US Borderlands both west and east. Other populations inhabit northern Eurasia. Summers in open tundra, seacoasts, and rocky mountain heights. Winters in similar open wind- and snow-swept rural countryside. Hunts for its prey of waterfowl, game birds, and small mammals, either from a high perch or while cruising over open countryside. Nest is a scrape on the ground situated on a cliff ledge or in an abandoned nest of a raven or hawk. Lays three or four whitish eggs spotted with reddish brown. Population appears to be stable.

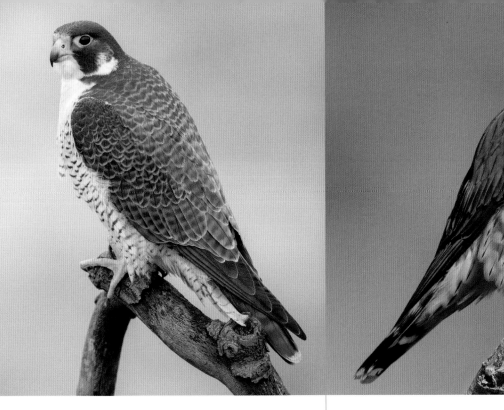

Peregrine Falcon *Falco peregrinus*
L 16" WS 41" ♂ = ♀ PEFA

This noble hunter summers across the Northern Hemisphere and has additional breeding populations around the world. Having recovered from its decimation from pesticide poisoning in the mid-twentieth century, it is now found widely across North America as a migrant and patchy breeder. Inhabits a wide range of open habitats, especially where there are cliffs or other safe places to roost and nest. Most commonly seen along the coast in autumn migration. A great hunter of waterfowl and wading birds, often stooping from heights down on the intended prey. Diet is almost exclusively birds of various sorts. Pairs nest on buildings and other structures in cities; others nest on cliffs or other protected high sites. Lays three or four whitish or buff eggs heavily marked with reddish brown.

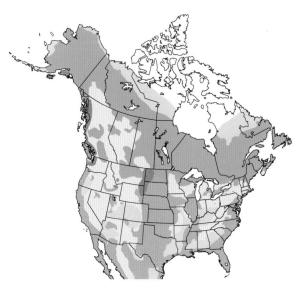

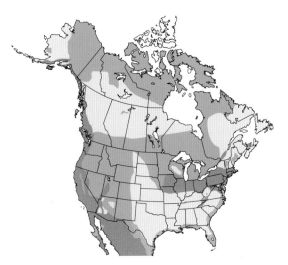

Merlin *Falco columbarius*
L 10" WS 24" ♂ ≈ ♀ MERL

A small and dark falcon of North America and Eurasia. Summers in boreal forests, prairie woodlots, and coastal temperate rainforest; winters southward. A permanent resident in the northern Great Plains. Winters as far south as Venezuela, in a wide range of open habitats such as marshlands and grasslands. A fast-flying and agile predator. Vocal around the nest. Diet is small birds and dragonflies, often consumed on the wing. Typically nests in an old crow nest high in a tree at the edge of an opening. Lays four or five whitish eggs marked with reddish brown. Has expanded its range considerably. The species is under no threat.

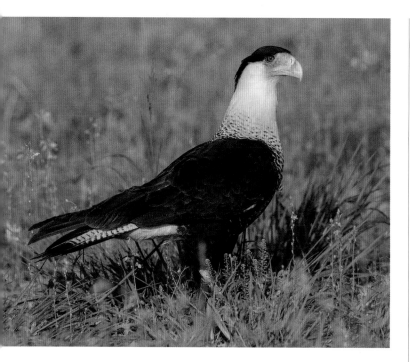

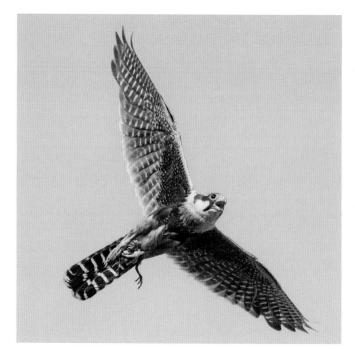

Crested Caracara *Caracara plancus*
L 23" WS 49" ♂ = ♀ CRCA

Often seen in flight—a strange-looking Neotropical raptor with a long neck, long tail, long legs, and long wings. This nonmigratory species ranges from South America north to Arizona, Texas, and Florida. Of late, wandering individuals have shown up in many additional states (e.g., Washington, South Dakota, and Maine). Inhabits arid brushland, prairie, and open rangeland. May steal prey from other birds. Diet includes carrion and small vertebrates. Spends much time on the ground. Nest, situated in a tree or shrub, is a bulky platform of sticks and other materials, often set atop the nest of another species. Lays two or three pale brown eggs blotched with dark brown. This is the national bird of Mexico. Florida population threatened. Texas population increasing.

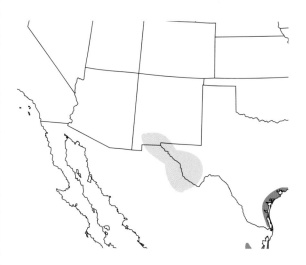

Aplomado Falcon *Falco femoralis*
L 16" WS 35" ♂ = ♀ APFA

A strikingly patterned and slim tropical falcon that ranges northward from South America to the Southwest Borderlands. US populations have been decimated by habitat loss. Recently subject to reintroduction efforts in the Lower Rio Grande Valley of South Texas. Formerly inhabited coastal prairie and desert grasslands. Individuals wander into New Mexico and West Texas from neighboring Chihuahua. Typically seen perched atop a yucca plant. Hunts in pairs, cruising low over grassland. Diet is mainly small birds and also arthropods. Nests in an abandoned stick nest of a raven or other large bird that is situated atop a yucca or other low bush. Lays three or four white or pinkish eggs spotted with brown.

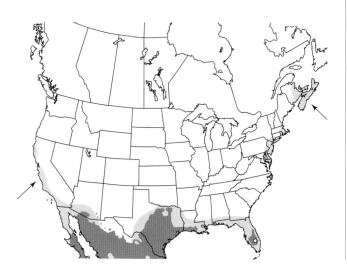

Prairie Falcon *Falco mexicanus*

L 16" WS 40" ♂ = ♀ PRFA

Our falcon of the arid Interior West. In winter it strays widely from its breeding sites. Paler and slimmer than the more familiar Peregrine. Inhabits dry hills, cliffs, plains, prairies, and desert lands, usually within access of its cliff nesting site. Known to hunt by cruising low over the ground and dropping on unsuspecting terrestrial prey (a small bird or mammal). Nest is situated on a cliff ledge with minimal adornment. Lays three or four whitish eggs spotted with brown. The species appears to be declining locally. The post-DDT expansion of nesting Peregrine Falcons may be having a negative impact on this smaller species.

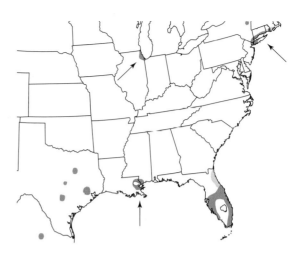

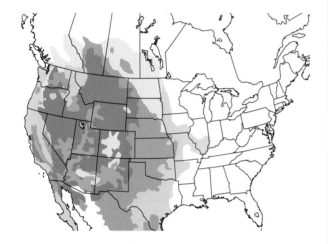

Monk Parakeet *Myiopsitta monachus*

L 12" WS 19" ♂ = ♀ MOPA

A small green parrot native to southern South America. Released captive birds have become established in various urban settings in the Lower 48. Groups roost year-round in their huge stick nest. Diet is mainly fruit and seeds, as well as blossoms and arthropods. Nests communally in a globular stick nest placed in a tree or utility pole. Lays five or six white eggs. This is the most abundant parrot-relative in North America. The species is capable of surviving harsh winters of New England and northern Illinois by adapting to local conditions—taking bird seed and roosting in groups.

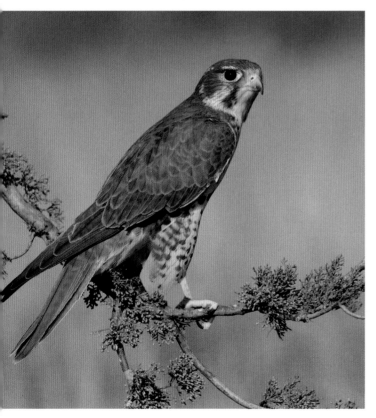

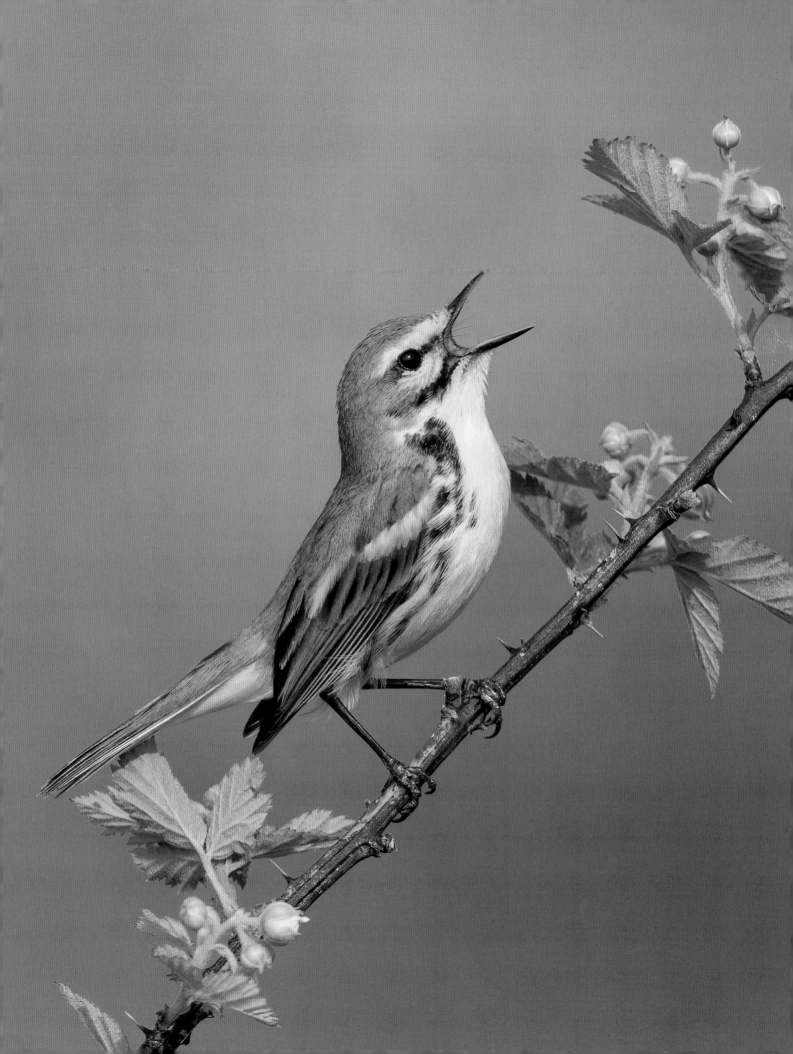

THE PASSERINES

Opposite: Prairie Warbler in song.
Right: Yellow-billed Magpie in flight.

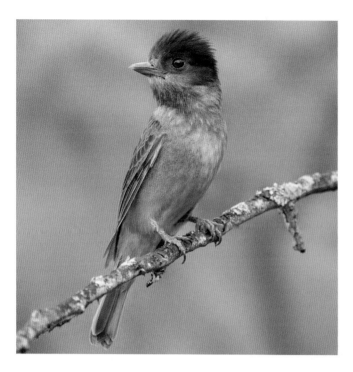

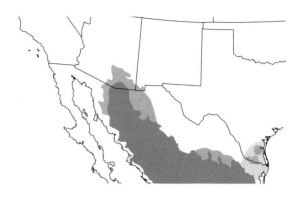

Northern Beardless Tyrannulet
Camptostoma imberbe
L 4.5" WS 7" ♂ = ♀ NOBT

This insubstantial tropical tyrannid ranges from Costa Rica north to our Southwest Borderlands—found in southernmost Arizona, southwesternmost New Mexico, and Texas. Best located by its high, clear call notes. Found in stream thickets, wooded canyons, and mesquite thickets. Moves through foliage to glean insects from leaves. Diet is mainly small arthropods and perhaps some berries. Nest is a small globe of grasses with an entrance hole high on the side. Lays one to three off-white eggs dotted with brown and gray. The species lacks the rictal bristles typical of the family. Birds summering in Arizona winter in northwestern Mexico.

Rose-throated Becard *Pachyramphus aglaiae*
L 7" WS 12" ♂ ≠ ♀ RTBE

A compact tropical songbird that ranges from Panama to northern Mexico and that, on occasion, summers in small numbers north of the Border in Arizona and South Texas. Breeding birds inhabit dry woodlands along streams and rivers, mainly in sycamores and cottonwoods. The becard spends its time in the canopy of larger trees, making itself difficult to see. Forages for arboreal arthropods and fruit. The nest is the most striking thing about this bird—a large globe of dried vegetation, with an entrance low on the side, suspended from a long hanging branch. Lays four to six whitish or buff eggs blotched with brown.

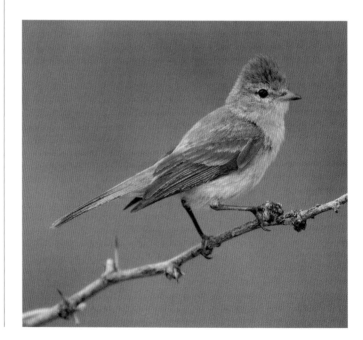

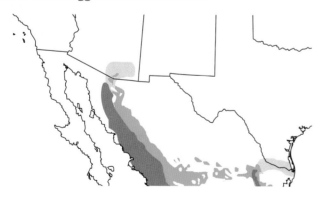

RANGE MAP COLOR LEGEND

summer migration year-round winter rare

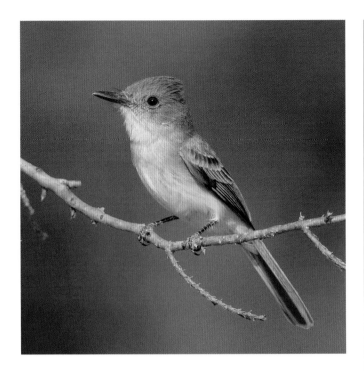

Dusky-capped Flycatcher *Myiarchus tuberculifer*
L 7" WS 10" ♂ = ♀ DCFL

One of our six *Myiarchus* flycatchers, this tropical species ranges from Argentina north to our Southwest Borderlands in the summer season. North American breeders winter south of the Border. Summers in pine-oak canyons, oak-dominated hillsides, and stands of juniper in rocky arid lands. Also found in cottonwoods and sycamores along stream beds. Hover-gleans from foliage in tall trees. Diet is mainly arthropods, with a small complement of berries. Nest is situated in a natural cavity or old woodpecker hole, often in an oak or sycamore. Lays four or five creamy-white eggs marked with darker colors.

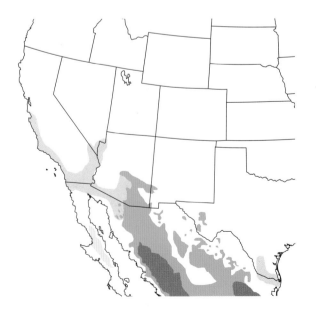

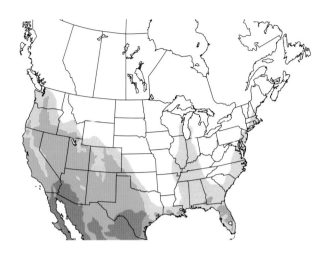

Ash-throated Flycatcher *Myiarchus cinerascens*
L 9" WS 12" ♂ = ♀ ATFL

Another of the *Myiarchus* flycatchers, this species summers through the Arid West and Mexico, wintering in Mexico, Central America, and our Borderlands. A year-round resident in southwestern Arizona. Wanders widely, especially to the Atlantic, Pacific, and Gulf Coasts. Summers in mesquite brushlands, desert, streamside habitats, rolling oak savanna, and pinyon-juniper woodlands in low country. Often difficult to locate as it perches within low vegetation. Diet is mainly insects taken by hover-gleaning; also takes fruit. Nest is a jumble of grasses situated in a natural cavity or in an old woodpecker hole in a tree or cactus. Lays four or five cream-colored eggs blotched with dark.

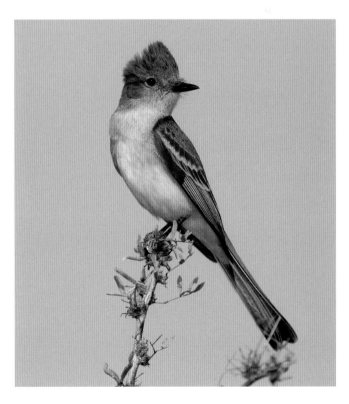

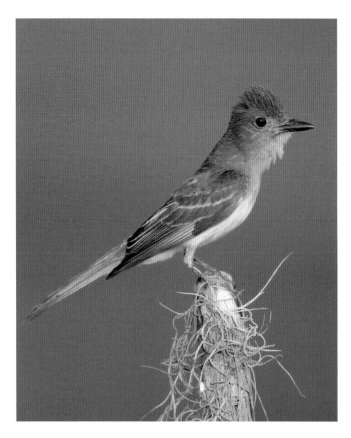

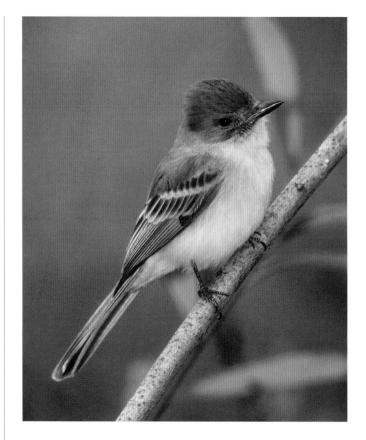

Nutting's Flycatcher *Myiarchus nuttingi*
L 8" WS 12" ♂ = ♀ NUFL

This tropical species ranges from Costa Rica northward to northwestern Mexico; exceptionally to the Arid Southwest, where it has bred in Arizona. Records also from southern California and Texas. Best distinguished from other members of the genus by voice. Also note the orange-colored lining of the mouth. Very similar to the Ash-throated Flycatcher. Found in low country of the Southwest Borderlands—mainly mesquite thickets and other low vegetation in desert. The species has a very broad range and is presumably not in any way threatened.

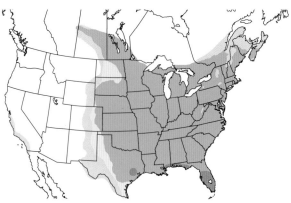

Great Crested Flycatcher *Myiarchus crinitus*
L 9" WS 13" ♂ = ♀ GCFL

The common and widespread *Myiarchus* flycatcher of the East and Midwest. Summers in the canopy of deciduous and mixed forest—both interior and at the edge of openings. Winters from South Florida and Cuba to southern Mexico and Colombia. Generally found foraging high in the forest canopy, sallying out for flying insects or hover-gleaning off foliage. Diet is mainly insects; also takes berries. Nest is situated in a natural cavity or old woodpecker hole, usually fairly high in the forest. Sometimes will nest in a nest box. Nest foundation is made of various strands of vegetation, and the nest is often adorned with a shed snake skin. Lays four to six whitish eggs marked with darker colors.

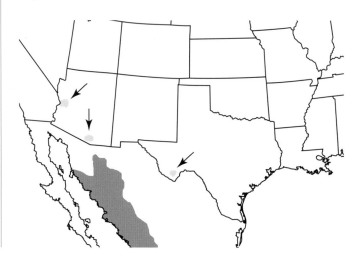

Brown-crested Flycatcher *Myiarchus tyrannulus*
L 9" WS 13" ♂ = ♀ BCFL

A tropical *Myiarchus* species that ranges from northern Argentina to our Arid Southwest—most commonly in southern Texas and southern Arizona. North American breeders mainly winter in nearby Mexico. Found where there are large trees—in canyons, low desert, and riverine bottoms. Favors sycamores, cottonwoods, and Saguaro cacti. Hover-gleans from relatively high in the vegetation. Diet is mainly arthropods, but will also take lizards and fruit. Nest is situated in a tree cavity or Saguaro—usually in the abandoned hole of a large woodpecker. Lays four or five whitish or pale buff eggs blotched with darker colors. Population stable.

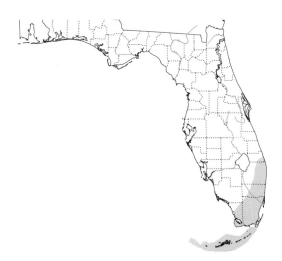

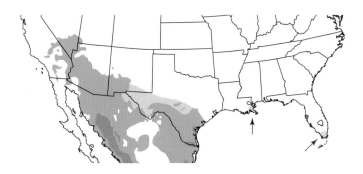

La Sagra's Flycatcher *Myiarchus sagrae*
L 7" WS 11" ♂ = ♀ LSFL

This *Myiarchus* flycatcher of the northwestern Caribbean is a rare stray to South Florida, with typically one or two records each year. Found mainly in winter and spring. Identified by the pale underparts and distinctive call note. Usually found in scrubby woodlands of native hardwood trees mixed with shrubs. Florida records from October to May.

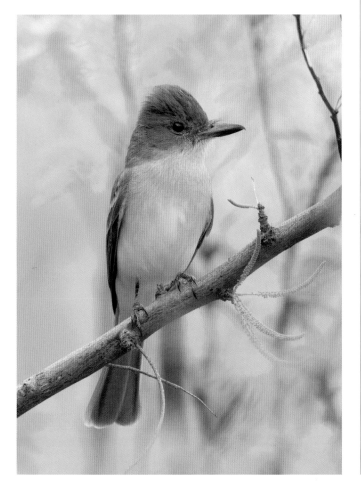

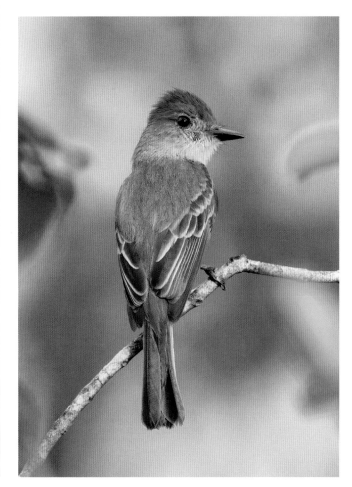

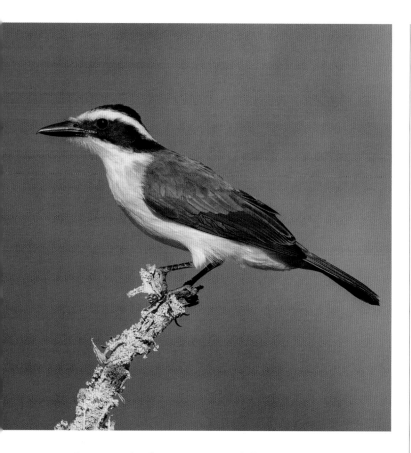

Sulphur-bellied Flycatcher
Myiodynastes luteiventris
L 9" WS 15" ♂ = ♀ SBFL

A Mexican and Central American breeding species that winters in South America. The species' range edges into southern Arizona, where it summers. Breeds in sycamore-walnut canyon bottoms in arid country. Hawks insects from a high perch and also hover-gleans arthropods from leaves. Diet includes insects and some fruit. In Arizona, typically nests in a large natural cavity (often in a sycamore). Cavity is filled with plant material upon which the eggs are laid. Lays three or four white eggs with heavy reddish-brown spotting.

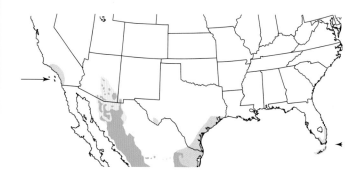

Great Kiskadee *Pitangus sulphuratus*
L 10" WS 15" ♂ = ♀ GKIS

This distinctive and vocal tropical species ranges from Argentina north to southern Texas, straying regularly into neighboring states. Prefers thick subtropical woodlands near water. Often perches low over water. Diverse foraging styles: hawking insects in the air, taking fish from water, and plucking fruit. Diet is arthropods, fruit, and small vertebrates, including fish, baby birds, mice, and lizards. Nest is a bulky globe of grass with an entrance on the side; nest is placed in branches of a tree or shrub. Lays two to five whitish eggs dotted with darker colors. Has a hidden bright yellow sagittal crest that it can raise provocatively when excited. Its range in Texas is creeping northward. This widespread species is not under threat.

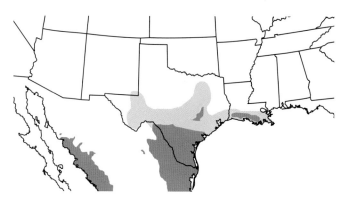

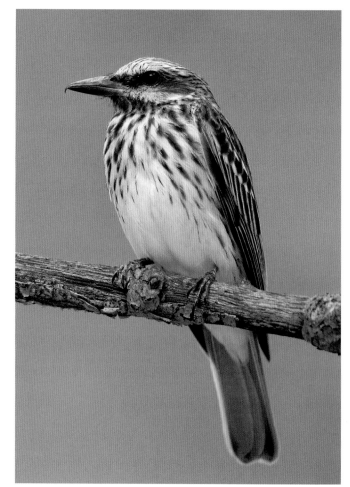

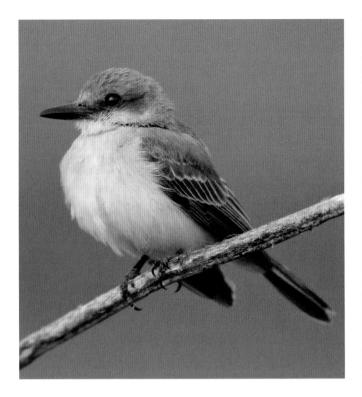

Tropical Kingbird *Tyrannus melancholicus*
L 9" WS 15" ♂ = ♀ TRKI

A tropical flycatcher that ranges from Argentina north to the Southwest Borderlands. Inhabits open country with large trees—places such as city parks, golf courses, and stream courses lined with cottonwoods. Distinguishable from the nearly identical Couch's Kingbird by voice. Hawks flying insects from a high perch; also drops on terrestrial arthropods. Nest is a grassy cup placed in the fork of a branch of a tree; nest is usually no more than 25 feet from the ground. Lays three or four buff or pinkish eggs with blotches of darker colors. North American breeders mainly winter south of the Border. Some birds winter in coastal California and South Florida. The northern edge of the range of this species is moving slowy northward. A vagrant to the Mid-Atlantic.

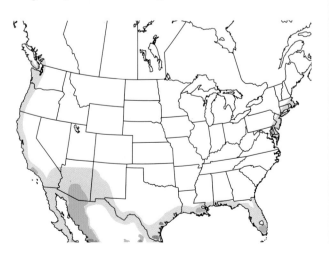

Couch's Kingbird *Tyrannus couchii*
L 9" WS 16" ♂ = ♀ COKI

An eastern Mexican species that ranges to Guatemala. The species summers northward into South Texas. Northernmost breeders mainly winter southward. Inhabits open landscapes with large trees near a river or stream; also found in dense brushland as well as in large trees in towns. A sit-and-watch hunter, launching out from a prominent perch to either hawk a flying insect, hover-glean an insect from a leaf, or take a terrestrial prey item from the ground. Diet is mainly insects and small fruit. Nest is a messy flat cup of twigs and other vegetation placed on a horizontal tree limb. Lays three or four pinkish or buff eggs blotched with darker colors. Best distinguished from the nearly identical Tropical Kingbird by voice. Range expanding.

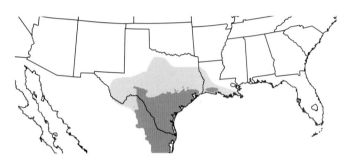

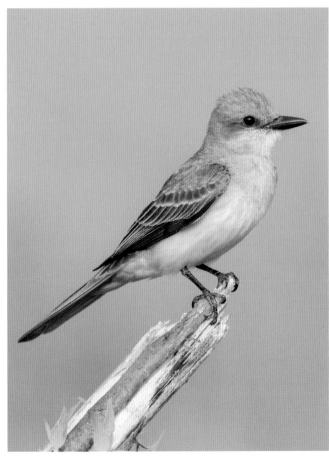

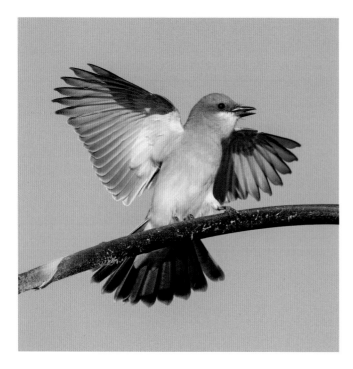

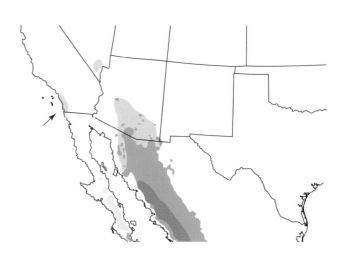

Cassin's Kingbird *Tyrannus vociferans*
L 9" WS 16" ♂ = ♀ CAKI

A very vocal kingbird that ranges from southern Mexico north to Montana and central California. Winters in Mexico and coastal Southern California. A species of the arid Interior West. Frequents openings in foothills and mountain country, especially pine forest, oak savanna, and cottonwoods along stream courses. Nest is a bulky cup of grass and twigs placed out on a horizontal branch out from the trunk. Lays three or four cream-colore

Thick-billed Kingbird *Tyrannus crassirostris*
L 10" WS 7" ♂ = ♀ TBKI

This Mexican species ranges in summer to the Borderlands of Arizona, where a few breed every year. Also a winter vagrant to Southern California and Nevada. Summers in cottonwoods and sycamores along permanent streams in the lowlands; vagrants in winter appear in urban parks with large trees. Hawks for flying insects from a high perch, making long swooping flights to capture its prey. Diet is arthropods—typically large insects. Nest is a messy cup of grass, twigs, and other vegetation set high in a sycamore or cottonwood. Lays three or four whitish eggs blotched with brown. The local distribution in Arizona has contracted in the last twenty years.

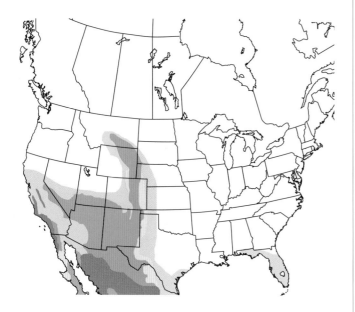

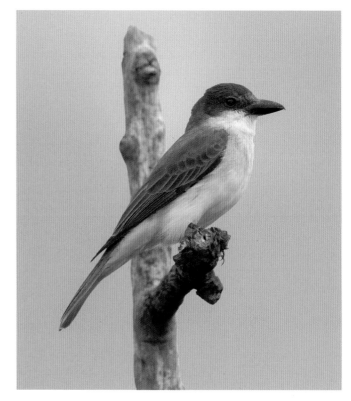

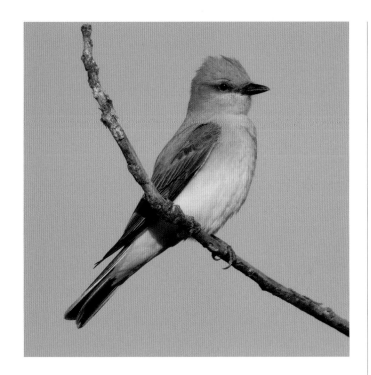

Western Kingbird *Tyrannus verticalis*
L 9" WS 16" ♂ = ♀ WEKI

The common open-country kingbird of the West. Summers from the Great Plains to California, preferring agricultural lands, rural roadsides, town parks, and streamside trees in prairie country. Winters southward to Central America. Hawks insects from a high perch, but also forages low to the ground in cool weather. Diet is mainly insects and a few kinds of fruit. Nest is a cup of grass and twigs placed on a branch up in a tree or in other protected locations (a building ledge, a cliff, or an abandoned shed). Lays three to five whitish eggs blotched with darker colors. Seen migrating in small flocks. Often found sharing breeding habitat with the Eastern Kingbird where ranges overlap. More common than the four other yellow-bellied kingbirds of the Southwest. The species' population is stable or perhaps increasing.

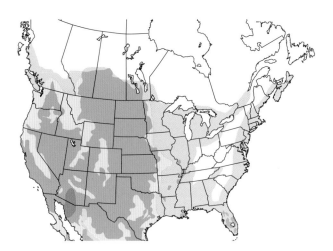

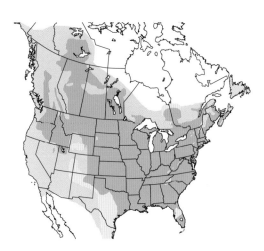

Eastern Kingbird *Tyrannus tyrannus*
L 8" WS 15" ♂ = ♀ EAKI

The common kingbird of the East and Midwest, ranging into the habitat of the Western Kingbird in the northern Great Plains and northern portion of the Interior West. Winters southward to northern Argentina. Breeding birds are commonplace in open country where shade trees mix with fields—especially orchards and farmlands and near water. Noisy and aggressive. Forages from prominent high perches, sallying out to capture passing arthropods. Diet is mainly insects supplemented with small fruits. Nest is a bulky and messy cup of weeds and grasses placed in a shrub or tree. Lays three or four white or pinkish eggs heavily blotched with brown. Migrates in flocks during the day.

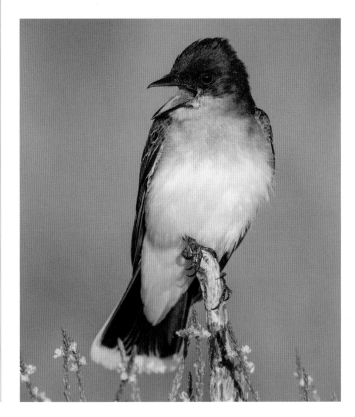

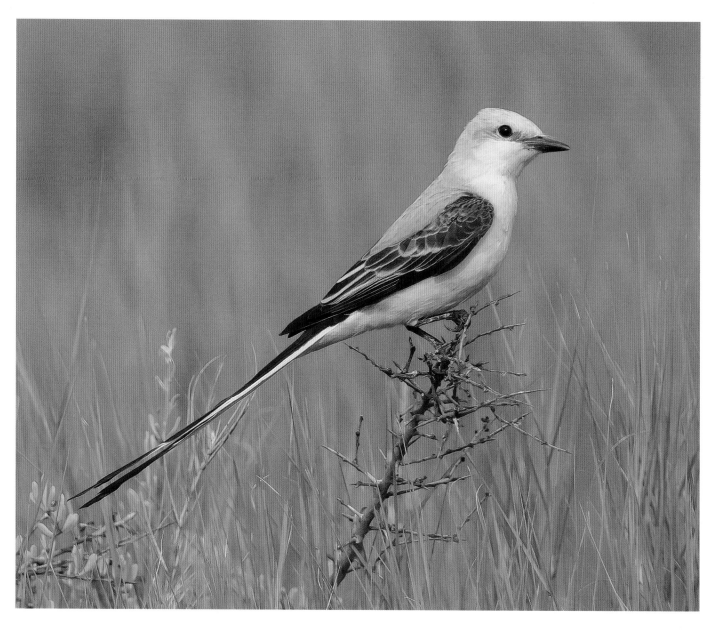

Scissor-tailed Flycatcher *Tyrannus forficatus*
L 15" WS 15" ♂ ≈ ♀ STFL

The Oklahoma state bird, this lovely pale streamer-tailed flycatcher of the lower Great Plains is a favorite of birders. It frequents roadside fence lines, ranches, farmland, and other open country mixing trees and grasslands. Winters in southern Mexico and Central America. A few birds regularly overwinter in Florida, Louisiana, and Texas. Sits atop a prominent open perch, launching out after winged insects in the air, on vegetation, or on the ground. Diet is mainly arthropods; in some seasons, consumes small quantities of fruit. Nest is a messy cup of grass, twigs, and other material placed on a branch in a tree or shrub. Lays three to five whitish eggs blotched with darker colors. Nesting birds aggressively defend their nest territories from other passing birds.

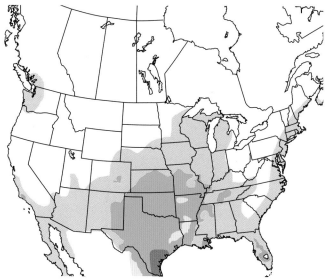

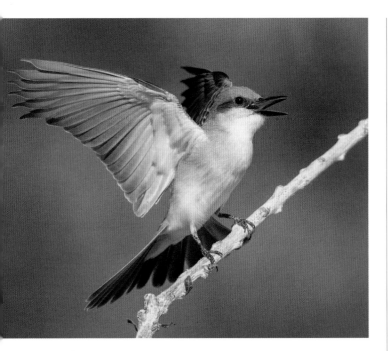

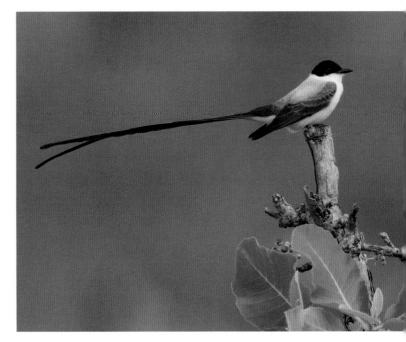

Gray Kingbird *Tyrannus dominicensis*
L 9" WS 14" ♂ = ♀ GRAK

This big, pale kingbird of the Caribbean and northern South America also breeds in virtually any Florida coastal habitat, and occasionally breeds on the coasts of Georgia, South Carolina, and Mississippi. Nonbreeders wander through the Lower 48 with regularity, especially along the Gulf and East Coasts. Found in mangroves, roadsides, and woodland edges. Foraging typical of the kingbirds. Diet is mainly insects with the occasional berry. Nest is a thin grassy cup placed in a mangrove, shade tree, or utility pole. Lays three or four pale pink to buff eggs blotched with brown. Winters outside of the United States. Population of the species appears stable.

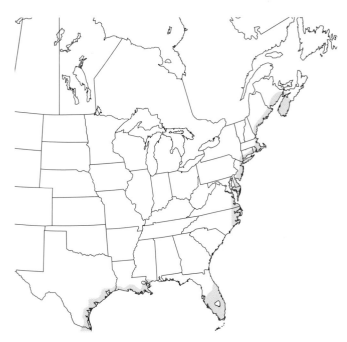

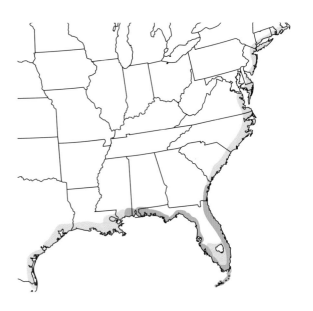

Fork-tailed Flycatcher *Tyrannus savana*
L 16" WS 14" ♂ ≈ ♀ FTFL

This striking streamer-tailed flycatcher of South and Central America wanders to the Lower 48 yearly, with about 10 records per annum—mainly along the Gulf and East Coasts. Habits are much like the Eastern Kingbird. Found in open habitats, foraging from prominent perches. The species migrates within South America, and our birds are probably migratory "overshoots." A common species through its broad breeding range. Not under threat.

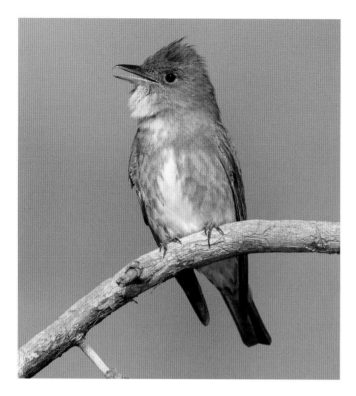

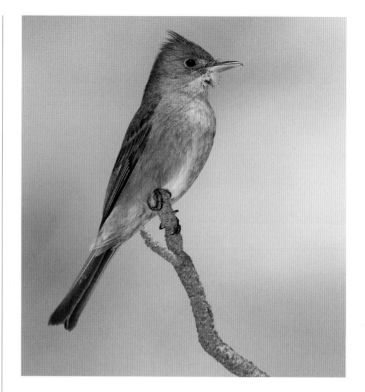

Olive-sided Flycatcher *Contopus cooperi*
L 8" WS 13" ♂ = ♀ OSFL *NT *WL

An uncommon flycatcher of boreal forests of the East and North and mountain conifer forests of the West. Also breeds along the West Coast. It is a late-spring migrant. Winters widely through the Neotropics. Has been in serious decline of late from unknown causes. Prefers openings at the edge of conifer forest. Invariably perches high atop of prominent dead branch, sallying out long distances to capture flying insects. Diet is exclusively winged arthropods. Nest is a low cup of twigs and grass hidden on a branch among foliage. Lays two to four white or pinkish eggs marked with darker colors.

Greater Pewee *Contopus pertinax*
L 8" WS 13" ♂ = ♀ GRPE

This very plain flycatcher of Mexico and Central America ranges north in summers to the Arid Southwest, breeding in southern New Mexico and Arizona in mountain pine and oak forests and canyon country. Also wanders into Texas and Southern California. Winters in northern Mexico. Notable for its loud "Jose Maria" song. It hawks passing insects from a high perch (typically a pine branch). Nest is a nice cup of grass and leaves held together by spider silk and encrusted with lichens. Lays three or four whitish eggs marked with darker colors. Exhibits a prominent orange lower mandible.

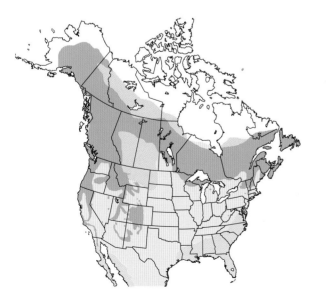

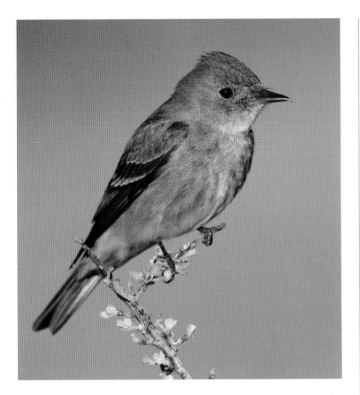

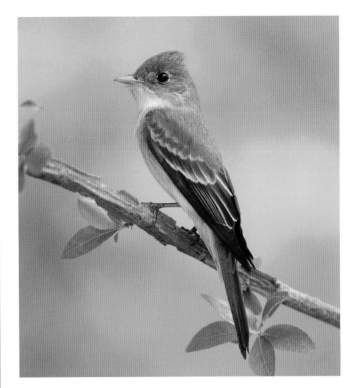

Western Wood-Pewee *Contopus sordidulus*
L 6" WS 11" ♂ = ♀ WEWP

This western counterpart of the familiar Eastern Wood-Pewee is best distinguished by its vocalization. It breeds in a range of open woodland habitats, including pine-oak forest, open pine woodland, and riverine groves. Winters from Central America to Bolivia. Hawks insects from the air and from vegetation from a mid-story perch in a woodland opening. Diet is mainly flying insects, plus some fruit. Nest is a flat, open cup of grass and plant fibers situated on a forked branch and placed at varying heights above the ground. Lays two to four whitish eggs blotched with darker colors.

Eastern Wood-Pewee *Contopus virens*
L 6" WS 10" ♂ = ♀ EAWP

A common and familiar voice of eastern forests in summer. Heard much more often than seen. Prefers the presence of forest openings, but tends to stay in vegetation. Winters across northern South America. Forages from a mid-story branch, usually in the shade, from which it hawks flying insects and hover-gleans arthropods from nearby leaves. Diet mainly arthropods and some fruit. Nest is placed on a branch within a deciduous tree or a pine; the compact cup nest is made of grass, plant fibers, and spider silk. Lays two to four whitish eggs blotched with darker colors.

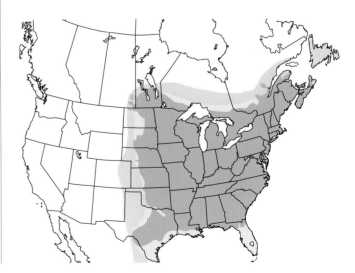

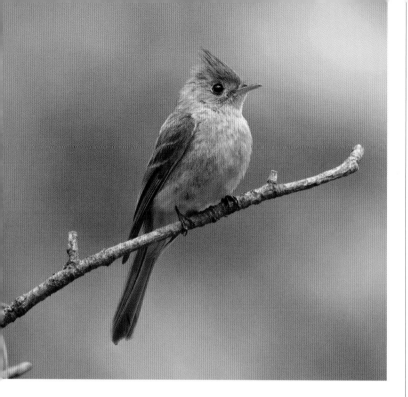

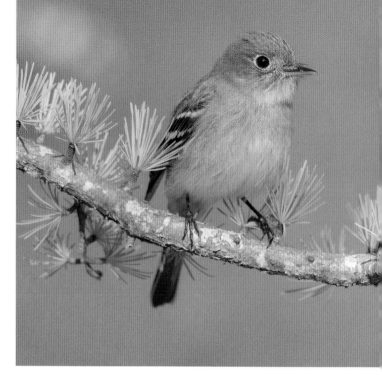

Tufted Flycatcher *Mitrephanes phaeocercus*
L 5" WS 7" ♂ = ♀ TUFL

This crested tropical species, which ranges from Colombia northward to northwestern Mexico, has attempted to nest a few times in southeastern Arizona. It is rare visitor to Arizona and very rare in West Texas. Prefers mountain pine forests. Sallies out to capture prey. Nest is a shallow cup of dark rootlets and green moss and lined with lichens. Lays two eggs. Population is stable.

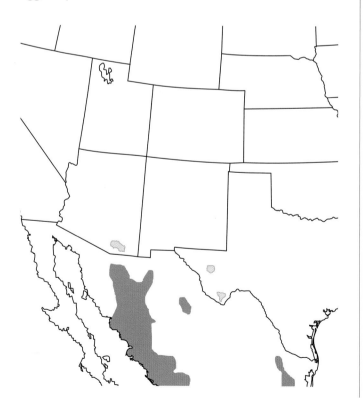

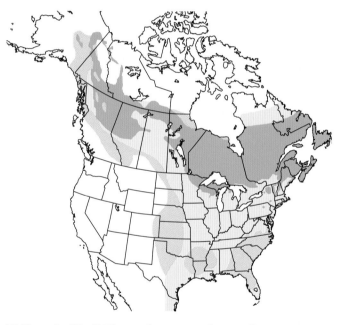

Yellow-bellied Flycatcher *Empidonax flaviventris*
L 5.5" WS 8" ♂ = ♀ YBFL

A summer denizen of thick northern conifer forests and spruce bogs. Also nests in white-cedar swamps and alder thickets along watercourses in conifer forest. Winters from Mexico through Central America. In migration, seen most often in fall and rarely in spring. Perches low in vegetation, hawking passing aerial arthropods. Typically stays out of sight and is heard more often than seen. Diet is mainly winged arthropods, spiders, caterpillars, and a small complement of fruit. The bulky cup nest of mosses, vegetation, and rootlets is placed on or near the ground in a hidden spot in conifer forest. Lays three or four whitish eggs spotted brown. Invariably located in summer by its vocalizations.

Acadian Flycatcher *Empidonax virescens*
L 5.8" WS 9" ♂ = ♀ ACFL

A common summer flycatcher of damp bottomland deciduous forest interior of the East and Midwest. Its explosive two-note song is the best means of locating this bird. Winters in Central America and northern South America. Mainly takes flying arthropods hawked from a perch within the shaded interior of forests. Diet is mainly arthropods and some fruit. Nest is a loose cup of grass and twigs and is suspended from a fork of a branch, with materials hanging off the cup. Lays two to four whitish eggs lightly spotted brown.

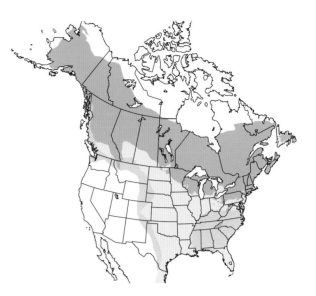

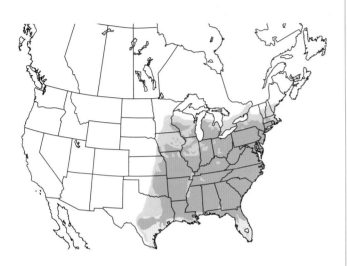

Alder Flycatcher *Empidonax alnorum*
L 5.8" WS 9" ♂ = ♀ ALFL

Distinguished from the very similar Willow Flycatcher by voice; Alder is the more northerly of the two. Winters in western South America. Inhabits thick, shrubby vegetation surrounding bogs and slow streams. Prefers alders and willows. Hawks winged arthropods from low in the vegetation; also takes some fruit. The shaggy nest is placed in a vertical fork in a low shrub. Nest is a cup of grass, strips of bark, and rootlets. Lays three or four white eggs spotted brown.

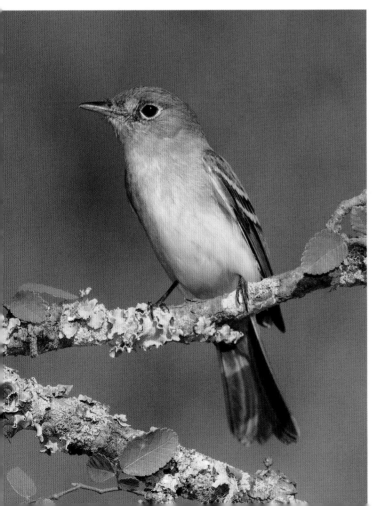

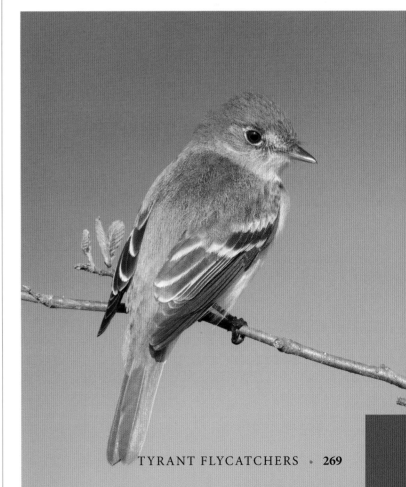

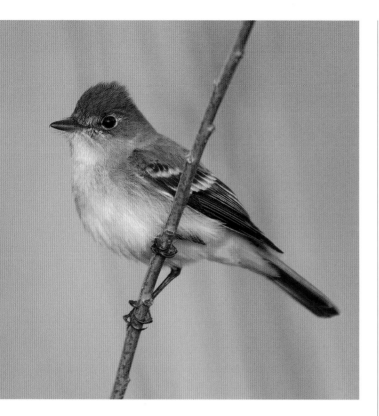

Willow Flycatcher *Empidonax traillii*

L 5.8" WS 9" ♂ = ♀ WIFL

A reclusive species of thickets and brushland, often but not always in wet spots. Summers across the Lower 48 and southern Canada, though mostly absent in the Deep South. Winters from southern Mexico to northern Peru. Breeding birds prefer deciduous thickets, both bottomland and wet, and upland and dry. Hawks flying arthropods from a perch in a bush or low tree. Also takes some fruit. The small cup nest of grass and plant fibers is set on a rising branch in a shrub. Lays three or four buff or whitish eggs with brown spots. Identified by habitat and distinctive voice.

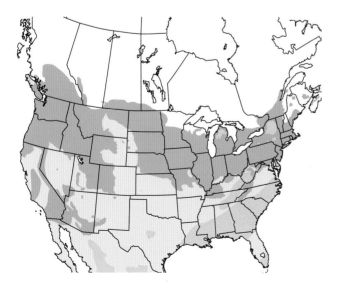

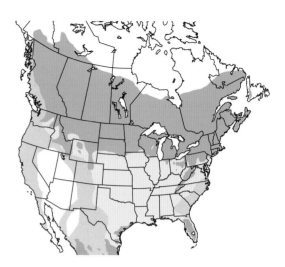

Least Flycatcher *Empidonax minimus*

L 5.3" WS 8" ♂ = ♀ LEFL

For birders, this forest-dweller is the northern counterpart to the Acadian Flycatcher, breeding in deciduous and mixed forests of Canada, the northern United States, and Appalachians. Winters in Mexico and Central America. Its distinctive *CHE-bek* call is heard in northern forests and forest openings. Hawks flying arthropods from a perch set in a forest tree, often at the edge of an opening. Summer diet is arthropods; takes fruit in the nonbreeding season. Nest is a small and tidy cup of grass and other plant material held together by spider silk and set in the vertical fork of a small tree in the forest. Lays three to five creamy-white eggs, occasionally with darker spotting.

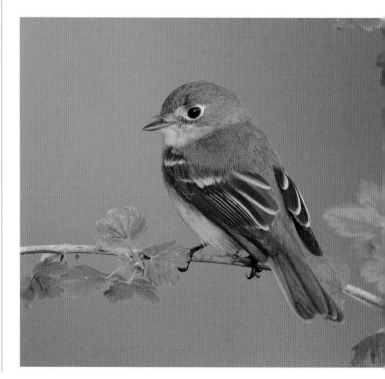

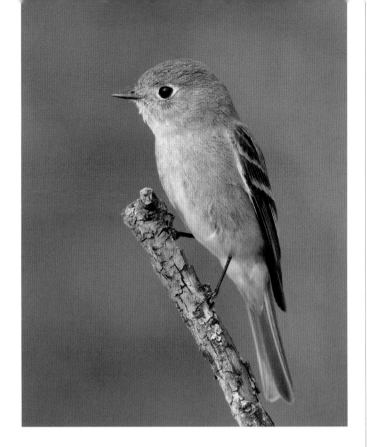

Hammond's Flycatcher *Empidonax hammondii*
L 5.5" WS 9" ♂ = ♀ HAFL

This western Empidonax flycatcher summers in mature conifer forests of the Mountain West from Alaska to New Mexico. In the Lower 48, it prefers cool upland conifer forests of Douglas-fir and spruce where there is a mix of aspens and other deciduous trees. Winters from the Arid Southwest to Guatemala. Forages for flying and perched arthropods from a perch in a forest opening. Diet is mainly insects. Nest is a cup made of grass and stems placed on a horizontal branch, either in a conifer or deciduous tree. Lays three or four creamy-white eggs lightly spotted reddish brown.

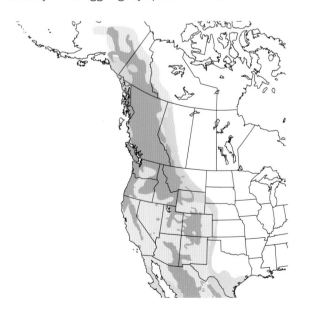

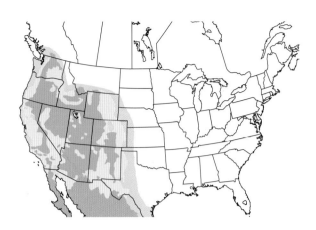

Gray Flycatcher *Empidonax wrightii*
L 6" WS 9" ♂ = ♀ GRFL

This washed-out little flycatcher, which distinctively dips its tail, summers in high arid lands of the Great Basin. Winters from southern Arizona to southern Mexico. Prefers dry summer habitats—sagebrush and open woodlands of pinyon pine and juniper. A population winters in southern Arizona in streamside willows and mesquite in low country. It hawks flying arthropods from a perch in a low bush; also takes prey from the ground. The nest is a deep cup placed in the vertical crotch of a sagebrush or branch of a pine or juniper. Nest is rough and made of various plant materials and lined with finer plant bits. Lays three or four creamy-white eggs.

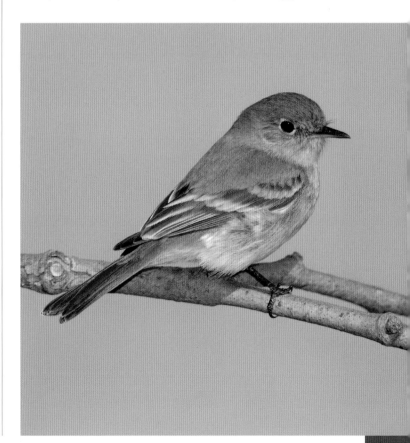

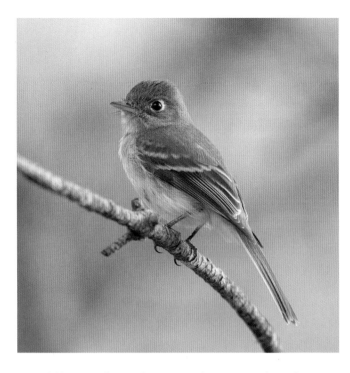

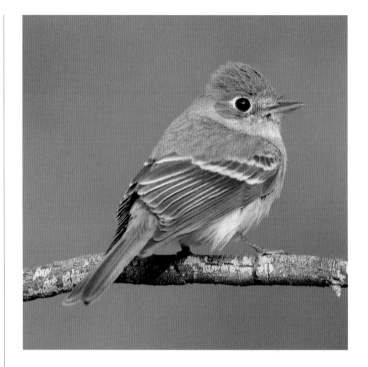

Cordilleran Flycatcher *Empidonax occidentalis*
L 5.8" WS 8" ♂ = ♀ COFL

This is the Interior West counterpart to the Pacific-slope Flycatcher. Formerly the two were treated as a single species ("Western Flycatcher"). Summers in forests and wooded canyons in the mountains, commonly in deciduous growth within a conifer forest. Perhaps prefers drier and more open habitats than the Pacific-slope Flycatcher. Winters in Mexico. Identical foraging habits to the Pacific-slope Flycatcher. Diet is entirely arthropods. Nest is a mossy cup placed in a protected site on a steep bank, under the roots of a treefall, or in the rafters of a shed or a similar site. Lays three to five whitish eggs with brownish blotches. Apparently intergrades with the Pacific-slope Flycatcher in the Interior Northwest.

Pacific-slope Flycatcher *Empidonax difficilis*
L 5.5" WS 8" ♂ = ♀ PSFL

This sister species of the Cordilleran Flycatcher summers on the moist western slopes of the West Coast ranges, where tall conifers dominate. Found in deciduous growth within mature conifer stands. Favors deep shade found along the bottom of mountain stream courses. Generally seems to prefer wetter habitats than the Cordilleran Flycatcher. Winters in Baja and coastal western Mexico. Forages from a perch, high or low, hawking and hover-gleaning. Diet is arthropods, many taken on the wing. Nest and eggs identical to the preceding species. Field identification of the two species is problematic and the two are best treated as "the Western Flycatcher complex."

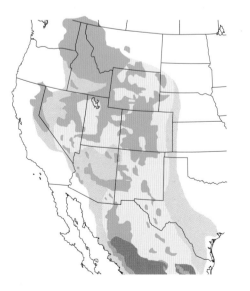

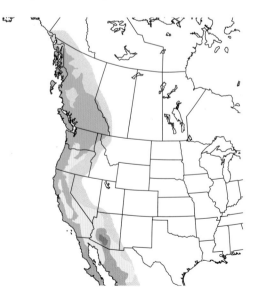

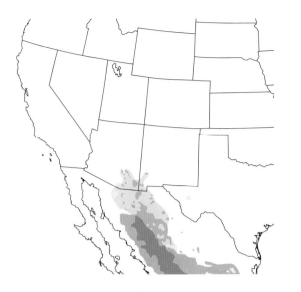

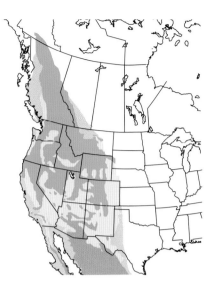

Buff-breasted Flycatcher *Empidonax fulvifrons*
L 5" WS 8" ♂ = ♀ BBFL

Of the confusingly similar *Empidonax* flycatchers, this is the smallest and most distinctive. Ranges from Nicaragua north to the Southwest Borderlands. Summers in southernmost Arizona and New Mexico, as well as the Davis Mountains of West Texas, in dry pine or oak woodland. Winters from northwestern Mexico to Honduras. Foraging habits are as for the other species of this genus but perhaps lower in the vegetation. Diet is entirely arthropods. Nest is a cup of plant parts wrapped in spider silk and decorated with lichens; it is situated on the branch of a tree well above the ground. Lays three or four creamy-white eggs.

Dusky Flycatcher *Empidonax oberholseri*
L 5.8" WS 8" ♂ = ♀ DUFL

Another of the confusingly similar *Empidonax* flycatchers— this one of open and brushy woodlands of middle elevations in the Interior West. Summers in mountain chaparral with a mix of openings and trees. A few winter in southern Arizona in streamside shrubbery; others winter to southern Mexico. Forages from a perch, from which it hawks winged insects, drops to the ground to take terrestrial invertebrates, or gathers an arthropod off the bark of a tree. Nest is a deep and unruly cup of bark, plant fibers, and twigs set on a crotch of a small limb and hidden within the interior of a bush or small conifer. Lays two to five whitish eggs.

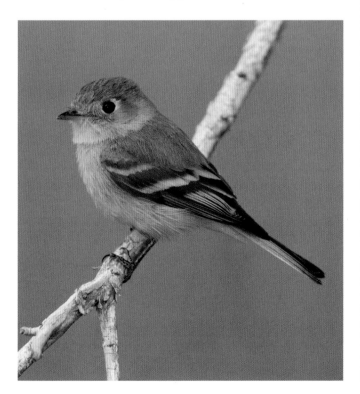

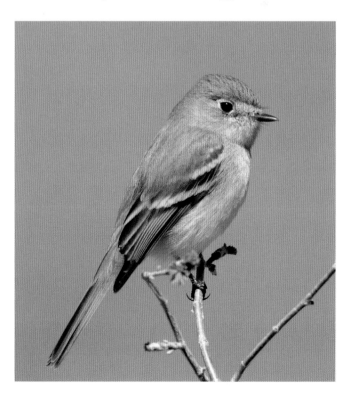

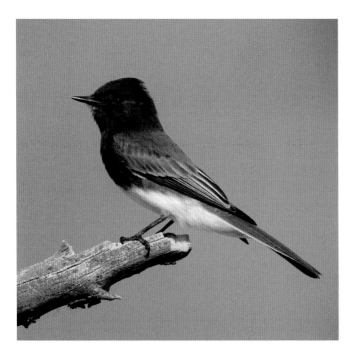

Eastern Phoebe *Sayornis phoebe*
L 7" WS 11" ♂ = ♀ EAPH

A familiar and beloved flycatcher of the East and Midwest that in spring is invariably found near water or near a covered structure where its nest can be situated. Winters from the Deep South to Mexico. Favors wooded openings, especially near streams, where it can obtain mud for its nest. Sits low in an opening in the woods, wagging its tail and calling lightly. Hunts in a manner identical to the Black Phoebe. Diet is arthropods and some fruit. The mud, moss, and grass cup nest is plastered in a protected site—under a bridge, a culvert, or under the lip of a cliff face or cave. Lays four to six white eggs, sometimes spotted.

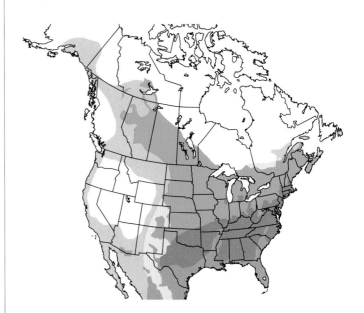

Black Phoebe *Sayornis nigricans*
L 7" WS 11" ♂ = ♀ BLPH

A commonplace and confiding flycatcher resident in the Far West and Southwest. It is typically found year-round in wooded openings near water—farm yards, rural towns, and stream bottoms. Perches low near water, wagging its tail. Launches from a low perch to capture arthropods in the air, on the ground, and in the vegetation. The species' range extends south to Argentina. Northernmost breeding birds winter southward. The mud nest is plastered in a sheltered spot—under a bridge, a culvert, or on a cliff face. Lays three to six white eggs, sometimes with reddish-brown spotting.

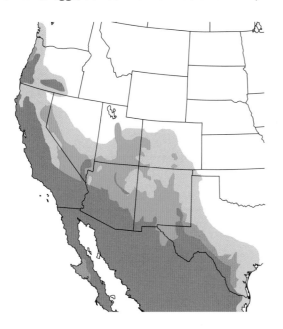

Say's Phoebe *Sayornis saya*
L 8" WS 13" ♂ = ♀ SAPH

An open-country phoebe that summers across the Interior West as well as the Northwest to Alaska. The species also breeds in northwestern Mexico. Northern breeders winter to the Borderlands and as far south as southern Mexico. Inhabits open country, often far from water—tundra, prairie, badlands, and farmland. Hunts from a low perch in the open, taking arthropods in the air or on the ground. Diet is mainly arthropods with a very minor complement of fruit. The flat open cup nest of grass, other plant material, and moss is bound by spider silk and set on a ledge, under eaves of a building, or even in a cavity in an earthen bank. Lays three to seven white eggs, some of which may have speckling. Wags its tail, as do the other phoebes.

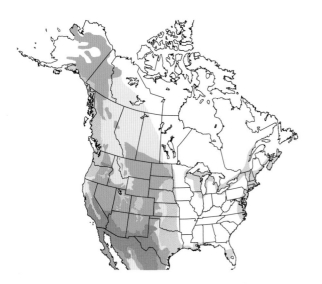

Vermilion Flycatcher *Pyrocephalus rubinus*
L 6" WS 10" ♂ ≠ ♀ VEFL

The male Vermilion Flycatcher is the fiery red flycatcher of the Arid Southwest. Inhabits open, brushy, arid country, especially near water. Hawks insects in the air and on the ground from a low, open perch. Diet is exclusively arthropods. The species' range extends south to Argentina. Nest is a compact cup of twigs, grass, and other plant material bound together with spider silk and frosted with lichens and set on the fork of a tree branch. Lays two to four whitish eggs boldly spotted with darker colors. Northernmost breeders winter southward.

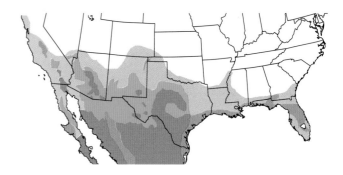

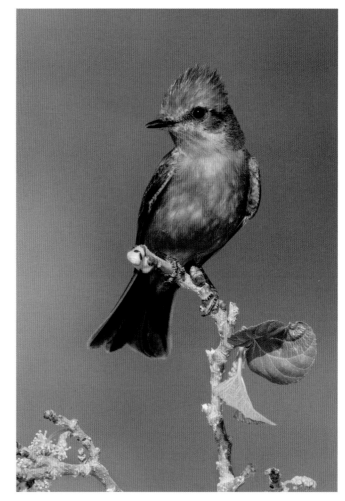

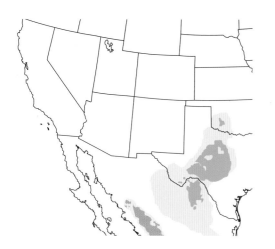

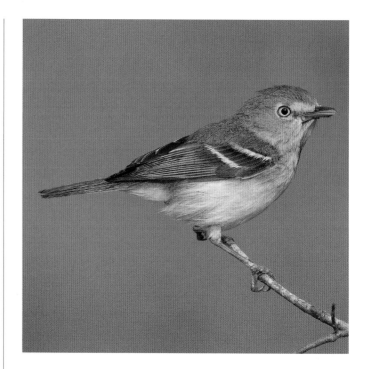

Black-capped Vireo *Vireo atricapilla*

L 5" WS 7" ♂ ≈ ♀ BCVI *VU *WL

This small and strikingly patterned vireo is a summer breeder in hill country in Texas and Oklahoma as well as northern Mexico. Winters in western and southern Mexico. Inhabits open and dry hill country with a scattering of oaks and junipers. A very active gleaner of arboreal foliage for arthropod prey; will also consume fruit from time to time. Nest is a pendant cup hung from a horizontal twig within a shrub or low tree. Nest is made of grass, bark strips, and other plant material bound together by spider silk and lined with finer material. Lays three or four white eggs. This is a declining species of concern across its limited nesting range. The breeding population in Texas has been harmed by nest parasitism by the Brown-headed Cowbird.

White-eyed Vireo *Vireo griseus*

L 5" WS 8" ♂ = ♀ WEVI

A vocal and active vireo of the South and East. Winters in the Deep South, Yucatán, and Cuba. Inhabits shrubby edge habitats—woodland edges, thickets, brambles, and scrub. Hunts and gleans arthropods from low, thick vegetation. Diet is mainly arthropods. Takes some fruit in winter. Nest is a deep cup hung from a fork in a small branch in a low tree or shrub. Nest is made of twigs, grass, roots, and other plant material bound together with spider silk. Lays three to five white eggs speckled with darker colors. Nests are commonly parasitized by the Brown-headed Cowbird.

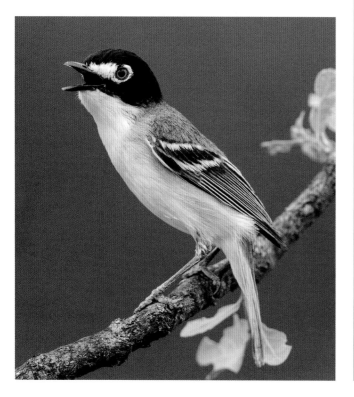

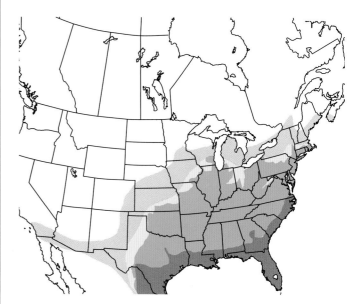

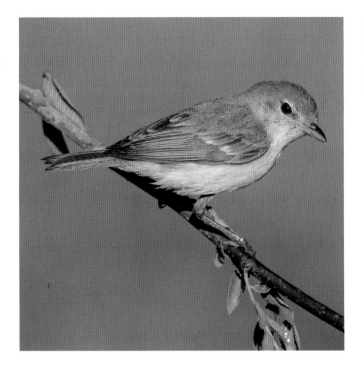

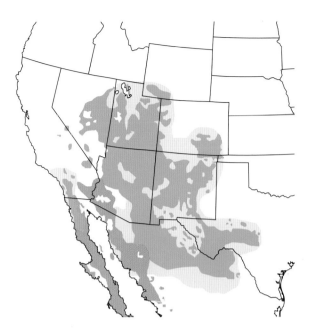

Bell's Vireo *Vireo bellii*
L 5" WS 7" ♂ = ♀ BEVI *NT

This rather plain vireo is an uncommon summer resident of the Midwest and Southwest. Its song is a rapid, zigzagging, rough warble unlike any other North American bird—a ready means of identification. Winters along the western coast of Mexico south to Guatemala. Summers in brushy vegetation in open habitats—shrubby roadside tangles, field borders, and streamside thickets. In the Southwest, it prefers streamside thickets. Forages for arthropods in the summer, gleaning foliage for prey. Takes some fruit in the winter. Nest is a deep cup hung in the fork of a small branch in a low shrub. Nest is made of grass and other plant fibers and bound together with spider silk. Lays three or four white eggs speckled with darker colors.

Gray Vireo *Vireo vicinior*
L 6" WS 8" ♂ = ♀ GRVI *WL

A very drab vireo that summers in the Interior Southwest and Great Basin. Winters in Baja, southwestern Arizona, and northwestern Mexico; rarely seen on migration. Summers in dry mountain country—brushland, chaparral, oak-juniper scrub, and sagebrush. Winter range dictated by the presence of Elephant Tree (*Bursera microphylla*). Forages low in shrubs, gleaning arthropods and fruit from vegetation. The deep cup nest, situated in a shrub, is hung from a fork in a small branch and fashioned of plant matter of various kinds bound up with spider silk and lined with fine material. Lays three to five pale pinkish eggs marked with dark speckling.

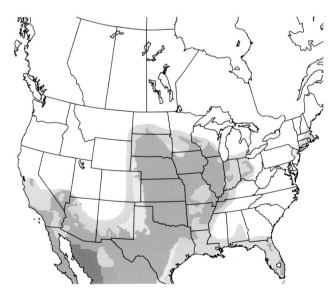

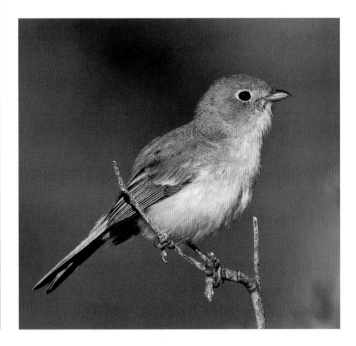

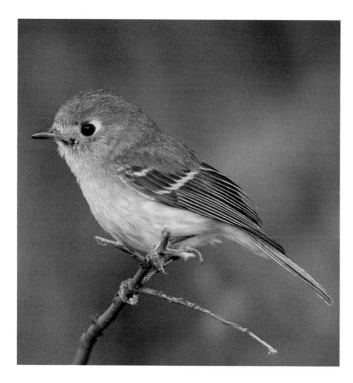

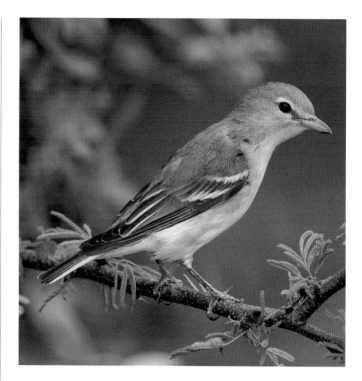

Hutton's Vireo *Vireo huttoni*
L 5" WS 8" ♂ = ♀ HUVI

Our smallest vireo, Hutton's Vireo closely resembles a Ruby-crowned Kinglet and even flicks its wings like that species. The vireo is slightly larger and has a thicker bill and blue-gray legs. Populations of this sedentary resident species of the Pacific Coast also extend south to Guatemala. Prefers forest edge and adjacent brush—especially tall chaparral, oak, and pine-oak woodland edges. Also inhabits shrubbery in openings of damp conifer forests. Forages for arthropods by gleaning twigs and sometimes hover-gleaning prey from leaves. Diet is a variety of arthropods as well as some fruit. Nest is a small round cup hung from the fork in a small branch; nest is made of bark fibers, moss, lichens, grass, and other plant material bound together by spider silk. Lays three to five white eggs with brown speckling. Individuals in autumn may wander a bit.

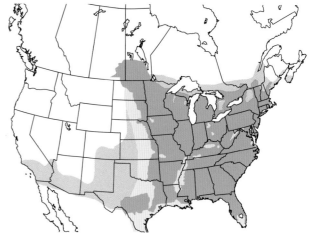

Yellow-throated Vireo *Vireo flavifrons*
L 6" WS 10" ♂ = ♀ YTVI

A summer resident of deciduous forests of the East and Midwest. Winters in the Caribbean, Central America, and northern South America. Inhabits the canopy and middle stories of deciduous forest and tall shade trees along streams and rivers. Individuals slowly glean branches and vegetation for arthropods. Diet includes mainly arthropods and some fruit. Nest, placed in a shade tree, is a substantial cup hung in the fork of a branch and constructed of a variety of plant materials bound together with spider silk and encrusted with moss and lichens. Lays three to five pinkish eggs heavily marked with darker colors. Migrants arrive in the Deep South early in spring.

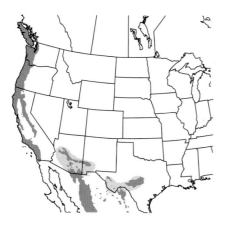

Cassin's Vireo *Vireo cassinii*

L 6" WS 10" ♂ = ♀ CAVI

This plain vireo summers in the Pacific Northwest and California, wintering in southern Arizona and Mexico. Inhabits coniferous forests and mixed forest of the Far West. A sluggish gleaner of arthropods from twigs and leaves in the middle stages of the forest. Nest is a cup hung in the fork of a branch and constructed of plant fibers, bark strips, and other materials; it is bound together with spider silk. Lays three to five white eggs lightly spotted with brown.

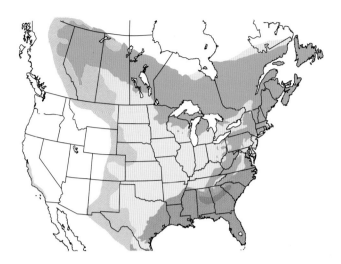

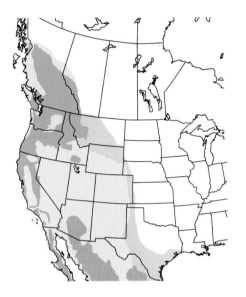

Blue-headed Vireo *Vireo solitarius*

L 6" WS 10" ♂ = ♀ BHVI

A pretty but retiring summer resident of mixed upland forests of the Appalachians, the Northeast, as well as the boreal forests of Canada. Some birds winter in the Deep South, but others head to Central America or Mexico. Breeds in coniferous and mixed forests. Slowly gleans twigs and vegetation for arthropods. Also takes some fruit. Nest is a cup hung in the fork of a branch and constructed of plant fibers, bark strips, and other materials; it is bound together with spider silk. Lays three to five white eggs spotted with brown. An early spring migrant.

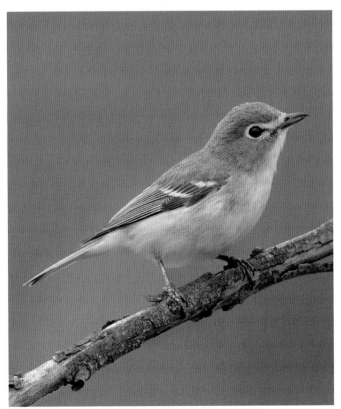

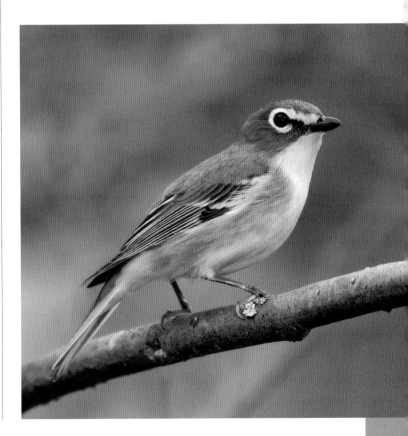

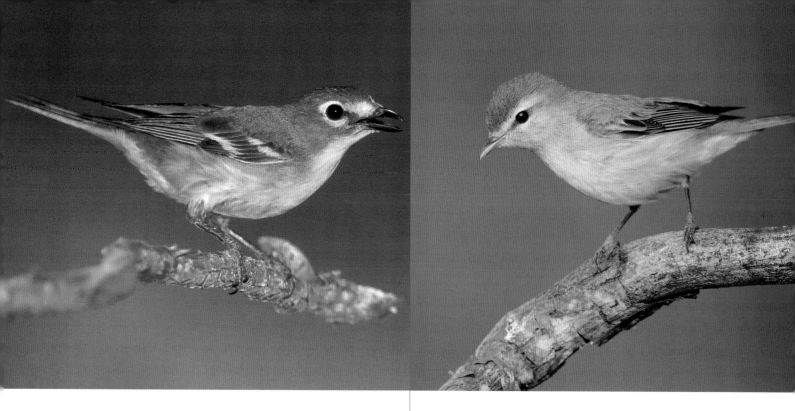

Plumbeous Vireo *Vireo plumbeus*
L 6" WS 10" ♂ = ♀ PLVI

A widespread summer breeder of the Interior West. Most North American birds winter in Mexico, though some US breeders winter in southern Arizona. Other populations breed in Mexico and Central America. Summers in coniferous and mixed forests, especially in dry, open pine forests. A sluggish forager of the middle stories of the forest, gleaning arthropods from twigs and leaves. Nest is a cup hung in the fork of a twig in a tree and constructed of plant fibers, bark strips, and other materials; it is bound together with spider silk. Lays three to five white eggs lightly spotted with brown.

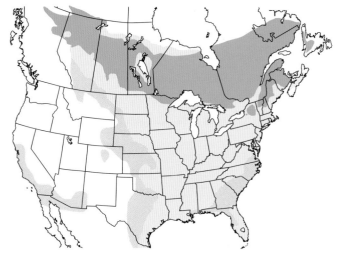

Philadelphia Vireo *Vireo philadelphicus*
L 5" WS 8" ♂ = ♀ PHVI

An uncommon and retiring vireo that summers in deciduous openings in boreal forest of the Northeast and Canada. Autumn migrants seen more often than those of spring. Winters from southern Mexico to Panama. Prefers clearings with aspens, poplars, or other early successional deciduous trees within boreal conifer forest or mixed forest. Song is puzzlingly similar to the Red-eyed Vireo, whose range entirely encompasses that of the Philadelphia. Gleans arthropods from twigs and leaves in the middle stages of deciduous trees. Diet includes some fruit. Nest is a small hanging cup set in the fork of a twig and manufactured of various plant fibers, bound up in spider silk, and lined with pine needles and down. Lays three to five white eggs marked with darker colors. This spring migrant arrives late in the United States.

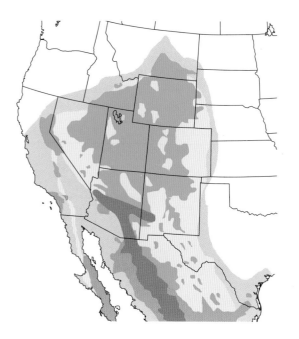

Warbling Vireo *Vireo gilvus*

L 6" WS 9" ♂ = ♀ WAVI

Summers in tall shade trees near water throughout much of North America, wintering from western Mexico south to Nicaragua. Best located by its distinctive burry warbled series, delivered from high in the canopy. Generally absent from the Deep South. Avoids forest interior. In West, inhabits deciduous trees of mountains, canyons, and prairies. Gleans and hover-gleans arthropods from twigs and leaves in middle and upper stages of canopy trees. Diet also includes some fruit. Nest is a compact, deep cup hung in the fork of a tree branch and constructed of plant fibers, bark strips, and other materials; it is bound together with spider silk. Lays three to five white eggs speckled with darker colors. Western breeders may be a distinct species.

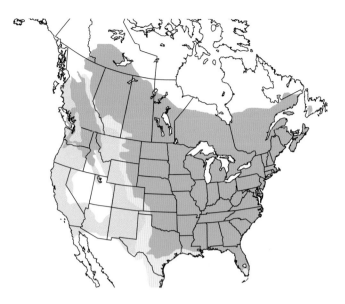

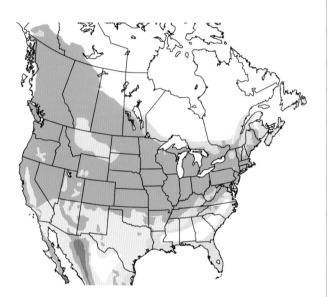

Red-eyed Vireo *Vireo olivaceus*

L 6" WS 10" ♂ = ♀ REVI

This species, for Eastern birders the most familiar vireo, summers through much of the East, Midwest, and Canada (to British Columbia and the Northwest Territories). Winters in northern South America. Our birds inhabit the canopy of deciduous and mixed forests, especially near openings and near watercourses. Commonplace and vocal. Gleans and hover-gleans arthropods from twigs and foliage. Diet includes some fruit. The compact and trim cup nest, hung in the fork of a small branch, is constructed of various plant fibers and bound with spider silk; it is situated in a tall shrub or a tree. Lays three to five white eggs spotted with darker colors. The song is a pleasant series of conversational notes. The species remains common, in spite of declines.

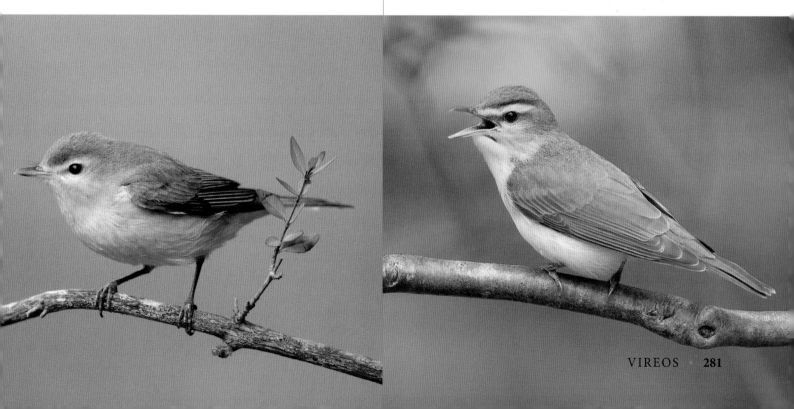

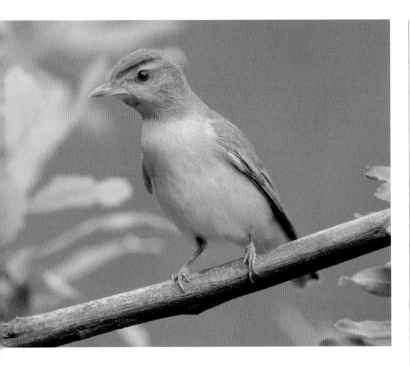

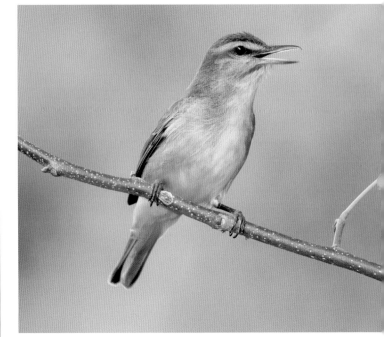

Yellow-green Vireo *Vireo flavoviridis*
L 6" WS 10" ♂ = ♀ YGVI

This Neotropical vireo ranges north to our Southwest Borderlands, creeping into the United States in the Lower Rio Grande Valley of South Texas as a rare summer breeder; exceptionally to southeastern Arizona. Most vagrants are found along the California coast. Winters from Colombia to Bolivia. Summers in woodlands and forest-edge of oxbow lakes and groves of shade trees. Gleans and hover-gleans arthropods from twigs and foliage. Diet includes some fruit. Nest is situated in a tree or shrub, either low or high. The nest is a trim cup hung from the fork of a branch and constructed of grass, plant fibers, and bark strips; it is bound with spider silk and lined with finer materials. Lays two or three white eggs speckled with brown. This species cocks its tail—a behavioral distinction from the very similar Red-eyed Vireo. The population of the species appears to be stable.

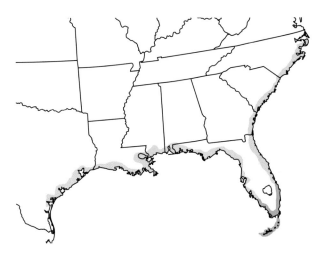

Black-whiskered Vireo *Vireo altiloquus*
L 6" WS 10" ♂ = ♀ BWVI

This Caribbean species also summers in southern Florida, singing loudly from mangroves along coastal waterways. Winters in South America. Breeds in mangroves and subtropical hardwood stands. Forages stolidly for arthropods by gleaning twigs and leaves. Also takes fruit in season. The nest is a basket-like tidy cup hung from a horizontal forked twig in a mangrove or hardwood tree. Nest is made of various plant components, wrapped in spider silk, and lined with grass and other fine materials. Lays two or three white eggs marked with darker colors. Strays northwestward along the Gulf Coast all the way into Texas. The diagnostic dark moustacial stripe is not always obvious in the field. The species appears to be doing well in Florida.

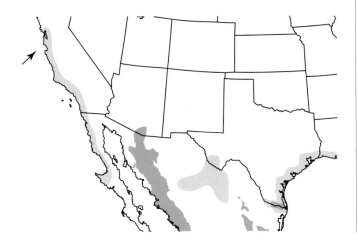

Loggerhead Shrike *Lanius ludovicianus*
L 9" WS 12" ♂ = ♀ LOSH *NT

A predatory songbird of open country in decline in the North and East but still common in the Deep South, the West, and Mexico. Inhabits open, mainly agricultural, country with suitable perches from which to hunt—fence lines, power-lines, hedgerows, or a scattering of trees. Watches from an exposed perch and drops down on terrestrial prey—an arthropod or small vertebrate. Its remarkable habit is to impale prey on a thorn or barbed wire for later consumption. Formerly known as "butcher bird" because of this grisly behavior. Hides its nest, a bulky stick cup with finer lining material, in the foliage of a shrub or low tree. Lays four to eight whitish or buff eggs spotted with darker colors. Northerly breeders winter southward.

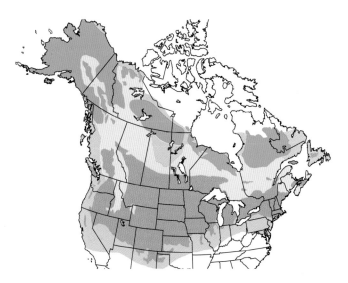

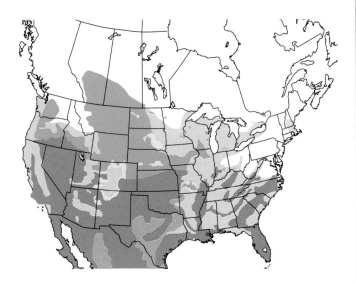

Northern Shrike *Lanius borealis*
L 10" WS 15" ♂ = ♀ NSHR

A predatory songbird that nests in northern Canada and Alaska and winters southward into the northern United States. Also breeds in central and eastern Asia. Larger and paler than the Loggerhead Shrike. Breeds in openings in boreal spruce forest. Sits atop an exposed perch, watching and then pouncing on prey—large arthropods, small birds, or rodents. Nest is a bulky cup of twigs and other plant matter lined with feathers and animal hair and hidden on a branch of a spruce or willow. Lays four to seven whitish or pale gray eggs spotted with darker colors. The annual movement of this species into the United States in winter appears irruptive—varying from year to year. Overall, wintering populations in the Lower 48 have apparently deceased of late.

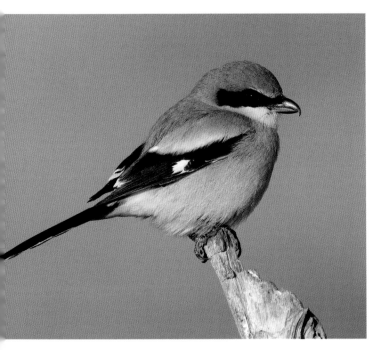

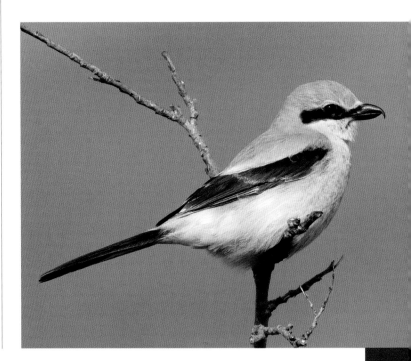

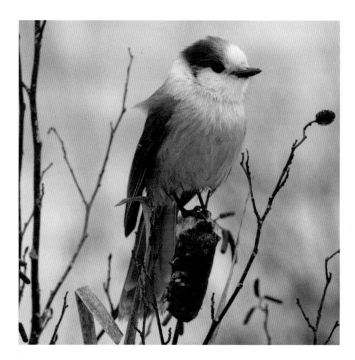

Canada Jay *Perisoreus canadensis*
L 12" WS 18" ♂ = ♀ CAJA

A distinctive permanent resident of the boreal spruce forests of the taiga zone of Canada, Alaska, and northern New England. Also found in the high-elevation conifer forests of the Rockies and Cascades. Typically found in family parties, which suddenly appear, explore a watcher's presence, then disappear. Tame and inquisitive. Sometimes they announce their presence with un-jay-like soft vocalizations. An omnivore, taking arthropods, fruit, small rodents, birds' eggs, and carrion. In winter, will take shelled peanuts or birdseed from the hand. Nests are initiated in late winter. Nest is a bulky low cup of twigs, lichens, and bark strips that is lined with finer materials and situated, well hidden, in a thick conifer. Lays three or four pale gray or greenish eggs spotted with darker colors. Formerly known as the Gray Jay.

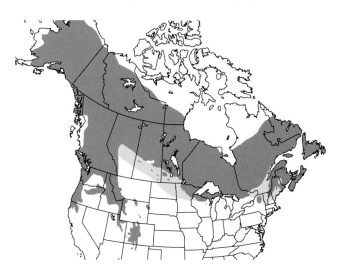

Pinyon Jay *Gymnorhinus cyanocephalus*
L 11" WS 19" ♂ = ♀ PIJA *VU *WL

This atypical and sociable jay inhabits the dry Interior West, subsisting largely on the seeds of various pinyon pines. Uncommon and unpredictable in distribution—nomadic. Favors forests of juniper and pinyon pine and affiliated wooded habitats. Very sociable, traveling in vocal foraging flocks—small or large. Diet is mainly pine seeds, especially of pinyon pine. Also takes other seeds, fruits, arthropods, and even nestling birds. Nest, placed in a pine, juniper, or oak, is a platform of twigs, sticks, and bark strips that is lined with finer materials. Lays four or five pale blue-green eggs dotted with brown. Nests in loose colonies. Populations of the species fluctuates, but overall appears in decline.

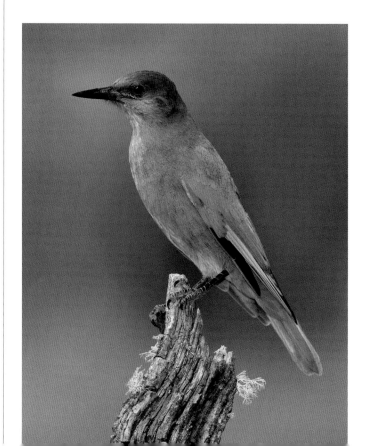

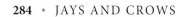

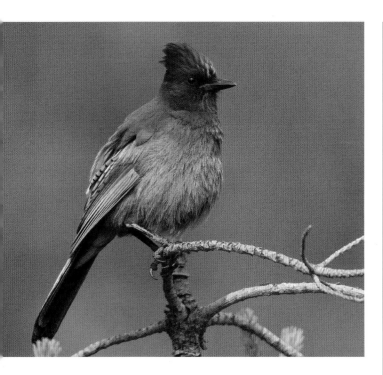

Steller's Jay *Cyanocitta stelleri*
L 12" WS 19" ♂ = ♀ STJA

A common and widespread permanent resident of mature conifer forests of the Rockies and West Coast. Ranges in mountains from Alaska south to Guatemala. Inhabits conifer forest as well as pine-oak forest. Does wander outward from these habitats in the nonbreeding season. A typical jay. An omnivore like most species of this family. Takes mainly seeds and fruit, but also consumes arthropods, birds' eggs, and the occasional small vertebrate. May shift up and down in elevation in mountainous country with the seasons. Nest is a bulky and ragged cup of twigs and other plant matter that is lined with finer materials and cemented together with mud. Nest sited in a tree, typically a conifer. Lays three to five pale blue-green eggs spotted with darker colors.

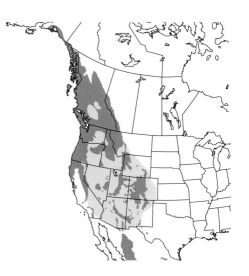

Blue Jay *Cyanocitta cristata*
L 11" WS 16" ♂ = ♀ BLJA

One of our familiar and common woodland birds that ranges widely east of the Rockies. Favors deciduous and mixed forest, especially woods with oaks and beech. Also found in wooded suburbs and urban wooded parks. Sociable and vocal much of the year, but when nesting it tends to be reclusive and quiet. A prominent daytime migrant in spring and fall, passing overhead in small flocks. Some individuals stay resident where they breed. Omnivorous. Favors acorns, beech nuts, and other seeds, as well as some fruit; in addition, will take birds' eggs, arthropods, the occasional small vertebrate, and carrion. Nest is a bulky open cup of twigs, grass, bark strips, and moss; in some instances, it is held together with a cementing of mud. Nest is placed in a tree, either near the trunk or out on a branch. Lays four or five greenish or buff eggs spotted with other colors.

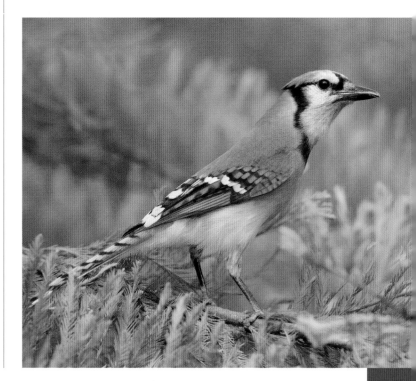

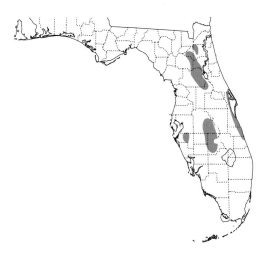

Florida Scrub-Jay *Aphelocoma coerulescens*
L 11" WS 14" ♂ = ♀ FLSJ *VU *WL

A sociable and very sedentary resident of sandy scrub-oak habitat in central Florida. In decline within its limited habitat. Restricted to scrub-oak woodland, pine scrub, and sand hills. Associates in long-term family groups, with nesting by a single senior pair helped by related associates. Offspring of one year ("helpers") often stay to help their parents with nesting in the following year. Usually forages in small groups, feeding on the ground and arboreally. Nest, placed in a low tree or shrub, is a substantial cup of twigs, grass, and moss lined with finer materials. Lays three to six pale green eggs spotted with darker colors. Formerly all the scrub-jays were treated as a single variable species. The widespread development of its scrub-oak habitat threatens this species.

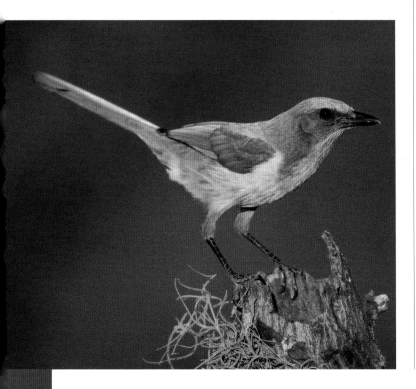

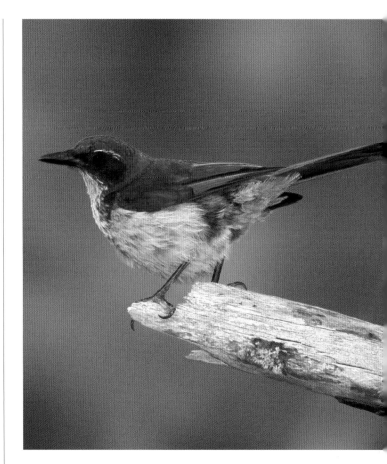

Island Scrub-Jay *Aphelocoma insularis*
L 13" WS 17" ♂ = ♀ ISSJ *WL

Larger and larger-billed than its mainland counterpart (the California Scrub-Jay), this insular endemic is restricted to Santa Cruz Island, off Southern California. Less sociable than its mainland relative. Inhabits all of the wooded habitats on Santa Cruz Island—oak woodlands, pine forest, and scrub. Omnivorous, like its mainland relative. The nest is a bulky cup of twigs placed in a dense bush or tree. Lays three or four pale blue-green eggs with faint dark spotting.

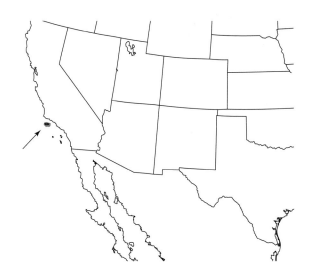

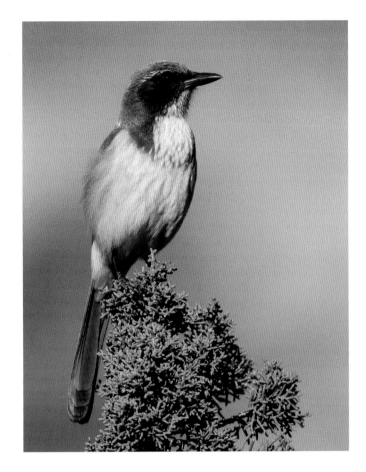

California Scrub-Jay *Aphelocoma californica*
L 11" WS 16" ♂ = ♀ CASJ

This familiar yard bird ranges along the West Coast, from southwestern British Columbia south to southern Baja. Frequents scrub-oak woodlands and chaparral as well as suburban gardens and wooded parks. Bold, vocal, and conspicuous. One of the commonplace garden birds in the Far West. An omnivore. Takes mainly acorns and other seeds but also some fruit, arthropods, the occasional small vertebrate, and birds' eggs. Nest is a thick-walled cup of twigs and other plant matter lined with finer materials; it is hidden in thick vegetation of a shrub or low tree. Lays three to six greenish eggs with darker spotting.

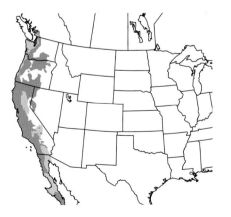

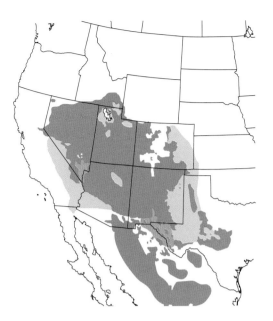

Woodhouse's Scrub-Jay *Aphelocoma woodhouseii*
L 12" WS 16" ♂ = ♀ WOSJ

Widespread but uncommon in the arid Interior West, ranging to southern Mexico. Inhabits open foothill forests of oak-pinyon and pinyon-juniper, and in some suburban habitats of Interior cities. Less commonplace, and more inconspicuous, than the California Scrub-Jay. Omnivorous; diet, nest, and eggs as for the preceding species. This species is shy and reclusive, only offering glimpses of the bird as it retreats from the observer. Nonmigratory, but highly irruptive.

Mexican Jay *Aphelocoma wollweberi*
L 12" WS 20" ♂ = ♀ MEJA

This Mexican species ranges northward into the Southwest Borderlands in Arizona, New Mexico, and the Big Bend region of Texas. Larger than the scrub-jays. Inhabits pine-oak and open oak woodlands, ranging up canyons into the mountains. Usually forages in groups. Arizona birds exhibit complex nesting by groups of males and females. Flocks defend permanent territories that carry over from year to year. Omnivorous. Diet is mainly acorns, other seeds, some fruit, arthropods, and a few small vertebrates. Nest, well hidden in an oak or conifer, is a bulky cup of sticks and twigs lined with finer material. Lays four or five pale green eggs, sometimes spotted. Nonmigratory and very sedentary.

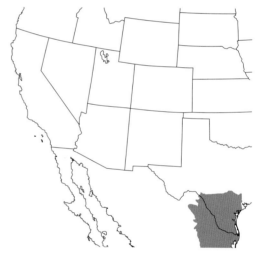

Green Jay *Cyanocorax yncas*
L 11" WS 14" ♂ = ♀ GRJA

A handsome and colorful jay of South Texas. This nonmigratory jay ranges south to the Andes of Bolivia. It inhabits woodland, dry brushland, and suburban parks near native habitat. Travels in active and vocal parties. Common at feeding stations. An omnivore, taking arthropods, fruit, small vertebrates, and birds' eggs. Nest, placed in a densely foliaged tree or shrub, is a bulky cup of sticks, twigs, and other plant matter lined with rootlet and other finer materials. Lays three to five pale gray or greenish eggs heavily spotted with darker colors. This is one of the main target birds for birders visiting the Lower Rio Grande of Texas. Given the breadth of habitats it uses, probably secure.

Yellow-billed Magpie *Pica nuttalli*

L 17" WS 24" ♂ = ♀ YBMA *NT *WL

This restricted-range endemic is confined to California's Central Valley and surrounding areas. Quite sedentary. Frequents ranchland, farms, oak groves, and streamside woodlands. Most common in open oak savanna. More recently has adapted to urban and suburban spaces within its range. Mainly walks on open ground to forage. Nonmigratory. Diet is omnivorous. Primarily takes arthropods, supplemented by acorns and other seeds and fruit. The species tends to nest colonially in clusters of tall trees infested with mistletoe. The large globular nest has an entrance on the side. It is constructed of sticks and twigs, and the interior has a base of mud lined with finer materials. Lays four to eight olive-buff eggs marked with dark colors. The species has declined from the West Nile virus.

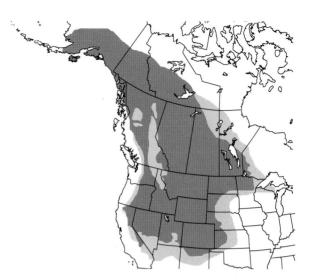

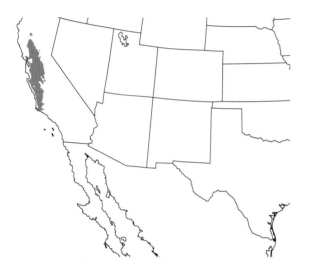

Black-billed Magpie *Pica hudsonia*

L 19" WS 25" ♂ = ♀ BBMA

A commonplace species of open country in the Interior West northward to Alaska and south to New Mexico. Favors streamside groves of trees in open country, farmlands, wooded suburbs, and urban parks. Often seen feeding on the ground in open grasslands, such as in a prairie-dog town. As with all the corvids, it is an omnivore. Takes mainly arthropods, supplemented by seeds of various types (especially acorns), and carrion. The cup nest of twigs, placed high on an outer limb of a tree or tall shrub, is surrounded by a large domed structure of sticks and twigs with an entrance on either side. The nest interior has a base of mud lined with fine plant materials. Lays six or seven greenish-gray eggs spotted with brown. Sometimes birds wander eastward in winter.

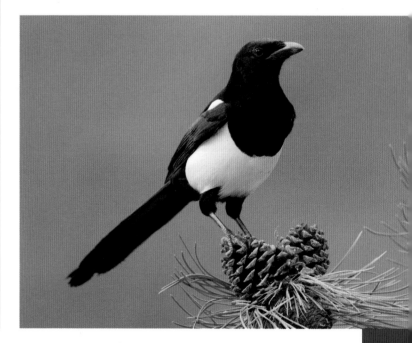

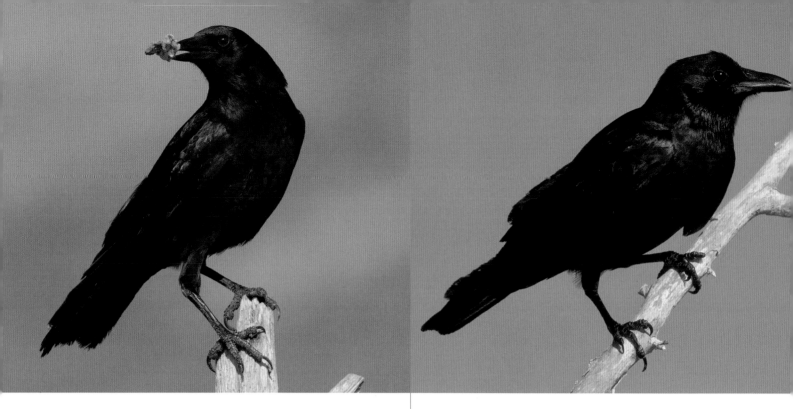

American Crow *Corvus brachyrhynchos*
L 18" WS 39" ♂ = ♀ AMCR

Another of our widespread and most familiar species, ranging from coast to coast. An abundant inhabitant of farmlands, woodland edges, towns, and city parks. Sociable. Often seen overhead in flocks. Large winter roosts may be used year after year. The prototypical omnivore, consuming all manner of plant and animal matter, including carrion. Nest, typically situated high in a tall tree, is a large and unruly platform of sticks, weeds, and mud lined with finer materials. Lays four to six blue-green eggs blotched with darker colors. Northernmost (mainly Canadian) breeders migrate southward into the Lower 48 for the winter. The populations of the Pacific Northwest, formerly known as the Northwestern Crow, are now considered conspecific with the American Crow. Has recovered from West Nile Virus decline.

Fish Crow *Corvus ossifragus*
L 15" WS 36" ♂ = ♀ FICR

This small version of the American Crow is most common along the East and Gulf Coasts, following river courses inland. Often common alongside American Crows, sharing suburban habitat. Inhabits a range of open wooded habitats, especially near water; has also colonized suburban shopping malls. Best identified by its soft nasal call notes. Sociable and flocking. Will join in wintering roosts of American Crows. Another omnivore, feeding on just about anything available—arthropods, fruit, eggs, garbage, carrion, fish, and crayfish. Nest, placed in a conifer or deciduous tree, is a bulky platform of sticks and bark strips lined with finer materials, including feathers or animal hair. Lays four or five blue-green eggs blotched with darker colors. Some northern Interior breeding populations winter southward.

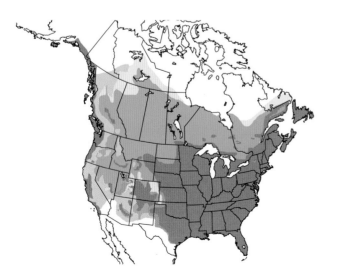

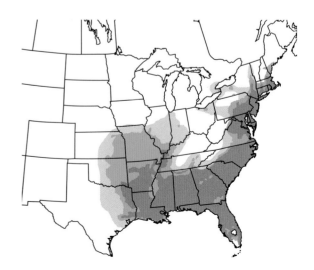

Common Raven *Corvus corax*
L 24" WS 53" ♂ = ♀ CORA

This is the largest of the songbirds—a raptor-sized black bird known for its tumbling acrobatic flight high over mountain ridges. Inhabits mountains, rugged and rocky coastal country, desert, boreal forest, and Arctic tundra. More recently is being found in the northern Great Plains and the coastal Northeast and Mid-Atlantic through its adaptation to nesting on cell towers, bridges, and other structures. Seems to be limited by its need for nesting habitat that approximates a cliff ledge. Mainly a permanent resident, but small numbers are seen moving in certain places in the autumn and spring. An omnivore, taking invertebrates, small vertebrates, and carrion, as well as garbage. The nest is usually situated on a cliff ledge or a tall tree. Nest is a bulky mass of sticks and twigs with a center cup lined with finer materials. Lays four to six greenish eggs blotched with darker colors.

Chihuahuan Raven *Corvus cryptoleucus*
L 20" WS 44" ♂ = ♀ CHRA

This smaller of our ravens inhabits arid grasslands of the Interior Southwest. Extremely similar in appearance to the common and widespread Common Raven. Frequents semi-arid grasslands, yucca flats, and dry brushlands, mainly in low country. Very sociable and may form large flocks in winter. Another omnivore—taking invertebrates, small vertebrates, and carrion, as well as garbage. Nest site is variable—on a utility pole or building, or atop a yucca or a shrub or tree. Nest is a bulky and messy platform of sticks and twigs lined with grass and other finer materials. Lays five or six pale olive eggs blotched with darker colors.

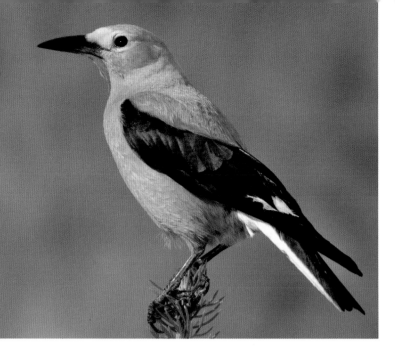

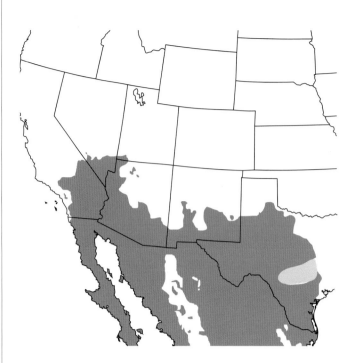

Clark's Nutcracker *Nucifraga columbiana*
L 12" WS 24" ♂ = ♀ CLNU

A western montane species inhabiting high elevations in the Rockies, Cascades, and Sierras. Usually a permanent resident, but in some years may disperse widely, appearing in valleys where it is rarely seen. Inhabits conifer forests and forest openings near the treeline. An inveterate harvester of the seeds of several montane pines. The nutcracker caches many of these seeds in the ground for future consumption. Forgotten seeds germinate to replant these conifer forests. Diet is mainly pine seeds and other seeds, berries, arthropods, birds' eggs, and carrion. Nest, sited up on a conifer branch, is a platform of sticks supporting a large, deep cup of grass, bark strips, and pine needles. Lays two to four pale green eggs lightly spotted with brown or gray.

Verdin *Auriparus flaviceps*
L 5" WS 7" ♂ ≈ ♀ VERD

Our only member of a primarily Old World family, the Remizidae. A small and commonplace warbler-like songbird of the Arid Southwest, ranging southward into central Mexico. Inhabits desert scrub and brushland as well as thickets in suburban areas. Solitary, active, and acrobatic, moving from thicket to thicket. Diet is mainly arthropods, supplemented by small fruits and nectar. Will visit hummingbird feeders. Nest, placed out on branch of a thorny shrub or cactus, is a conspicuous, large, globular mass of thorny twigs with an entrance low on one side; lined with various finer materials. Lays four or five pale blue-green eggs with red-brown dots. Nonmigratory. Locate by vocalizations.

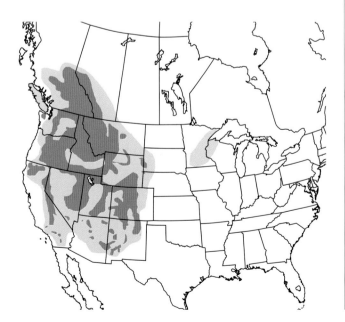

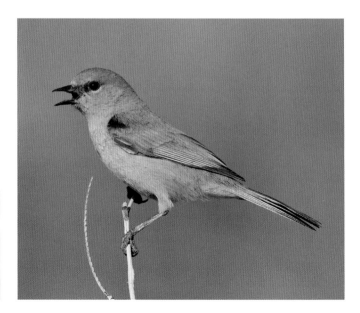

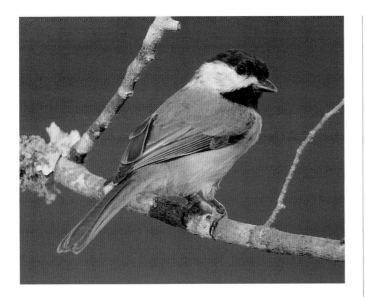

Carolina Chickadee *Poecile carolinensis*

L 5" WS 8" ♂ = ♀ CACH

A commonplace little songbird of backyard feeders and neighborhood woodlots in the South and Southeast. Replaced by the Black-capped Chickadee north of the Mason-Dixon Line. The two species hybridize in areas of overlap. Common in mixed flocks in deciduous woodlands as well as suburban parks and neighborhoods. Curious and vocal, but not as confiding as the Black-capped Chickadee. In winter, it flocks with Tufted Titmice, White-breasted Nuthatches, Downy Woodpeckers, and Carolina Wrens. Forages for arthropods by gleaning most of the year, but adds small fruits and seeds to its diet in autumn and winter. Nest is situated in a natural cavity in a tree, an old woodpecker hole, or a nest box. Eggs are placed on a layer of plant materials. Lays five to eight white eggs dotted with reddish brown. A permanent resident.

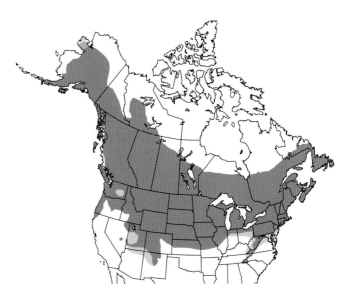

Black-capped Chickadee *Poecile atricapillus*

L 5" WS 8" ♂ = ♀ BCCH

Inhabits the northern sector of the Lower 48, Canada, and Alaska—a northern counterpart to the Carolina Chickadee. Where the two meet in the Appalachians, the Black-cap inhabits the higher elevation, though the two species do mix and hybridize in a narrow band across the East and Midwest. A sociable species of mixed and deciduous forests, wooded parks, and boreal conifer forest in the North. Usually seen in small parties, often joined in winter by other small landbirds, such as nuthatches, woodpeckers, and wrens. Gleans vegetation, twigs, and bark for small arthropods; will also seasonally take fruit and seeds. Nest is situated in a natural cavity in a tree, an old woodpecker hole, or a nest box. Eggs are placed on a layer of fine and soft materials. Lays six to eight white eggs with fine red-brown spotting. In some years northern birds shift their range southward in an irruptive migration.

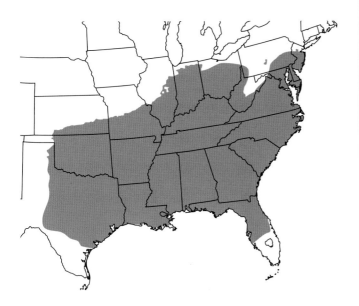

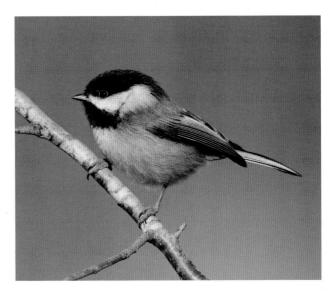

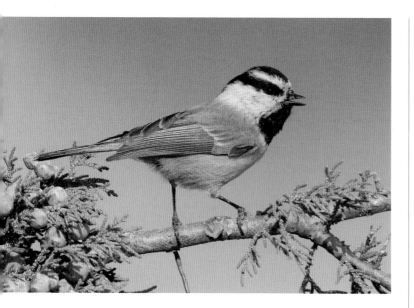

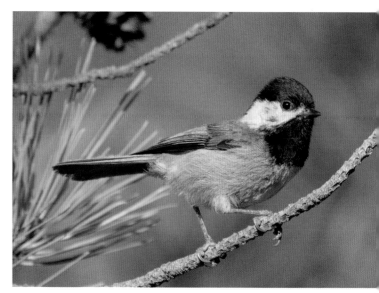

Mountain Chickadee *Poecile gambeli*

L 5" WS 9" ♂ = ♀ MOCH

A widespread species of the Mountain West. Frequents coni-fer forests and aspen groves in western mountains. Some shift to lower elevations in winter. Gleans bark, twigs, and leaves for small arthropods, often foraging in mixed flocks with other songbirds. Also consumes small fruit and seeds. Nest is placed in a natural cavity in a tree, an old wood-pecker hole, or a nest box. Eggs are placed on a layer of fine and soft materials. Lays seven to nine white eggs with red-brown dots. Has been recorded ranging up to the timberline. The species is apparently in decline over much of its range.

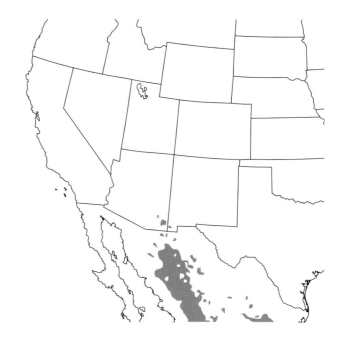

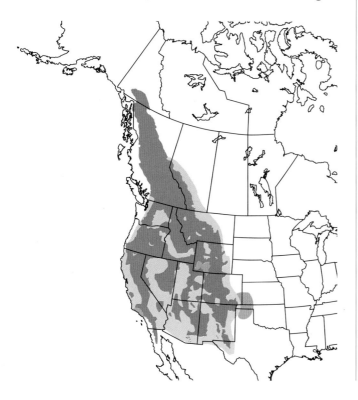

Mexican Chickadee *Poecile sclateri*

L 5" WS 8" ♂ = ♀ MECH *WL

This widespread Mexican species—the southernmost of the chickadees—breeds in the Chiricahua Mountains of south-eastern Arizona and in the mountains of southwesternmost New Mexico. Breeds in montane conifer forests of pine, spruce, and Douglas-fir. In winter, may be found in pine-oak forest and sycamore groves at lower elevations. Gleans veg-etation for arthropods and probably also consumes fruit and seeds in the winter. Nests in a hole in a tree or a nest box. Nest has a foundation of bark fibers and moss lined with softer and finer material. Lays five to nine white eggs with reddish-brown spotting. In decline.

Gray-headed Chickadee *Poecile cinctus*

L 6" WS 9" ♂ = ♀ GHCH

Perhaps the most reclusive of our North American breeding birds. Not more than a dozen eBird reports (all from Alaska) in the last decade. Confined to inaccessible tundra-edge thickets of riverine birch, alder, and willows mixed with spruce in northern Alaska and northwesternmost Canada. Also ranges through Arctic Eurasia, from Siberia west to Scandinavia. Usually located in pairs or small family parties. Will share habitat with Boreal and Black-capped Chickadees, making its discovery even more challenging. Gleans twigs, conifer needles, and bark for arthropods. Seeds probably make up the majority of its diet during the long, dark winter. Nest placed in a natural cavity or abandoned woodpecker nest, usually relatively low to the ground. Nest has a foundation of decaying wood chips, grass, and moss, as well as a lining of animal hair. Lays 6–10 white eggs with red-brown speckling.

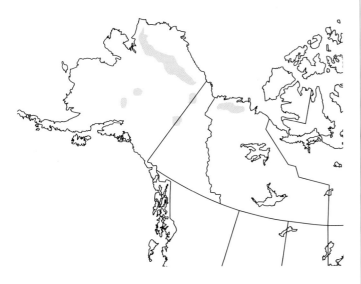

Boreal Chickadee *Poecile hudsonicus*

L 6" WS 8" ♂ = ♀ BOCH

A reclusive resident of boreal and montane conifer forests of New England, Canada, Alaska, and the interior Pacific Northwest. Mainly found in dense spruce-fir stands across the boreal forest, and in montane conifer forests in the Interior Northwest. Usually found in small family parties in dark thickets of spruce. Often difficult to locate during the nesting season. Gleans bark, twigs, and needles of conifers for arthropods. Also consumes various seeds, mainly in the nonbreeding season. Nest is placed in a natural cavity or abandoned woodpecker nest, usually relatively low to the ground. Nest has a foundation of moss, bark, feathers, and lichens with a finer lining of plant down and animal hair. Lays five to eight white eggs with red-brown speckling. Individuals occasionally stray far out of range in winter. In decline in the southern verge of its range.

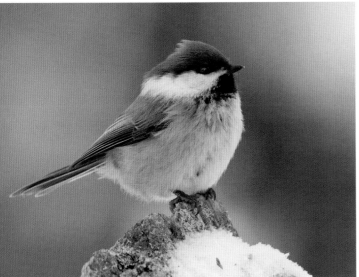

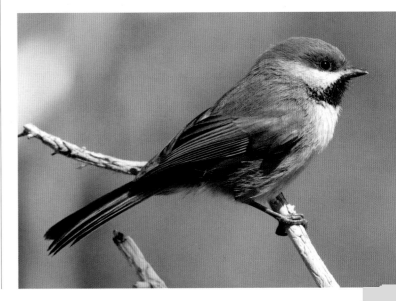

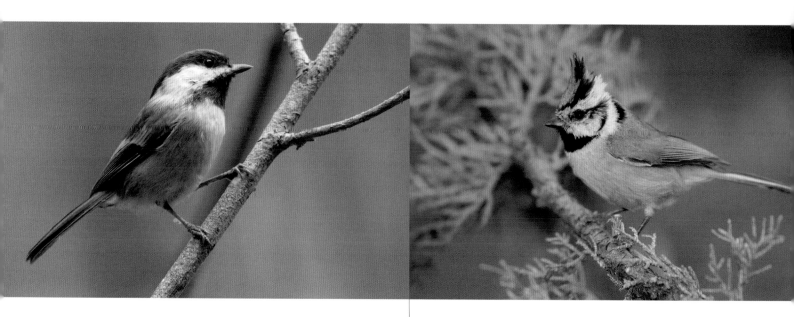

Chestnut-backed Chickadee *Poecile rufescens*
L 5" WS 8" ♂ = ♀ CBCH

Restricted to the Pacific Northwest and Far West, southward to Southern California. A pretty and petite chickadee that is vocal and sprightly. Prefers moist and shadowy conifer forests and adjacent woodlands. Gleans arthropods from bark, twigs, and leaves; also hover-gleans and takes seed and suet from feeders. Nests in a hole in a tree or a nest box. Nest has a foundation of moss, lichens, and bark fibers lined with softer and finer material. Lays six or seven white eggs with red-brown dots. Nonmigratory. The species has been expanding its range southeastward in recent decades.

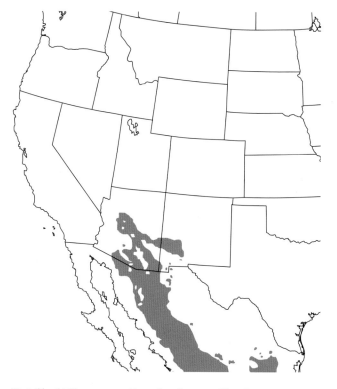

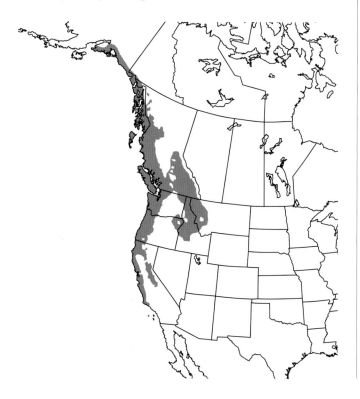

Bridled Titmouse *Baeolophus wollweberi*
L 5" WS 8" ♂ = ♀ BRTI

A handsome and sociable titmouse of oak woods in mid-elevation canyons of the Arid Southwest. Winters at lower elevations in cottonwoods and willow thickets along streams. In summer, it favors pine-oak woodlands and canyons of sycamore and oak. Gleans twigs and leaves for arthropod prey; in winter, it will take seeds. Nest is situated in a hole in a tree—either a natural cavity or woodpecker hole. Nest is lined with soft plant parts, lichens, and spider silk. Lays five to seven white eggs. Possibly in decline in its US range.

Oak Titmouse *Baeolophus inornatus*

L 6" WS 9" ♂ = ♀ OATI *WL

A plain but vocal titmouse of the Far West; the western counterpart of the Juniper Titmouse of the Interior West. Not sociable. Inhabits oak woodlands, streamside cottonwoods, forest edge, and oak-juniper groves. Gleans insects and consumes seeds. Common in woodsy suburbs and backyards. Nest is placed in a cavity, such as an old woodpecker hole. Nest is lined with grasses, animal fur, and feathers. Lays five to eight white eggs spotted with brown. Nonmigratory.

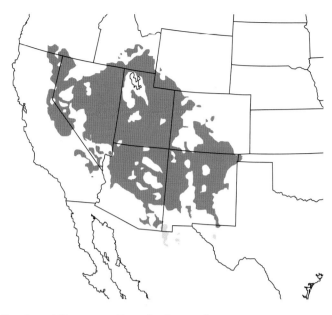

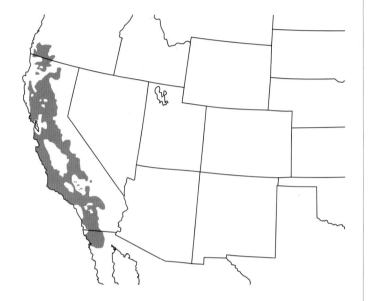

Juniper Titmouse *Baeolophus ridgwayi*

L 6" WS 9" ♂ = ♀ JUTI

An uncommon titmouse of the arid Interior West. A permanent resident of pinyon-juniper woodlands, but periodically irrupts into lowlands and south of its normal range. Gleans arthropods from vegetation and also consumes seeds. Nest is placed in a cavity in a tree or fencepost. The nest is lined with grasses, animal fur, and feathers. Lays five to eight white eggs with brown spotting. Can be distinguished from the Oak Titmouse by its distinct vocalization and its range.

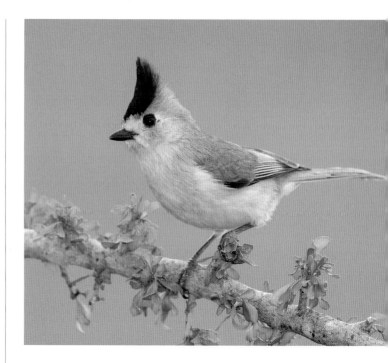

Black-crested Titmouse *Baeolophus atricristatus*
L 7" WS 10" ♂ = ♀ BCTI

This eastern Mexican species ranges north up through central Texas to the Oklahoma border. A close relative of the Tufted Titmouse, which it hybridizes with where the two meet. Inhabits mature woodlands of oak and mesquite. Also found in suburban woodland parks. Abundant in the riverine forests of the Rio Grande Valley. Habits and foraging are similar to that of Tufted Titmouse. Joins mixed-species flocks of small landbirds. Nest placed in a natural cavity or an old woodpecker hole. Nest has a foundation of rough vegetation lined by finer materials. Lays four to seven white eggs with red-brown speckling. Nonmigratory.

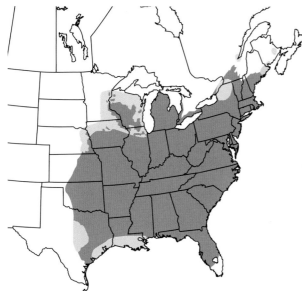

Tufted Titmouse *Baeolophus bicolor*
L 7" WS 10" ♂ = ♀ TUTI

The common titmouse of woodlands of the East and Midwest. Inhabits deciduous woods and suburban parkland. For much of the year, it will be found foraging in mixed flocks with chickadees, nuthatches, Downy Woodpeckers, and Carolina Wrens. Diet is a mix of arthropods and seeds. Gleans twigs and foliage for insects. Visits backyard bird feeders. Nest is placed in a natural cavity or an old woodpecker hole; may nest in a nest box. Nest foundation is of grass, moss, leaves, and bark strips lined with soft and finer materials such as animal hair. Lays five or six white eggs spotted with darker colors. Nonmigratory but irruptive.

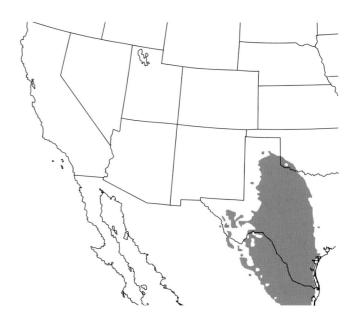

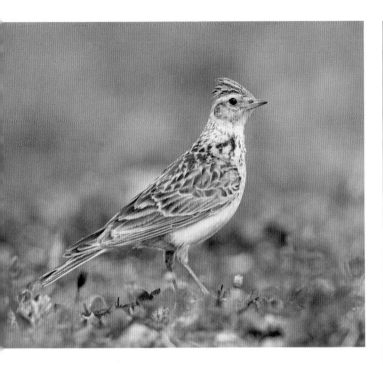

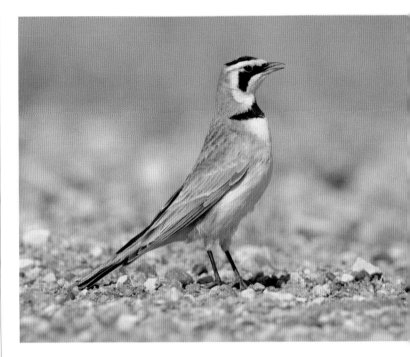

Horned Lark *Eremophila alpestris*

L 7" WS 12" ♂ ≠ ♀ HOLA

Ranges across virtually all of North America, from Alaska to South Texas. Also inhabits much of Eurasia. Departs from the northern half of its breeding range in winter to more southerly climes. A year-round resident across most of the Lower 48. A common and sociable bird of open country, inhabiting fields, tundra, airports, sandy shores, and prairies. Forages on the ground for seeds and arthropods. A flock will flush up from the ground in a swirling group. The nest, placed on the ground in open country, is a depression constructed of grass and lined with plant down and other fine material. Lays three or four pale gray eggs blotched with brown. Males in spring make a vocal display flight.

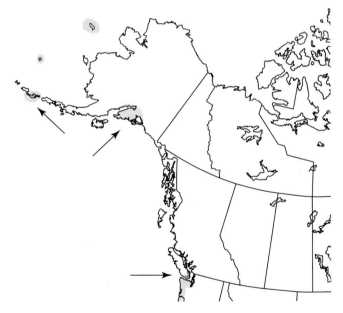

Eurasian Skylark *Alauda arvensis*

L 7" WS 13" ♂ = ♀ EUSK

A lark common in western Europe, ranging to East Asia. There is a small introduced population on Vancouver Island, British Columbia, and vagrants from Siberia are occasionally encountered in Alaska and exceptionally along the West Coast. The declining Vancouver Island population inhabits the airport and adjacent farmland and grassy fields. Forages on the ground, taking seeds and arthropods. Nest, situated on the ground in short grass, is a slight depression built with grass and lined with finer materials. Lays three to five pale gray eggs heavily spotted with darker colors.

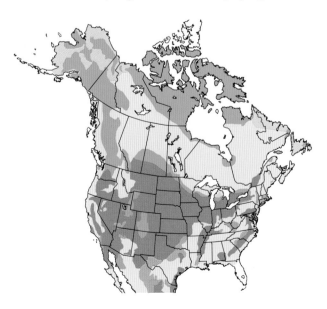

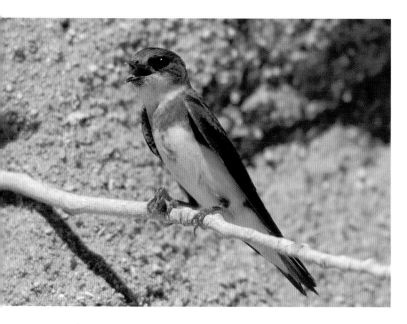

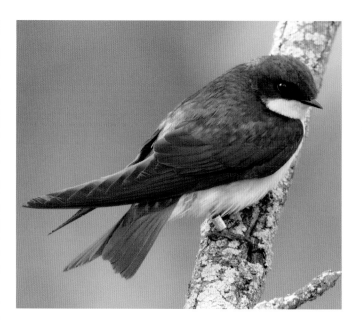

Bank Swallow *Riparia riparia*
L 5" WS 13" ♂ = ♀ BANS

A small brown-and-white flocking swallow that summers across much of the northern two-thirds of North America. Winters from western Mexico to South America. Other populations breed across Eurasia. This swallow favors open habitats near water, especially where there are earthen cliffs or sand banks where the birds can dig their nesting burrows, forming large colonies. Typically forages for aerial arthropods low over water. Diet is entirely small flying insects. The burrow nest is made of grass and lined with feathers. Lays four or five white eggs. It is remarkable that this diminutive, small-billed bird can dig its long nesting burrow into a sandbank.

Tree Swallow *Tachycineta bicolor*
L 6" WS 15" ♂ ≈ ♀ TRSW

A widespread and common breeder across much of North America, wintering in the Deep South, Southwest Borderlands, Cuba, Mexico, and Central America. Prefers open country near water—mowed fields, meadows, and marshlands. In summer, it hawks winged insects in flight. In the autumn and winter, it will perch on shrubs and take berries—especially bayberries. This flexibility to eat fruit allows the species to winter farther north than other swallows that only eat insects. Nests in a natural cavity, an old woodpecker hole, or a nest box. Will use nest boxes put out for bluebirds. Nest is a stack of grass and leaves lined with feathers. Lays four to seven pink or white eggs. In late summer and autumn, large migratory flocks gather along the Atlantic Coast, often roosting in marsh grass.

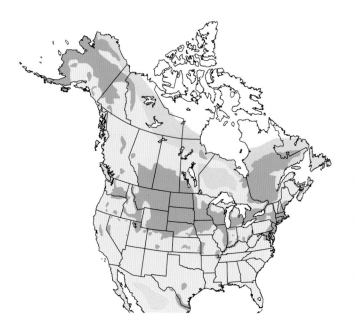

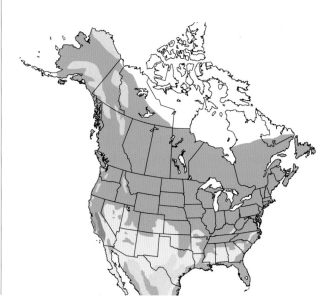

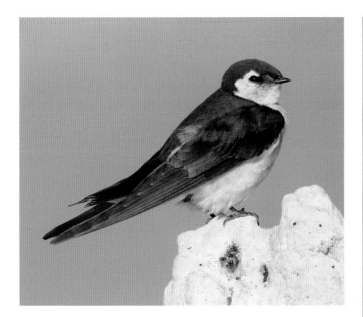

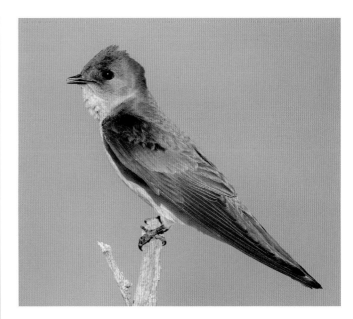

Violet-green Swallow *Tachycineta thalassina*
L 5" WS 14" ♂ ≈ ♀ VGSW

A common swallow of open country of the West. Breeding populations range from Alaska south to Mexico. Some birds winter as far south as Central America; small numbers winter on the coast of Southern California. Similar to the Tree Swallow but smaller and displays prominent white saddlebags. Widespread in summer in most open habitats of the West. Prefers openings near water. Often seen flying higher than other swallows. Usually forages in a flock. Diet is flying insects hawked from the air. Nest is usually placed in a natural cavity or an old woodpecker hole. Will also use a nest box. Nest is a cup of grass and twigs lined with feathers. Lays four to six white eggs.

Northern Rough-winged Swallow
Stelgidopteryx serripennis
L 6" WS 14" ♂ = ♀ NRWS

This plain swallow summers across the United States and southern Canada and breeds southward into Central America. Winters along our Southwest Borderlands and southward. Northern-breeding birds arrive in early spring. Prefers openings near water, especially where earthen banks are available for nesting. Not as sociable as other swallows. Often seen singly or in pairs. Forages in the air by hawking flying insects. Nests in a burrow in a bank or cliff, either one discarded by another species or one constructed themselves. Nest is a platform of twigs and bark fibers lined with finer materials. Lays five to seven white eggs.

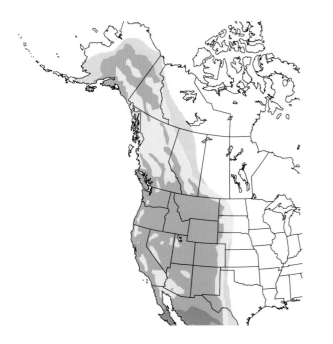

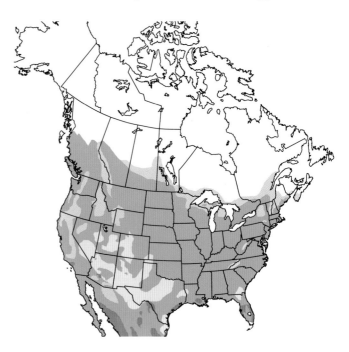

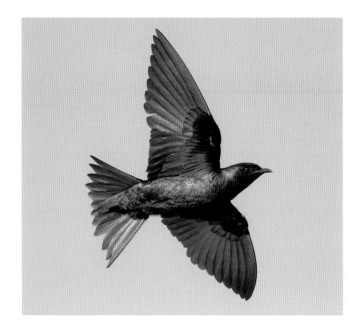

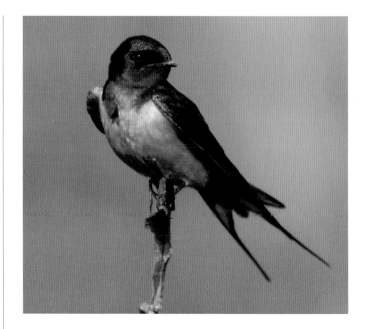

Purple Martin *Progne subis*

L 8" WS 18" ♂ ≠ ♀ PUMA

Our largest, and perhaps our favorite, swallow. Summers in the East, Far West, and patchily in the Southwest; winters in South America. Prefers openings in farmland, towns, and woodland edges where a suitable nest box is properly sited and erected. Hawks flying insects from the air, often quite high in the sky. A notable songster at the nest. Diet is entirely arthropods. In the Sonoran Desert, natural cavities are used for nesting, often old woodpecker holes in Saguaro cacti. In other areas, these birds mainly depend on special "apartment house" nest boxes set on high poles. This species is very particular about its nest boxes. The nest is a cup of grass, leaves, twigs, and mud. Lays four or five white eggs. In some regions the species is showing serious decline.

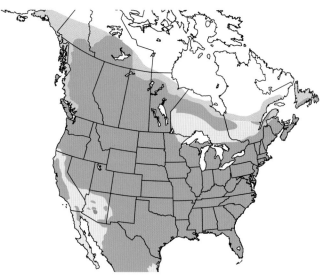

Barn Swallow *Hirundo rustica*

L 7" WS 15" ♂ ≈ ♀ BARS

Our most familiar swallow, summering across all of North America but for parts of the Arid Southwest. The species winters (and now summers) in South America. It also ranges across Eurasia, wintering southward. Prefers verdant open country—farmlands, fields, meadows, lakes, and marshlands. A swooping acrobatic flier. Sociable but not colonial. Several pairs may nest together in a barn or under a covered porch. Hawks flying insects out of the air, in graceful flight, often low over water or a meadow. Takes the occasional berry, presumably mainly in autumn and winter. Nest is a mud and grass cup plastered on the side of a barn under protective eaves. Lays four or five white eggs spotted with brown. These confiding birds seem to have established a close relationship with farms and farm environs.

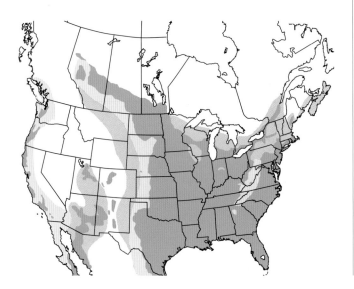

Cliff Swallow *Petrochelidon pyrrhonota*
L 6" WS 14" ♂ = ♀ CLSW

Summers across most of North America—all but some parts of the Southeast and Southwest. Winters in South America. Hawks insects from the air. Also takes the occasional berry. Favors all sorts of open country, especially near water and where there are suitable nesting sites (bridges, culverts, or barns). A strongly colonial species, often with hundreds of nests plastered on a vertical wall under a highway bridge crossing a river. Nests are globular with a side entrance hole and fashioned of mud, lined with grass and feathers. Lays four or five white or pinkish eggs spotted with brown. This species migrates in flocks, traveling during the daytime.

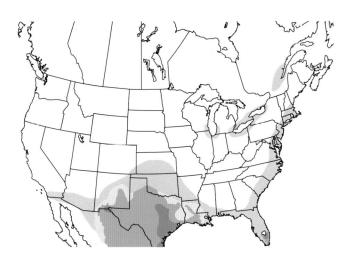

Cave Swallow *Petrochelidon fulva*
L 6" WS 13" ♂ = ♀ CASW

This subtropical swallow is a close relative of the Cliff Swallow. It summers in Texas and adjacent states as well as in South Florida; also widespread in Mexico and the Caribbean. Winters in Central America and in the southern Lower 48. This species is actively expanding its range. Favors all sorts of open country, especially near water and where there are suitable nesting sites (bridges or culverts). Forages in the same manner as the Cliff Swallow. Hawks insects from the air. Plasters its mud nest on the sides of walls under bridges or culverts. Seems to like more cave-like sites (lower, darker) than the Cliff Swallow. Nest is a partially enclosed half-bowl, distinct from the gourd-like nest of the Cliff Swallow. In some spots, both species may nest under the same bridge. Lays three or four white eggs spotted with darker colors.

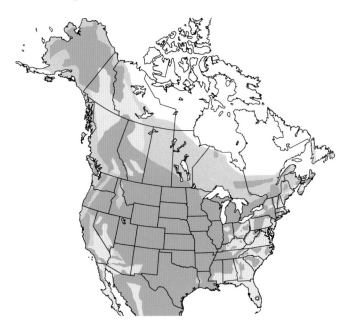

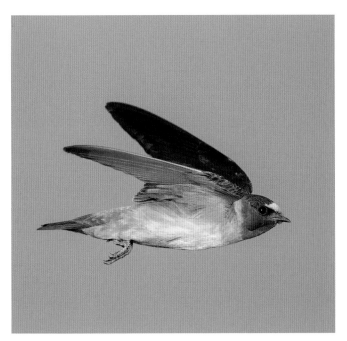

Bushtit *Psaltriparus minimus*
L 4.5" WS 6" ♂ ≈ ♀ BUSH

A tiny and drab songbird that is very sociable but often inconspicuous. Our only member of the Old World family Aegithalidae. Nonmigratory, the species ranges from southern British Columbia south through the West to Guatemala. Inhabits chaparral, scrub-oak woodlands, pinyons, and junipers. Chattering flocks swarm over low trees and bushes in search of small arthropods. Diet is mainly arthropods but also some berries and seeds. Nest is a globular vessel with an entrance near the top leading down to a nest chamber woven of plant materials, spider silk, and moss; nest cup is lined with fur, plant down, and feathers. Lays five to seven white eggs. Birds may shift to lower elevations in winter, but otherwise populations are resident and not migratory. Much smaller and shorter-tailed than the Wrentit.

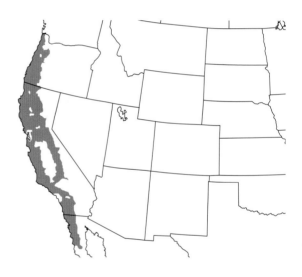

Wrentit *Chamaea fasciata*
L 7" WS 7" ♂ = ♀ WREN *WL

This little brown pale-eyed songbird is confined to the West Coast, ranging from northwestern Oregon south to northern Baja. A member of the Old World family Sylviidae. Inhabits chaparral and other brushy habitats, including those found in backyards and suburbs. Usually solitary or in pairs, heard calling from the safety of a thicket. Gleans twigs in low brush. Diet is small arthropods and berries; will visit backyard hummingbird feeders for sugar-water. The cup-shaped nest, hidden in a bush, is composed of bark, lined with animal hair and fine plant materials, and wrapped in spider silk. Lays three to five pale blue-green eggs. Nonmigratory. Virtually all of the global range of this species occurs in California and Oregon. The population appears stable.

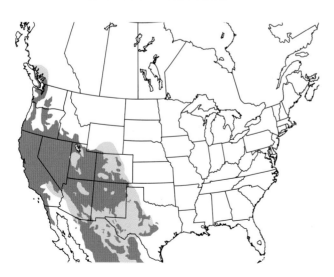

Ruby-crowned Kinglet *Corthylio calendula*

L 4" WS 8" ♂ ≈ ♀ RCKI

This tiny ball of olive feathers summers in Canada, Alaska, New England, and in mountains of the West, wintering in the southern United States and Mexico. Summers in mature conifer forests where its bubbling musical song fills the landscape—remarkable for such a small bird. Winters in open deciduous woods and stream thickets. Nervous and fast-moving, gleaning or hover-gleaning twigs for small arthropods. Takes a few berries in winter. The hanging cup nest is suspended on a conifer twig high in a tree and well hidden. The deep cup is made of moss, lichens, and other plant materials; it is wrapped with spider silk and lined with finer materials. Lays seven or eight whitish eggs spotted with brown. Not as sociable as its counterpart, the Golden-crowned Kinglet. The species is in local decline in California.

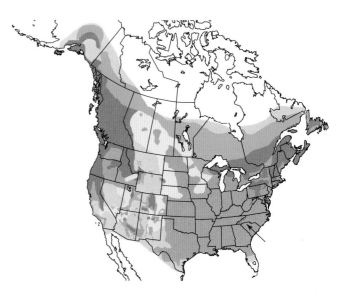

Golden-crowned Kinglet *Regulus satrapa*

L 4" WS 7" ♂ ≈ ♀ GCKI

Our smallest songbird, even smaller than the Ruby-crowned Kinglet. Summers in conifer stands and boreal forests of the North, the western mountains, and the Appalachians. Winters throughout the Lower 48. Heard more often than seen. Summers in mature spruce and fir forests as well as monoculture conifer plantations. Winters in mixed forests and deciduous woodland edges. Gleans and hover-gleans tiny arthropods from tall conifers in summer and in twigs at habitat edges in winter. Joins mixed foraging parties of small songbirds in winter. Diet is mainly arthropods, but will visit sap wells and takes the occasional berry. Cup nest is hung from a conifer branch. Nest is constructed of moss and lichen, wrapped in spider silk, and lined with fine and soft materials. Lays eight or nine whitish eggs marked with brown spots. Population of the species apparently stable.

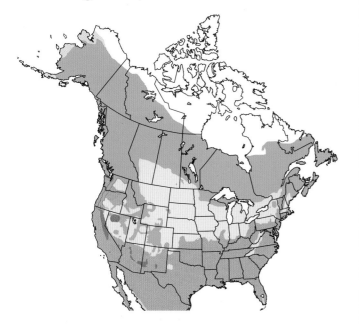

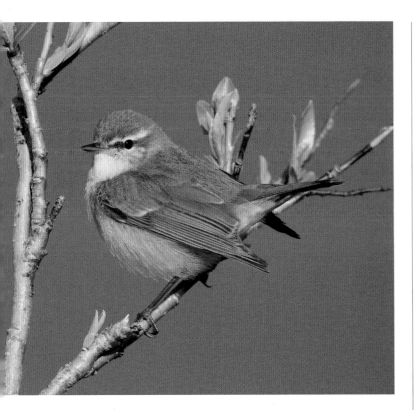

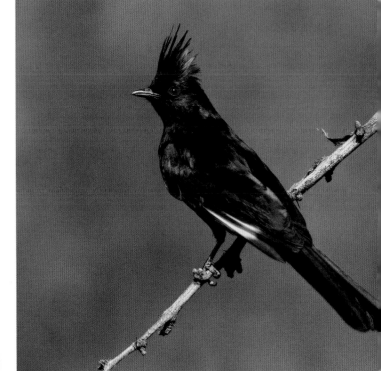

Arctic Warbler *Phylloscopus borealis*
L 5" WS 8" ♂ = ♀ ARWA

A drably plumaged summer breeder in western Alaska as well as adjacent Siberia and westward all the way to Scandinavia. Winters in Southeast Asia. North American birds summer in willow thickets along interior streams. An active and acrobatic forager for tiny insects—gleaning, hover-gleaning, and hawking midges and other arthropods. The nest, hidden on the ground under vegetation, is a domed structure of fine plant parts with a side entrance. Lays six or seven white eggs finely dotted with brown. A few have strayed to California and Baja in autumn (but difficult to distinguish from Kamchatka Leaf Warbler).

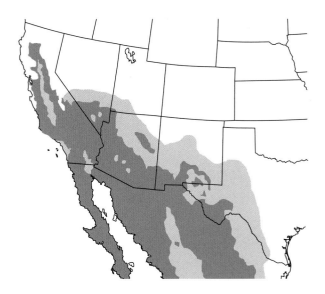

Phainopepla *Phainopepla nitens*
L 8" WS 11" ♂ ≠ ♀ PHAI

This is a handsome and crested mistletoe specialist of the Arid Southwest. Inhabits arid lowland and foothill scrub of mesquite and oak, wherever there are crops of mistletoe infesting the vegetation. The species hawks winged arthropods with a fluttery flight. Also takes a variety of small fruits. The male carries out a display flight high over its nesting area. The small, shallow cup nest is constructed of twigs, leaves, and fibers, bound in spider silk, and lined with finer materials. Lays two or three gray eggs marked with darker colors. Highly nomadic. Population stable.

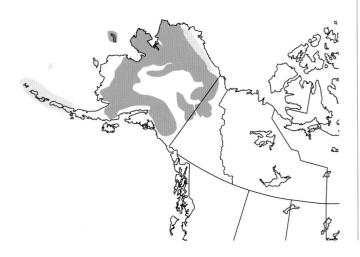

Bohemian Waxwing *Bombycilla garrulus*

L 8" WS 15" ♂ = ♀ BOWA

This widespread boreal nester of the New and Old Worlds wanders widely in winter. Most common in the Interior West in winter. Flocks come and go unpredictably. Summers in mature conifer forests of the Far North. Winters in northern towns and suburbs in search of planted fruit trees such as mountain-ash, junipers, and an array of exotic berry-producers. Hawks for flying arthropods in summer; relies on fruit in winter. Nest is an open cup set on a branch of a spruce. Nest is composed of twigs, grass, and moss lined with finer materials. Lays four to six pale bluish-gray eggs marked with black spots. Population of the species appears stable.

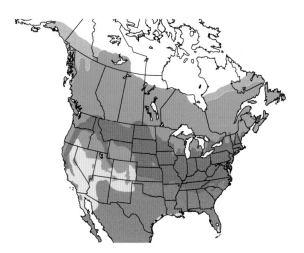

Cedar Waxwing *Bombycilla cedrorum*

L 7" WS 12" ♂ = ♀ CEDW

The more southerly of our two waxwings, and the commonplace waxwing of the Lower 48. Typically seen in vocal flocks. Summers across the middle of North America; winters southward, moving about year-round in search of fruiting resources. In summer, found in openings in woodlands, often near water. Hawks flying insects in summer; takes berries during the remainder of the year. Much of the year, the species is seen overhead in tight groups that resemble starling flocks. Nest is a loosely constructed cup of weeds and other plants, lined with finer materials, and situated on a horizontal limb of a tree. Lays three to five pale blue-gray eggs spotted with darker colors.

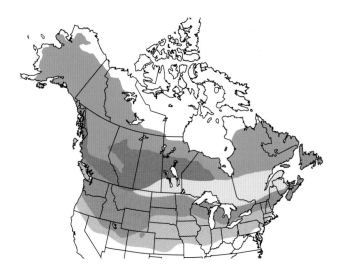

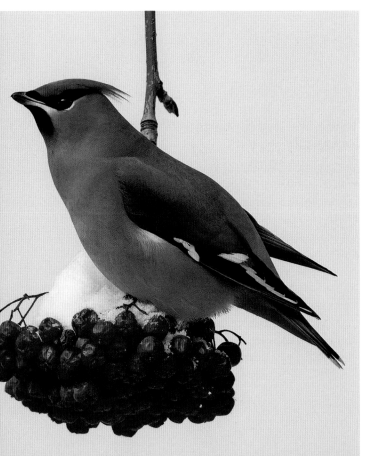

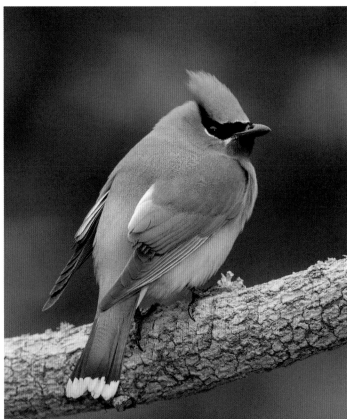

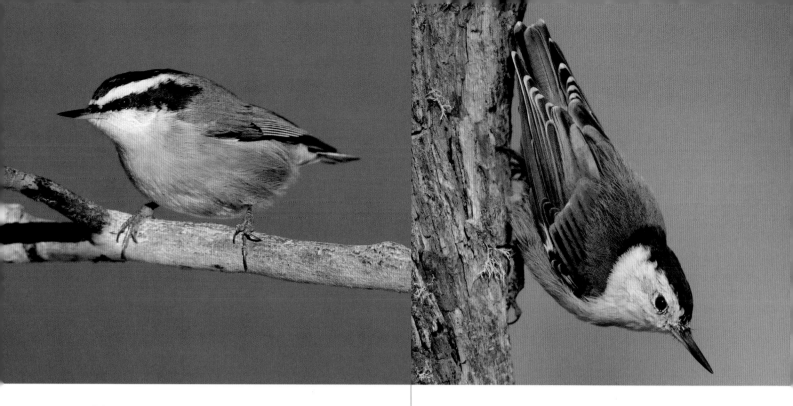

Red-breasted Nuthatch *Sitta canadensis*

L 5" WS 9" ♂ ≈ ♀ RBNU

This adorable little songbird summers in northern and western conifer forests; it winters southward and appears in autumn in large numbers during irruption years. Summers in mature spruce and fir forests as well as mixed forests. Winters widely in forests and woodlands, but especially those with a mix of deciduous and conifer trees. Joins winter flocks of songbirds; visits backyard feeding stations, especially favoring suet. Diet is mainly arthropods in summer and seeds (especially of conifers) in winter. Adults construct a small hole-nest in a standing stub of rotten wood. Nest bottom is lined with soft and fine materials. Lays five or six white eggs spotted with reddish brown.

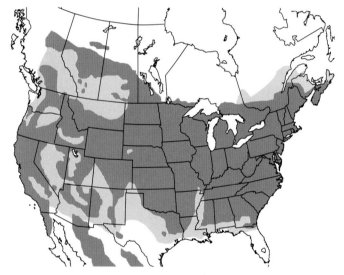

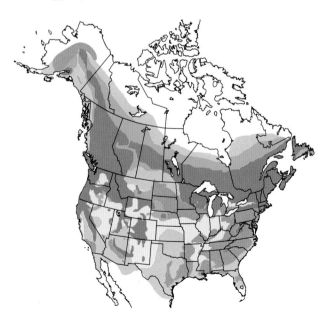

White-breasted Nuthatch *Sitta carolinensis*

L 6" WS 11" ♂ ≈ ♀ WBNU

The common nuthatch of backyard feeders and deciduous forests of the East. Also occurs across the West and into central Mexico. Generally nonmigratory but periodically irruptive—moving in autumn in some years. Inhabits the upper stages of deciduous and mixed forests. Creeps up and down trunks and larger branches of deciduous trees, gleaning arthropods from bark crevices. In winter, will take seeds and suet. Typically nests in a natural cavity or an old woodpecker hole. Nest is lined with bark fibers and finer material. Lays five to nine white eggs with red-brown spots. May comprise three cryptic species: Eastern, Interior West, and Pacific. All nuthatches are vocal, heard before seen.

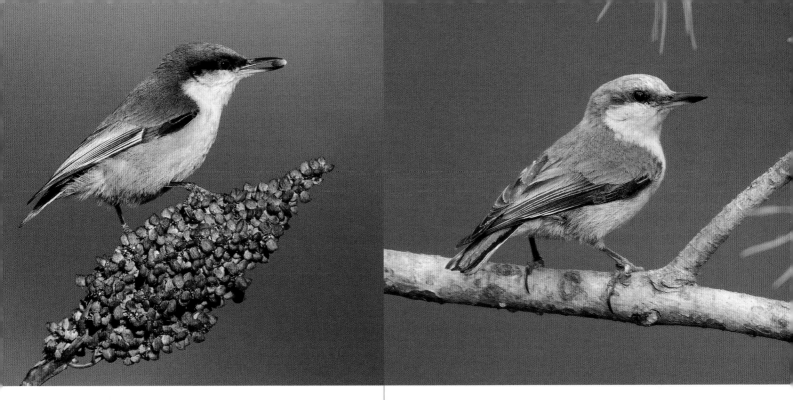

Pygmy Nuthatch *Sitta pygmaea*
L 4" WS 8" ♂ = ♀ PYNU

The western counterpart to the Brown-headed Nuthatch, the Pygmy Nuthatch inhabits pine forests of the Interior Mountain West and the California coast. Also can be found in other western conifer forests. A common permanent resident of mature pine forests. Species' range extends to southern Mexico. Very sociable and vocal. Joins mixed-species songbird flocks, especially in the nonbreeding season. Creeps on bark, branches, and cones searching for hidden arthropods. A nest hole is excavated by the two breeding birds assisted by helpers. Nest base is lined with bark fibers, plant down, and feathers. Lays six to eight white eggs dotted with reddish brown. Some birds shift to lower elevations in winter. Declines have been noted in some states.

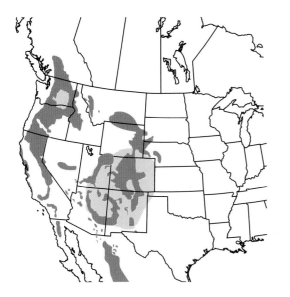

Brown-headed Nuthatch *Sitta pusilla*
L 5" WS 8" ♂ = ♀ BHNU

A tiny, sociable nuthatch of mature pine forests of the Southeast and Deep South. Prefers mature forests dominated by various species of pine; will also use monoculture pine plantations, especially older ones with large trees. The species travels in vocal flocks, typically high in the forest canopy. In winter, joins mixed flocks of foraging birds in piney woods. Diet is mainly insects. Consumes pine seeds in winter. Will come in to bird feeders. Nest is drilled low in a dead tree or stub. Bottom of the nest cavity is layered with plant materials and lined with finer materials. Lays four to six white eggs with red-brown marks. Nonmigratory, but individuals do wander quite a bit.

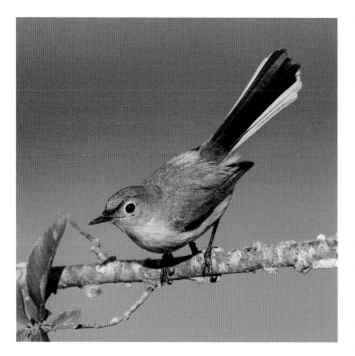

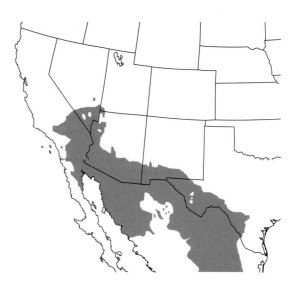

Blue-gray Gnatcatcher *Polioptila caerulea*

L 4.5" WS 6" ♂ ≈ ♀ BGGN

A small, slight, drab, and nervous songbird of the upper stages of deciduous trees at the forest edge. Summers across much of the United States; winters from the Deep South to Honduras. In the East, prefers open deciduous woodland. In the West, found in a range of brushy habitats—chaparral, oak woodlands, and pinyon-juniper. Actively forages for arthropods—gleaning, hover-gleaning, and hawking. Quite vocal around the nest tree—giving its high-pitched and lisping call notes. Diet is a range of small arthropods. The compact cup nest, set atop a horizontal tree branch, is composed of plant materials, lined with finer materials, wrapped in spider silk, and decorated with lichens. Lays four or five bluish-white eggs dotted reddish brown.

Black-tailed Gnatcatcher *Polioptila melanura*

L 4.5" WS 5.5" ♂ = ♀ BTGN

A year-round resident of arid scrub of the Southwest, ranging to central Mexico. Typically found in pairs. Inhabits mesquite, dry washes, ravines, and desert brushland. Gleans and hover-gleans leaves (summer) and twigs (winter) for small arthropods. Diet is small arthropods. In winter, will sometimes be found taking small fruit. The compact nest cup, situated in a shrub, is composed of various plant materials, lined with finer matter, and wrapped in spider silk. Lays three to five bluish-white eggs dotted with reddish brown. The population of this species is apparently stable.

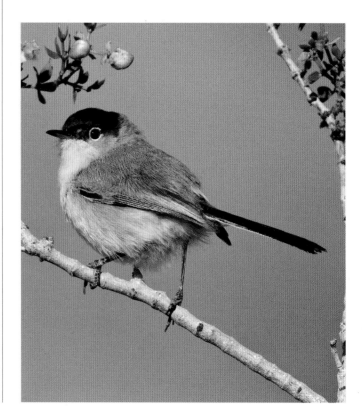

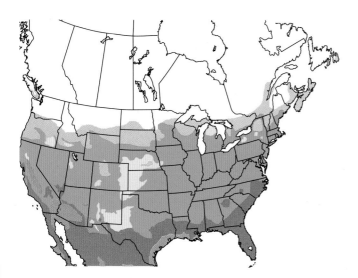

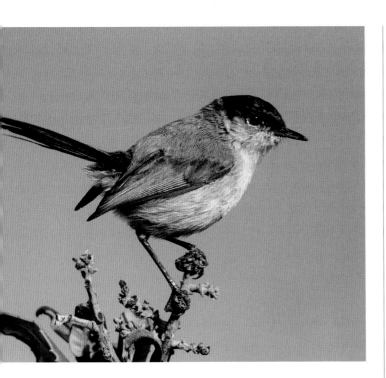

California Gnatcatcher *Polioptila californica*
L 4.5" WS 5.5" ♂ ≠ ♀ CAGN *WL

This small songbird is restricted to Southern California and Baja. Breeding is impacted by parasitism by the Brown-headed Cowbird. California populations are also threatened by residential development of its prime breeding habitat. Inhabits coastal sage scrub of California and brushlands of Baja. Gleans and hover-gleans leaves and twigs for small arthropods. Diet is small arthropods. In winter, will sometimes be found taking small fruit. The compact nest cup, situated in a low shrub, is made from various plant materials, lined with finer matter, and wrapped in spider silk. Lays three to five bluish-white eggs dotted with reddish brown. Nonmigratory. California populations have been listed as Threatened by the US Fish & Wildlife Service.

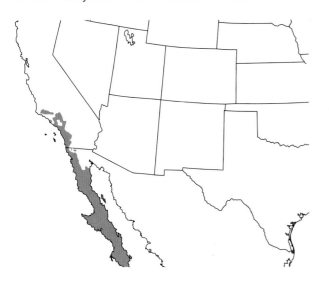

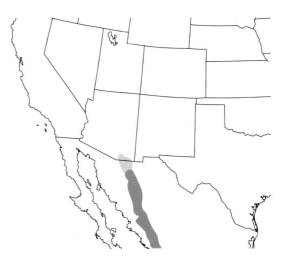

Black-capped Gnatcatcher *Polioptila nigriceps*
L 4.3" WS 6" ♂ ≠ ♀ BCGN *WL

This western Mexican species ranges north to the Borderlands of southeastern Arizona, where it occasionally nests. Found in hackberry thickets in dry foothill canyons. Shares its habitat with the more widespread Black-tailed and Blue-gray Gnatcatchers. Habits are like the Black-tailed. Nest is a compact cup placed in a mesquite or other desert bush. Lays three or four bluish-white eggs dotted with reddish brown. Nonmigratory. Population fluctuates with drought cycles.

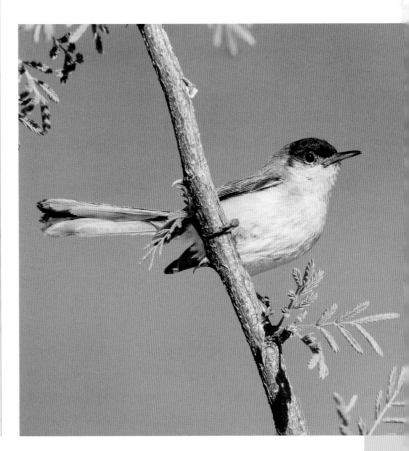

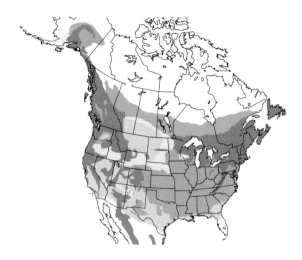

Brown Creeper *Certhia americana*
L 5" WS 8" ♂ = ♀ BRCR

A widespread but easily overlooked little songbird of woodlands. Summers in the shady interior of mature deciduous, mixed, or conifer forests of the northern United States and Canada and southward in the Appalachians and Rockies. Winters in woodlands. Creeps up a tree trunk and, upon reaching the top, flies to the base of the next tree to repeat the process. Summer diet is bark arthropods. Winter diet may include some seeds. Will visit suet feeders. Nest, typically hidden behind a large, loose patch of bark still on the tree trunk, is a shallow half-cup made of twigs, bark strips, and other materials and lined with fine bark fibers. Lays five or six white eggs dotted reddish brown. Northernmost breeders winter southward.

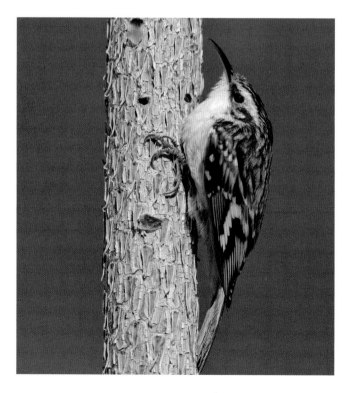

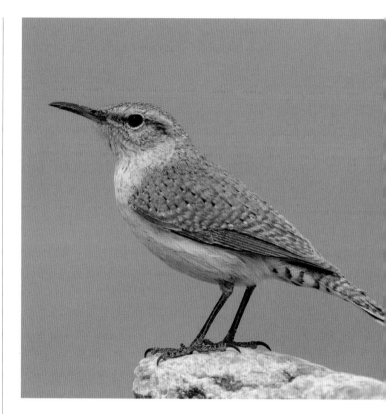

Rock Wren *Salpinctes obsoletus*
L 6" WS 9" ♂ = ♀ ROWR

A vocal inhabitant of rocky canyons and dry slopes of loose rocks. Ranges from lowlands to high in the mountains. Summers northward into western Canada and winters in the Southwest and Mexico. The breeding range of the species extends south to Costa Rica. Bounces up and down on its short legs. Best found by its loud series of ringing notes. Forages for various arthropods on the ground or among rocks, probing crevices with its long bill. The rough cup nest, made of a range of plant materials with fine materials as lining, is hidden in a rocky crevice or other protected place. A paving of pebbles leads to the nest entrance. Northern breeders winter southward or to lower elevations.

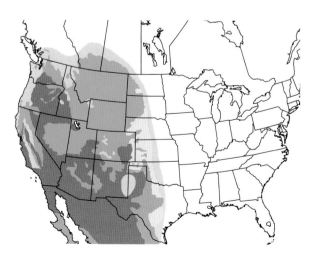

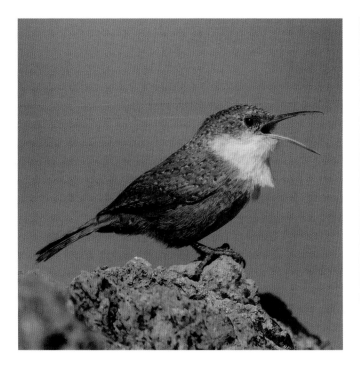

Canyon Wren *Catherpes mexicanus*

L 6" WS 8" ♂ = ♀ CANW

This loud songster of canyons and cliffs is a permanent resident of the West, ranging from southernmost British Columbia to Texas and southward to southern Mexico. Inhabits steep rock faces of canyons and the base of cliffs, and is sometimes found in association with stone buildings. In winter, may be found in streamside thickets. Heard more often than seen; elusive and skulking. Forages among rocks for arthropod prey taken mainly by gleaning rock surfaces. The rough nest has a base of coarse plant matter topped with a cup of finer materials and lined with animal hair and down. This is situated in a rock crevice. Lays four to six white eggs lightly dotted with red-brown spots. Nonmigratory.

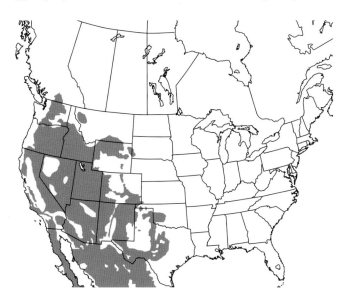

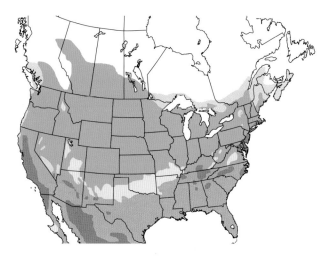

House Wren *Troglodytes aedon*

L 5" WS 6" ♂ = ♀ HOWR

A widespread and common summer resident across the United States and southern Canada. Winters in the Deep South and further southward. The species ranges through Mexico, the Caribbean, and South and Central America. Frequents backyards, thickets, woodland edge, woodlots, and suburban parklands. The backyard habit, plus its ebullient song, make it a favorite of homeowners. Actively gleans shrubbery and other vegetation for small arthropods. Nests in a natural cavity or nest box. The nest has a foundation of twigs with a cup of finer materials sitting atop. Lays six or seven white eggs with red-brown dots.

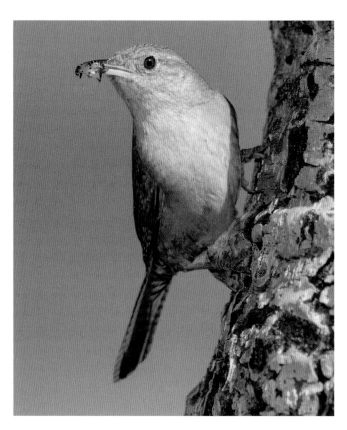

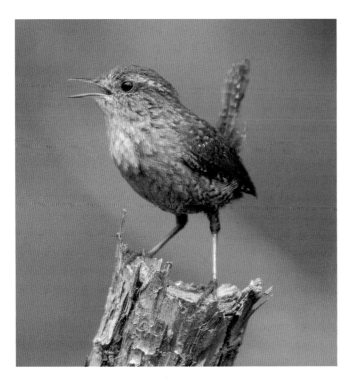

Winter Wren *Troglodytes hiemalis*
L 4" WS 6" ♂ = ♀ WIWR

This tiny brown songster summers in boreal Canada, New England, and the Appalachians, wintering in the East and Midwest. Summer or winter, this species prefers tangles within conifer or mixed forests. Winter finds them in any woodland with tangles, often near streams. The male in the breeding season sings his marvelously complex tinkling song from an open perch. In other seasons, the species is retiring and difficult to see. Gleans small arthropods from twigs and roots within tangles. Nest is placed in a natural cavity near the ground. The nest is a jumble of plant material lined with animal hair and down. Lays five or six white eggs with reddish-brown markings.

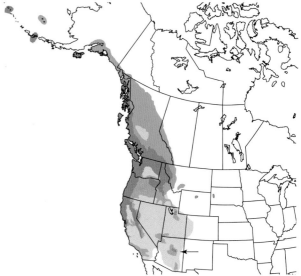

Pacific Wren *Troglodytes pacificus*
L 4" WS 6" ♂ = ♀ PAWR

This tiny, dark brown sprite of damp conifer forests and treeless islands of the Pacific Northwest is the western counterpart to the Winter Wren. The two are very similar and were long treated as a single widespread species. The Pacific Wren inhabits thickets within mature conifer and mixed forests. This tiny bird has a big voice that fills the habitat. Gleans arthropods among tangles of dead and fallen vegetation, often near water. Nest is a messy globe of leaves and twigs with a side entrance, lined with finer material. The nest is typically hidden among the roots of a treefall. Lays five or six white eggs spotted with reddish brown.

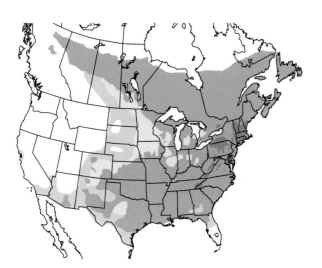

Sedge Wren *Cistothorus stellaris*

L 5" WS 6" ♂ = ♀ SEWR

Typically elusive, this small wren summers in wet meadows of the upper Midwest and Canadian prairies. Winters in the Southeast and northeastern Mexico. Found by its chattering voice in the breeding season. In other seasons, this little wren tends to disappear into rank weedy fields. Breeds in expansive low marshlands of grass and sedge, as well as hayfields and grasslands. Winters in low grasslands and coastal prairie. A stealthy hunter of small arthropods low in thick grass and sedge. Rarely seen except when in spring song. The nest, placed low in the grass, is a globe of woven grass blades with a side entrance and lined with finer materials. Lays four to eight white eggs.

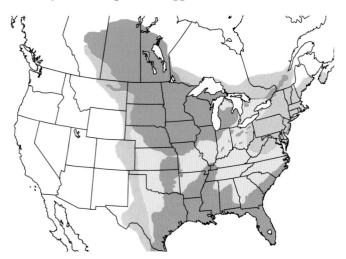

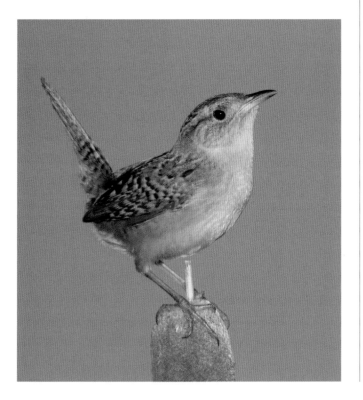

Marsh Wren *Cistothorus palustris*

L 5" WS 6" ♂ = ♀ MAWR

A wren of wetlands that is more common, more vocal, and less stealthy than the Sedge Wren. Summers in deep brackish or freshwater marshes of cattails, bullrushes, and reeds. Winters in similar marshlands to southern Mexico. Migrants can be found in weedy fields. Gleans small arthropods from low in marsh vegetation, occasionally taken from the surface of water; also consumes snails. The nest, a globe of marsh vegetation with a side entrance, is anchored on stems of cattails or other sturdy vegetation; the interior is lined with finer materials. Lays four or five pale brown eggs heavily speckled dark brown. The species is apparently increasing in the West and declining in the East.

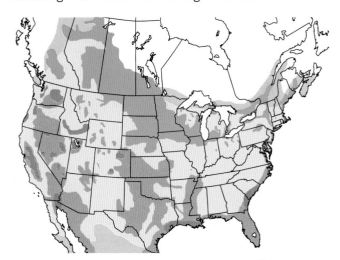

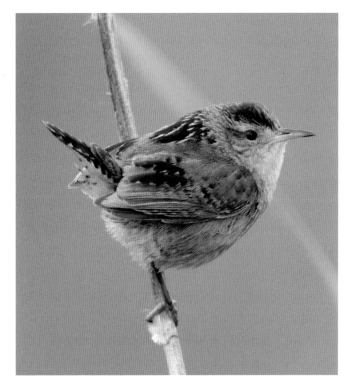

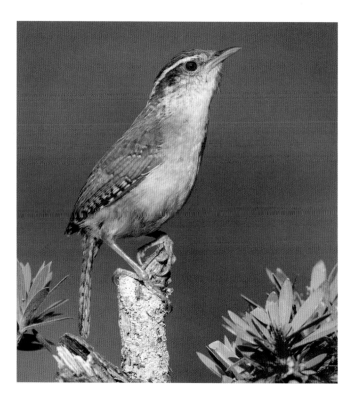

Carolina Wren *Thryothorus ludovicianus*
L 6" WS 8" ♂ = ♀ CARW

The loud-singing wren of the East. This permanent resident is another commonplace backyard nester. Inhabits undergrowth and thickets in woodlands, suburban parks, and backyards. Bright and inquisitive; visits bird feeders, especially for suet. Gleans insects from tangles, thickets, branches, trunks, and the ground; will consume other invertebrates, tiny vertebrates, and fruit (in winter). The unkempt globular nest with a side entrance is placed in a crevice, natural cavity, nest box, or some acceptable space in a work shed or other covered location. Lays four or five white eggs with brown blotches. Nonmigratory. Northernmost breeding populations sometimes suffer mortality during particularly cold and snowy winters.

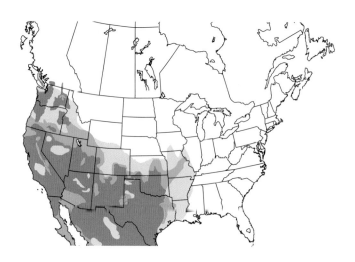

Bewick's Wren *Thryomanes bewickii*
L 5" WS 7" ♂ = ♀ BEWR

This species can be considered a western counterpart to the Carolina Wren—similar-looking and commonplace but with a distinct vocalization more like that of a Song Sparrow. Eastern populations have been disappearing over the last several decades. Inhabits brushland, thick edge habitat, chaparral, and suburban yards in the West. Flicks its long tail sideways. Forages for small arthropods in thickets and edge, gleaning from twigs and leaves, as well as on the ground. The species' range extends south into southern Mexico. Nest is situated in a cavity—natural or human-made. Nest, set on a platform of twigs and other plant materials, is a cup of moss with fine materials lining the interior. Lays five to seven white eggs blotched with darker colors. Largely nonmigratory. Some northern and eastern range-edge populations move southward in winter.

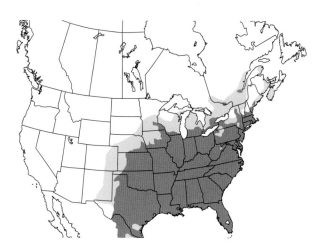

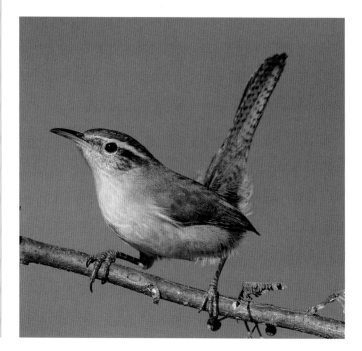

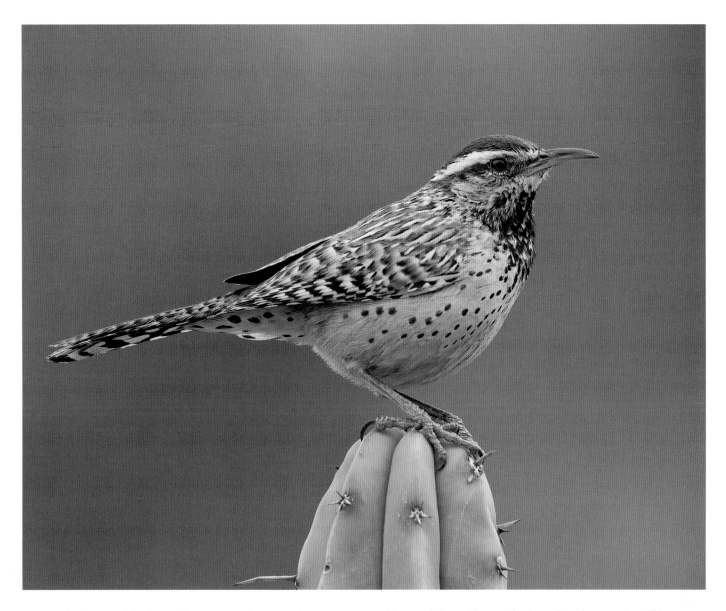

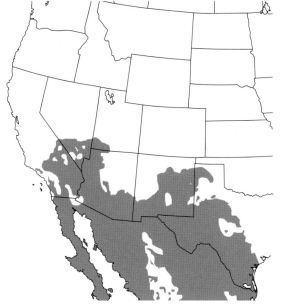

Cactus Wren *Campylorhynchus brunneicapillus*
L 9" WS 11" ♂ = ♀ CACW

Our largest wren, the Cactus Wren is an active and bold
resident of the lowlands of the Arid Southwest. Inhabits
desert vegetation, arid brush, and thorny shrublands. The
species' range extends to central Mexico. Very sociable and
curious; often seen in family groups. Forages on the ground,
in thickets, and in low trees, gleaning arthropods and small
vertebrates. Diet includes a range of plant material: fruit,
seeds, and nectar. The football-shaped nest, often fortified
in a cactus, has an entrance tunnel at one end. Nest is
made of weeds, twigs, grass, and other plant material and
is lined with finer materials. Lays three or four whitish or
pinkish eggs heavily spotted brown. Local populations have
exhibited declines. Probably overall the species population
is stable. The species is very sedentary. This oversized wren
has the look of a small thrasher.

Gray Catbird *Dumetella carolinensis*
L 9" WS 11" ♂ = ♀ GRCA

A common and vocal songbird of backyard thickets, ranging from the East Coast to British Columbia in summer, and wintering in the Deep South, Caribbean, Mexico, and Central America. Another favorite of nature-loving homeowners. Prefers the dark shade of hedgerows, brush, and tangles, but avoids deep forest interior. Both reclusive and somewhat confiding. Often heard before seen. Vocalizations are conversational and pleasant—often the dominant sounds in a back yard. Forages on the ground and low vegetation for arthropods and fruit. Nest, a bulky cup of weeds and twigs lined with finer materials, is hidden in a tangle. Lays three or four blue-green eggs, sometimes with reddish spotting.

Curve-billed Thrasher *Toxostoma curvirostre*
L 11" WS 14" ♂ = ♀ CBTH

The commonplace and least reclusive thrasher of the Arid Southwest. A permanent resident of arid brushlands, chaparral, and open grasslands, especially in association with Cholla and other cactus species. Does much foraging on the ground, digging into the soil and turning over leaves and stones with its bill. Diet is mainly terrestrial arthropods and other invertebrates, as well as a variety of fruit. Nest, typically placed in the fork of a cactus, is bulky cup of thorny twigs lined with finer materials. Lays two to four pale blue-green eggs with tiny darker spots. Nonmigratory. Species population appears stable. Prefers drier habitats than those used by the Long-billed Thrasher.

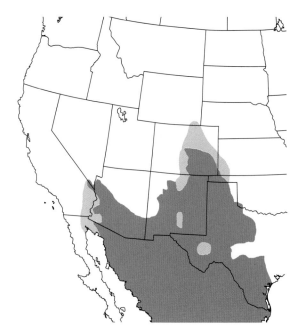

Long-billed Thrasher *Toxostoma longirostre*
L 12" WS 12" ♂ = ♀ LBTH

A range-restricted southern counterpart of the Brown Thrasher, found as a permanent resident in South Texas and eastern Mexico. Inhabits brushy woodlands, especially near water. Commonly seen foraging on the ground for terrestrial arthropods and other small creatures. Diet is a mix of arthropods, small vertebrates, fruit, and nuts. The bulky, untidy nest cup of sticks and twigs lined with finer materials is hidden in a spiny bush. Lays three or four pale blue eggs spotted with russet. Very similar to the Brown Thrasher but not as reddish-brown as its eastern counterpart. The two are rarely found together. Population may be in decline from habitat loss.

Brown Thrasher *Toxostoma rufum*
L 12" WS 13" ♂ = ♀ BRTH

A rather shy thrasher widespread east of the Rockies, where in most places it is the only thrasher. Often heard before seen. Winters mainly in the Deep South. Prefers to hide within tangles and thickets, but occasionally is seen foraging out on the ground in the open. Frequents suburban parks, backyards, and woodland edges. A noted vocalist, giving a series of pleasant repeated phrases. Diet is a mix of arthropods, fruit, and seeds; also takes a few small vertebrates. The bulky nest is placed in a vine tangle; the stick foundation supports a cup of various plant materials lined with finer materials. Lays three to five pale blue eggs with red-brown dots. Apparently in decline in the Northeast.

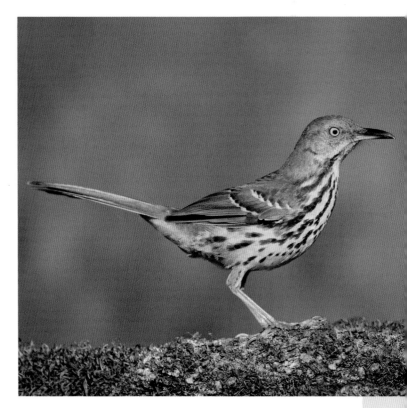

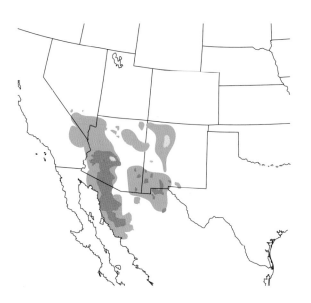

Bendire's Thrasher *Toxostoma bendirei*

L 10" WS 13" ♂ = ♀ BETH *VU *WL

An uncommon resident of the Arid Southwest. A permanent resident in southern Arizona and northwestern Mexico, and a summer visitor to Southern California, northern Arizona, and northern New Mexico. Inhabits brushy desert, thorn scrub, and farmland hedgerows. Forages mainly on the ground, taking arthropods, cactus fruits, and seeds. The compact cup nest is placed in a dense low bush or cactus. Outer cup is twigs, and interior is lined with fine materials. Smaller than nests of other thrashers. Lays three whitish or pale green eggs with some darker blotching.

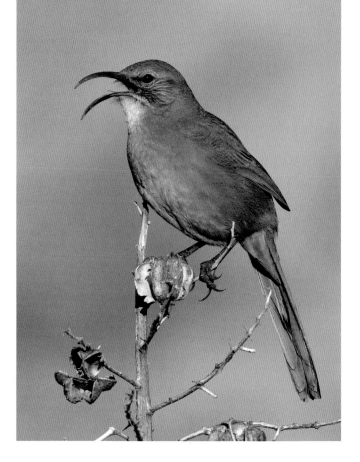

California Thrasher *Toxostoma redivivum*

L 12" WS 13" ♂ = ♀ CATH *WL

A large, plain, sickle-billed thrasher of California and northern Baja. A sedentary permanent resident of chaparral, thickets, parks, gardens, and foothills to mid-mountains. Forages mainly on the ground, flipping leaves and digging with its long, curved bill. Diet is a mix of arthropods, berries, seeds, and acorns. The bulky open cup nest is situated low in a thicket; outer structure is sticks and twigs, and inner is finer and softer materials. Lays three or four pale blue eggs spotted with brown. Probably in decline from habitat loss.

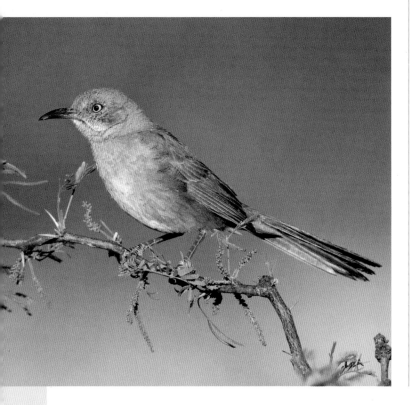

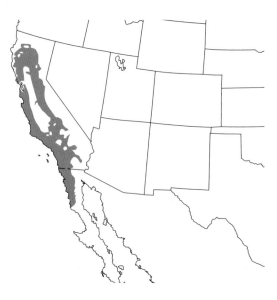

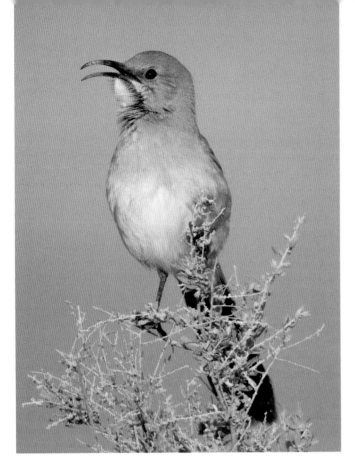

LeConte's Thrasher *Toxostoma lecontei*

L 11" WS 12" ♂ = ♀ LCTH *WL

This pale thrasher is an elusive permanent resident of the Mojave and Sonoran Deserts. Mainly found in southern California, southwestern Arizona, southern Nevada, and northwestern Mexico. A rare thrasher of open desert flats with sparse vegetation of Creosote Bush, saltbush, mesquite, and Cholla cactus. Rarely flies; instead, it scoots about desert flats from bush to bush on foot. Diet is mainly arthropods gleaned from the ground, as well as some fruit and seeds. The bulky open cup nest is typically situated in a dense Cholla cactus a few feet from the ground. The nest cup is of thorny twigs lined with plant down. Lays three or four pale blue-green eggs with brown spots. Sedentary.

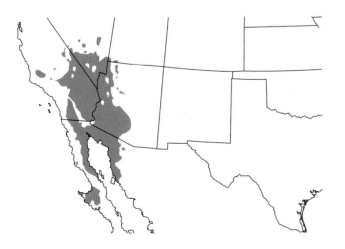

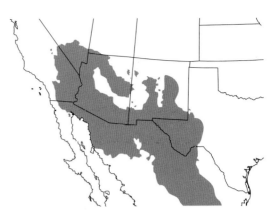

Crissal Thrasher *Toxostoma crissale*

L 12" WS 13" ♂ = ♀ CRTH

A large, dark, and retiring thrasher of desert scrub of the Southwest. This permanent resident ranges from southern Nevada to central Mexico. Inhabits thickets of mesquite as well as thick brush along desert stream courses and dense chaparral in the mountains. Forages for terrestrial arthropods and other invertebrates on the ground under dense brush. Also can be found perched in fruiting bushes, consuming berries. The bulky open cup nest of thorny twigs is situated low in dense brush. Nest is lined with fine materials. Lays two or three blue-green eggs. Some birds wander from their breeding habitat in winter. In decline as a result of habitat degradation and conversion from local urbanization.

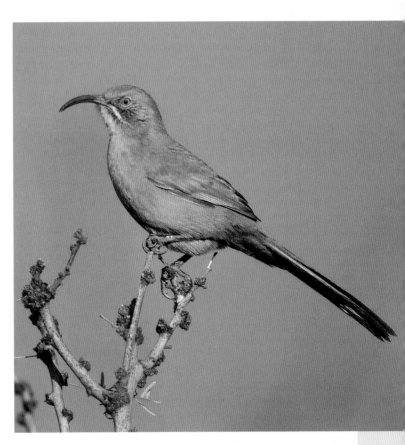

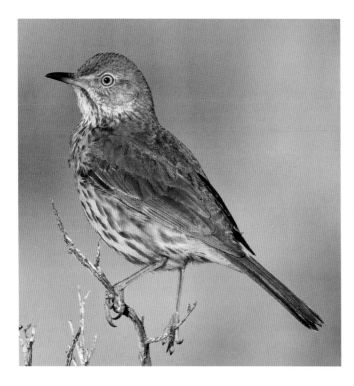

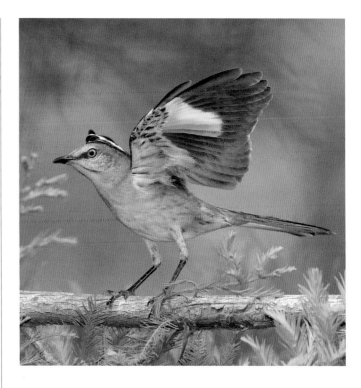

Sage Thrasher *Oreoscoptes montanus*
L 9" WS 12" ♂ = ♀ SATH

Our smallest thrasher, the Sage Thrasher summers in expansive sagebrush plains and other similar open habitats across the upper Great Basin and western Great Plains. Winters in a wide variety of open habitats in the Southwest Borderlands. Inhabits sagebrush, edges of pinyon-juniper woodlands, and brush-filled slopes. Sings incessantly during the breeding season. Retreats into brush when approached. Diet is mainly arthropods in summer and fruit and berries in winter. The bulky cup nest of twigs is situated low in a shrub. Nest is lined with fine and soft materials. Lays three to five deep blue-green eggs with brown splotches mainly on the larger end of the egg.

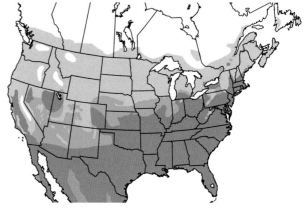

Northern Mockingbird *Mimus polyglottos*
L 10" WS 14" ♂ = ♀ NOMO

This familiar and popular songbird of neighborhoods, yards, farmland, and roadsides ranges from the East Coast to Southern California, mainly residing in the southern half of the United States. Good numbers of the species migrate southward in the winter. The species ranges into southern Mexico and the Caribbean. It is perhaps most noted for singing at night in the summer. Inhabits suburbs, open parks, roadside hedges, and thickets in open land. The species is bold and inquisitive. An inveterate songster. Forages for arthropods on the ground and takes berries from bushes. The nest is a platform of twigs supporting a cup of finer material that is lined with plant down and other soft material. This is situated within the confines of a thick bush or low sapling. Lays three or four greenish or bluish eggs blotched with brown, mainly at the larger end.

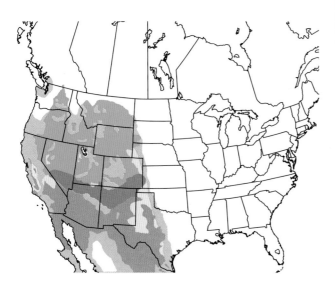

European Starling *Sturnus vulgaris*

L 9" WS 16" ♂ = ♀ EUST

Individuals of this Eurasian species were released in Central Park, New York, in 1890, and now the species inhabits the entire Lower 48 and much of human-settled Canada, and it has urban populations in Alaska. A commonplace and sociable resident of all human-dominated environments: urban landscapes, city parks, farmland, and suburbia. Generally absent from wild or untamed lands. Very much a human commensal. Forms large flocks in autumn and winter. Mainly in family groups in summer. Diet is largely invertebrates in the summer and fruit and seeds in the nonbreeding season. Nest is situated in a cavity, such as a birdhouse or woodpecker hole; the cavity is lined with an assortment of twigs, grass, and feathers. Lays four to six unmarked pale green or blue eggs. Northernmost breeders migrate southward, and other populations are known to move in winter.

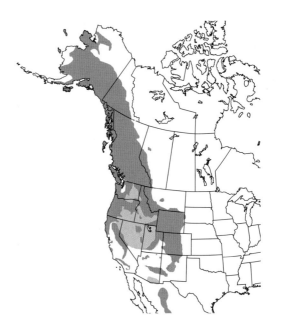

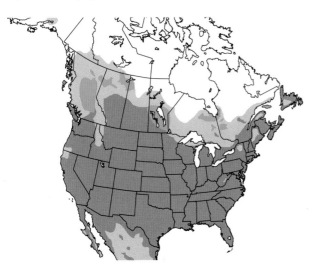

American Dipper *Cinclus mexicanus*

L 8" WS 11" ♂ = ♀ AMDI

An active and vocal permanent resident of rocky mountain clear-water streams of the West. Our only songbird that swims underwater. The species' range extends southward to Panama. A strict streamside specialist. Typically seeing fluttering low over a stream course or dipping up and down on a wet streamside rock. Diet is aquatic invertebrates and small fish captured from the water. The large nest, constructed of moss, roots, and twigs, is a globe with a large entrance hole on one side; it is placed under a bridge or in a cleft on a streamside bank. Lays four or five white eggs. Nonmigratory, but in northern populations there is some minor movement of individuals downslope or southward in winter.

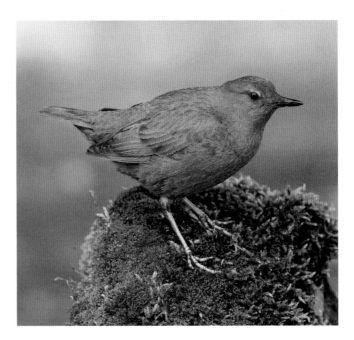

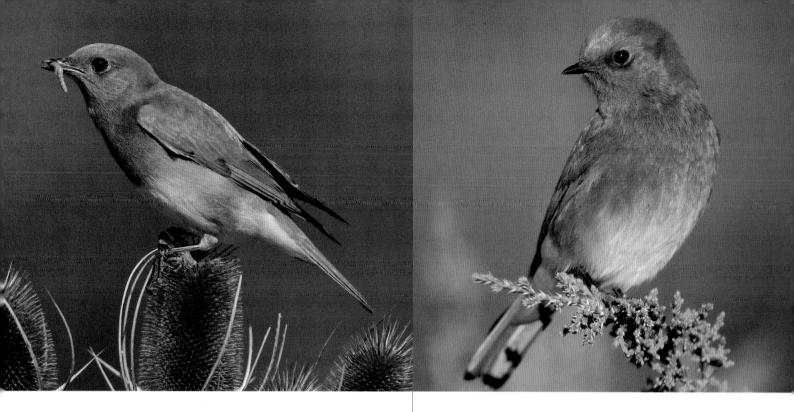

Eastern Bluebird *Sialia sialis*
L 7" WS 13" ♂ ≠ ♀ EABL

A favorite of many rural homeowners, who will put out nest boxes on fence posts to attract these lovely birds. The species favors open country across the eastern and central United States and southern Canada. Breeding populations also extend south to Nicaragua. Birds in the northern part of the range move southward in winter. Prefers farmland, roadsides, orchards, forest clearings, and wooded suburbs. Wanders in flocks in winter and, in that season, can show up in more wooded habitats. Perches distinctively on wires, fence lines, or fence posts, dropping down on arthropods seen on the ground. Summer diet is mainly arthropods; takes berries in winter. Nests in nest boxes set out for these birds or in some natural cavity, such as a woodpecker hole. Nest is a rough cup of dried plant material lined with soft material. Lays four or five pale blue eggs.

Western Bluebird *Sialia mexicana*
L 7" WS 14" ♂ ≠ ♀ WEBL

The western counterpart to the Eastern Bluebird. Summers from southern British Columbia to Mexico. Our birds winter from western Washington to the Border; less migratory than Eastern and Mountain Bluebirds, and many are year-round residents. Inhabits grassy openings in a variety of wooded habitats, both deciduous and conifer. Sits atop a fencepost or other open perch and flies down to capture terrestrial arthropods. Takes mainly arthropods in summer and a mix of arthropods and berries in winter. Nests in a natural cavity or nest box; the nest is an untidy cup of weeds and twigs. Lays four to six pale blue eggs. The species appears to be in good shape, with local increases in some areas of the Far West. Females of the bluebirds pose an ID challenge.

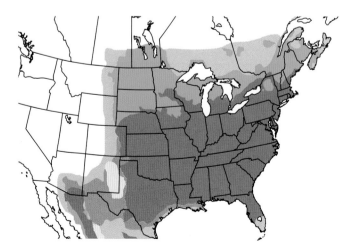

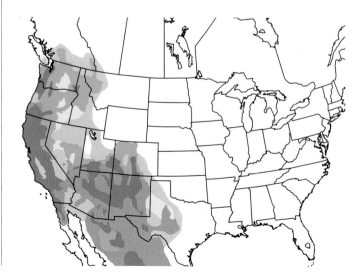

Mountain Bluebird *Sialia currucoides*
L 7" WS 14" ♂ ≠ ♀ MOBL

This beautiful sky-blue songbird summers in the Northwest and Mountain West, wintering in the Southwest. This is a summer bird of mountain meadows and high plains. Widespread in open country and openings in woodlands in winter. Hovers over open ground to locate terrestrial arthropod prey. Forms sizeable flocks in winter. Takes mainly arthropods in summer and berries and arthropods in winter. Nest, a loose cup of stems, twigs, and grass lined with soft material, is sited in a cavity or crevice. Lays five or six pale blue eggs. Nest boxes have substantially aided this species.

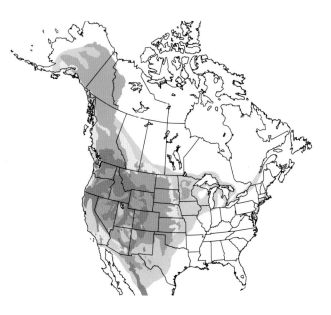

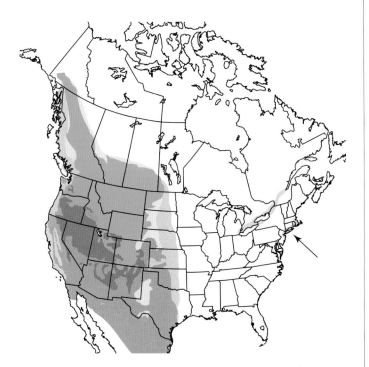

Townsend's Solitaire *Myadestes townsendi*
L 9" WS 15" ♂ = ♀ TOSO

This rather plain long-tailed thrush summers in the western mountains and Pacific Northwest. Winters in the Great Basin and northern Mexico. Breeds in upland conifer forests. Winters widely through open woodlands of the West. Perches on a branch at the edge of a woodland opening, hawking aerial insects or dropping down onto terrestrial arthropods. Also hover-gleans fruit from vegetation. Diet is mainly arthropods in summer and berries, especially juniper berries, in winter. The nest, a loose cup of plant material lined with fine materials, is placed in a protected crevice, under a bank overhang, or in a tangle of upturned roots. Lays four whitish or pale blue eggs. Some birds winter eastward into the Great Plains.

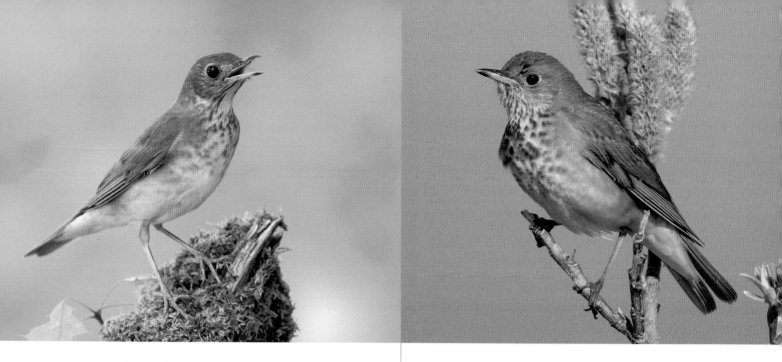

Veery *Catharus fuscescens*
L 7" WS 12" ♂ = ♀ VEER

The Veery is a favorite of those who love beautiful birdsong. Its song outmatches that of the more famous Nightingale of Europe. The Veery summers across the northern part of the Lower 48 and southern Canada, wintering in South America. Breeds in thickets within damp deciduous or mixed forest. Forages on the ground or in low vegetation. Diet is mainly invertebrates in summer and a mix of arthropods and fruit in the nonbreeding seasons. The nest has a foundation of leaves supporting a cup of twigs and other plant matter with finer lining material. It is situated on the ground against a fallen log or hidden low in a bush. Lays three to five pale blue-green eggs that are sometimes marked with brown blotching. Nests of this species commonly get parasitized by Brown-headed Cowbirds. Overall, the species may be exhibiting a slow decline across its range. Presumably harmed by forest fragmentation.

Gray-cheeked Thrush *Catharus minimus*
L 7" WS 13" ♂ = ♀ GCTH

This often-overlooked species breeds in boreal spruce-fir forests and tundra-edge scrub of northern Canada and Alaska and winters in northern South America. Best located at one of the well-known migrant traps (e.g., Magee Marsh, Ohio, or High Island, Texas) in late spring or at Nome, Alaska, where it is conspicuous and common. In summer, it forages for arthropods on the ground in shady conifer undergrowth. In migration, found in typical *Catharus* thrush habitat—on the ground in a tangle in the interior of deciduous woods. Summer diet is terrestrial arthropods; nonbreeding diet includes some fruit. The nest is either hidden within a low spruce or placed on the ground in a thicket. Nest is a nicely crafted cup of grass, twigs, and bark fibers held together with mud and lined with rootlets and finer grass. Lays three to five pale blue eggs, lightly marked. In autumn, birds head eastward, migrating over the Atlantic to South America.

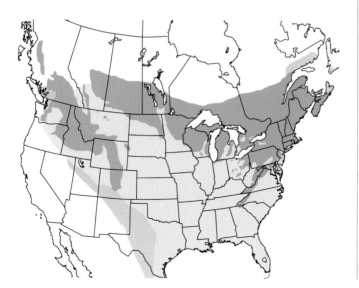

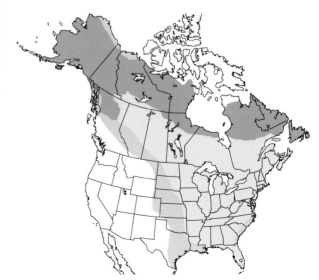

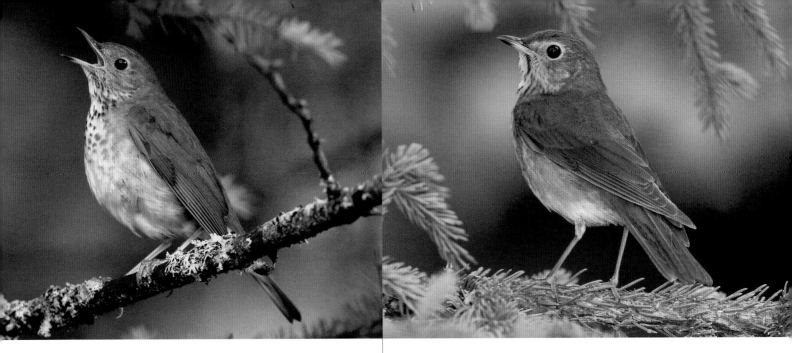

Bicknell's Thrush *Catharus bicknelli*
L 7" WS 12" ♂ = ♀ BITH *VU *WL

Essentially identical to the Gray-cheeked Thrush.
Distinguished by song. Best found during June in dwarf
spruce-fir forest atop mountains in New York, New England,
Quebec, New Brunswick, and Nova Scotia. Winters mainly
in the mountains of Hispaniola and other islands in the
Greater Antilles. Both Bicknell's and Gray-cheeked use the
same habitat in migration (on ground in thickets within
shaded woodland interior). Presumably, summering birds
forage mainly on the ground for arthropods within thick coni-
fer stands. Summer birds consume arthropods; wintering
birds take a mix of arthropods and fruit. Nest, placed low in
a spruce or fir, is a bulky cup constructed of twigs and moss
and lined with fine and soft materials. Lays three or four
pale blue eggs with fine brown speckling. Deforestation on
wintering ground on Hispaniola a threat to the species.

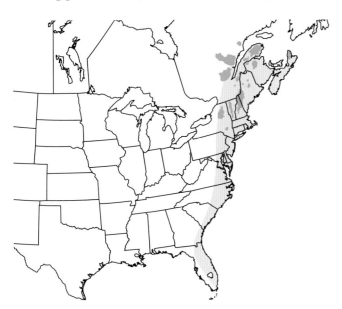

Swainson's Thrush *Catharus ustulatus*
L 7" WS 12" ♂ = ♀ SWTH

The most common and widespread of the brown-backed
thrushes. Summers in conifer and mixed forest of the North,
the Rockies, the Northwest, and mountains of the West
Coast. Winters in Central and South America. Breeds in
mixed and conifer forests in the northern US Borderlands
and Canada, and in various mountain ranges in the East
and West. Prefers thickets near wetlands or at forest edge.
In migration, in shady interior woodlands. Forages for arthro-
pods on the ground or low in undergrowth; will also take ber-
ries year-round. Nest is a bulky cup of twigs and other plant
material held together with mud; it is situated in a conifer (in
East) or thick shrub or deciduous tree (in West). Lays three
or four pale blue eggs with brown spotting. Sings commonly
in migration, making the species easy to find and to identify.

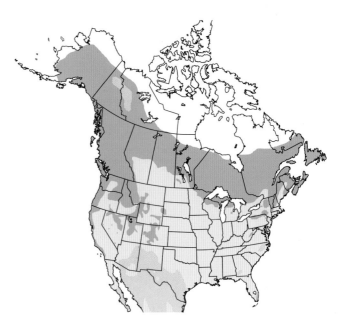

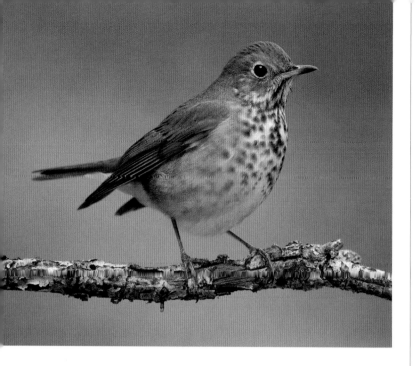

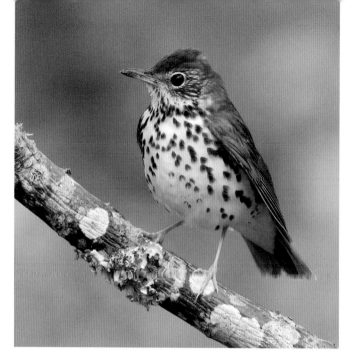

Hermit Thrush *Catharus guttatus*
L 7" WS 12" ♂ = ♀ HETH

The only brown-backed thrush that winters in the Lower 48 (though some wintering birds travel as far as Guatemala). Breeds in the North, the West, and along the Appalachians. The song of this thrush is comparable to that of the Veery in beauty. In summer, it inhabits shady thickets associated with conifer and mixed forests. Winters in bottomland woods. Western birds show slightly different habitat preferences—using drier habitats with juniper and pine. When disturbed, will ascend to a perch and give an alarm call and flick its tail and wings. Forages mainly on or near the ground, taking arthropods; also consumes fruit in winter. Nest in East is mainly placed on or near the ground; in West, placed in a tree. Nest is a bulky cup of moss, twigs, bark, and ferns and is lined with finer material. Lays four blue-green eggs, either plain or marked with brown.

Wood Thrush *Hylocichla mustelina*
L 8" WS 13" ♂ = ♀ WOTH *WL

The largest and brightest of the brown-backed thrushes, with bolder black spotting on the breast. Famous for its pleasing song, heard from shaded bottomland woods. Summers across the eastern United States. Winters mainly in Central America. Breeds in damp bottoms of mature forest interior, especially broadleaf woods. In migration, can be found in any woodland interior. Forages mainly on the ground, especially on leafy forest floor. Diet is terrestrial arthropods and berries. The well-built, large cup nest is composed of grass, leaves, moss, and bark; it is held together with mud and lined with finer and softer material. Nest is placed in a fork of a tree or set on a horizontal branch. Lays three or four pale blue-green eggs. Forest fragmentation and nest parasitism by the Brown-headed Cowbird has harmed populations of this species.

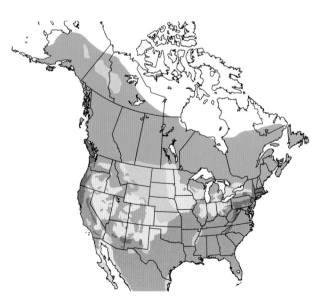

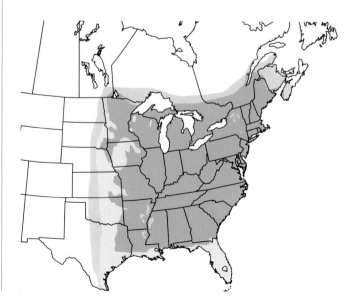

Clay-colored Thrush *Turdus grayi*

L 9" WS 16" ♂ = ♀ CCTH

This widespread tropical thrush ranges from northern South America to South Texas, where it now breeds in numbers. Prefers thick vegetation within woods, especially near water. Also comes to clearings and sometimes feeds on the ground in the open. Rather shy. Diet includes fruit and various invertebrates. Nest is a heavy cup made of grasses and moss held together with mud. Lays two to four pale blue eggs. Strays have been recorded in Arizona and New Mexico.

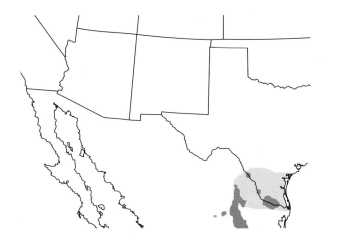

Rufous-backed Robin *Turdus rufopalliatus*

L 9" WS 16" ♂ = ♀ RBRO

A species of southern and western Mexico that wanders to our Southwest Borderlands, especially in southeastern Arizona, mainly in the winter season. Looks quite like our American Robin, but note the warm brown back and wings. Prefers the seclusion of lowland streamside thickets dominated by hackberry. Typically solitary, foraging on the ground under vegetation. Diet is terrestrial arthropods and fruit. US records are rare and variable from year to year.

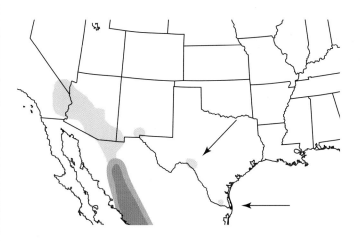

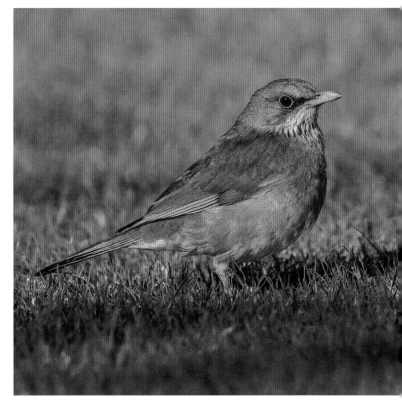

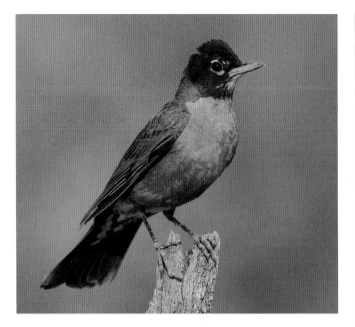

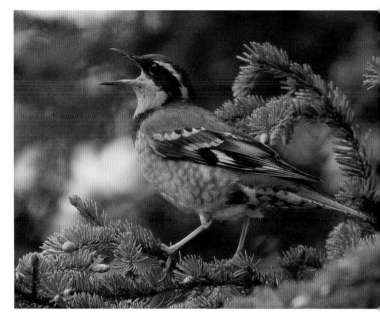

American Robin *Turdus migratorius*

L 10" WS 17" ♂ ≈ ♀ AMRO

One of our most commonplace songbirds, ranging from coast to coast. Northern birds migrate southward in winter. Much of the United States has the species year-round. The Deep South and Southwest Borderlands mainly see the species during the winter. There are additional breeding populations found through the mountains of Mexico. This common garden bird is also a forest-dweller that inhabits mixed and conifer forests to Labrador and Alaska. Forms foraging flocks in winter that can be quite large. Summer diet is mainly invertebrates; winter diet sees an increased proportion of fruit. The substantial cup nest is situated in a small tree or shrub. Nest is constructed of grass, twigs, and bark held together with mud and lined with finer plant material. Lays four pale blue eggs.

Varied Thrush *Ixoreus naevius*

L 10" WS 16" ♂ ≠ ♀ VATH

This retiring forest-lover of the Pacific Northwest is most often detected by its strange, extended burry song note, delivered from a hidden perch in the forest interior. This vocalization sounds like some malfunctioning electronic device. Northern populations migrate southward. Summers in dark and damp conifer forest. Winters in similar habitats and also other thickly vegetated habitats, especially near streams. Forages on or near the ground in thick cover. Diet is a mix of fruit and arthropods. Nest is placed in a conifer. The cup nest is a bulky cup of bark, leaves, twigs, and moss lined with finer plant materials. Lays three or four pale blue eggs that are lightly marked with brown.

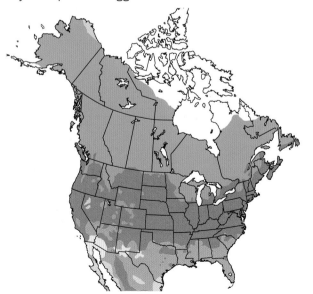

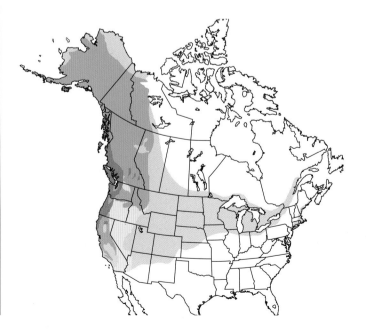

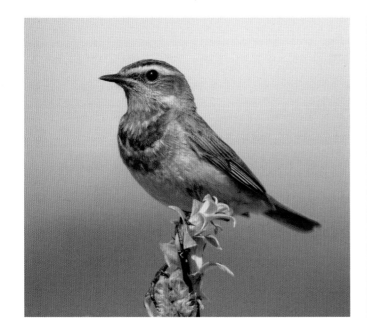

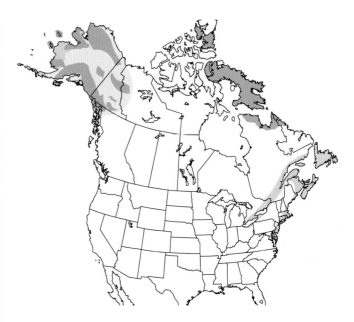

Bluethroat *Cyanecula* (*Luscinia*) *svecica*

L 6" WS 9" ♂ ≠ ♀ BLUE

This handsome, small Old World flycatcher summers at the edge of tundra in northern Alaska. Additional populations breed in northern Eurasia. Our summering birds winter to Southeast Asia. Inhabits streamside dwarf willow thickets adjacent to tundra expanses. Generally a reclusive denizen of thick brush. Male occasionally sings from flight or from atop a bush. Forages mainly on the ground under the cover of a thicket. Diet is mainly invertebrates, but it takes some berries in the nonbreeding season. The cup nest, made of grass, twigs, and moss, is lined with finer materials; it is situated on the ground under shrubbery and set against a tussock. Lays five or six pale blue-green eggs with fine spotting of reddish brown. There is a record from San Clemente Island, Southern California, from September 2008.

Northern Wheatear *Oenanthe oenanthe*

L 6" WS 12" ♂ ≠ ♀ NOWH

This widespread Old World flycatcher summers in Alaska and northwestern and eastern Arctic Canada, as well as across northern Eurasia to the Russian Far East. Winters mainly in Africa. Summers in barren and rocky tundra of the Arctic. Migrants and vagrants appear in a wide range of open habitats, such as fields, meadows, and beaches. Southern Canada and the Lower 48 receive reports of about 10 strays a year. Actively hunts arthropods on the ground or from a low perch. Diet is mainly arthropods, with a mix of fruit in the nonbreeding season. Situated in a crevice or an old ground-squirrel burrow in dry tundra, the nest is a cup of twigs, grass, and other plant matter lined with finer material. Lays five or six pale blue eggs, sometimes lightly marked.

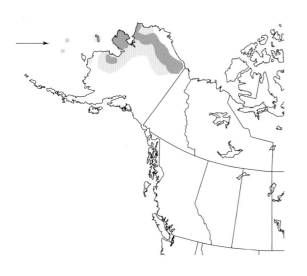

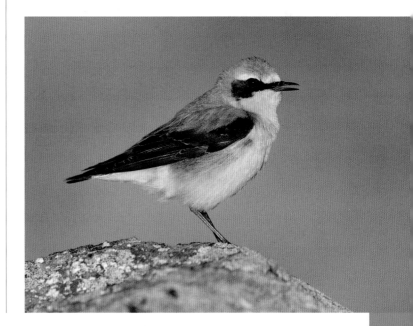

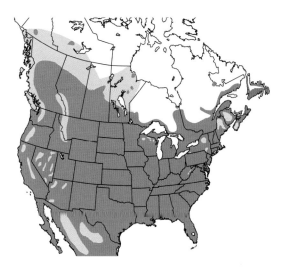

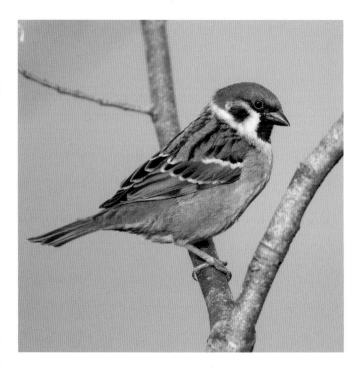

House Sparrow *Passer domesticus*
L 6" WS 10" ♂ ≠ ♀ HOSP

This Eurasian native was introduced in 1851 to New York City and has since extended its range across North America, except for the Far North. It now inhabits virtually every major city in the world. Most common in association with human-dominated environments—farms, urban landscapes, and suburban yards that provide large, evergreen broadleaf shrubs for roosting by wintering flocks. Always is found near to human structures. Absent from wildlands and forest interior. Sociable, adaptable, and confiding. Diet is mainly seeds but also some arthropods, as well as waste foods provided by human activity. The nest is typically placed in a cavity or crevice in a building or a nest box. Nest is a mass of grass, twigs, and other detritus lined with finer materials. When placed in the open, the nest is a messy globular mass with a side entrance. Lays three to six whitish or pale green eggs with some darker markings. In decline.

Eurasian Tree Sparrow *Passer montanus*
L 6" WS 9" ♂ = ♀ ETSP

A flock of 20 of this widespread Eurasian species was released in 1870 in Saint Louis, Missouri, where it subsequently became established. More recently, the species has expanded northward into Iowa and Illinois. Inhabits urban parks, suburbia, and farms. Very sociable but less pugnacious and aggressive than the House Sparrow. Diet is mainly seeds, waste grain, and arthropods. Nest is situated in a cavity, a crevice, a nest box, or an old woodpecker hole. Nest is a mass of grass, twigs, and other rough components lined with finer materials. Lays four to six whitish eggs that are marked with brown speckling. Nonmigratory, but individuals do disperse.

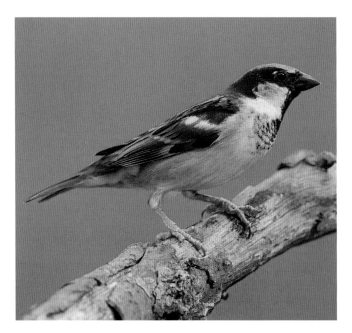

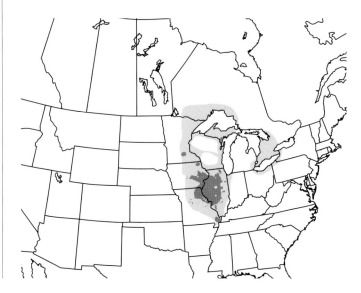

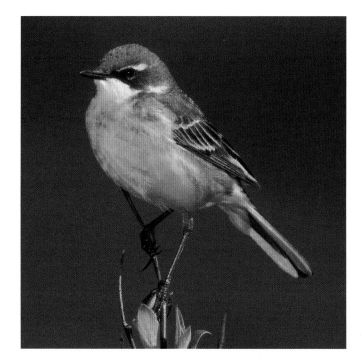

Eastern Yellow Wagtail *Motacilla tschutschensis*
L 7" WS 10" ♂ ≈ ♀ EYWA

Summers in western and northern Alaska, as well as Siberia and northern China. Winters in Southeast Asia and Australia. Breeds in marshy streamside scrub or in birch and willow in areas of tundra. Forages for arthropods on the ground, especially along edges of streams and other shallow waters. The cup nest, made of grass, moss, lichens, and leaves, and lined with finer materials, is hidden on the ground under a tussock of grass. Lays four or five whitish or buff eggs with brown speckling. Formerly considered a subspecies of the Yellow Wagtail. The breeding population in Alaska has exhibited substantial declines in recent decades, perhaps because of winter trapping of migrants in Asia.

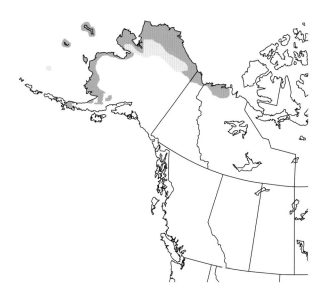

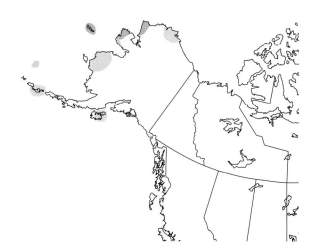

White Wagtail *Motacilla alba*
L 7" WS 11" ♂ ≈ ♀ WHWA

This commonplace Eurasian wagtail summers on St. Lawrence Island and on the coast of northwestern Alaska. Alaskan breeders winter in Southeast Asia. Eurasian breeders winter in Africa and South Asia. Alaskan birds in summer seem to prefer towns, but also occur on rocky coasts, cliffs, and stony river flats. Forages on open ground, especially near water edges. Diet is arthropods gleaned by the walking bird from the ground or grabbed from the air. Typically nests in a crevice of an abandoned building or waterside rocks. The cup nest is made of twigs, grass, rootlets, and moss; it is lined with finer materials. Lays five to seven whitish to grayish eggs speckled with brown or gray. Strays appear regularly on the West Coast, irregularly on the East Coast, and sparingly in the Interior.

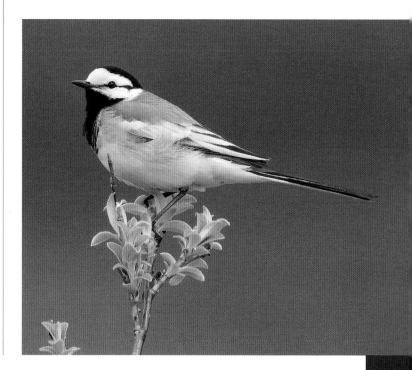

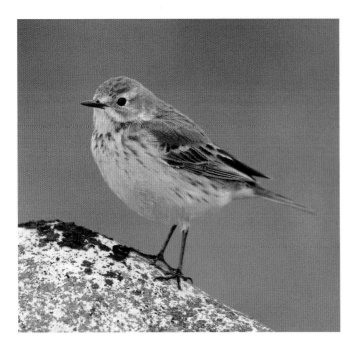

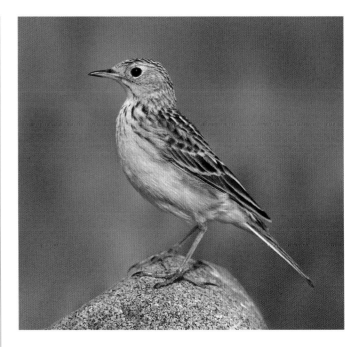

American Pipit *Anthus rubescens*
L 7" WS 11" ♂ = ♀ AMPI

Summers in the Far North and on mountaintops of the Lower 48. A common migrant through North America; it winters in the South, Southeast, and along the West Coast. Some birds winter to southern Mexico. Summers on tundra and rocky and open alpine summits and high plateaus. Winters on bare fields, prairies, and coastal beaches. Wags its tail when foraging. Male performs a display flight when on the breeding territory. Diet is arthropods in the summer and weed and grass seeds in winter. Nest, which is situated on the ground hidden under a tussock or beside a rock, is a cup of moss, grass, and sedges lined with finer materials, including feathers or animal hair. Lays four to six whitish or pale buff eggs heavily spotted with brown and gray.

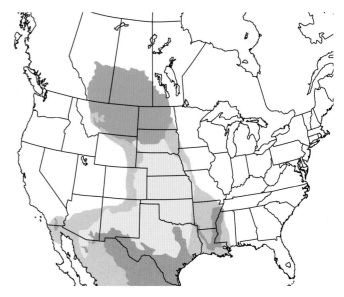

Sprague's Pipit *Anthus spragueii*
L 7" WS 10" ♂ = ♀ SPPI *VU *WL

This elusive songbird summers in the shortgrass prairies of the northern Great Plains and winters in Texas and the Southern Borderlands. It is perhaps most famous for its spring display flight, when it utters its tinkling call from high overhead. Winters on dry shortgrass plains and occasionally on bare-earth fields in Texas. Solitary and secretive. Difficult to locate and observe, except when male is giving its song flight. Apparently its diet is mainly arthropods, with some small grass seeds added in winter. Nest is situated in a depression within a grass field. Nest is a cup of woven grasses with slightly finer lining. Lays four or five whitish eggs with blotching of purplish brown.

Red-throated Pipit *Anthus cervinus*
L 6" WS 11" ♂ ≠ ♀ RTPI

This widespread Eurasian species summers in small numbers on the coast of northwestern Alaska and several offshore islands. Winters in Southeast Asia. Summers in rocky outcrops in tundra. Stray birds are found in fall migration along the West Coast south to Baja as singletons in plowed or shortgrass fields with American Pipits. A retiring species. Forages on ground for arthropods, other invertebrates, and seeds. Nest, which is situated on the ground abutting a tussock or rock, is a cup of moss, grass, and leaves lined with finer materials. Lays five or six pale gray or buff eggs speckled with brown or gray.

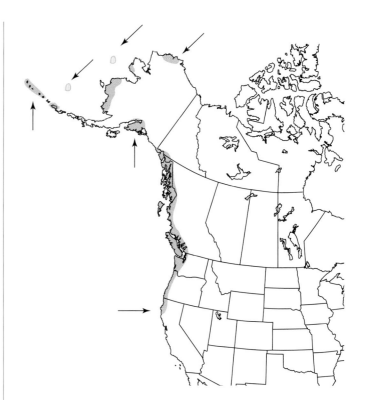

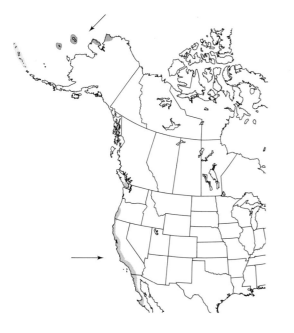

Brambling *Fringilla montifringilla*
L 6" WS 11" ♂ ≠ ♀ BRAM

This widespread Eurasian finch is a rare but regular migrant visiting the western Aleutian Islands, the Pribilof Islands, and Saint Lawrence Island in Alaska. Also wanders to mainland Alaska and down the Pacific Coast. The eastern populations of this species winter to East Asia. Vagrants often appear at bird feeders, often associating with juncos. Feeds on seeds and some arthropods.

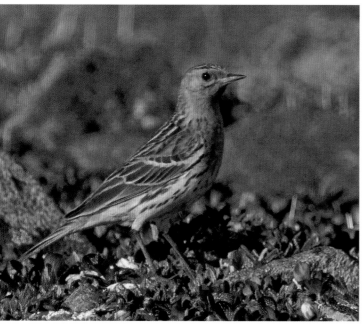

Gray-crowned Rosy-Finch *Leucosticte tephrocotis*
L 6" WS 13" ♂ ≠ ♀ GCRF

This is the rosy-finch of the Pacific Northwest and Alaska, its range patchily extending to the Sierras of California and mountains of western Montana. It winters through the mountains and uplands of the Interior West. Summers on tundra, rocky alpine summits, and rock fields, often near glaciers. Winters at lower elevations, when it can be found in a variety of open habitats and in fields and towns. Travels in flocks in the nonbreeding season and readily visits feeders. Forages on barren ground mainly. Diet is mainly grass and tundra plant seeds but also some arthropods. The bulky cup nest of grass, roots, moss, and lichens with a finer lining is typically situated in a crevice, under a rock, or otherwise hidden. Lays four or five white eggs, sometimes with some brown speckling. Population probably stable.

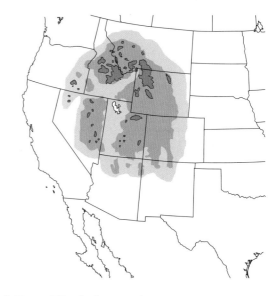

Black Rosy-Finch *Leucosticte atrata*
L 6" WS 13" ♂ ≠ ♀ BLRF *WL

This uncommon finch inhabits mountains of the Great Basin. Breeds in the rocky alpine zone and winters at lower elevation and wanders widely. In winter, all three rosy-finches can be found in the same flock. Summers at high elevations in alpine meadows and near ice fields. Winters in wandering flocks in open country in mountain valleys and can be found in towns visiting feeders. Diet is seeds and some arthropods, mainly taken from the ground. The bulky cup nest is hidden in a rock crevice or in a hole in a cliff-side. Nest is composed of moss and grass and is lined with assorted fine materials. Lays four or five unmarked white eggs.

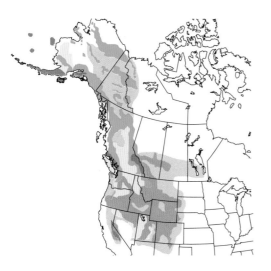

Brown-capped Rosy-Finch *Leucosticte australis*
L 6" WS 13" ♂ ≠ ♀ BCRF *WL

Summers atop high mountain summits of southern Wyoming, Colorado, and northern New Mexico. Winters at lower elevations. Breeds in isolated and remote alpine tundra. Winters in open country at lower elevations and does visit bird feeders, which it can share with other rosy-finches. Habits and diet are much like the other rosy-finches. Nest is a bulky cup like that of the other rosy-finches, also placed in crevice in rocks. Lays three to five unmarked white eggs.

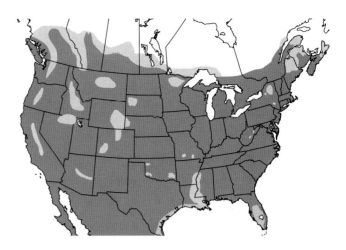

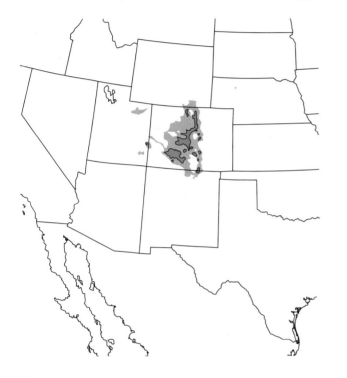

House Finch *Haemorhous mexicanus*
L 6" WS 10" ♂ ≠ ♀ HOFI

A commonplace resident from coast to coast. A regular visitor to backyard feeders. This species, native to the Southwest and Mexico, was introduced into New York City in 1940 and then spread throughout the East and Midwest, eventually meeting up with the western populations of the species. Inhabits urban and suburban habitats, farms, and weedy fields, as well as brushlands in the West. Usually found in small, mobile, and vocal flocks. Male is an accomplished songster in spring. Diet is seeds, fruit, and arthropods. The rough grass nest cup with some finer lining material can be placed in a wide variety of sites—in a natural cavity, a thick tangle in a tree, or even a tight space under a porch roof. Lays four or five pale blue eggs with blotching of various darker colors.

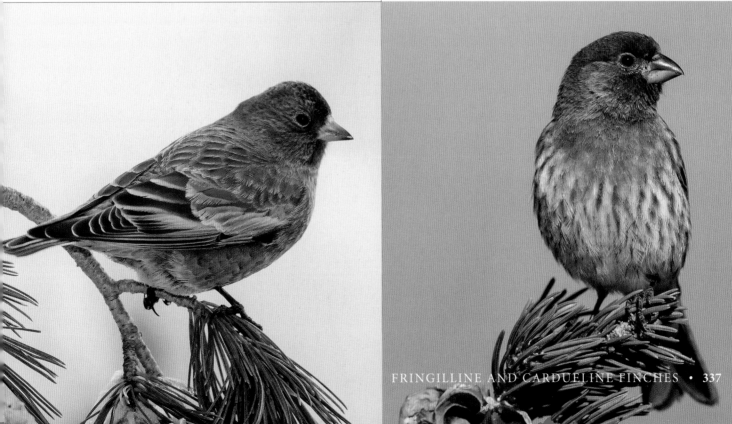

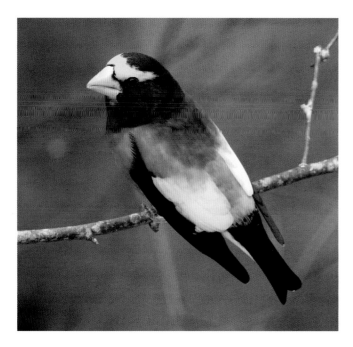

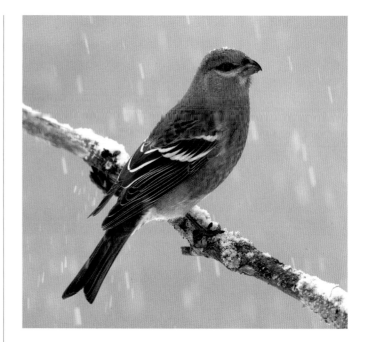

Evening Grosbeak *Coccothraustes vespertinus*
L 8" WS 14" ♂ ≠ ♀ EVGR *WL

This handsomely patterned songbird is one of our favorite winter finches, best known for arriving at backyard feeders in flocks from the North late in the year during a periodic irruption. The species has declined in the East in recent years. It summers in boreal conifer forests of the North and West, ranging southward in the Rockies and Sierras. Winters widely searching for black oil sunflower seeds in feeders or for trees that produce favored seeds: Box Elder, other maples, and other fruiting trees. Diet comprises seeds, fruits, and some arthropods (e.g., spruce budworm). Typically found in vocal foraging flocks. Eastern populations migrate southward from breeding habitat on flight years, which arise irregularly and presumably relate to failure of a winter food crop. The shaggy nest cup, made of twigs and lined with finer materials, is placed on a horizontal or rising tree branch quite high above the ground. Lays three or four pale blue or blue-green eggs with blotching of several colors.

Pine Grosbeak *Pinicola enucleator*
L 9" WS 15" ♂ ≠ ♀ PIGR

An uncommon large finch of boreal forests and mountains of the West. Summers in Canada, Alaska, and mountains in the western Lower 48. Winters southward to the northern Lower 48, mainly during irruption years. Summers in spruce-fir forests. In winter, flocks search for seeds of fruit-producing trees such as American Mountain-Ash and American Ash. Can be very tame in winter. Feeds in trees on fruit and seeds and on the ground as well, taking fallen fruits. Diet is mainly plant material, though will take some arthropods in summer. The cup nest is placed on a horizontal branch in a spruce or fir. Nest is a bulky cup of twigs, weeds, and roots lined with finer material. Typically lays four blue-green eggs spotted with darker colors.

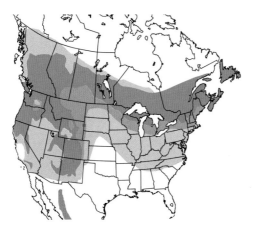

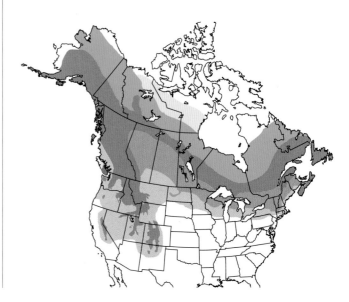

Cassin's Finch *Haemorhous cassinii*
L 6" WS 12" ♂ ≠ ♀ CAFI *NT *WL

Summers in mountain conifer forests of the Interior West. Winters in these places as well as more broadly and at lower elevations. Replaces the Purple Finch in this region. Breeds in high-elevation spruce-fir forests as well as Douglas-fir and pinyon-juniper. In winter, uncommonly moves into the high plains east of the Rockies and throughout the intermountain West. Moves about in small nomadic flocks in the nonbreeding season. For much of the year, feeds high in trees. Diet is a mix of seeds, buds, berries, and arthropods. Nest is a cup of twigs, bark, lichens, and rootlets lined with finer materials. Nest is placed in a conifer or deciduous tree branch. Lays four or five blue-green eggs with some darker blotching. A species in substantial decline.

Purple Finch *Haemorhous purpureus*
L 6" WS 10" ♂ ≠ ♀ PUFI

One of the more commonplace of our seed-eating finches. As a "winter finch" it irrupts southward every few years. A regular feeder visitor in winter. Summers in conifer and mixed forests of the Appalachians, the Northeast, Canada, and the West Coast. Winters southward into the East and Midwest—visiting shrubby fields, tangles in openings in woodlands, and suburban landscapes. Forms small flocks in the nonbreeding season. Forages in trees and on the ground in woodlands. Diet includes seeds, berries, buds, and arthropods. Nest is a compact cup of twigs, bark, and roots lined with finer matter; it is placed in the fork of a tree branch. Nests mainly in conifers in the East. Lays three to five pale blue-green eggs blotched with darker colors.

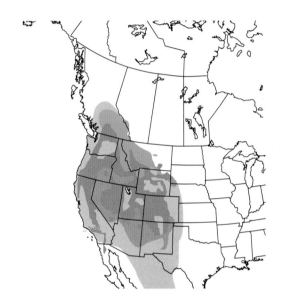

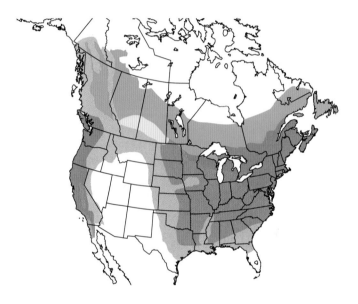

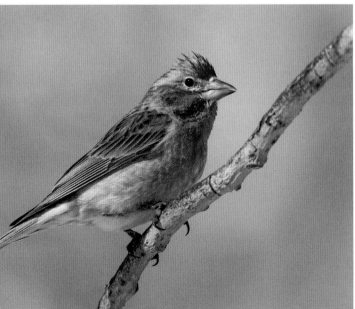

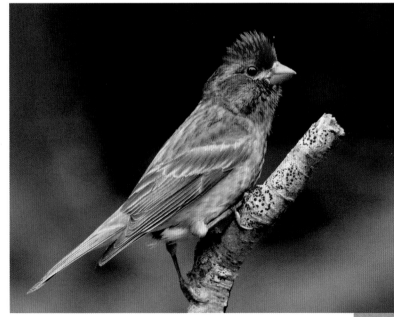

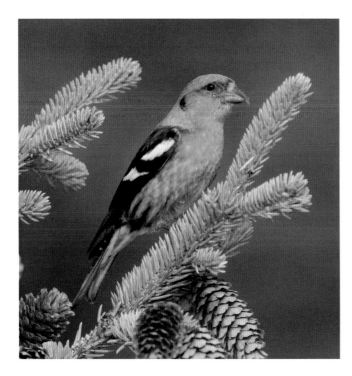

White-winged Crossbill *Loxia leucoptera*
L 6.5" WS 11" ♂ ≠ ♀ WWCR

This is the crossbill of boreal spruce forests of Canada, Alaska, New England, and a few spots in the Mountain West. Less common than the Red Crossbill. Summers in forests of spruce, tamarack, and fir. Winters in conifer forest, occasionally wandering out of these haunts into the northern United States. Additional populations inhabit northern Eurasia. Travels in vocal flocks that forage on ripe cones high in fruiting conifers. Diet is mainly conifer seeds, but will also take buds and seeds of other plant types. Will visit snowy roads to collect salt or other grit laid down by the highway department. Nest, placed on a horizontal branch of a conifer, is a cup of twigs, bark strips, and grass lined with moss, lichens, animal hair, and plant fibers. Lays two to four whitish or pale blue-green eggs marked with darker blotches at the larger end. Nests when it finds a good conifer crop.

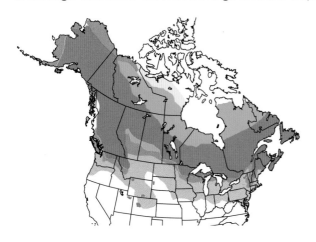

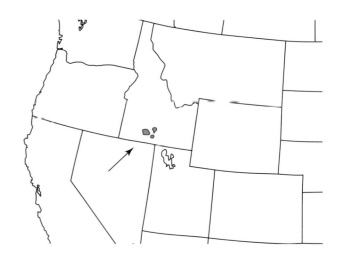

Cassia Crossbill *Loxia sinesciuris*
L 6" WS 11" ♂ ≠ ♀ CACR

A recently recognized species inhabiting the South Hills and Albion Mountains of Cassia County, Idaho. A largely sedentary species that remains in upland forests of Lodgepole Pines. The relationship between this bird and seeding Lodgepole Pine is distinct in range because of the local absence of squirrels, which are competing seed predators. Otherwise, plumage and nesting details are identical to those of the Red Crossbill. Some authorities doubt the distinctiveness of this newly described species, noting the great variability of morphology and voice exhibited by the Red Crossbill across its very large range. Population of the Cassia Crossbill is estimated to be 6,000. Recently in decline.

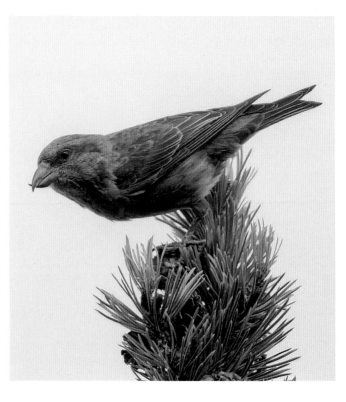

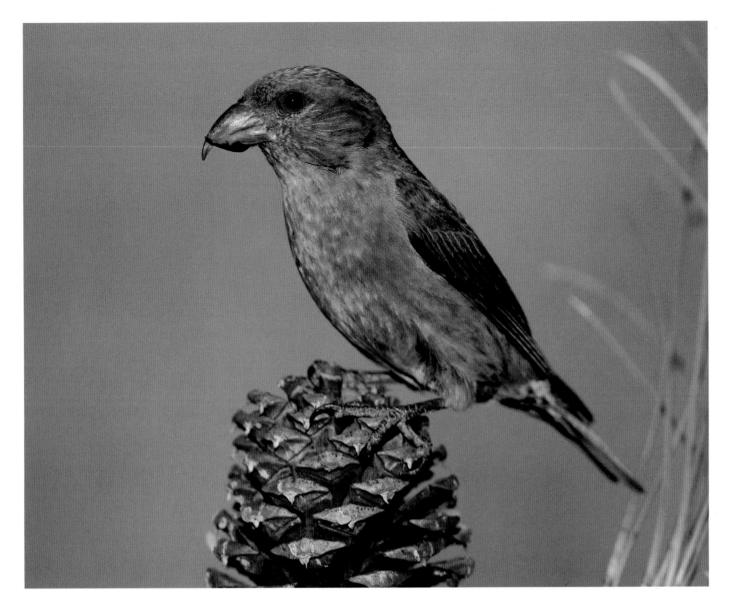

Red Crossbill *Loxia curvirostra*

L 6" WS 11" ♂ ≠ ♀ RECR

The Red Crossbill travels widely in flocks, searching for ripe conifer seeds. Most prevalent in the boreal conifer forests of Canada and the upland forests of the Mountain West. The crossbills are found in areas where conifers are abundant, especially pines and spruces but other conifer genera as well. Uncommon and irruptive. Typically heard flying high overhead in flocks or when perched high among cones atop a conifer. Diet is mainly conifer seeds but will also take seeds of other plants, including deciduous trees, weedy grasses, and tree buds. The species nests when it finds a large local lode of conifers producing ripe seed, even in full winter. The bulky cup of twigs, bark, grass, and roots is lined with finer materials. The nest is set on a horizontal limb of a conifer. Lays three or four pale green or blue eggs with darker blotching at the larger end. Populations fluctuate.

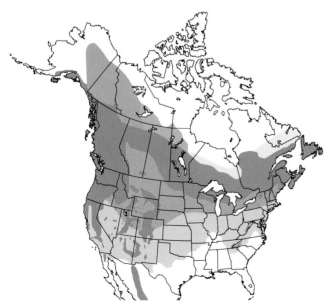

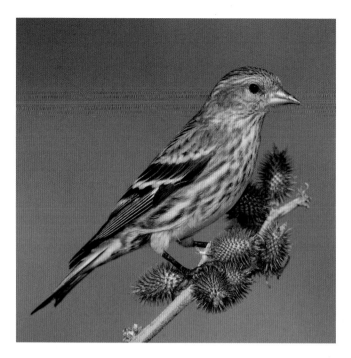

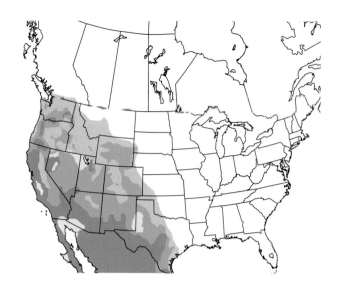

Pine Siskin *Spinus pinus*

L 5" WS 9" ♂ ≈ ♀ PISI

One of the more common of our winter finches, eastern populations of this species irrupt from their boreal forest summer haunts every few winters, ranging widely in restless flocks across the Lower 48. Summers in conifer or mixed woods in the Northeast and Mountain West. Winters widely during irruption years, found in open brushy habitats. A vocal flocking species similar in habits to the American Goldfinch. A common feeder visitor, favoring Nyjer seed. Diet is seeds, buds, and arthropods. Does favor the seeds of conifers. The nest, placed on a branch high in a conifer, is a shallow cup of twigs, bark strips, grass, and roots lined with moss, animal hair, and feathers. Lays three or four pale blue-green eggs that are marked with dark spots that are concentrated at the larger end.

Lesser Goldfinch *Spinus psaltria*

L 5" WS 8" ♂ ≠ ♀ LEGO

A common open-country finch of the western sector of the Lower 48. Ranges southward to northern South America. The adult males in the northwest of the species' range are greenbacked. Those in the southeast are black-backed. Inhabits weedy fields, brushlands, woodland edges, and backyard gardens. Commonly seen in roving flocks. Quite vocal: an inveterate mimic. This species is a seed-lover; also takes some arthropods. The compact cup nest, woven of plant fibers and grass and lined with plant down, is situated among some vertical branchlets in a tree or shrub. Lays four or five pale blue or blue-green eggs. The range of the species has expanded eastward and northward.

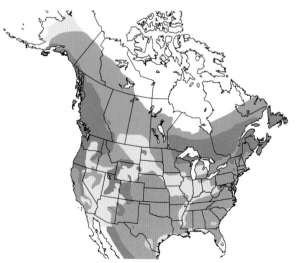

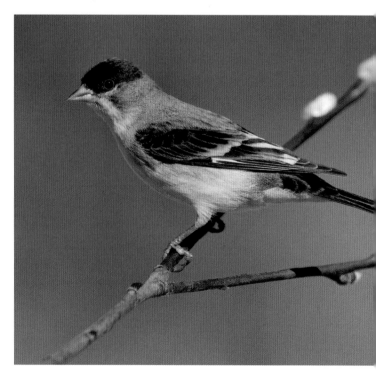

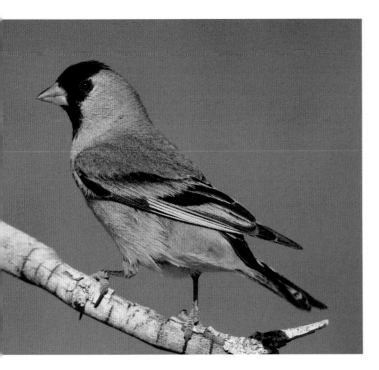

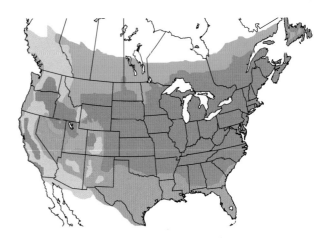

American Goldfinch *Spinus tristis*
L 5" WS 9" ♂ ≠ ♀ AMGO

This familiar feeder bird summers from coast to coast in the United States and southern Canada. Winters into the Deep South and eastern Mexico. Inhabits brushy openings, woodland clearings, stream sides, and any place there is an abundance of seeds. This small species is seen in flocks overhead, calling and flying with a strongly undulating flight. Diet includes seeds of weeds and various flowering plants, as well as some arthropods. Nest is a solid and compact cup of plant fibers wrapped with spider silk and lined with plant down. The nest is placed in the fork of a branch. Lays four to six pale bluish-white eggs, sometimes with some dark markings. In spring, the jubilant song of this species emanates from tall elms and other seeding or flowering shade trees. This species is showing a decline in California.

Lawrence's Goldfinch *Spinus lawrencei*
L 5" WS 8" ♂ ≠ ♀ LAGO *WL

An uncommon goldfinch of the Far West and northwestern Mexico. Wanders unpredictably in the nonbreeding season. Summers in wooded oak-pine and chaparral foothills of California and Baja. Winters in weedy fields and brushlands. A flocking species. The males sing complex songs that include phrases borrowed from other species. A seed-eater; it will also take some arthropods. The nest is a small cup of grass lined with plant down and animal hair and placed in a tree. Lays four or five whitish or pale blue eggs, either unmarked or with red-brown spotting. During some winters the species wanders widely into the desert and in other winters not at all. Environmental factors that spawn these winter peregrinations are not known. In spite of its mysterious movements, the species is deemed secure.

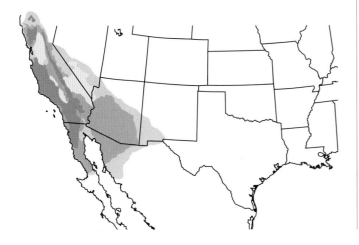

Common Redpoll *Acanthis flammea*
L 5" WS 9" ♂ ≈ ♀ CORE

An irruptive flocking finch that appears in fluctuating numbers in northern US states from winter to winter. Summers in northern Canada and Alaska in brushy openings in spruce forest and thickets in tundra, from James Bay northward. Winters in weedy fields and shrubby edges to agricultural land and backyard feeders. Forms restless flocks that wander in search of good feeding sites in the nonbreeding season. Takes some arthropods in summer but focuses on plant matter the remainder of the year—grass seeds, tree buds and catkins, and conifer seeds. Flocks forage on the ground and in grasses. The nest, a cup of twigs, moss, and grass lined with feathers, is hidden low in a bush or thicket. Lays four or five pale green or blue-green eggs with variable dark blotching, mainly at the larger end. Substantial declines have been reported in North America of late.

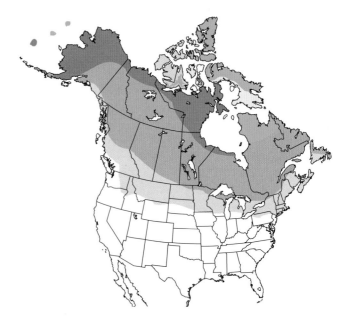

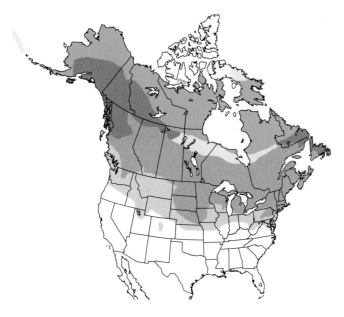

Hoary Redpoll *Acanthis hornemanni*
L 6" WS 9" ♂ ≈ ♀ HORE

A rare and difficult-to-identify High Arctic "winter finch" that wanders southward in flocks of Common Redpolls during some winters. Summers in the Arctic, nesting in tundra willows. Most winter in weedy fields and brushy edges of openings in central Canada. Those moving further south do so in association with Common Redpolls. Habits appear indistinguishable from its sister species. Diet as for the Common Redpoll. The nest, placed in a low shrub, is an open cup of grass, roots, and leaves with a lining of feathers and animal hair. Lays four or five pale green or blue-green eggs marked with reddish-brown spots on larger end. Quite variable. Some studies suggest this is just a plumage morph of the preceding species. Population status unknown.

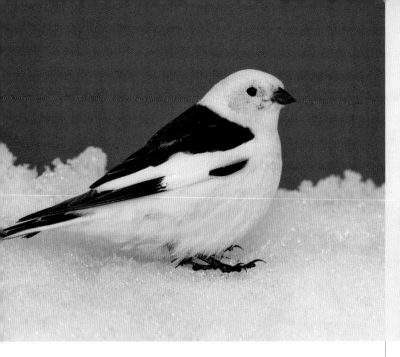

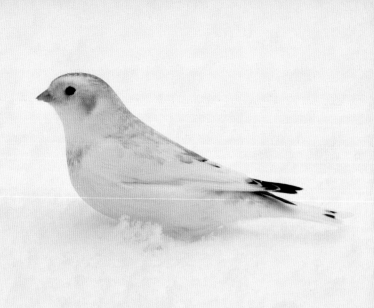

Snow Bunting *Plectrophenax nivalis*

L 7" WS 14" ♂ ≠ ♀ SNBU

This mainly white, open-country bunting summers in the Arctic across the Northern Hemisphere, wintering southward in roaming and nervous flocks that take flight at the least disturbance. A winter finch that irrupts southward in varying numbers from year to year. Breeds in tundra where there are boulders, outcrops, cliffs, and other breaks in the physiography. Winters in open country—agricultural fields, beach shores, and shortgrass prairie. Summer diet is seeds and arthropods. In winter, diet is mainly weed seeds. Consumes buds and young leaves in spring. Nest is a bulky cup of grass and moss lined with finer materials and hidden in a rocky crevice or other protected site. Lays four to seven whitish to pale blue-green eggs marked with darker blotches.

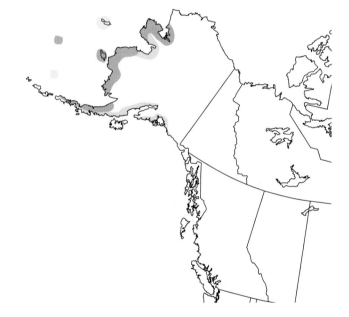

McKay's Bunting *Plectrophenax hyperboreus*

L 7" WS 14" ♂ ≠ ♀ MKBU *WL

A rare Alaskan bunting. Summers on just a few islands in the Bering Sea and winters on the mainland coast. Regularly breeds on Saint Matthew and Hall Islands in the Bering Sea. Breeds in tundra, rocky barrens, and shorelines. Strays on migration to Saint Lawrence. Winters on coastal beaches and low shoreline vegetation. Flocks in the nonbreeding season. Will mix with the more common Snow Bunting. Forages on the ground, mainly for seeds but also takes some small invertebrates. Nest is shallow cup of grass lined with finer materials and hidden in a rocky crevice or under some driftwood. Lays four or five pale green eggs with brown markings. Highly vulnerable, given tiny breeding range.

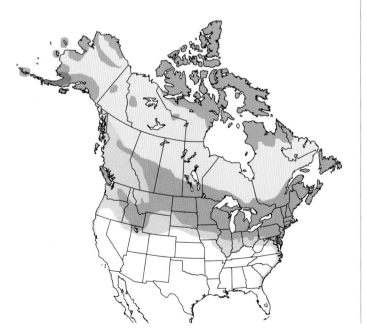

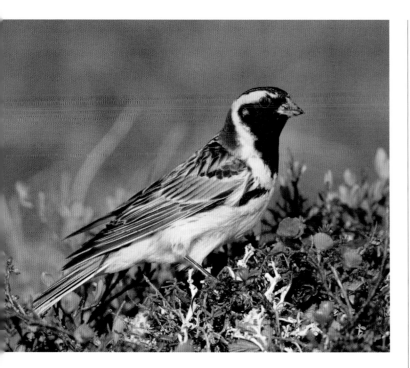

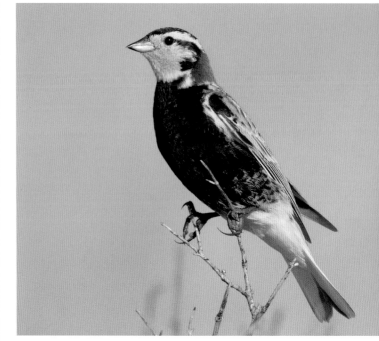

Lapland Longspur *Calcarius lapponicus*

L 6.3" WS 12" ♂ ≠ ♀ LALO

This black-faced longspur summers in the Far North of Canada, Alaska, Scandinavia, and Siberia. North American birds winter southward in flocks, especially in the Great Plains. Breeds on open tundra. In winter, often seen associating with flocks of Horned Larks and Snow Buntings in tundra-like open habitats in the agricultural Midwest. Forages on the ground for seeds and arthropods. Winter diet probably exclusively grass seeds. The cup nest of grass and moss, with a finer lining, is hidden in a depression on the ground in the low tundra. Lays four to six pale greenish eggs with darker markings. Population stable.

Chestnut-collared Longspur *Calcarius ornatus*

L 6" WS 11" ♂ ≠ ♀ CCLO *NT *WL

This black-bellied longspur summers in the northern Great Plains, wintering in the southern Great Plains, Southwest Borderlands, and Mexico. Breeds in shortgrass prairie, preferring lush and wet sites. Winters in prairie and short grass fields. Travels in flocks in the nonbreeding season. After the breeding season, it regularly associates with flocks of Thick-billed Longspurs. Typically hidden in grass. Summer diet is seeds and arthropods; winter diet is mainly weed seeds. The shallow cup of grass, lined with finer materials, is placed in a depression in the ground near a clump of grass or other object. Lays four or five whitish eggs marked with dark blotches. A species in substantial decline.

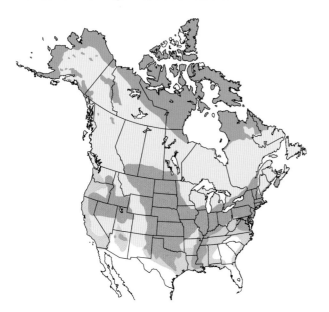

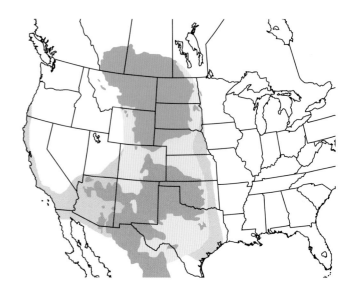

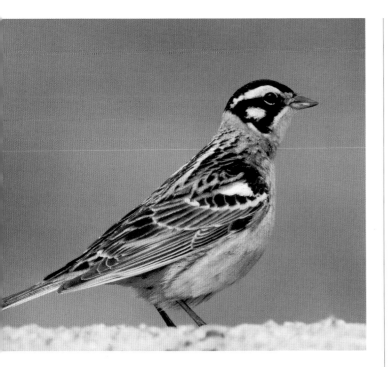

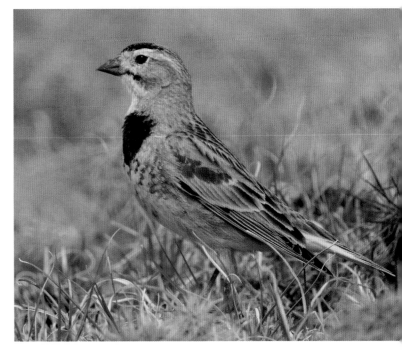

Smith's Longspur *Calcarius pictus*
L 6.3" WS 11" ♂ ≠ ♀ SMLO

This ochre-breasted longspur summers in grassy tundra of northern Canada and eastern Alaska. Winters in short-grass fields, airfields, and heavily grazed pastures of the southeastern Great Plains. Breeds in low tundra adjacent to treeline. Flocks retreat skittishly when approached. Does not usually associate with other longspurs. Summer diet is seeds and arthropods; winter diet is weed seeds. Nest is an open cup of grass and sedge leaves lined with lichens, feathers, and animal hair and placed on the ground in a depression in the tundra. Lays three to five pale tan or pale green eggs with lavender and brown splotching.

Thick-billed Longspur *Rhynchophanes mccownii*
L 6" WS 11" ♂ ≠ ♀ TBLO *WL

This black-bibbed longspur summers in the northwestern Great Plains, wintering in the southwestern Great Plains, Southwest Borderlands, and northern Mexico. Prefers shortgrass prairie, frequenting sites drier and less lush than those selected by the Chestnut-collared Longspur. Winters in barren flats and open plains. In spring, the males conduct conspicuous display flights. Most of the year it is found in flocks. Summer diet is seeds and arthropods; winter diet is weed seeds. The nest is an open cup of grass, rootlets, and lichens that is lined with finer plant material and placed on the ground near the base of a grass tussock or other source of protection. Lays two to four pale olive eggs marked with brown and lavender. Commonly flocks with Horned Larks.

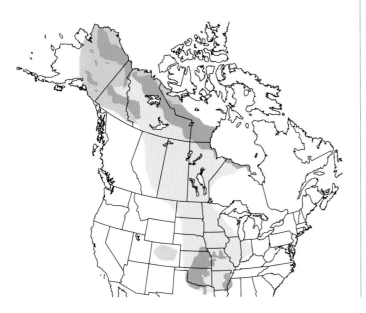

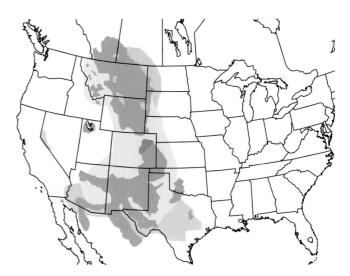

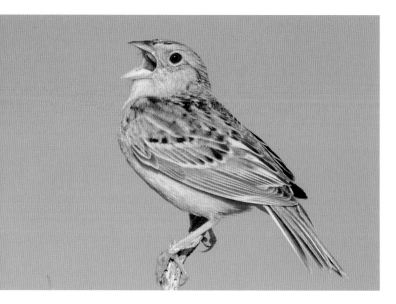

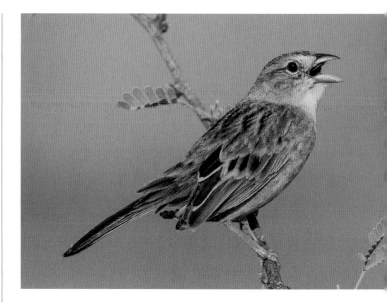

Grasshopper Sparrow *Ammodramus savannarum*
L 5" WS 8" ♂ = ♀ GRSP

This easily overlooked grassland sparrow summers widely across the United States and southern Canada. It winters in the Deep South and southward into Central America and the Caribbean. Breeds in ungrazed fields and tallgrass prairies. Winters in a range of grassland habitats. Shy and secretive. Best located by listening for the singing males in spring, but their high-pitched insect-like trill can be hard to pick out on a noisy spring morning with other birds in song. Summer diet is a mix of arthropods and seeds; winter diet is mainly weed seeds. Nest is an open cup of grass and other plant materials lined with finer matter. Nest is sometimes domed with grass and is typically placed on the ground hidden at the base of a shrub. Lays four or five whitish eggs with spotting of darker colors. Overall the species is in decline. The resident Florida subspecies is on the verge of extinction.

Botteri's Sparrow *Peucaea botterii*
L 6" WS 8" ♂ = ♀ BOSP

An uncommon summer resident of the Borderlands of Arizona and southernmost Texas. The species ranges southward to Central America. Summers in desert grassland in southeastern Arizona, southwestern New Mexico, and coastal prairie in South Texas. Breeding in parts of the range is triggered by summer monsoon rains. Sings from atop a low shrub. Often difficult to locate, as it hides in grass and forages on the ground. Summer diet is mainly arthropods; winter diet is mainly seeds. Nest is a shallow cup of grass situated on the ground or in the base of a clump of grass. Lays two to five whitish or pale blue eggs. Winters mainly in Mexico. The US populations have exhibited substantial declines because of degradation and conversion of native habitat favored by the bird. Best located by listening for the territorial song of the male.

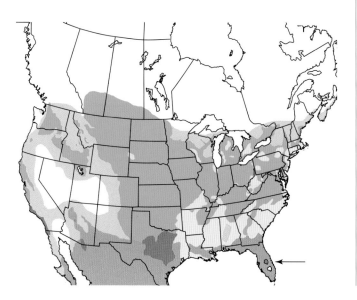

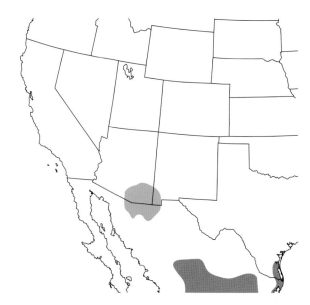

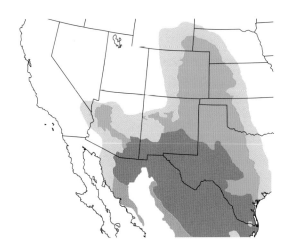

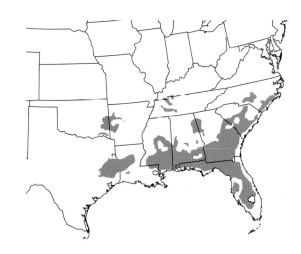

Cassin's Sparrow *Peucaea cassinii*

L 6" WS 8" ♂ = ♀ CASP

Summers in the southern Great Plains and winters in the Southwest Borderlands and Mexico. The species' range extends south to central Mexico. Breeds in dry shrubby grasslands. Winters in grassland, deserts, and brushland. In spring and summer, the male carries out a vocal display flight, but most of the time the species is very secretive. Breeding in parts of the range is triggered by summer monsoon rains. Summer diet is a mix of arthropods and seeds; winter diet is mainly weed seeds. Nest is an open cup of dried grass and other plant materials lined with fine grass. Nest is hidden on the ground or in a low shrub. Lays three to five white eggs.

Bachman's Sparrow *Peucaea aestivalis*

L 6" WS 7" ♂ = ♀ BACS *NT *WL

A sparrow of open pine savanna of the Deep South. Best located by the beautiful song of the male. Favors grasslands in association with mature Longleaf Pine stands. Secretive and solitary. Does not join mixed-species foraging groups with other sparrows. Summer diet is a mix of arthropods and seeds; winter diet is mainly weed seeds. Nest is an open cup of grass and other plant materials lined with finer matter. Nest is sometimes domed with grass. Typically placed on the ground at the base of a shrub. Lays three or four white eggs. Northernmost breeders shift southward in the winter. The entire range of this species is restricted to the southern United States, from Oklahoma to Florida. The range of the species has contracted southward.

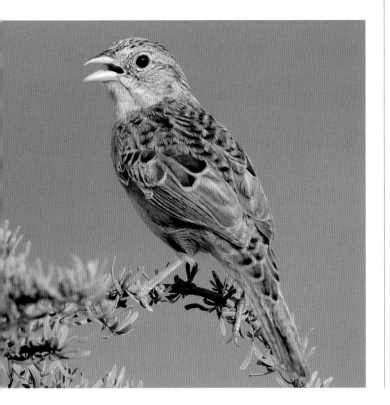

Rufous-winged Sparrow *Peucaea carpalis*
L 6" WS 8" ♂ = ♀ RWSP *WL

A year-round resident of southeastern Arizona ranging into western Mexico. Inhabits low-elevation mesquite desert grasslands. Prefers well-vegetated areas (especially with tall sacaton grass), and avoids overgrazed habitat. Forages on the ground in small family groups, sometimes in association with other sparrows. Summer diet is mainly arthropods; winter diet is mainly seeds. Nest is a deep cup of grass and twigs lined with finer materials; it is situated in a shrub or cactus. Typically lays four bluish-white eggs. Wintering birds may wander from their breeding territories.

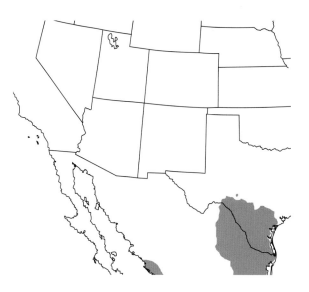

Olive Sparrow *Arremonops rufivirgatus*
L 6" WS 8" ♂ = ♀ OLSP

This nonmigratory tropical sparrow ranges from Costa Rica northward to South Texas. It inhabits undergrowth of woodlands and thickets in Texas brushlands. It is shy, retiring, and terrestrial, foraging in leaf litter. Diet is a mix of arthropods and seeds taken from the ground. The large and bulky cup nest, constructed of grass, twigs, and other plant material, is lined with finer matter and domed with grass. It is placed in a shrub in a thicket. Lays three to five white eggs. Found in patches of native habitat in South Texas. Favored habitat has declined in recent decades, but the bird remains fairly common in its preferred brushland thicket habitat. Presumably the species is secure.

Five-striped Sparrow *Amphispizopsis quinquestriata*
L 6" WS 8" ♂ = ♀ FSSP *WL

Named for the nifty markings on its face, this western Mexican species crosses the Border into southeastern Arizona, where it is rare. Some Arizona birds winter in place; others may shift into Mexico. Hides in dense thickets on steep hillsides above upland canyon streams. Forages on the ground under vegetation. Solitary or in pairs year-round. Diet is mainly arthropods in summer and a mix of arthropods, seeds, and berries in the other seasons. Nest is a deep cup of grass, lined with finer materials, and situated low in a clump of grass or a shrub. Lays three or four white eggs. Breeding was first confirmed in the US in 1969.

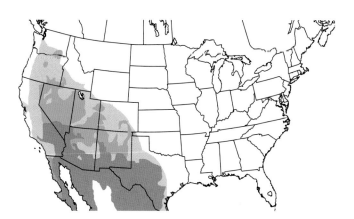

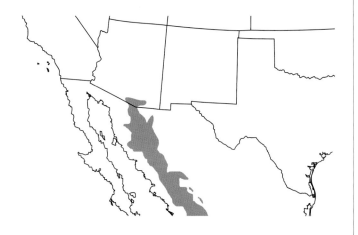

Black-throated Sparrow *Amphispiza bilineata*
L 6" WS 8" ♂ = ♀ BTSP

This black-bibbed sparrow summers widely in the arid Interior West. Its breeding range also extends into central Mexico. Northern breeders winter south into the Borderlands. Inhabits arid scrub, sagebrush flats, and brushy grasslands with open ground. In spring, the male sings from atop a shrub. Forages mainly on the ground in openings. Summer diet is a mix of arthropods, buds, and seeds. Winter diet is mainly seeds and berries. Nest is a bulky cup of grass, twiglets, and other plant matter that is lined with plant down and animal hair and situated low in a shrub or cactus. Lays three or four whitish or pale blue eggs.

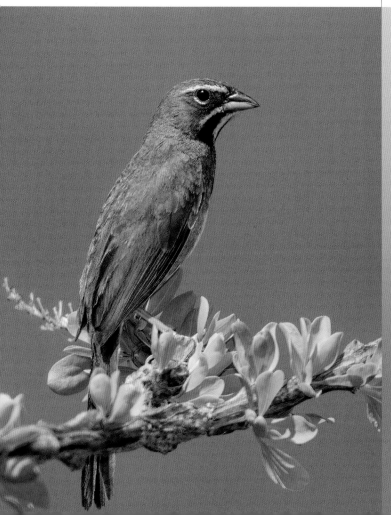

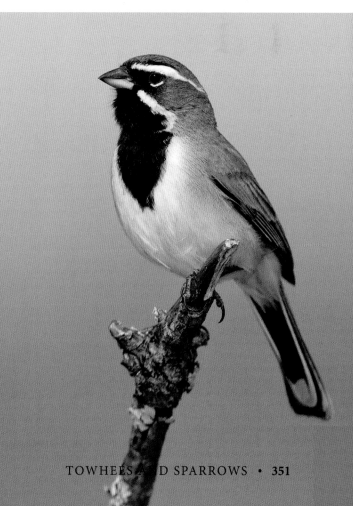

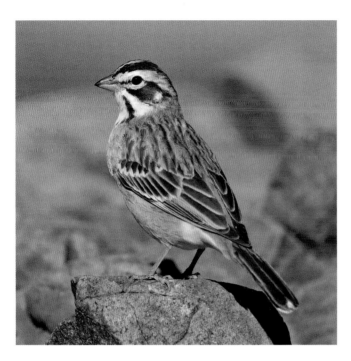

Lark Sparrow *Chondestes grammacus*

L 7" WS 11" ♂ = ♀ LASP

This large sparrow with a bright facial pattern summers through the Midwest, Southwest, and Interior West. The species winters in the Southwest and into southern Mexico. It summers in farmland, roadsides, and open country that mix bare ground with woody vegetation. Winters in weedy fields, farm yards, and other open spaces. Forages on the ground in clearings, often in small parties. Diet in summer is arthropods and seeds; winter diet is mainly seeds. The open cup nest of grass and twigs, lined with finer material, is situated on the ground near the base of a tussock or in a low shrub. Lays four or five cream-colored eggs with dark spotting. Small numbers appear along the East Coast in the autumn. Perhaps its eastern range-edge is contracting.

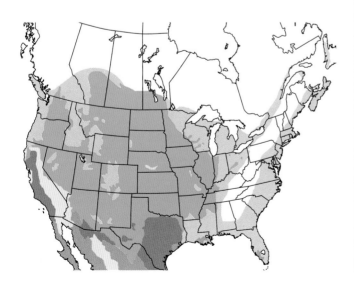

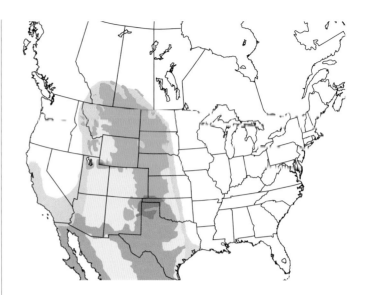

Lark Bunting *Calamospiza melanocorys*

L 7" WS 11" ♂ ≠ ♀ LARB

A distinctive songbird that summers on the northwestern Great Plains, wintering from northern Texas and the Borderlands into central Mexico. A summer inhabitant of shortgrass prairie and high plains. Winters in a range of open lands: desert grasslands, prairies, farm fields, and barren ground. The black-and-white male carries out a song flight in spring. Forages on open ground. Summer diet is arthropods and seeds; winter diet is mainly seeds. The nest is a cup of grass and rootlets lined with finer materials and situated on the ground under a canopy of grass. Lays four or five pale blue or blue-green eggs, sometimes marked with brown. The winter male loses its rich black plumage and looks similar to the female. Declining in northern plains.

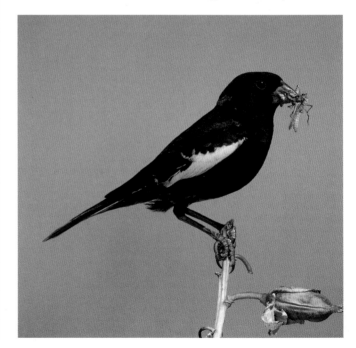

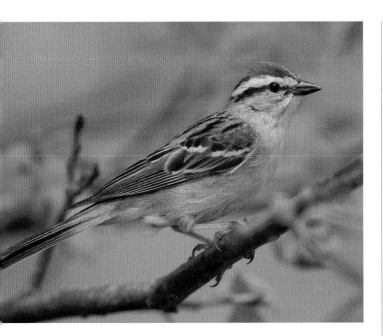

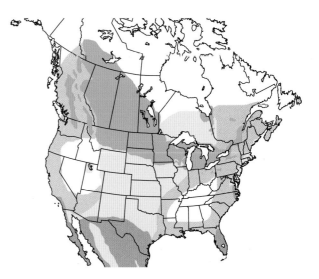

Chipping Sparrow *Spizella passerina*
L 5.5" WS 9" ♂ = ♀ CHSP

This cute little sparrow summers across North America, wintering in the Deep South and Mexico. The species ranges to Central America. Breeding habitat is forest edge, open parkland, roadsides, and mowed lawns surrounded by tall conifers. Winters in thickets, brush, and farmland. In spring, the male sings from high in a tall conifer. Forages on the ground in openings with short grass. Summer diet is mainly arthropods; winter diet is mainly seeds. The nest is a compact cup of grass and rootlets lined with finer material, typically situated in a conifer. Lays three or four pale blue-green eggs marked with dark spots. Migrates in flocks.

Clay-colored Sparrow *Spizella pallida*
L 5.5" WS 8" ♂ = ♀ CCSP

This prairie species summers in the interior of the northern United States and southern and western Canada, wintering in Mexico. Breeds in wooded scrub, woodland edge, and stands of young Jack Pine. Winters in brushy fields, dry scrub, and desert grasslands. The male in spring often sings from atop a small pine or other tree at the edge of an opening. Forages on the ground in clearings. Summer diet is seeds and arthropods, with some buds and berries. Winter diet is mainly seeds. Nest is an open cup of grass, twigs, and rootlets lined with finer materials and situated low in a shrub or on the ground. Lays three to five pale blue-green eggs marked with dark brown spotting. Migrates through the Great Plains. Population of the species is stable.

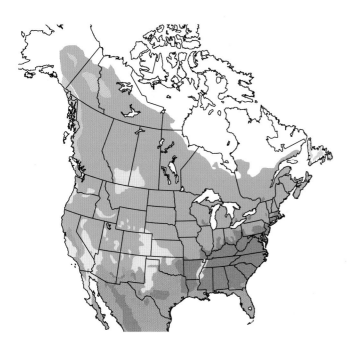

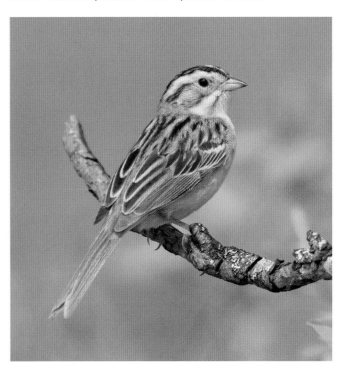

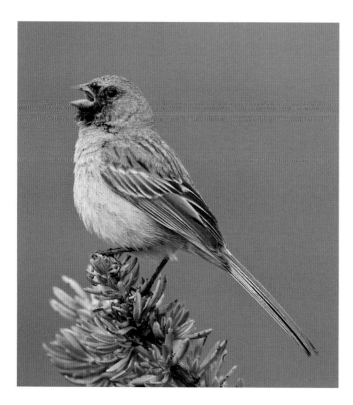

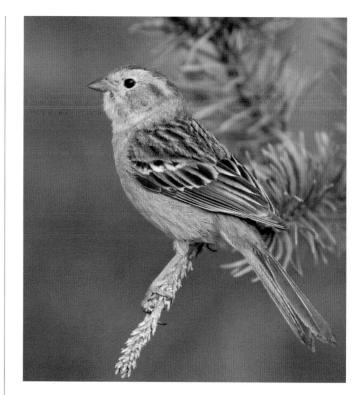

Black-chinned Sparrow *Spizella atrogularis*
L 5.8" WS 8" ♂ ≈ ♀ BCSP *WL

This mainly gray sparrow is a summer inhabitant of arid brushlands on canyon slopes in the Southwest and Far West. Winters in desert shrublands of the Southwest Borderlands and in Mexico. The species ranges to southern Mexico. Forages on the ground in loose flocks, sometimes in association with other sparrow species. Summer diet is arthropods and seeds; winter diet is mainly seeds. Nest is a shallow cup of grass and plant fibers lined with finer materials and placed low in a shrub. Lays two to four pale blue eggs, sometimes marked with brown spotting. Those in the Borderlands are mainly resident though they do move to lower elevations in winter.

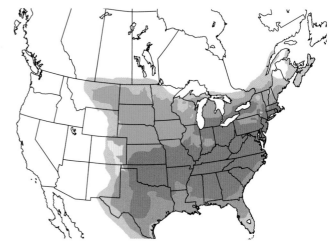

Field Sparrow *Spizella pusilla*
L 5.8" WS 8" ♂ = ♀ FISP

This pink-billed songster is widespread from the East to the Midwest, wintering in the Deep South. Inhabits overgrown fields featuring bushes and shrubs as well as woodland edge and overgrown and weedy hedgerows in agricultural country. In the nonbreeding season, it can be found in small groups, foraging in thickets and on the ground under shrubbery. Summer diet is arthropods and seeds; winter diet is seeds. Nest is a woven cup of grass lined with finer material and situated on or near the ground in a shrub. Lays three to five whitish or pale blue eggs with dark markings at the larger end. Northernmost breeders shift southward in winter. Southern breeders are sedentary. Population is stable.

American Tree Sparrow *Spizelloides arborea*
L 6" WS 10" ♂ = ♀ ATSP

This becoming rufous-capped sparrow summers in tundra edge in the Far North of Canada and Alaska. It winters southward into the Lower 48. Breeds where the treeline meets the tundra, in Arctic scrub. Winters in weedy fields with a scattering of woody vegetation. Wintering birds typically forage in small groups on the ground. Summer diet is mainly small invertebrates; winter diet is mainly seeds. Visits feeders. Nest is a cup of grasses, twigs, and moss lined with finer matter and situated on the ground in tundra or in a low shrub. Lays four to six pale greenish or bluish eggs with dark spotting mainly on the larger end. Species is in decline.

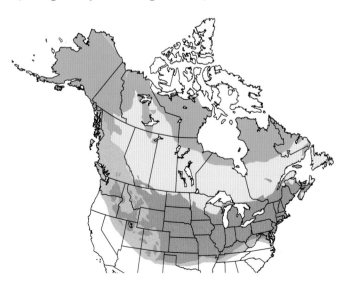

Brewer's Sparrow *Spizella breweri*
L 6" WS 8" ♂ = ♀ BRSP

This small, gray-breasted sparrow summers in the Interior West. Winters from the Borderlands into Mexico. Summers in sagebrush flats, brushland plains, and near treeline in the Canadian Rockies. Winters in open plains and in desert featuring Creosote Bush. The male is an accomplished songster in spring. Forages on the ground and in low vegetation. Diet is arthropods and seeds in summer and mainly seeds in winter. Nest is a small cup of grasses, twigs, and roots lined with finer material and hidden in a low shrub. Lays three or four pale blue-green eggs with brown spotting concentrated on the larger end. Species has shown a slow decline.

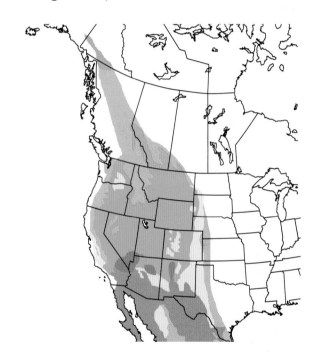

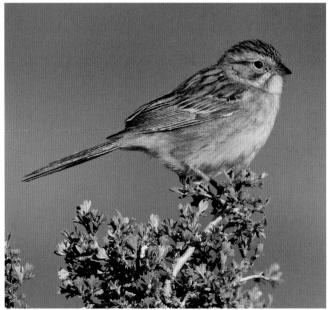

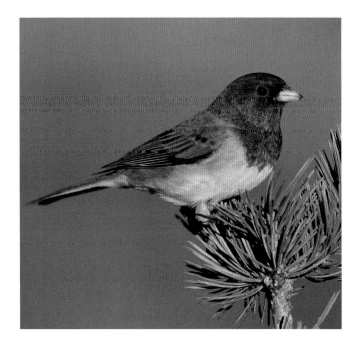

Dark-eyed Junco *Junco hyemalis*

L 6" WS 9" ♂ ≈ ♀ DEJU

Known informally as the "snowbird," this confiding, grey-headed and white-bellied sparrow summers in the Appalachians, New England, Canada, the Mountain West, and Alaska. It winters southward through most of the Lower 48 and into northern Mexico. It breeds in mixed and conifer forests, wintering in openings in wooded thickets, forest edge, roadsides, and backyards. Forages on the ground in openings and under bird feeders. Often in small roving flocks in winter. Summer diet is a mix of arthropods and seeds; in winter, it takes mainly seeds. Nest is a cup of grass and leaves lined with finer matter and hidden on the ground under a canopy of grass or aside a fallen log. Lays three to five whitish or pale blue eggs marked with brown and gray. Populations are quite variable in plumage.

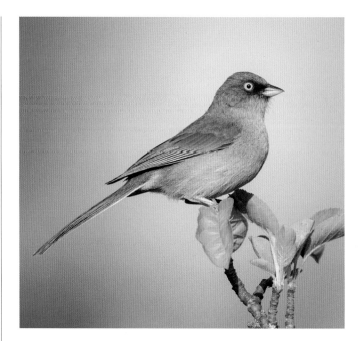

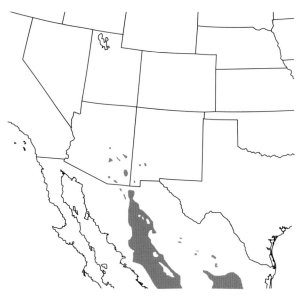

Yellow-eyed Junco *Junco phaeonotus*

L 6" WS 10" ♂ = ♀ YEJU

This mountain-dwelling species ranges from Guatemala north to southeastern Arizona and adjacent southwestern New Mexico. It is a year-round resident of mountain forests of pine and other conifers. It winters at slightly lower elevations into scrub oak and pinyon-juniper. Forages on the ground in search of seeds and arthropods. Summer diet is mainly arthropods. Winter diet is mainly seeds. Nest is a shallow cup of grass lined with finer matter and situated on the ground or in the protection of a fallen log, rock, or base of a shrub. Lays three or four pale gray or bluish-white eggs with red-brown markings. The species exhibits an unusual shuffling gait when foraging. Species population is stable.

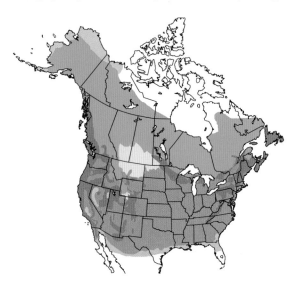

Golden-crowned Sparrow *Zonotrichia atricapilla*
L 7" WS 10" ♂ = ♀ GCSP

A large sparrow of the Far West with a black-and-yellow crown. Summers in western Canada and Alaska, wintering on the West Coast. Breeds in boreal scrub and the edges of spruce-fir forest; winters in a variety of brushlands—thickets, chaparral, and gardens. In winter, it prefers denser thickets than the White-crowned Sparrow, with which it shares its winter range. Summer diet is arthropods and plant matter; winter diet is mainly grass seeds. Nest is a bulky cup of grass, ferns, and other plant matter lined with finer materials and situated on the ground hidden under a shrub. Lays three or four whitish to pale greenish eggs with red-brown spots. Species population appears stable.

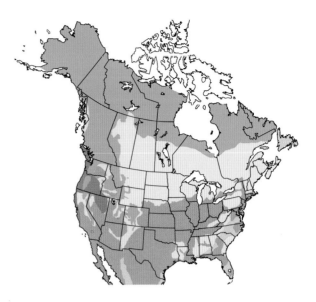

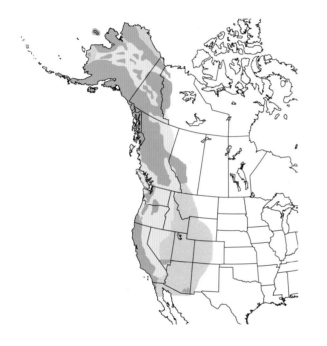

White-crowned Sparrow *Zonotrichia leucophrys*
L 7" WS 10" ♂ = ♀ WCSP

This big sparrow with the skunk-striped crown summers in Alaska, northern Canada, and southward in the mountains of the West. Winters widely in the southern two-thirds of the Lower 48 and into northern Mexico. Breeds in boreal conifer scrub, boreal forest edge, shrubbery in high mountains of the West, and forests along the West Coast. Winters in hedgerows, shrubby fields, and desert thickets. More common in the West than the East. Mainly forages in clearings on the ground. A noted songster. Summer diet is plant matter and arthropods; winter diet is mainly seeds. Nest is a cup of grass, twigs, and rootlets lined with finer materials, including feathers and animal hair. Nest is situated on the ground or in a shrub. Lays four or five whitish or pale greenish eggs heavily marked with red-brown spotting. Much outnumbered by White-throated Sparrows in the East.

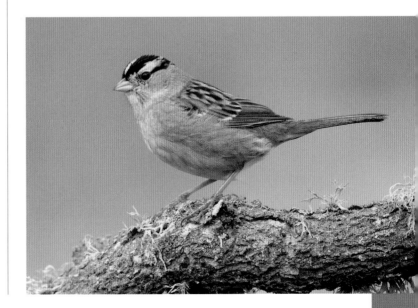

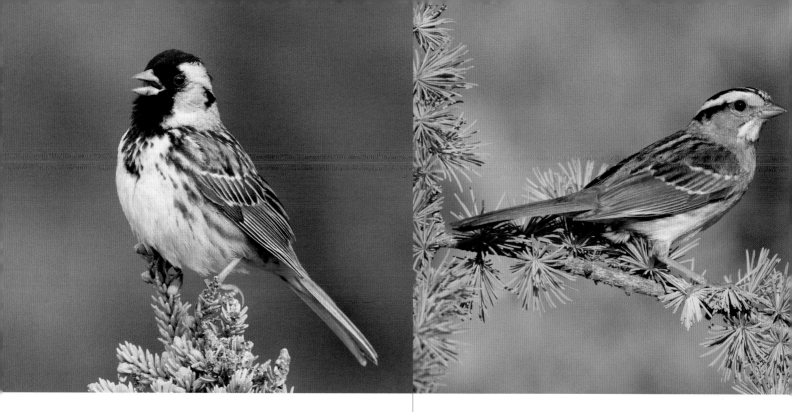

Harris's Sparrow *Zonotrichia querula*
L 8" WS 11" ♂ = ♀ HASP *WL

Black-faced and pink-billed, this large sparrow summers in north-central Canada and winters in the southern Great Plains. Rare in winter in the East and West. Breeds in dwarf boreal conifer forest. Winters in brushy edge habitats and hedgerows, often with White-crowned Sparrows. Forages on the ground in openings, retreating to thickets when approached. Summer diet is berries and arthropods. Winter diet is grass seeds. Nest is a cup of moss, lichens, and twigs with a lining of finer materials; it is situated on the ground hidden under a shrub or dwarf conifer. Lays three to five pale green eggs speckled with brown. Population stable.

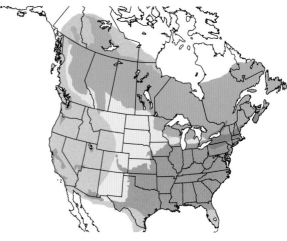

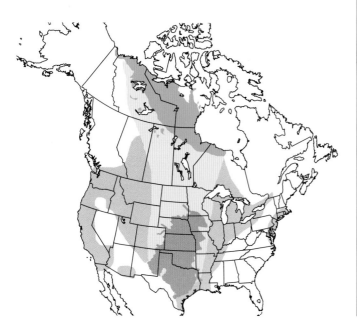

White-throated Sparrow *Zonotrichia albicollis*
L 7" WS 9" ♂ = ♀ WTSP

Most famous for its sad whistled song, this widespread sparrow summers in Canada and the Northeast and winters in the eastern two-thirds of the Lower 48. Its whistled song in a minor key is heard in summer and winter. Breeds in mixed and conifer forests, wintering in woodland thickets, and often feeding under backyard bird feeders (in small numbers in West). More of a forest-dweller than the similar White-crowned Sparrow. Forages in small parties on the ground under shrubbery or in clearings with the protection of shrubbery nearby. Summer diet is mainly arthropods. Winter diet is grass seeds and berries. Nest is a cup of grass and twigs lined with finer matter and situated on the ground hidden under a shrub. Lays four or five pale blue or blue-green eggs marked with darker colors. Population in slow decline.

Sagebrush Sparrow *Artemisiospiza nevadensis*
L 6" WS 8" ♂ = ♀ SABS

A sparrow that summers in the Interior West, especially the sagebrush plains of the Great Basin. Winters in the Southwest and into northern Mexico. Summers in sagebrush flats, foothills, and lower mountains up to 8,000 feet elevation. Winters in arid shrublands near the Border. Forages on the ground, with its long tail often cocked up. The male sings in spring from the top of a shrub, wagging its tail. Summer diet is arthropods and seeds; winter diet is mainly grass seeds. Nest is a loose cup of sagebrush lined with animal hair and well hidden in a shrub. Lays three or four bluish-white eggs that are speckled. This is a species in decline. Identification keys and winter ranges are still being worked out for this and the following species.

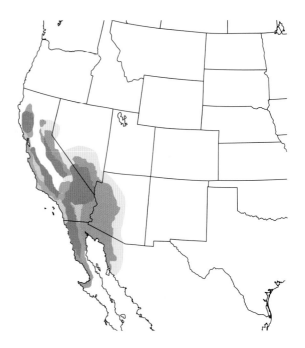

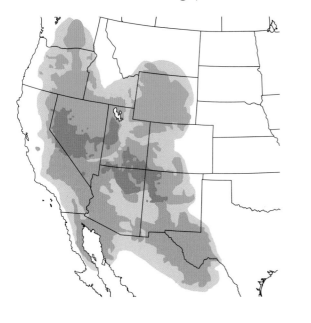

Bell's Sparrow *Artemisiospiza belli*
L 6" WS 8" ♂ = ♀ BESP

This close relative of the Sagebrush Sparrow is a largely sedentary species that summers in California and Baja and winters into western Arizona. Inhabits dry chaparral, sage scrub, brushlands in hills and southern mountains, and low desert scrub. Forages on the ground, distinctively flicking its long tail. Summer diet is arthropods and seeds; winter diet is mainly seeds. Nest is a loose cup of brush lined with fur and hidden in a shrub. Lays three or four bluish-white eggs that are speckled with darker colors. Populations of this species are in decline.

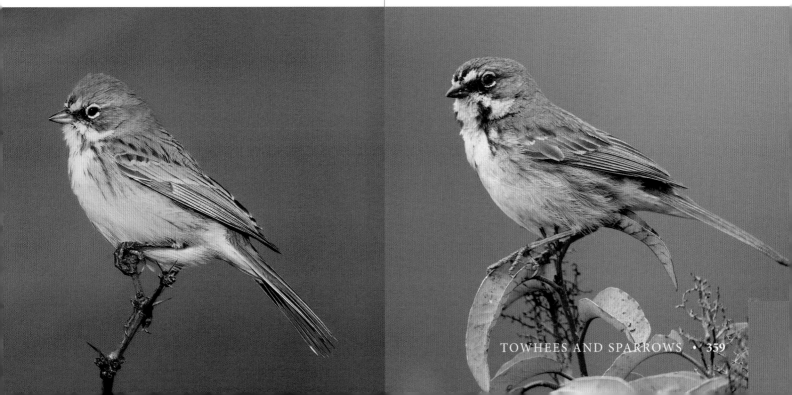

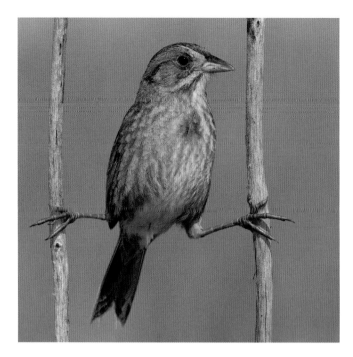

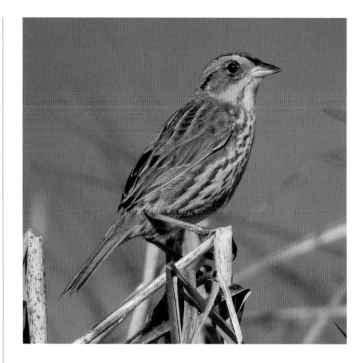

Seaside Sparrow *Ammospiza maritima*
L 6" WS 8" ♂ = ♀ SESP *WL

This big, dark marshland sparrow is a permanent resident of Atlantic and Gulf coastal saltmarshes. Populations are distinct, especially those living on the southern tip of mainland Florida (the Cape Sable subspecies). A year-round inhabitant of tidal saltmarsh. Solitary and secretive, though singing birds in spring can be conspicuous when they perch in the open. Usually seen flying up from marsh grass only to drop back into the vegetation out of sight. Summer diet is mainly arthropods with some seeds; winter diet mainly seeds. Nest is a cup of grass lined with finer grasses and hidden in marsh vegetation just above the level of the highest tide of the season. Lays three or four bluish-white eggs marked with brown blotching at the larger end. Northernmost breeders shift southward in winter. Cape Sable race threatened.

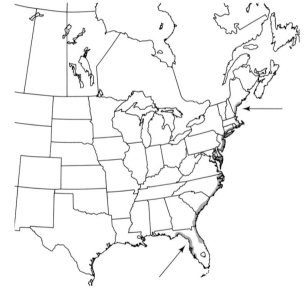

Saltmarsh Sparrow *Ammospiza caudacuta*
L 5" WS 7" ♂ = ♀ SALS *VU *WL

Breeding range of this wetlands sparrow is the Atlantic Coast from southern Maine to Delmarva Virginia. Winters southward to the Atlantic and Gulf Coasts of northern Florida. Summers and winters mainly in coastal saltmarsh. Solitary and secretive. Typically stays hidden in marsh grass. Diet is mainly small invertebrates and some plant matter. Nest is a bulky cup of grass lined with finer grass and, in some instances, domed over. The nest is situated low in thick grass but above the seasonal high-tide line. Lays three to five pale green or blue eggs marked heavily with red-brown blotches. Populations in decline.

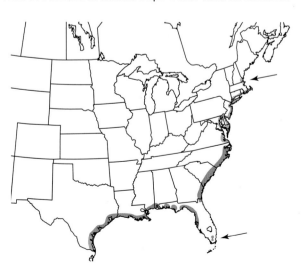

Nelson's Sparrow *Ammospiza nelsoni*

L 5" WS 7" ♂ = ♀ NESP *WL

This species is quite similar to the Saltmarsh Sparrow, with which it shares breeding habitat on the coast of Maine. It summers along the coast of the Northeast as well as along the northern US Borderlands into central Canada. Additional populations nest along the shores of James and Hudson Bays. Winters southward along the Gulf and Atlantic Coasts. Summers in coastal saltmarsh and northern Interior freshwater marshland. Winters in coastal saltmarsh. Nests in wetter marsh habitat than the LeConte's Sparrow. Solitary and secretive. Summer and winter diet mainly arthropods with some seeds. Nest is a bulky cup of grass built up around the sides and hidden in thick marsh grass. Lays three to five pale green or pale blue eggs with red-brown markings.

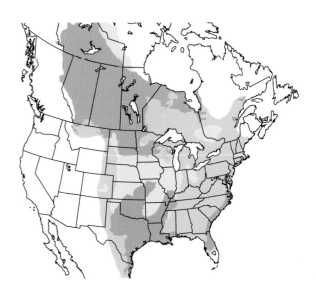

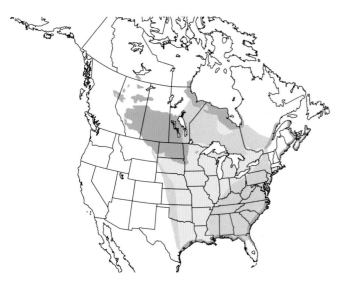

LeConte's Sparrow *Ammospiza leconteii*

L 5" WS 7" ♂ = ♀ LCSP

This elusive species summers in wet grasslands of the northern US Borderlands and central Canada, wintering in the lower Mississippi and Deep South. Summers in wet sedge or weedy meadows and the edges of shallow freshwater marshes. Winters in coastal prairies, shallow marshes, and weedy fields near water. Solitary and secretive; easily located only when the males are singing in spring to establish or maintain their territories, but the high-pitched buzz is difficult to hear. Summer diet is mainly arthropods with some seeds; winter diet mainly seeds. Nest is a cup of grass lined with finer matter and attached to the bases of standing grass low to the ground. Lays three to five off-white eggs spotted with darker colors. Difficult to track down in migration and winter. Uncommon but stable species population.

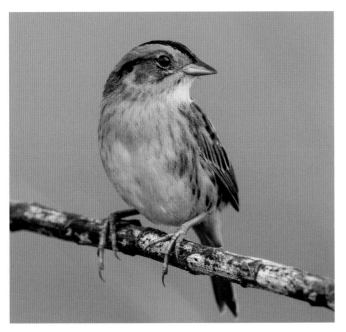

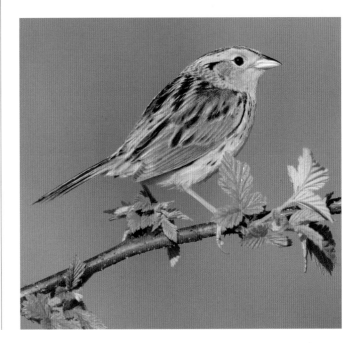

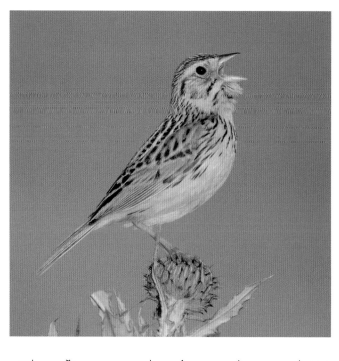

Henslow's Sparrow *Centronyx henslowii*
L 5" WS 7" ♂ = ♀ HESP *NT *WL

This secretive sparrow summers in the interior Midwest and winters in the Deep South. Nests mainly in expansive weedy fields with a scattering of shrubs; also in tallgrass prairie. Winters in abandoned and overgrown fields and pine savanna. One of the more elusive and difficult to find of the grassland sparrows, though singing birds in summer can be conspicuous, typically most vocal at dawn. Summer diet is mainly arthropods and some plant matter; winter diet mainly grass seeds. Nest is a cup of grass lined with finer matter and hidden on or near the ground concealed by thick grass. Lays three to five whitish or greenish-white eggs marked with darker blotches mainly on the larger end. Song of the male is a brief insect-like two-syllable slur.

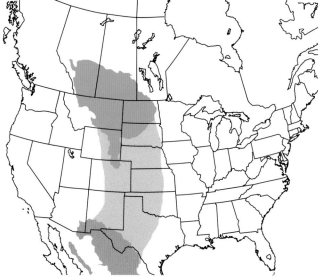

Baird's Sparrow *Centronyx bairdii*
L 6" WS 9" ♂ = ♀ BAIS *WL

Summers in a small sector of the Northern Interior high plains; winters in northern Mexico, West Texas, New Mexico, and Arizona. Breeds in lush and dense grass of native short-grass prairie. Winters in shortgrass prairie of the Southwest. The territorial male gives a distinctive musical song. When not in song, the species is secretive and reclusive. Summer diet is mainly arthropods; winter diet is mainly grass seeds. The nest is a shallow cup of dry grass lined with finer matter and hidden on the ground under a windrow of grass. Lays four or five off-white eggs heavy spotted with darker colors. Rarely seen in migration. Declines on breeding habitat due to degradation of native prairie habitat.

Savannah Sparrow *Passerculus sandwichensis*

L 5.5" WS 9" ♂ = ♀ SAVS

This is the most common and widespread sparrow of grasslands across the Continent. Summers across the northern two-thirds of North America. Winters southward to the Atlantic, Pacific, and Gulf Coasts and much of the southern sectors of the United States and into Mexico. Summers in tundra, meadows, fields, pastures, and marsh edges. Winters on sandy shores, barren fields, marshlands, and other open habitats. Not nearly as reclusive as many other sparrows. Summer diet is small invertebrates and plant matter. Winter diet is mainly grass seeds. Nest is a cup of grass lined with finer materials and situated on the ground under the cover of a tussock of grass. Lays two to six off-white or pale green eggs marked with brown blotches on the larger end.

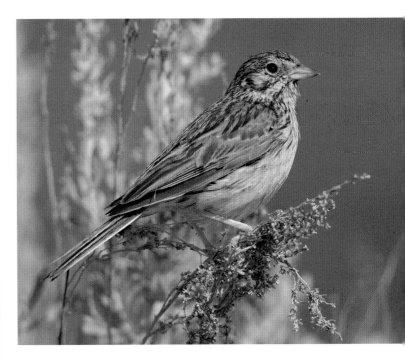

Vesper Sparrow *Pooecetes gramineus*

L 6.3" WS 10" ♂ = ♀ VESP

This demurely-marked sparrow summers across much of North America, wintering in the Deep South, Southwest, and Mexico. Inhabits weedy pastures, plowed fields, and roadsides in agricultural countryside. The male is quite vocal in spring and summer, and the species is more confiding than many other grassland sparrows. Summer diet is arthropods and seeds; winter diet is mainly grass seeds. Nest is a bulky cup of grass lined with finer material and sited on the ground at the base of a tussock. Lays three or four whitish or pale greenish eggs marked with gray and brown. Has been declining in the East.

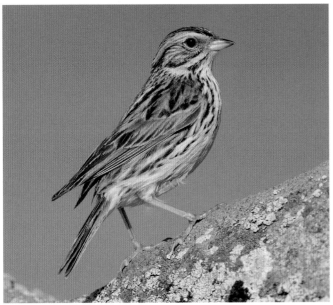

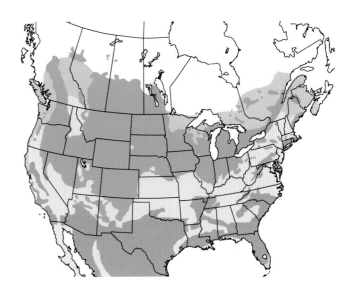

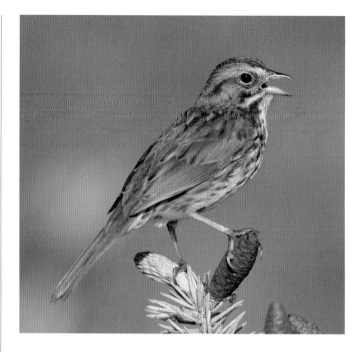

Fox Sparrow *Passerella iliaca*
L 7" WS 11" ♂ = ♀ FOSP

This large and geographically variable sparrow summers in the boreal forests of the North and the mountains of the West. It winters in the southern United States and the Far West. Summers in deciduous thickets in boreal or montane clearings; winters in thickets and the leafy understory of parklands. In winter, individuals scratch about in a thick carpet of dried leaves under a mix of evergreen shrubs and canopy trees, making considerable noise. Can be reclusive on the breeding ground, but vocalizing males can be obvious. Best found by the distinctive song of the male on territory. Summer diet is arthropods and plant matter; winter diet is mainly seeds. The nest, a cup of grass and moss lined with finer matter, is situated on the ground or a low shrub. Lays two to five pale green eggs marked with red-brown markings. Population stable.

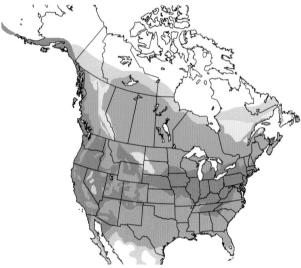

Song Sparrow *Melospiza melodia*
L 6" WS 8" ♂ = ♀ SOSP

This brown-striped sparrow is common and widespread across much of North America. Summers from Alaska and central Canada south to the Mid-Atlantic in the East and Southern Arizona in the West. Northernmost breeders winter through much of the Lower 48. Inhabits thickets and brushy habitat near openings, including suburban yards, roadsides, and stream and woodland edges. A fine singer, and often a fairly confiding resident of suburban habitats. Summer diet is small invertebrates and plant matter; winter diet is mainly grass seeds. Nest is a cup of woven grass, rootlets, and bark lined with finer materials; nest situated on the ground or low in a shrub. Lays three to five pale green eggs heavily marked with red-brown spotting.

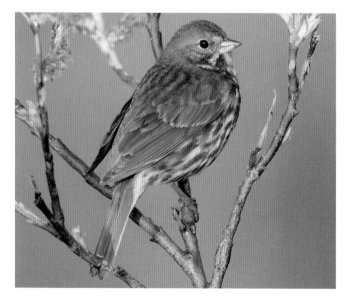

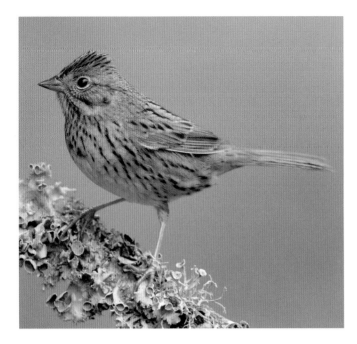

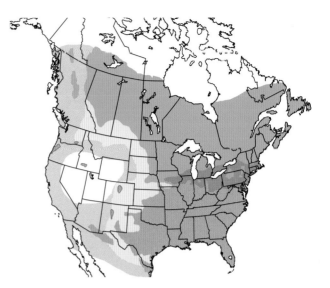

Lincoln's Sparrow *Melospiza lincolnii*
L 6" WS 8" ♂ = ♀ LISP

Summers in boreal Canada, Alaska, the northern US Borderlands, and the Mountain West. Winters in the Deep South, the lower Mississippi, the West Coast, and Mexico. Summers in shrubbery at the edges of bogs and muskeg, as well as in willow and alder thickets in the Far North. Winters in overgrown fields and thickets. The male sings a beautiful House Wren-like song in spring; otherwise, this is a shy and secretive species of thickets. Summer diet is a mix of seeds and arthropods. Winter diet mainly grass seeds. The nest is a shallow cup of grass lined with finer matter and hidden under concealing vegetation. Lays three to five pale green eggs marked with darker spotting. Population stable.

Swamp Sparrow *Melospiza georgiana*
L 6" WS 7" ♂ = ♀ SWSP

This gray-breasted and rufous-capped marsh sparrow summers in the Northeast, northern Midwest, and much of boreal Canada. It winters in the South, Southeast, and southern Borderlands. Summers in marshes with high vegetation and other brushy wetlands. Winters in marshes, streamside thickets, and weedy fields. Except when the male is singing in spring, this species is retiring and best located by its loud and sharp call notes. Forages on the ground near water or at the edge of thickets. Summer diet is mainly arthropods and some plant matter. Winter diet is mainly weed seeds. The bulky cup nest sits atop a platform of reeds and is woven of grass and lined with finer materials. It is set in tall marsh vegetation. The four or five pale green eggs are marked with reddish brown.

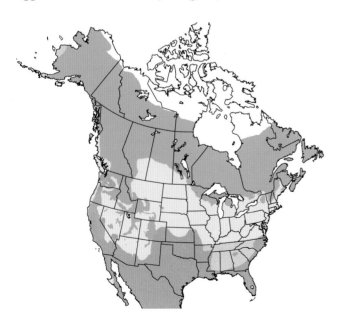

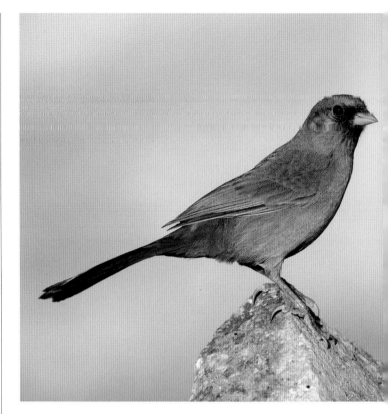

Rufous-crowned Sparrow *Aimophila ruficeps*
L 6" WS 8" ♂ = ♀ RCSP

A sedentary but widespread sparrow of arid hills and canyons of California and the Southwest, ranging southward into southern Mexico. Inhabits brushlands of foothills and canyons, including chaparral, understory of pine-oak woods, and rocky outcrops. Resident pairs inhabit dense cover and are heard more often than seen. Summer diet is arthropods and seeds; winter diet is mainly seeds. Nest is a cup of small twigs lined with finer materials, such as animal hair, and situated on the ground at the base of a tussock or hidden low in thick shrub. Lays three or four bluish-white eggs.

Abert's Towhee *Melozone aberti*
L 10" WS 11" ♂ = ♀ ABTO

This permanent resident of the Arid Southwest is mainly confined to southern Arizona, southeastern California, and southern Nevada, barely edging into Mexico. Mainly at lower elevations than the Canyon Towhee. Inhabits arid lowlands: mesquite, brushlands, and desert stream thickets. Forages on the ground, often under the cover of thickets. Diet is a mix of arthropods and seeds. Nest, hidden in a shrub, is a bulky cup made of weeds, bark strips, grass, and vines; it is lined with finer plant matter and some animal hair. Lays one to four whitish or pale blue eggs marked with brown and black. The species has exhibited substantial declines.

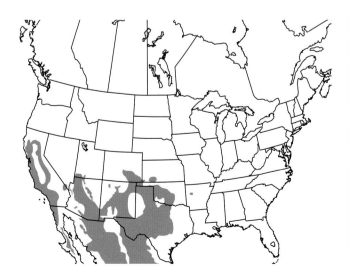

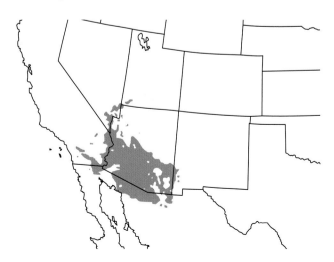

Canyon Towhee *Melozone fusca*

L 9" WS 12" ♂ = ♀ CANT

This very sedentary Mexican species ranges up through the Interior Southwest. It inhabits brushlands—chaparral, pinyon-juniper, and desert scrub in foothills. Forages on the ground, scuffing the ground in search of food items. Commonly forages under vegetation and other cover. Diet includes arthropods, berries, and seeds. Nest is a solid and bulky cup of twigs and other plant matter that is lined with finer materials and situated in a shrub or placed on a branch against the trunk of a low tree. Lays three or four off-white eggs marked with red-brown scrawls and spots.

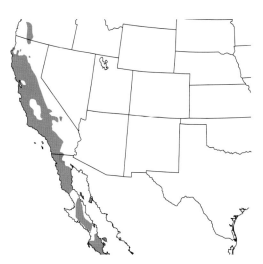

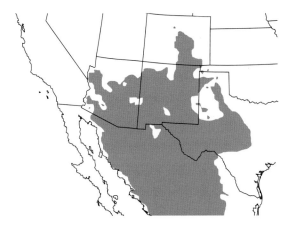

California Towhee *Melozone crissalis*

L 9" WS 12" ♂ = ♀ CALT

This plain brown towhee is a permanent resident of the West Coast, from southern Oregon to Baja. It inhabits brushy areas—chaparral, gardens, park thickets, and coastal scrub. Forages on the ground, often underneath shrubbery, giving distinctive call notes and male-female duets. Diet is a mix of seeds, berries, and arthropods. Nest is a bulky and loosely made cup of twigs, grasses, and other plant matter lined with finer material and situated in a dense shrub. Lays three or four pale bluish-white eggs marked with brown and black.

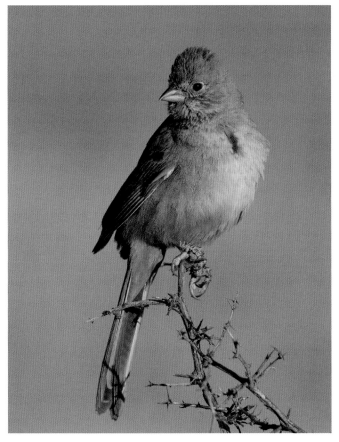

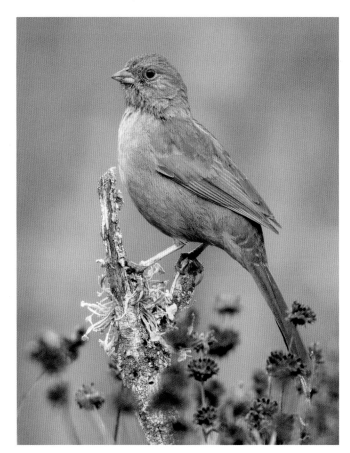

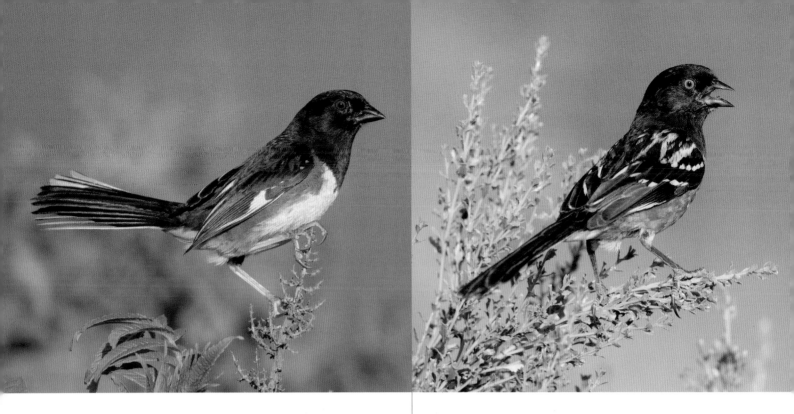

Eastern Towhee *Pipilo erythrophthalmus*
L 9" WS 11" ♂ ≠ ♀ EATO

This handsomely patterned ground-dweller is widespread through the East and Midwest. Northern populations migrate southward in winter, whereas southern populations remain sedentary. Inhabits thickets, woodland edge, and shrubby areas. Heard before seen. Forages on ground by scraping leafy ground with both feet. Summer diet includes berries, invertebrates, and small vertebrates. Winter diet is mainly seeds. Nest is a cup of grass and other plant material lined with finer material, such as animal fur. Nest is situated on the ground under a shrub or hidden low in a bush. Lays three or four off-white eggs marked with darker colors. Northern populations in apparent decline.

Spotted Towhee *Pipilo maculatus*
L 9" WS 11" ♂ ≈ ♀ SPTO

This bird, the western counterpart to the Eastern Towhee, is widespread in the West. The populations from the West Coast south and east to New Mexico are sedentary. The populations in the northern Great Plains migrate to the Southwest Borderlands and the southern Great Plains. Inhabits chaparral, montane thickets, and woodlands with dense understory. Forages on the ground under vegetation, scratching through leaves with both feet. Typically heard before seen. Summer diet includes berries, invertebrates, and small vertebrates. Winter diet is mainly seeds. Nest is a loose cup set in a dense bush quite near the ground. Lays three to six white eggs with darker spotting.

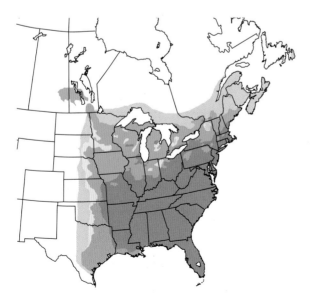

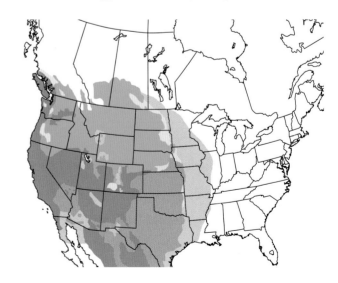

Green-tailed Towhee *Pipilo chlorurus*

L 7" WS 10" ♂ = ♀ GTTO

Summers in the uplands of the Interior West. Winters in Mexico and the Southwest Borderlands. Summers in mountain brushlands, open pinelands, and river bottom woodlands. Winters in thick low brush, especially near creek bottoms. This thicket-dweller is heard before being seen. Forages by scratching with both feet on the leafy ground under the cover of shrubbery. Diet includes arthropods, berries, and seeds. The large and deep cup nest is placed on the ground or in a low shrub. The nest is composed of twigs and other plant matter and lined with finer materials. Lays three or four whitish eggs speckled with darker colors.

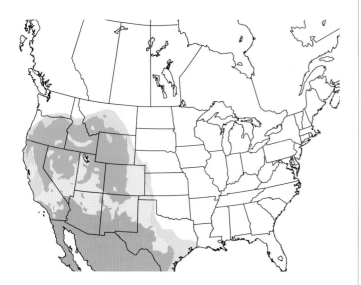

Western Spindalis *Spindalis zena*

L 7" WS 10" ♂ ≠ ♀ WESP

This Caribbean specialty, now placed in its own family with the Jamaican, Puerto Rican, and Hispaniolan Spindalises, is a rare visitor to South Florida, where it has bred in Everglades National Park. This island species is usually found near the coast when it shows up in Florida. Found in wooded gardens, thickets, shrubbery, and hardwood hammocks. Typically found feeding in fruiting and flowering trees. Nest is a cup composed of various plant materials. Lays two to four pale blue eggs with darker markings at the larger end. Typically a few records per annum.

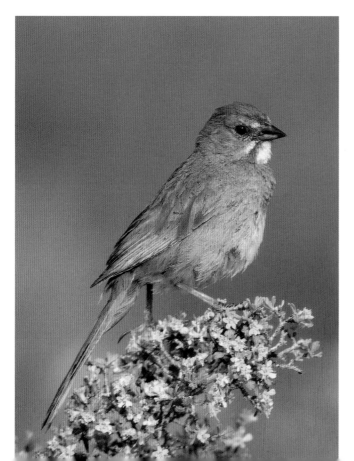

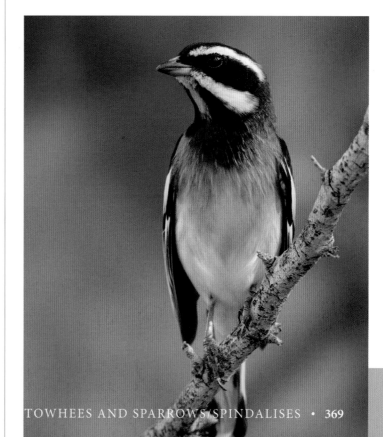

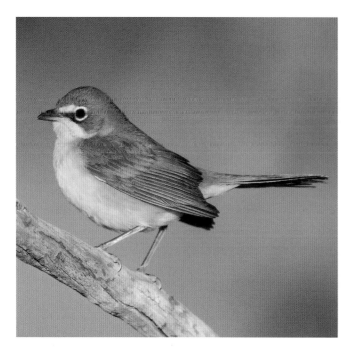

Yellow-breasted Chat *Icteria virens*

L 8" WS 10" ♂ ≈ ♀ YBCH

This striking and vocal songbird, having the look of a super-sized yellowthroat, is now placed in its own family. Summer range extends from coast to coast, though it is absent from the upper Great Plains and much of New England. Inhabits tangles in weedy fields and streamside thickets. Exhibits a remarkable array of vocalizations; the male on territory carries out strange song flights, fluttering over briar patches. Diet includes arthropods and berries. The large cup nest, hidden in a thicket, is made of vines sitting atop a base of dead leaves; it is lined with fine stems and other plant material. Lays three or four off-white eggs marked with dark colors at the larger end. Individuals in winter sometimes show up at backyard bird feeders in the Northeast.

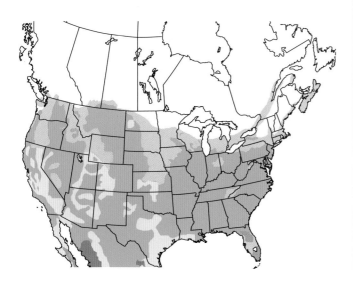

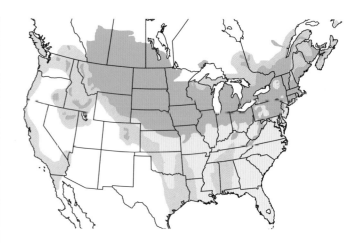

Bobolink *Dolichonyx oryzivorus*

L 7" WS 12" ♂ ≠ ♀ BOBO *WL

This strongly migratory blackbird relative, sometimes known as the "ricebird," summers across the northern third of the Lower 48 plus southern Canada. It winters in northern Argentina and Paraguay. Summers in damp meadows, prairies, and hayfields. Migrants stop over in weedy fields and marshes. The very showy male carries out a wonderfully musical song flight over its nesting field in late spring. Summer diet is a mix of arthropods and weed seeds. Nest is a shallow cup of grass and weed stems lined with finer materials; it is well hidden on the ground in thick grass. Lays five or six grayish to pale reddish-brown eggs blotched with brown and lavender. A species in decline.

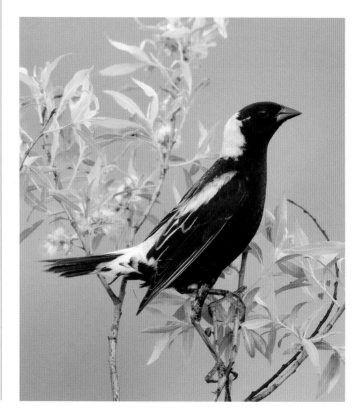

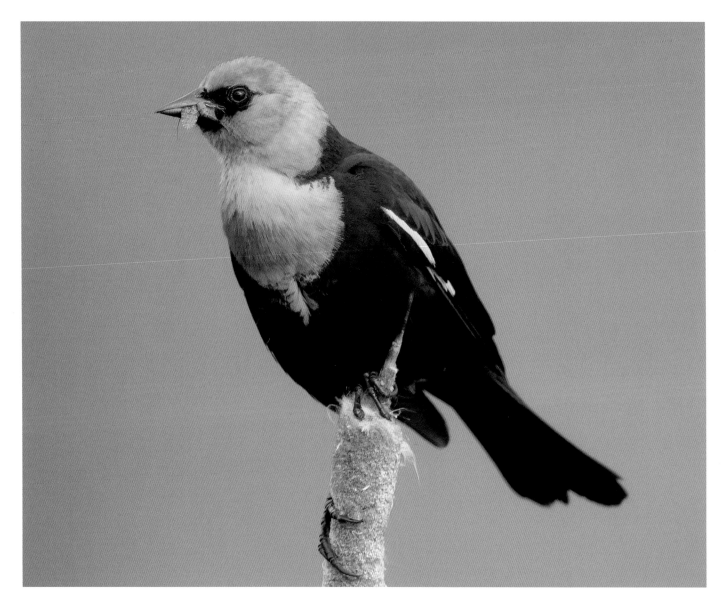

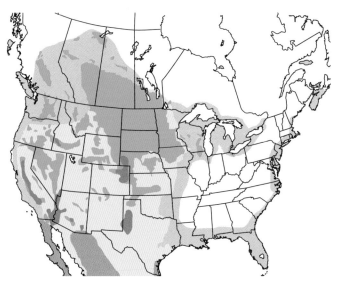

Yellow-headed Blackbird
Xanthocephalus xanthocephalus
L 10" WS 15" ♂ ≠ ♀ YHBL

This distinctive, large, and vocal marsh-dweller summers throughout the Interior West. Winters along the Southwest Borderlands and southward to southern Mexico. Summers in dense freshwater reed marshes, foraging in nearby fields. Winters in a range of open-country habitats—pastures, bare fields, mowed lawns, and feedlots. The striking male, perched atop a cattail, is a noisy vocalist, producing a variety of harsh sounds. Breeds colonially and forages in flocks much of the year. Diet is a mix of invertebrates and seeds. Nest is a bulky and deep cup of marsh vegetation lined with finer plant matter and lashed to upright marsh stems. Lays three to five pale green eggs marked with darker colors at the broader end. Population is perhaps expanding.

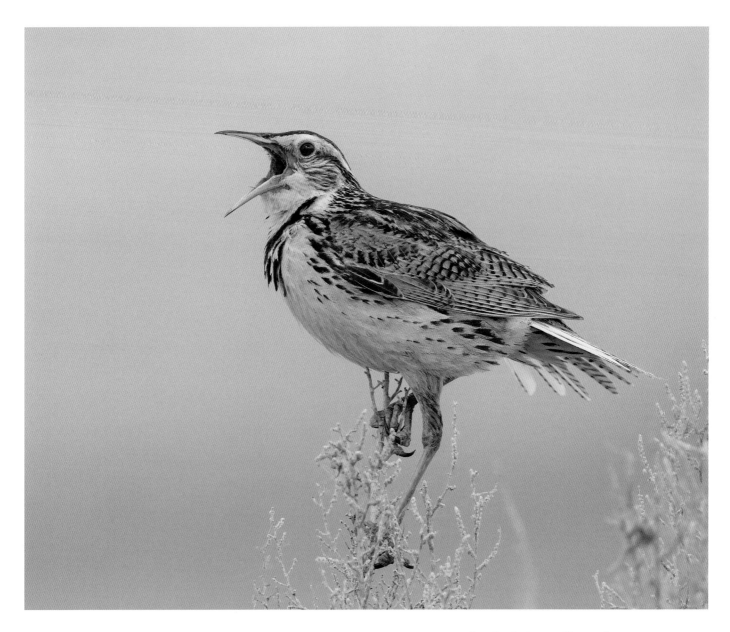

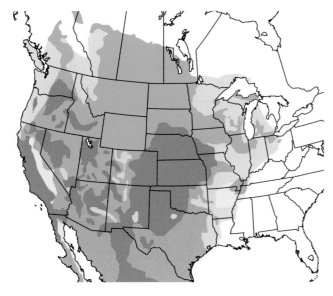

Western Meadowlark *Sturnella neglecta*
L 10" WS 15" ♂ = ♀ WEME

This western relative to the Eastern Meadowlark summers from Michigan to the West Coast and south into Texas and Mexico. Northern breeders winter southward. The species has breeding populations that range into central Mexico. Also introduced to Kauai (Hawaii). Summers in fields, pastures, meadows, and prairies. Winters in a wide range of open grasslands. Breeding and winter ranges of this and the other two meadowlarks show considerable overlap; distinct songs allow them to be separated. Summer diet is a mix of arthropods and plant matter; winter diet mainly grass seeds. The ground nest, hidden in the grass, is a domed grassy structure with a side entrance. Lays three to seven white eggs heavily marked with purple and brown. US populations of this species are in decline.

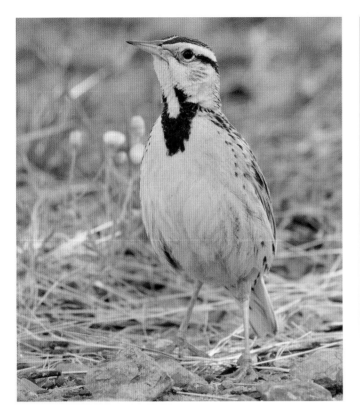

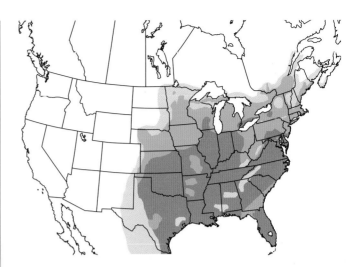

Eastern Meadowlark *Sturnella magna*
L 10" WS 14" ♂ = ♀ EAME

This familiar songbird of rural agricultural lands breeds through the East, Midwest, and Deep South. The species also has breeding populations south into northern South America. Summers in fields, pastures, meadows, and prairies. Winters in open grasslands. The male's pleasant spring song is much a part of our rural agricultural soundscape. Travels in small flocks in winter. Summer diet is a mix of arthropods and plant matter; winter diet mainly grass seeds. The ground nest, hidden in the grass, is a domed grassy structure with a side entrance. Lays three to five white eggs heavily speckled with dark colors. Northern breeders tend to shift southward in winter. Habitat loss is causing declines.

Chihuahuan Meadowlark *Sturnella lilianae*
L 10" WS 14" ♂ = ♀ CHME

This meadowlark, which ranges from the southwestern United States to central Mexico, was long considered a subspecies of the widespread Eastern Meadowlark. Western Meadowlark range overlaps this newly-split species. The Chihuahuan Meadowlark's outer four tail feathers are almost completely white. Call note is distinct. Prefers tall, undisturbed grassland areas, often scattered with oak trees. Feeds on the ground where it usually stays well hidden, and sometimes sits on exposed perches, especially when singing. The ground nest, hidden in the grass, is a domed grassy structure with a side entrance. Lays four pale blue eggs.

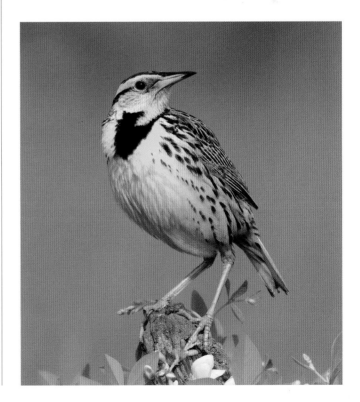

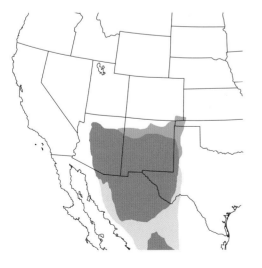

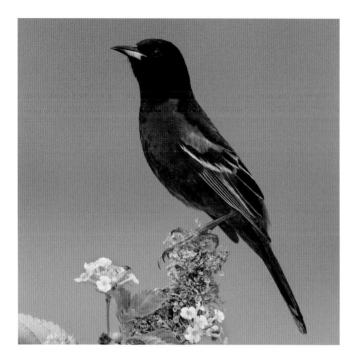

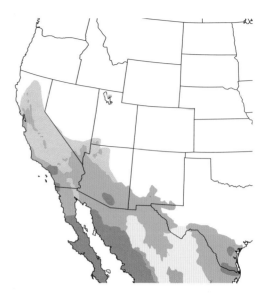

Orchard Oriole *Icterus spurius*

L 7" WS 10" ♂ ≠ ♀ OROR

This burnished black-and-chestnut oriole summers through the East and Midwest, with breeding populations ranging into Mexico. Winters from Mexico to northern South America. Summers in overgrown orchard openings, woodland edge, and tall shade trees, especially by water. The male sings his complex and ringing song from high in a shade tree. Diet is mainly arthropods in summer with the addition of some fruit and nectar in other seasons. Nest, hung from a branch in a tree, is a pouch of woven grasses and other plant materials lined with fine plant fibers. Lays four or five pale blue eggs marked with various darker colors. Young male is distinct—greenish with a small black bib.

Hooded Oriole *Icterus cucullatus*

L 8" WS 11" ♂ ≠ ♀ HOOR

This snazzy oriole summers from the West Coast down along the Southwest Borderlands, with additional breeding populations south to Belize. Most US birds winter to southern Mexico. Inhabits shade trees, open woodlands, well-planted suburbs, and palm groves. The male sings a complex song that includes phrases borrowed from other bird species. Diet includes arthropods, fruit, and nectar. Nest is a woven pouch lined with finer plant fibers and other soft materials; it is hung from a palm frond or other suitable limb or branch. Lays three to five white eggs that are blotched with darker colors. Declines in Texas may be because of nest parasitism by the Bronzed Cowbird, whose range is expanding.

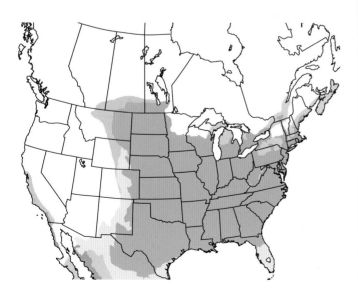

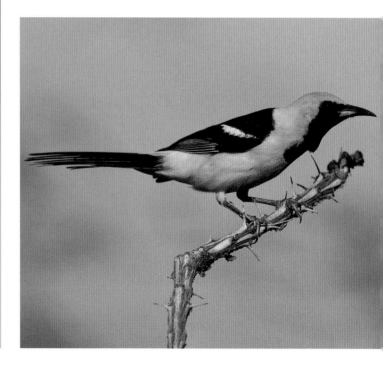

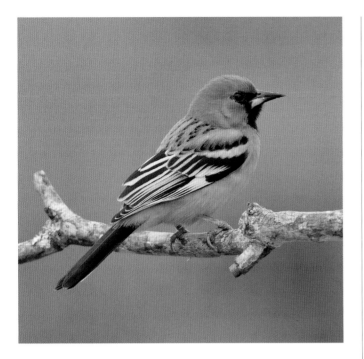

Streak-backed Oriole *Icterus pustulatus*

L 8" WS 13" ♂ ≠ ♀ SBAO

This fiery-headed oriole of Central America and Mexico ranges northward to the Borderlands of Arizona, where it is a rare visitor. Has been recorded breeding in that state. Found in arid scrub, brushy woodlands, and well-planted suburban yards, where it will visit flowering plants and hummingbird feeders for nectar. Diet is presumably a mix of arthropods, fruit, and nectar. Nest is a pendulous pouch of woven grasses hung from a branch of a thorny tree or shrub. Lays three or four whitish to pale blue eggs scrawled and blotched with dark brown. Species population stable. Strays have been recorded from Oregon, Utah, Colorado, New Mexico, Texas, and Wisconsin.

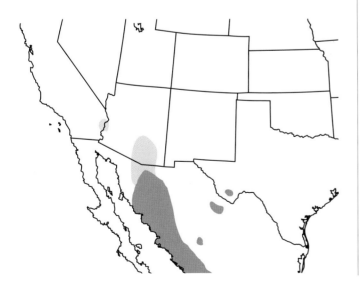

Baltimore Oriole *Icterus galbula*

L 9" WS 12" ♂ ≠ ♀ BAOR

This iconic summer songbird breeds in the East and Midwest, from Louisiana northeastward to New Brunswick and northwestward to Alberta. Winters from Florida and South Texas to northern South America. Summers in shade trees by streams and rivers (especially sycamores), openings in woodlands, and well-wooded suburbs. In spring, the male sings his distinctive and varied song from high in a shade tree. Diet is a mix of arthropods, fruit, and nectar. Will visit feeding stations that offer fruit or nectar. Nest is a woven pouch of plant materials lined with finer matter and hung from the end of a horizontal or drooping branch high in a shade tree. Lays four or five off-white or pale blue eggs marked with darker colors at the larger end. Migrates in flocks. Minor declines have been detected.

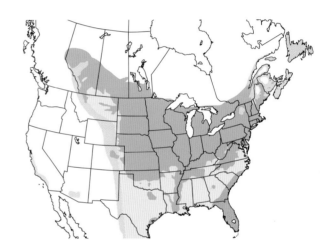

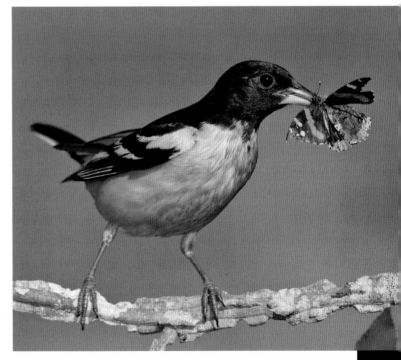

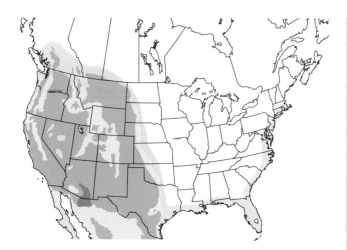

Bullock's Oriole *Icterus bullockii*

L 9" WS 12" ♂ ≠ ♀ BUOR

Bullock's Oriole, the western counterpart to the Baltimore Oriole, summers across the West and winters widely in Mexico. It summers in woodland openings, streamside cottonwoods, edges of forest, farmland, and well-wooded suburbs. Behavior much like the Baltimore Oriole. Male sings from high in a shade tree. Diet is arthropods, fruit, and nectar. The nest is a tidy woven pouch of plant fibers hung from the tip of a tree branch. Lays four to six grayish eggs marked with darker colors. Bullock's and Baltimore Orioles hybridize where their ranges meet in the Great Plains.

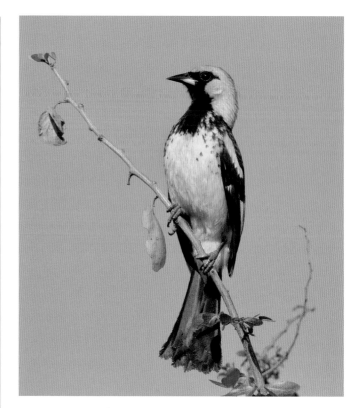

Spot-breasted Oriole *Icterus pectoralis*

L 10" WS 13" ♂ = ♀ SBOR *WL

This handsome Central American and Mexican oriole was accidentally introduced to the Miami area in 1949 and is now established in southeastern Florida as a breeding bird. Inhabits richly planted gardens and yards from Palm Beach south to Homestead. Uncommon and solitary. Diet is arthropods, fruit, and nectar. Nest is a woven hanging pouch of palm fibers hung from a small branch of a tree. Lays four whitish eggs with blackish scrawls. Sedentary.

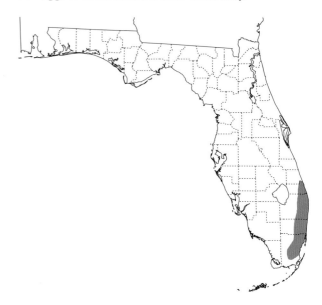

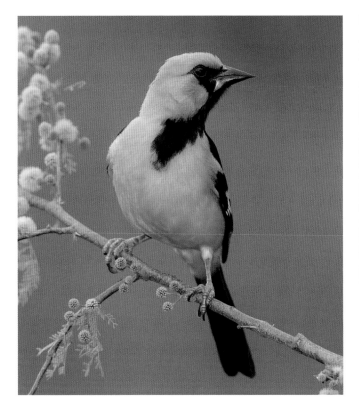

Altamira Oriole *Icterus gularis*

L 10" WS 14" ♂ = ♀ ALOR

This gorgeous resident of Mexico and Central America has naturally extended its range northward into the Lower Rio Grande Valley of the Texas Borderlands. It inhabits native scrub woodlands that border the Rio Grande. Diet is a mix of arthropods, fruit, and nectar. Will visit feeding stations that offer fruit and nectar. The conspicuous nest is a long pendant pouch up to two feet long, woven of various plant materials hung from a horizontal branch in a tree. Lays four to six pale blue eggs scrawled with darker colors. Sedentary and nonmigratory. The species ranges southward to Nicaragua. The Texas range of this species is tiny and the state considers it threatened. The species is classified by the Red List as Least Concern. Note the distinctive thick-based bill.

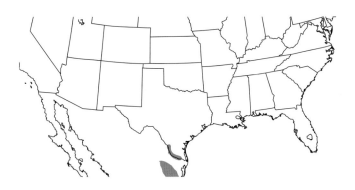

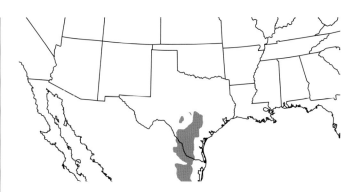

Audubon's Oriole *Icterus graduacauda*

L 10" WS 12" ♂ = ♀ AUOR *WL

This widespread Mexican resident extends its range northward into South Texas, where it is sedentary and uncommon. Inhabits woodlands and thickets, including mesquite brushland and oak groves. Forages inconspicuously within the protection of thick vegetation. Easily overlooked except for the loud, slurred, whistled song. Diet includes arthropods, berries, and nectar. Nest is a hanging pouch of woven plant fibers lined with finer materials and set on an outer branch of a tree or a clump of Spanish Moss. Lays three to five off-white or pale blue eggs marked with darker colors at the larger end. The species population in Texas appears to be creeping northward. This is our oriole with a black cowl contrasting the bright back and breast.

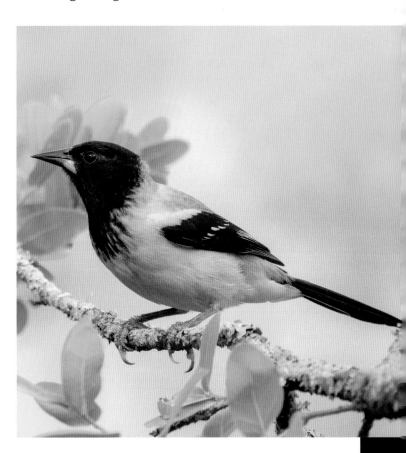

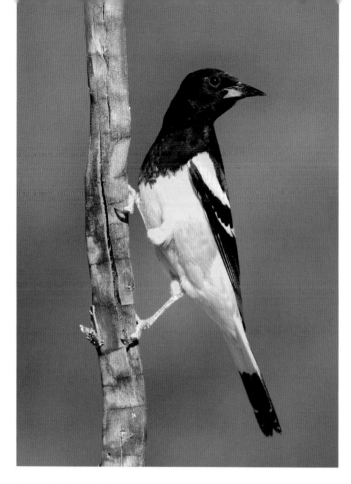

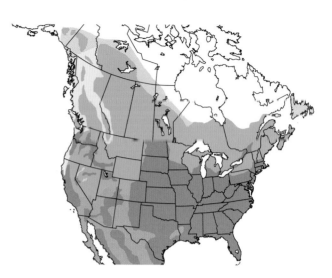

Red-winged Blackbird *Agelaius phoeniceus*

L 9" WS 13" ♂ ≠ ♀ RWBL

One of North America's best known and most abundant species, breeding across the entire Continent except in the tundra of the Far North, and with additional breeding populations extending south to Costa Rica. The more northern summering populations winter southward through the Lower 48. Summers in marshland, wooded swamps, wet roadside ditches, and hayfields. Winters in large flocks in open agricultural country. In spring, the male displays and sings from an open perch within his territory, while the female tends to hide in marsh grass. Summer diet is a mix of arthropods and plant matter. Winter diet is mainly grass seeds and waste grain, with some berries. Nest is a bulky cup made of coarse plant materials lined with finer grasses and lashed to stems of vertical cattails or other stout reeds. Lay three or four pale blue-green eggs marked with darker colors.

Scott's Oriole *Icterus parisorum*

L 9" WS 13" ♂ ≠ ♀ SCOR

Summers widely in the arid Interior Southwest (and Mexico). Winters mainly in Mexico, with a few birds wintering in Southern California and southern Arizona. Summers in arid woodlands of yucca, agave, Joshua Tree, palm, oak, sycamore, cottonwood, juniper, and pinyon pine. Avoids true desert. Solitary and retiring, but the male gives an attractive song that is the best means of finding the species. Diet is a mix of arthropods, fruit, and nectar. The nest, often situated in a Joshua Tree, yucca, or palm, is a hanging pouch crafted of a variety of plant fibers and lined with fine plant materials and animal hair. Lays two to four pale blue eggs marked with darker colors. Population appears stable.

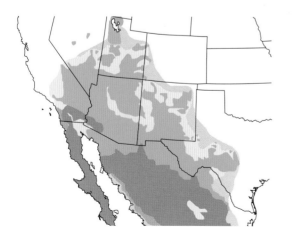

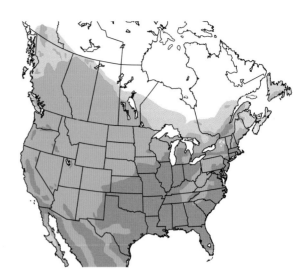

Brown-headed Cowbird *Molothrus ater*
L 8" WS 12" ♂ ≠ ♀ BHCO

This nest parasite summers across North America except for the Far North. Many of the northern breeders winter southward into the Lower 48 and northern Mexico. The species also breeds throughout all but southernmost Mexico. Apparently this species was a commensal of the great Bison herds that roamed across the North American landscape before they were decimated by European settlers. Today, the cowbirds associate with cattle, preferring agricultural lands, pastures, fields, and suburban lawns. Diet is a mixed of seeds and arthropods. This cowbird lays its eggs in the nests of other songbirds. The eggs are off-white with darker spotting on the larger end. The female may lay as many as 40 eggs in a breeding season. Cowbird parasitism of Kirtland's Warbler nests nearly led to the extinction of that range-restricted species. Now the cowbird is in decline.

Tricolored Blackbird *Agelaius tricolor*
L 9" WS 14" ♂ ≠ ♀ TRBL *EN

This Pacific Coast specialty, which is mainly found in California's interior valleys, ranges from Washington south to northern Baja. Nests in large colonies in marshes of cattail or Tule (a species of marsh grass—a giant sedge named *Schoenoplectus acutus*). Forages year-round in flocks in pastures, farm fields, and other open habitats. A sociable species, foraging in flocks of its own kind or mixed with other blackbirds. Summer diet is mainly arthropods. Winter diet is primarily grass seeds and waste grain. Nest is a bulky cup made of coarse plant materials lined with finer grasses and lashed to stems of vertical cattails, Tule, or other stout reeds. Lays three to five pale blue-green eggs marked with darker colors at the larger end. In fall and winter, northernmost nesters shift southward and many interior breeders move to the coast. Population has declined by half in two decades.

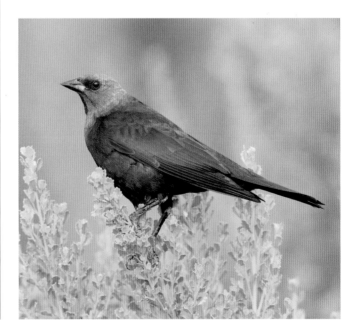

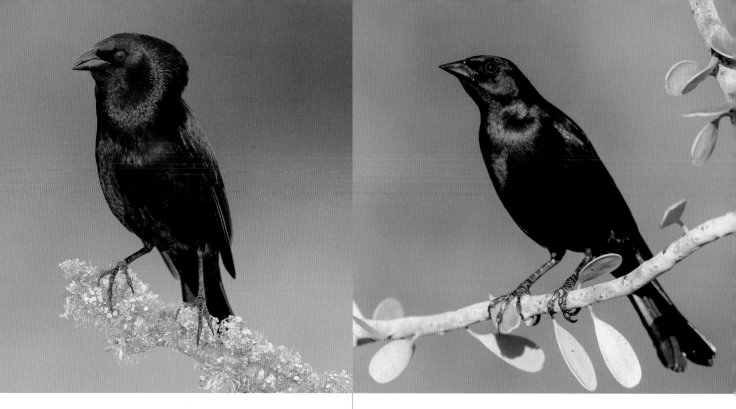

Bronzed Cowbird *Molothrus aeneus*

L 9" WS 14" ♂ ≠ ♀ BROC

This larger Mexican and Central American cowbird ranges north to the Arid Southwest and coastally in parts of the Deep South. Birds summer widely in the Southwest Borderlands, but most of these birds winter in Mexico. Prefers farmland, brushlands, feedlots, and openings in woodlands. Males and females wander widely in the summer in search of nests in which to lay eggs. Diet is a mix of arthropods, berries, and seeds. Does not make a nest, instead the female lays her pale blue-green eggs in the nests of other songbirds, especially orioles. Expanding into Gulf states. Adult male shows the very strange expanded neck feathering that gives it a weird cobra-like appearance. The population in the US appears stable.

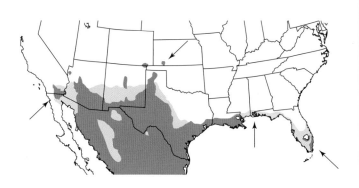

Shiny Cowbird *Molothrus bonariensis*

L 8" WS 12" ♂ ≠ ♀ SHCO

A South American species that first colonized the West Indies and then showed up in South Florida (in 1985). Today, it is expanding northward up both of Florida's coasts. In Florida, the species seems to have a preference for open habitats near the coast. This nest parasite is often found in association with that other nest parasite, the Brown-headed Cowbird. Diet is apparently a mix of seeds and arthropods. Forages mainly on open ground. The female lays its heavily spotted white eggs in the nests of other songbirds. Birds seem to be on the move in the spring.

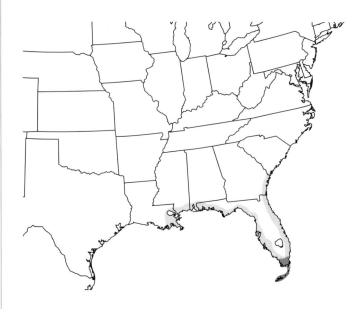

Rusty Blackbird *Euphagus carolinus*
L 9" WS 14" ♂ ≠ ♀ RUBL *VU

This denizen of wooded swamps summers in Alaska, Canada, and northern New England. It appears to be declining in the southern portions of its breeding range. Winters across the southern two-thirds of the East and the Midwest. Breeds in muskeg and boreal spruce bogs. Winters in wooded swamps as well as harvested agricultural fields. Travels in flocks during the nonbreeding season. Will join flocks of other foraging blackbirds but prefers to stay isolated. Diet is mainly invertebrates during the summer and seeds and waste grain during the winter. The nest is a bulky cup of twigs and grass lined with dried aquatic vegetation and fine grass, hidden in a conifer low over the water. Lays four or five pale blue-green eggs marked with darker colors.

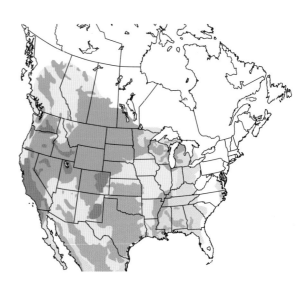

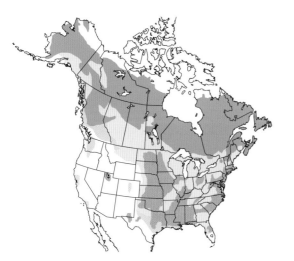

Brewer's Blackbird *Euphagus cyanocephalus*
L 9" WS 16" ♂ ≠ ♀ BRBL

This commonplace blackbird of the West summers from the Great Lakes to the West Coast and northward into western Canada. Winters across the southern United States and into Mexico. Summers in open country of the West—fields, farmland, stockyards, and prairies. Winters in a wide range of open habitats, including urban and suburban environs. Travels in small flocks and will associate with other blackbirds. Summer diet is a mix of arthropods and berries. Winter diet is mainly seeds and waste grain. Nest is a bulky cup of twigs and other plant matter lined with finer materials and set in a tree, bush, or protected niche in a cliffside. Lays four to six variably gray eggs spotted with brown.

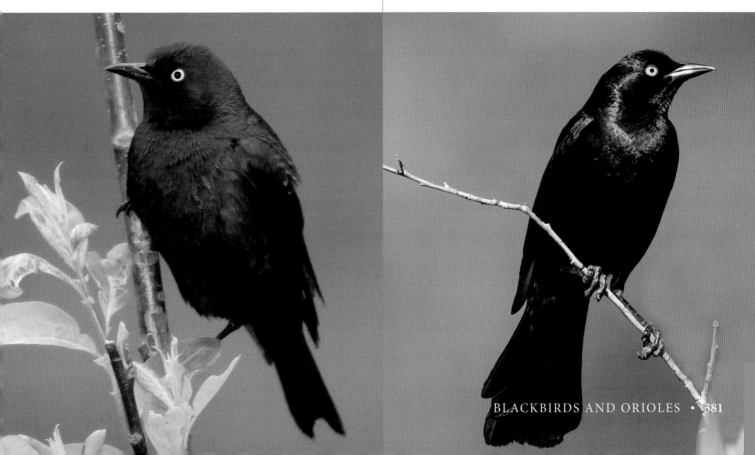

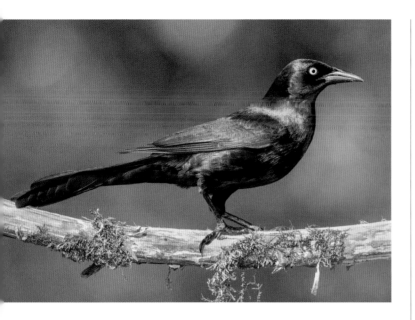

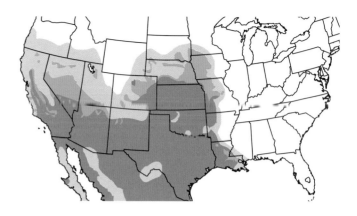

Great-tailed Grackle *Quiscalus mexicanus*

L 18" WS 23" ♂ ≠ ♀ GTGR

This common western grackle with the waving tail ranges from northern South America to southern Minnesota and California. Range overlaps with that of the Boat-tailed Grackle in coastal Louisiana and Texas. Inhabits farmland, irrigated fields, marshes, suburban and urban habitats, and other open lands; found near water in arid lands. The adult males are noisy and demonstrative. The species forms large roosting flocks in the nonbreeding season. Diet includes invertebrates, small vertebrates, various arthropods, eggs, seeds, and waste grain. Nest is a bulky cup of twigs and other plant matter lined with finer material and with some mud set in the base. Lays three or four pale blue-green eggs marked and scrawled with darker colors. Northern breeders shift southward in winter.

Common Grackle *Quiscalus quiscula*

L 13" WS 17" ♂ ≈ ♀ COGR *NT

This familiar blackbird summers across the eastern three-quarters of North America, ranging northward to the southern end of James Bay and southernmost Northwest Territories. Winters southward and eastward to the Deep South and Mid-Atlantic. Summers across a range of open and semi-open habitats, including marshes, parks, suburban yards, and pastures. Winters in agricultural landscapes and other open country. Travels in large flocks in winter. Omnivorous, taking invertebrates, small vertebrates, eggs, and a variety of plant matter. Mainly takes seeds, waste grain, and some fruit in winter. Tends to nest in small groups, usually in densely vegetated shrubs or conifers. Nest is a bulky cup of plant matter of various sorts cemented with some mud and lined with fine grass, well hidden in the vegetation. Lays four or five pale blue eggs blotched with brown. Substantial decline over the last 40 years.

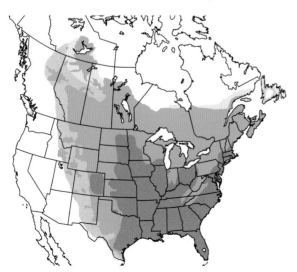

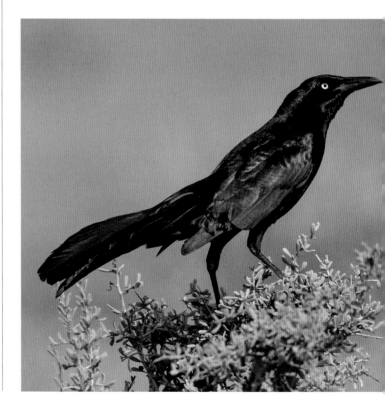

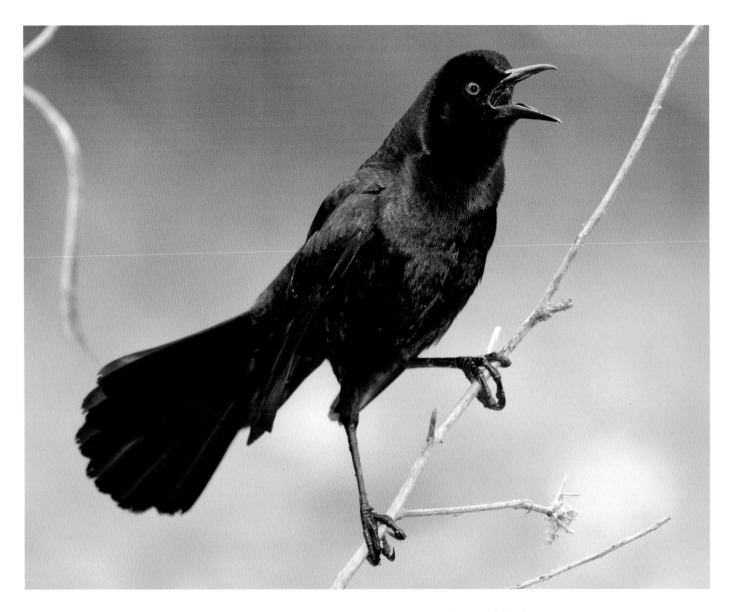

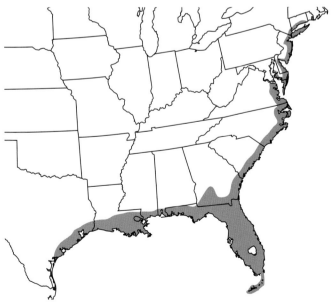

Boat-tailed Grackle *Quiscalus major*
L 17" WS 23" ♂ ≠ ♀ BTGR

Along the Atlantic and Gulf Coasts, this big grackle is a year-round resident of coastal saltmarsh from southern New England to Texas, though in Florida it is more widespread, also using the interior. Always in association with water, even in Florida. Travels in small flocks or family parties. In spring, the males carry out vocal posturing displays. Diet includes aquatic invertebrates, small vertebrates, various arthropods, eggs, and seeds. Nest is a bulky cup of twigs and other plant matter, with some mud set in the base. The nest is situated in tall marsh vegetation. Lays two to four pale blue-green eggs marked with darker colors. A common species within its limited habitat. Its range has been slowly expanding northward up the East Coast for decades. Population appears stable, in spite of the very small range of the species, confined to the southeastern United States.

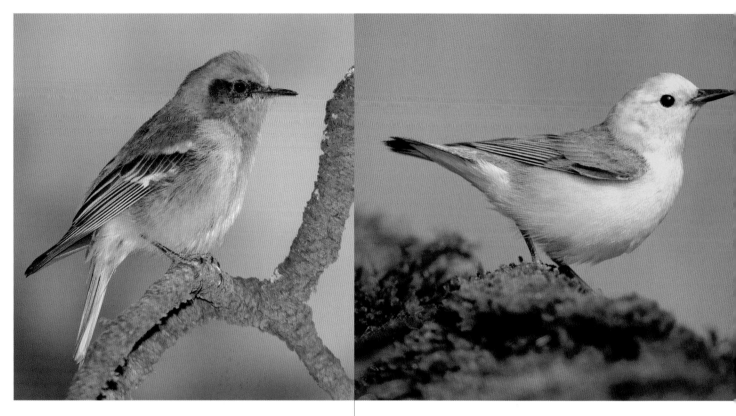

Olive Warbler *Peucedramus taeniatus*

L 5" WS 9" ♂ ≠ ♀ OLWA

This warbler look-alike, now placed in its own family (the Peucedramidae), summers in mountains of the Southwest and winters in the mountains of the Southwest as well as Mexico. The species ranges in the mountains south to Nicaragua. A resident breeder of high-elevation forests of pine, fir, and other conifers. Some birds winter at lower elevations in oak woodlands. Forages high in tall conifers, gleaning arthropods from needles and twigs. During the nonbreeding season, will join flocks of other small song-birds. Diet presumably is dominated by arthropods. Nest is typically placed high in a tall pine out on a branch far from the trunk. Nest is an open cup made of moss, lichen, and other plant material that is lined with finer and softer components. Lays three or four pale blue eggs with olive and brown marks at the larger end.

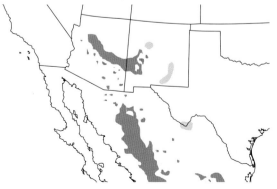

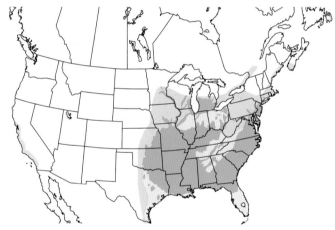

Prothonotary Warbler *Protonotaria citrea*

L 6" WS 9" ♂ ≈ ♀ PROW *WL

Summers through the Southeast and Mississippi drainage, populations edging northward up river valleys. Winters in northern South America, the Caribbean, and Central America. Informally known as the Golden Swamp Warbler, this species nests over water of wooded swamps and inundated forests along slow streams and rivers. The loud song of the male rings out in swamplands in spring. Diet is arthropods and small invertebrates. Nest is set in a hole in a standing tree over water. Cavity is filled with assorted plant material and lined with finer materials. Lays four to six cream-colored or pinkish eggs marked with brown spotting.

Tennessee Warbler *Leiothlypis peregrina*
L 5" WS 8" ♂ ≠ ♀ TEWA

Summers in boreal conifer forests across Canada and in the northern Borderlands from Montana to Maine. Winters in Central America and northern South America. Breeds in open spruce-fir forest. In spring, male sings loudly and persistently. Diet is mainly arthropods, along with nectar and berries. This is one of the species that favors spruce bud-worms; local breeding populations rise and fall in concert with spruce budworm outbreaks. The cup nest is made of grass and lined with a mix of finer materials. Nest is set on the mossy ground hidden by a tussock. Lays five or six white eggs marked with darker colors.

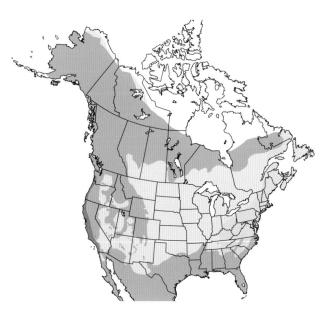

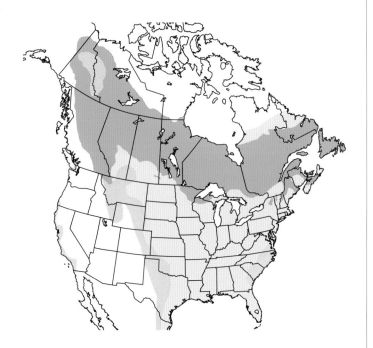

Orange-crowned Warbler *Leiothlypis celata*
L 5" WS 7" ♂ ≈ ♀ OCWA

This drab wood-warbler summers across boreal Canada to Alaska and southward in the West to California and New Mexico. Winters in the Deep South, Southwest Borderlands, and Mexico. Much more common in the West than in the East. Breeds in deciduous shrubs in clearings in conifer or mixed forest. Winters in tangles and brushy openings in woodlands. Summer diet is mainly arthropods. Winter diet a mix of arthropods, berries, and nectar. Nest is situated on the ground or in a low shrub, obscured by overhanging vegetation. Nest is a cup of leaves, twigs, bark, and grass lined by fine grass and animal hair. Lays four or five white or creamy eggs speckled with darker colors at the larger end. This common species is doing well.

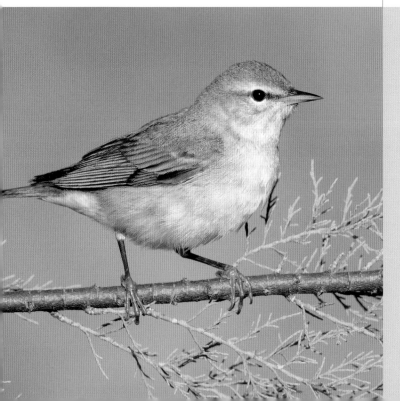

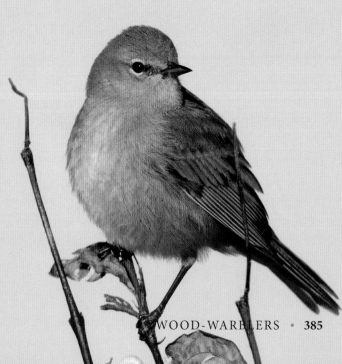

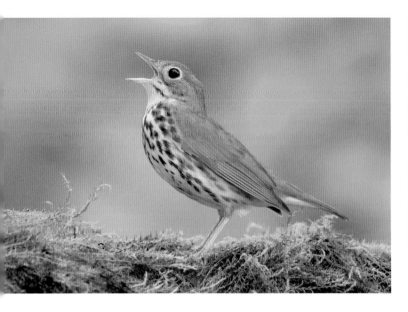

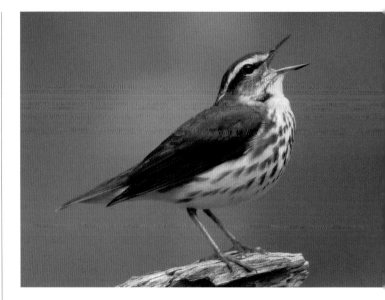

Ovenbird *Seiurus aurocapilla*
L 6" WS 10" ♂ = ♀ OVEN

This thrush-like ground warbler summers across much of North America, from the southern Yukon to Newfoundland and Alabama. Winters from Florida to Panama, the Caribbean, and northern South America. Summers in deciduous and mixed woods. Winters in thickets and tangles. Spends much time walking the leafy floor of forest interior. In spring, the male sings loudly from the lower or middle levels of the forest. Summer diet is arthropods and other invertebrates. The domed nest is crafted of dead leaves and other plant parts, lined with animal hair, and hidden on the forest floor. Lays four or five white eggs marked with brown spotting. A widespread and common species in decline.

Louisiana Waterthrush *Parkesia motacilla*
L 6" WS 10" ♂ = ♀ LOWA

A ground-feeding warbler that summers in the East and Midwest. Winters in the Caribbean and from Mexico southward to northern South America. Summers along clear-water streams in ravines of deciduous forests and in forested swamps in the Deep South. Forages along edges of fresh water within woodland interiors, all the while bobbing the back end of its body. The loud sweetly slurred song of the male is the best way of locating the species on breeding territory in spring. Diet is invertebrates and the occasional small vertebrate. Nest is a cup made of various plant materials and hidden within roots of a treefall or a similar place near the ground and often near water. Lays three to six creamy whitish eggs marked with darker colors. Geographic range of this species is expanding in the Northeast. Species population is showing slight decline. The males arrive on their breeding territories very early in spring.

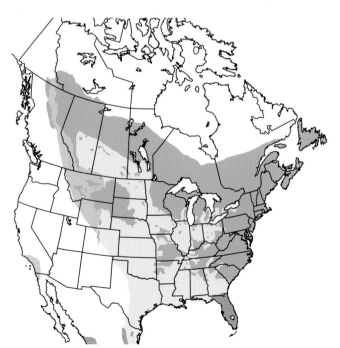

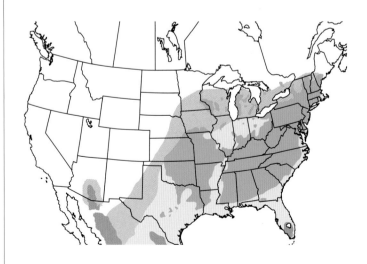

Northern Waterthrush *Parkesia noveboracensis*

L 6" WS 10" ♂ = ♀ NOWA

This close relative of the Louisiana Waterthrush summers in the Appalachians, New England, Canada, the northern Rockies, and Alaska. Winters in parts of the Deep South, Mexico, Central America, and northern South America. Summers in northern conifer or mixed forest near wooded swamps, bogs, or slow streams. In migration, most common in shaded woodlands near water. Teeters the back of its body up and down while foraging on the ground near water. Diet is invertebrates and the occasional small fish. Nest is a cup made of various plant materials and hidden within roots of a treefall or a similar place near the ground and often near water. Lays four or five whitish eggs marked with darker colors. Note the loud unmusical and chattering song.

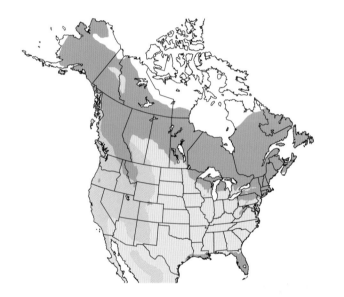

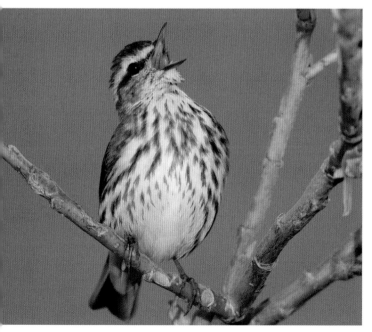

Black-and-white Warbler *Mniotilta varia*

L 5" WS 8" ♂ ≠ ♀ BAWW

Summers widely across the eastern two-thirds of North America, from the Northwest Territories southeastward to Georgia and Texas. Winters in the Deep South, Mexico, the Caribbean, Central America, and northern South America. Summers in mature deciduous and mixed forests. Forages creeper-like, gleaning bark insects from the trunks and larger branches of trees. The nest is a cup of leaves and other plant parts lined with fine grass or animal hair and situated on or near the ground adjacent to a stump or other object that offers protection or hides the nest. Lays four to six off-white eggs marked with brown spots at the larger end. This is one of the early-arriving spring migrant warblers. Species population appears stable.

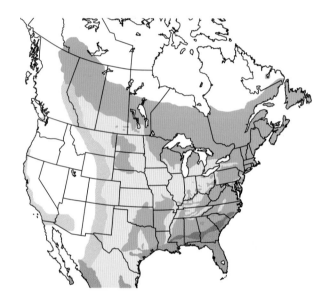

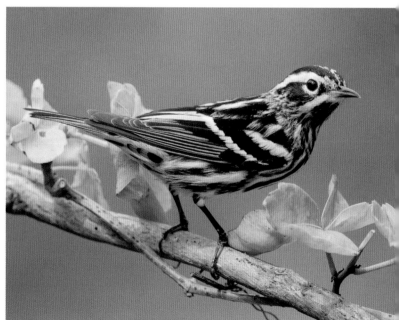

Worm-eating Warbler *Helmitheros vermivorum*
L 5" WS 9" ♂ = ♀ WEWA

This plain but comely warbler with the dry trilling vocalization summers in the East, wintering in the Yucatán, Central America, and the Caribbean. Breeds in deciduous forest interior, preferring well-vegetated and dry rocky and oak-clad slopes. Summer diet is arthropods. Forages in summer by probing curled and dried leaves in the understory. Nest, hidden in leaves on the forest floor, is a cup of dead leaf skeletons lined with fungus filaments, moss, other plant parts, and animal hair. Lays four or five white eggs with brown markings. This species suffers from fragmentation of favored forest tracts.

Swainson's Warbler *Limnothlypis swainsonii*
L 6" WS 9" ♂ = ♀ SWWA

This washed-out warbler with the big voice summers in the Southeast and Deep South. Winters in the Caribbean and the Yucatán. Summers in cane thickets in bottomland forests as well as in upland rhododendron thickets of the southern Appalachians. Shy and reclusive on the breeding ground, but the male is a noted loud songster. Diet is arthropods. The nest is a large cup of all manner of plant materials lined with finer plant parts. Nest is situated on the ground or in a shrub, usually near or over water. Lays two to five white eggs, sometimes lightly marked. Populations are in decline in the Mid-Atlantic and in East Texas. Spring song is reminiscent of the song of the Louisiana Waterthrush, but briefer. This night migrant crosses the Gulf of Mexico in spring, arriving early in spring to southern parts of its range.

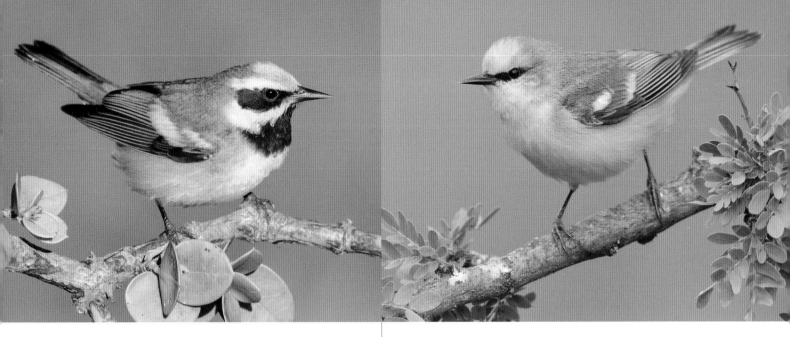

Golden-winged Warbler *Vermivora chrysoptera*
L 5" WS 8" ♂ ≠ ♀ GWWA *NT *WL

This gorgeous but uncommon wood-warbler, much
sought-after by birders, summers in the Appalachians and
northern Borderlands from Vermont west to Manitoba. The
summer breeding range of this species has been withdraw-
ing northwestward over the last several decades. Winters
from southern Mexico to northern South America. Summers
in regenerating old fields, recovering clear-felled areas, and
wooded edges of boggy north country. Hybridizes with the
Blue-winged Warbler in places where the two share breed-
ing habitat. Summer diet is arthropods, gleaned from tree
branches at woodland edge. The nest, hidden in a tussock
on the ground, is a cup made of leaves, bark strips, and
grass lined with fine plant material. Lays four to seven
off-white or pink eggs marked with streaks and blotches of
darker colors. This Watch List species is Near Threatened.

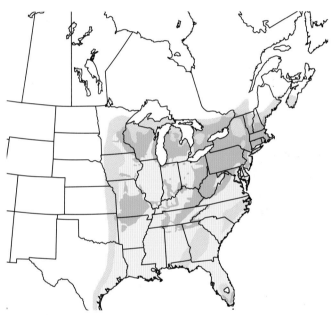

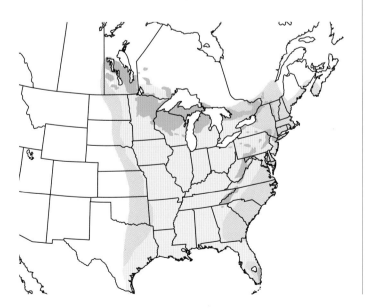

Blue-winged Warbler *Vermivora cyanoptera*
L 5" WS 8" ♂ ≈ ♀ BWWA

This close relative of the Golden-winged Warbler summers
patchily in the Midwest and Northeast. Winters in southern
Mexico and Central America. Breeds in brushy pastures,
regenerating openings, and streamside thickets, generally
favoring later successional open woodland than Golden-
winged Warbler. Hybridizes with the Golden-winged Warbler,
producing the named hybrids—Brewster's and Lawrence's
Warblers—as well as many intermediate plumages. Summer
diet is arthropods. The bulky cup nest of vines and grass
lined with fine plant fibers and animal hair is placed in
grass or a blackberry thicket on or near the ground and well
hidden from view. Lays four to seven white eggs marked
with fine dark spots on the larger end.

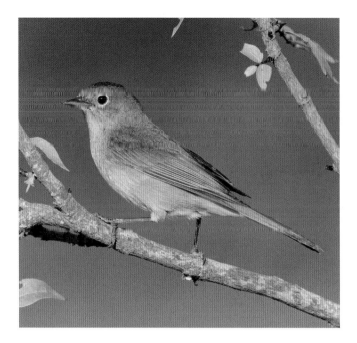

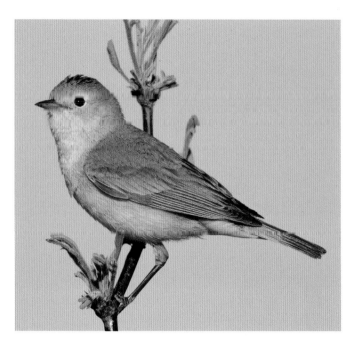

Colima Warbler *Leiothlypis crissalis*

L 6" WS 8" ♂ = ♀ COLW *WL

This rare species of northern Mexico summers in the United States in the Chisos Mountains of Big Bend and sparingly in the Davis Mountains of West Texas (where it has hybridized with Virginia's Warbler). Winters in southern Mexico. Breeds above 6,000 feet elevation in oak woodlands of canyons and slopes. Birders seeking this species north of the Border must make a substantial hike in Big Bend National Park to access the breeding habitat. Diet is mainly arthropods. Nest is a loose cup of grass and bark strips lined with animal hair and hidden under vegetation in a crevice on the ground. Lays four cream-colored eggs with a circle of brown marks on the larger end. US population fewer than 100. This tiny US population rises and falls depending on local climate.

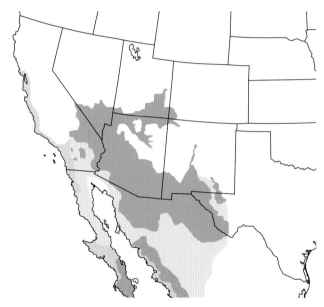

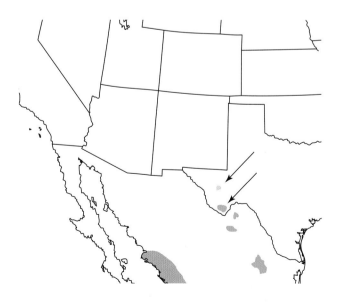

Lucy's Warbler *Leiothlypis luciae*

L 4" WS 7" ♂ = ♀ LUWA

Lucy's Warbler, one of the plainest and drabbest of the wood-warblers, summers in hot desert lowlands of the Arid Southwest and northern Mexico. Winters in western Mexico. An early migrant, both in spring and fall. Breeds in mesquite and cottonwoods of desert washes and in sycamores and live oaks of the lower parts of arid canyons. An active forager in desert shrubbery. Diet is mainly arthropods. Nest is placed in a hollow or an old woodpecker hole. The compact cup, lined with animal hair and feathers, is set on a mass of assembled plant material within the cavity. Lays four or five white or cream-colored eggs with red-brown markings on the larger end. The species is in decline from habitat loss.

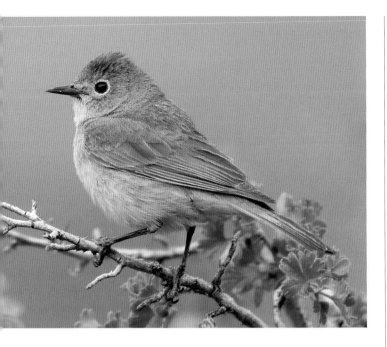

Virginia's Warbler *Leiothlypis virginiae*

L 5" WS 8" ♂ ≠ ♀ VIWA *WL

Summers in arid mountain country of the Interior West, from southern Idaho and South Dakota to Arizona and West Texas. Winters in central and southern Mexico. Breeds in brushlands in canyons and slopes of dry mountain country. Best located by song. Diet is arthropods. Nest is hidden under a grass tussock on the ground. Nest is a rough cup of coarse grass, bark strips, and other plant material with a lining of moss and animal hair. Lays three to five white or cream-colored eggs with red-brown speckling. Watch Listed.

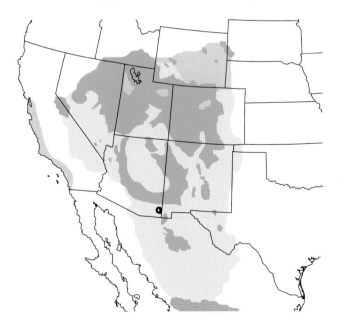

Nashville Warbler *Leiothlypis ruficapilla*

L 5" WS 8" ♂ ≠ ♀ NAWA

Two summering populations: one in the Appalachians, New England, and boreal eastern and central Canada; the other in the Pacific Northwest and mountains of California. The species winters in Mexico and Guatemala. Summers in open conifer or mixed woodlands, spruce bogs, and mountain thickets. Gleans arthropods from the outer vegetation of conifers and deciduous trees and shrubs in clearings. Diet is arthropods. The cup nest is placed on the ground, hidden by shrubbery. Nest is constructed of coarse grass, ferns, and bark strips; it is rimmed with moss. The nest is lined with finer materials. Lays four or five white eggs with red-brown markings on the larger end. Population stable.

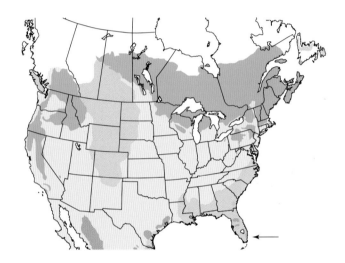

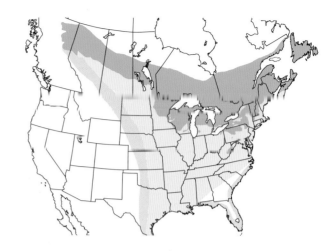

Mourning Warbler *Geothlypis philadelphia*
L 5" WS 8" ♂ ≠ ♀ MOWA

This shy and handsome warbler summers in the Appalachians, New England, and boreal Canada from Newfoundland to northeastern British Columbia. Winters from Honduras to northern South America. Summers in northern thickets and tangles, especially regrowth from a burn or a logging clear cut. Very elusive, spending most time in the cover of a dense thicket. Summer diet is mainly or exclusively arthropods. In winter, takes some plant material. Nest is hidden on ground under vegetation or low in a thick shrub. Nest is a bulky cup of weeds and coarse grass lined with finer grass and animal hair. Lays three or four off-white eggs blotched with brown. This species has a lovely song that has been used repeatedly in TV commercials. One finds this bird by that ringing song. A late-spring migrant.

Connecticut Warbler *Oporornis agilis*
L 6" WS 9" ♂ ≈ ♀ COWA *WL

This big and vocal, but very elusive, warbler summers across boreal Canada, from Quebec to northeastern British Columbia, with sparse breeding populations ranging southward into northern Minnesota, northern Wisconsin, and the upper peninsula of Michigan. A thicket-loving warbler that summers in spruce-tamarack bogs, Jack Pine barrens, and also poplar and aspen stands on dry ridges. Difficult to see because the species spends most time on or near the ground in thick vegetation. Diet mainly arthropods, also takes some berries. Winters in South America where it is a rarely-seen phantom. Nest is a cup made of leaves, grass, and bark strips lined with finer grass and hidden on the ground in sphagnum under the cover of a tussock or thick shrub. Lays four or five off-white eggs marked variably with darker colors. Males on territory give a loud and distinctive song. Migrates farther west in spring and farther east in fall, though migrants funnel through Florida in both seasons.

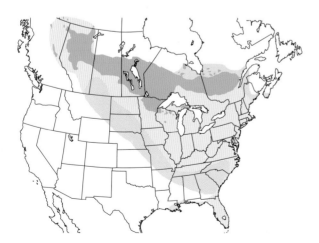

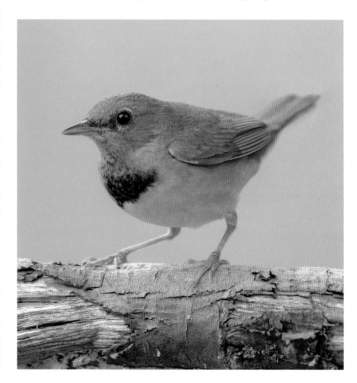

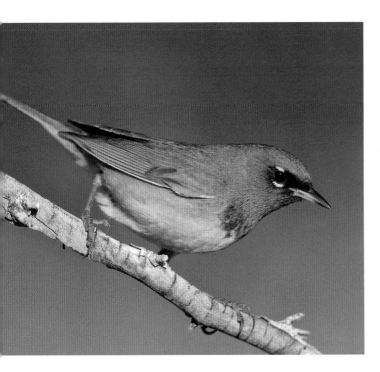

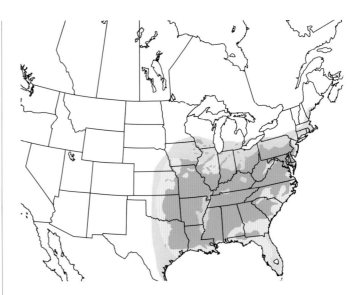

Kentucky Warbler *Geothlypis formosa*
L 5" WS 9" ♂ ≈ ♀ KEWA *WL

This gorgeous ground-forager summers in the East and Midwest, from northern New Jersey to Iowa and south to Louisiana. Winters in the Caribbean, southern Mexico, Central America, and northern South America. Summers in undergrowth in the damp interior of deciduous forest where the male belts out its rich, ringing song from exposed perches. Forages in leaf litter under forest shrubbery. Diet is mainly arthropods with some berries. The nest, placed on the ground or near to it, is a bulky cup of leaves and weeds lined with rootlets and animal hair. Lays four or five cream-white eggs marked with brown. The species appears to be in decline.

MacGillivray's Warbler *Geothlypis tolmiei*
L 5" WS 8" ♂ ≠ ♀ MGWA

This western counterpart to the Mourning Warbler summers widely in the Mountain West. Winters from Mexico to western Panama. Breeds in brushy thickets in clearings near water, usually in association with conifer forest. Skulks within the protection of thickets. Best found by the loud song of the male in spring. Diet is mainly arthropods. The cup nest, loosely constructed of rough plant material and lined with finer matter, is well hidden low in a shrub or damp weedy thicket. Lays three to five cream-white eggs marked variously with darker colors. A commonly seen autumn migrant in the West. Population appears stable.

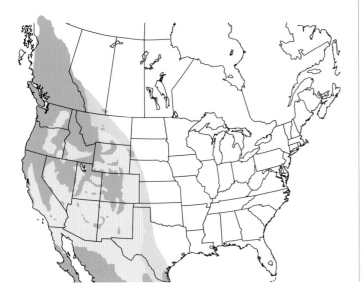

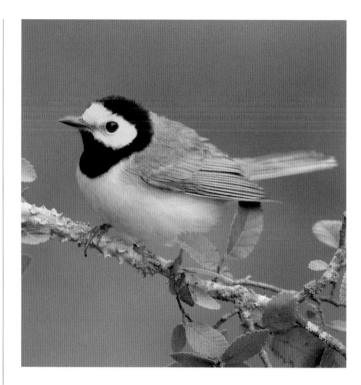

Common Yellowthroat *Geothlypis trichas*
L 5" WS 7" ♂ ≠ ♀ COYE

The Common Yellowthroat, our most commonplace wood-warbler, summers across North America and winters in the Deep South, Southwest Borderlands, Caribbean, Mexico, and Central America. Breeds in marshes, swamps, wet thickets, and brushy forest edges. Male sings its distinctive song from a low perch in spring. The bird's call note is heard frequently from wetland thickets. Spends most of its time skulking in dense grass, reeds, or thickets. Diet is mainly arthropods with a bit of plant matter. Nest is sited typically in the protection of a low shrub or thick ferns. The loosely constructed nest is made of rough plant material lined with rootlets and animal hair. Lays three to five whitish eggs marked with brown. Population stable.

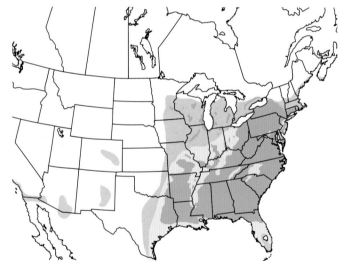

Hooded Warbler *Setophaga citrina*
L 5" WS 7" ♂ ≠ ♀ HOWA

This brightly colored warbler of the forest understory summers in the East and winters in Mexico, Central America, and the Caribbean. Breeds in the interior of mature deciduous forest. In spring, the male sings loudly from a sapling branch in the forest interior. Diet is arthropods. Nest is a cup of leaves and other coarse plant matter lined with fine plant and animal matter, including spider silk and animal hair. Nest is situated low in a shrub. Lays four creamy-white eggs with brown spots. This is mainly a trans-Gulf migrant. Population appears stable, though the species is sensitive to forest fragmentation on the breeding ground.

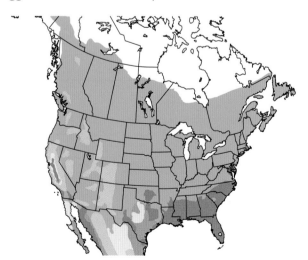

Kirtland's Warbler *Setophaga kirtlandii*
L 6" WS 9" ♂ ≈ ♀ KIWA *NT *WL

This large warbler is a Jack Pine-specialist that summers mainly in the upper sector of the lower peninsula of Michigan, with some minor but growing subpopulations in Wisconsin and Ontario. Winters in the Bahamas. Breeds in young stands of monoculture Jack Pine and Red Pine that are planted expressly by the state and federal governments to serve as nesting habitat. Thanks to substantial intervention over several decades, this species has been brought back from the brink of extinction. The species is vocal, confiding, and easy to observe in its minimalist breeding habitat. Diet is a mix of arthropods and berries. Nest is a cup of grass and other coarse plant materials lined with finer materials and situated on the ground, hidden at the base of a Jack Pine. Lays three to six buff eggs marked with brown spotting on the larger end. There were fewer than 200 breeding males in its Michigan breeding redoubt in the early 1970s. By 2018 there were 2,300 breeding males.

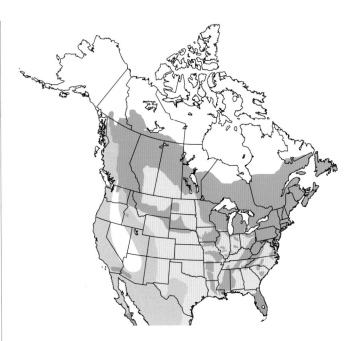

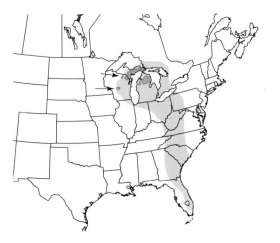

American Redstart *Setophaga ruticilla*
L 5" WS 8" ♂ ≠ ♀ AMRE

This frisky black-and-orange woodland-dweller summers widely, from Louisiana north to Newfoundland and west to the southern Yukon, but is absent from the Arid West. Winters in Florida, Mexico, the Caribbean, Central America, and northern South America. Breeds in young deciduous and mixed forest and edge; also uses streamside thickets. A very active forager in open woodlands, mixing gleaning with active hawking of prey. Diet is insects and a few berries. The nest, placed in the fork of a tree branch, is a cup of plant fibers decorated with lichens and lined with feathers. Lays two to five whitish eggs marked with darker colors.

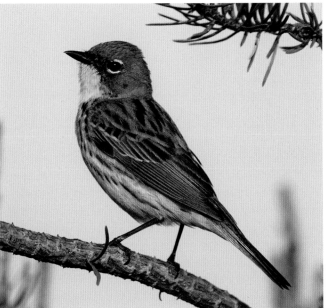

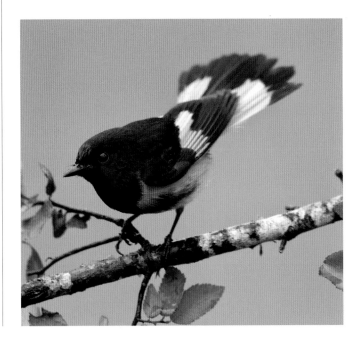

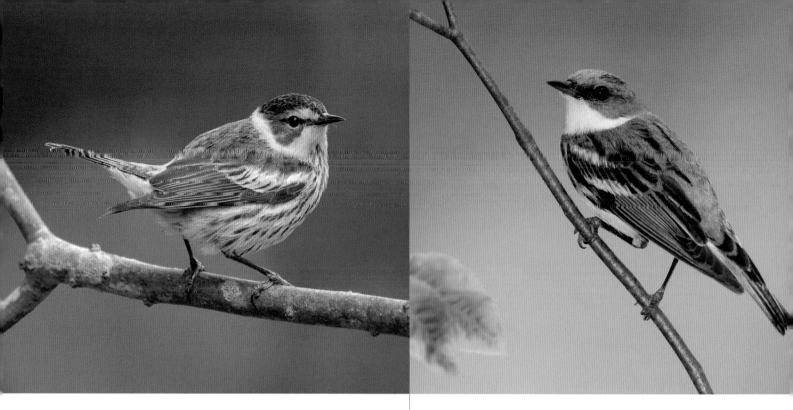

Cape May Warbler *Setophaga tigrina*
L 5" WS 8" ♂ ≠ ♀ CMWA *WL

This favorite of birders is found breeding across boreal Canada from Atlantic Canada west to Alberta and the Northwest Territories, and marginally into the northern US Borderlands. Winters in southeastern Florida, the Caribbean, the Yucatán, Central America, and northern South America. Breeds in taiga forests of spruce-fir. This species is a spruce budworm specialist whose population cycles with that of the budworm in conifer forests of the North Woods. Diet is a mix of arthropods, fruit, sap, and nectar. Nest is a cup of rough plant matter lined with fine materials, such as feathers and fur, and set high on a branch of a tall conifer. Lays six or seven whitish eggs with red-brown speckling.

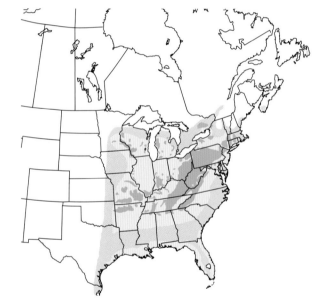

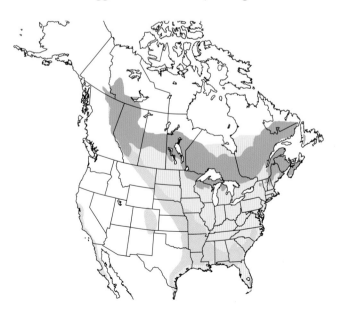

Cerulean Warbler *Setophaga cerulea*
L 5" WS 8" ♂ ≠ ♀ CERW *VU *WL

This much sought-after blue-and-white warbler summers mainly in the Upper Mississippi drainage, the lower Great Lakes, the Ozarks, and Appalachia. Winters in the mountains of northwestern South America. Breeds in the canopy of mature deciduous forest—along ridge crests with oaks and hickories as well as along stream bottoms. On territory, birds spend most of the time foraging high off the ground. Diet is arthropods. The nest, situated on a high tree branch, is a shallow cup of bark, grasses, weeds, and spider silk lined with moss and animal hair. Lays three to five off-white eggs that are speckled brown. A species in decline.

Tropical Parula *Setophaga pitiayumi*
L 5" WS 6" ♂ ≈ ♀ TRPA

This diminutive warbler, very similar to the Northern Parula, summers in southwestern Texas and is a resident in the Lower Rio Grande Valley. The species ranges widely in the Tropics—from northern Mexico to Uruguay. In Texas, the species inhabits Texas Live Oaks, especially those festooned with Spanish Moss, in river valleys. Forages actively in the outer shell of vegetation of oak trees. Diet is arthropods. Nest is a cup of moss and roots set within a clump of Spanish Moss in the canopy of an oak tree. Lays three or four cream-colored eggs with red-brown speckling.

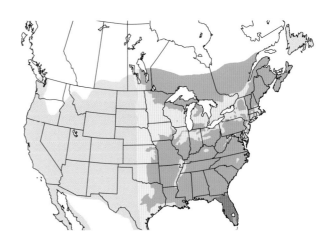

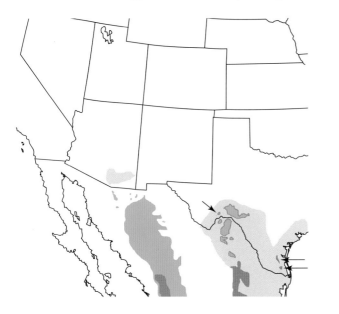

Northern Parula *Setophaga americana*
L 5" WS 7" ♂ ≈ ♀ NOPA

This tiny canopy-dweller summers in the East, the lower Mississippi, and Canadian Borderlands west to Manitoba. It winters in South Florida, southern Mexico, the Caribbean, and northernmost Central America. Summers in humid deciduous and mixed forests, especially where Spanish Moss or a species of old man's beard (*Usnea*) lichen hangs from the trees. Forages high in the woods, usually out in the twigs and leaves. Diet is mainly arthropods and a few berries. Nest is usually placed in the hollow created in a hanging bunch of moss or lichen out on a canopy tree branch. The nest is a small pouch of lichens and twigs lined with finer materials. Lays four or five whitish eggs marked with brown. This is an early migrant in spring, arriving in March on the East Coast. Population stable.

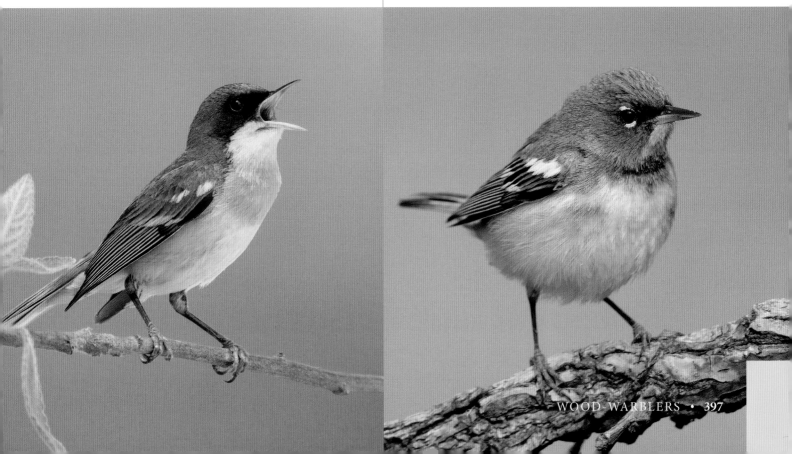

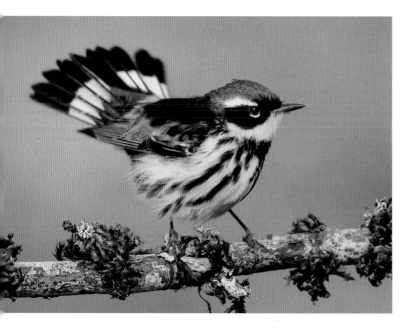

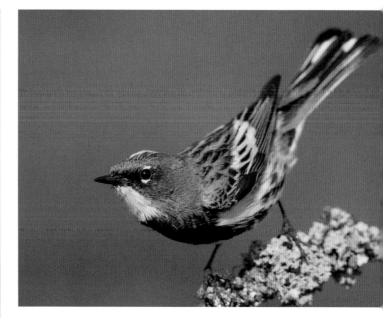

Magnolia Warbler *Setophaga magnolia*
L 5" WS 8" ♂ ≠ ♀ MAWA

Summers in the Appalachians, New England, and boreal Canada to the Northwest Territories. Winters in South Florida, the Caribbean, and Central America. Summers in young conifer forests and in dense understory of mature boreal forest. Forages in the lower stages of vegetation, making it easy to locate. Diet is arthropods, as well as some berries when its main staple is unavailable. Nest is a flimsy cup of coarse plant matter lined with fine black rootlets. Lays three to five white eggs marked with various darker colors. Population stable or increasing due to the species' use of second-growth forest.

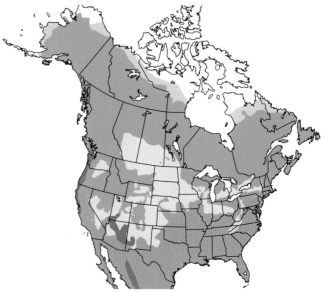

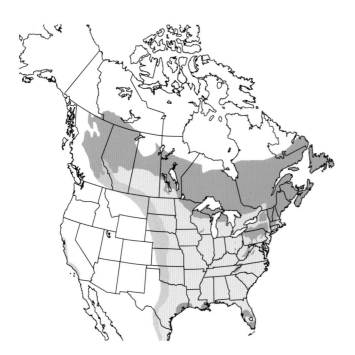

Yellow-rumped Warbler *Setophaga coronata*
L 6" WS 9" ♂ ≠ ♀ YRWA

Summers through the Appalachians, New England, and boreal Canada west to Alaska (the white-throated "Myrtle Warbler"). Also breeds in the Mountain West south into Mexico ("Audubon's Warbler"; see image above). Winters across the southern half of North America and into Mexico and Central America. Breeds in open conifer and mixed forests. Winters in most wooded habitats. In winter, travels in roving flocks, often mixing with other songbirds. Winter populations concentrate along the East and West Coasts. Diet is arthropods and berries. Nest, placed out on a conifer branch, is a cup of coarse plant matter lined with animal hair and feathers. Lays four or five cream-colored eggs marked with darker colors. Northerly birds subsist on berries in winter.

Bay-breasted Warbler *Setophaga castanea*

L 6" WS 9" ♂ ≠ ♀ BBWA

This bird, another of the spruce budworm specialists, summers in boreal Canada and the northern US Borderlands. Winters from Nicaragua to Colombia. Breeds in dense spruce-fir forests. In migration, stops over preferentially in oak woods. Populations cycle with the rising and falling abundance of spruce budworm. Diet is mainly arthropods and some berries. Nest is a large cup of coarse plant material lined with bark strips and animal hair and placed on a horizontal branch of a tree. Lays four or five whitish eggs marked with darker colors. Autumn female nearly identical to the autumn female Blackpoll Warbler

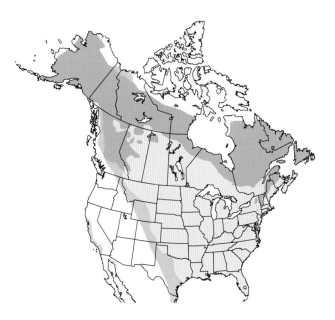

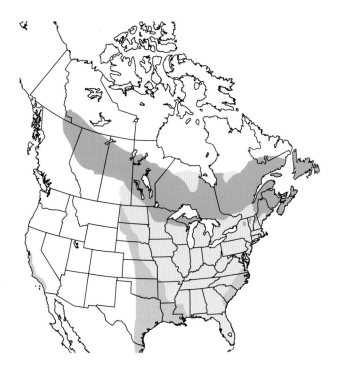

Blackpoll Warbler *Setophaga striata*

L 6" WS 9" ♂ ≠ ♀ BLPW

Summers in mountains of the Northeast and across boreal Canada from Atlantic Canada northwest to Alaska. Winters across northwestern South America. Breeds in dense spruce-fir stands on mountain summits or in expanses of boreal forest. Migrants stop over in forests, woodlands, and forest edge. In autumn, the adults depart from the coast of New England and the Mid-Atlantic and fly nonstop over the sea to South America. Diet is mainly arthropods and a few berries. The bulky cup nest, made of twigs, bark, other coarse plant material, is lined with finer matter. Nest is hidden on a horizontal branch of a young spruce. Lays four or five whitish eggs marked with darker colors. In spring, many migrants pass through Florida.

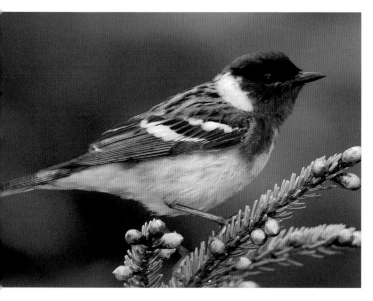

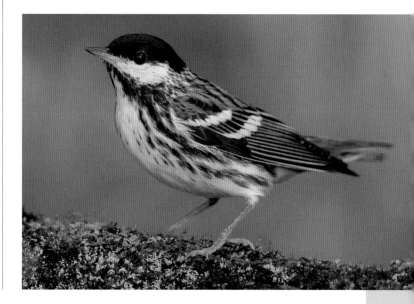

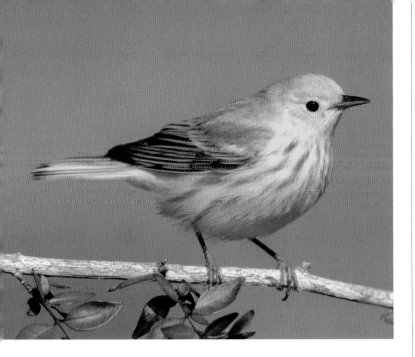

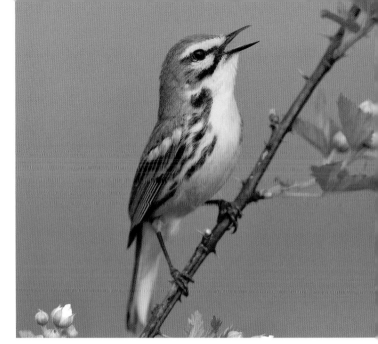

Yellow Warbler *Setophaga petechia*
L 5" WS 8" ♂ ≠ ♀ YEWA

This warbler with its oh-so-cheery song summers across most of North America except for the Deep South and parts of the Arid Southwest. Additional populations breed south of the Border and in the Caribbean. Winters in Florida, South Texas, the Bahamas, and Mexico south to Ecuador. Breeds in open shrubby country near willows and marshland. Favors streamside thickets in the Arid Southwest. The male is a favorite songster in spring, holding forth from atop a willow in bright sunshine. Summer diet is arthropods. Nest is a compact cup of coarse plant material lined with plant down or fur and set in a shrub at woodland edge. Lays four or five pale green eggs, variably marked with darker colors. The species is prospering. In many open wetland woods this is the dominant breeding wood-warbler, its song filling the landscape. The continent's large population of the species appears stable, in spite of nest parasitism by cowbirds.

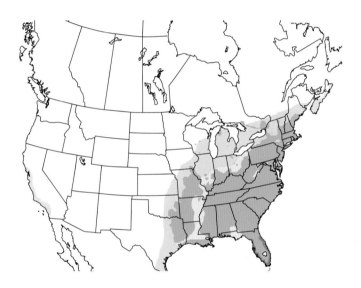

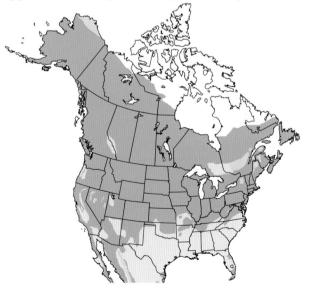

Prairie Warbler *Setophaga discolor*
L 5" WS 7" ♂ ≈ ♀ PRAW *WL

Nests in the East, Midwest, and Deep South, from eastern Texas to southern Maine. Winters in Florida, Louisiana, the Yucatán, and the Caribbean. In the Northeast, breeds in open pine-oak barrens, old brushy pastures, and roadside cedars. In the Southeast, prefers open scrub; in Florida, will breed in mangroves. In spring, the male sings his buzzy ascending song from a sunny perch atop of small tree in a clearing. Diet is mainly arthropods but also takes some berries and sap. The nest, set low in a small tree, is a cup of soft plant material lined with animal hair and feathers. Lays three to five whitish eggs marked with brown spotting at the larger end. The species appears to be in decline in parts of its breeding range. This warbler wags its tail. The name "Prairie Warbler" is a misnomer; perhaps better named the "Old Field Warbler." In the east its abundance depends on the presence of successional habitats that come and go.

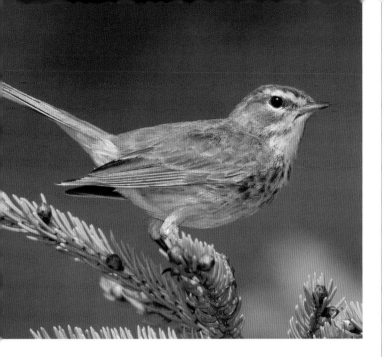

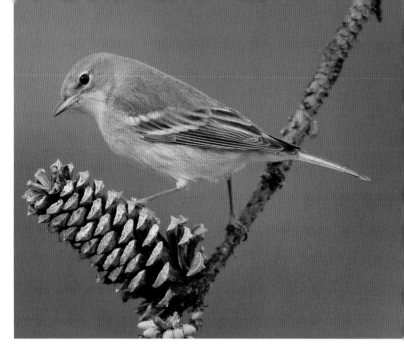

Palm Warbler *Setophaga palmarum*
L 6" WS 8" ♂ = ♀ PAWA

Summers in bogs of boreal Canada and the northern US Borderlands from Minnesota to Maine. Winters in the Deep South, coastal Yucatán, and the Caribbean. Breeds in spruce-tamarack bogs and muskeg. Winters in old fields, hedgerows, and other weedy openings. Nonbreeding birds spend a lot of time on or near the ground, their bobbing tails making them obvious. Diet is arthropods and berries, as well as other plant matter. Nest is a cup of dry grass stems lined with feathers and hidden at the base of a stunted conifer in a bog. Lays four or five cream-colored eggs marked with brown. This species is one of the very early wood-warbler arrivals in spring. Eastern-breeding birds are more yellow on the breast and belly.

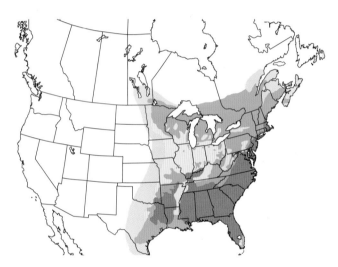

Pine Warbler *Setophaga pinus*
L 6" WS 9" ♂ = ♀ PIWA

This dull-plumaged pine-specialist summers throughout the East, from Texas and Minnesota to Atlantic Canada. Winters in the Deep South, where the migrants join permanent residents there. Breeding populations also inhabit the Bahamas and Hispaniola. Breeds in stands of pine of various species. In winter, may use a variety of open habitats. Diet is a mix of arthropods, seeds, and berries. The nest, set out on a branch high in a pine, is a deep cup of coarse plant material and spider silk lined with feathers. Lays three to five whitish eggs marked with brown speckling. Sometimes seen foraging on the ground with other wintering birds. Species population appears stable or on the increase. One of the very early migrant warblers. The soft sweet trill, delivered from high in the branches of a pine grove, is one of the early spring sounds that alerts birders to the coming wave of spring songbird migrants. One of the few wood-warblers to visit backyard feeding stations for suet and treats.

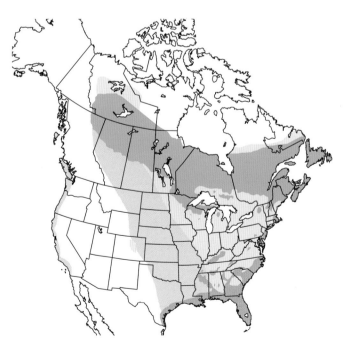

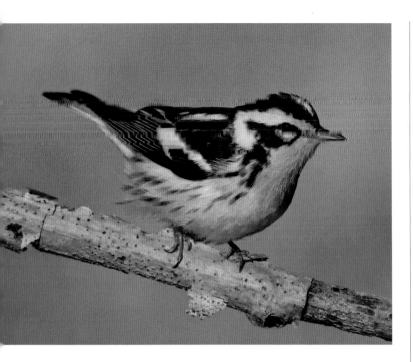

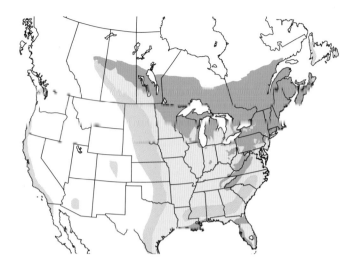

Blackburnian Warbler *Setophaga fusca*

L 5" WS 9" ♂ ≠ ♀ BLBW

This fire-throated warbler summers in the Appalachians, New England, and boreal Canada from Atlantic Canada west to Alberta. Winters from Costa Rica to Bolivia. Breeds preferentially in hemlock stands or other mature conifers but also will nest in deciduous trees in Pennsylvania. Migrants stop over in mature forests. Spends most time high in the forest canopy, where its high-pitched song can be difficult to discern. Summer diet is arthropods. The cup nest, made of twigs, bark, and plant fibers and lined with lichens and fine material, is set on the outer reaches of a high conifer branch. Lays three to five whitish or pale green eggs with red-brown markings at the larger end. The species seems to be faring well overall, though in the southern parts of its range where its favored hemlocks are being killed by the woolly adelgid pest this bird's population is declining.

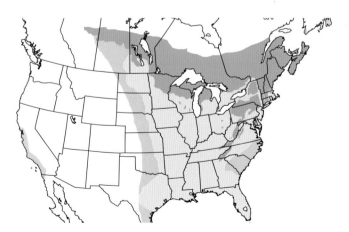

Chestnut-sided Warbler *Setophaga pensylvanica*

L 5" WS 8" ♂ ≠ ♀ CSWA

Summers in the Appalachians and New England westward to Illinois and Alberta. Winters from southern Mexico to Colombia. Breeds in brush-filled wet pastures, cleared woodlands, and second growth—habitats with a slightly more boreal aspect than the habitat of the Yellow Warbler. Song of the male is suggestive of the Yellow Warbler but ends with a more explosive flourish. Summer diet is mainly arthropods and a few berries. Nest is a loose cup of coarse plant matter lined with fine grass and animal hair and situated in a low dense shrub in a clearing. Lays three to five whitish eggs marked with brown.

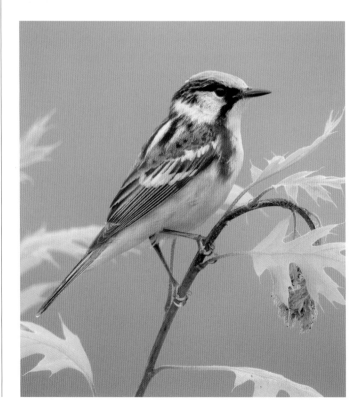

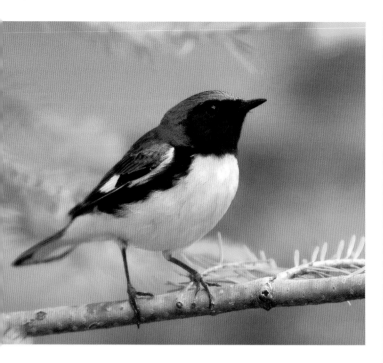

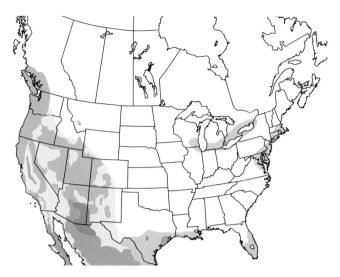

Black-throated Blue Warbler
Setophaga caerulescens
L 5" WS 8" ♂ ≠ ♀ BTBW

This engagingly patterned wood-warbler summers in the Appalachians, the Northeast, and upper Great Lakes into the boreal forests of Canada from southwestern Ontario east to Nova Scotia. Rare in migration west of the Mississippi. Winters in eastern Florida, the Caribbean, the Yucatán, and Central America. Breeds in mature deciduous and mixed forest with a substantial understory of shrubs and tangles. Migrants stop over in woods or thickets. Summer birds inhabit the lower stories of the forest interior. Diet is mainly arthropods and some berries and nectar. Nest, situated in a low shrub in forest interior, is a cup of coarse plant matter lined with pine needles, moss, and animal hair. Lays two to four off-white eggs blotched with darker colors.

Black-throated Gray Warbler
Setophaga nigrescens
L 5" WS 8" ♂ ≈ ♀ BTYW

Summers across the West in foothills and mountain country; winters patchily in California, Arizona, and Texas, as well as through much of Mexico. Breeds in dry conifer and mixed woods, with a preference for openings, hillsides, and canyons. Migrants frequent deciduous growth along stream bottoms. Diet is arthropods. The nest, set out on a branch of a conifer or oak, is a tidy cup of plant materials lined with feathers, fur, and moss. Lays three to five cream-colored eggs marked with brown spotting at larger end.

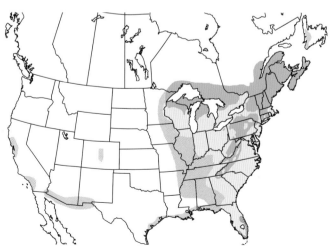

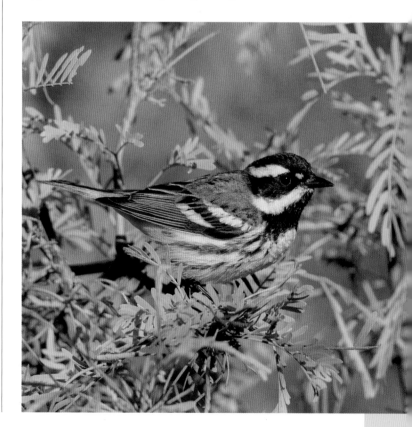

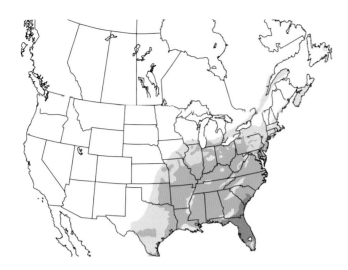

Yellow-throated Warbler *Setophaga dominica*
L 6" WS 8" ♂ ≈ ♀ YTWA

Summers from Iowa and Pennsylvania south to Texas and Florida. Winters in Florida, the Caribbean, Mexico, and Central America. Breeds in riverside sycamores, tall pines, cypress swamps, and Southern Live Oaks festooned with Spanish Moss. Forages creeper-like in the canopy of tall trees. Diet is arthropods. The nest, placed out on a high branch or hidden in Spanish Moss, is a cup of rough plant matter lined with plant down and feathers. Lays four or five off-white eggs marked with various darker colors.

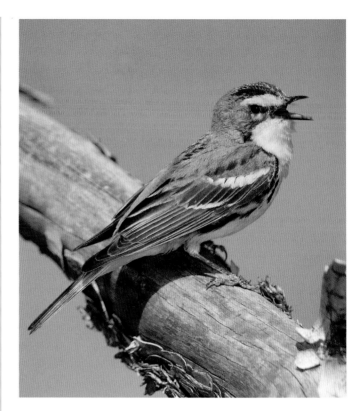

Grace's Warbler *Setophaga graciae*
L 5" WS 8" ♂ ≈ ♀ GRWA

Summers in mountains of the Arid Southwest. Also breeds from the mountains of Mexico south to Nicaragua. Winters in southern Mexico and Central America. Breeds in mountain pine-oak forest. Spends most time foraging high in tall pines. Diet is arthropods. Nest, placed in a tall conifer, is a compact cup of plant material bound by spider silk and lined with animal hair and feathers. Lays three or four cream-colored eggs marked with darker colors at the larger end. US population is widespread in the mountains of the Southwest and appears to be in good shape. Plumage pattern closely resembles that of the Yellow-throated Warbler.

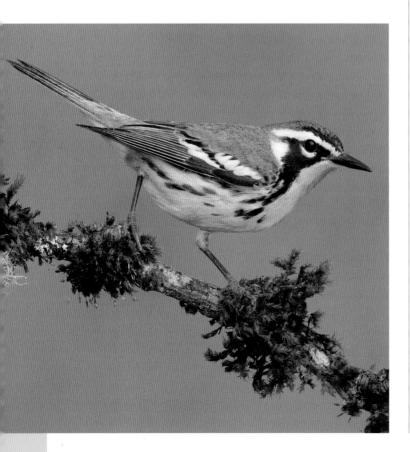

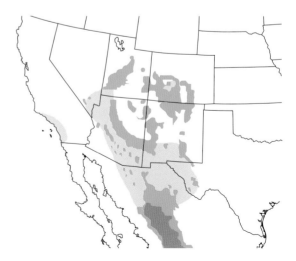

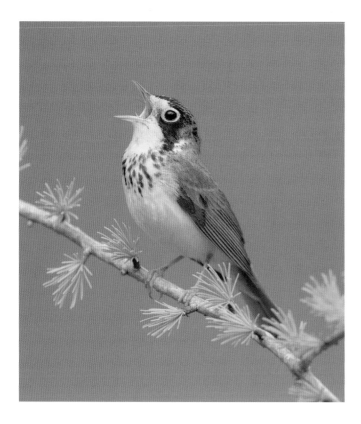

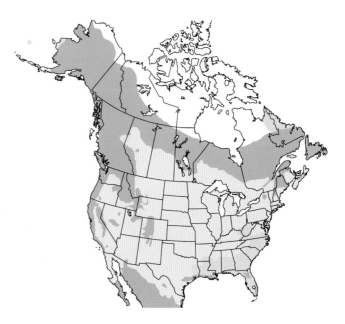

Canada Warbler *Cardellina canadensis*

L 5" WS 8" ♂ ≈ ♀ CAWA *WL

This yellow-and-gray warbler with the black necklace summers in the Appalachians, New England, the northern US Borderlands, and boreal Canada from British Columbia to Atlantic Canada. Winters from Costa Rica to southern Peru. Summers in thick, damp undergrowth of mature mixed or deciduous forest, especially swampy thickets. Actively forages for arthropods. The nest, hidden on or near the ground, is a bulky cup of loose and coarse plant matter, lined with fern roots. Lays three to five off-white eggs marked with brown. One of the later spring migrants.

Wilson's Warbler *Cardellina pusilla*

L 5" WS 7" ♂ ≠ ♀ WIWA

This little yellow warbler with a round black cap summers in the northeastern and northwestern US Borderlands, the California coast, the Mountain West, and across boreal Canada to Alaska. Winters sparsely along the Southern Borderlands and Gulf Coast, but also in Florida, Mexico, and Central America. More common in the West. Breeds in bog vegetation as well as alder and willow thickets north to the treeline. Nonbreeding birds frequent shrubby forest edge and other open habitats. Flicks tail while foraging. Diet is mainly arthropods and some berries. Nest, hidden on or near the ground at the base of a shrub, is a bulky cup of leaves, grass, and moss lined with fine grass and animal hair. Lays four to six cream-colored eggs marked with brown.

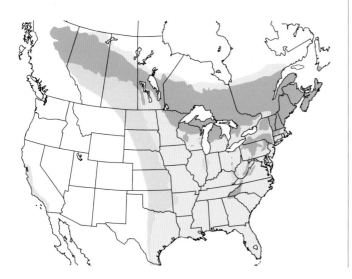

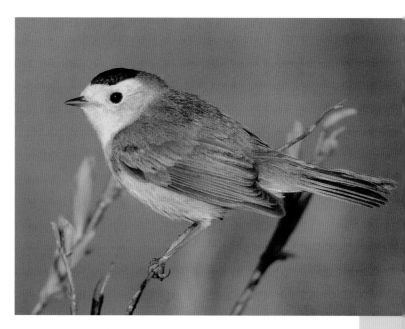

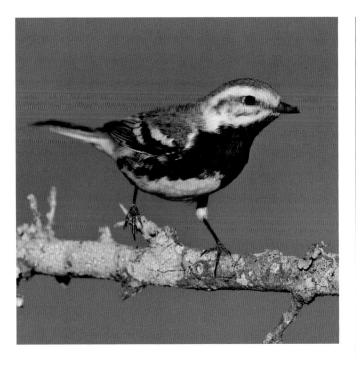

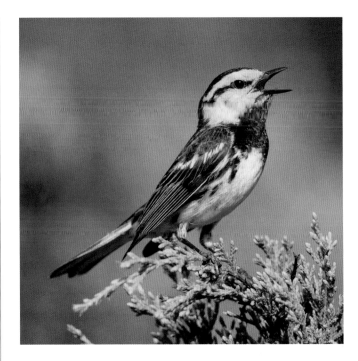

Black-throated Green Warbler *Setophaga virens*
L 5" WS 8" ♂ ≈ ♀ BTNW

Summers in the Appalachians, the northern US Borderlands, boreal Canada, and also the coastal lowlands of the Deep South. Winters in Florida, South Texas, Mexico, Central America, and the Caribbean. Breeds in conifer and mixed forest—hemlock, spruce, White and Jack Pine, and cypress. Migrants frequent oak woods. Diet is arthropods; also some berries in the nonbreeding season. Nest, hidden in a conifer, is a cup of coarse plant matter, lined with finer material and wrapped in spider silk. Lays three to five cream-colored eggs with red-brown markings. This is one of the most familiar and beloved migrant wood-warblers to birders in the East. Arrives relatively early in spring, heralding the coming rush of migration with its distinctive musical series of buzzy notes. The species population is apparently stable. In the East this species has no confusing relatives to make ID difficult.

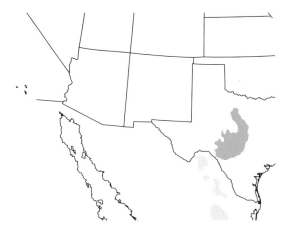

Golden-cheeked Warbler *Setophaga chrysoparia*
L 5" WS 8" ♂ ≈ ♀ GCWA *EN *WL

Summers in a section of the Texas Hill Country. Winters in southernmost Mexico and northern Central America. Breeds on hillsides of juniper that are interspersed between stands of oak and other deciduous trees. Diet is arthropods. Nest, placed in a juniper or small deciduous tree, is a compact and deep cup of bark strips from Ashe Juniper bound together with spider silk and lined with rootlets, feathers, and animal hair. Lays three or four whitish eggs marked with brown at the larger end. Often shares habitat with the Black-capped Vireo—these two are Texas specialties. The entire global breeding population of this species is confined to central Texas, making the species vulnerable to various threats. Main issue is local economic development in their breeding area. The breeding population is an estimated 13,500 pairs.

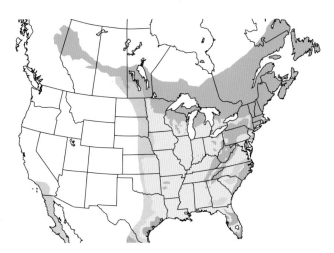

Hermit Warbler *Setophaga occidentalis*

L 5" WS 8" ♂ ≈ ♀ HEWA

Summers in mountains of the Pacific Northwest, from Washington to Southern California. Winters sparsely in coastal California; mainly in Mexico and Central America. Breeds in dense and shady stands of mature conifers both at low and high elevations. Birds wintering in California prefer oaks and conifers along the Coast. Individuals forage high in the canopy of tall conifers, making them difficult to see. Migrant and winter birds join mixed songbird flocks. Diet is arthropods. The nest, set on a horizontal branch in a tree > 20 feet up, is a compact and deep cup made of coarse plant material and lined with soft bark, feathers, and animal hair. Lays four or five cream-colored eggs speckled with brown in a wreath around the larger end.

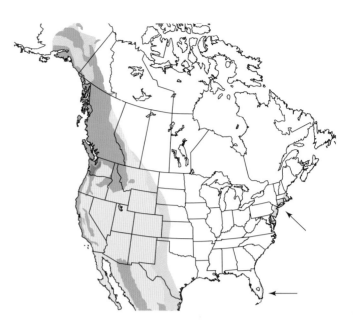

Townsend's Warbler *Setophaga townsendi*

L 5" WS 8" ♂ ≈ ♀ TOWA

Summers in the Pacific Northwest, from Oregon and western Montana to Alaska. Winters along the West Coast and in Mexico and Central America. Breeds in tall, cool, and damp conifer forests of spruce, fir, Douglas-fir, and hemlock. Winters in oaks and conifers. Male in spring sings from high in a mature conifer. Diet is mainly arthropods and some seeds. The nest, set atop a high conifer branch, is a large and shallow cup of coarse plant matter lined with moss, feathers, and animal hair. Lays four or five white eggs marked with brown blotching.

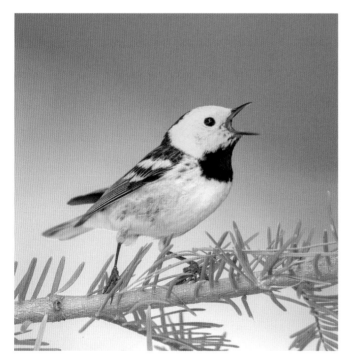

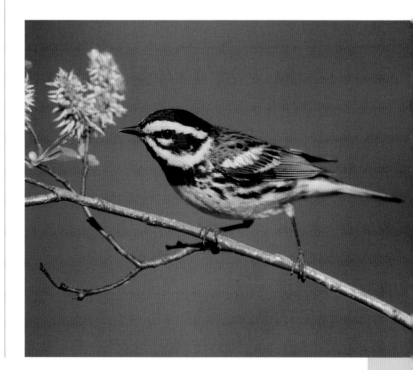

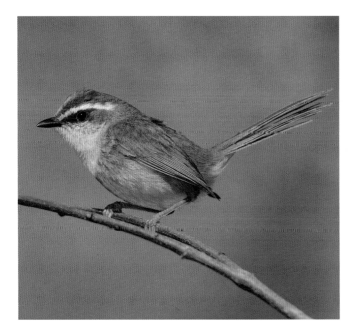

Rufous-capped Warbler *Basileuterus rufifrons*

L 5" WS 7" ♂ = ♀ RCWA

A resident of northern Mexico with populations ranging south to Guatemala. Has bred in the United States, though the nearest regular breeding populations to the Border are in northern Sonora and northeast of Monterrey, Mexico. Inhabits scrub, open woodland, and edge. Avoids forest. Diet is mainly arthropods, also some berries. The nest is domed with a side entrance; it is constructed of grass and other plant materials, and is set on the ground on a rocky bank. Lays three or four white eggs flecked with brown. A member of a genus of wood-warblers (*Basileuterus*) unfamiliar to most birders north of the Border. This is a genus that is best represented in Central and South America. Looking for this warbler in the Southwest Borderlands, it is best located by the vocalization. The species population appears stable.

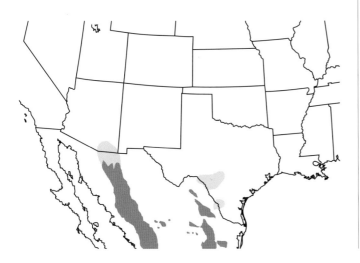

Red-faced Warbler *Cardellina rubrifrons*

L 6" WS 9" ♂ ≈ ♀ RFWA

The red-and-black face sets this warbler apart. It summers in New Mexico, Arizona, and northern Mexico. Winters in Mexico southward to Honduras. Breeds in deciduous maple groves in streamside canyons surrounded by montane conifer forest above 6,000 feet elevation. Diet is arthropods. The nest, hidden on the ground in leaf litter, is a cup of grass and bark lined with plant fibers and animal hair. Lays three or four pink eggs speckled with brown.

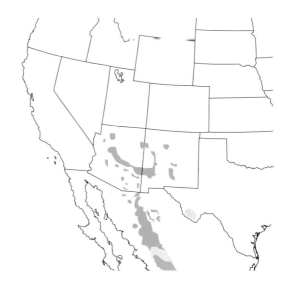

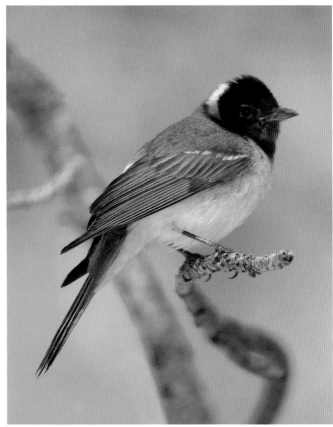

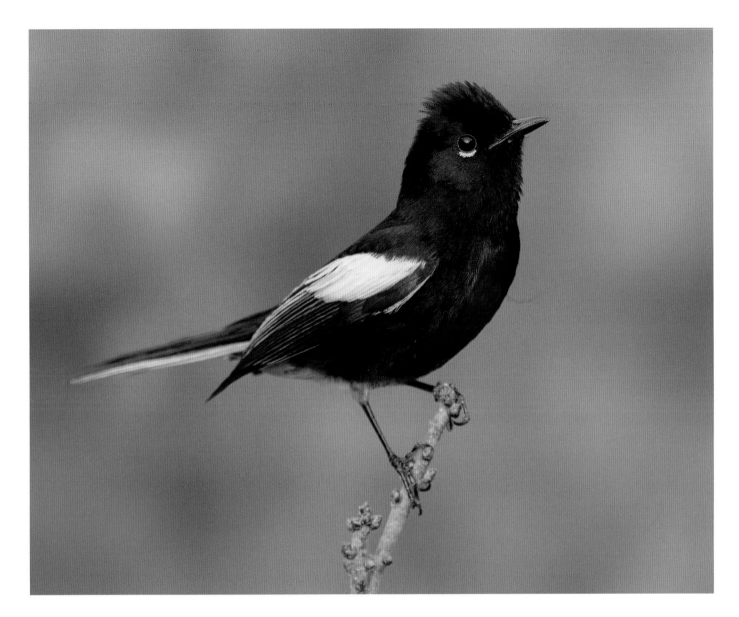

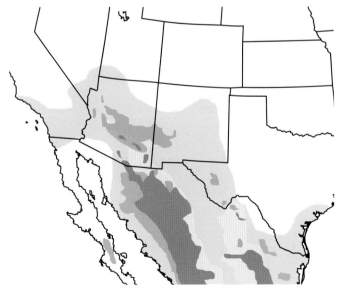

Painted Redstart *Myioborus pictus*
L 5" WS 9" ♂ = ♀ PARE

This handsome red, black, and white warbler summers in Arizona, New Mexico, and West Texas. Winters in southern Arizona, Mexico, and Central America. Breeds in oak and pine canyons above 5,000 feet elevation. An active and acrobatic forager; readily joins mixed songbird flocks. Diet is arthropods. Also may take nectar from hummingbird feeders. The nest, hidden on the ground under deciduous vegetation, is a shallow cup of coarse plant material lined with fine grass and animal hair. Lays three or four off-white eggs speckled with brown. This subtropical wood-warbler is a member of a genus (*Myioborus*) that ranges from Mexico to South America, best represented in the Andes and northern South America.

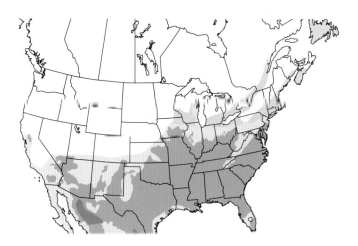

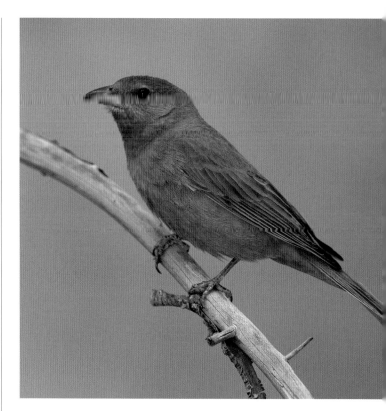

Summer Tanager *Piranga rubra*

L 8" WS 12" ♂ ≠ ♀ SUTA

This tanager, featuring the all-red male and dull yellow female, summers in the Southeast, lower Mississippi, and Southwest, and winters from northern Mexico to northern South America. A few birds also winter in southeastern Texas and Florida. In the East, it breeds in dry oak woods, often with hickory and pine. In the Southwest, it breeds in streamside deciduous woodland. Forages deliberately in the upper stories of forest. Diet is mainly arthropods with some berries. The nest, set on a branch high in a tree, is a shallow cup of coarse plant materials, lined with rootlets and fine grass. Lays two to five pale blue-green eggs spotted with brown. The Summer Tanager and Scarlet Tanager each have a distinctive, loud note that aids in detecting these birds.

Hepatic Tanager *Piranga flava*

L 8" WS 13" ♂ ≠ ♀ HETA

The male is a dull red tanager that summers in mountains of the Southwest. The female is dull yellow and olive (typical of the genus). The range of the species extends into South America. Our birds presumably winter into Mexico, though some overwinter in southernmost Arizona and Southern California. Breeds in mid-montane forest of pine and oak. Forages sedately in forest canopy. Diet is mainly arthropods as well as some berries. The nest, set in a tall conifer or broadleaf tree, is a shallow cup made of coarse plant materials and lined with fine grass. Lays three to five blue-green eggs with brown spotting toward the larger end.

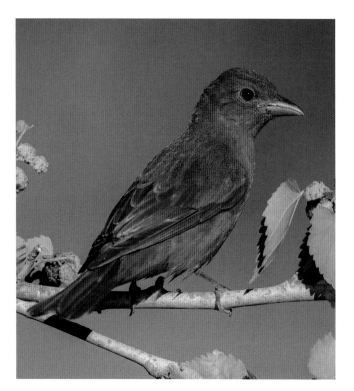

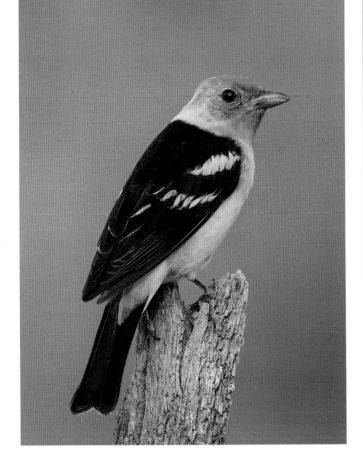

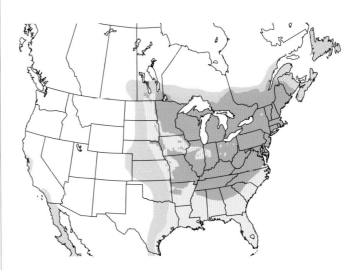

Scarlet Tanager *Piranga olivacea*

L 7" WS 12" ♂ ≠ ♀ SCTA

Male is a gorgeous black-and-red tanager that summers across the East and Midwest and winters in Central and South America. Breeds in deciduous and mixed forest. Best located by either its distinctive burry warbled series or its loud call notes, delivered from the forest canopy. Diet is mainly arthropods, some fruit. The nest, set out from trunk on a branch in a deciduous tree, is a shallow cup of coarse plant materials lined with fine grass and rootlets. Lays two to five pale blue-green eggs spotted with brown. Female is plain olive-green above and dull yellow below.

Western Tanager *Piranga ludoviciana*

L 7" WS 12" ♂ ≠ ♀ WETA

The male is a beautiful tanager that summers in the Mountain West as far north as the Northwest Territories. Winters in Mexico and Central America. Breeds in open coniferous and mixed forests of western mountains and taiga forest in western Canada. Forages high in the canopy. Diet is arthropods and some fruit. The nest, set on a branch out from the trunk in a conifer tree, is a shallow cup of coarse plant materials lined with fine rootlets and animal hair. Lays three to five pale blue eggs blotched with brown.

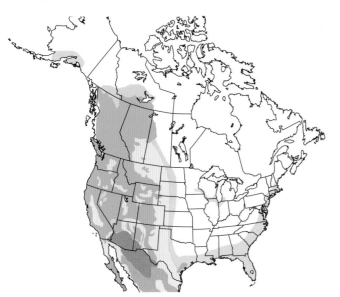

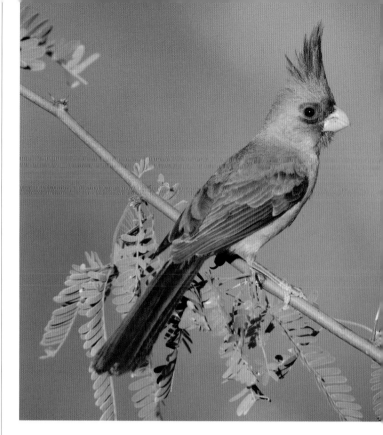

Northern Cardinal *Cardinalis cardinalis*

L 9" WS 12" ♂ ≠ ♀ NOCA

This commonplace beauty—the state bird for seven states—is a permanent resident of the East, Midwest, the Southwest Borderlands, and much of Mexico. It inhabits suburban parks, brushy thickets, and woodland edge. In winter, it can be seen in numbers attracted to backyard feeders. Diet is a mix of seeds, arthropods, and berries. The nest, hidden in a shrub, is a cup of coarse plant materials lined with fine grass and animal hair. Lays three or four whitish, bluish, or greenish eggs marked with darker colors. Nonmigratory. Populations have been creeping northward in the East over a number of decades.

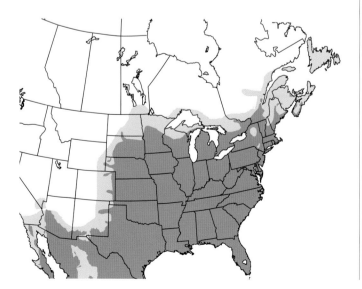

Pyrrhuloxia *Cardinalis sinuatus*

L 9" WS 12" ♂ ≠ ♀ PYRR

Resident in brushlands of the Arid Southwest, the Pyrrhuloxia also ranges southward into central Mexico. It inhabits desert, thorn scrub, and mesquite, typically in drier habitat than that of the Northern Cardinal. Wanders into additional open habitats in winter. Behavior similar to that of the Northern Cardinal. Diet is a mix of seeds, arthropods, and fruit. Visits feeders for sunflower seeds. The nest, hidden in a thorny shrub or clump of mistletoe, is a cup of coarse plant materials (including thorny twigs) lined with plant fibers and fine grass. Lays three or four grayish or greenish eggs marked with darker colors. In winter, forms flocks and does sometimes wander from its breeding habitat. Species population is apparently stable, but degradation and loss of its favored arid habitat is a potential concern. The male is unique. The female could be confused with the female of the Northern Cardinal. Note the very tall crest.

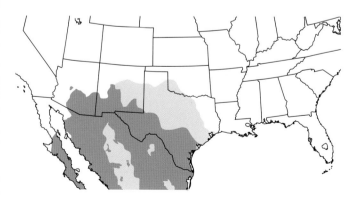

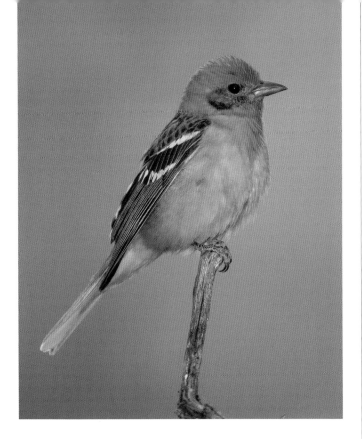

Flame-colored Tanager *Piranga bidentata*
L 8" WS 12" ♂ ≠ ♀ FCTA *WL

This tropical species is a permanent resident of the mountains of Mexico and Central America, sporadically appearing in the Borderlands of Arizona and Texas. Has nested in Arizona, where it has been known to interbreed with the Western Tanager. Found in pine-oak woods in mountain canyons. Diet is presumed to be mainly arthropods, some fruit. The cup nest, composed of rootlets, twigs, and tendrils, is lined with grass stems and set on a tree branch 15–50 feet up. Lays two to five blue-green eggs speckled with a darker color.

Rose-breasted Grosbeak *Pheucticus ludovicianus*
L 8" WS 13" ♂ ≠ ♀ RBGR

This lovely songbird with its beautiful song summers in the Appalachians, the Northeast, the Midwest, and boreal Canada as far north as the southern Yukon. Winters in Cuba and Mexico south to northern South America. Breeds in deciduous and mixed forests, especially near brushy openings. A noted songster, with its voice a bright and clear version of that of the American Robin. Diet is a mix of arthropods, seeds, and fruit. The nest, set in a tree or shrub, is a loose cup of coarse plant materials lined with fine twigs, rootlets, and animal hair. Lays three to five pale blue-green eggs with red-brown markings.

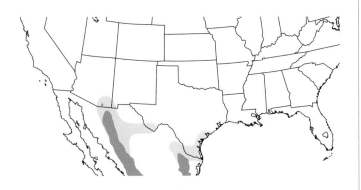

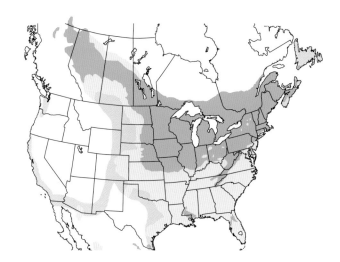

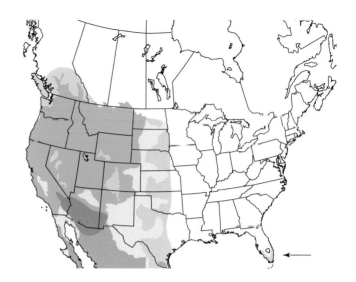

Indigo Bunting *Passerina cyanea*
L 5.5" WS 8" ♂ ≠ ♀ INBU

The male is a gorgeous little sprite that summers across the East and Midwest. Females of all these buntings are very plain. Winters along the Gulf Coast and from Mexico to Central America and the Caribbean. Breeds in brushy pastures and woodland edges—roadsides, old fields, and rights-of-way. In spring, the male is a bright songster, vocalizing from atop a prominent open perch. In spring, the species migrates north up the Mississippi Valley in large numbers; often seen in migrant flocks. Diet is a mix of seeds and arthropods; also takes some berries. The nest, set in a shrub, is a cup of coarse plant materials lined with finer material. Lays three or four white or pale blue eggs. The complex song of the male is one of familiar summer sounds in shrubby clearings. This is one of our more abundant migrant songbirds. Range has expanded into the Southwest.

Lazuli Bunting *Passerina amoena*
L 5.5" WS 9" ♂ ≠ ♀ LAZB

This striking bunting summers through the West and winters throughout western and central Mexico. Breeds in open brushlands and streamside shrubs in arid country. In spring, the male sings from a prominent perch atop a shrub or solitary tree. Diet is a mix of arthropods and seeds. The nest, set in a shrub, is a cup of coarse plant materials lined with fine grass and animal hair. Lays three to five pale bluish-white eggs. This species and the Indigo Bunting meet in the western Great Plains, and not uncommonly, the two mate and produce hybrid offspring. Population appears stable.

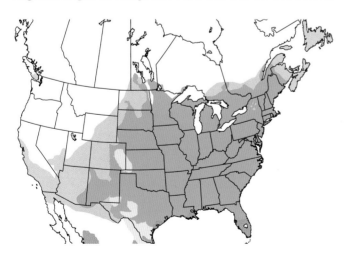

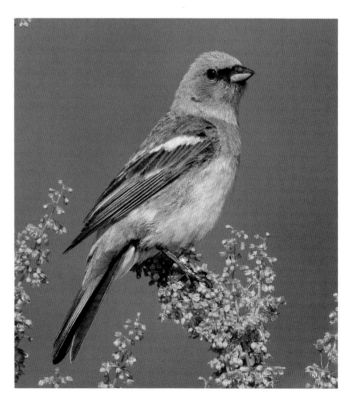

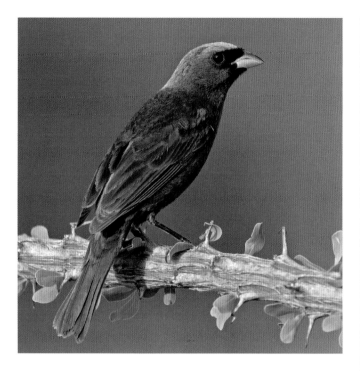

Varied Bunting *Passerina versicolor*

L 5.5" WS 8" ♂ ≠ ♀ VABU

Our third small, colorful bunting breeds in the Southwest Borderlands southward into central Mexico and Guatemala. North American birds winter in Mexico. Breeds in streamside thickets and brush in arid country—especially streamside canyon slopes with Ocotillo. In spring, the male is a prominent songster, vocalizing from atop a thorny bush. Diet is apparently a mix of seeds and arthropods. The nest, hidden in a dense shrub, is a compact cup of coarse plant materials lined with finer matter. Lays three to five unmarked white or bluish-white eggs. Population stable. Often hidden in a thicket and difficult to see unless the male ascends to an open perch to sing. The coloration of the male is peculiar.

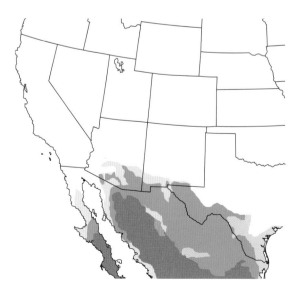

Painted Bunting *Passerina ciris*

L 5.5" WS 9" ♂ ≠ ♀ PABU *NT

The male Painted Bunting is splashed with bright red, lime green, and deep blue, making it the photographer's favorite. The species summers in the lower Great Plains, the coastal Southeast, the lower Mississippi, and northeastern Mexico. It winters in Florida, the Caribbean, Mexico, and Central America. Breeds at woodland edge, roadsides, brush, towns, and gardens. Winters in similar habitats. In spring, the male of this typically retiring species is a prominent songster, vocalizing from atop a hedge or bush. Diet is a mix of seeds and arthropods. The nest, hidden in dense brush, is a cup of coarse plant matter lined with fine grass, rootlets, and animal hair. Lays three or four whitish or bluish-white eggs marked with reddish spots at the larger end. Threatened by trapping for the bird trade south of the Border. Classed as Near Threatened.

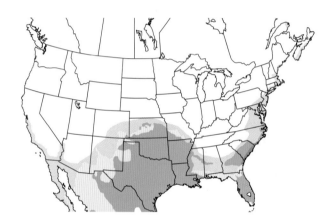

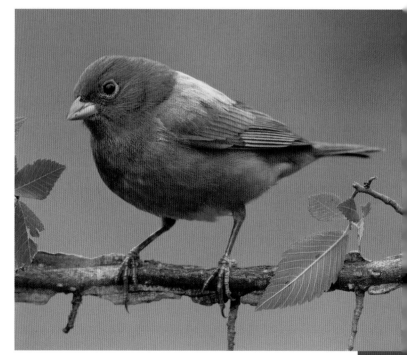

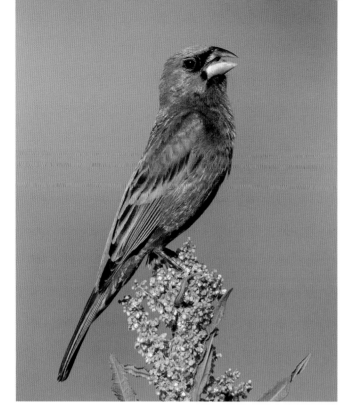

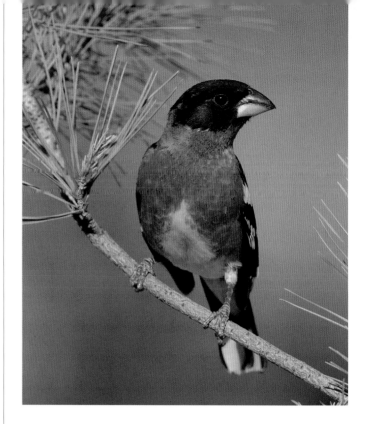

Blue Grosbeak *Passerina caerulea*
L 7" WS 11" ♂ ≠ ♀ BLGR

This dark blue grosbeak of open country summers across the southern half of the Lower 48 (but not South Florida). Populations also breed from northern Mexico south to Costa Rica. Winters in South Florida, the Caribbean, Mexico, and Central America. Breeds in hedgerows and tree rows in agricultural country, as well as streamside thickets. In spring, the male sings from prominent treetops in open country. Forages mainly on or near the ground in weeds. Diet is a mix of arthropods and seeds. The nest, hidden in a thick shrub, is a compact cup of coarse plant materials lined with finer plant materials and animal hair. Lays three to five pale blue eggs, usually unmarked.

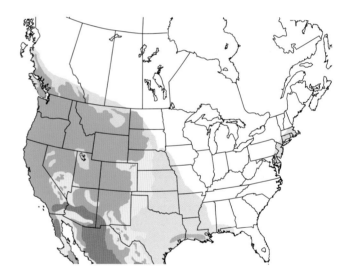

Black-headed Grosbeak *Pheucticus melanocephalus*
L 8" WS 13" ♂ ≠ ♀ BHGR

The very handsome male is a close relative of the Rose-breasted Grosbeak. Females of both are brown-streaked and distinct from the male. The species summers across the West, from British Columbia south to southern Mexico. Winters in western and eastern Mexico. Breeds in deciduous and mixed woods, especially streamside groves of cottonwoods and pine-oak woods in the mountains. The male, in spring, is a prominent vocalist. Diet is a mix of arthropods, seeds, and fruit. The nest, set in a deciduous tree or shrub, is a loose cup of coarse plant materials lined with finer plant matter and animal hair. Lays three or four pale greenish eggs with red-brown speckling.

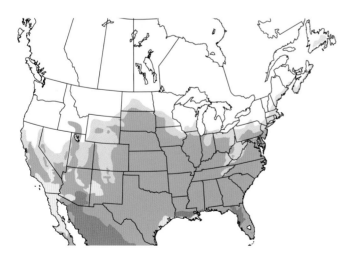

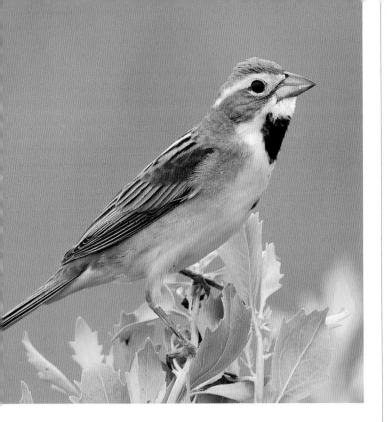

Dickcissel *Spiza americana*
L 6" WS 10" ♂ ≠ ♀ DICK

This songbird summers abundantly across the Great Plains and Midwest, and sparingly in the East. Winters from Mexico to Venezuela. Breeds in alfalfa and other agricultural fields, meadows, and prairie grasslands. A few winter at feeders, associating with House Sparrows. In spring, the male is a prominent songster, vocalizing from atop a hedge or bush in a pasture or farm field. Diet is a mix of arthropods, weed seeds, and waste grain. The nest, set on or near the ground in thick grass or shrubbery, is a bulky cup of coarse plant matter lined with fine grass and rootlets. Lays three to five pale blue eggs. Migrates in flocks, which can be detected when individuals give their buzzy single note that sounds like an electric buzzer. Loss of native habitat a concern.

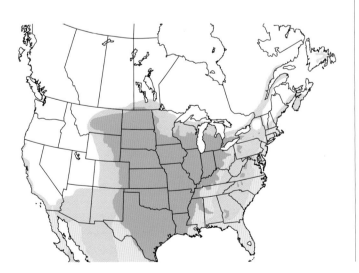

Morelet's Seedeater *Sporophila morelleti*
L 5" WS 6" ♂ ≠ ♀ MOSE

This widespread Mexican and Central American resident ranges sparingly north to the Texas Borderlands. Breeds in stands of tall native cane grass along the Lower Rio Grande; formerly more common when its cane habitat was more extensive. Travels in softly vocalizing flocks. Diet is seeds and arthropods. The nest, set in a shrub or ragweed, is a small and compact cup of a variety of plant matter. Lays two to four pale blue or pale gray eggs spotted with brown at the larger end. Nonmigratory, but flocks do wander a bit in the nonbreeding season. Tiny US population is holding on.

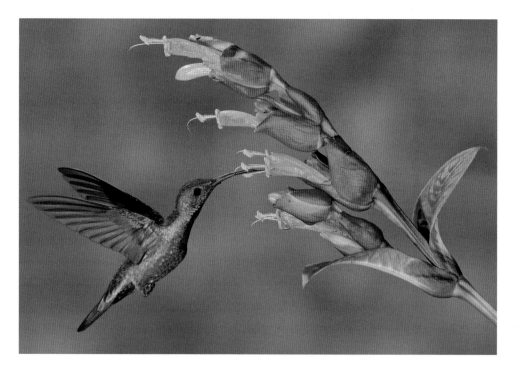

Opposite: Lewis's Woodpecker carrying an acorn. Right: Male Green-breasted Mango.

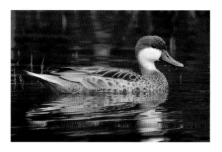

White-cheeked Pintail *Anas bahamensis*

L 17" ♂ = ♀ WCHP

This Caribbean and South American species strays to Florida annually, but there appears to be some question about the provenance of some of the birds seen in that state. Records from other states may be mainly escapees from local waterfowl collections. A resident in the nearby Bahamas and Cuba. Prefers saline or brackish waters. Mainly dabbles. Travels with migrating Blue-winged Teal.

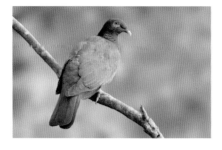

Scaly-naped Pigeon *Patagioenas squamosa*

L 14" ♂ = ♀ SNPI

A large and distinctive pigeon that inhabits subtropical woodlands. This Caribbean species is known from two old records from Florida (1898 and 1929) and a 2019 record from Sanibel Island, southwestern Florida. Diet is diverse. Declining on some islands but not globally threatened. Range includes Cuba and Hispaniola (south to Tobago).

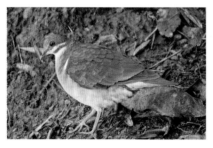

Ruddy Quail-Dove *Geotrygon montana*

L 10" ♂ ≠ ♀ RUQD

A widespread Caribbean resident also ranging through the Neotropics. Plainer than the Key West Quail-Dove. Forages on the ground in woodlands. Only two records in the decade 2010–2020 (Miami and Key West, Florida). There is a 1996 record from the Lower Rio Grande Valley of Texas. This is a forest-dweller than also can be found in second growth.

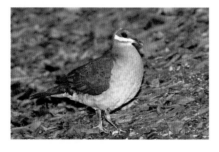

Key West Quail-Dove *Geotrygon chrysia*

L 12" ♂ = ♀ KWQD

This resident of the Bahamas and the Greater Antilles is a retiring ground-forager that hides in thick vegetation. More prominently marked on the face than the Ruddy Ground Dove. A handful of records from South Florida in the last decade. Apparently was a resident of the Keys until the mid-nineteenth century. Inhabits a range of woody habitats.

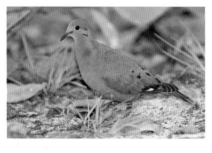

Zenaida Dove *Zenaida aurita*

L 10" ♂ ≠ ♀ ZEND

Quite similar to the Mourning Dove, this dove is a common resident of the Bahamas and the Greater and Lesser Antilles. Recently observed at Kendall and on Long Key, South Florida. Most North American records come from the autumn and winter. Audubon reported that this species bred in the Keys. Rather shy. Widespread in its choice of habitat. Feeds on the ground much like the Mourning Dove.

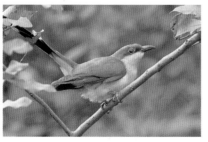

Dark-billed Cuckoo *Coccyzus melacoryphus*

L 11" ♂ = ♀ DBCU

A widespread South American species, ranging from western Colombia to Argentina, as well as the Galápagos Islands and Trinidad. There are records from Palm Beach, Florida, and from Hidalgo County, South Texas. Diet mainly caterpillars. Inhabits a wide range of woodland and forest.

White-collared Swift *Streptoprocne zonaris*

L 9" ♂ = ♀ WCSW

This large swift with its distinctive and rapid high aerial flight is a widespread resident of Mexico, the Caribbean, and Central and South America. There are ca. 10 records from North America—including Florida, Texas, California, Michigan, and Ontario. The only record from the last decade came from Florida. Larger than the Black Swift.

Antillean Palm-Swift *Tachornis phoenicobia*

L 4" ♂ = ♀ ANPS

A tiny swift, resident in the Greater Antilles. Flight bat-like. Note rapid wingbeats and short twisting glides. Generally seen flying low among the trees. There are several North American records from the Florida Keys.

Green-breasted Mango *Anthracothorax prevostii*

L 5" ♂ ≠ ♀ GNBM

This large and colorful hummer is resident from eastern Mexico south to Venezuela. Most of the more than 20 North American records come from southeastern Texas in fall and winter; also recorded from Mississippi, Louisiana, North Carolina, Georgia, and Wisconsin. Vagrants are typically young birds.

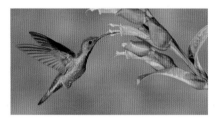

Amethyst-throated Mountain-gem *Lampornis amethystinus*

L 5" ♂ ≠ ♀ ATMG

This tropical montane species is resident from northeastern Mexico south to Honduras. Inhabits forest and edge. Diet is nectar and small insects captured in flight. Nonmigratory. North American records come from Quebec and Texas. Inhabits forest and edge. Feeds on nectar and arthropods. Generally sedentary. Not globally threatened.

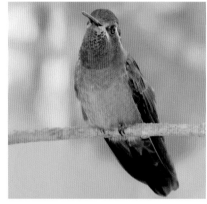

Bahama Woodstar *Nesophlox evelynae*

L 4" ♂ ≠ ♀ BAWO

Resident of the Bahamas and the Turks and Caicos Islands. Five North American records come from southeastern Florida; another comes from Lancaster County, Pennsylvania. On its native islands is found in all habitats. Forages for nectar and arthropods.

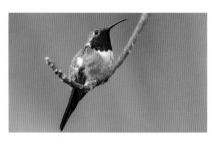

Bumblebee Hummingbird *Selasphorus heloisa*

L 3" ♂ ≠ ♀ BUHU *WL

This tiny hummer (smaller than the Calliope) is resident of montane forests of northern and central Mexico. Known from the United States from two female specimens (reputedly) collected in the Huachuca Mountains near Ramsey Canyon, Arizona, in the summer of 1896. Takes nectar and insects. Appears common throughout its native range. Not globally threatened.

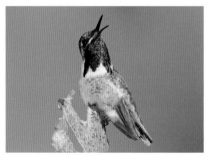

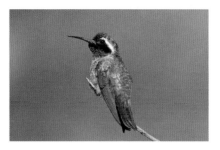

Xantus's Hummingbird *Basilinna xantusii*

L 4" ♂ ≠ ♀ XAHU *WL

This sister species to the White-eared Hummingbird is an endemic resident of southern Baja, Mexico. North American records include California (Anza Borrego State Park and Ventura), and southwestern British Columbia.

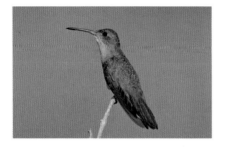

Cinnamon Hummingbird *Amazilia rutila*

L 5" ♂ = ♀ CIHU

This cinnamon-tailed hummer is resident from northwestern Mexico and the Yucatán south to Costa Rica. There are two North American records: Patagonia, Arizona, and Santa Teresa, New Mexico. Inhabits lowlands and mountains, and has a range of habitat preferences from scrub to closed forest.

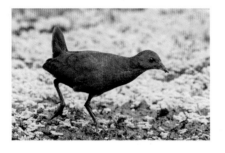

Paint-billed Crake *Neocrex erythrops*

L 8" ♂ = ♀ PBCR

A resident of Costa Rica, eastern Panama, the Galápagos Islands, and South America (Venezuela to Argentina). North American records come from Brazos County, Texas, and near Richmond, Virginia. On its breeding ground it inhabits a broad array of marshy, swampy, and scrubby habitats. Nonmigratory but does wander from time to time. Not under threat.

Spotted Rail *Pardirallus maculatus*

L 11" ♂ = ♀ SPRA

A resident breeder from Mexico and the Caribbean south to Argentina. North American records include the following: Beaver County, Pennsylvania; Brown County, Texas; and Choke Canyon Reservoir, Texas. Inhabits marshland and wet grasslands. Nonmigratory, but does wander widely.

Rufous-necked Wood-Rail *Aramides axillaris*

L 12" ♂ = ♀ RNWR *WL

Ranges from western Mexico to northern South America. A single North American record comes from Bosque del Apache National Wildlife Refuge, New Mexico. Inhabits wetlands and swamplands. Consumes mainly crabs. Typically hides in the local habitat and difficult to see. Not globally threatened.

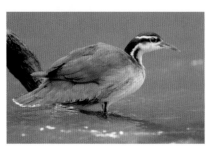

Sungrebe *Heliornis fulica*

L 11" ♂ ≈ ♀ SUNG

Resident from eastern Mexico to Paraguay. A single North American record from Bosque del Apache National Wildlife Refuge, New Mexico. Rocks neck back and forth like a Common Gallinule. Does not dive. Swims in fresh water in areas near the protection of vegetation. Not globally threatened.

Double-striped Thick-knee *Burhinus bistriatus*

L 17" ♂ = ♀ DSTK

Resident of dry grasslands from northeastern Mexico and Hispaniola south to northern Brazil. The single North American record comes from the King Ranch, Kleberg County, Texas. A distinctive terrestrial "shorebird"—crepuscular, nocturnal, and plover-like. Not associated with water. Not globally threatened.

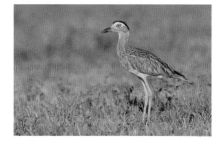

Collared Plover *Charadrius collaris*

L 5" ♂ = ♀ COPL

Resident from western Mexico to southern South America, frequenting coastal beaches, gravel bars of rivers, ponds, and dry grasslands. Two North American records: Uvalde, Texas; and Hidalgo County, Texas. The species is nonmigratory and sedentary. Not globally threatened.

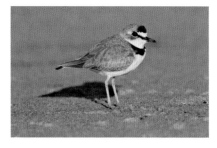

Swallow-tailed Gull *Creagrus furcatus*

L 22" ♂ = ♀ STGU

An insular species from South America, breeding on the Galápagos Islands, Ecuador, and Isla de Malpelo, Colombia. Spends much of its life at sea, with oceanic records from Chile north to Nicaragua. Five North American records from the West Coast. Plumage pattern reminiscent of adult Sabine's Gull.

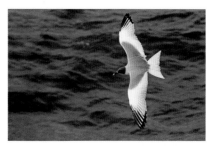

Gray-hooded Gull *Chroicocephalus cirrocephalus*

L 16" ♂ = ♀ GHGU

A resident of sub-Saharan Africa and South America. Inhabits tropical and subtropical coasts. Two North American records: Apalachicola, Florida, and Brooklyn, New York. Inhabits a broad range of environments, from coasts to inland lakes. Some populations are migratory, others sedentary.

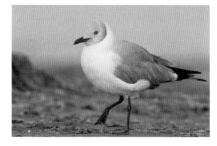

Belcher's Gull *Larus belcheri*

L 20" ♂ = ♀ BEGU

Inhabits the western coastline of South America, from Ecuador south to Chile. North American records: Naples, Florida, and San Diego, California. There are additional Florida records. Very similar to the slightly larger Olrog's Gull.

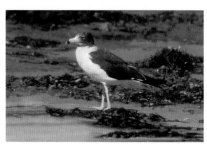

Kelp Gull *Larus dominicanus*

L 23" ♂ = ♀ KEGU

A bird of the southern seas, breeding in southern Africa, Australia, New Zealand, and coastal South America. Of late, recorded about once every year or two in North America. Starting in 1989, the species nested in the Chandeleur Islands off southeastern Louisiana for about a decade. It was found to hybridize with Herring Gulls there. No recent breeding records reported. Strays reported most recently from California, Pennsylvania, Ohio, Texas, and Atlantic Canada.

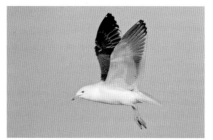

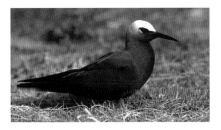

Black Noddy *Anous minutus*

L 14" ♂ = ♀ BLNO

A widespread tropical seabird, breeding in the southern Caribbean, Atlantic, and Pacific. An irregular nonbreeding visitor to the nesting colony of Brown Noddies on the Dry Tortugas of South Florida. A regular breeder in the Hawaiian Islands. Other records come from the west coast of Florida and the upper coast of Texas.

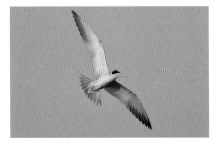

Large-billed Tern *Phaetusa simplex*

L 15" ♂ = ♀ LBTE

This tropical tern is resident on fresh water in the interior of South America and Trinidad; it winters widely, but may concentrate along the eastern coastline of South America. There are late spring and summer records from the United States: Illinois, Ohio, and New Jersey. The species exhibits an oversized yellow bill and striking plumage patterning of the upperparts in flight that is reminiscent of Sabine's Gull.

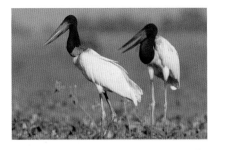

Jabiru *Jabiru mycteria*

L 55" ♂ = ♀ JABI

This huge and striking-looking stork is widespread in southeastern Mexico and also Central and South America. It occasionally wanders northward in late summer to the Gulf Coast of South Texas, where there are approximately 10 records in total. Has also strayed to Oklahoma, Louisiana, and Mississippi. A bird of open country. In the United States, may be expected to associate with the Wood Stork.

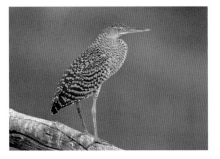

Bare-throated Tiger-Heron *Tigrisoma mexicanum*

L 30" ♂ = ♀ BTTH

Inhabits Mexico, Central America, and northwesternmost South America, both in coastal habitats and the interior. Two US records: Bentsen-Rio Grande Valley State Park, South Texas; and Uvalde County, Texas. Roughly has the size and shape of an American Bittern. Inhabits hill forest interior and edge, and lowland lakes and rivers.

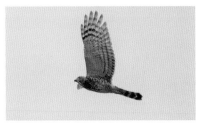

Double-toothed Kite *Harpagus bidentatus*

L 15" ♂ = ♀ DTKI

Ranges from southern Mexico to southeastern Brazil. The species has the look of an accipiter. Two North American records: High Island, Texas, and Hernando, Florida. Inhabits forest and edge, from lowlands to uplands. Diet is a mix of arthropods and small vertebrates. Not globally threatened.

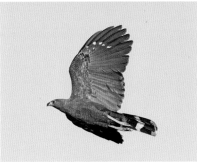

Crane Hawk *Geranospiza caerulescens*

L 20" ♂ = ♀ CRHA

Inhabits Mexico, Central America, and South America. Ranges from northwestern Mexico south to Uruguay. A single North American record: Santa Ana National Wildlife Refuge, South Texas. Found in virtually all lowland and hill habitats. Consumes invertebrates and vertebrates. Sedentary. Not threatened. The US bird was in the northern black plumage (subspecies *nigra,* which is shown here).

Great Black Hawk *Buteogallus urubitinga*
L 25" ♂ = ♀ GBHA

Inhabits Mexico, Central America, and South America. Ranges from northwestern Mexico south to Uruguay. Most of our records come from South Florida. Additional records come from Maine and Texas, which apparently pertain to the same wandering individual.

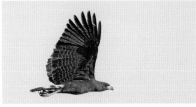

Roadside Hawk *Rupornis magnirostris*
L 14" ♂ = ♀ ROHA

This commonplace Neotropical species ranges from central Mexico to southern South America. It is a rare winter visitor to the Lower Rio Grande Valley of South Texas. Apparently a single bird, seen in various spots around Mission, Texas, is the only US record in the last decade. A bird of open country. Often seen sitting on telephone poles or their wires; confiding.

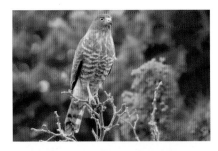

Mottled Owl *Strix virgata*
L 14" ♂ = ♀ MOOW

This widespread tropical relative of our Barred Owl ranges from northwestern Mexico to southeastern South America. Inhabits just about any wooded habitat in its range. A road-killed bird was collected at Bentsen-Rio Grande Valley State Park, Texas. In addition, there was a sighting from Weslaco, Texas. Often found near towns and cities. Takes a wide range of invertebrates and vertebrates. Apparently an opportunistic forager. Nonmigratory. The species is globally not under threat.

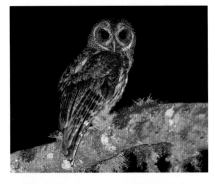

Stygian Owl *Asio stygius*
L 17" ♂ = ♀ STOW

Ranges from northwestern Mexico and the Caribbean to southeastern South America. Frequents forests and woodlands. Two winter records from the same location in the Lower Rio Grande Valley: Bentsen-Rio Grande Valley State Park. A close relative of our Long-eared Owl. Inhabits all types of forest as well as edge habitats. Diet is mainly small vertebrates. The species' population is not under threat.

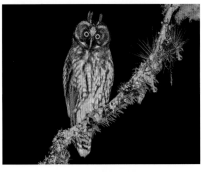

Amazon Kingfisher *Chloroceryle amazona*
L 11" ♂ ≠ ♀ AMKI

Inhabits Mexico, Central America, and South America. Frequents all sorts of water bodies—streams, rivers, lake shores, mangroves, and tidal estuaries. Three records from along the Rio Grande in South Texas: two from Laredo and one in San Benito. All three records were of females.

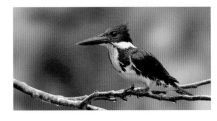

Collared Forest-Falcon *Micrastur semitorquatus*
L 20" ♂ = ♀ COFF

Ranges from northeastern Mexico to northern Argentina. Inhabits tropical forest and woodland. Nearest population to the US is found in the mountains south of Monterrey, Mexico. A single record from North America: Bentsen-Rio Grande Valley State Park, Texas—a pale morph adult.

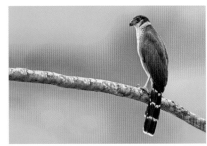

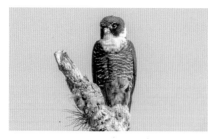

Bat Falcon *Falco rufigularis*

L 11" ♂ = ♀ BAFA

Ranges from northwestern and northeastern Mexico south to southern Brazil and northern Argentina. Nearest breeding population is in Monterrey, Mexico. The first North American record comes from Santa Ana National Wildlife Refuge in the Lower Rio Grande Valley of South Texas in 2021–2022.

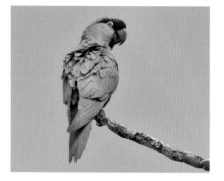

Thick-billed Parrot *Rhynchopsitta pachyrhyncha*

L 16" ♂ = ♀ TBPA *EN *WL

This big green parrot with red highlights inhabits the Sierra Madre Occidental of Mexico. It formerly strayed into the Southwest Borderlands of the United States. These incursions ceased by 1938. The species is now much reduced because of the depredations of the pet trade and habitat destruction in Mexico. A North American reintroduction effort in the 1980s failed. Viable populations remain in Chihuahua, not far from the New Mexico border. The species is a specialist on the seeds of pines. No US records in the last decade.

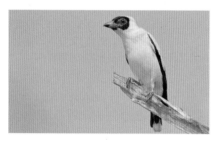

Masked Tityra *Tityra semifasciata*

L 9" ♂ ≠ ♀ MATI

A boldly patterned tropical songbird. Range extends from northwestern Mexico to Amazonia. Nearest breeding population is in southern Sonora, Mexico. A single North American record: Bentsen-Rio Grande Valley State Park, Texas. Inhabits the canopy of forest and forest-edge. Diet is fruit, arthropods, and the occasional lizard. Sedentary. Global population not threatened.

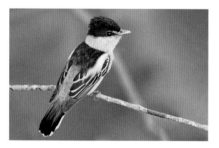

Gray-collared Becard *Pachyramphus major*

L 6" ♂ ≠ ♀ GCBE *WL

Ranges from northern Mexico south to Nicaragua. Nearest breeding population is in Monterrey, Mexico. A single record for North America: Cave Creek Canyon, Arizona. Inhabits pine and broadleaf forest and edge. Diet is arthropods and fruit. Joins mixed-species flocks. The species population is under no threat. Split into two species by some authorities. Arizona bird was a "Western Gray-collared Becard."

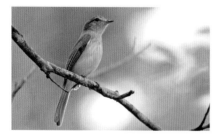

Greenish Elaenia *Myiopagis viridicata*

L 6" ♂ = ♀ GREL

Ranges from western Mexico to Paraguay. Nearest breeding population is in Tamaulipas, Mexico. There is a single North American record: High Island, Texas. Common in Mexico. Diet is insects and some berries. Inhabits forest, especially near streams.

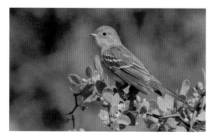

Small-billed Elaenia *Elaenia parvirostris*

L 6" ♂ = ♀ SBEL

This is a southern South American species that migrates northward annually within South America. Records from Illinois (2), Quebec, Texas, and California. Uses a range of habitats. Not under threat.

White-crested Elaenia *Elaenia albiceps*

L 6" ♂ = ♀ WCEL

Breeds through the Andes of South America, from Colombia to Chile. Winters eastward into Amazonia and southeastern South America. US records are likely individuals from the southernmost population of austral migrants—the "Chilean" White-crested Elaenia. The North American records come from South Padre Island, Texas, and Grand Forks, North Dakota.

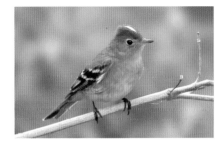

Social Flycatcher *Myiozetetes similis*

L 7" ♂ = ♀ SOFL

Ranges from northern Mexico to Paraguay. Nearest breeding population is in Monterrey, Mexico. Several Texas records: Cameron County, in 1885 (a specimen); Anzalduas Park; Bentsen-Rio Grande Valley State Park; and Brownsville.

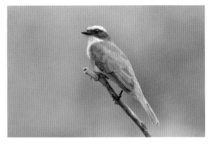

Piratic Flycatcher *Legatus leucophaius*

L 7" ♂ = ♀ PIRF

Ranges from central Mexico south to Argentina. Mexican population migrates south for the winter. Nearest breeding population is in San Luis Potosi, Mexico. There are Florida records from the Dry Tortugas and Fort Myers. Additional records from Texas, New Mexico, and Kansas.

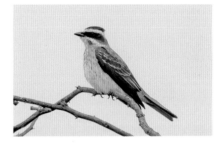

Variegated Flycatcher *Empidonomus varius*

L 8" ♂ = ♀ VAFL

This South American species ranges from Venezuela to northern Argentina. The species is a seasonal migrant within South America. There are North American records from Texas, Florida (three records), Tennessee, Maine, Ontario, and Washington. These are apparently migratory "overshoots."

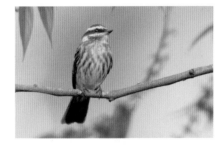

Crowned Slaty Flycatcher *Empidonomus aurantioatrocristatus*

L 7" ♂ = ♀ CSFL

A South American species that migrates within that continent, wintering in Amazonia. A single North American record, from Johnson Bayou, Cameron Parish, Louisiana. Uses a wide range of habitats. Feeds on insects and some fruit. Not globally threatened.

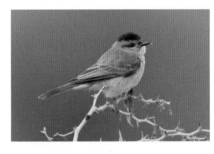

Loggerhead Kingbird *Tyrannus caudifasciatus*

L 9" ♂ = ♀ LOKI

This heavy-billed Caribbean resident inhabits the Bahamas, Cayman Islands, and Greater Antilles. All North American records come from Florida: Key West, Dry Tortugas, Key Biscayne, and Hialeah.

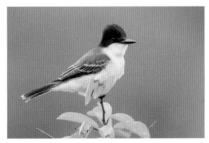

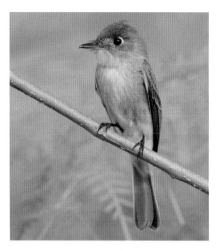

Cuban Pewee *Contopus caribaeus*
L 6" ♂ = ♀ CUPE

This typical pewee is endemic to the Bahamas and Cuba and some Cuban offshore islets. North American records all come from Florida. The species is confiding and forages low to the ground. The species inhabits broadleaf and pine forests as well as other wooded habitats. Ranges into the mountains on its breeding habitat. Diet is composed mainly of arthropods but also some fruit. Flicks its tail upon landing on a perch. The species is nonmigratory. Not under any threat.

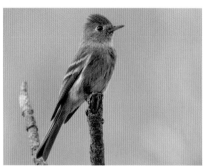

Pine Flycatcher *Empidonax affinis*
L 6" ♂ = ♀ PINF

Ranges from northeastern and northwestern Mexico southward to Guatemala. Nearest breeding population is in the mountains of western Chihuahua, due south of the Border with western New Mexico. The two North American records are from Aliso Spring, northwest of Sonoita, Arizona, and Rose Canyon Campground, Santa Catalina Mts, Arizona. It attempted to breed at Aliso Spring.

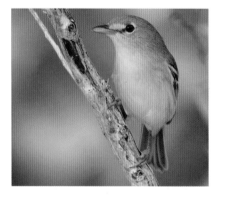

Thick-billed Vireo *Vireo crassirostris*
L 6" ♂ = ♀ TBVI

This is a Caribbean small-island specialist, inhabiting the Bahamas, Caicos, Cayman Islands, and at least one additional tiny island off the north coast of Cuba. Appears to be an island representative of the lineage that includes White-eyed Vireo. There are a number of North American records from southeastern Florida and the Florida Keys. Also a single record from the west coast of Florida. The species prefers edge and scrub habitats, especially dry woodland openings. The diet is a mix of arthropods and some fruit. Not under threat.

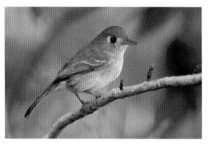

Cuban Vireo *Vireo gundlachii*
L 5" ♂ = ♀ CUVI

A Cuban endemic, where it frequents woodlands on mainland Cuba and a number of small fringing islands. There are three North American records, all from the Florida Keys. Inhabits a range of forest and woodland types as well as edge. Diet is composed of arthropods and fruit.

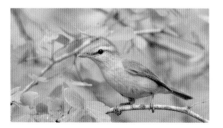

Yucatan Vireo *Vireo magister*
L 6" ♂ = ♀ YUVI

Inhabits the east coast of the Yucatán, Belize, and other nearby islands, including Grand Cayman Island and several islands off Honduras. A single North American record: Bolivar Peninsula, Texas. Inhabits a range of forest and woodland types: mangroves, coastal forest, pine thickets, etc. Not under threat.

Brown Jay *Psilorhinus morio*

L 17" ♂ = ♀ BRJA

This large and lanky brown-and-buff jay ranges from northeastern Mexico south to western Panama. Nearest population is just south of the Border, northwest of Monterrey, in Nuevo León state. Formerly, it was resident on the US side of the Rio Grande, at Salineño and Chapeño (South Texas). A group was seen recently in Chapeño.

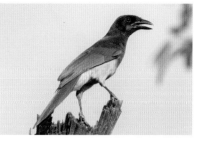

Tamaulipas Crow *Corvus imparatus*

L 15" ♂ = ♀ TACR *WL

A resident of a small area of northeastern Mexico, from eastern Nuevo León south to northern Veracruz. Historically found north of the Border at the Brownsville landfill (South Texas). Numbers there have declined in recent years, but there are still individuals recorded there on occasion. In the last decade, this species has been recorded along the Texas coast north to Galveston. Prefers open habitats of various sorts. Omnivorous. Forages in groups. Resident and nonmigratory.

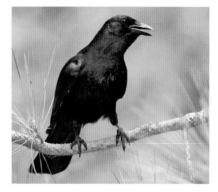

Bahama Swallow *Tachycineta cyaneoviridis*

L 6" ♂ = ♀ BAHS *EN

Breeds on islands of the Bahamas. Winters southward to various small islands and eastern Cuba. Several North American records, all from South Florida: Long Key, Sanibel Island, and Marathon (involving multiple individuals).

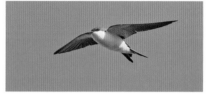

Mangrove Swallow *Tachycineta albilinea*

L 5" ♂ = ♀ MANS

Ranges from northwestern and northeastern Mexico south to Panama. Nearest breeding sites to US Border are both in Mexico: the coast west of Hermosillo, Sonora state; and eastern Tamaulipas state. There is a single North American record from Viera Wetlands, Brevard County, Florida.

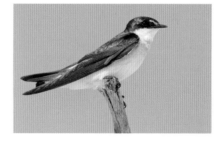

Blue-and-white Swallow *Pygochelidon cyanoleuca*

L 5" ♂ = ♀ BAWS

Resident across much of South America and in southern Central America. The more southerly populations migrate northward during the nonbreeding season, as far as Costa Rica. There is a single North American record: Progreso Lakes, Hidalgo County, South Texas.

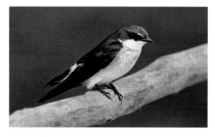

Brown-chested Martin *Progne tapera*

L 6" ♂ = ♀ BCMA

A widespread South American swallow. Southern populations winter northward. North American records, mainly in summer and autumn, include: Monomoy Island, Massachusetts; Cape May, New Jersey; Nogales, Arizona; Groton, Connecticut; Cameron Parish, Louisiana; Plymouth, Massachusetts; Kiptopeke, Virginia; and Brevard County, Florida.

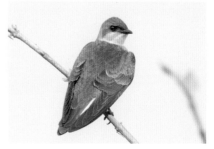

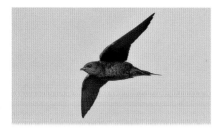

Southern Martin *Progne elegans*
L 7" ♂ ≠ ♀ SOMA

Breeds in southern South America, migrating north into the Amazon in the nonbreeding season. There is a single North American specimen record from Key West, Florida, from 1890. Prefers open lowland habitats. Common around towns and agricultural areas. Not under any threat.

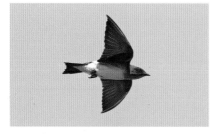

Gray-breasted Martin *Progne chalybea*
L 7" ♂ ≠ ♀ GYBM

Ranges from northern Mexico (Sinaloa and Tamaulipas) south to Argentina. Southern populations migrate northward in the nonbreeding season. Two old specimen records (one of uncertain provenance) from North America: Rio Grande City, Texas, and Hidalgo County, Texas. Also a well-documented recent record from New York City in 2021.

Cuban Martin *Progne cryptoleuca*
L 8" ♂ ≠ ♀ CUMA

Breeds on Cuba, Isle of Pines, and some northern fringing islets to Cuba. Winter range unknown, but probably in South America. A specimen taken in Key West, Florida, in 1895, is the single confirmed record. Male is very similar to the Purple Martin in plumage. Prefers openings near water. We await the discovery of this species' wintering habitat. Under no global threat, apparently.

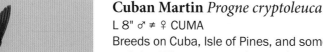

Gray Silky-flycatcher *Ptiliogonys cinereus*
L 8" ♂ ≠ ♀ GRSF

Ranges from northern Mexico south to Guatemala. Closest breeding population is in Monterrey, Mexico. US records include the following: Laguna Atascosa National Wildlife Refuge, South Texas; El Paso, Texas; and Orange County, California. Somewhat nomadic in the non-breeding season, moving in flocks downslope in winter. The two Southern California records are of uncertain provenance. Diet is arthropods and fruit. Travels in pairs and small parties. Not globally threatened.

Sinaloa Wren *Thryophilus sinaloa*
L 5" ♂ = ♀ SIWR

A western Mexican endemic, ranging from northern Sonora south to western Oaxaca. Nearest breeding population is just south of the Arizona Border in Sonora. Recent records from southern Arizona. Nest-building by the species has been observed in Arizona, though breeding not yet confirmed.

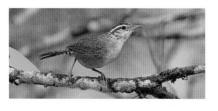

Blue Mockingbird *Melanotis caerulescens*
L 10" ♂ = ♀ BLMO

Widespread in Mexico, from Sonora south to Veracruz and Oaxaca. A scattering of North American records from the Southwest Borderlands, from southernmost Texas to New Mexico, Arizona, and Southern California. Mexican resident populations lie quite close to the Lower Rio Grande Valley of Texas and to southeastern Arizona. Frequents dense brushlands. Secretive and thrasher-like, though vocally conspicuous.

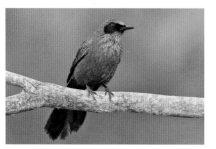

Bahama Mockingbird *Mimus gundlachii*

L 11" ♂ ≈ ♀ BAMO

This insular species inhabits the Bahamas, the Turks and Caicos Islands, small islands just north of Cuba, and southern Jamaica. The United States gets two or three records per annum, mainly of birds in coastal southeastern Florida or the Keys. A secretive denizen of thickets and dense brush.

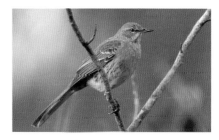

Brown-backed Solitaire *Myadestes occidentalis*

L 8" ♂ = ♀ BBSO

This rather plain thrush inhabits mountain forest from northwestern Mexico south to Honduras. Nearest breeding populations are in western Chihuahua and eastern Sonora, just south of the border with western New Mexico. Two North American records, both in Arizona: Madera Canyon, and Miller Canyon and then nearby Ramsey Canyon. This songbird produces a complex musical song. The species is apparently in decline because of loss of favored habitat in Mexico, yet not under threat as a species. Diet is apparently largely fruit. Mainly sedentary, but descends downslope in winter.

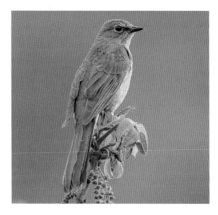

Orange-billed Nightingale-Thrush *Catharus aurantiirostris*

L 7" ♂ = ♀ OBNT

Ranges from northwestern Mexico to northern South America. Inhabits woodlands and edge. Nearest breeding population is in Monterrey, Mexico. North American records: Laguna Atascosa National Wildlife Refuge, Texas; Edinburg, Texas; Spearfish Canyon, South Dakota; Zuni Mountains, New Mexico; Cochise, AZ.

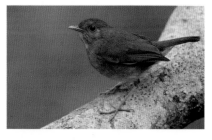

Black-headed Nightingale-Thrush *Catharus mexicanus*

L 7" ♂ = ♀ BHNT

Ranges from eastern Mexico south to western Panama. Nearest breeding population is in Monterrey, Mexico. Inhabits interior of closed evergreen mountain forest. A single North American record from Pharr, in the Lower Rio Grande Valley of Texas. Diet is arthropods and fruit. Northernmost populations may shift southward in winter. Not globally threatened.

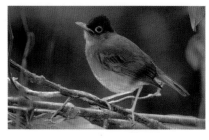

White-throated Thrush *Turdus assimilis*

L 10" ♂ = ♀ WTTH

Ranges from northwestern and northeastern Mexico south to Panama. A mountain forest-dweller. Dozens of records from the Lower Rio Grande Valley (Mission to Brownsville); also two Arizona records (Tucson and Madera Canyon).

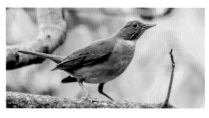

Red-legged Thrush *Turdus plumbeus*

L 11" ♂ = ♀ RLTH

Ranges through the northern Caribbean: northern Bahamas, Cuba, Isle of Pines, Cayman Islands, Hispaniola, Puerto Rico, and Dominica. Frequents woodlands, forests, and thickets. Four records from Florida: Melbourne Beach, Palm Beach, Miami Beach, and Key West. Apparently sedentary. Not under any threat.

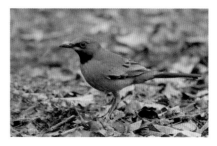

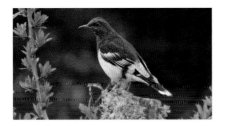

Aztec Thrush *Ridgwayia pinicola*
L 9" ♂ ≠ ♀ AZTH *WL

This pied thrush ranges through the mountains of Mexico, from Chihuahua to Oaxaca. It inhabits humid ravines in conifer and pine-oak forest. Nearest breeding birds can be found in eastern Sonora and Monterrey. US records come mainly from southeastern Arizona (in late summer), southeast Texas, and Big Bend.

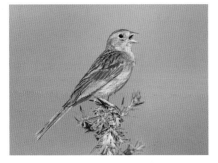

Worthen's Sparrow *Spizella wortheni*
L 6" ♂ = ♀ WOSP *EN *WL

This threatened species is restricted to dry mountain scrub between Monterrey and Guadalajara in central Mexico. The total population of the species may number in the hundreds. The sole North American record is the type specimen, collected at Silver City, New Mexico, 16 June 1884. Has not been recorded in the US since. Resembles the Field Sparrow. Best known from a single breeding site on the Central Mexican Plateau, where it associates with a prairie dog colony.

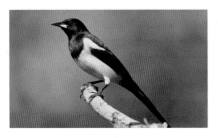

Black-vented Oriole *Icterus wagleri*
L 9" ♂ = ♀ BVOR

Ranges from northwestern Mexico to Nicaragua. It frequents dry woodland and scrub in interior uplands of Middle America. There are North American records from South Texas, Big Bend, Texas, and southernmost Arizona.

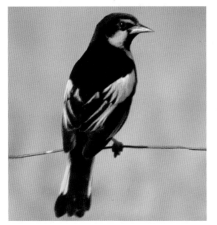

Black-backed Oriole *Icterus abeillei*
L 8" ♂ ≠ ♀ BBOR *WL

Inhabits central Mexico, wintering slightly south of its breeding range. There are several North American records from Pennsylvania, Connecticut, and Massachusetts. There is also a record of uncertain provenance from Southern California. This is a Mexican endemic. Northern populations are migratory. Found in the open forest, forest-edge, and orchards. Its breeding habitat is in the mountain uplands. Diet includes arthropods, fruit, and nectar. Population appears stable.

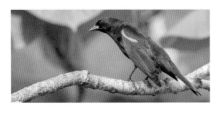

Tawny-shouldered Blackbird *Agelaius humeralis*
L 8" ♂ ≈ ♀ TSBL

Resident of Cuba and Haiti. Inhabits open woodland and edge, including farmland and sloughs. Two specimens were collected on Key West, Florida, in 1936.

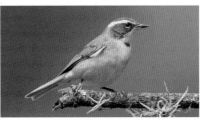

Crescent-chested Warbler *Oreothlypis superciliosa*
L 5" ♂ ≈ ♀ CCWA

This Mexican and Central American warbler has populations that occasionally reach southeastern Arizona, where there is a breeding record. Inhabits mid-elevation pine forests. Joins mixed foraging flocks of small songbirds. Diet is presumably mainly arthropods. The cup nest is made of moss, grass, and conifer needles lined with finer materials. Lays three white eggs.

Gray-crowned Yellowthroat *Geothlypis poliocephala*
L 6" ♂ ≈ ♀ GCYE

Ranges from western and eastern Mexico south to western Panama. Nearest breeding population is in Monterrey, Mexico. Formerly bred in the Brownsville area of the Lower Rio Grande Valley of South Texas. That breeding population was eliminated by the early 1900s. Recent records (documented between March and May) are strays from Mexico—confined to protected areas between Brownsville and Mission, in South Texas. The situation is complicated by hybridization with the Common Yellowthroat.

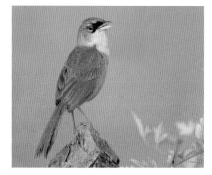

Fan-tailed Warbler *Basileuterus lachrymosus*
L 6" ♂ = ♀ FTWA

Ranges from northwestern Mexico to Nicaragua. Nearest breeding population is in northeastern Sonora, Mexico. Frequents oak woods along streams in the foothills. There are records from southeastern Arizona, east-central New Mexico, and from Big Bend, Texas.

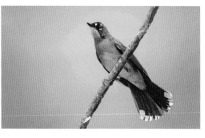

Golden-crowned Warbler *Basileuterus culicivorus*
L 5" ♂ = ♀ GCRW

Ranges from northeastern Mexico to Uruguay. Nearest breeding population is in Monterrey, Mexico. Inhabits a range of woody habitats and edge. There are records from the Lower Rio Grande Valley of South Texas; the mid-Gulf Coast around Corpus Christi, Texas; New Mexico; and Colorado.

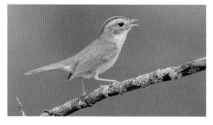

Slate-throated Redstart *Myioborus miniatus*
L 6" ♂ = ♀ STRE

Ranges from northwestern Mexico to Peru. Nearest breeding populations are in northwestern Chihuahua and northern Sonora, Mexico. Strays to the United States appear in spring and summer. Most records come from southeastern Arizona, where it has paired and nested with a Painted Redstart. Other records come from South Texas; Big Bend, Texas; West Texas; and southeastern New Mexico. Mainly found in montane pine-oak forest.

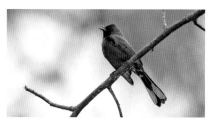

Crimson-collared Grosbeak *Rhodothraupis celaeno*
L 9" ♂ ≠ ♀ CCGR *WL

This species' limited range is confined to northeastern Mexico. Nearest breeding population is in the mountains just northeast of Monterrey. US records come from along the Rio Grande from Laredo to Brownsville, Texas; also along the Texas Gulf Coast north to Port Aransas. It forages on leaves and fruit close to the ground in dense thickets. Sometimes in small groups.

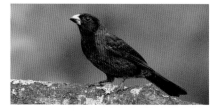

Yellow Grosbeak *Pheucticus chrysopeplus*
L 9" ♂ ≠ ♀ YEGR *WL

Ranges from northwestern Mexico to Guatemala. Nearest breeding population is in central Sonora, Mexico. Frequents open woodlands and canyon bottoms in foothills. Most North American records come from southeastern Arizona. Additional records come from New Mexico, southwest Texas, and Colorado. Mainly seen from late spring to early summer. Northernmost breeders shift southward in winter. Note the oversized bill. Diet is apparently a mix of seeds, fruit, and nectar.

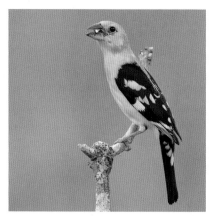

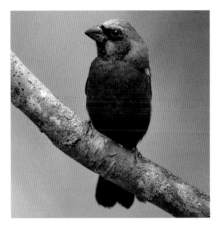

Blue Bunting *Cyanocompsa parellina*
L 6" ♂ ≠ ♀ BLBU *WL

Ranges from northwestern and northeastern Mexico south to northern Nicaragua. North American records come mainly from the Lower Rio Grande Valley of Texas, from Laredo to Laguna Atascosa. There are additional records from up the Gulf Coast to southwestern Louisiana. One record from San Antonio, Texas. In the United States, it frequents dense brushy woods, but on several occasions has been found at seed feeders. In Mexico, this species prefers forest-edge, scrub, and thickets. Ranges into the mountains. Sedentary. The species is not under threat.

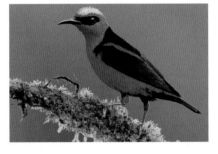

Red-legged Honeycreeper *Cyanerpes cyaneus*
L 5" ♂ ≠ ♀ RLHO

This gem ranges from eastern Mexico to southeastern Brazil. Records mainly from South Florida, but also from Louisiana and Texas. A considerable invasion occurred in Florida during the autumn/winter of 2022–2023. Frequents flowering trees and forest-edge. Diet is nectar, fruit, and arthropods.

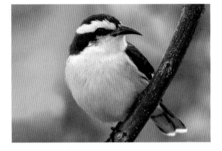

Bananaquit *Coereba flaveola*
L 5" ♂ = ♀ BANA

This diminutive nectar-feeder with its distinctive pointed and decurved bill ranges from the Caribbean and southern Mexico to Uruguay. Inhabits a wide range of habitats. A rare visitor to southeastern Florida and the western Florida Keys—with typically a single record per annum (probably birds from the Bahamas). Visitors to Florida are found mainly January to March. Generally resident but moves in search of flower nectar.

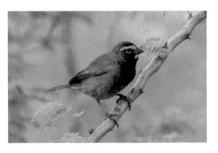

Yellow-faced Grassquit *Tiaris olivaceus*
L 4" ♂ ≠ ♀ YFGR

Ranges from northeastern Mexico to Ecuador; also found in the Caribbean (the Greater Antilles). Four records from southernmost Florida and four records from the Lower Rio Grande Valley of South Texas. Also a record from Goose Island State Park, Texas. Frequents weedy fields and brushy edges. Diet is mainly grass seeds. Generally resident but does disperse on occasion. Not under threat.

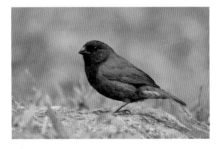

Black-faced Grassquit *Melanospiza bicolor*
L 4" ♂ ≠ ♀ BFGR

Ranges widely through the Caribbean (Bahamas to Grenada) as well as northern South America (Colombia and Venezuela). There are about a dozen records from southeastern mainland Florida, as well as the Florida Keys. The species frequents weedy edges, thickets, and brush in small flocks. Diet is seeds. Often found in small groups. The species is resident with occasional disperal events. Not under threat.

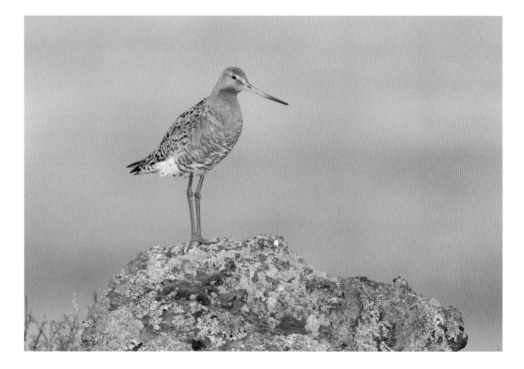

Adult male Black-tailed Godwit.

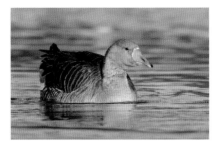

Graylag Goose *Anser anser*

L 31" ♂ = ♀ GRGO

A dark Eurasian goose commonly found in domestication. Hybridizes with the domesticated white-plumaged Swan Goose. These piebald birds are seen on farms and in city parks. There are only a handful of sightings of wild individuals in North America. Records verified from the Northeast to Atlantic Canada; also an Alaskan record.

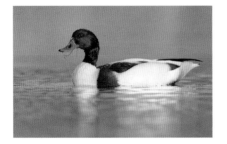

Common Shelduck *Tadorna tadorna*

L 25" ♂ ≈ ♀ COMS

A widespread Eurasian species, wintering southward into North Africa, South Asia, and Southeast Asia. Nearest breeding population is in Iceland. North American records from Labrador to Pennsylvania. This is another species popular in aviculture, thus making it difficult to determine the provenance of many sightings. Not under threat.

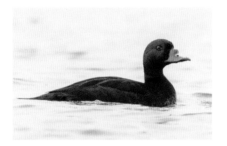

Common Scoter *Melanitta nigra*

L 19" ♂ ≠ ♀ COSC

Eurasian counterpart to our Black Scoter. Distinguished by the black knob atop the orange bill of the male. Nearest breeding location is Iceland. Two North American records: Crescent City, California; and Siletz Bay National Wildlife Refuge, near Lincoln City, Oregon.

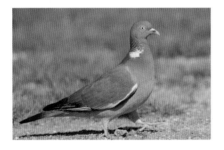

Common Wood Pigeon *Columba palumbus*

L 17" ♂ = ♀ CWPI

A widespread western European species that ranges to central Asia and the Himalayas. Also inhabits North Africa. Nearest breeding population is in Iceland. A single North American record from La Romaine, Quebec. Widespread in woodland and edge. Forages mainly on the ground. Takes buds, flowers, fruits, grains, and seeds. Northern populations are migratory. Not globally threatened.

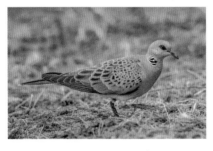

European Turtle-Dove *Streptopelia turtur*

L 11" ♂ = ♀ EUTD *VU

Ranges from western Europe to central Asia. Nearest breeding population is in Iceland. North American records: Saint-Pierre (town), Saint Pierre and Miquelon (Atlantic Canada); Tuckernuck Island, Massachusetts; and Lower Matecumbe Key, Florida. Classed as Vulnerable.

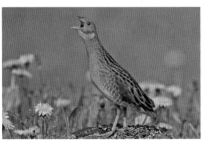

Corn Crake *Crex crex*

L 11" ♂ = ♀ CORC

Widespread in Eurasia, wintering in Africa. A declining species. Five recent records come from Atlantic Canada; there are historical records from Maryland northward up the East Coast. The most recent record is from Paradise, on the Avalon Peninsula, Newfoundland, in 2021. Inhabits wet meadows and lush grasslands. Very rare in the United Kingdom, but classified as of Least Concern for the species.

Common (Eurasian) Moorhen *Gallinula chloropus*
L 12" ♂ = ♀ COMO

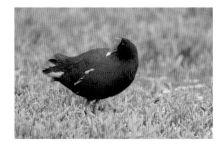

The Old World counterpart to our Common Gallinule. Formerly treated as conspecific. Summers from western Europe to East Asia. Winters southward. Nearest breeding population is in Iceland. A single North American record: Shemya Island, Aleutian Islands. Inhabits marshlands and lakeside wetlands. Not threatened.

Eurasian Coot *Fulica atra*
L 16" ♂ = ♀ EUCO

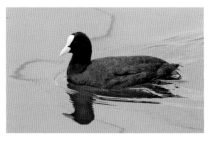

A widespread Eurasian species that also inhabits Australia and New Zealand. Nearest breeding population is in Iceland. Several North American records from Labrador, Quebec, and Newfoundland. All are December records. In addition, there are May records from the western Aleutian Islands and October and November records from the Pribilof Islands, Alaska.

Common Crane *Grus grus*
L 45" ♂ = ♀ CCRA

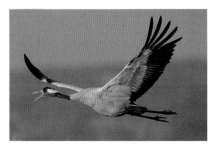

Widespread, ranging from western Europe to East Asia. Winters to southern Europe, Africa, and China. Typically North America receives a single stray per annum. These are mainly found in the West and Northwest as singletons embedded in flocks of Sandhill Cranes. These individuals have been known to pair with Sandhill Cranes to produce hybrid offspring. Perhaps most birds stray from East Asia.

Eurasian Oystercatcher *Haematopus ostralegus*
L 17" ♂ = ♀ EUOY

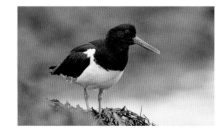

Widespread from western Europe to East Asia. Nearest breeding populations are from Iceland and Kamchatka, Russia. Three records from Newfoundland and one from Buldir Island, in the western Aleutian Islands, Alaska. Three of four records come from the spring.

European Golden-Plover *Pluvialis apricaria*
L 11" ♂ ≠ ♀ EUGP

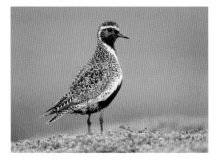

Summers from western Europe to central Siberia. Winters southward to the Mediterranean. Nearest breeding populations are in Greenland and Iceland. There are about 20 North American records, mainly from the Northeast (Delaware to Labrador). Atlantic Canada records come mainly from April and May, produced by strong storms in the Atlantic; Mid-Atlantic birds in late summer. There are also records from New Mexico and Alaska. The species is classed as Least Concern.

Eurasian Curlew *Numenius arquata*
L 22" ♂ = ♀ EUCU *NT

This large curlew summers from northern Europe to Siberia and northern China, wintering southward. Seven North American records, from Newfoundland south to Long Island, New York, and Florida; these range from autumn (September) to winter (February). These have all been coastal records. Breeds on bogs and fens. Winters as far as South Africa. Classified as Near Threatened.

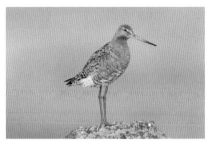

Black-tailed Godwit *Limosa limosa*
L 17" ♂ ≠ ♀ BLTG *NT

This bird, the sister species to our Hudsonian Godwit, summers from western Europe to East Asia and winters in Africa and Australia. Nearest breeding populations are in Iceland and far eastern Siberia. Stray migrants show up on the East Coast and Alaska. East Coast records are typically fewer than one per annum, mainly between April and August. Alaskan records are mainly in May and June.

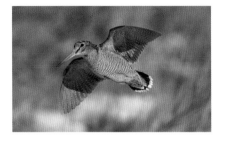

Eurasian Woodcock *Scolopax rusticola*
L 15" ♂ = ♀ EUWO

Summers across northern Eurasia. Winters southward to the Mediterranean (and to eastern China). Nearest breeding population is in Scotland. Substantially larger than our woodcock. Formerly a very rare visitor to the Northeast, with records from Newfoundland, Quebec, Pennsylvania, Ohio, and Alabama between 1859 and 1935. The most recent record is from Goshen, New Jersey, in 1956.

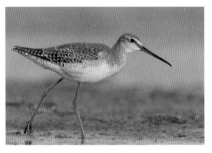

Spotted Redshank *Tringa erythropus*
L 13" ♂ = ♀ SPRE

Summers across Eurasia, from northern Europe to eastern Asia. Winters in Africa, South Asia, and Southeast Asia. Nearest breeding populations are in Iceland and northeastern Siberia. Strays to the East Coast, Great Lakes, West Coast, and islands off western Alaska (with perhaps 30 records for North America). East Coast records are mainly late summer to late autumn. Alaskan records in spring and autumn.

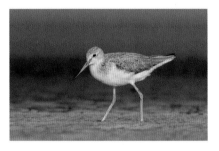

Common Greenshank *Tringa nebularia*
L 14" ♂ = ♀ COMG

Summers from northern Europe to eastern Siberia. Winters in Africa, southern Asia, and Australasia. Nearest breeding population is in Chukotka (northeastern Siberia), Russia. There are a handful of records from the Northeast (Atlantic Canada south to New Jersey, in spring and fall). More records from the islands of western Alaska (mainly in spring). Additional records from Florida and California.

Common Redshank *Tringa totanus*
L 11" ♂ = ♀ CREH

Summers from western Europe to East Asia. Winters to Africa and South and Southeast Asia. Nearest breeding population is in Iceland. A regular stray to Greenland. There is one winter record and several spring/summer records from Newfoundland. One in breeding plumage at Point Mouillee, Michigan in July 2022 is a real outlier.

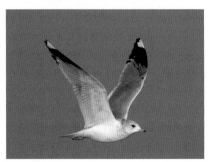

Common Gull *Larus canus*
L 18" ♂ = ♀ COGU

Summers from northern Europe to eastern Siberia. Formerly considered conspecific with the Short-billed Gull of North America (then known as the Mew Gull). The European-breeding subspecies *canus* is a rare annual visitor to Atlantic Canada and the East Coast south to North Carolina, the Great Lakes, and the Saint Lawrence valley. East Asian-breeding *kamtschatschensis* is a scarce visitor to Alaska and a rare visitor to northeastern North America.

Yellow-legged Gull *Larus michahellis*
L 24" ♂ = ♀ YLGU

This Herring Gull relative is a resident of western Europe, the Azores, the Canary Islands, and Turkey. It is an occasional winter visitor to Atlantic Canada (especially eastern Newfoundland, where there are about a dozen records). Also recorded from Washington, DC; Maryland; Virginia; and Texas (December and March).

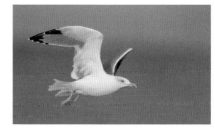

White-winged Tern *Chlidonias leucopterus*
L 10" ♂ = ♀ WWTE

This handsome relative of our Black Tern summers in central and eastern Europe, eastward to East Asia. Winters in Africa and Southeast Asia to Australia. Strays appear along the East Coast, from Newfoundland to South Carolina (mainly May–August). Also along the Saint Lawrence and Great Lakes, the West Coast, and western and southern Alaska. Apparently less frequent in the last two decades. Found in habitats similar to that of Black Tern—mainly lakes and marshlands.

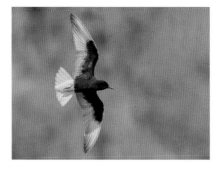

Whiskered Tern *Chlidonias hybrida*
L 11" ♂ = ♀ WHST

Summers patchily from southern Europe to East Asia. Winters southward to sub-Saharan Africa, southern Asia, and Australia. Also resident in southern Africa. Three records from Cape May, New Jersey. The 1993 bird moved to the eastern shore of Delaware, staying until late August.

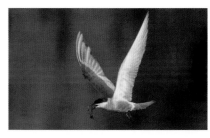

Gray Heron *Ardea cinerea*
L 40" ♂ = ♀ GRAH

Summers from western Europe to East Asia; northern birds winter southward. Resident populations also inhabit sub-Saharan Africa and South and Southeast Asia. Nearest breeding population is in Scotland. About 10 records from Newfoundland; additional records from the East Coast; several records from the islands of western Alaska. Eastern records year-round. Western records from April and October.

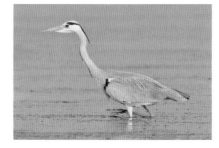

Little Egret *Egretta garzetta*
L 26" ♂ = ♀ LIEG

Ranges patchily from western Europe to East Asia; also resident in sub-Saharan Africa, South and Southeast Asia, and Australasia. Breeds in the Lesser Antilles. Strays to the East Coast have been recorded from Newfoundland to North Carolina. East Coast records from April to December. Also along the Saint Lawrence (May–October). One record from the western Aleutian Islands, Alaska.

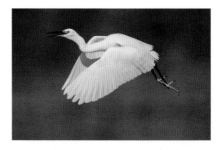

Western Reef-Heron *Egretta gularis*
L 25" ♂ = ♀ WERH

Resident from West Africa to eastern India. Six East Coast records (1983, 2005, 2006, 2007) of dark-morph individuals, ranging from northern New Jersey to Newfoundland. These may represent only several wandering individuals. Frequents tidal flats and beaches—with a strong coastal orientation. The species is classed as Least Concern.

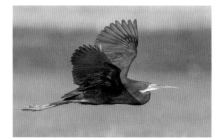

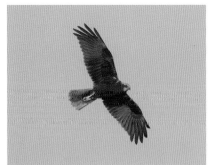

Western (Eurasian) Marsh Harrier *Circus aeruginosus*
L 22" ♂ ≠ ♀ WMHA

This relative of our Northern Harrier breeds from Europe to central Asia and winters to Africa and India. The first accepted North American record comes from coastal Maine in August 2022. Perhaps this same bird was struck and killed by a commercial aircraft in northern New Jersey in November 2022. There is also a sight record from Chincoteague National Wildlife Refuge, Virginia, on 4 December 1994.

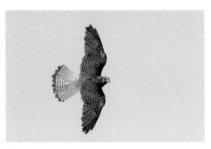

Eurasian Kestrel *Falco tinnunculus*
L 14" ♂ ≠ ♀ EUKE

This small falcon, something akin to the Old World's version of our American Kestrel, is widespread through Eurasia and Africa. Nearest breeding population is in eastern Siberia. There are East Coast records from Atlantic Canada, Massachusetts, New Jersey, and Florida. West Coast records come from British Columbia, Washington, and California. Five Alaskan records from the western Aleutian Islands.

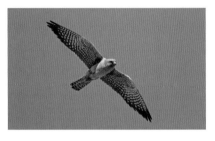

Red-footed Falcon *Falco vespertinus*
L 13" ♂ ≠ ♀ RFFA *VU

This slim and gregarious falcon with highly migratory habits summers from eastern Europe to central Siberia. It winters in southern Africa. The single North America record was a first-summer male at Martha's Vineyard, Massachusetts, in 2004. Prefers open habitats with trees. Diet is arthropods and small vertebrates. Vulnerable.

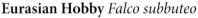

Eurasian Hobby *Falco subbuteo*
L 12" ♂ = ♀ EHOB

Summers from western Europe to eastern Siberia. Nearest breeding population is in Kamchatka, Russia. There are East Coast records from Newfoundland and Massachusetts (in spring). West Coast records come from British Columbia and Washington (in autumn). Alaskan records come from the western Aleutian Islands and the Bering Sea region. One additional record is from Nome, Alaska.

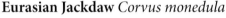

Eurasian Jackdaw *Corvus monedula*
L 13" ♂ = ♀ EUJA

Ranges from western Europe to central Asia. Records from the Northeast: Newfoundland, Quebec, Ontario, Massachusetts, Connecticut, and Pennsylvania. Most records (possibly ship-assisted) from the 1980s. Most recent record is from Newfoundland in 1999. No records since. Inhabits all sorts of open country in Eurasia.

Mistle Thrush *Turdus viscivorus*
L 11" ♂ = ♀ MITH

This large spot-breasted thrush ranges from western Europe to central Asia. Nearest breeding population is in Scotland. The single North American record comes from Miramichi, New Brunswick, December 2017–March 2018. Prefers openings in woodlands. The species is in slight decline in Eurasia, but considered of Least Concern.

Eurasian Blackbird *Turdus merula*
L 11" ♂ = ♀ EUBB
Ranges from western Europe to central Asia. Nearest breeding population is on Iceland. Quite a few strays to Greenland. North American records come from Newfoundland, Quebec, and Ontario (April and December).

Fieldfare *Turdus pilaris*
L 10" ♂ = ♀ FIEL
Breeds from northern Europe to east-central Siberia. Winters southward. Nearest breeding population is in southern Greenland. Most North American records come from Atlantic Canada, Saint Lawrence valley, and the East Coast, south to Delaware. Additional records from Saskatchewan, British Columbia, and Alaska (Saint Lawrence Island and Utqiagvik).

Redwing *Turdus iliacus*
L 8" ♂ = ♀ REDW *NT
Summers from northern Europe to northeastern Siberia. Winters southward in Europe and in western Asia. Nearest breeding population is in Iceland. Most North American records come from Atlantic Canada. There are also records from Maine, New Hampshire, New York, Pennsylvania, Washington, British Columbia, and Alaska.

Song Thrush *Turdus philomelos*
L 9" ♂ = ♀ SOTH
Summers from western Europe to central Siberia. Winters in North Africa and West Asia. Three North American records: Quebec and Alaska (Pribilof Islands and Utqiagvik). Breeds in forest and woodland of all types. Diet is invertebrates and fruit. Northern breeding populations are migratory. The species is classed as Least Concern.

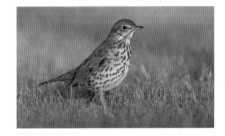

European Robin *Erithacus rubecula*
L 6" ♂ = ♀ EURO
Ranges from western Europe to central Asia. Winters in North Africa and West Asia. First North American record comes from Bucks County, Pennsylvania (2015). Two birds were photographed in Broward County, Florida (2018, 2022), one clearly was ship-assisted.

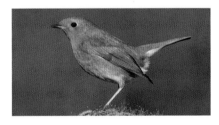

Citrine Wagtail *Motacilla citreola*
L 7" ♂ ≠ ♀ CIWA
Summers from eastern Europe to western China and central Siberia. Winters in South and Southeast Asia. North American records from Mississippi, British Columbia, California, and Alaska.

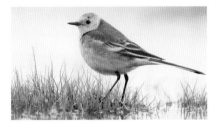

Common Chaffinch *Fringilla coelebs*
L 6" ♂ ≠ ♀ CCHA
Ranges from western Europe to central Asia. Northern populations winter southward. Several North American records come from the Northeast—from Newfoundland to Massachusetts. Also records from Wisconsin, Quebec, and Alaska. The first wo of these are possibly escapes from captivity, as this is a popular cage bird.

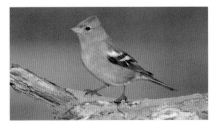

Opposite: A solitary crane settles into a marsh at sunset. Right: Steller's Sea-Eagle soars over snowy mountains. In 2022 and 2023, an errant individual visited various sites in Maine and Atlantic Canada, attracting legions of eager birders wishing to add this magnificent raptor to their life lists.

Lesser White-fronted Goose *Anser erythropus*

L 24" ♂ = ♀ LWFG *VU

This smaller white-front species breeds in northern Eurasia, from Scandinavia to northeastern Siberia. Nearest breeding population is in Chukotka, Russia. Records from North America: Attu Island, western Aleutian Islands, Alaska; and Pribilof Islands, Alaska.

Taiga Bean-Goose *Anser fabalis*

L 33" ♂ = ♀ TABG

A dark Eurasian goose, larger than the Tundra Bean-Goose. Breeds from Scandinavia to eastern Siberia; winters in Europe, China, and Japan. North American records from Alaska (western Aleutian Islands, Pribilof Islands, and Saint Lawrence Island), the Yukon, and the West Coast (British Columbia and Washington).

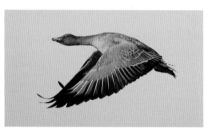

Tundra Bean-Goose *Anser serrirostris*

L 30" ♂ = ♀ TUBG

A dark Eurasian goose, smaller than the Taiga Bean-Goose. Summers in northern Russia from western Siberia to Chukotka. Winters south to central and eastern Europe and East Asia. There more than a dozen records from Alaska. Also a few records from the West Coast, the Interior, and the Northeast.

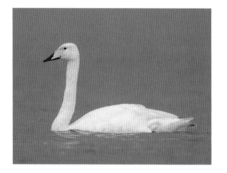

Whooper Swan *Cygnus cygnus*

L 59" ♂ = ♀ WHOS

A large Eurasian swan. Summers from northern Europe to eastern Siberia. Also breeds on Iceland. Winters southward. Most North American records come from Alaska: the Aleutian Islands, the Bering Sea Islands, and mainland Alaska. Has bred on Attu Island (western Aleutians). There are also about a dozen records from the West and a half dozen records from the Northeast and Atlantic Canada. This is a popular bird in aviculture, so many of these records may refer to escapees.

Baikal Teal *Sibirionetta formosa*

L 16" ♂ ≠ ♀ BATE

Reminiscent of the Falcated Duck, this freshwater dabbler breeds in central and eastern Siberia and winters in East Asia. Most North American records come from the western Aleutian Islands, Alaska; additional sightings from the Pribilof Islands, mainland Alaska, and the West Coast, as well as Montana and Arizona.

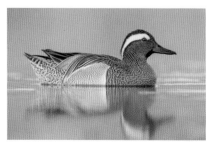

Garganey *Spatula querquedula*

L 16" ♂ ≠ ♀ GARG

Summers from western Europe through Siberia to Kamchatka. Winters in southern Asia and Africa. North American records widespread, from Alaska to the Northeast. Typically several sightings per annum, mainly in the spring, but numbers have declined, probably because of declines of the species in Eurasia.

Falcated Duck *Mareca falcata*

L 20" ♂ ≠ ♀ FADU *NT

Summers across central and northeastern Asia to Kamchatka, Russia. Winters in India, China, and Japan. This East Asian duck strays to the Aleutian and Pribilof Islands, western mainland Alaska, and less frequently to the West Coast. Fewer than 10 records every decade. Breeds on lakes and other interior waters. Classed as Near Threatened.

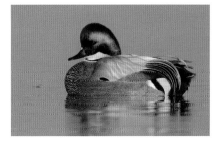

Eastern Spot-billed Duck *Anas zonorhyncha*

L 22" ♂ = ♀ ESBD

This Mallard relative ranges across East Asia and northern Southeast Asia. Nearest breeding population is on Sakhalin Island, Russia. There are North American records in May, September, and November from Attu, Adak, and Kodiak Islands, Alaska. Inhabits freshwater marshes, lakes, and rivers. The species is apparently in decline.

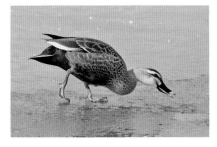

Common Pochard *Aythya ferina*

L 18" ♂ ≠ ♀ COMP

This Eurasian bay duck looks much like our Redhead, which is a close relative. Breeds from western Europe to the interior of East Asia. Winters in Africa and South and Southeast Asia as well as Japan. North American records come from Alaska—the Aleutian Islands, Bering Sea Islands, and southwestern mainland Alaska—and the West Coast south to California.

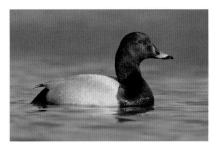

Stejneger's Scoter *Melanitta stejnegeri*

L 21" ♂ ≠ ♀ STSC

Nearly identical to our White-winged Scoter; adult males can be distinguished by the bulbous nostrils, bill coloring and black flanks. North American records include the Aleutian Islands, Pribilof Islands, Chukchi Sea, and mainland Alaska; also Montana. Now known to be regular in northwestern Alaska in summer, mixing in with White-winged Scoters at Nome.

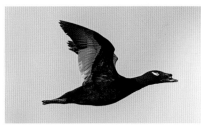

Smew *Mergellus albellus*

L 16" ♂ ≠ ♀ SMEW

A diminutive pied merganser of Eurasia. Breeds from Scandinavia to eastern Siberia. Winters in central and eastern Europe and coastal East Asia. North American records: western Aleutian Islands, Pribilof Islands, Saint Lawrence Island, Kodiak Island, and mainland Alaska; also British Columbia south to California. Great Lakes and East Coast records problematic because the species is popular in aviculture.

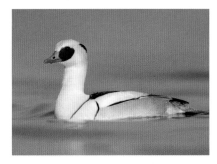

Oriental Turtle-Dove *Streptopelia orientalis*

L 13" ♂ = ♀ ORTD

Slightly larger and stockier than our Mourning Dove, this species ranges from central and South Asia to East and Southeast Asia. Nearest breeding population is on Sakhalin Island, Russia. North American records include Aleutian Islands, Pribilof Islands, and Saint Lawrence Island, Alaska, as well as a few West Coast records south to California. The species is not under threat.

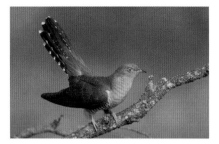

Common Cuckoo *Cuculus canorus*

L 13" ♂ ≠ ♀ COCU

This cuckoo summers from western Europe to eastern Siberia. Winters in Africa and southern Asia. Nearest breeding population is in eastern Siberia. North American records: mainly from the Aleutian and Bering Sea Islands in Alaska (May, June, July, and September) and coastal mainland Alaska (June, July, and September), plus central California (October), and the East (May, September, November).

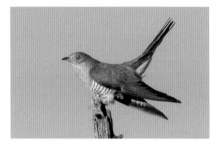

Oriental Cuckoo *Cuculus optatus*

L 13" ♂ ≠ ♀ ORCU

This species is virtually identical to the Common Cuckoo. Summers from western Russia to eastern Siberia; winters south to Southeast Asia, New Guinea, and Australia. Nearest breeding population is in eastern Siberia. There are a handful of records from the Aleutian and Bering Sea Islands, Alaska. Records from May to August.

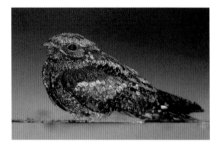

Gray Nightjar *Caprimulgus jotaka*

L 13" ♂ ≈ ♀ GRNI

Summers from the Himalayas to East Asia. Winters in Southeast Asia. A single North American record: Buldir Island, western Aleutian Islands, Alaska, May 1977. Inhabits a wide range of woodlands and edge habitats. Has also strayed to New Guinea and Australia. Formerly considered a subspecies of the Jungle Nightjar. Not under threat.

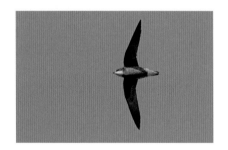

White-throated Needletail *Hirundapus caudacutus*

L 8" ♂ = ♀ WTNE

This large and fast-flying swift breeds in the Himalayas and central and East Asia, wintering in Australasia. North American records come from the western Aleutian Islands (May) and Pribilof Islands (June–July) of Alaska. Wide-ranging and found in a diversity of habitats, foraging over rainforests as well as sparsely vegetated uplands.

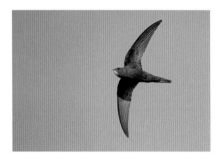

Common Swift *Apus apus*

L 7" ♂ = ♀ COSW

This species summers from western Europe to East Asia. Winters in southern Africa. North American records include three June records from the Pribilof Islands, Alaska; a July record from Seguam Island in the Aleutian Islands, Alaska; an October record from Southern California; several records (May, June, and July) from Newfoundland and St. Pierre and Miquelon; a May record from Montreal, Quebec; and an October record from the Outer Banks, North Carolina.

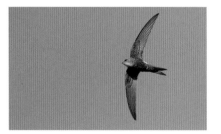

Fork-tailed (Pacific) Swift *Apus pacificus*

L 8" ♂ = ♀ FTSW

This large swift breeds through the Himalayas, central Asia, China, and eastern Siberia, wintering in Southeast Asia and Australia. Quite a few records from the Alaska region: the Aleutian Islands, Bering Sea Islands, Middleton Island, and mainland Alaska. Some of the insular records constituted groups of 20–30 individuals.

Hooded Crane *Grus monacha*

L 39" ♂ = ♀ HOCR *VU

Summers in eastern Russia and northeastern China. Winters in eastern China. Several North American records: Alaska, Nebraska, Tennessee, Indiana, and Idaho. A single roaming individual may be responsible for several of these state records.

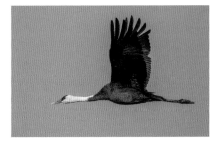

Black-winged Stilt *Himantopus himantopus*

L 14" ♂ = ♀ BWST

Summers from Europe to central Asia; winters in North Africa and Southeast Asia. Additional resident populations range through sub-Saharan Africa, South and Southeast Asia, and Australasia. Three records from Alaska: two from the western Aleutian Islands—Nizki Island and Shemya Island, and an additional record from Saint George, Pribilof Islands.

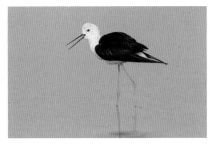

Eurasian Dotterel *Charadrius morinellus*

L 8" ♂ ≈ ♀ EUDO

Summers from northern Europe to northeastern Siberia and central Asia. Winters in North Africa and West Asia. Has bred sparingly in northwestern Alaska (Seward Peninsula and Saint Lawrence Island). Formerly a regular migrant and stray to North America, though there are few recent records (Shemya Island, western Aleutian Islands, Alaska, in 2005, and Bruce Peninsula, Ontario, in 2015).

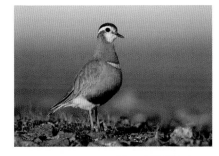

Little Ringed Plover *Charadrius dubius*

L 7" ♂ = ♀ LRPL

Summers from western Europe and North Africa to Northeast Asia. These birds winter to sub-Saharan Africa and East and Southeast Asia. Additional resident breeding populations inhabit South Asia, mainland Southeast Asia, the Philippines, and New Guinea. North American records come from the western Aleutian Islands, Alaska (Attu Island and Shemya Island).

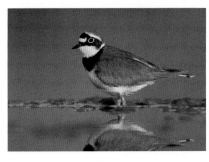

Greater Sand-Plover *Charadrius leschenaultii*

L 10" ♂ ≠ ♀ GSAP

Summers from Turkey east to interior East Asia. Winters in East Africa, West Asia, South and Southeast Asia, and Australasia. Two North American records: Bolinas Lagoon, California; and Duval County, Florida. Breeds in interior deserts. Winters to coastlines. Classified as Least Concern by the Red List.

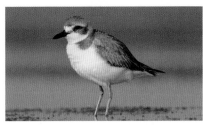

Little Curlew *Numenius minutus*

L 12" ♂ = ♀ LICU

This diminutive and short-billed curlew summers in north-central and northeastern Siberia, wintering in Australasia. There are five North American records from two locations: Saint Lawrence Island, Alaska; and central California. Foraging birds frequent shortgrass fields.

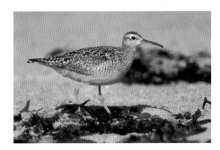

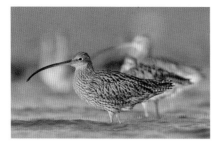

Far Eastern Curlew *Numenius madagascariensis*

L 25" ♂ = ♀ FECU *EN

This largest of the curlews summers in interior East Asia to Kamchatka, Russia, wintering in Australasia. There are more than a dozen records from the western Aleutian Islands in Alaska (May and June) and additional records from the Pribilof Islands in Alaska (May and June), southwest mainland Alaska (July), Yukon (July), and Vancouver, British Columbia (September).

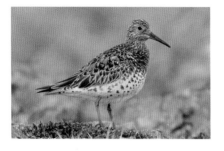

Great Knot *Calidris tenuirostris*

L 11" ♂ = ♀ GRKN *EN

This, the Asian counterpart to our Red Knot, summers in eastern Siberia and winters in Southeast Asia and Australasia. North American records: the Aleutian and Bering Sea Islands and mainland western Alaska (in spring); also Oregon, West Virginia, and Maine (in July, August, and September). A species in substantial decline, mainly from the Asian harvest during migration. Classified as Endangered.

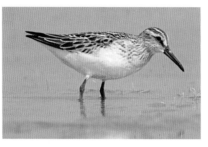

Broad-billed Sandpiper *Calidris falcinellus*

L 7" ♂ = ♀ BBIS

Summers from Scandinavia to northeastern Siberia. Winters southward to coastal Africa, Asia, and Australasia. Western North American records come from the western Aleutian and Pribilof Islands of Alaska. East Coast records come from Massachusetts and New York. All records from August and September.

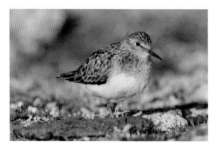

Temminck's Stint *Calidris temminckii*

L 6" ♂ = ♀ TEST

Summers across northern Eurasia, from Scandinavia to northeastern Siberia. Winters in Africa and South and Southeast Asia. North American records come from Alaska—the western Aleutian Islands, the Pribilof Islands, and Saint Lawrence Island (May, June, August, and September), as well as the North Slope of Alaska (June–July)—as well as British Columbia and Washington (autumn).

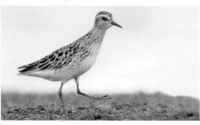

Long-toed Stint *Calidris subminuta*

L 6" ♂ = ♀ LTST

This counterpart to our Least Sandpiper summers from central Asia to eastern Siberia and the Kuril Islands. Winters in South and Southeast Asia and Australia. North American records come from the Aleutian and Bering Sea Islands of Alaska, coastal Alaska, coastal Oregon, and California (May, June, July, August, and September).

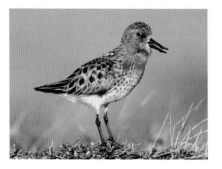

Spoon-billed Sandpiper *Calidris pygmea*

L 6" ♂ = ♀ SBSA *CR

Summers from Chukotka to northern Kamchatka (eastern Siberia). Winters in coastal Southeast Asia. As of 2022, the species population hovered around 500 in the wild. North American records come from Attu Island, western Aleutian Islands, Alaska; Pribilof Islands, Alaska; Utqiagvik, Alaska; Wainwright, Alaska; and British Columbia. Birds now are being captive-bred.

Little Stint *Calidris minuta*
L 6" ♂ = ♀ LIST

Summers coastally across northern Eurasia. Winters in Africa and South Asia. North American records come from the Aleutian and Bering Sea Islands of Alaska, the North Slope of Alaska, and the Pacific Coast from Anchorage, Alaska, to Southern California. Also a handful of records from the Interior and more than a dozen records from the East Coast, ranging from South Carolina to Newfoundland. Size and shape closest to Semipalmated Sandpiper. Classified as Least Concern.

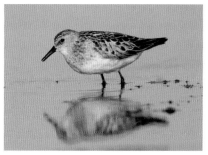

Jack Snipe *Lymnocryptes minimus*
L 7" ♂ = ♀ JASN

This diminutive snipe summers across northern Eurasia, wintering in western Europe, Africa, and South Asia. North American records come from Alaska—the Pribilof Islands, Saint Lawrence Island, and south-west coastal Alaska—Oregon, California, Newfoundland, and Labrador. Records from spring, autumn, and winter.

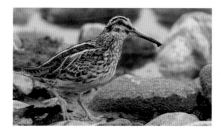

Solitary Snipe *Gallinago solitaria*
L 12" ♂ = ♀ SOSN

Ranges from central Asia to eastern Siberia (Kamchatka). Winters locally and to coastal East Asia. North American records: Attu Island, western Aleutian Islands, Alaska; and Saint Paul Island, Pribilof Islands, Alaska.

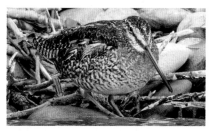

Pin-tailed Snipe *Gallinago stenura*
L 10" ♂ = ♀ PTSN

Summers across Siberia nearly to the Bering Sea. Winters in South and Southeast Asia. There are three spring specimen records from Attu Island, the Aleutian Islands, Alaska. Records documented by photograph come from St. Paul Island in the Pribilofs. Additional uncon-firmed Alaskan sight records come from Attu, the Pribilof Islands, and Saint Lawrence Island. Field identification of this species is fraught because of other near-identical species (e.g., Swinhoe's Snipe).

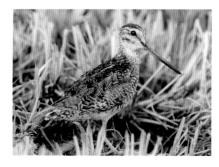

Common Snipe *Gallinago gallinago*
L 11" ♂ = ♀ COSN

Summers from western Europe to eastern Siberia. Reported to have bred in the western Aleutian Islands. Winters in Africa and South and Southeast Asia. Most North American records come from the Aleutian and Pribilof Islands of Alaska. Additional records from Saint Lawrence Island and Utqiagvik, Alaska, as well as California, Newfoundland, and Labrador.

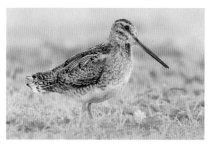

Terek Sandpiper *Xenus cinereus*
L 9" ♂ = ♀ TESA

This sandpiper with the distinctive recurved bill and hyperactive foraging style summers from Scandinavia to eastern Siberia. Winters coastally to Africa, Asia, and Australia. Most North American records come from the Aleutian and Bering Sea Islands of Alaska. There are additional records from Anchorage, Alaska, south to California. The three East Coast records come from Massachusetts to Virginia.

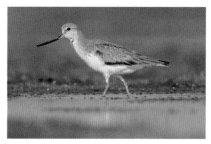

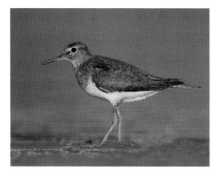

Common Sandpiper *Actitis hypoleucos*

L 8" ♂ = ♀ COSA

This Old World counterpart to our Spotted Sandpiper summers from Europe to eastern Siberia. Winters south to Africa, southern Asia, and Australasia. Most North American records come from Alaska: the western Aleutian Islands, Pribilof Islands, and Saint Lawrence Island. Additional records come from the central Aleutian Islands and the Seward Peninsula and Utqiagvik (Barrow), on the Alaska mainland. The species has nested on Attu Island, western Aleutians, Alaska.

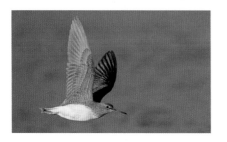

Green Sandpiper *Tringa ochropus*

L 9" ♂ = ♀ GRSA

Summers across northern Eurasia to the Russian Far East. Winters in Europe, Africa, and South and Southeast Asia. It is a spring vagrant to Alaska—the western Aleutian Islands, the Pribilof Islands, and Saint Lawrence Island. Apparently the Old World sister species to our Solitary Sandpiper. The species is not globally threatened.

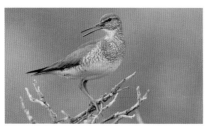

Gray-tailed Tattler *Tringa brevipes*

L 10" ♂ = ♀ GTTA *NT

This bird, a close relative of our Wandering Tattler, summers in western and far eastern Siberia. Winters in Southeast Asia and Australasia. It is an annual visitor to western Alaska. Additional records come from British Columbia, California, Florida, Maine, and Massachusetts. Records from May, June, July, August, September, and October.

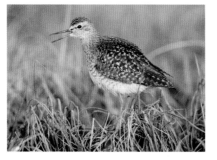

Wood Sandpiper *Tringa glareola*

L 8" ♂ = ♀ WOSA

Summers across northern Eurasia to eastern Siberia and Kamchatka. Winters in Africa, South and Southeast Asia, and Australasia. Has bred in the Aleutian Islands, Alaska, a region for which there are a substantial number of sight records. Also recorded from islands in the Bering Sea, various coastal points on mainland Alaska. There are clusters of records from the West Coast and the coastal Northeast. One Interior West record from Montana.

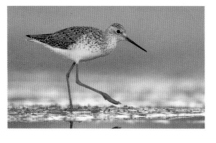

Marsh Sandpiper *Tringa stagnatilis*

L 9" ♂ = ♀ MASA

Summers from eastern Europe to central Asia. Winters in Africa, South Asia, and Australia. Several Alaskan records from the Aleutian Islands in autumn; additional records from the Pribilof Islands. In addition, multiple records from Hawaii and California; also a record from Ontario. This is quite similar to the Green and Wood Sandpipers.

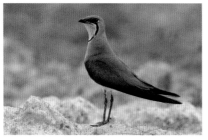

Oriental Pratincole *Glareola maldivarum*

L 10" ♂ = ♀ ORPR

This bird, which looks like a cross between a shorebird and a swallow, summers in China, Southeast Asia, and the northern India. It winters in South and Southeast Asia and Australia. North American records are from Alaska: Attu Island, western Aleutians; and Saint Lawrence Island, northern Bering Sea.

Pallas's Gull *Ichthyaetus ichthyaetus*
L 28" ♂ = ♀ PAGU

Summers from western Russia to central Asia. Winters south to the coasts of northeastern Africa (Red Sea), West Asia, and South Asia. A single North American record comes from Shemya Island, western Aleutian Islands, Alaska. Also known as Great Black-headed Gull. Second in size to Great Black-backed Gull. Diet is mainly fish and crustaceans. Classified as of Least Concern.

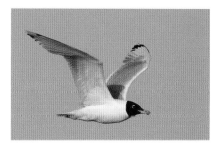

Black-tailed Gull *Larus crassirostris*
L 19" ♂ = ♀ BTGU

Summers along coastal East Asia. Winters southward into coastal China. A rare visitor to coastal and insular Alaska. Additional records are scattered down the West Coast to Southern California. There are also records from the East Coast between Newfoundland and North Carolina and a handful of records from the Interior.

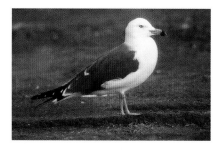

Yellow Bittern *Ixobrychus sinensis*
L 16" ♂ = ♀ YEBI

This diminutive bittern summers across East Asia. These birds winter to insular Southeast Asia and the New Guinea region. Also is resident through South and Southeast Asia. Known from North America from a single record: Attu Island, western Aleutian Islands, Alaska. An Asian counterpart to our Least Bittern.

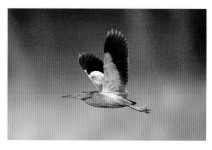

Intermediate Egret *Ardea intermedia*
L 27" ♂ = ♀ INEG

This smaller version of our Great Egret is resident of sub-Saharan Africa, South and Southeast Asia, and Australasia. There are North American records from the Aleutian Islands of Alaska: Buldir Island, and Shemya Island. The English name for this middling bird is appropriate though perhaps uninspired.

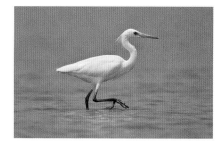

Chinese Egret *Egretta eulophotes*
L 27" ♂ = ♀ CHEG *VU

This declining egret has a tiny summer range that is confined to the coasts of Korea and northeastern and eastern China. May also breed in the Russian Far East. Winters in Southeast Asia. There is a single specimen record from North America: Agattu Island, western Aleutian Islands, in 1974. Classed at Vulnerable.

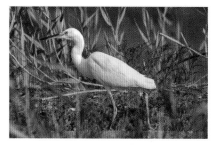

Chinese Pond-Heron *Ardeola bacchus*
L 18" ♂ ≈ ♀ CHPH

Breeds in China. Winters in Southeast Asia. Three Alaskan insular records, all of breeding plumage adults: Pribilof Islands; Attu Island, western Aleutian Islands; and Saint Lawrence Island, northern Bering Sea. Frequents flooded fields, swamps, and other wetlands. Classified as Least Concern.

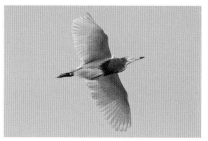

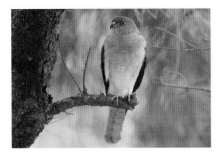

Chinese Sparrowhawk *Accipiter soloensis*
L 14" ♂ = ♀ CHIS

This diminutive Asian accipiter summers across Korea and eastern China. Winters in Southeast Asia and western New Guinea. A single unsubstantiated North American record comes from Nizki Island, western Aleutian Islands, Alaska, in 1995. Hunts open country for insects, frogs, reptiles, and small birds. Some times called the Frog Hawk. Classified as of Least Concern.

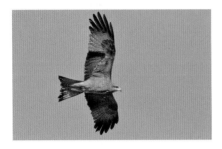

Black Kite *Milvus migrans*
L 24" ♂ = ♀ BLAK

Summers from western Europe to southeastern Siberia. Resident in Africa, South and Southeast Asia, and Australasia. The single North American record comes from the Pribilof Islands, Alaska. Additional New World records from the Caribbean. A commonplace open country raptor across the Old World. Northern populations are migratory. The species is classified as of Least Concern.

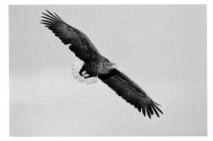

White-tailed Eagle *Haliaeetus albicilla*
L 36" ♂ = ♀ WTEA

Summers from western Europe to eastern Siberia, including Iceland and southern Greenland. Winters southward. Nearest breeding population is in eastern Siberia. Various Alaskan records from the Aleutian Islands, Pribilof Islands, Saint Lawrence Island, and Kodiak Island. Probably nested on Attu Island from the 1970s to the late 1990s. Also a record from the Lower 48: Oswego County, New York, in 1993.

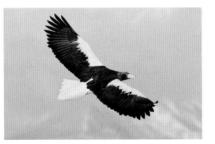

Steller's Sea-Eagle *Haliaeetus pelagicus*
L 41" ♂ = ♀ STSE *VU

Breeds in coastal northeastern Russia, including Kamchatka. Winters in northern Japan and Korea. About a dozen records from Alaska, from the Aleutian Islands to Juneau (records from January to November). A recent set of East Coast records, apparently of a single adult bird, ranged from Quebec to Texas in 2021–2023. The species is classified as Vulnerable.

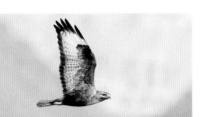

Long-legged Buzzard *Buteo rufinus*
L 26" ♂ = ♀ LLBU

Breeds from North Africa and southeastern Europe to central Asia. Winters southward. There is a single Alaskan record from the Pribilof Islands, in 2019. The species is classified as Least Concern. Inhabits steppe and open country. Diet is small mammals.

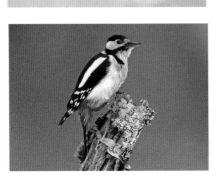

Great Spotted Woodpecker *Dendrocopos major*
L 9" ♂ ≠ ♀ GSWO

This black-and-white bird somewhat resembling our Hairy Woodpecker is resident from western Europe and northwestern Africa to eastern Siberia and China. Nearest breeding population is in Kamchatka, Russia. Ten records from Alaska: the western Aleutian Islands, the Pribilof Islands, and the mainland from near Anchorage north to Talkeetna.

Oriental Scops-Owl *Otus sunia*

L 8" ♂ = ♀ ORSO

This screech-owl look-alike ranges from South and Southeast Asia to Northeast Asia. Northern populations winter to Southeast Asia. Two records come from the western Aleutian Islands, Alaska: Buldir Island and Amchitka Island. This is one of the most widespread owls on Earth. Classified as of Least Concern.

Northern Boobook *Ninox japonica*

L 13" ♂ = ♀ NOBB

This very slim and large-eyed owl breeds across East Asia, wintering in Southeast Asia. Two Alaskan records: Pribilof Islands; and Kiska Island, Aleutian Islands. In flight has the look of an accipiter or small falcon. This is a member of a species-rich genus from Asia and Australasia. Population stable. This is the most widespread of the hawk-owls in the genus *Ninox*.

Eurasian Hoopoe *Upupa epops*

L 11" ♂ = ♀ EHOO

This fantastic bird breeds from western Europe and Africa to South, East, and Southeast Asia. Several North American records from Alaska: Yukon-Kuskokwim Delta; Chukchi Sea; and Pribilof Islands. Without doubt, this is one of the most desired species for first-time birders in Eurasia.

Eurasian Wryneck *Jynx torquilla*

L 6" ♂ = ♀ EUWR

This strange woodpecker relative breeds from Europe to East Asia, wintering in sub-Saharan Africa and South and Southeast Asia. Several autumn records from Alaska: Cape Prince of Wales and Saint Lawrence Island (two records). In addition, there is a record from San Clemente Island, California, in 2017.

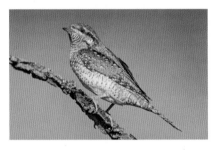

Brown Shrike *Lanius cristatus*

L 8" ♂ ≈ ♀ BROS

Summers from central Asia and eastern China to northeastern Siberia. Winters in South and Southeast Asia. Various North American records: the western Aleutian Islands (June–July), the Pribilof Islands (September–October), Saint Lawrence Island (September), and mainland Alaska (September); British Columbia (October); California (January–December); and Nova Scotia (November–December).

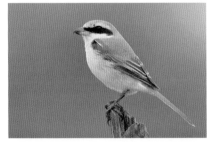

Red-backed Shrike *Lanius collurio*

L 7" ♂ ≠ ♀ RBSH

Ranges from western Europe to central Asia. Winters in southern Africa. Two North American records: Saint Lawrence Island, northern Bering Sea, Alaska; and Powell River, British Columbia. Inhabits open terrain with brushes and shrubs for hunting perches. Classed as not under threat.

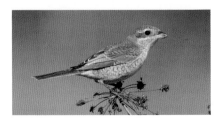

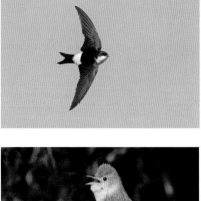

Common House-Martin *Delichon urbicum*

L 6" ♂ = ♀ COHM

Summers from western Europe and northwestern Africa to central Asia. Winters in sub-Saharan Africa and southernmost India. All but one North American record is from Alaska: the Pribilof Islands (June, August, and September), Saint Lawrence Island (six records, May, June, September), and Nome (June). Also St. Pierre et Miquelon (Atlantic Canada) in May.

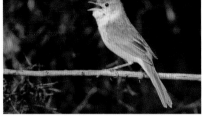

Thick-billed Warbler *Arundinax aedon*

L 7" ♂ = ♀ TBWA

This large and plain Old World warbler summers from central Asia to eastern Siberia. Winters in South and Southeast Asia. A single North American record: Saint Lawrence Island, northern Bering Sea, Alaska. Favors brushy habitats of all sorts, including gardens and roadsides. Winters in marshy wetlands. Population appears stable. Forages in shrubbery, taking arthropods of various sorts.

Icterine Warbler *Hippolais icterina*

L 6" ♂ = ♀ ICWA

Summers from central Europe eastward to southwestern Siberia and northern Kazakhstan. Winters to south-central and southern Africa. A single North American record: Saint Lawrence Island, northern Bering Sea, Alaska. A notable vocalist. Inhabits a variety of woodland types. Forages from the ground up into the woodland vegetation, sometimes chasing insects in the air.

Sedge Warbler *Acrocephalus schoenobaenus*

L 5" ♂ = ♀ SEWA

Summers from western and northern Europe to central Siberia. Winters in sub-Saharan Africa. Two records from North America, both from Saint Lawrence Island, northern Bering Sea, Alaska. Favors dense low vegetation, often in association with water. Forages low in thick shrubbery, sometimes on the ground. Classified as not under threat.

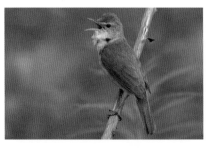

Blyth's Reed Warbler *Acrocephalus dumetorum*

L 5" ♂ = ♀ BREW

Summers from northern Europe to western Asia and central Siberia. Winters in South and Southeast Asia. Several records for North America: all from Saint Lawrence Island, northern Bering Sea, Alaska. An excellent vocalist, heard mainly at night. Favors a variety of habitats: shrublands, woodland edge, orchards, and the like. Forages primarily in low vegetation. Not under threat.

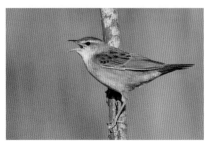

Pallas's Grasshopper Warbler *Helopsaltes certhiola*

L 6" ♂ = ♀ PGWA

Summers from central Asia to eastern China and northeastern Siberia. Winters in South and Southeast Asia. A single North American record: Saint Lawrence Island, northern Bering Sea, Alaska. Breeds in meadows, riverside grass, moist boreal woodland and brushy steppe. In winter frequents swamps and marsh grass.

Middendorff's Grasshopper Warbler *Helopsaltes ochotensis*

L 6" ♂ = ♀ MGRW

Summer range confined to northern Japan and eastern coastal Russia, including Kamchatka. Winters in the Philippines and northern Malaysia. All North American records come from insular Alaska: the western Aleutian and Pribilof Islands and Saint Lawrence Island (northern Bering Sea). Records from May, June, July, and September.

Lanceolated Warbler *Locustella lanceolata*

L 5" ♂ = ♀ L

Summers from Finland east to northeast Siberia and Kamchatka, Russia. Winters in the Himalayas and Southeast Asia. North American records come mainly from insular Alaska: the western Aleutian Islands (mainly Attu), Pribilof Islands, and Saint Lawrence Island. Records from September, July, August, and May and June. Bred on Buldir Island, western Aleutians, in 2007. Also a record from the Farallon Islands, California, in 1995.

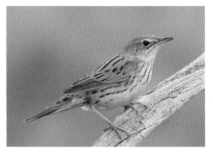

River Warbler *Locustella fluviatilis*

L 6" ♂ = ♀ RIWA

This secretive Old World warbler summers across central and eastern Europe. Winters in southeastern Africa. A single North American record comes from Saint Lawrence Island, northern Bering Sea, Alaska. Population appears stable.

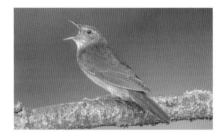

Willow Warbler *Phylloscopus trochilus*

L 4" ♂ = ♀ WILW

Summers from western Europe to eastern Siberia. Winters in sub-Saharan Africa. Most North American records come from insular Alaska in August and September: the western Aleutian Islands, the Pribilof Islands, and Saint Lawrence Island (northern Bering Sea). Also a California record (October). Breeds in forest with birch or willow as prominent tree species. Widespread in any wooded habitat during migration. Not under threat.

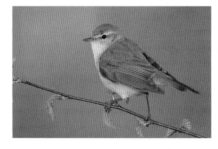

Common Chiffchaff *Phylloscopus collybita*

L 5" ♂ = ♀ CCHI

Summers from western Europe to central Russia. Winters in northern Africa, Arabia, and South Asia. Three Alaskan records (June, July, and September): Pribilof Islands, Saint Lawrence Island in the northern Bering Sea, and Utqiagvik (Point Barrow). Inhabits woodlands, parks, and hedgerows. Not under threat. Very similar to preceding species.

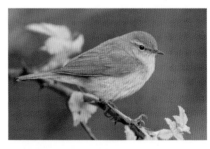

Wood Warbler *Phylloscopus sibilatrix*

L 5" ♂ = ♀ WOWA

Summers from western Europe to central Russia. Winters in central Africa. Alaskan records come from four insular locations (September and October): the western Aleutian Islands, the Pribilof Islands, Saint Lawrence Island, and Middleton Island. One California record (October). Winters in tropical forest and edge. Not under threat.

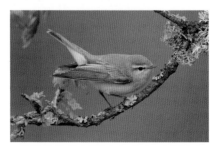

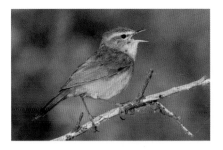

Dusky Warbler *Phylloscopus fuscatus*
L 5" ♂ = ♀ DUWA

Summers from central Asia and northern China to eastern Siberia. Winters in the Himalayas, southern China, and Southeast Asia. North American records include Alaska—the Aleutian and Pribilof Islands, Saint Lawrence Island, and Middleton Island—as well as coastal Oregon and California. Records from August, September, and October (and possibly June).

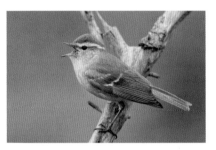

Pallas's Leaf Warbler *Phylloscopus proregulus*
L 4" ♂ = ♀ PLEW

This kinglet look-alike summers in central and East Asia. Winters in southern China and northern Vietnam. A single North American record comes from Saint Lawrence Island, northern Bering Sea, Alaska. Inhabits boreal conifer and mixed forests of northern Asia. Most likely to be confused with the Chinese Leaf Warbler.

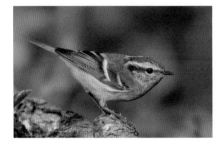

Yellow-browed Warbler *Phylloscopus inornatus*
L 4" ♂ = ♀ YBWA

Summers from western Russia to eastern Siberia. Winters in southern China and Southeast Asia. North American records come from Alaska: the western Aleutian Islands, the Pribilof Islands, Saint Lawrence Island, and Middleton Island; also British Columbia, near Lake Tahoe, California; Wisconsin; and Ontario.

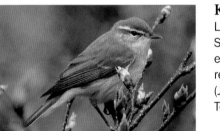

Kamchatka Leaf Warbler *Phylloscopus examinandus*
L 5" ♂ = ♀ KLWA

Summers on Kamchatka and Sakhalin Island in Russia and in northern Japan. Winters in insular eastern Southeast Asia. North American records come from the western Aleutian and Pribilof Islands, Alaska (June, September, and October), mainland Alaska, and the Northwest Territories, Canada.

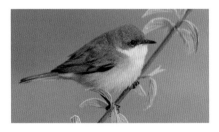

Lesser Whitethroat *Sylvia curruca*
L 5" ♂ = ♀ LEWH

This demure white-throated sylviid warbler summers from western Europe to east-central Russia and northwestern China. Winters in northeastern Africa and western and southern Asia. A single record from North America: Saint Lawrence Island, northern Bering Sea, Alaska.

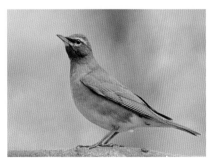

Eyebrowed Thrush *Turdus obscurus*
L 9" ♂ ≈ ♀ EYTH

Summers from central to eastern Russia, including Kamchatka. Winters in southern China and Southeast Asia. North American records include various insular Alaskan locations, as well as southeastern mainland Alaska and the interior of Southern California. Alaskan records from the western Aleutian Islands, Pribilof Islands, Saint Lawrence Island, and Saint Matthew Island. Records from May-October.

Dusky Thrush *Turdus eunomus*
L 9.5" ♂ ≈ ♀ DUTH
Summers from central Russia east to eastern Siberian, including Kamchatka. Winters in China and Japan. North American records extend all across insular and coastal Alaska, as well as records from northern and southern Yukon, British Columbia, Washington, and Oregon. Records from January, February, March, May, June, July, and October.

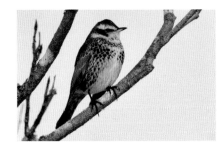

Naumann's Thrush *Turdus naumanni*
L 10" ♂ ≠ ♀ NATH
Summers across central and eastern Russia. Winters in northeastern China. Several North American records, all from Alaska: Attu, Adak, and Shemya Islands, western Aleutian Islands; and Saint Lawrence Island, northern Bering Sea.

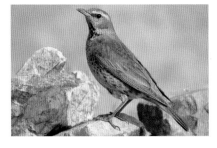

Rufous-tailed Rock-thrush *Monticola saxatilis*
L 8" ♂ ≠ ♀ RTRT
Also known as the Common Rock-thrush. Summers from western Europe to interior East Asia. Winters in East Africa. A single North American record: Utqiagvik (Barrow), Alaska, in 2021. Breeds on rocky mountainsides and other rough open habitats. Ranges into the high mountains. Perches atop a rock and scans for insect prey. The species is not under threat.

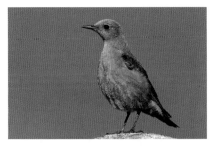

Gray-streaked Flycatcher *Muscicapa griseisticta*
L 6" ♂ = ♀ GSFL
Summers from northeastern China into eastern Siberia, Russia, including Kamchatka. Winters in insular Southeast Asia and western New Guinea. North American records are confined to insular Alaska: the western Aleutian and Pribilof Islands (May, June, July, August, September, and October).

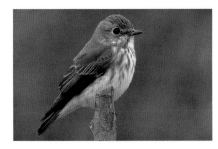

Asian Brown Flycatcher *Muscicapa dauurica*
L 6" ♂ = ♀ ABFL
Summers from central Asia to Japan and Sakhalin Island, Russia, as well as the Himalayas. Winters in South and Southeast Asia. North American records come from insular Alaska: the western Aleutian Islands, Pribilof Islands, and Saint Lawrence Island. Records from May, June, and September.

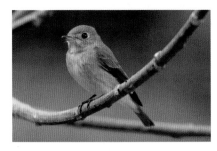

Spotted Flycatcher *Muscicapa striata*
L 6" ♂ = ♀ SPFL
This rather drab Old World flycatcher summers from western Europe to central Asia. Winters in central and southern Africa. The single North American record is from Saint Lawrence Island, northern Bering Sea, Alaska. Usually seen on a prominent perch. The species is declining in Europe, but it is classed as of Least Concern.

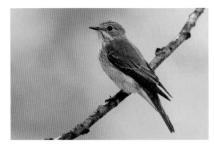

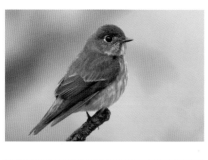

Dark-sided Flycatcher *Muscicapa sibirica*

L 6" ♂ = ♀ DSFL

Summers in the Himalayas, southwestern China, and the Russian Far East (including Kamchatka). Winters in southern China and Southeast Asia. North American records confined to Alaska: the western Aleutian Islands, the Pribilof Islands, and Utqiagvik (Barrow). Records from May, June, August, and September. Breeds in montane forest.

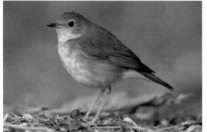

Siberian Blue Robin *Larvivora cyane*

L 6" ♂ ≠ ♀ SBRO

Summers from central Siberia to the Russian Far East, Korea, Japan, and Sakhalin Island, Russia. Winters in Southeast Asia. Two North American records: Saint Lawrence Island, northern Bering Sea, Alaska; and Attu Island, western Aleutian Islands. Breeds in thick boreal conifer forest. Winters in the understory of humid tropical or subtropical forest.

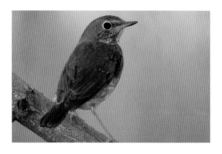

Rufous-tailed Robin *Larvivora sibilans*

L 6" ♂ ≠ ♀ RTRO

Summers in Russia from central Siberia to southeastern Siberia and Kamchatka. Winters in southern China and northern Indochina. North American records come from Alaska: Attu Island, western Aleutian Islands; the Pribilof Islands and Saint Lawrence Island, Bering Sea. Records from June and September.

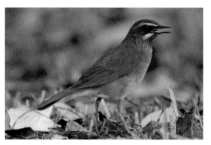

Siberian Rubythroat *Calliope calliope*

L 6" ♂ ≠ ♀ SIRU

Summers from central Russia to eastern Siberia, northern Japan, and Sakhalin Island, Russia. Winters in southernmost China and Southeast Asia. North American records from Alaska and Ontario. Widespread Alaskan insular records; mainland Alaska records from Nome and Utqiagvik. An Ontario record from suburban Toronto is from 1983.

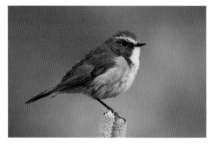

Red-flanked Bluetail *Tarsiger cyanurus*

L 6" ♂ ≠ ♀ RFBL

Summers from Scandinavia east across Siberia to Kamchatka and northeastern China. Winters in southern China and Korea. Alaskan records include the western Aleutian Islands, the Pribilof Islands, and Saint Lawrence Island in the northern Bering Sea. Lower 48 records include Washington, Oregon, Idaho, California, Wyoming, and British Columbia. Records from the year round.

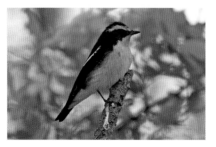

Narcissus Flycatcher *Ficedula narcissina*

L 5" ♂ ≠ ♀ NAFL

Summers in Japan, southern Sakhalin (Russia), and coastal Ussuriland (Russia). Winters in Hainan (China), the Philippines, and northern Borneo. Two North American records come from Attu Island, western Aleutian Islands, Alaska. Breeds in broadleaf and conifer forest. Winters in forest and edge. Not threatened.

Mugimaki Flycatcher *Ficedula mugimaki*

L 5" ♂ ≠ ♀ MUFL

Summers from central Siberia and northern Mongolia east to northern Korea and Russia (Ussuriland and Sakhalin Island). Winters in southern China and Southeast Asia. The single North American record is from Shemya Island, western Aleutian Islands. Breeds in forest and wet scrub. Winters in woods and forest.

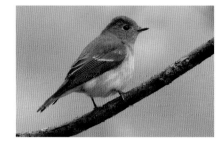

Taiga Flycatcher *Ficedula albicilla*

L 5" ♂ ≠ ♀ TAFL

Summers from western Siberia to far eastern Siberia. Winters in South Asia, Southeast Asia, and southern China. North American records come mainly from insular Alaska: the western Aleutian Islands, the Pribilof Islands, and Saint Lawrence Island, northern Bering Sea. Also a record from near Sacramento, California. Records from May, June, August, September, and October.

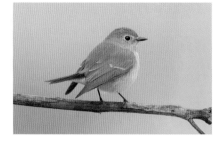

Common Redstart *Phoenicurus phoenicurus*

L 6" ♂ ≠ ♀ CRET

Summers from western Europe to central Siberia and northern Mongolia. Also western Asia. Winters in Equatorial Africa. The single North American record is from St. Paul Island, Pribilof Islands, Alaska. A commonplace European songbird. Breeds in forest, woodland, and parkland. Not under threat.

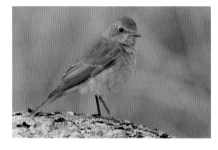

Asian (Siberian) Stonechat *Saxicola maurus*

L 5" ♂ ≠ ♀ ASST

Summers from western Europe to eastern Siberia and central China. Also patchily through Africa and western Asia. Winters in northern Africa, Arabia, South Asia, and Southeast Asia. A scattering of North American records. Alaskan records include Saint Lawrence Island (10+ records), Hall Island (Bering Sea), Anchorage, and the North Slope. Additional records come from California and New Brunswick. Records from spring and autumn. The "Amur Stonechat" of some authorities.

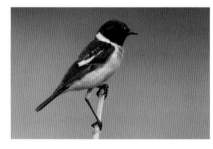

Pied Wheatear *Oenanthe pleschanka*

L 7" ♂ ≠ ♀ PIWH

Summers from the shores of the Black Sea to interior East Asia. Winters in East Africa. A single North America record comes from the Seward Peninsula of Alaska (Nome, 2017). Frequents rocky open land. Winters in a range of open habitats. Forages from shubbery or on ground. Not under current threat. In spring, it sings on a remarkable display flight.

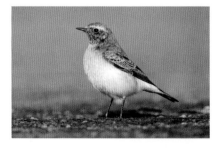

Siberian Accentor *Prunella montanella*

L 6" ♂ = ♀ SIAC

Summers from western Siberia to the Russian Far East, as well as southeastern Siberia and northern Mongolia. Winters in northeastern China and Korea. North American records come mainly from the Aleutian and Bering Sea Islands of Alaska; also from southwestern mainland Alaska, southeastern Alaska, and the Pacific Northwest (some five records). Most records from autumn and winter.

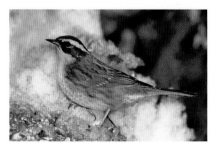

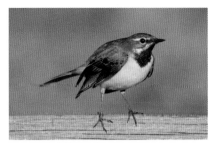

Gray Wagtail *Motacilla cinerea*
L 8" ♂ ≠ ♀ GRAW

Breeds from western Europe to East Asia and eastern Siberia. Winters in coastal Africa, South Asia, Southeast Asia, and New Guinea. North American records come mainly from Alaska: the Aleutian and Pribilof Islands, Saint Lawrence Island in the northern Bering Sea, and Seward Peninsula. Additional records from the Northwest Territories, Washington, and California. Spring and autumn records.

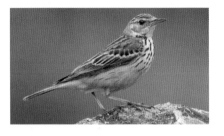

Tree Pipit *Anthus trivialis*
L 6" ♂ = ♀ TRPI

Summers from western Europe to eastern Siberia. Winters in Africa and South Asia. All North American records come from Alaska: Saint Lawrence Island in the northern Bering Sea (four records in June and September) and the Seward Peninsula (June). Breeds in openings in woodland and heathlands. Winters in similar habitats.

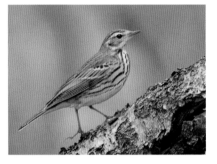

Olive-backed Pipit *Anthus hodgsoni*
L 6" ♂ = ♀ OBPI

Summers from western to eastern Siberia in Russia, including Kamchatka and Sakhalin Island, and in China and East Asia. North American records come from insular Alaska (the western Aleutian Islands, Pribilof Islands, Middleton Island, and Saint Lawrence Island), coastal mainland Alaska (Utqiagvik, Goodnews Bay, Seward, and Juneau), and the Lower 48 (California, Nevada). Records from May to November. Probably nested on Attu in 1998.

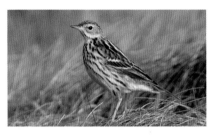

Pechora Pipit *Anthus gustavi*
L 6" ♂ = ♀ PEPI

Summers from northwestern to northeastern Russia, including Kamchatka and Chukotka. Winters in the Philippines. North American records are confined to insular Alaska: the western Aleutian Islands (spring), the Pribilof Islands (autumn), and Saint Lawrence Island, northern Bering Sea (mainly autumn).

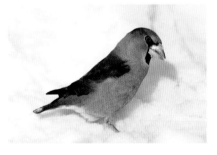

Hawfinch *Coccothraustes coccothraustes*
L 7" ♂ ≈ ♀ HAWF

Breeds from western Europe to the Russian Far East, including Kamchatka. Winters southward. North American records mainly from Alaska—the Aleutian Islands, the Pribilof Islands, Saint Lawrence Island, the Seward Peninsula, and the Anchorage area. Also a record from the southern Yukon. Records all seasons.

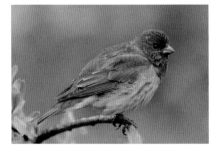

Common Rosefinch *Carpodacus erythrinus*
L 6" ♂ ≠ ♀ CORO

Summers from Scandinavia and eastern Europe to the Russian Far East and central China. Winters in South and Southeast Asia as well as southeastern China. North American records come from Alaska—the western Aleutian Islands, the Pribilof Islands, Saint Lawrence Island in the northern Bering Sea, and the Alaska and Seward Peninsulas of mainland Alaska (spring); also the Farallon Islands of central California (autumn). The species is not under threat.

Pallas's Rosefinch *Carpodacus roseus*

L 7" ♂ ≠ ♀ PARO

This Asian finch summers throughout Siberia; also resident in northern Mongolia. Winters in central and East Asia. There is a single North American record: Saint Paul Island, Pribilof Islands, Bering Sea, Alaska. In winter found in small or medium-sized nomadic flocks. Species population appears stable.

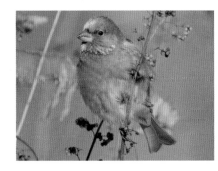

Eurasian Bullfinch *Pyrrhula pyrrhula*

L 7" ♂ ≠ ♀ EUBU

Breeds from eastern Europe to the Russian Far East, including Kamchatka. Winters southward into southern Europe, western Asia, and Korea. North American records all come from Alaska: the Aleutian Islands, Pribilof Islands, and Saint Lawrence Island in the northern Bering Sea; also records from southwestern and southeastern mainland Alaska, as well as the Alaska interior (Fairbanks). Records from throughout the year.

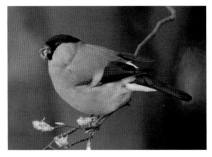

Asian Rosy-Finch *Leucosticte arctoa*

L 7" ♂ ≈ ♀ ASRF

Summers in northern China, as well as in southeastern and northeastern Siberia and Kamchatka, Russia. Winters in northeastern China, Korea, and Japan. A resident population breeds in northern Mongolia. There is a single North American record from Adak, western Aleutian Islands, Alaska.

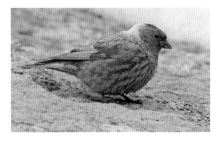

Oriental Greenfinch *Chloris sinica*

L 6" ♂ ≈ ♀ ORGR

A resident of central and eastern China, Korea, and Japan. Wanders to Sakhalin and Kamchatka, Russia. Most North American records come from insular Alaska: the Aleutian Islands and the Pribilof Islands. Additional records come from southeastern Alaska, British Columbia, Oregon, and Northern California.

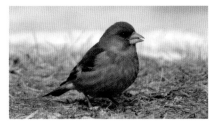

Eurasian Siskin *Spinus spinus*

L 5" ♂ ≠ ♀ EUSI

Summers from northern Europe to the Russian Far East. Winters in the Mediterranean, China, and Japan. North American records include the following: Alaska: Attu Island, western Aleutian Islands (May and June); Unalaska Island, central Aleutian Islands (December-March); Atlantic Canada: Labrador (June-July); and Maine (January).

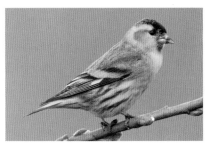

Pine Bunting *Emberiza leucocephalos*

L 7" ♂ ≠ ♀ PIBU

Summers from central Russia to eastern Siberia. Winters in central Asia, eastern China, Korea, and southeastern Siberia. North American records come from insular Alaska: Attu Island; the Pribilof Islands; and Saint Lawrence Island, northern Bering Sea. Also a record from Victoria, British Columbia.

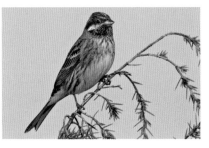

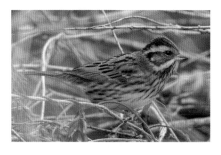

Yellow-browed Bunting *Emberiza chrysophrys*

L 6" ♂ ≈ ♀ YBWB

The breeding plumage adult male closely resembles the White-throated Sparrow. Summers in interior central-eastern Siberia. Winters in southeastern China. The single North American record comes from Saint Lawrence Island, northern Bering Sea, Alaska. Breeding range is very small, but species population appears stable.

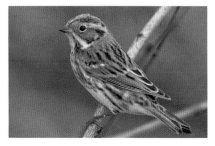

Little Bunting *Emberiza pusilla*

L 5" ♂ = ♀ LIBU

Summers from northern Scandinavia to northeastern Siberia. Winters in southern China. More than a dozen North American records: Alaska (Saint Lawrence Island in the northern Bering Sea, the Pribilof Islands, the western Aleutian Islands, the North Slope, and southeastern mainland Alaska); the West Coast; and the Interior West (Oregon and Arizona). Records in March, April, May, August, September, October, November, and December.

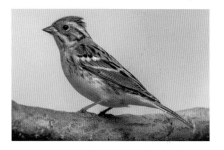

Rustic Bunting *Emberiza rustica*

L 6" ♂ ≠ ♀ RUBU *VU

Summers from Scandinavia to eastern Siberia. Winters in Japan and eastern China. The dozens of records from North America come from insular western Alaska, coastal southern Alaska, interior Alaska, and the West Coast of the Lower 48. Records from spring, autumn, and winter. Breeds in swampy lowland boreal forest. In winter frequents woodland edge and other open habitats. Classified as Vulnerable.

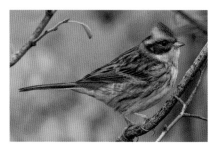

Yellow-throated Bunting *Emberiza elegans*

L 6" ♂ ≠ ♀ YTBU

Summers in northeastern China and southeasternmost Siberia. Winters in Japan and southeastern China. Also a resident population in central China. The single North American record comes from Attu Island, western Aleutian Islands, Alaska. Inhabits forest, edge, thickets, clearings, and especially near water.

Yellow-breasted Bunting *Emberiza aureola*

L 6" ♂ ≠ ♀ YBSB *CR

Summers from Finland and western Russia to eastern Siberia and Kamchatka, Russia. Winters in the Himalayas, southern coastal China, and Southeast Asia. North American records come from Attu Island, western Aleutian Islands, Alaska; Saint Lawrence Island, northern Bering Sea, Alaska; and southern Labrador. Classified as Critically Endangered.

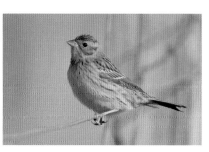

Gray Bunting *Emberiza variabilis*

L 7" ♂ ≠ ♀ GRBU

Summers on Kamchatka and Sakhalin Island in Russia and in northern Japan. Winters in southern Japan. North American records come from the western Aleutian Islands, Alaska: Attu and Shemya Islands.

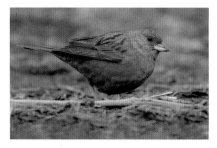

Pallas's Bunting *Emberiza pallasi*

L 5" ♂ ≠ ♀ PALB

Summers widely through Siberia; also northern Mongolia. Winters in eastern China. North American records come from Alaska: Saint Lawrence Island, northern Bering Sea (May, June, August, and September); and Pribilof Islands (October).

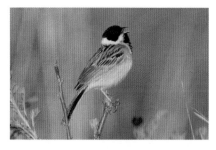

Reed Bunting *Emberiza schoeniclus*

L 6" ♂ ≠ ♀ REBU

Summers from western Europe to southeastern Siberia and Kamchatka, Russia. Winters in the Mediterranean, western Asia, and central and eastern China. North American records come from Attu and Shemya Islands (May and June), western Aleutian Islands, Alaska. Frequents reedy wetlands and other similar marshlands. Winters in similar habitats. Not under threat.

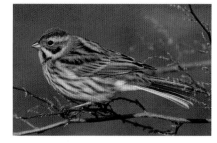

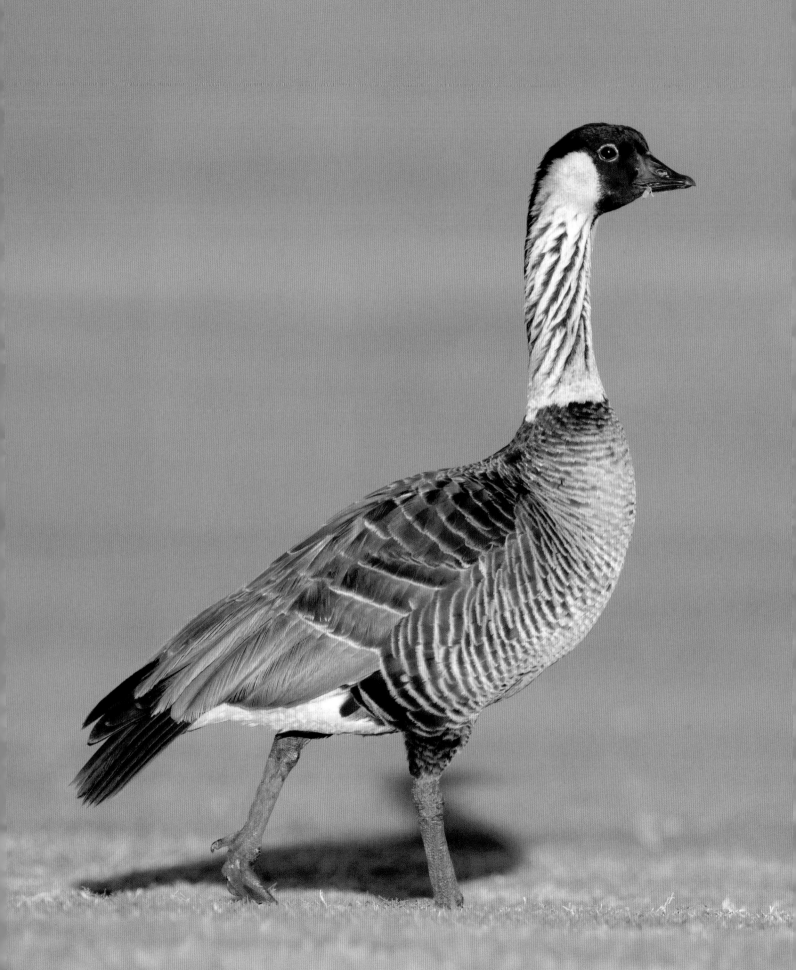

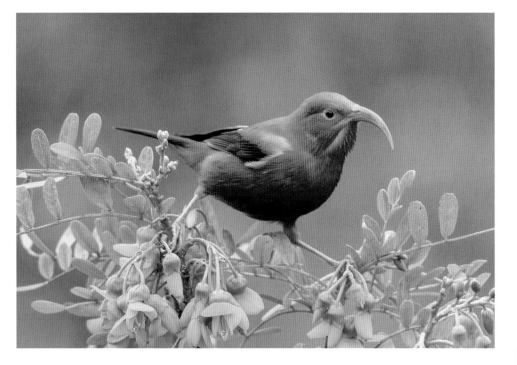

Opposite: Hawaiian Goose or Nene.
Right: Iiwi.

Hawaiian Goose *Branta sandvicensis*
L 27" ♂ = ♀ HAGO *NT

This handsome goose is endemic to the Hawaiian Islands. Currently can be found in numbers on Kauai, Maui, and Hawaii, with a few birds on Oahu and Molokai. The species came close to extinction in the early 1950s, surviving only on the Big Island of Hawaii. Captive-bred birds gave rise to present populations.

Laysan Duck *Anas laysanensis*
L 16" ♂ = ♀ LAYD *CR

A small, dark reddish-brown insular relative of the Pacific Black Duck (*Anas superciliosa*). Historically restricted to Laysan Island of the Northwestern Hawaiian Islands. Fossil evidence shows the species was widespread through the islands prior to Polynesian settlement. It has recovered from its decline to the brink of extinction in the early twentieth century but remains Critically Endangered. Birds have been translocated to Midway and Kure Atolls to increase the species' viability.

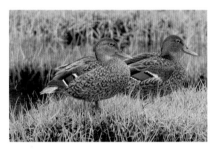

Hawaiian Duck *Anas wyvilliana*
L 20" ♂ = ♀ HAWD *EN

Endemic to the Hawaiian Islands. Natural populations remain on Kauai and Niihau. It has been reintroduced to Oahu, Maui, and Hawaii. Hybridization with Mallards threatens the species' genetic integrity. Nests and forages on upland streams and typically does not affiliate with domestic Mallards. The species is Endangered.

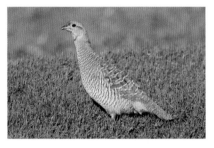

Gray Francolin *Francolinus pondicerianus*
L 13" ♂ = ♀ GRAF

Resident from India to southern Iran. Introduced to Hawaii in 1959. Now resident on the major islands. Forages in dry open habitats in small groups. Frequents lawns and golf courses. Often seen at roadsides. Seldom seen on Oahu or Kauai. In its native range, prefers grassland and scrub. The species is globally not under threat.

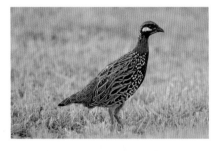

Black Francolin *Francolinus francolinus*
L 14" ♂ ≠ ♀ GRAF

Native range is western Asia and South Asia, east to Bangladesh and Assam. Introduced to Hawaii in 1959. Today, resident on the main islands. Frequents dry grasslands and pasturelands. This attractive species continues to be released in places in mainland North America for sport hunting. Vocalizing males choose an open perch to call.

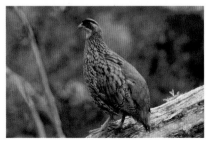

Erckel's Francolin *Pternistis erckelii*
L 16" ♂ = ♀ ERFR

Native to northeastern Africa (mainly Ethiopia). Introduced to Hawaii in 1957. Today, found on the main islands, mostly in the mountains. A ground-dweller of grasslands and open woodland. This is the francolin most often seen in wetter areas of the State. Local and seldom seen on Oahu. The species is globally not under threat.

Red Junglefowl *Gallus gallus*

L 30" ♂ ≠ ♀ REJU

This handsome wild relative of the domestic chicken, introduced to Hawaii, is native to South and Southeast Asia. This in, in fact, a true pheasant, though because of its wide domestication, it receives little respect. Not uncommon on the main islands of Hawaii, with wild birds frequenting towns and rural area. Has colonized the forest interior mainly on mongoose-free Kauai. The species is under no global threat.

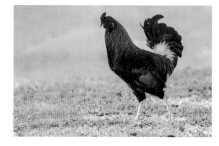

Kalij Pheasant *Lophura leucomelanos*

L 51" ♂ ≠ ♀ KAPH

Native to the Himalayas, Burma, and Thailand. Introduced to Hawaii in 1962. Widespread on Hawaii, less so on Oahu. There are records from Maui and Kauai. Frequents forest and edge where it lives in family groups. Note the long dark tail and curved hind crest. Usually seen foraging in early morning in clearings.

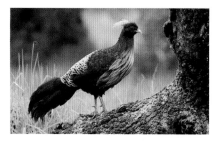

Chestnut-bellied Sandgrouse *Pterocles exustus*

L 13" ♂ ≠ ♀ CBSA

This exotic-looking game bird is native to tropical Africa, western Asia, and South Asia. Introduced to Hawaii in 1961. Has somewhat the look of a pigeon. Today, resident on the Big Island of Hawaii. Frequents dry grasslands and pastures, mainly in open country. Travels in flocks, often seen visiting watering places. Note the long pointed tail.

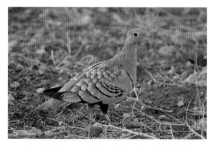

Zebra Dove *Geopelia striata*

L 8" ♂ = ♀ ZEBD

A tiny and long-tailed ground-dweller. Introduced to Hawaii in 1950. Now abundant on all the main islands. Commonplace in cities and other human-dominated environments. A human commensal, found in urban areas of Waikiki. The voice is a commonplace sound in the lowlands of the State.

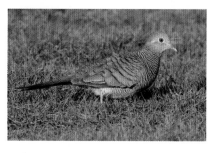

Mariana Swiftlet *Aerodramus bartschi*

L 4" ♂ = ♀ MASW

An endangered species in its native range (Guam and other Mariana Islands, Micronesia). Introduced to Oahu in 1962, where a small population nests in an abandoned water tunnel. Formerly treated as a race of the widespread Gray Swiftlet (*Aerodramus vanikorensis*), which is identical and featured in the image to the right.

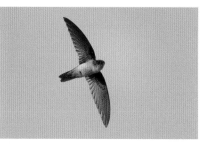

Hawaiian Coot *Fulica alai*

L 16" ♂ = ♀ HACO *VU

Endemic to the Hawaiian Islands. Found on all the major islands. Frequents freshwater and saltwater ponds, marshes, and estuaries. The red forehead is diagnostic. State population in the low thousands. This Vulnerable species is widespread across the islands, but for Lanai. In the past it has been treated as a subspecies of the American Coot.

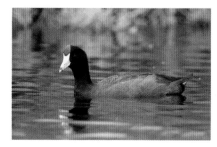

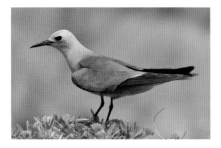

Blue-gray Noddy *Anous ceruleus*

L 11" ♂ = ♀ BGNO

Ranges across the central and Southwest Pacific. Breeds in Hawaii—Gardner Pinnacles east to Nihoa and Kaula of the Northwestern Hawaiian Islands. A few records from Kauai. Comes in two color morphs—one pale and one darker. Seldom seen far from nesting islands. The paler morph somewhat resembles the White Tern.

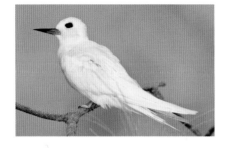

White Tern *Gygis alba*

L 12" ♂ = ♀ WHTT

This striking-looking all-white tern breeds on islands in tropical seas. Resident on all the main Hawaiian Islands. This, the official "City Bird" of Honolulu, can be easily seen there in urban parks, even in downtown Waikiki. Flight is graceful and light. Note large dark eye. Nests in trees, where it lays its single egg on the fork of a bare branch.

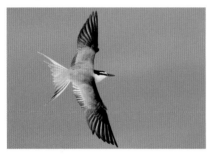

Gray-backed Tern *Onychoprion lunatus*

L 15" ♂ = ♀ GBAT

Breeds in small numbers on islands across the tropical Pacific including the Northwestern Hawaiian Islands and a few rocky bird islets off the main islands (Kaula and Moku Manu). Feeds on fish and squid taken on aerial dives. Another name for this species is Spectacled Tern. Not under threat globally.

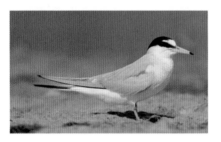

Little Tern *Sternula albifrons*

L 9" ♂ = ♀ LITE

Widespread across the Old World into Australasia. There are a handful of records from Midway Atoll, Northwestern Hawaiian Islands. Records from April through to September. Nearest breeding population is distant—Japan or the Solomon Islands. This species is a counterpart to our familar Least Tern, looking identical to it. Not under threat.

Inca Tern *Larosterna inca*

L 17" ♂ = ♀ INTE *NT

Ranges along the western coast of South America from Peru to Chile. The first Hawaiian record is of a bird found at South Point, the Big Island of Hawaii, in 2021. A second Hawaiian record, possibly the same bird, comes from between Lanai Lookout and Sandy Beach, Oahu Island, Hawaii, 2021–2022.

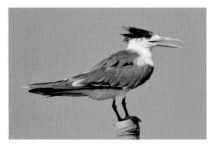

Great Crested Tern *Thalasseus bergii*

L 21" ♂ = ♀ GCTE

Ranges through tropical and subtropical seas from East Africa to Australia and the central Pacific. Records come from Oahu in the autumn of 1988 and from the Northwestern Hawaiian Islands (French Frigate Shoals) in July 1991. This is one of our larger terns. Note the oversized yellow beak. The species is not under threat globally.

Red-tailed Tropicbird *Phaethon rubricauda*

L 37" ♂ = ♀ RTTR *WL

This white-winged tropicbird ranges across the tropical Indian and Pacific Oceans. Nests widely but sparingly in the Hawaiian Islands. Also is observed in waters far off the coast of California. Diet is mainly flying fish. This is the most pelagic of the tropicbirds. Nest is placed in a rocky crevice or a sheltered scrape on the ground. Not under threat.

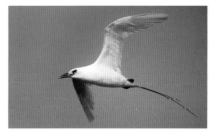

Kermadec Petrel *Pterodroma neglecta*

L 15" ♂ = ♀ KEPE

Ranges across the South Pacific. Wanders north to the waters around Hawaii on occasion. More than a dozen State records. Suspected of trying to nest on Kauai. Variable colored and medium-sized. Not a ship-follower. Flight low over the water, with loose and deep wing beats followed by long glides.

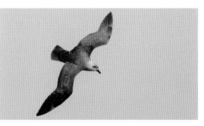

Herald Petrel *Pterodroma heraldica*

L 15" ♂ = ♀ HEPE

Ranges across the tropical South Pacific. Variable plumage. Several records from Hawaii's waters in August, October, and November. The dark morph of this species is very similar to the dark morph of the preceding species. A bird of open seas and offshore waters.

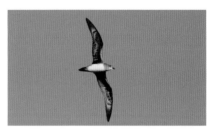

Juan Fernandez Petrel *Pterodroma externa*

L 17" ♂ = ♀ JFPE *VU

Breeds on Selkirk Island in the Juan Fernandez Islands off Chile. Ranges across the eastern Pacific. Many records from Hawaii's waters. Apparently occurs year-round but most frequent from May to November. A bird of open tropical seas. Flight is powerful, exhibited by high wheeling arcs and glides. There is also a record from Arizona.

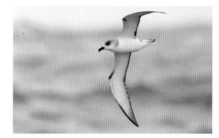

White-necked Petrel *Pterodroma cervicalis*

L 17" ♂ = ♀ WNPE *VU

This little-known species ranges across the tropical and subtropical western Pacific, north to Japan and also occasionally east to Baja, Mexico. Many records from Hawaii's waters from September to June. Similar to the Juan Fernandez Petrel but exhibits a white collar. Behavior also similar to that other species. Breeds on the Kermadec Islands of New Zealand. Highly pelagic, often in areas of upwelling. Usually found far from land. Breeds on oceanic islands. Classified as Vulnerable. A trans-equatorial migrant.

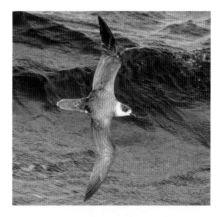

Bonin Petrel *Pterodroma hypoleuca*

L 12" ♂ = ♀ BOPE

Breeds (January–June) on the Bonin Islands, Volcano Islands, and Northwestern Hawaiian Islands. Ranges through the northwestern Pacific. Seldom reported from the main Hawaiian Islands. A small petrel of open seas and offshore waters. Not attracted to ships. Highly pelagic and rarely approaches land except to nest. Disperses widely eastward from its nesting islands. Not under threat.

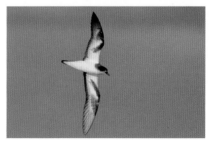

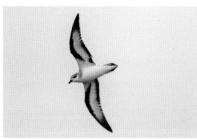

Black-winged Petrel *Pterodroma nigripennis*

L 13" ♂ = ♀ BWPE

Ranges widely across the Pacific, from eastern Australia and Japan eastward to Mexico and Peru. Breeds on islands in the South Pacific. Many records from Hawaiian waters, migrants passing through in spring and autumn. Diet is mainly squid and shrimp. Highly pelagic, living far from land except when nesting. Not threatened.

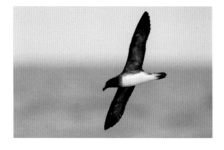

Tahiti Petrel *Pseudobulweria rostrata*

L 17" ♂ = ♀ TAPE *NT

Breeds in the tropical South Pacific. Ranges across the subtropical and tropical Pacific. Strays into the eastern Indian Ocean. A handful of records from Hawaiian waters during the months of August to October. Also a North Carolina record. Note blackish throat and upper breast sharply-demarcated from white breast and belly. A solitary petrel of open ocean.

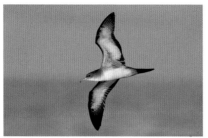

Wedge-tailed Shearwater *Ardenna pacifica*

L 17" ♂ = ♀ WTSH

Breeds across the western and South Pacific. Apparently the pale morph breeds north of the Equator and the dark morph to the south. Breeds on the Hawaiian Islands. The most common shearwater in Hawaiian waters. A few warm-season records from the waters off Southern California. Records also from North Carolina, Florida, Texas, and Arizona.

Christmas Shearwater *Puffinus nativitatis*

L 14" ♂ = ♀ CHSH

This medium-sized shearwater with short and rounded wings ranges across the tropical central Pacific. It breeds in Hawaii between April and October. Breeding locations include the Northwestern Hawaiian Islands and islets fringing Kauai and Oahu. Comes and goes to breeding colonies at night. Very tame. The bird's flight is graceful and buoyant. Note the rapid wingbeats and long glides in flight. Forages over warm waters mainly. Main threat to the species is at the nest, from exotic invasive mammals as well as human subsistence harvest. That said, the species is not currently under threat.

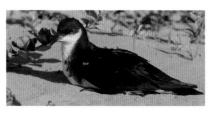

Newell's Shearwater *Puffinus newelli*

L 13" ♂ = ♀ NESH *CR

This small shearwater breeds only in the Hawaiian Islands (June–October). Ranges mainly south and east from its breeding base. A bird of open tropical seas. Listed as Critically Endangered.

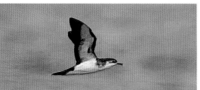

Bryan's Shearwater *Puffinus bryani*

L 11" ♂ = ♀ BRYS *CR

A rare and poorly known species ranging across the subtropical Northwest Pacific. Presumed to breed in winter on the Bonin Islands. Records from Midway Atoll, Northwestern Hawaiian Islands. Listed as Critically Endangered.

Hawaiian Hawk *Buteo solitarius*

L 16" ♂ = ♀ HAWH *NT

A Hawaiian endemic. Breeds on the Big Island of Hawaii. Stray individuals have been recorded from other islands. This is a small dichromatic hawk with pale and dark morphs. Seen in pairs or as solitary individuals. Usually seen when soaring over fields or forest. Frequents all sorts of habitats and ranges high into the mountains. Forages for insects, birds, and rodents. Classified as Near Threatened.

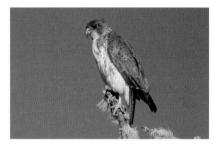

Kauai Elepaio *Chasiempis sclateri*

L 6" ♂ = ♀ KAEL *VU

Endemic to the upland forests of Kauai Island. Formerly all the elepaios were treated as a single polytypic species. Now Hawaii, Kauai, and Oahu each have their own endemic species, and Hawaii has three distinct subspecies. The species resemble fantails (Rhipiduridae) but are currently treated as members of the Monarch family.

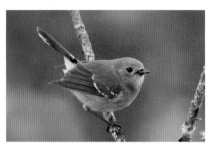

Oahu Elepaio *Chasiempis ibidis*

L 6" ♂ = ♀ OAEL *EN

Endemic to the upland forests of Oahu Island. A small and active flycatcher. Note that the tail is often cocked upward. The Oahu species displays a black throat, white chin, and white belly. This island species is uncommon and under threat. The elepaios inhabits the interior of humid forest, mainly in the uplands. This species is classified as Endangered.

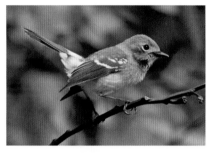

Hawaii Elepaio *Chasiempis sandwichensis*

L 6" ♂ ≠ ♀ HAEL *VU

Endemic to the forests of the Big Island of Hawaii. Includes three distinct subspecies on the island. In fact the most plumage variation exhibited by the elepaios is found on the Big Island. Here is a remarkable example of bold microgeographic plumage differentiation on a single relatively young volcanic island.

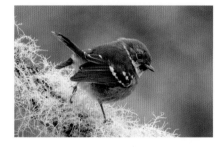

Hawaiian Crow (ʻAlalā) *Corvus hawaiiensis*

L 19" ♂ = ♀ HCRO *EW

Endemic to the Big Island of Hawaii. Now survives only as a small captive population (110 birds as of February 2022). Attempts at reintroduction to its native habitat have not yet been successful. This is the most endangered species of crow on Earth. Probably occurred on Maui in earlier times. Last wild individual was observed in 2002. Now classified as Extinct in the Wild.

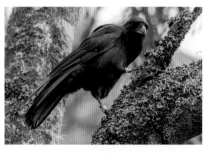

Millerbird *Acrocephalus familiaris*

L 5" ♂ = ♀ MILL *CR

Endemic to Laysan and Nihoa Islands of the Northwestern Hawaiian Islands. A reclusive inhabitant of hillside brushlands. The Laysan population disappeared by 1923. The Nihoa population is Red-Listed as Critically Endangered. Nihoa birds have been reintroduced to Laysan. Feeds on insects. Territorial and sedentary.

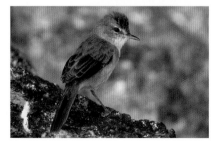

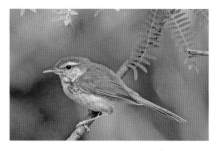

Japanese Bush-Warbler *Horornis diphone*
L 7" ♂ = ♀ JABW

Breeds in Japan, eastern China, and parts of Korea and Sakhalin Island, Russia. Winters in southern China and Hainan. Introduced to Hawaii in the 1930s. Now resident on all the main islands. A reclusive inhabitant of upland forest undergrowth; heard often and seen infrequently. The species is considered globally secure.

Warbling White-eye *Zosterops japonicus*
L 4" ♂ = ♀ WAWE

Also known as the Japanese White-eye. This East Asian native was introduced to Hawaii around 1930. Now it is abundant across all the main islands. Found in all wooded habitats. Traveling in foraging flocks, can be encountered virtually anywhere in the State. The species is classified as of Least Concern.

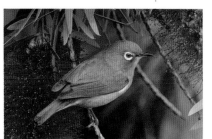

Greater Necklaced Laughingthrush *Garrulax pectoralis*
L 13" ♂ = ♀ GNLA

Native to the eastern Himalayas, Southeast Asia, and central and southern China. Introduced to Kauai around 1920, where it remains thinly distributed across the lowlands and foothills. Inhabits stream valleys of wet forest and edge, foaging in small flocks. Feeds mainly on the ground for arthropods and other invertebrates.

Hwamei *Garrulax canorus*
L 9" ♂ = ♀ HWAM

This native of China and northern Vietnam was introduced to Hawaii in the early 1900s. Currently found on Kauai, Oahu, Maui, and Hawaii (gone from Molokai?). Typically retiring and difficult to observe. Most easily seen when crossing a road from thicket to thicket. Forages singly or in small parties. Searches the ground for arthropods.

Red-billed Leiothrix *Leiothrix lutea*
L 6" ♂ = ♀ RBLE

Native to the Himalayas east to China. Introduced to Hawaii the 1920s. The species swelled in population and then more recently declined. Today found to be common on Molokai, Hawaii, and Maui, but rare on Oahu and perhaps vanished from Kauai. Frequents thick undergrowth near forest edge. Diet is arthropods and fruit. Large flocks have been seen on the Big Island. The species is not under threat.

Olomao *Myadestes lanaiensis*
L 7" ♂ = ♀ OLOM *CR

This plain thrush is endemic to the central Hawaiian Islands. Endemic to Molokai, Lanai, and Maui Islands. Inhabits the interior of wet montane forest. A shy and retiring species with a lovely song. Last seen on Lanai in 1933. Extirpated in historic times on Maui. The last known population, on Molokai, is classed as Critically Endangered. This and the following two are relatives of the solitaires

Omao *Myadestes obscurus*
L 7" ♂ = ♀ OMAO *VU

This very dull-colored thrush is endemic to the Big Island of Hawaii. Inhabits upland Ohia forest interior, Ohia scrub on lava flows, and alpine heights. Very inconspicuous but for the loud and distinctive vocalization. Unlike any other bird found on the Big Island. Diet is fruit and arthropods. Song is complex and pleasant. Classed as Vulnerable.

Puaiohi *Myadestes palmeri*
L 7" ♂ = ♀ PUAI *CR

Another very plain small thrush, which is endemic to Kauai. Inhabits upland forest interior of the Alakai Wilderness Preserve. Male sings a brief and modest song. Diet is fruit and arthropods. Forages in vegetation. Has long been a rare species. The global population is today a few hundred birds. The species is classed as Critically Endangered.

White-rumped Shama *Copsychus malabaricus*
L 10" ♂ ≠ ♀ WRSH

Native to India and Southeast Asia. Introduced to Hawaii in 1931. Today, established from Kauai down the chain to Maui. This famed songster inhabits the understory of the interior and edges of forest of various types. Frequents shady ravines. It has a fine and complex song that reminds us that this is a thrush. Common on Kauai and Oahu.

African Silverbill *Euodice cantans*
L 4" ♂ = ♀ AFSI

Native to tropical Africa and southern Arabia. Introduced to Hawaii, where now present on all the main islands. Frequents open dry habitats. A very plain and small estrildid. Note the longish pointed tail and the unmarked underparts. Diet is mainly grass seeds as well as a few arthropods. Forms flocks in the nonbreeding season. Not threatened.

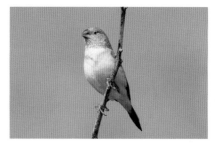

Java Sparrow *Padda oryzivora*
L 6" ♂ = ♀ JASP *EN

This very distinct and large-billed estrildid is native to Java and Bali. It was introduced to Hawaii, where now resident on all the main islands. Frequents towns, cities, and surrounding countryside. Inhabits rice fields, grasslands, and open woodland. Aggressive and abundant at bird-feeders. Very boldly patterned and quite gregarious. Mostly found in urban areas. The species is Endangered in its native haunts.

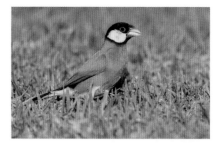

Chestnut Munia *Lonchura atricapilla*
L 5" ♂ = ♀ CHMU

Native to northern India and Nepal eastward to mainland and insular Southeast Asia. Introduced to Hawaii, where it is widespread on Kauai, Oahu, and Maui; also an incipient population was recently reported on the Big Island of Hawaii, and another on Lanai in 2020. Forages in flocks in grasslands and other open habitats. Not under threat.

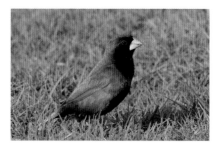

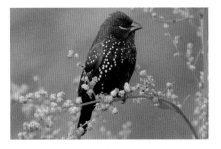

Red Avadavat *Amandava amandava*

L 45" ♂ ≠ ♀ REAV

This beautiful estrildid finch is native to South and Southeast Asia. Introduced to Hawaii, where it is commonplace on Kauai, Oahu, and Hawaii. Uncertain on Maui. Inhabits grasslands, fields, wetlands, and scrub. Tiny. Very gregarious. Diet is grass seeds. Will feed on the ground. The species is not under threat.

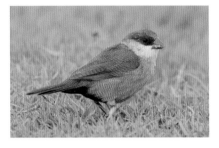

Common Waxbill *Estrilda astrild*

L 5" ♂ = ♀ COMW

Resident in tropical and southern Africa. Introduced to Hawaii. Widespread and abundant on Kauai, Oahu, Maui, and the Big Island. Inhabits open grasslands and marshes. Flocks of these birds can be found in weedy fields, usually near water. Frequents all manner of open habitats. Diet is grass seeds as well as small arthropods. The species is not under threat.

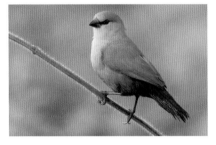

Lavender Waxbill *Glaucestrilda caerulescens*

L 4" ♂ = ♀ LAWA

A pearly gray estrildid finch native to a very narrow east-west band of habitat in West and central Africa. Introduced to the State in the early 1960s. Established on the Big Island of Hawaii. No recent records from Oahu. Inhabits thickets and edge. Diet is a mix of grass seeds, small fruits, flowers, and a few arthropods. Not under threat.

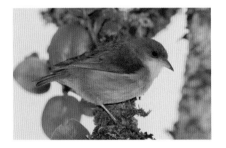

Akikiki *Oreomystis bairdi*

L 5" ♂ = ♀ AKIK *CR

This diminutive "fluffy ball of gray and white feathers," as described by H. Douglas Pratt, is endemic to Kauai Island. This is a specialized bark-creeper only rarely found at flowers. Population has recently exhibited a precipitous decline and now barely hanging on in the Alakai Wilderness Preserve of central Kauai.

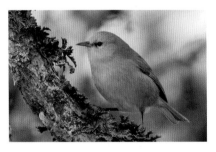

Maui Alauahio *Paroreomyza montana*

L 5" ♂ ≈ ♀ MAAL *EN

Endemic to Maui and formerly Lanai. Survives in montane forest interior of East Maui. Typical found foraging in leaves and twigs, less commonly found bark creeping. Similar to the Amakihi in appearance. Diet is arthropods and nectar. Forages among leaves and bark. The species is classified as Endangered.

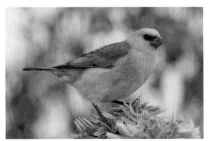

Palila *Loxioides bailleui*

L 8" ♂ ≠ ♀ PALI *EN

One of the iconic Hawaiian Honeycreepers. Endemic to the Big Island of Hawaii. Confined to upland Mamane forests, where it travels in small foraging flocks that feed almost exclusively on the seed pods of Mamane (*Sophora chrysophylla*). Has a distinctive song. Found only on the upper slopes of Mauna Kea.

Laysan Finch *Telespiza cantans*

L 8" ♂ ≠ ♀ LAFI *VU

This large finchlike Hawaiian honeycreeper is endemic to Laysan Island, Northwestern Hawaiian Islands. Has been introduced to Pearl and Hermes Atoll in order to expand this endemic species' distribution and reduce the threat to its existence. Frequents atoll scrub vegetation. The species is an omnivore. Has a canary-like warbling song.

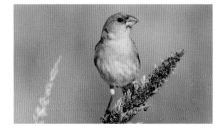

Nihoa Finch *Telespiza ultima*

L 7" ♂ ≠ ♀ NIFI *CR

Endemic to Nihoa Island, Northwestern Hawaiian Islands. Inhabits scrub hillside vegetation. Similar to the preceding species but smaller without the hook at the tip of the upper mandible. A notable songster. Diet includes arthropods, seeds, leaves, flowers, and fruits. The species is classified as Critically Endangered.

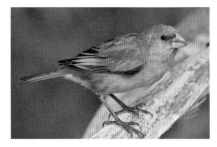

Akohekohe *Palmeria dolei*

L 7" ♂ = ♀ AKOH *CR

With is forehead pompom, this is perhaps the most remarkable-looking of the surviving Hawaiian Honecreepers. Formerly inhabited Molokai. Now confined to the upland forests of East Maui. Forages for nectar in the canopy of forest trees, especially Ohia. Critically Endangered.

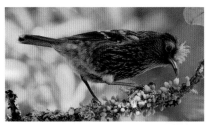

Apapane *Himatione sanguinea*

L 5" ♂ = ♀ APAP

This pretty little dark red bird is endemic to the Hawaiian Islands. Currently inhabits all the main islands. This species is one of the least threatened of the honeycreepers. Inhabits Ohia forest. Note the short and pointed black bill. Found at flowering trees. Typically the tail is cocked upward. One of the very few Hawaiian honeycreepers that is not under threat.

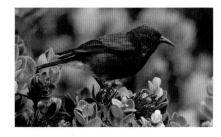

Iiwi *Drepanis coccinea*

L 6" ♂ = ♀ IIWI *VU

Endemic to the Hawaiian Islands. Recorded from the main islands, but now extirpated from Lanai and Molokai. Today, the most substantial populations are on Maui and Hawaii. This is a specialized nectar-feeder. Slow and deliberate in its foraging. Much more difficult to observe than the preceding species. Classed as Vulnerable.

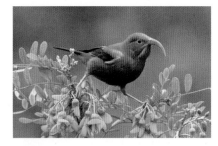

Maui Parrotbill *Pseudonestor xanthophrys*

L 6" ♂ ≈ ♀ MAPA *CR

This Hawaiian honeycreeper with the large hooked bill is endemic to Maui. Confined to the upland forests of East Maui. Formerly more widespread but its range has steadily contracted. Stocky and short-tailed. Note the bright yellow eyebrow. A stolid forager on bark and branches, searching for arthropod prey. Occasionally takes some nectar. Parrot-like in its movements. The species is classed as Critically Endangered, found only on the eastern slopes of Haleakala. In decline. Fewer than 500 individuals remain.

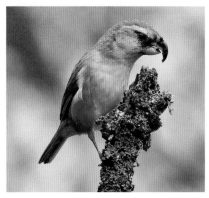

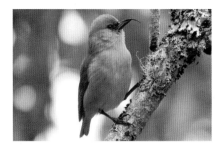

Akiapolaau *Hemignathus wilsoni*

L 6" ♂ ≠ ♀ AKIA *EN

This chunky and short-tailed honeycreeper is endemic to the Big Island of Hawaii. It inhabits upland forests of Ohia and Koa and formerly Mamane parklands. Its beak is unique among birds with the sickle-billed maxilla and straight mandible. This specialized bill is used for extracting insect larvae from wood, taken while creeping on bark.

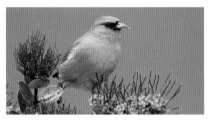

Anianiau *Magumma parva*

L 4" ♂ ≈ ♀ ANIA *VU

This tiny yellow songbird is endemic to Kauai. Inhabits the interior of montane forest. Forages mainly at flowers for nectar but also among leaves and twigs for arthropods, as well as soft fruits. Joins mixed foraging flocks in the forest. The species is classified as Vulnerable.

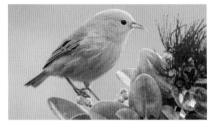

Hawaii Amakihi *Chlorodrepanis virens*

L 4" ♂ ≈ ♀ HAAM

This small yellow-green songbird with the pointed and decurved bill inhabits the Big Island of Hawaii, Molokai, and Maui. Formerly inhabited Lanai. Frequents forest and edge and high elevation shrublands. One of the most common of the honeycreepers. Not under threat.

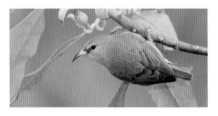

Oahu Amakihi *Chlorodrepanis flava*

L 4" ♂ ≠ ♀ OAAM *VU

Endemic to the upland forests of Oahu, including habitat within the city limits of Honolulu. This species and the Apapane are the two honeycreepers that birders visiting Oahu might expect to glimpse if they visit green spaces at the verge of the urban area. Classed as Vulnerable.

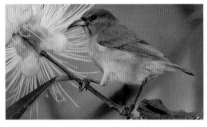

Kauai Amakihi *Chlorodrepanis stejnegeri*

L 4" ♂ ≈ ♀ KAAM *VU

Larger-billed than the other species of Amakihis. Endemic to Kauai. Inhabits montane forest, where it forages by creeping over branches and twigs in search of insects. Also visits flowers for nectar and consumes some fruit. Classified as Vulnerable.

Hawaii Creeper *Loxops mana*

L 5" ♂ = ♀ HCRE *EN

This small olive-green songbird is endemic to the upland forests of the Big Island of Hawaii. Dark bill is only slightly decurved. Creeps over bark and branches. Seen singly or in small famiy groups. Prefers mixed Koa/Ohia forests. Diet is mainly arthropods, but also takes some other invertebrates, such as small land snails. Classed as Endangered.

Akekee *Loxops caeruleirostris*

L 4" ♂ ≈ ♀ AKEK *CR

A small yellow-olive songbird that is endemic to the upland forests of Kauai. Remaining population confined to the Alakai Wilderness Preserve. Note the pale blue conical bill. Entirely insectivorous. The species is categorized as Critically Endangered.

Hawaii Akepa *Loxops coccineus*

L 4" ♂ ≠ ♀ HAAK *EN

This sexually dichromatic little songbird is endemic to the Big Island of Hawaii. Inhabits upland forest. Male is all-red whereas the female is an indistinct olive. Often seen in small parties, keeping to the leafy canopies of the forest, foraging among leaves and buds and to a lesser extent flowers. This single-island endemic is Endangered.

Yellow-fronted Canary *Crithagra mozambica*

L 5" ♂ ≠ ♀ YFCA

The native range of this species is from West Africa to southern Africa. Introduced to Hawaii circa 1964. Most widespread on the Big Island of Hawaii and Oahu. Inhabits parks, lawns, and woodland edges. A small finch with highlights of yellow on the breast, rump, and throat. Travels in flocks. Not under threat as a species.

Island Canary *Serinus canaria*

L 6" ♂ ≈ ♀ ISCA

Native to the Azores, Madeira, and Canary Islands. Domestic stock canaries were introduced in 1911 to Midway Atoll, where their buttercup yellow descendants remain commonplace to this day. This seed eater is mostly found in tree groves but also occasionally foraging on the ground. Of course this species is famous for its long and complex song. Not under threat as a species.

Red-crested Cardinal *Paroaria coronata*

L 8" ♂ = ♀ RCCA

This very handsome songbird is native to central and southeastern South America. Introduced to the Hawaiian Islands. Found on the main islands from Kauai to Maui, with a few records of the species from the Big Island of Hawaii. Frequents city parks, openings, and lawns. Essentially omnivorous, taking fruit, seeds, young shoots, and arthropods. Not under threat as a species.

Yellow-billed Cardinal *Paroaria capitata*

L 7" ♂ = ♀ YBCA

Native to south-central South America. Introduced to the Big Island of Hawaii and has not spread to other islands. Mainly coastal. Inhabits dry thickets, often near fish ponds along the coast. Diet is omnivorous. Likes to forage in underbrush. Has a pleasant song. Not threatened.

Saffron Finch *Sicalis flaveola*

L 7" ♂ ≠ ♀ SAFI

Native to South America. Introduced to the Hawaiian Islands. Today, present on Kauai, Oahu, Maui, and especially the Big Island of Hawaii. Flocks frequent lawns, parks, and weedy roadsides and fields. The male is stunningly colored. Female is duller. Usually seen in openings foraging on the ground for seeds. Species not under threat.

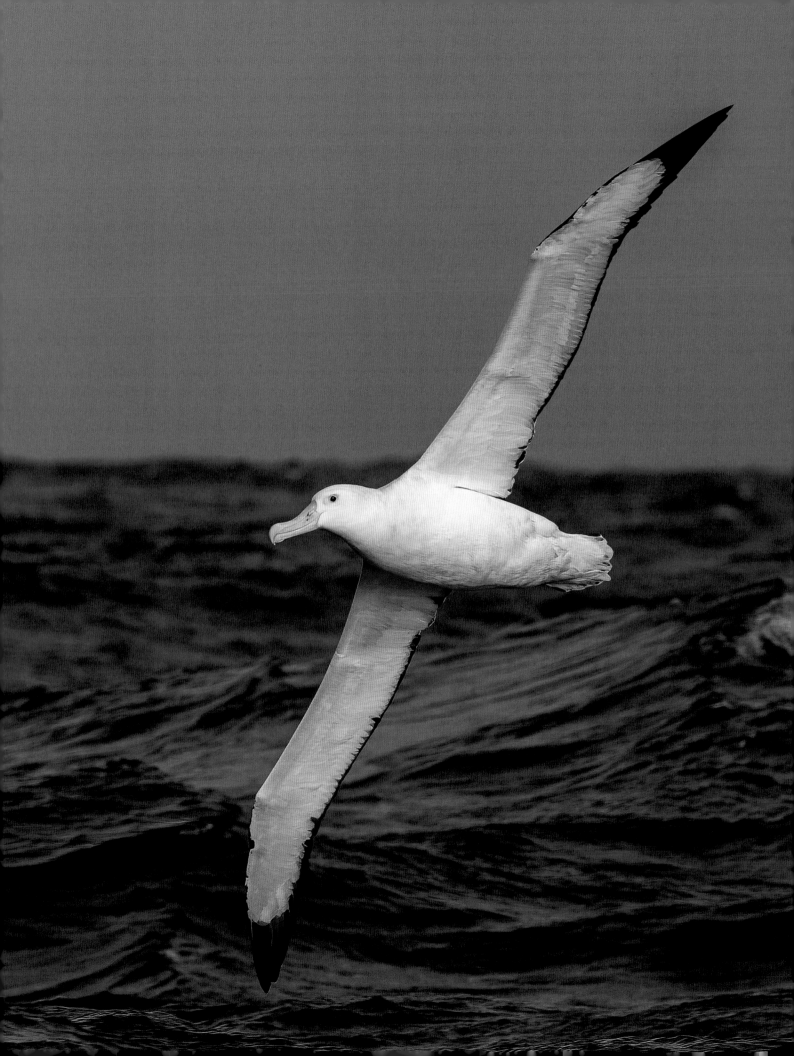

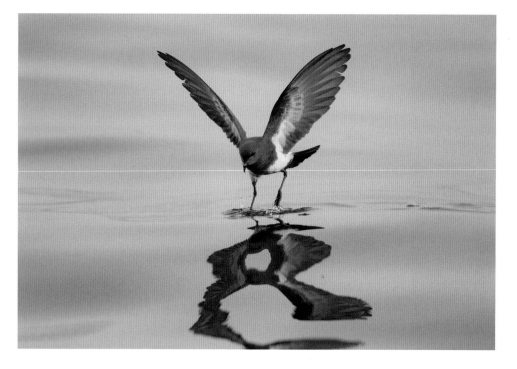

Opposite: Wandering Albatross.
Right: Black-bellied Storm-Petrel.

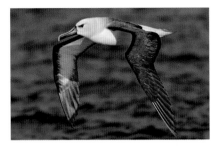

Yellow-nosed Albatross *Thalassarche chlororhynchos*

L 30" ♂ = ♀ YNAL *EN

The Atlantic population is a very rare warm-season visitor to the Atlantic coast of North America. The species breeds in the far southern waters of the Atlantic and Indian Oceans and wanders northward in the nonbreeding season. eBird lists 13 Atlantic/East Coast records from the last decade. The species is classified as Endangered.

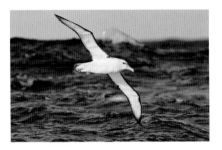

White-capped Albatross *Thalassarche cauta*

L 37" ♂ = ♀ WCAL *NT

Breeds on Tasmania and New Zealand and occasionally wanders to the West Coast of the United States. Spends most time in and around the far southern seas. Only a handful of records from North America off California and Oregon. Also known as the Shy Albatross. Diet is mainly squid. The species classified as Near Threatened.

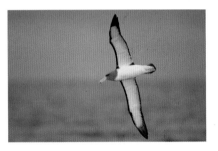

Chatham Albatross *Thalassarche eremita*

L 36" ♂ = ♀ CHAL *VU

Breeds on the Chatham Islands of New Zealand and wanders to the western coast of South America. A single North American record from the waters off Point Reyes, California. This and the preceding species sometimes grouped together as part of the Shy Albatross complex. The species is classified as Vulnerable.

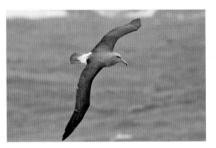

Salvin's Albatross *Thalassarche salvini*

L 37" ♂ = ♀ SAAL *VU

Breeds on islands off New Zealand and in the Crozet Islands of the southwestern Indian Ocean. Most nonbreeding records come from the western coast of southern South America. North American records come from the Aleutian Islands, Alaska; Half Moon Bay, California; and Hawaii.

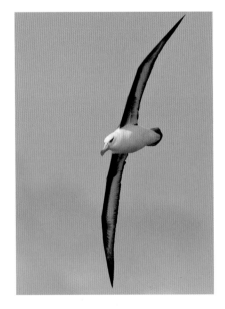

Black-browed Albatross *Thalassarche melanophris*

L 33" ♂ = ♀ BBAL *NT

A small albatross of the far southern seas, which only rarely wanders to pelagic waters off the East Coast. Breeds on South Temperate and sub-Antarctic islands. North American records come from Newfoundland and Labrador south to North Carolina. Fewer than 10 records per decade. This is one of the most numerous of the albatrosses and wanders widely from its sub-Antarctic homelands. Circumpolar in the southern oceans. Most similar to the Yellow-nosed Albatross. North Atlantic wanderers are more commonly observed in European waters. Showed substantial declines in the late 20th century but since has exhibited a recovery. Species population is more than a million birds. In spite of this is classified as Near Threatened.

Light-mantled Albatross *Phoebetria palpebrata*

L 37" ♂ = ♀ LMAL *NT

A little-known albatross of the far southern seas. Breeds on sub-Antarctic islands and wanders through the cold far southern seas. A single North American record comes from off the coast of Northern California. Diet is mainly squid. Occasionally will follow ships, especially fishing boats. Classified as Near Threatened.

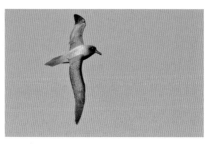

Wandering Albatross *Diomedea exulans*

L 53" ♂ = ♀ WAAL *VU

By wingspan, this is the largest flying bird. One of the great oceanic wind-sailors. Travels the far southern seas. Breeds on sub-Antarctic islands. Rare north of the Equator. Known from our region from a handful of records from Oregon and California (July and September).

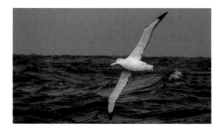

Black-bellied Storm-Petrel *Fregetta tropica*

L 8" ♂ = ♀ BBSP

A small pied storm-petrel of tropical and far southern seas. Regularly travels north of the Equator only in the Indian Ocean. Four records from North America come from waters off North Carolina (late May to mid-August). Classified as not under threat.

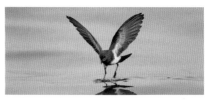

European Storm-Petrel *Hydrobates pelagicus*

L 6" ♂ = ♀ EUSP

A tiny and very dark storm-petrel with a white rump and a distinctive fluttering flight. Ranges through the Atlantic, from the far north to the far south. Breeds on islands in the northeastern Atlantic and Mediterranean. Individuals are observed nearly every spring off the coast of North Carolina or the Atlantic coast of northern Florida.

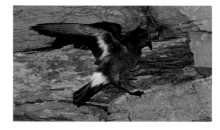

Ringed Storm-Petrel *Hydrobates hornbyi*

L 9" ♂ = ♀ RISP

A large gray-and-white storm-petrel. Inhabits the Pacific off the western coast of South America. Known in North America from a single record off Southern California. Another possible record comes from Oregon waters in May.

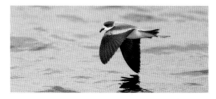

Swinhoe's Storm-Petrel *Hydrobates monorhis*

L 8" ♂ = ♀ SSTP

A large, all-dark storm-petrel with an erratic and bounding flight. Breeds in Northeast Asia and wanders through the western Pacific and Indian Ocean. Records come from the seas off North Carolina, in spring, and an unconfirmed sighting from off Kodiak Island, Alaska.

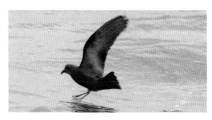

Wedge-rumped Storm-Petrel *Hydrobates tethys*

L 6" ♂ = ♀ WRSP

A small storm-petrel with a large white rump patch. A common pelagic species of the eastern tropical Pacific, breeding on the Galápagos Islands and islets off Peru. Recorded fifteen times far offshore of California and once in numbers in Arizona over 7–8 September 2016, blown inland by a tropical storm.

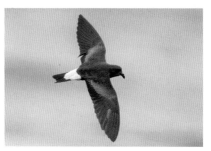

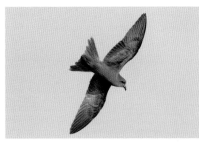

Tristram's Storm-Petrel *Hydrobates tristrami*
L 10" ♂ = ♀ TRSP *NT

A large, all-dark, fork-tailed storm-petrel of the western and central Pacific. Breeds off Japan and in the Hawaiian Islands. Three records from waters offshore California (March, April, July): a bird photographed, a bird captured and banded on the Farallon Islands, and a dead individual found at the same locality.

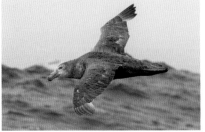

Northern Giant-Petrel *Macronectes halli*
L 34" ♂ = ♀ NOGP

A huge and dark pelagic petrel with a very large bill. Breeds and travels throughout the far southern seas. The single North American sighting comes from off the coast of Washington in December 2019. Breeds on subantarctic islands. Accompanies ships and scavenges at fishing boats. Classified as not under threat.

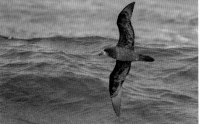

Gray-faced Petrel *Pterodroma gouldii*
L 18" ♂ = ♀ GFPE

A large and dark, long-winged petrel that nests in New Zealand waters. Range seems mainly confined to a small portion of the Southwest Pacific between southern Australia and the Chatham Islands. Several North American records come from off the coast of California (July–October). Classified as not under threat.

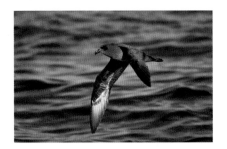

Providence Petrel *Pterodroma solandri*
L 16" ♂ = ♀ PRPE *VU

This large dark petrel breeds on islands east of the Australian mainland. Ranges across the central and western Pacific. North American records come from the western Aleutian Islands, Alaska, and the West Coast. In addition, there are several unsubstantiated records from off the coast of California between June and December.

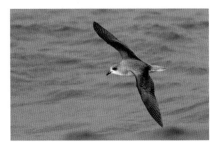

Zino's Petrel *Pterodroma madeira*
L 14" ♂ = ♀ ZIPE *EN

This petrel breeds on Madeira, off northwest Africa. Presumably the species ranges across the North Atlantic. The sole North American record is a September 1995 sighting in waters off North Carolina. Smaller and more lightly built than Fea's Petrel, which is a close relative. The species is classified as Endangered.

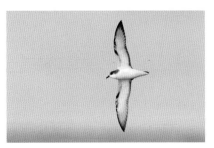

Stejneger's Petrel *Pterodroma longirostris*
L 11" ♂ = ♀ STPE *VU

A small gray, white, and charcoal petrel that breeds in the Juan Fernandez Islands of Chile. Apparently nonbreeders range northward into the central Pacific. Recorded several times off the coast of California (April, September, and November). Additional North American records come from far off the West Coast. There is a single September record from the Gulf Coast of Texas.

Bulwer's Petrel *Bulweria bulwerii*

L 11" ♂ = ♀ BUPE

A small, dark petrel found widely through tropical and subtropical waters. Breeds on islands in the eastern, southern, and central Pacific, including the Hawaiian Islands. Atlantic populations breed in islands off West Africa. North American sightings come from Virginia, North Carolina, Florida, and California.

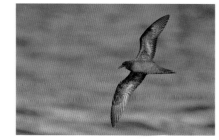

Jouanin's Petrel *Bulweria fallax*

L 14" ♂ = ♀ JOPE *NT

Very similar to Bulwer's Petrel but larger and with broader wings. Breeds on islands in the Indian Ocean. Ranges from the shores of Arabia southeast to northwestern Australia. North American sightings come from Southern California (June) and Midway Atoll, Northwestern Hawaiian Islands (August).

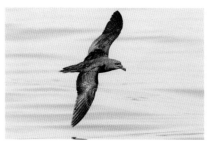

White-chinned Petrel *Procellaria aequinoctialis*

L 22" ♂ = ♀ WCPE *VU

A large, dark petrel of the southern seas. Breeds on sub-Antarctic islands. There are seven reports from North America in waters off California, Texas, Maine, and North Carolina. Generally frequents deep waters off the continental shelf. Diet is squid and shrimp. The species is classed as Vulnerable.

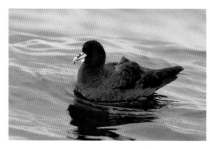

Parkinson's Petrel *Procellaria parkinsoni*

L 17" ♂ = ♀ PAPE *VU *WL

Very similar but slightly smaller than the White-chinned Petrel. Breeds on islands off northern New Zealand and ranges north and east to the west coast of Mexico. A single North American record comes from the waters off Point Reyes, California, October 2005.

Streaked Shearwater *Calonectris leucomelas*

L 19" ♂ = ♀ STRS

A distinctive and large-billed pied shearwater with languid soaring flight. Gregarious and sometimes gathers in large flocks. This shearwater of the eastern Pacific breeds off East Asia and ranges from Kamchatka, Russia, south to Australia. North American records come from Hawaii and the West Coast; additional records come from interior California and Wyoming.

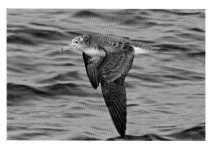

Cape Verde Shearwater *Calonectris edwardsii*

L 16" ♂ = ♀ CVSH *NT

Like a smaller, darker-billed version of the commonplace Cory's Shearwater. Breeds in the Cape Verde Islands off West Africa. North American records come from the waters off North Carolina and off Chatham, Massachusetts. The report from the waters off coastal Maryland was not been accepted by the state records committee.

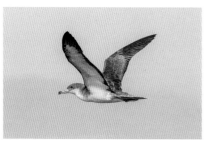

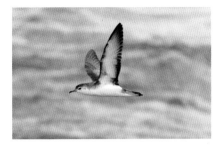

Barolo Shearwater *Puffinus baroli*

L 11" ♂ = ♀ BASH

A member of the Audubon's Shearwater complex—the smallest of this group. Similar in appearance to the larger, longer-tailed Audubon's Shearwater. Breeds off northwestern Africa. There are more than a dozen North American records from Nova Scotia and Massachusetts, mainly in late summer. Lumped by some authorities into Audubon's Shearwater. Breeding population presumably very small.

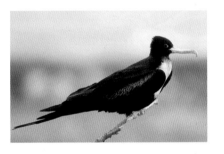

Lesser Frigatebird *Fregata ariel*

L 30" ♂ ≠ ♀ LEFR

This is the smallest of the five species of frigatebirds. Ranges mainly through the tropical seas of the Indian and southwestern and central Pacific Oceans. Also breeds off the coast of Brazil. There are four records from North America: Maine (July), Wyoming (July), Michigan (September), and Northern California (July). Nests on small and remote islands. The species nests colonially. Diet is mainly flying-fish and squid. But generally omnivorous and preys on eggs and nestlings of seabirds. Females are the dominant kleptoparasites, stealing prey from other species of seabirds. Classified as not threatened.

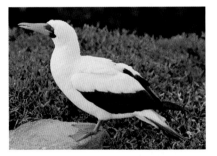

Great Frigatebird *Fregata minor*

L 37" ♂ ≠ ♀ GREF

Considerably larger than the Lesser Frigatebird, but smaller than the better-known Magnificent Frigatebird. Breeding is widespread in the Indian and Pacific Oceans (including Hawaii). Three records from the waters off California (March, October, and November) and one from Oklahoma (November).

Nazca Booby *Sula granti*

L 32" ♂ = ♀ NABO

This species was split from the Masked Booby in 2000. Breeds from the Galápagos Islands north and east to islands off western Mexico. Has invaded waters off the West Coast in recent years with many records accumulating quickly. This species is very similar to the Masked Booby but differs in bill color and tail pattern. Young birds are challenging to distinguish from those of Masked Booby.

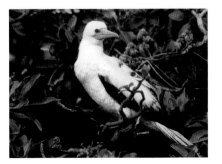

Red-footed Booby *Sula sula*

L 28" ♂ = ♀ RFBO

This bird, the smallest booby, is quite variable in plumage. Widespread through tropical seas, including Hawaii. A rare visitor to the waters off California and southern Florida. Additional records come also from Oregon, Washington, Alaska, Texas, Louisiana, Mississippi, Alabama, Georgia, South Carolina, North Carolina, and Nova Scotia. Records range from January to December.

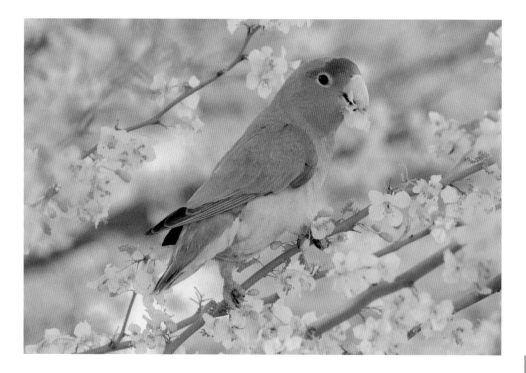

Right: Rosy-faced Lovebird.

Egyptian Goose *Alopochen aegyptiaca*

L 27" ♂ = ♀ EGGO

This distinctive goose is native to the southern three-quarters of Africa. The species has become established in southeastern Florida, Texas, and California. Frequents city parks and golf courses. The leafy and reedy nest is placed on the ground or in a tree hole or old nest of another bird. Lays 5–12 creamy-white eggs. The species is secure.

Indian Peafowl *Pavo cristatus*

L 63" ♂ ≠ ♀ INPE

This iconic South Asian pheasant is popular in aviculture and has been introduced to many large private estates. Feral populations have become established widely in Florida, southern California, and Hawaii. Most commonly seen in large, open green spaces, such parks and estate properties. Seen searching the ground for fruit, seeds, invertebrates, or small vertebrates. Nest is on the ground hidden under shrubbery and lined by plant materials. Lays three to six buff-white eggs.

Himalayan Snowcock *Tetraogallus himalayensis*

L 26" ♂ = ♀ HISN

A large central Asian pheasant introduced from the Himalayas in 1963 and now resident high in the Ruby Mountains of Nevada. A desired quarry both of birders and hunters of exotic game birds. Prefers rocky meadows near alpine snowfields in the Ruby Mountains. The Nevada population totals a few hundred individuals. Feeds on alpine vegetation—mainly roots and seeds. Ground nest is a sheltered scrape in a protected site. Lays 5–12 buff eggs blotched brown.

Spotted Dove *Streptopelia chinensis*

L 12" ♂ = ♀ SPDO

This species of Southeast and East Asia has been introduced to various places in Southern California, where it first expanded and more recently has declined. Currently found in Fresno, Bakersfield, and Los Angeles, as well as on Catalina Island. Found in suburbs and gardens. Common in Hawaii. Diet is mainly seeds. The nest, set on a branch in a shrub or tree, is a loose platform of twigs. Lays two white eggs.

African Collared-Dove *Streptopelia roseogrisea*

L 11" ♂ = ♀ AFCD

Breeds from West Africa to Yemen. Very similar to the Eurasian Collared-Dove, which is distinct in exhibiting gray (not white) undertail coverts. The domesticated form of this species, known as the Ringed Turtle-Dove, is popular with aviculturists, pigeon fanciers, and magicians. Feral populations can be seen in coastal Florida and California.

Scarlet Ibis *Eudocimus ruber*

L 24" ♂ = ♀ SCIB

Inhabits northern South America, from Ecuador and Colombia to Venezuela. An isolated population occurs in southeastern Brazil. Visits Trinidad, where it formerly bred. No recent North American records. There are some accepted records for Florida from the nineteenth century. Various records in the twentieth century, mainly of introduced or individuals escaped from captivity. Will hybridize with White Ibis. Recently introduced to the British Virgin Islands.

Gray-headed Swamphen *Porphyrio poliocephalus*

L 16" ♂ = ♀ GHSW

This South Asian species (the "Purple Swamphen *Porphyrio porphyrio*" of some authorities) has been introduced to South Florida, where it has become established. Inhabits freshwater marshes and reed beds. The nest, set over water and hidden in marsh vegetation, is a substantial structure of dead marsh grasses with a shallow cup and a covering canopy. Lays three to seven eggs that are tan with brown spots.

Nanday Parakeet *Aratinga nenday*

L 14" ♂ = ♀ NAPA

A native of south-central South America. Now established in Southern California and Florida. US populations inhabit suburbs and surrounding countryside. Gives high and loud screeching notes. Diet is seeds, nuts, fruits, and blossoms, often taken from the ground. Nests in cavities; lays three or four dull white eggs.

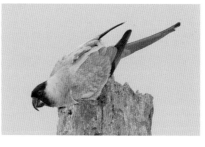

Green Parakeet *Psittacara holochlorus*

L 13" ♂ = ♀ GREP *WL

A parakeet native to Central America and Mexico. Established feral populations are now found in the Lower Rio Grande Valley of South Texas as well as in South Florida. It inhabits suburban woodlands in the US. Diet is mainly seeds and grain. Nests in a tree cavity. Lays four eggs. The native species population in Mexico and Central America is classified as of Least Concern.

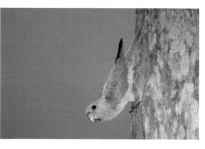

Red-masked Parakeet *Psittacara erythrogenys*

L 14" ♂ = ♀ RMPA *NT

A parakeet native to western South America, with a tiny range extending from western Ecuador to northwestern Peru. Has been introduced to the United States, where it is apparently established in Hawaii, San Francisco, Los Angeles, and San Diego, as well as in Miami, Palm Beach, and Bradenton, Florida. Inhabits suburban woodlands. Diet is mainly seeds and grain. Nests in a tree cavity. Lays two to four eggs.

Mitred Parakeet *Psittacara mitratus*

L 15" ♂ = ♀ MIPA

Native to the Andes of South America, this species has become established in the Los Angeles area and South Florida. Has been introduced to Hawaii, as well, though its status there is uncertain. Occupies suburban habitats. Diet includes fruit and grain. Nests in tree cavities. Lays two or three eggs. The species is of Least Concern.

White-winged Parakeet *Brotogeris versicolurus*

L 9" ♂ = ♀ WWPA

A native of northern South America, now established in Miami. Los Angeles population in sharp decline. Seems to have adapted to some urban and suburban habitats in the United States, including parks and gardens. Nest is placed in a natural cavity or hidden in a cluster of dead palm fronds. Lays five white eggs.

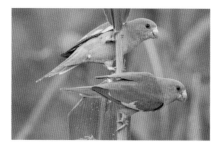

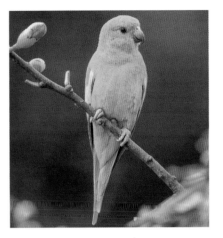

Yellow-chevroned Parakeet *Brotogeris chiriri*

L 9" ♂ = ♀ YCPA

This handsome small parrot species is a native of central South America. It is now established in Southern California and southeastern Florida, where it is found mainly in urban and suburban habitats. Seen to nest in Florida in a hole excavated in a date palm in a residential neighborhood. Lays five or six eggs. In its native South America, the species frequents a range of wooded habitats, from gallery forest to flooded grassland. Seasonally forms large flocks. In its native habitat the species is not under any threat.

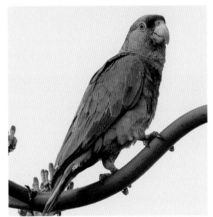

Red-crowned Parrot *Amazona viridigenalis*

L 12" ♂ = ♀ RCPA *EN *WL

This amazon, from a small range in eastern Mexico, now has established populations in three urban settings in the United States—Southern California, southernmost Texas, and South Florida. Frequents mainly urban and suburban parklands. The feral population in the United States may now be larger than the native population in Mexico. Highly gregarious. Flocks are vocal in morning and evening. Nests in natural cavities and those created by other birds. Lays two to five white eggs.

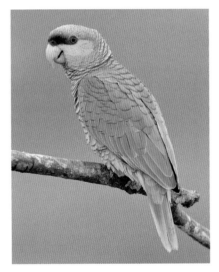

Lilac-crowned Parrot *Amazona finschi*

L 13" ♂ = ♀ LCPA *EN *WL

This amazon parrot, whose native populations range up and down the west coast of Mexico, now has established populations in Santa Barbara, Los Angeles, and San Diego, California; El Paso, Texas; and southeastern Florida. The species mainly inhabits urban and suburban parklands. In the US, it is seen in small flocks, which may join up with other feral parrot species. Nests in a tree cavity. Lays one to four whitish eggs. The native population of the species is classified as Endangered. In Mexico, the species may be shot because it is considered a crop pest in in that country.

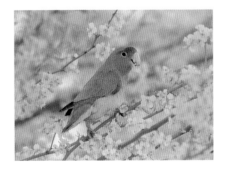

Rosy-faced Lovebird *Agapornis roseicollis*

L 7" ♂ = ♀ RFLO

This native of southwestern Africa is now established in the Phoenix, Arizona, area and is expanding to Tucson and elsewhere. In the United States, it seems to inhabit urban and suburban habitats. Diet is seeds, grain, and plant buds. Nests in cavities, especially in Saguaro cacti. Lays four to six eggs. Is considered a pest of grain crops in its native Africa. The species is classified as of Least Concern.

Rose-ringed Parakeet *Psittacula krameri*

L 16" ♂ ≠ ♀ RRPA

This long-tailed and handsome green parrot is native to South Asia and sub-Saharan Africa. Escapes from captivity have bred in Southern California and Florida. It is also widespread as an introduced species in the Old World. US populations have become established in Los Angeles and Bakersfield, California, as well as in Naples, Florida. Flocks of these birds are quite noisy. Diet is seeds, grain, and fruit. Nests in a tree cavity. Lays three or four eggs. The species can be a pest of crops in its native range. It is a commonplace urban and suburban bird in India. A very popular cage bird.

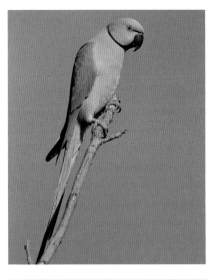

Common Myna *Acridotheres tristis*

L 10" ♂ = ♀ COMY

A myna introduced from South Asia that is now common in Hawaii and South Florida. This myna is now commonplace in many spots around the world. A human commensal that, in its adopted countries, prefers urban and suburban environments—shopping malls, city parks, and the like. Vocal and adaptable. Diet is a mix of fruit and invertebrate prey. Places its messy nest of all manner of materials in a cavity or crevice. Lays four to six pale blue eggs.

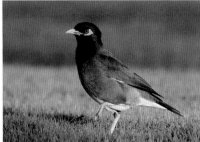

Common Hill Myna *Gracula religiosa*

L 11" ♂ = ♀ CHMY

A popular cage bird introduced to South Florida, mainly found in small numbers in the Miami area. The species is native to South and Southeast Asia. In the United States, it inhabits suburban and urban habitats with rich tropical plantings. Vocal and sociable. Seen perched from high open perches in tall trees. Diet is mainly fruit with a complement of arthropods. Nest, a pad of leaves, is placed in a tree cavity. Lays two or three blue eggs.

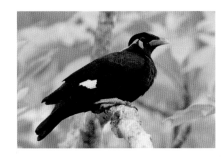

Black-throated Magpie-Jay *Calocitta colliei*

L 27" ♂ = ♀ BTMJ

This gorgeous and showy jay inhabits northwestern Mexico. Nearest native breeding population is in southeastern Sonora. Escaped cage birds have colonized California; it is apparently establishing itself in San Diego and another population is now found south of Escondido. In its native range this jay inhabits dry woodlands and deciduous forest near watercourses. Known to be a vocal caller making a plethora of sounds. Feeds on arthropods and a variety of fruit. Forages in treetops and shrubbery. Nonmigratory. The species is of Least Concern.

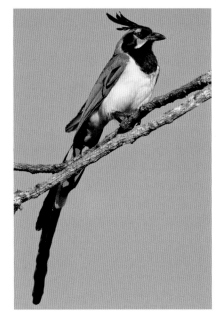

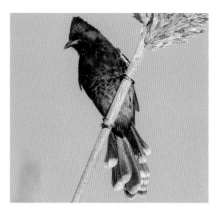

Red-vented Bulbul *Pycnonotus cafer*

L 9" ♂ = ♀ RVBU

A common South Asian species. Escaped cage birds have successfully colonized the Houston metropolitan area and Hawaii. Frequents deciduous wooded parkland and suburban habitats. Vocal and confiding, often perching in the open. Diet is a mix of fruit and small arthropods. The cup nest of leaves and fine grasses is wrapped in spider silk and placed in the fork of a branch in a shrub or tree. Lays two to four pinkish-white eggs blotched brownish-purple. This and the next species are two of the most common and widespread species on the Indian Subcontinent. Classified as Least Concern.

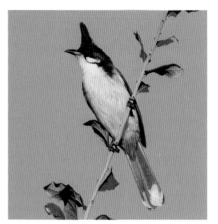

Red-whiskered Bulbul *Pycnonotus jocosus*

L 7" ♂ = ♀ RWBU

Another common South and Southeast Asian species colonizing the United States. Populations have been founded by escaped cage birds. Currently found in wooded suburbs of Miami, suburban Los Angeles, and Oahu, Hawaii. Inhabits suburban residential areas where an array of exotic plant species provide a year-round supply of fruit for consumption. Travels in parties when searching for trees with ripe fruit. Diet is small fruits and arthropods. The cup nest, composed of a variety of fine plant materials and decorated with a variety of found materials, is hidden in a shrub or small tree, usually low to the ground. Lays two to four pinkish eggs spotted reddish brown.

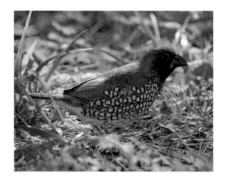

Scaly-breasted Munia *Lonchura punctulata*

L 4" ♂ = ♀ SBMU

This species is commonplace in South and Southeast Asia. Escaped cage birds have successfully colonized Hawaii, Southern California, South Florida, Houston, and New Orleans. Inhabits weedy fields, stream rights-of-way, and other places where grasslands flourish in urban settings. Travels and forages in tight flocks. Forages on grass seeds. Nest is a loosely constructed globe of plant materials, with a side entrance, that is situated in epiphytes in a tree or shrub. Lays three to six eggs.

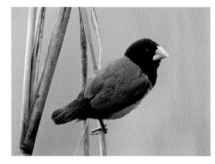

Tricolored Munia *Lonchura malacca*

L 5" ♂ = ♀ TRMU

Resident of peninsular India and Sri Lanka. Escaped cagebirds have widely colonized the Caribbean and Central and South America. Today, a handful of records from South Florida, the first of which were probably dispersing from expanding populations in the Caribbean. Apparently breeding south of Lake Okeechobee. Additional individual records come from Alabama, South Carolina, Tennessee, and Texas. Native population classed as Least Concern.

Bronze Mannikin *Spermestes cucullata*

L 4" ♂ = ♀ BRMA

A widespread resident of sub-Saharan Africa, this small finch has been introduced to Los Angeles and Houston, where it seems to be establishing itself in those urban landscapes. In the United States, confined to urban and suburban environs. A flocking species year-round. Diet is seeds and some arthropods. Nest is a globe of plant materials, with a side entrance, situated in a tree or shrub. Lays four to eight eggs.

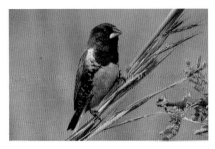

Northern Red Bishop *Euplectes franciscanus*

L 4" ♂ ≠ ♀ NRBI

Cagebird escapees of this resident of northern sub-Saharan Africa have colonized Southern California, South Florida, and Houston. Frequents weedy tracts, especially along stream beds with grassy swales. Very gregarious. Diet is mainly seeds and some arthropods. Nest is a globe of grass and flower parts with a side entrance; it is situated in tall grass. Lays two to four blue eggs.

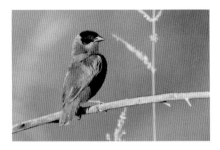

Pin-tailed Whydah *Vidua macroura*

L 12" ♂ ≠ ♀ PTWH

Another sub-Saharan finch in which cagebird escapees have colonized the Los Angeles area and seems to be establishing a beachhead there. Also reported from Houston, New Orleans, and South Florida. Inhabits grassy urban and suburban habitats. The long-tailed male gives a remarkable display flight. Presumably grass seeds dominate the diet. This nest parasite lays its eggs in the nests of Scaly-breasted Munias. Lays sets of three or four white eggs.

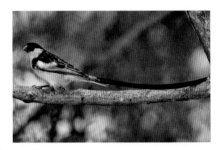

European Goldfinch *Carduelis carduelis*

L 5" ♂ = ♀ EUGO

Cagebird escapees of this common Eurasian species have become established north of Chicago, Illinois, and to a lesser extent in Brooklyn, New York. Found in urban and suburban environs; visits bird feeders. Habits are much like the American Goldfinch. Diet is mainly seeds, as well as buds, flowers, fruit, and some arthropods. Nest is a small and compact cup of grasses, moss, plant fibers, and other constituents set in a bush or low tree. Lays four to six pale bluish-white eggs blotched with other colors.

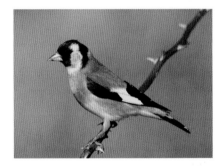

Swinhoe's White-eye *Zosterops simplex*

L 4" ♂ = ♀ SWWE

A typical Asian white-eye, native to eastern China and Southeast Asia, not unlike the species found in Hawaii (often considered the same species). Introduced to southern California and now breeding there. Ranges mainly from Los Angeles south to Tijuana, Mexico. Also records from Santa Barbara and San Francisco. Forages on small fruits, nectar, and arthropods in shrubs and trees. Nest is a cup of grass bound with spider silk. Lays 2–6 bluish eggs.

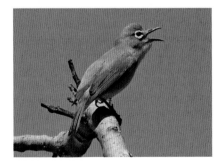

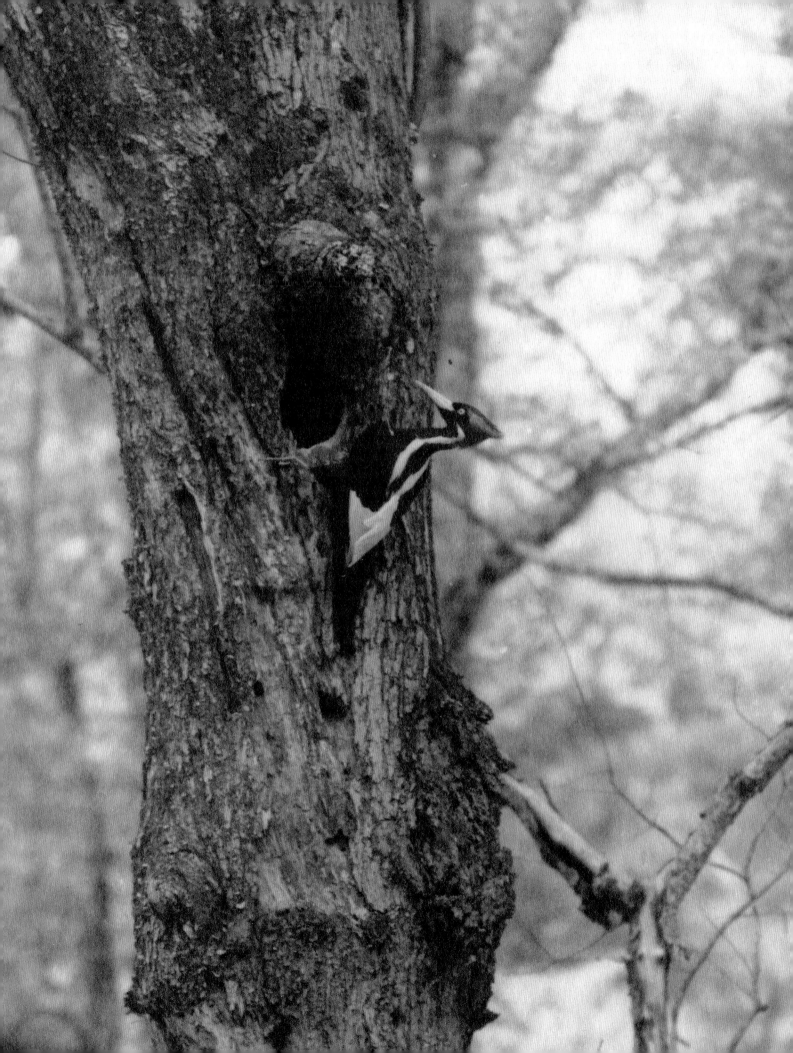

Opposite: An adult male Ivory-billed Woodpecker photographed in the Tensas Basin of Louisiana by Arthur A. Allen on 12 April 1935. Right: Eskimo Curlew painting by John Schmitt.

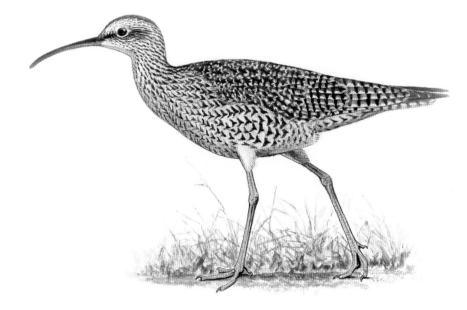

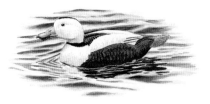

Labrador Duck *Camptorhynchus labradorius*

L 23" ♂ ≠ ♀ LABD *EX

This duck wintered off the coast of the Mid-Atlantic. Breeding grounds unknown but presumed to be in Atlantic Canada or further north. Last specimen was taken from the waters off Long Island, New York, in 1875. Reason for decline unknown—possibly because of market hunting of the wintering populations of the bird.

Passenger Pigeon *Ectopistes migratorius*

L 16" ♂ ≈ ♀ PAPI *EX

This pigeon ranged widely across the eastern half of the Lower 48 and southern Canada, traveling in huge flocks. Believed to have once been the most abundant bird species living in North America. Last wild specimen was taken in 1900 from Ohio. Last sighted in Missouri in 1902. Last individual in captivity died at the Cincinnati Zoo in September 1914. Decline of the species was probably caused by market hunting and woodland habitat loss. One flock seen in 1808 was estimated to exceed a billion birds. Diet included acorns, chestnuts, and beech nuts.

Laysan Rail *Zapornia palmeri*

L 6" ♂ = ♀ LARA *EX

This small flightless rail was endemic to Laysan Island in the Northwestern Hawaiian Islands. Before the Laysan Island population winked out some time between 1923 and 1936, birds were introduced to several nearby islands in the Northwestern Hawaiian Islands. These all disappeared by 1944. The island extirpations were caused by habitat destruction wrought by introduced rabbits and guinea pigs (Laysan Island) and storms and introduced rats (the other islands).

Hawaiian Rail *Zapornia sandwichensis*

L 5" ♂ = ♀ HARA *EX

This tiny flightless rail was endemic to the Big Island of Hawaii. Last seen in 1884.

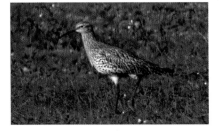

Slender-billed Curlew *Numenius tenuirostris*

L 15" ♂ = ♀ SBCU *CR

This small Eurasian curlew bred in southwestern Siberia and wintered to North Africa and West Asia. Much in decline by the 1970s. Wintering birds last definitively seen in Morocco in 1995. The single North American record is a specimen taken at Crescent Beach, Ontario, on or about 1925. Last verified record for the species was apparently in 2001. Classed as Critically Endangered but certainly extinct.

Eskimo Curlew *Numenius borealis*

L 14" ♂ = ♀ ESCU *EX

This small curlew bred in Arctic Canada and wintered in the Pampas of Argentina. In spring, it migrated north through the Great Plains. In autumn, it migrated eastward to New England and then down over the Atlantic to South America. The last known wild individual was a specimen shot in Barbados on 4 September 1963. Last North American observation was from Galveston Island, Texas, in 1962. Probable cause of extinction was excessive market hunting in the late nineteenth century that reduced populations below sustainable levels.

Great Auk *Pinguinus impennis*

L 30" ♂ = ♀ GRAU *EX

This giant flightless auk nested on islands off Quebec and Newfoundland, and it wintered southward to the waters off Massachusetts. There are a scattering of records south to the waters off South Carolina. Last collection was of two birds taken in Iceland in June 1844. Apparently wintered east to the Mediterranean. Cause of extinction was presumably market harvest for meat, feathers, and oil.

Ivory-billed Woodpecker *Campephilus principalis*

L 20" ♂ ≠ ♀ IBWO *EX

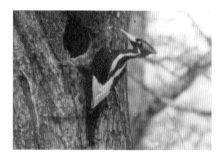

This great woodpecker inhabited forests of the the Deep South, including Florida. The North American population was reduced mainly by forest clear-felling and trophy hunting. The last authenticated sightings were from the Tensas River bottomlands of northern Louisiana in 1944. Other possible sightings in the Deep South continued into the 1950s. Widely reported observations in 2005 in Arkansas were never validated.

Carolina Parakeet *Conuropsis carolinensis*

L 13" ♂ = ♀ CAPA *EX

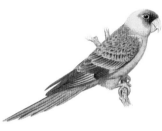

This handsome parrot inhabited the US East and Midwest to the Deep South and Florida. Was endemic to the United States. Last wild bird was a specimen collected in Florida in 1904. Last captive bird died in the Cincinnati Zoo in 1918. Decline of the species was tied to harvest for feathers, food, and aviculture, as well as elimination of foraging flocks to protect fruit orchards.

Kamao *Myadestes myadestinus*

L 8" ♂ = ♀ KAMA *EX

This larger forest-dwelling thrush was endemic to Kauai, Hawaii, where it inhabited dense montane forest. Related to the other Hawaiian thrushes (such as the one just below) and, this cluster of species is most closely related to the solitaires of mainland North, Central, and South America. Formerly was widespread on the island but retreated to the safety of montane forest, where malaria brought about extinction.

Amaui *Myadestes woahensis*

L ?" ♂ = ♀ AMAU *EX

This thrush inhabited Oahu Island, Hawaii. Known only from the type specimen, collected by Bloxam in 1825, who at the time reported it to be common.

Kauai Oo *Moho braccatus*

L 8" ♂ = ♀ KAOO *EX

This sooty songbird that looks much like a honeyeater was endemic to Kauai Island, Hawaii. In the late twentieth century, it was confined to the Alakai Wilderness Preserve of central Kauai. Apparently last recorded by vocalization in 1987. Decline of the species probably caused by depredations of rats, disease-carrying mosquitoes, and habitat destruction.

Oahu Oo *Moho apicalis*
L 12" ♂ = ♀ OAOO *EX

This large and showy songbird was endemic to the montane forests of Oahu Island, Hawaii. Last collected in the upland forests behind Honolulu in 1837. Nothing is known of its habits or the reason for its extinction.

Bishop's Oo *Moho bishopi*
L 12" ♂ = ♀ BIOO *EX

This showy black-and-gold songbird inhabited the forests of Molokai and Maui Islands. It disappeared from Molokai after 1904, with unconfirmed reports to 1915. A single bird of this species was reported in 1981 from the northeastern slopes of Haleakala in montane forest, but the fact that it was never seen again in spite of intensive investigation calls this observation into question.

Hawaii Oo *Moho nobilis*
L 12" ♂ = ♀ HAOO *EX

This showy black-gold-and-white songbird inhabited the forests of the Big Island of Hawaii. Last collected in 1902 and last observed in 1934. It is estimated that 1,000 skins of this species were collected in 1889, probably hastening the decline of the species.

Kioea *Chaetoptila angustipluma*
L 13" ♂ = ♀ KIOE *EX

In historic times, known only from the Big Island of Hawaii. A total of four specimens were collected between 1840 and 1859. Recent fieldwork has found subfossil specimens from Oahu and Maui, showing the bird had a more widespread distribution prior to arrival of western explorers.

Poo-uli *Melamprosops phaeosoma*
L 6" ♂ = ♀ POUL *EX

The last of the Hawaiian honeycreepers to be discovered, in 1973, in the Hanawi watershed of the northeastern slopes of Haleakala on Maui Island. This species inhabited a high-rainfall mountain forest far from human habitation. Attempts at captive breeding failed. The last birds were seen in the wild in 2004.

Oahu Alauahio *Paroreomyza maculata*
L 5" ♂ ≠ ♀ OAAL *EX

A small songbird looking much like the more common Oahu Amakihi, with which it shared forest habitat on Oahu. Last confirmed record came in 1968.

Kakawahie *Paroreomyza flammea*

L 5" ♂ ≠ ♀ KAKA *EX

This tiny songbird with a small pointed bill (and the fiery male plumage) was endemic to Molokai Island. Last observed in 1963 on the Ohialele Plateau.

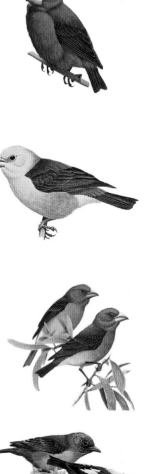

Kona Grosbeak *Chloridops kona*

L 6" ♂ = ♀ KOGR *EX

An olive-green finch-like bird with a huge buff-pink bill. Endemic to the Big Island of Hawaii. Known from a small area in the Kona District of the Big Island. Last recorded in 1894. Fed on hard seeds of the Naio tree. The bird was best located by listening for the loud cracking sounds of the seeds it was eating.

Lesser Koa-Finch *Rhodacanthis flaviceps*

L 8" ♂ ≠ ♀ LEKF *EX

An olive-green finch-like songbird with a grosbeak-like bill. Male had a yellow head. Endemic to the Big Island of Hawaii. Known from a few specimens collected at Kona, Hawaii, in 1891. Never seen again. Why it was so rare in 1891 is a mystery. Subfossil remains of this or a similar species reported from Oahu and Maui Islands.

Greater Koa-Finch *Rhodacanthis palmeri*

L 9" ♂ ≠ ♀ GRKF *EX

This finch-like bird exhibited a large dark bill. The male showed a bright golden-orange head and breast. Known only from 1,000 m elevation in the Kona and Kau Districts of the Big Island of Hawaii. Last seen around 1896. Apparently foraged exclusively on seeds of the Koa tree.

Ula-ai-hawane *Ciridops anna*

L 5" ♂ ≠ ♀ UAIH *EX

This small, compact small-billed songbird was found in historic times on the Big Island of Hawaii. Subfossil material for this monotypic genus comes from Molokai, Oahu, and Kauai Islands. Last seen in the early 1890s in Kohala, Hawaii.

Laysan Honeycreeper *Himatione fraithii*

L 5" ♂ = ♀ LAYH *EX

Formerly considered conspecific with the widespread Apapane. This pretty, dark-red songbird was endemic to Laysan Island, Northwestern Hawaiian Islands. The introduction of rabbits led to the temporary destruction of the island's vegetation. Last recorded in 1923.

Hawaii Mamo *Drepanis pacifica*

L 9" ♂ = ♀ HAMA *EX

A handsome black-and-gold sickle-billed songbird endemic to the Big Island of Hawaii. It supplied the brightest yellow feathers for Hawaiian featherwork, which likely contributed to the species' demise. Last seen in 1899 near Kaumana, Hawaii. It used its specialized bill to forage at native lobelia flowers in the forest understory.

Black Mamo *Drepanis funerea*

L 8" ♂ = ♀ BLMA *EX

This all-black sickle-billed songbird was found on Molokai Island, Hawaii. As with the Hawaii Mamo, it used its specialized bill for forage at flowers, primarily lobelias and Ohia-lehua. Last seen in 1907. Subfossil remains of this species (or one identical to it) were found on Maui.

Ou *Psittirostra psittacea*

L 7" ♂ ≠ ♀ OU *EX

This large and handsome finch-like songbird with the yellow head was native to the six largest Hawaiian islands. The last credible observation came from the Kauai, in the Alakai Wilderness Preserve, in 1989.

Lanai Hookbill *Dysmorodrepanis munroi*

L 5" ♂ = ♀ LANH *EX

This obscure, parrot-billed songbird was known from Lanai Island, based on a single specimen collected in 1913, plus sightings in 1916 and 1918. The species foraged on fruit of the Akoko tree in the Lanai lowlands. These forests were cleared for pineapple plantations in the 1910s, which, along with predation by rats and cats, probably led to the disappearance of the species.

Kauai Nukupuu *Hemignathus hanapepe*

L 6" ♂ ≠ ♀ KANU *EX

This songbird with a peculiar "half-beak" sicklebill was endemic to Kauai Island. It inhabited wet Ohia forest interior where it likely died out at the beginning of the twentieth century.

Oahu Nukupuu *Hemignathus lucidus*

L 6" ♂ ≠ ♀ OANU *EX

This little sicklebill was endemic to the Koa forests of Oahu Island. Last specimen was taken in 1837. Probably extinct by 1891 owing to the arrival of mosquitoes and the avian malaria they carry.

Maui Nukupuu *Hemignathus affinis*

L 6" ♂ ≠ ♀ MANU *EX

This bright-yellow-breasted sicklebill was endemic to Maui Island, Hawaii. It disappeared sometime in the last century.

Lesser Akialoa *Akialoa obscura*

L 7" ♂ ≠ ♀ LEAK *EX

This olive-plumaged sicklebill was discovered in the forests of the Big Island of Hawaii and last seen in 1903.

Kauai Akialoa *Akialoa stejnegeri*

L 8" ♂ = ♀ KAAK *EX

This olive-plumage sicklebill exhibited a less decurved but very long bill. It inhabited the upland and lowland forests of Kauai Island, Hawaii. It was near extinction by 1944, and the last bird encountered was in the Alakai Wilderness Preserve of central Kauai in 1965.

Oahu Akialoa *Akialoa ellisiana*

L 7" ♂ ≈ ♀ OAKI *EX

This dull olive sicklebill was endemic to the montane forests of Oahu Island, Hawaii. Two specimens were collected in 1837. Subsequently, there were unconfirmed sightings in 1937 and 1940.

Maui-nui Akialoa *Akialoa lanaiensis*

L 7" ♂ ≠ ♀ MNAK *EX

This sexually dichromatic sicklebill was historically known from Lanai Island, although subfossil evidence indicates it also ranged to Molokai and Maui. First collected in 1893, and presumably extinct by the early twentieth century.

Greater Amakihi *Viridonia sagittirostris*

L 7" ♂ = ♀ GRAM *EX

This olive-green songbird with a pointed and straight bill was endemic to the Big Island of Hawaii, where it inhabited the drenched rainforest above Hilo. First collected in 1892, it was last seen only nine years later, in 1901.

Maui Akepa *Loxops ochraceus*

L 4" ♂ ≠ ♀ MAAK *EX

This small dichromatic and short-billed honeycreeper was endemic to Maui Island. Confined to the montane rainforest of East Maui. Disappeared in the twentieth century.

Oahu Akepa *Loxops wolstenholmei*

L 4" ♂ ≠ ♀ OAKE *EX

This warbler-like songbird, the male red and the female grayish olive, was endemic to Oahu Island, Hawaii. Last confirmed sighting came in 1900.

Bachman's Warbler *Vermivora bachmanii*

L 5" ♂ ≠ ♀ BAWA *EX

This North American breeder formerly inhabited canebrakes in bottomland swamp forest of the Deep South and Mississippi Basin. Wintered on Cuba and Isle of Pines. Last sighting was in 1962, north of Charleston, South Carolina.

A BIRD FAMILY IS A CLUSTER of related species of birds. For instance, the ducks, swans, and geese constitute a bird family—the Anatidae—which comprises 159 species of duck-like birds that can be found around the world. In terms of hierarchy of relationship, evolutionary lineages of animals and plants are classified in increasingly inclusive groupings: subspecies, species, genus, tribe, family, order, class. Most of this taxonomic "bookkeeping" remains in the realm of behind-the-scenes technical work, not important to the average reader. The two groupings that are important to this particular treatment of the birds of North America are species and families. Learning the species and families of birds of North America is enough to deal with unless one wishes to become a professional ornithologist.

We have dealt with all of North America's *species* in the earlier sections of the book. Now, we discuss the 101 bird *families* that occur in North America (including Hawaii). It's good to be familiar with the various bird families to gain an understanding of relationships among species. Families that are listed near each other are understood to be more closely related, but note that the linear sequence of families is a somewhat artificial "flattening" of what is actually a multi-dimensional "bush" of relationships. Our understanding of the relationships among the many bird families has evolved over the last two decades because of the progress in the field of molecular systematics. But it seems likely we are still in the early days of exploring DNA's mysteries to divine the evolution of life. Expect bird family sequences to be reshuffled in future iterations of the American Birding Association (ABA) checklist (followed here) and the field guides that you use. We are in times of considerable instability in bird taxonomy and systematics.

Each family account presents the common name(s) for the members of the family, the scientific name of the family in parentheses, the number of species recorded from North America, and the number of species worldwide. Each account also lists the major members of the family, along with their world distribution, their major characteristics, and interesting aspects of their natural history.

The world's birds can be divided into two major groupings: the passerines, birds such as the American Robin, and the non-passerines, birds such as the Canada Goose. The passerines are known as the "perching birds," and we recognize them as mainly our small backyard birds. The non-passerines include most of the larger birds, thought to be evolutionarily older and more diverse.

There are 52 families of non-passerine birds in North America and 49 passerine families.

Opposite: A male Kentucky Warbler bathes in a woodland pool.

THE NON-PASSERINE FAMILIES

Ducks, Geese, and Swans (Anatidae) NA: 71 species World: 159 species (p. 32)
The waterfowl family comprises the ducks, geese, and swans—a large assemblage of water-loving birds that exhibit webbed feet, dense waterproof feathering, and broadened bills adapted for living and feeding on the water. The species range widely in size. In North America, the Green-winged Teal (0.75 lb.) is the smallest and Trumpeter Swan (23 lb.) is the largest. Most species are good fliers and tend to be sociable. Diet is diverse. Most nest on the ground near water, though some nest in trees. In North America, most species breed in the North and tend to winter southward. In late winter, the males of many ducks exhibit active courtship displays to the female.

Curassows and Guans (Cracidae) NA: 1 World: 54 (p. 60)
This Neotropical lineage of large fowl-like birds is mainly found in forests of the Neo-tropics, with a single species (the Plain Chachalaca) ranging northward into South Texas. Members of the family have the look of a pheasant or chicken, typically with a rather long tail and short, rounded wings that make for noisy and labored flight. They spend a lot of time up in trees foraging for fruit. The stick nest is mainly placed up in a bush or tree.

New World Quail (Odontophoridae) NA: 6 World: 33 (p. 61)
The New World Quail constitute a compact and well-defined cluster of small, handsome-ly patterned upland game birds that travel in groups on the ground and forage in open habitats for seeds, other plant matter, and arthropods. The birds are compact, with short, rounded wings, a short tail, and short legs. Although they are explosive fliers, they get around mainly on foot. This New World family is found mainly in the Neotropics. In North America, most species inhabit the Arid Southwest.

An adult male Scaled Quail calls from its weedy perch.

Grouse, Turkeys, and Old World Quail (Phasianidae) NA: 23 World: 178 (p. 64)
This rather large assemblage includes both native and introduced species of upland game birds, some smallish and globular, some large and long-tailed. The introduced species are mainly from Eurasia and vary from small to large chicken-like birds, including the Indian Peafowl ("the peacock") and the Ring-necked Pheasant. The native species include the grouse, sage-grouse, prairie-chickens, Wild Turkey, and ptarmigans. All forage on the ground and, when disturbed, flush noisily from the ground with whirring wings. The Red Junglefowl, commonplace as a naturalized species on the Hawaiian Islands and Key West, Florida, is the wild version of our chicken. Most species live in Asia and Africa.

Flamingos (Phoenicopteridae) NA: 1 World: 6 (p. 74)
This small lineage of very long-legged, large wading birds inhabits both the Old and New Worlds, ranging from India to Africa, southern France, and South and Central America. A single species occasionally strays from the Caribbean to South Florida and the Gulf Coast. All flamingos exhibit long pink or yellow legs, pinkish-tinged plumage, and a pecu-liar-looking downwardly bent bill that is used for foraging in water for invertebrates.

Grebes (Podicipedidae) NA: 7 World: 22 (p. 74)
This lineage of unusual-looking waterbirds ranges worldwide, from Australia to Alaska and Patagonia. Small and slim-headed. The species vary from small and drab to large and colorful. All possess lobed toes and legs set far back on the body to aid swimming and div-ing for their prey of fish, other small vertebrates, and aquatic invertebrates. All construct a low nest floating on the water. Seldom seen on land or in flight but adept on or in the water. Note the showy courtship of these birds in pairs on the water.

Sandgrouse (Pteroclidae) NA: 1 World: 16 (p. 467)
The sandgrouse are a group of desert-loving game birds that somewhat resemble either

pigeons or partridges. The family inhabits Eurasia and Africa, most commonly in dry country. The group is represented in North America by a single species that has been introduced to the Hawaiian Islands. Most are colored in buff and brown, with heavy patterning in some instances. Also, many exhibit a pointed tail. Most often seen when a flock of these birds visits a water hole. The species feed on the ground mainly for hard seeds.

Pigeons and Doves (Columbidae) NA: 21 World: 313 (p. 78)

This gigantic and diverse group can be found worldwide except for the polar regions. This family will be familiar to all readers because of knowledge of the introduced Rock Pigeon and the commonplace Mourning Dove. Pigeons are small-headed, short-legged, and small-billed. Size ranges from starling-sized to pheasant-sized. Most feed on the ground for seeds and other plant matter. Often seen in pairs and flocks. Both sexes produce a nutritious substance known as "pigeon milk" that they feed to their young nestlings. Some species are migratory. Pigeon nests are rough platforms of twigs placed on a branch or ledge. In addition to our native species, several Eurasian species have been introduced to Hawaii and the mainland United States.

Band-tailed Pigeon in flight, exhibiting the details of the flight feathers in its wings and tail.

Cuckoos, Roadrunner, and Anis (Cuculidae) NA: 9 World: 140 (p. 84)

The Cuculidae is a worldwide group that includes several distinct lineages, ranging from large and long-tailed to quite small and compact. All the species are zygodactyl—meaning they have two toes pointing forward and two toes pointing backward. The true cuckoos are small-billed and specialize on caterpillars; this group is perhaps most famous for its tendency to nest parasitize (laying its eggs in the nest of other bird species). The ground cuckoos are large, ground-dwelling, and long-tailed; they forage for lizards and large arthropods. The anis are ungainly scrub-dwellers that are very sociable and nest in groups.

Goatsuckers or Nightjars (Caprimulgidae) NA: 10 World: 92 (p. 87)

This is a group of vocal nightbirds that ranges to all the continents except for Antarctica. The lineage is species-rich, but the species are all physically quite similar (though males of certain species exhibit specialized and elongated wing or tail feathers). All have plumage patterned like dried leaves, which allows them to sleep safely on the ground during the day. All have a wide mouth and rictal bristles that aid in capturing flying insects. The birds hunt by sitting and flying out to capture an insect or by patrolling an air space and taking aerial arthropods. Can be identified by their loud and distinctive nocturnal vocalizations.

Swifts (Apodidae) NA: 10 World: 99 (p. 92)

This large and worldwide group is most species-rich in the humid Tropics. Species range from quite small to quite large, but all have the same body plan—slender and tubular bodies, small bills, tiny legs and feet, and long, stiff wings. These most aerial of birds spend the majority of their lives flying. Some are known to mate and to sleep in flight. Because of their tiny legs, most are unable to perch upright on a branch; instead, they must hang from a vertical surface. Although they resemble swallows in flight, the swifts are most closely related to the hummingbirds, also great fliers and tiny-footed.

Hummingbirds (Trochilidae) NA: 24 World: 338 (p. 94)

Here is a very large but morphologically compact lineage of non-passerine birds. The group is confined to the Western Hemisphere, most abundant in South America, and only marginally ranging into North America with a relatively few northerly species. All exhibit long and narrow bills, narrow and stiff wings, tiny legs and feet, and iridescent plumage. The range of plumage variation in the family is stunning on these exquisite, tiny birds. Hummingbirds are accomplished fliers—the only birds that can fly backward, their wings beating 30 times per second. The smallest eggs of any bird can be found in this family.

The typically elusive Clapper Rail emerges from a marsh into the sunlight—a birder's delight.

Rails, Gallinules, and Coots (Rallidae) NA: 20 World: 138 (p. 103)

This diverse group of ground-dwellers includes species that resemble ducks as well as species that resemble quail. This worldwide group includes four main lineages—the true rails, the flufftails, the gallinules, and the coots. Species of rails have colonized virtually all of the islands of the Pacific and some subsequently evolved flightlessness (e.g., Laysan Rail and Hawaiian Rail). The North American species vary from the colorful Purple Gallinule to the tiny and sooty-colored Black Rail. All the North American species are associated with water or marshlands. The family is most closely related to the cranes and the Limpkin. Diet is mainly invertebrates and plant matter.

Sungrebes (Heliornithidae) NA: 1 World: 3 (p. 422)

This tiny and strange group of water-dwellers inhabits the Neotropics, Africa, and Southeast Asia. The single species that inhabits Mexico and the Neotropics (the Sungrebe) has strayed to North America on one occasion. Looks something like a grebe but the bill is more loon-like.

Limpkins (Aramidae) NA: 1 World: 1 (p. 109)

A family of one extant species, which is resident from Argentina to southern Georgia. This vocal swamp-dweller, resembling an ibis, is a foraging specialist, taking mainly large aquatic snails. Its bill is adapted to extract the snail's body from its shell without breaking the shell. The Limpkin wailing call is a distinctive sound of the swamps of the Deep South.

Cranes (Gruidae) NA: 4 World: 15 (p. 108)

A small but renowned family of large, long-necked wading birds that exhibits a distribution that ranges from Eurasia to Australia, Africa, and North America. Absent from the Neotropics. Cranes superficially resemble large herons but the latter exhibit a crooked neck that is tucked-in during flight. Cranes are very large and graceful birds that inhabit open country—tundra, prairie, savanna, and marshland—where they forage for plant matter as well as small vertebrates and invertebrates, such as crabs and crayfish. Pairs apparently mate for life. In early spring, crane pairs can be found "dancing"—carrying out their striking mating displays. A number of crane species are threatened with extinction.

Thick-knees and Stone-curlews (Burhinidae) NA: 1 World: 9 (p. 423)

This small family exhibits a worldwide distribution, with species in Australia, Asia, Europe, Africa, and the Neotropics; it is most common and widespread in the Southern Hemisphere. Birds resemble large, long-legged plovers. Most species are mainly nocturnal and crepuscular. The various species inhabit open country—plains, deserts, savanna, and beaches. They hunt for arthropods, other invertebrates, and small vertebrates. Typically solitary or in pairs, but otherwise not sociable. Their large and staring yellow eyes are presumably adapted to seeing in low light conditions. The birds spend much of the day sheltering under a bush.

Stilts and Avocets (Recurvirostridae) NA: 3 World: 7 (p. 110)

This is a small group of attractive wading birds that resemble very long-legged sandpipers. Members of the family range from Alberta to Argentina and from France to South Africa and Australia, inhabiting both the New and Old World. They are mainly found in warmer climes. The species exhibit long, spindly legs and very slim, elongated bills, in some cases recurved. These birds wade in shallow water and forage for aquatic or marine invertebrates. Avocets are capable of swimming and will visit deeper water than the stilts.

Oystercatchers (Haematopodidae) NA: 3 World: 13 (p. 111)

This rather small group of large wading shorebirds is very homogeneous—the 13 species all follow identical body plans and are either all black or are pied black, brown, and white.

The family ranges widely—from Alaska to Australia and southern Africa. Most species prefer the seacoast, but some Eurasian and South American populations inhabit continental interior habitats. The birds forage mainly on bivalves of various sorts but also take other invertebrates.

Lapwings and Plovers (Charadriidae) NA: 17 World: 67 (p. 112)

Members of this large radiation of wading birds can be found worldwide—from Siberia to Patagonia and from South Africa to Greenland. Species range from quite small to moderately large, and habitat preferences vary from seashore beaches to interior savannas and prairies. All North American species are migratory. Two of the golden-plover species nest in the Arctic and migrate to the far Southern Hemisphere for the winter. Many exhibit a distinct stop-and-start gait. Diet is mainly arthropods and other invertebrates.

Jacanas (Jacanidae) NA: 1 World: 8 (p. 118)

This is a small family of peculiar wading birds with a primarily tropical distribution. Species can be found in Australia, South and Southeast Asia, Africa, South America and Middle America. A single species that breeds in Mexico and Central America has strayed on several occasions to our Southwest Borderlands. Sometimes called a lily trotter because it uses its very long-toed feet to patter over floating lily pads. Adults of some species have spurs on the bend of their wings, apparently used in territorial defense. The female, larger than the male, is polyandrous, laying eggs for several males, who care for the broods.

Sandpipers, Phalaropes, and Allies (Scolopacidae) NA: 66 World: 94 (p. 118)

This large family encompasses most of the shorebirds (known as waders in Europe). Worldwide in distribution, many species breed in the Arctic and winter to Australia, southern Africa, and the Southern Cone of South America. The family includes some prodigious migrators—the godwits in particular. Species are typically long-legged with a long and narrow bill (straight, decurved, or recurved), which is used for foraging for invertebrates and small fish. This is a very popular group with birders because of its diversity and migratory habits. The phalaropes are a distinct sub-lineage in which the polyandrous female is larger and more brightly plumaged than the male. Two phalarope species winter in flocks out on the open ocean.

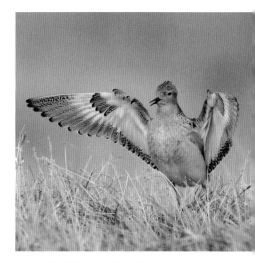

A male Buff-breasted Sandpiper displaying to a nearby female on the Arctic tundra.

Pratincoles and Coursers (Glareolidae) NA: 1 World: 17 (p. 450)

The Glareolidae is a small family that inhabits Eurasia, Africa, and Australasia. A single species of pratincole has strayed to Alaska on two occasions. The coursers are long-legged and plover-like, whereas the pratincoles are short-legged and swallow-like. All inhabit open country and forage on the ground. Diet is mainly arthropods.

Skuas and Jaegers (Stercorariidae) NA: 5 World: 7 (p. 140)

The skuas and jaegers are sea-going wanderers that resemble gulls. They are predatory, mainly stealing prey from other seabirds, especially terns and gulls. On their tundra nesting grounds, these species take bird's eggs and nestlings (as well as lemmings). They breed in the Arctic and Antarctic regions but wander the seas for most of the year. Skuas are large, dark, and formidable. The jaegers are lithe and handsome and are either pied or all dark. The species of this family are rarely seen over land except on their breeding grounds.

Auks, Murres, and Puffins (Alcidae) NA: 23 World: 25 (p. 142)

The Alcidae are typified by the well-known puffin but include a diverse array of smaller and larger species—dovekies, murres, guillemots, auks, auklets, and murrelets. Birders call the members of this group "alcids." Members of this small family of swimming and diving seabirds nest mainly on far northern islands, but some inhabit West Coast islands south into Mexico. Most nest on cliffs or in island burrows. These birds spend most of the year

on the surface of the sea, diving for fish and crustaceans. The family has a pan-boreal distribution, ranging southward in winter. The greatest concentration of species can be found in the waters between Alaska and Russia.

Gulls, Terns, and Skimmers (Laridae) NA: 57 World: 99 (p. 154)

Gulls and terns are familiar coastal birds with a familial distribution reaching across every ocean and island group. Gulls tend to be larger, blunt-billed, and more omnivorous. The more graceful terns tend to be slim, smaller, and pointed-billed, with a more restricted diet. Skimmers exhibit an oversized bill used for scooping up small fish on the surface of water. North American species breed in the Far North, the coastlines, and also in the Interior. All are migratory. The Arctic Tern is reputed to exhibit the longest annual migration of any bird, ranging from the Arctic to Antarctica and back. Many species nest colonially.

Tropicbirds (Phaethontidae) NA: 3 World: 3 (p. 174)

This very small family of handsome white seabirds exhibits a worldwide distribution across the tropical seas. These graceful fliers nest on tropical islands. The three species, all of which have been recorded in North America, resemble large terns but fly on shallow, stiff wingbeats and also possess a very long pair of central tail streamers that give them an especially exotic look. Usually seen as singletons out over the open ocean. Diet is mainly fish—especially flying-fish. They come to land only to nest and typically choose a cliffside nest that is safe from predators and has ready access from the air. Easiest to see in Hawaii.

Loons (Gaviidae) NA: 5 World: 5 (p. 176)

The loons very superficially resemble cormorants, but they float lower in the water, have a short neck, and exhibit a sharp, dagger-like bill. These long-lived waterbirds are excellent divers and spend little time on dry land. Their legs are placed far back on the body, aiding their movement in the water but impeding their walking on land. Diet is mainly fish and crustaceans. The family exhibits a pan-boreal distribution—nesting on the Arctic tundra or on lakes in boreal forests. They winter mainly to coastal waters. The species give haunting vocalizations on their breeding grounds in the summer.

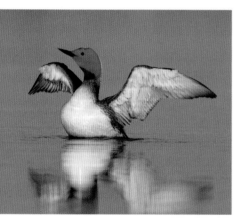

A Red-throated Loon spreads its wings on a placid sub-Arctic lake in Alaska.

Albatrosses (Diomedeidae) NA: 10 World: 24 (p. 178)

This small family of gigantic, long-winged seabirds has a wide distribution across the seas of the Southern Hemisphere and the Tropics. Rare in the North Temperate regions except for three species that live exclusively in the North Pacific. All nest on oceanic islands but spend most of every year wandering the oceans in regions where there are reliable winds to aid their soaring flight. The Wandering Albatross is famed as being the bird with the largest wingspan—exceeding 11 feet. Very long-lived, known to exceed 50 years. Diet is mainly squid, fish, and crustaceans. Form pair bonds and conduct elaborate displays.

Southern Storm-Petrels (Oceanitidae) NA: 3 World: 8 (p. 180)

This compact family of very small seabirds breeds mainly on islands of the far southern seas and the central Pacific, and the species wander widely through the oceans of the world (but never into cold seas of the Far North). All are songbird-sized and typically blackish, usually marked with some white (especially on belly and rump). Diet is invertebrates and small items found on the surface of the sea. The members of this family are longer-legged and shorter-winged than members of the following family.

Northern Storm-Petrels (Hydrobatidae) NA: 12 World: 15 (p. 181)

This group of small seabirds is quite similar to the Oceanitidae but breeds in burrows on islands in both the Northern and Southern Hemispheres. Most are blackish or gray and in some instances white-rumped. These birds flutter over the surface of the sea, picking edible tidbits off the water's surface. They spend most of their lives out on the open ocean.

Shearwaters and Petrels (Procellariidae) NA: 42 World: 84 (p. 184)

This large group of seabirds features a diversity of species, which are small (diving petrels, Little Shearwater) to large and long-winged (Northern Giant-Petrel, Cory's Shearwater). All exhibit narrow wings and rather large bills topped with a specialized pair of tubes that drains a salt gland in the forehead (a feature also found in species of the Diomedeidae, Oceanitidae, and Hydrobatidae). Shearwaters and petrels nest on islands around the world but spend most of their lives wandering across the open ocean. They rest on the water in flocks but forage by surface-feeding or diving for fish and marine invertebrates or scavenging. Most are rarely seen on land except at their breeding islands, and many nest within the protection of a burrow.

Storks (Ciconiidae) NA: 2 World: 19 (p. 195)

The storks constitute a small group of very large and long-legged wading birds with a prominent large beak. Most exhibit some bare facial skin, in some cases brightly colored. The species mainly inhabit Asia, Africa, and South America. Two species inhabit Europe. A single species, the Wood Stork, breeds in North America, with a second species, the Jabiru, occasionally straying north from Central America. The species frequent marshland, savanna, and other open habitats. Diet is broad—including carrion, small vertebrates, and large invertebrates. As raptors do, storks often circle high in the sky riding thermals.

Frigatebirds (Fregatidae) NA: 3 World: 5 (p. 194)

This is a small and compact family of large-winged seabirds that soar over tropical seas and nest on tropical and subtropical islands. The species are "all wings, tail, and beak," with relatively puny bodies. They are accomplished fliers but rarely land on the surface of the sea. Their stick nests are placed atop a bush on an island. The adult males inflate their bright red throat pouches in courtship display. Diet is mainly fish stolen from other seabirds—mainly terns and gulls. Foraging individuals also pluck items from the sea surface.

Boobies and Gannets (Sulidae) NA: 6 World: 10 (p. 196)

This is a small family of sturdy seabirds, with the boobies found in tropical seas and with the gannets (larger species) breeding in temperate seas. All species are excellent fliers, plunge-diving for fish from the air. Species nest colonially on islands or on protected cliffs. Boobies are typically uncommon in North American waters, mainly occurring in the warm waters south of the Border; several species are increasing in North America. Northern Gannets are seasonally common along the Atlantic Coast.

Darters (Anhingidae) NA: 1 World: 4 (p. 195)

This is a small family of diving waterbirds that resemble cormorants but possess a distinct long, bluntly-rounded tail and a long, pointed beak. The family has member species in the Neotropics, Africa, Asia, and Australia. The range of the single Neotropical species extends north to swamplands of the Deep South. An accomplished diver that subsists mainly on fish. Birds dry out after foraging by perching on an open branch and letting the sun bake their spread wings.

Cormorants (Phalacrocoracidae) NA: 6 World: 31 (p. 198)

The cormorants represent a cohesive and compact group of diving waterbirds, mainly plumaged in black or pied black-and-white. All possess a narrow and elongated bill with a terminal hook used to snag fish. They also exhibit very short legs, large webbed feet, and a long, rounded tail. The cormorants are excellent swimmers and divers and subsist mainly on fish. They are somewhat loon-like but hold their head tilted upward when swimming in the water. The family has a worldwide distribution and is found most commonly along coastlines. Cormorant species nest in colonies.

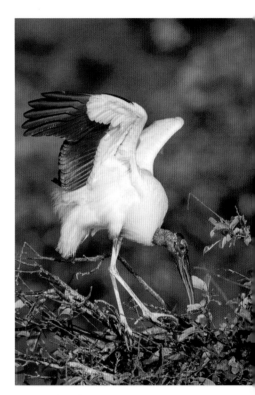

A Wood Stork constructs its nest atop a shrubby mangrove in Florida.

Pelicans (Pelecanidae) NA: 2 World: 8 (p. 201)

The pelicans are a small and cohesive group of very large waterbirds found on all the major continents (including Australia) but absent from the Arctic and Antarctic regions. They capture fish using their large pouched bill, either by dipping it while floating in the water or by plunge-diving from the air when in flight. Pelicans are dumpy-looking when perched, but airborne they are graceful and accomplished fliers, often soaring in groups high in the sky. They frequent coastlines, marshlands, and interior lakes.

Bitterns, Herons, and Allies (Ardeidae) NA: 20 World: 63 (p. 202)

This group of familiar long-legged wading birds ranges worldwide but for the Far North and Antarctica. The species vary from quite small to very large and from forest-dwelling to reef-frequenting. Most exhibit a long crooked neck, long legs, and a long pointed bill, although there are exceptions (e.g., the Boat-billed Heron of the Neotropics). North American species mainly inhabit marshlands, coastal mudflats, wooded swamps, lakes, and ponds. Diet includes fish, frogs, and crustaceans. The bitterns are the most vocal of the lineage.

Ibises and Spoonbills (Threskiornithidae) NA: 5 World: 34 (p. 208)

A group of long-legged wading birds that exhibit a specialized narrow and decurved, or spoon-shaped bill. Most of the species inhabit Eurasia and Africa, but the family ranges across the warmer parts of the world, from Australia to South America. Quite sociable and found foraging and traveling in flocks. Forages for arthropods, crustaceans, fish, and small aquatic invertebrates. Typically nests colonially, often with other waterbirds.

New World Vultures (Cathartidae) NA: 3 World: 7 (p. 210)

The New World vultures, as the name proclaims, are confined to the Western Hemisphere. This small group of scavengers mainly forages on the carcasses of dead vertebrates. The group includes the Andean Condor of South America, reputed to be the heaviest flying bird. Some species (e.g., the Turkey Vulture) have an excellent sense of smell, whereas others (e.g., the Black Vulture) do not. Vultures soar over open country in search of carrion. They look like hawks but are placed in a distinct but closely-related family. Unlike most hawks and eagles, vultures have weak feet and are unable to pick up and carry away prey items. They have a habit of sunning their spread wings in the morning to warm up and dry their feathers. They do this, typically, from a branch atop a tree. Although they have the same scavenging habits, the Old World Vultures are members of the Accipitridae—the family that includes the eagles and hawks.

Ospreys (Pandionidae) NA: 1 World: 1 (p. 211)

The single species of Osprey ranges from Alaska and Brazil to Siberia and Australia, always living near water where it can hunt for fish, which it drops upon with its sharp claws. Northern populations are migratory, traveling south to South America and Africa. Populations in South Florida are mainly resident. This long-winged raptor nests in large stick nests constructed over marshland or other open wetlands.

Hawks, Kites, Eagles, and Allies (Accipitridae) NA: 33 World: 240 (p. 212)

This worldwide group of more than 200 species inhabits nearly every terrestrial habitat on Earth. Species range from very small (Tiny Hawk) to huge and powerful (Harpy Eagle). No longer considered related to the similar-seeming falcons (Falconidae), which are now placed near the parrots. Most members of the family are predators, taking animal life by attack. Their diet ranges from arthropods to monkeys and tree kangaroos. Most are quite vocal around their nesting territory. Some (e.g., Broad-winged Hawk) are highly migratory, traveling south in autumn in large flocks high in the sky.

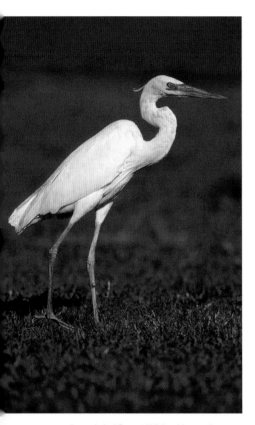

An adult "Great White Heron," which is currently considered a South Florida subspecies of the familiar Great Blue Heron. Some authorities consider the Great White Heron to be a valid species. Hybrids between the two are distinctive and are known as "Würdemann's Heron."

Barn Owls (Tytonidae) NA: 1 World: 19 (p. 224)

The barn owls are a distinct group of nocturnal predators, ranging worldwide—even to many isolated Pacific islands. Unlike the typical owls (Strigidae), the barn owls exhibit a large heart-shaped facial disk, a large head, and a tapering body with a short tail. These birds give a shrieking cry after dark. The species mainly forage upon small mammals, which they capture in flight.

Typical Owls (Strigidae) NA: 22 World: 194 (p. 224)

The typical owls are a large group of nocturnal (and in some cases diurnal) predators with a worldwide distribution. Many species are endemic to islands in the Asia-Pacific region. Typical owls range from starling-sized (Elf Owl) to very large (Snowy Owl). Species are known to inhabit forests, marshes, deserts, and tundra. Most are readily identified by their species-specific nocturnal call. Members of the family prey upon mammals, ducks, small birds, rodents, insects, and fish.

Trogons (Trogonidae) NA: 2 World: 44 (p. 234)

The trogons inhabit the Neotropics, Africa, and South and Southeast Asia. Most species inhabit tropical woodlands or forest. Two species that breed in Mexico are known to range northward into the Southwest Borderlands of North America. Most species are brightly colored but rather stolid in behavior, sitting quietly on a tree branch for long periods. Species forage on fruit and arthropods. The family boasts the rather fantastic Resplendent Quetzal, which ranges from southern Mexico to western Panama. The adult male quetzal sports a very long pair of iridescent green central "tail" feathers (elongated tail coverts).

Hoopoes (Upupidae) NA: 1 World: 1 (p. 453)

A small family that features a single iconic bird of the Old World—the Eurasian Hoopoe. That species ranges from western Europe, Africa, and Madagascar, east to Southeast and East Asia. There are several North American records of strays to Alaska. The single species is striking, with a black-and-white barred body, a cinnamon head, a fanciful erectile crest, and a long and decurved bill. This is a species of open country. Diet is mainly arthropods. Nests in a tree hole. Some authorities treat the Madagascan birds as distinct.

A male Yellow-bellied Sapsucker peers from its nest hole as the female arrives to take over nest duties.

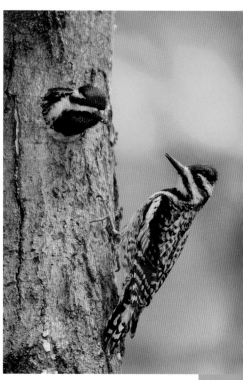

Kingfishers (Alcedinidae) NA: 4 World: 91 (p. 236)

The kingfishers are another worldwide group with considerable diversity in the family. It includes the kookaburras (of Australasia and Southeast Asia), which are primarily terrestrial-feeding, taking mainly arthropods and lizards. The true kingfishers are, indeed, fish-eating and are associated with water. The family ranges from Alaska to Australia, with many species in the Southwest Pacific. Most Western Hemisphere species inhabit the Tropics and Subtropics, with only four species found north of the Mexican border. Our species nest in burrows dug into sandbanks and stream-cuts.

Woodpeckers and Allies (Picidae) NA: 25 World: 217 (p. 238)

The woodpecker family is a large and distinctive group that also includes the wrynecks and the piculets—tropical and subtropical woodpecker-relatives that lack the stiff and pointed tail feathers of the typical members of the family. Woodpeckers are widespread in the New and Old Worlds but do not cross Wallace's Line into the Australasian region. The members of the family range from nuthatch-sized (the piculets) to crow-sized (e.g., the Imperial Woodpecker of Mexico, now extinct). Woodpeckers have a distinctive chisel-bill for excavating wood to get at beetles and grubs. They all nest in cavities, which in most instances they dig out themselves. Early in the breeding season, woodpeckers drum on hollow logs (or other resonating surfaces) to signal territories. Many species can be identified by the pattern of their drumming.

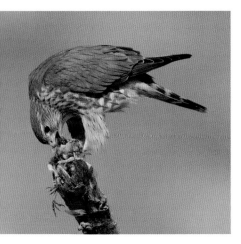

A Merlin feasts on a songbird that it most likely caught on the wing.

Caracaras and Falcons (Falconidae) NA: 12 World: 64 (p. 250)

The Falconidae comprises a large assemblage of predatory birds, which range across the globe. The family includes the typical falcons, which are aerial hunting predators of mammals and birds, and also the atypical lineage known as the caracaras, which are largely carrion-eating. The caracaras look more like typical raptors, whereas the falcons are sleeker and more streamlined to foster rapid hunting flight. The members of the family range in size from starling-sized (e.g., the falconets of southern Asia) to very large (e.g., Gyrfalcon). The falcons are thought to be the fastest of birds—the Peregrine Falcon has reportedly been clocked at 240 miles per hour in a steep dive.

Parakeets, Macaws, and Parrots (Psittacidae) NA: 9 World: 167 (pp. 253, 487)

These are the African and New World parrots, which include the macaws and parakeets. They range from very small to very large and include the largest species of the several families of parrot-relatives—the Hyacinth Macaw of tropical South America. This species-rich family ranges from Africa to South and Central America. North America was the native home to the now extinct Carolina Parakeet and today is home to eight introduced species—primarily birds native to Mexico. These birds are mainly seed-eaters, and they nest in cavities. They are colorful and many species are popular as cage birds.

Lories, Lovebirds, and Australasian Parrots (Psittaculidae) NA: 2 World: 184 (p. 488)

The Psittaculidae is a lineage of parrots distinct from the Psittacidae. It has species found in Africa, Asia, and Australasia. Its members include tiny (e.g., the pygmy-parrots of New Guinea) as well as very large species, and they vary considerably in color and shape. North America is home to two introduced species from this family—one from Africa and the other from South Asia and Africa. As with the Psittacidae, these colorful birds are mainly seed-eaters, nesting in cavities, and popular as cage birds.

THE PASSERINE FAMILIES

Becards, Tityras, and Allies (Tityridae) NA: 3 World: 35 (p. 256)

The Tityridae is a small family of flycatcher-like songbirds that inhabit South and Central America; three species have been recorded in the Southwest Borderlands of North America. The species typically sally out for insects from a tree perch. They also take berries and fruit. Most species of the family are found in South America.

Tyrant Flycatchers (Tyrannidae) NA: 47 World: 306 (p. 256)

The Tyrannidae, the largest passerine family, is found only in the Western Hemisphere. The vast preponderance of species inhabits South America, a lesser proportion inhabits Central America and Mexico, and a relatively small component of 47 species can be found in North America. The species range from very small to medium-sized songbirds. Although there are some brightly colored species (e.g., Vermilion Flycatcher) most are colored in combinations of olive, green, brown, or yellow. The more distinctive North American species include the Great Kiskadee and the Scissor-tailed Flycatcher. Most forage by sallying after insects.

Vireos (Vireonidae) NA: 17 World: 62 (p. 276)

This newly restructured family now includes shrike-babblers and *Erpornis* from Southeast Asia, the Neotropical peppershrikes, shrike-vireos, and greenlets, as well as the typical vireos, which range widely through the Western Hemisphere. Vireos inhabit virtually all wooded habitats in North America. The species are stolid arboreal foragers in woodlands and forests, hunting for arthropods among twigs and vegetation. The North American species are mostly migratory, with most species heading south of the Border to warmer climes for the winter. Our species are distinctive vocalists.

Monarch Flycatchers (Monarchidae) NA: 3 World: 96 (p. 471)

The monarch flycatcher family is a Pacific lineage that is most abundant in the greater New Guinea region, but which also ranges into South Asia and tropical Africa. Many species have colonized small Pacific islands. Our three North America monarchs all inhabit the Hawaiian Islands. These are the three species of elepaio, which are forest-dwelling songbirds that subsist on arthropods.

Shrikes (Laniidae) NA: 4 World: 34 (p. 283)

The shrike family is a mainly Eurasian and African lineage, with species ranging to New Guinea, North America, and Mexico. Shrikes, sometimes known informally as "butcherbirds," are predatory songbirds, hunting arthropods and small vertebrates. They sometimes hang prey on a thorn or a strand of barbed wire. Species inhabit open country, where they launch out from a perch to capture active prey on the ground. The species are accomplished songsters. The four species recorded from North American include two breeders and two strays from East Asia.

Jays and Crows (Corvidae) NA: 21 World: 126 (p. 284)

The Corvidae is a worldwide family found on all the main continents and ranging from Alaska to Australia and from Siberia to South Africa. The species range from small (e.g., Dwarf Jay) to very large (e.g., Common Raven), and plain black (e.g., American Crow) to brightly colored and long-tailed (e.g., Black-throated Magpie-Jay). The North American species are widespread and familiar to most people—crows, ravens, jays, magpies, and nutcrackers. The species tend to be opportunistic and omnivorous. Many adapt well to human environments.

Verdin and Penduline Tits (Remizidae) NA: 1 World: 10 (p. 292)

The Remizidae is a mainly Old World assemblage of small songbirds. They exhibit a short and pointed bill and build a distinctive woven and pendulous nest. The species range from western Europe to northeastern Asia and Africa. Diet is mainly arthropods. Our single North American species, the Verdin, is native to the Arid Southwest and Mexico. Our Verdin might be confused for a plain-looking warbler.

Chickadees and Titmice (Paridae) NA: 12 World: 59 (p. 293)

The Paridae is a family of small and active songbirds that range through North America, Eurasia, and Africa. The species are mainly known as "tits" in Europe and Asia. Species range from Alaska to the Philippines and South Africa. These birds inhabit forests, woodlands, and scrub and often travel in mixed-species flocks in search of arthropods as well as fruit and seeds. They are mostly nonmigratory. "Tit flocks" are commonplace in the eastern United States in winter. These are foraging songbird flocks that include chickadees, titmice, wrens, creepers, and woodpeckers.

Larks (Alaudidae) NA: 2 World: 93 (p. 299)

The larks are a mainly Old World family, with most species inhabiting Eurasia and Africa. One species ranges naturally to Australia. A well-known species that ranges across the Northern Hemisphere is the Horned Lark—a native breeder in North America. Another, the Eurasian Skylark, has been introduced to Australia and to British Columbia (and also naturally strays to Alaska from Northeast Asia). Larks frequent open ground in deserts, savannas, and other open lands. Birds forage on the ground for seeds and invertebrates. Species commonly travel in flocks.

Reed Warblers (Acrocephalidae) NA: 5 World: 59 (p. 454)

The reed warbler family is a Eurasian lineage that also ranges into the small islands of the tropical Pacific. Eurasian species often winter to southern Africa and to South and South-

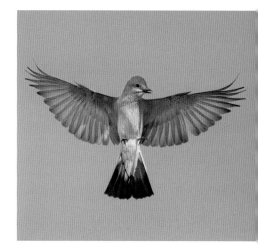

A Western Kingbird hovers over the photographer, showing off its saffron underparts.

east Asia. These are plain songbirds with distinctive and complex songs. Most species are skulkers, remaining hidden in vegetation. Diet is mainly arthropods. One species is endemic to the Northwestern Hawaiian Islands. Three East Asian species have strayed to Alaska.

Grassbirds (Locustellidae) NA: 4 World: 57 (p. 454)

Grassbirds are smallish and rather plain or dully streaked songbirds that resemble Old World warblers. Species can be found inhabiting vegetation of open habitats as well as tropical rainforest interior. These are reclusive species that are best located by their striking vocalizations. Diet is mainly arthropods. The species recorded from North America are all strays from Asia.

Swallows (Hirundinidae) NA: 16 World: 84 (p. 300)

The swallows are a large and familiar group that ranges worldwide. The northern-breeding species are highly migratory. Some Southern Hemisphere temperate species migrate north to the Tropics (of Africa and South America). These are graceful aerial foragers that hawk flying arthropods. Our Tree Swallow, notably, consumes berries in autumn. Although superficially similar to swifts, swallows can perch on utility lines and on the ground, whereas swifts cannot; as well, swallows are more diverse and colorful in plumage. Most swallows are gregarious and inhabit open country, especially near water. Some species nest in colonies.

Bushtits (Aegithalidae) NA: 1 World: 10 (p. 304)

The Aegithalidae include small and active songbirds that inhabit western North America as well as Eurasia. Most of the species are found in central and eastern Asia. One species is found in the mountains of Java. The species are, indeed, superficially tit-like, though some species have long narrow tails. Most are rather dully plumaged, though some exhibit an attractive facial pattern. These are sociable insectivores often found in thickets and woodlands. Our only species is the Bushtit.

Bush-Warblers (Cettiidae) NA: 1 World: 32 (p. 472)

Yet another Old World warbler-like group of songbirds that ranges through Eurasia to the western Pacific. Species are small or very small and quite diverse, from wren-like to warbler-like to tailorbird-like. These are mainly forest-dwelling insectivores. A single Asian-breeding species has been introduced to Hawaii.

Leaf Warblers (Phylloscopidae) NA: 8 World: 77 (pp. 306, 455)

The leaf warblers are small greenish-tinged or yellowish songbirds that, in some instances, look a bit like kinglets or a Tennessee Warbler. Some species are yellow-breasted and distinctive, but most are not. The family ranges from western Europe to East Asia and islands of the western Pacific. All are gleaning insectivores that frequent trees and bushes. All are vocal songsters. A single East Asian species ranges into western Alaska, where it summers. Other Asian species are strays to Alaska and the West Coast.

Bulbuls (Pycnonotidae) NA: 2 World: 130 (p. 490)

The bulbuls and greenbuls make up a large family of mainly African and Asian songbirds that inhabit forest, woodland, and edge. Some of the most commonplace species in Africa and Asia are bulbuls. Most are the size of blackbirds, and many are blackish or greenish. Most are dully plumaged, though some are quite handsome and are crested. Diet is fruit and arthropods. Often found in flocks. Two Asian species have been introduced to North America and inhabit urban centers.

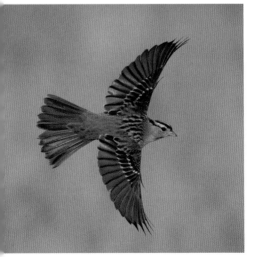

A White-crowned Sparrow in flight.

Sylviid Warblers (Sylviidae) NA: 2 World: 62 (p. 456)

Once a family that was thought to encompass all the Old World warblers, this considerably pared down family now includes species formerly placed in the babblers (Timaliidae). The family now features warbler-like species, tit-like species, and finch-like species, as well as the fantastic Fire-tailed Myzornis—quite a diverse selection of Old World species. All are insectivores, but the parrotbills also use their finch-like bill to take plant matter of various sorts. The family ranges from the western United States (e.g., Wrentit) to Eurasia. Most species are found in central Asia and the Himalayas.

White-eyes (Zosteropidae) NA: 2 World: 122 (pp. 472, 491)

The Zosteropidae now include both the white-eyes and the Asian-dwelling yuhinas—formerly placed in the babblers (Timaliidae). The family ranges from Africa east through Asia and into the Pacific. These are small songbirds that consume fruit, nectar, and arthropods. Yuhinas resemble crested tits and many true white-eyes look like warblers, olive-backed and white and yellow on the underparts, with a distinctive white eye-ring. A species from East Asia (the Warbling White-eye) has been introduced to Hawaii. A close relative, the Swinhoe's White-eye is now becoming established in Southern California.

Laughingthrushes (Leiothrichidae) NA: 3 World: 125 (p. 472)

The laughingthrushes, formerly placed within the babblers (Timaliidae), have been recognized as belonging to their own family. This Himalayan and East Asian group also ranges to central Africa and Indonesia. It encompasses a diversity of forest- and scrub-dwelling songbirds, some plain and others quite handsomely plumaged with crests, various colors, and striking patterns. The species are mainly insectivorous, and most are quite sociable. In the eastern Himalayas, members of this family join in very large mixed-species flocks in the nonbreeding season. Three East Asian species have been introduced to Hawaii.

Kinglets (Regulidae) NA: 2 World: 6 (p. 305)

The kinglets are a small and compact group of tiny warbler-like songbirds that inhabit North America and Eurasia. The family includes but two genera. Most species summer in northern forests and winter southward. The family ranges from North America and western Europe east to Korea and Taiwan. These birds most closely resemble certain leaf warblers but uniquely exhibit a bright erectile sagittal crest. The two North American species breed in the Appalachians, boreal conifer forest, and western mountains, wintering mainly in the Lower 48.

Waxwings (Bombycillidae) NA: 2 World: 3 (p. 307)

The waxwings are another small and distinctive family of Northern Hemisphere songbirds that encompass but a single genus. The family ranges from North America to Eurasia and insular East Asia. Waxwings are handsome songbirds that travel in flocks and are famous for their vagrancy (tendency to wander)—they move about the year-round in search of fruit resources. The species nest late for songbirds—in late spring and summer, and at that time consume mainly arthropods.

Silky-flycatchers (Ptiliogonatidae) NA: 2 World: 4 (pp. 306, 430)

Here is another small family of distinctive songbirds. The four species are all found in Mexico and Central America, ranging from our Southwest Borderlands to Panama. Three of the species are crested. These birds are distinctive in perching upright and exhibiting a silky plumage. The species inhabit forest and shrubland, and they forage for fruit and arthropods. The blackish-colored and red-eyed Phainopepla is a familiar species of the Arid Southwest.

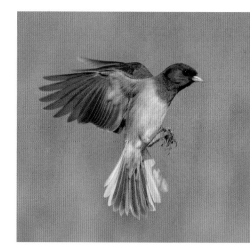

An adult of the "Oregon" race of the Dark-eyed Junco.

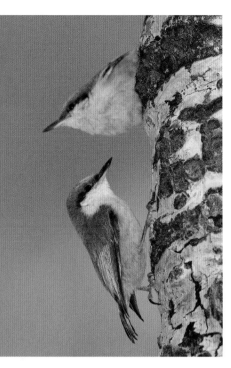

A Pygmy Nuthatch clambering up a vertical trunk in search of a hidden bark insect.

Hawaiian Mohos (Mohoidae) NA: 5 World: 5 (p. 495)

The mohos are a small family of honeyeater-like songbirds that once inhabited the islands of Hawaii. All are now extinct. All exhibited a decurved pointed bill, and four of the five were black-plumaged with highlights of yellow and white. Four species sported an elongated tail. The Kauai O'o was last recorded in the highlands of Kauai in 1987.

Nuthatches (Sittidae) NA: 4 World: 28 (p. 308)

The nuthatches, familiar visitors to backyard suet feeders, are small creeping songbirds that mainly inhabit Northern Hemisphere forests of both the New and Old Worlds. Species range from Alaska and North Africa to Siberia, the Philippines, and Java. Absent from South America. Three species range into Mexico, and one into the Bahamas. These are bark-foraging insectivores that readily move up and down vertical tree trunks.

Creepers (Certhiidae) NA: 1 World: 9 (p. 312)

The creepers are a small family encompassing a single genus of retiring and creeping songbirds that range from North America to East Asia (including the Himalayas). All the species are very similar—brown-and-white marked above (resembling tree bark) and plain and unmarked below. Creepers exhibit a set of stiffened and pointed tail feathers that they use to prop themselves against vertical tree trunks. They creep up a trunk by circling the trunk at an upward angle. They then swoop down to the base of the next tree. The birds place their nest under a patch of loose bark. The single North American species nests in forests and feeds exclusively on bark arthropods.

Gnatcatchers and Gnatwrens (Polioptilidae) NA: 4 World: 15 (p. 310)

This family inhabits the Western Hemisphere, ranging from southern Ontario to Southern California and Argentina. The gnatwrens, with their very long and narrow bills, are tropical forest inhabitants. The gnatcatchers inhabit the Tropics and the Temperate Zone regions of North America. These are small, slim, modestly plumaged songbirds with upwardly cocked tails and nervous habits. They are insectivores that forage in vegetation, mainly gleaning from twigs and leaves.

Wrens (Troglodytidae) NA: 11 World: 82 (p. 312)

This large and mainly Western Hemisphere family of small and vocal songbirds is also represented in Eurasia by a single widespread species. It includes some of our smallest birds as well as some of our best songsters. The more common species are well-known backyard residents. In the New World, they range from Alaska to Patagonia. These are compact and feisty brown-feathered creatures that have a lot of personality. Some can be found joining mixed foraging flocks. Species are largely or wholly insectivorous.

Mockingbirds and Thrashers (Mimidae) NA: 12 World: 34 (p. 318)

This family is another New World lineage, ranging from southern Canada to Argentina. These medium-sized songbirds are rather drably plumaged but are excellent vocalists. The Northern Mockingbird is famous for singing persistently late on summer evenings. Diet is mainly arthropods. The birds have long tails and long legs, and they spend much time foraging on the ground, often under the cover of a thicket.

Starlings (Sturnidae) NA: 3 World: 114 (pp. 323, 489)

This large Old World family ranges from Eurasia and Africa to Australia and the Pacific. The species are mainly medium-sized and largely dark-plumaged (with some notable exceptions). Some starlings are quite beautiful, and others are famous as mimics (e.g., the mynas), which makes them popular cagebirds. The preponderance of species are found in tropical Africa and East Asia. The three North American species are all imports from Eurasia, and they are found mainly in association with human environments. The Common

Myna is widespread in Hawaii and South Florida. The European Starling is commonplace across much of North America.

Dippers (Cinclidae) NA: 1 World: 5 (p. 323)

This small family comprising a single genus inhabits streamsides in the mountains of western North America, Middle America, the Andes of South America, and parts of Eurasia. Species are plump, compact, short-tailed, and mainly colored brown or gray. The species are strict habitat specialists found only in association with tumbling and rocky clear-water streams. These are the only songbirds that forage under water. Diet is primarily aquatic invertebrates gleaned from wet rocks and other stream substrates. Very vocal and active. The only streamside specialist in our western mountains.

Thrushes (Turdidae) NA: 33 World: 159 (p. 324)

The thrushes are a large and worldwide family of arboreal and terrestrial songbirds that are admired for their songs. Species range from smallish to medium-sized and vary greatly in plumage, from quite dull and cryptic to very colorful. The family is found from Alaska to Australia and many Pacific islands. Diet is typically a mix of arthropods and fruit. The prototypical thrush is our American Robin, which is found throughout North America in every wooded habitat. The family includes some of our best songsters, in particular the Veery and the Hermit Thrush.

Old World Flycatchers (Muscicapidae) NA: 18 World: 303 (pp. 331, 457)

This gigantic family of small and often brightly patterned songbirds inhabits mainly Eurasia and Africa, with North America's only two native breeding species in Alaska (Northern Wheatear and Bluethroat). One species has been introduced to Hawaii and quite a few East Asian species have strayed to Alaska and the West Coast. The family includes arboreal and terrestrial insectivores. The family today includes the Old World chats and other lineages formerly allied with the thrushes.

Olive Warblers (Peucedramidae) NA: 1 World: 1 (p. 384)

This one-species family features the peculiar songbird that closely resembles a wood-warbler and which for many decades was placed in that family (the Parulidae). Notable is the burnt-orange wash on the head and throat. The Olive Warbler inhabits montane pine-oak forests of the Arid Southwest and Mexico. Recent molecular systematic studies indicate this single-species lineage is quite isolated, possibly showing a link to the accentors (Prunellidae).

Waxbills (Estrildidae) NA: 7 World: 131 (p. 473)

The waxbills are a family of very small and finch-billed seed-eaters that mainly inhabit tropical grasslands of Africa, southern Asia, and Australasia. All exhibit a strong conical bill. Plumages vary greatly, with some species brightly colored and others patterned in black, brown, and white. Typically these birds travel in flocks and forage on or near the ground. All the North American species have been introduced, with most found in Hawaii.

Indigobirds and Whydahs (Viduidae) NA: 1 World: 20 (p. 491)

The Viduidae is a small African radiation of finch-billed songbirds that are famous for their flamboyantly long tail feathers as well as their habit of obligate nest parasitism—laying their eggs in the nests of other birds. The males of the whydahs sport fantastic tail feathers. The males of the indigobirds, by contrast, are short-tailed and all blue black. Females of the Viduidae are invariably sparrow-like and plain.

A male Mountain Bluebird carries its arthropod prey to its nest.

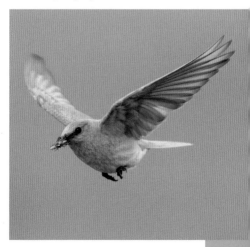

Weavers (Ploceidae) NA: 1 World: 115 (p. 491)

This family is represented in North America solely by a single exotic species, the Northern Red Bishop. This group of small songbirds are famous for their coloniality and their nest-building prowess. Hence the name "weavers." The family lives mainly in sub-Saharan Africa, Madagascar, and South Asia, ranging east to southwestern China. Some species weave intricate basketlike nests. Males of certain species are very brightly colored, others (especially females) are quite plain.

Accentors (Prunellidae) NA: 1 World: 12 (p. 459)

The accentors, or hedge-sparrows, are sparrow-like songbirds with thin and pointed bills that range from western Europe to western Asia and the Russian Far East. These are ground-feeders that take arthropods and some seeds. Populations of some northern species are migratory. A single East Asian species has strayed to Alaska and the West Coast.

Old World Sparrows (Passeridae) NA: 2 World: 38 (p. 332)

The Old World sparrows inhabit Eurasia and Africa. These are sociable ground-feeders that tend to be opportunistic omnivores—taking mainly seeds and arthropods. All frequent open habitats and some species are human commensals. Includes the snowfinches that inhabit rocky alpine heights. The two North American species were introduced from Europe. One of these, the House Sparrow, has invaded most of North America.

Wagtails and Pipits (Motacillidae) NA: 10 World: 67 (p. 333)

The wagtails and pipits exhibit a worldwide distribution, with most species in Africa and Asia. These are ground-foragers of open habitats—tundra, savanna, prairie, and desert. The pipits are dull-plumaged, colored in mainly browns. The wagtails are long-tailed and typically pied with black, white, gray, and yellow. All are primarily insectivorous. The northern species tend to be migratory.

Fringilline and Cardueline Finches (Fringillidae) NA: 67 World: 221 (p. 335, 441)

This large and diverse assemblage of finch-like songbirds encompasses the South American euphonias, the Hawaiian honeycreepers, the rosefinches, the bullfinches, some of the grosbeaks, the rosy-finches, the canaries, the fringillid seed-eaters, the crossbills, and the siskins. The family includes small and large songbirds with a wide range of plumage patterns. The family is native to North, Middle, and South America, as well as Eurasia and Africa. The species are mainly seed-eating and include both forest and nonforest species.

Longspurs and Snow Buntings (Calcariidae) NA: 6 World: 6 (p. 346)

This small family of sparrow-like seed-eaters inhabits North America and Eurasia. Species summer in northern tundra and northern high plains, wintering southward in flocks. The species are found in open country during both summer and winter. Longspurs possess a distinctive long claw on the hind toe.

Old World Buntings (Emberizidae) NA: 9 World: 41 (p. 461)

The Old World buntings are a rather uniform lineage of sparrow-like songbirds. They tend to be heavily hunted in Eurasia for artisanal consumption by rural folk. The species range through Eurasia and Africa. A number of species stray to Alaska. In many species, the male is brightly patterned, the female plain. Many closely resemble our North American sparrows, and their behavior is much the same—foraging on the ground for seeds.

Towhees and Sparrows (Passerellidae) NA: 44 World: 127 (p. 348)

The New World sparrows include the larger towhees and the smaller sparrows. Most are colored with browns and grays, often streaked (but with some prominent exceptions, such as the brush-finches and bush-tanagers of the Neotropics). The family ranges throughout

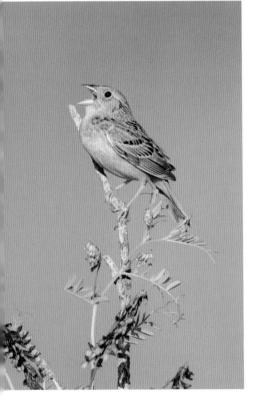

A singing male Grasshopper Sparrow perches above a flowering milkvetch.

the New World, with most species concentrated in South America. Species inhabit forest, thickets, marshlands, prairie, and desert. Many are accomplished songsters. Species that breed in the Far North migrate southward for the winter. Diet is seeds and arthropods.

Spindalises (Spindalidae) NA: 1 World: 4 (p. 369)
This tiny Caribbean family includes four species of tanager-like songbirds. Males are brightly patterned, and females are dull olive-green. Mainly fruit-eating. The species inhabit woodland and forest. Our single species is a rare stray to South Florida.

Yellow-breasted Chat (Icteriidae) NA: 1 World: 1 (p. 370)
This brightly colored and vocal songbird was long treated as an aberrant wood-warbler. It is now subsumed in its own family of one species. The single species summers from southern Canada to northern Mexico, wintering to Central America. This chat frequents scrubby old fields and thickets at the edge of woodlands. Diet is arthropods and fruit. It does a song flight over its breeding territory.

Blackbirds (Icteridae) NA: 26 World: 105 (p. 370)
This family of the Western Hemisphere comprises a wide range of medium-sized to large songbirds, many quite colorful and distinctive. The species range from Alaska to Patagonia and inhabit forest, woodland, marshland, prairie, and arid lands. This is perhaps one of the most commonplace families in North America—with species found in every habitat. Many of the northern species are migratory, some forming huge flocks in winter. The family includes the brood-parasitic cowbirds as well as the colorful New World orioles. The Red-winged Blackbird is perhaps the most abundant species in North America.

Wood-Warblers (Parulidae) NA: 56 World: 108 (p. 384)
This family of small and brightly colored songbirds is perhaps the favorite among North American bird-watchers. Many of the species summer in northern forests and migrate south to winter in the Tropics. Spring migration is a favored time to look for the warblers as they make their way back to their northern breeding haunts. Males are typically more brightly plumaged than the females. They are noted songsters. The family ranges through the New World, and there are many South American resident species.

A male Rose-breasted Grosbeak forages on unripe peaches.

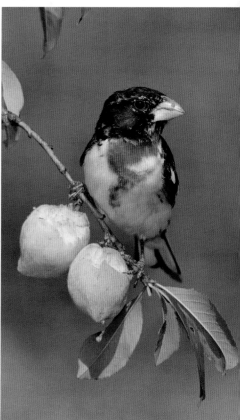

Cardinals, Piranga Tanagers, and Allies (Cardinalidae) NA: 18 World: 48 (p. 412)
The Cardinalidae is a medium-sized bird family that inhabits the New World, ranging from west-central Canada south to Argentina. The family includes the Rose-breasted Grosbeak and the Northern Cardinal, two familiar feeder birds in the United States. Also included are the Scarlet Tanager and Indigo Bunting, two favorites of North America birders. All the species exhibit a blunt finch-like bill and feed on seeds and arthropods.

Tanagers and Allies (Thraupidae) NA: 8 World: 371 (pp. 434, 477)
The Thraupidae includes the true tanagers (distinct from the Piranga tanagers, such as the Scarlet Tanager), honeycreepers, Darwin's finches, and seedeaters. The vast majority of species in this very large family inhabit South America. The eight species recorded in North America include one breeding species along the southern border as well as strays from Mexico and the Caribbean (two honeycreepers, a seedeater, and two grassquits) and introduced species to Hawaii (two *Paroaria* cardinals and the Saffron Finch).

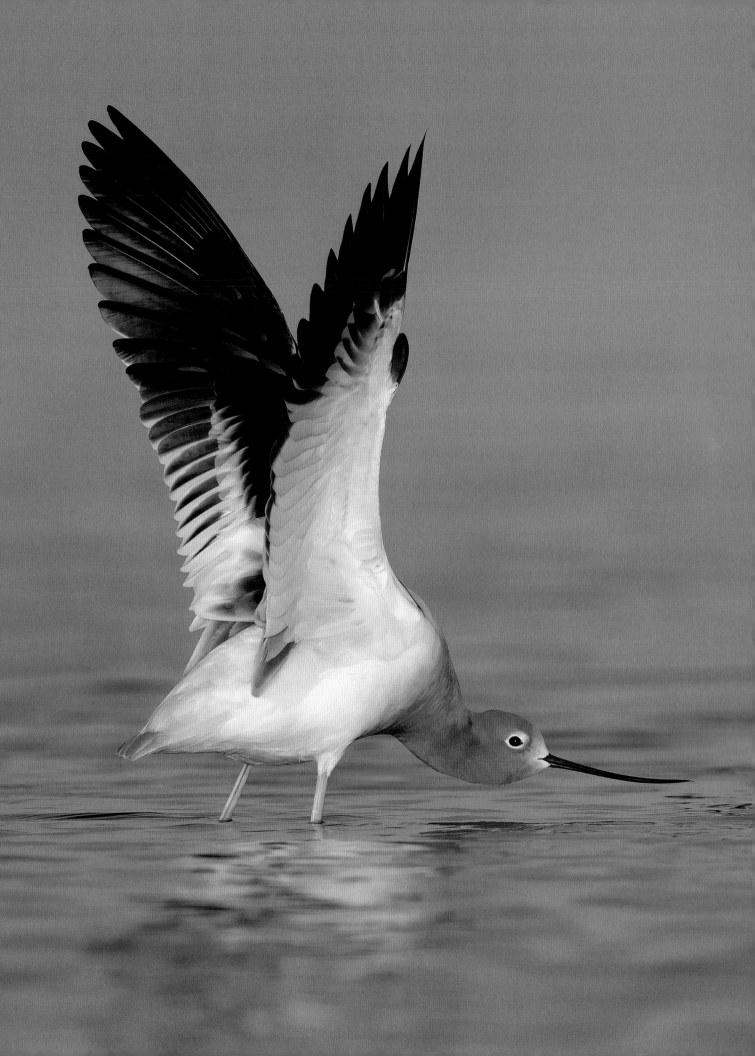

S O, NOW YOU HAVE BROWSED the species accounts and now want to get out into the field to see some of those cool birds you never knew even existed. The following sections in this chapter will tell you about birding apps, birding gear, how to plan a field trip, tips on feeding the birds, useful birding references, and thoughts on how we can help conserve our birdlife. This should get you up to speed toward becoming a full-fledged member of the birding community.

BEST BIRDING APPS AND WEBSITES

Each passing year brings new applications for smartphones and computers to assist in identifying, recording, and studying our birdlife. Here are some of them. ✶

eBird is the superstar among ornithological apps and websites. It is a searchable database of geo-referenced and dated bird observations from around the world, all presented on a map that one can zoom in and out of. eBird includes too many tools to mention, but here are a few things a smart birder can do in eBird. You can generate seasonal abundance charts for a favored birding hotspot (or your neighborhood). You can check for the location of recent observations of a particular desired species in your area. You can determine the winter range of a species by filtering the data for that season. Each species observation point can be clicked on in order to draw out the complete checklist of observations from that point for that particular day by a named observer; the list may even include sound recordings and photographs. Suffice it to say, you should upload all of your birding observations to eBird. This is a way of managing your own life list, while contributing to an amazing global database on the distribution of birds. Your daily observations of birds may well have scientific value to a graduate student researcher conducting ornithological studies in years to come. Website: ebird.org.

eBird Mobile is a birding observations upload app for smartphones. It is now possible to upload your observations on the fly as your do your birding. The leading US birders do this and perhaps so should you.

Merlin Bird ID is a bird identification tool for your smartphone. It asks you a series of questions and references your answers to the eBird database, which uses your location and

✶ Much of this chapter is adapted from material found in chapters 21–25 in the author's *Birds of Maryland, Delaware, and the District of Columbia* (see the annotated bibliography on p. 541).

Opposite: An adult American Avocet stretches its wings while foraging in the shallows.

observation date to identify the bird you have seen. It is also a digital field guide that has images and sound recordings of each species. Perhaps most exciting is Merlin's sound ID feature. You simply turn on the app, point your phone at a bird song, and the app suggests possible matches (and does produce errors at times). Still, this is a big step forward in field identification of birds. The app also has a photo ID feature—take a photo of a bird or choose one from your library and the app will identify the species. Using apps with play-back drains the battery, so you may wish to add a battery pack when in the field. Website: merlin.allaboutbirds.org.

BirdsEye is a bird-finding app. It uses the eBird dataset to inform the user of either (a) what birds have been recently observed at your site, or (b) where to locate a particular bird species nearby based on recent observations. It is very useful for planning an outing in search of particular birds. Website: birdseyebirding.com.

BirdCast, a website managed by the Cornell Lab of Ornithology, provides both forecasts and recent summaries of bird migration across North America. Great for planning week-end birding trips during the fall and spring. Website: birdcast.info.

The *Sibley Birds v2* app is the Sibley field guide as a smart phone app. In addition to the original book's illustrations, range map, and species account text, the app includes a fairly comprehensive collection of bird sounds to aid in identification. Other avian field guide apps for North America include the iBird Pro Guide to Birds and the Audubon Bird Guide app. All provide an array of art, maps, sound, and text to aid bird identification. Having a field guide app on your phone means not having to carry a hard-copy field guide, and, more importantly, provides access to bird vocalizations—something a paper field guide cannot do. The sound collection is certainly the most valuable thing about these apps, per-mitting the observer to instantly compare a sound heard in the field with a playback from the app. Website: sibleyguides.com/product/sibley-birds-v2-app.

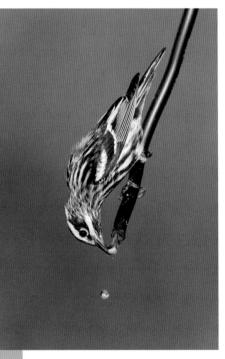

A male Black-and-white Warbler drinks from a natural water tap.

Project FeederWatch is a winter-long survey of birds that visit feeders at backyards, nature centers, and community areas across North America. FeederWatchers periodically count the birds they see at their feeders from November through early April and send their counts to Project FeederWatch at the Cornell Lab. This helps scientists track broad-scale movements of winter bird populations and long-term trends in bird distribution and abundance. Anyone can participate by signing up and paying a small participation fee. FeederWatch is conducted by people of all skill levels, including children, families, indi-viduals, classrooms, retired persons, youth groups, and bird clubs. Website: feederwatch.org.

The Cornell Lab of Ornithology provides an online field guide (*All About Birds*), a huge collection of downloadable bird sounds and bird images (the Macaulay Library), active bird cams, bird conservation information, advice on bird feeding, advice on building nest boxes, and an online store. The Lab also provides home-study courses in ornithology. Website: birds.cornell.edu.

Hawk Migration Association of North America provides all manner of information regarding the 200+ hawk-watch sites in North America. This includes location, watch season, and a written description of the site, plus all the years of data (day by day) of the hawk species and numbers observed. By noting the date and weather conditions on a bountiful day in past years, birders to plan best timing of a hawk-watch visit (most important details: wind direction, wind speed, and cloud cover). Who would have thought that Snicker's Gap, Virginia, could have recorded 19,004 Broad-winged Hawks on 18 September 1998? Website: hmana.org.

BIRDING GEAR

One of the nice things about birding is that it is easy to get started—you mainly need a willingness to get outside and start listening and looking. That said, as with all hobbies, gear has become a part of birding, and those who are gear-inclined can spend a lot of time and money loading up with the latest and finest. Below we review the basics.

A birder uses his binoculars to scan a flock of waterfowl on the Salton Sea.

Binoculars. The single most important tool for birding is binoculars: a bad pair will leave you frustrated, but a good pair will brighten every bird you see. Today, there are scores of binocular makes and models to choose from, making the choice a challenge. You can purchase perfectly workable binoculars for less than $150. Those with a taste for the very best will pay more than $2,500. If you intend to bird for life, go for the best pair you can afford, because they will last longer and provide a better experience. For the average beginning birder, select a pair featuring 7, 7.5, or 8 power, with the objective lens between 40 mm and 42 mm. These will be advertised as 7 × 40, 7.5 × 40, 8 × 42, and so on. A larger objective lens provides more light, and the power is, essentially, the magnification of the image. A lower magnification with a larger objective lens (such as 7 × 45) provides a lot of light and a wider field of view—making it easier to find the moving bird with your binoculars. That said, many advanced birders choose 10× binoculars because of the extra magnification provided, which can make the difference between identifying a distant hawk or letting it go. However, 10× binoculars are a bit more difficult to manage for beginners because they are heavier and have a narrower field of view.

A final consideration is the eyecup and exit pupil—at the top end of the binocular—the end you put up to your eye. It is important for you to be able to see easily through the front of the binocular. This is particularly relevant to people who wear eyeglasses. If you wear glasses be sure to test the binoculars while wearing your glasses. This is best done with the eyecups of the binocular folded down, so your eyeglasses are as close to the lens as possible. Buy a pair of binoculars that is comfortable to hold, easy to focus, and easy to look through with your glasses on. The Cornell Lab of Ornithology and the National Audubon Society periodically carry out reviews of the leading binoculars. Look for the latest review articles online. It is worthwhile to visit a well-stocked birding store to try out different models to see which one provides the best feel and utility.

Field Guides. As with binoculars, there is a dizzying array of field guides available. For most of us, the best bets are the *Sibley East* and *Sibley West* guides (see p. 544). They are compact and well illustrated. They include nice (but small) color range maps, and they

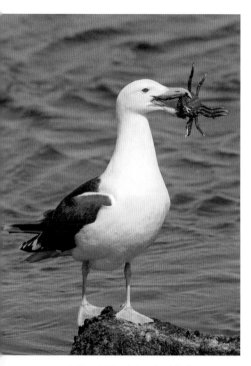

A Great Black-backed Gull manipulates a spider crab.

restrict their focus to birds of eastern or western North America (north of Mexico). For true beginners, the Peterson East and West field guides are a good match. These guides have large, color range maps, which are easier to use. The high-powered birder will prefer to use the full Sibley guide or the National Geographic guide (both covering all of North America). These are very complex, include scores of vagrant species unlikely to be seen by the majority of birders, and they tend to feature too many illustrations of marginally distinct subspecies or plumages to be helpful to beginners.

Handbooks. Birders tend to have books for the field and also books for home—the latter too large or too heavy to carry around in the field. *The Sibley Guide to Birds*, which is a bulky and heavy field guide, falls into this latter category. We tend to keep this guide in the house or car and carry the *Sibley East* or *Sibley West* into the field, when necessary. The most comprehensive and up-to-date North American handbook is the *National Audubon Society Birds of North America*. This is jammed with photos of all the species of North America and includes useful detailed accounts for each (see p. 543).

Spotting Scope. Perhaps the next most important item to a field birder is a spotting scope. This is a telescope with a 20× or 25× objective lens (or a 20×–60× zoom lens) that sits on a tripod and is used for looking at birds too distant to be identified with binoculars (e.g., distant ducks, gulls, shorebirds, and seabirds sitting on water or on distant mudflats). With the need to purchase the scope, the objective lens, and the tripod, this is an expensive proposition. The more expensive scopes merit the more expensive heavy-duty tripods and so forth. We recommend doing research on scopes and tripods online, perhaps at the Cornell Lab of Ornithology website or other similar websites offering buying guides. Better yet, go on some organized birding field trips and test out the scopes carried by the leaders. They can advise on details of usability. Many of the best scopes will cost more than $1,000 (when the eyepiece is included).

Digiscoping. Advanced birders have developed a technique of bird photography that combines a spotting scope and a digital camera (even the one on your smartphone will do). This allows ready documentation of sightings of rare species that can be shared online. Digiscoping is a less expensive option to the purchase of a digital SLR or mirrorless camera with a long lens. There are special adapters that link the spotting scope to the camera to allow remarkably sharp images to be captured.

Hearing Aids. Most birders over 55 start losing their ability to hear some birdsong, especially those songs of a higher pitch. Hearing aids can assist in bringing back the ability to hear many of these "lost" sounds. Expensive but very helpful.

Digital Camera and Long Lens. Many birders today go out with both binoculars and camera, seeking to capture images of the birds they are seeing. The most affordable path to bird photography is digiscoping, but the other option is to purchase a digital SLR or mirrorless camera and an accompanying lens. A camera body will cost between $500 and $6,000. Professional-quality images can be made with bodies at the lower end of that

range. The more expensive bodies simply have many more bells and whistles not necessarily required for bird photography. The lens choice is between a standard telephoto lens (300 mm, 400 mm, 500 mm, 600 mm) or a zoom lens (say, 200–400 mm or 150–600 mm). The zoom, as its name implies, allows the user to quickly change the magnification (lower zoom for a large heron, higher zoom for a hummingbird). Zoom lenses tend to be more expensive and produce marginally less-sharp images for their dollar value (because they are so much more complicated to build). Most birders who are beginning bird photography go with a 400 mm f/5.6 lens. The other option is to get a smaller telephoto lens (say, a 300 mm) and add a tele-extender on the back end that increases magnification 1.4× or 2.0× times. There are many options here, and each birder needs to do a fair amount of research (especially reading user reviews) to discover the best option that combines cost and quality. A final note: the big expensive lenses are heavy and can weigh down a birder in the field. There is a world of difference between birding and bird photography.

Notebook or Digital Recorder. With the advent of eBird, everyone can contribute bird occurrence information to a dataset that is used by researchers and birders around the world. And now, images and recorded sounds can be submitted to eBird to accompany the bird lists. But for those less technically minded, one can handwrite sightings into a field notebook or, alternatively, carry a small digital sound recorder (which is tiny and can be worn around the neck) and speak your observations into it—or use the voice memo feature on your cell phone. The important thing is to record your sightings in some manner and to then upload them to eBird. And, of course now it is possible to record bird songs using your smart phone. And don't forget the sound ID feature in the Merlin Bird ID app, mentioned above.

A bird photographer points his long lens at a confiding Great Gray Owl in the falling snow of Minnesota.

Footwear. For most around-town birding, footwear is not a concern. For longer and gnarlier field travels, it pays to wear the right shoes or boots, or your day may be spoiled by having to trudge around with wet, cold feet. We simply want to recommend that, for going afield, one often overlooked but excellent option is the tall, rubber, unlined pull-on knee boot known variously as Wellingtons, muck boots, galoshes, or gum boots. These cheap rubber pull-on boots can be purchased at a big box store for less than $25 and are most comfortable when worn with two layers of socks—a thin nylon liner sock and a thicker hiking sock over that. For these, it is also good to consider a foot insert to ease strain on the feet. This boot option is waterproof and provides some leg protection, and it has the added benefit of repelling deer ticks, especially when the outer surface of the boot is sprayed with repellent before the beginning of a bird walk.

Outerwear. Catalog companies such as L.L.Bean, REI, BigPockets, Gander RV, and Bass Pro Shops sell all sorts of hunting and outdoor clothing made of new miracle fiber materials, some quite expensive. Our only suggestion is that when you head out birding, it may pay to keep your outer layers to camo, olive, or gray colors. Birds are not color blind, and they may be alerted to your presence by bright parkas and raincoats. Hunters have it figured out. You want to blend in, not stand out. There are also birder's vests with lots of pockets for gear and field guides.

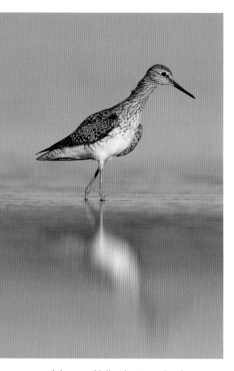

A Lesser Yellowlegs wades in a glassy-surfaced flooded mudflat.

Cooler and Thermos. Having a decent-sized cooler in the back of the car is always a good idea. Pack it with plenty of bottled water and some snacks that will raise sagging energy levels during breaks in the birding. For winter birding, a thermos with hot coffee or cocoa is a must.

PLANNING YOUR BIRDING FIELD TRIP

Many birders go birding with their local bird club, which typically offer a variety of seasonal field trips. Here is what to do if you are planning your own trip. Some advance planning can make the field trip more comfortable, more fun, and more successful. It is thus best to make some plans well before you set off. The farther you travel, and longer the trip, the more planning is needed. What follows are steps to a better field trip.

First, some general guidelines. The best birding field trips require adequate time. It is always preferable to allot more time to the effort. The travel time to and from the destination, the time for a snack or a meal, and adequate time to be out in the habitat eat up a day. Rushing a birding field trip destroys the whole point of the trip—to have fun and to relax. Also, do not plan to attend a social event on the evening of an all-day field trip, because you probably will get home late, dirty, and tired. Always take food and water with you, and a field guide—and don't forget the binoculars!

In most cases, the best time for birding is at dawn or shortly thereafter. Midafternoon is typically the worst time for birding, especially in the height of summer when it gets hot and uncomfortable. There are some exceptions. If you are headed out on the Eastern Shore area of the Delmarva Peninsula in search of the big flocks of Snow Geese, be aware that such flocks depart from their aquatic roosting places very early to range about in the fields in search of waste grain. Also plan visits to specific birding sites to take account of the sun, if possible. It's no fun scanning a huge flock of shorebirds with the sun low behind the birds. It's all about being in the right place at the right time.

eBird it! BirdsEye it! If you are planning a day trip to Bombay Hook National Wildlife Refuge in coastal Delaware, do some online research on what special birds one might expect in the environs the time of year you are going, and also look for the most recent field reports from the area. There may be a Little Gull at nearby Port Mahon and a Ruff at Shearness Pool. And maybe there is a Northern Wheatear reported at a small park that is right along your route to Bombay Hook. If you know this in advance, you can plan your day around searching for these various rare species.

Weather Channel it! It is useful to use an online weather service to predict a day with weather appropriate for good birding. A warm front in spring, or a cold front in autumn, or a rain system all can produce a wealth of migrant birds. That said, weather is probably the single most uncontrollable variable that can determine the success of a birding trip. Wind can ruin a day of birding. If you are out in spring in search of singing songbirds, a strong and blustery wind will be your downfall. Wind tends to build during the day, and midafternoon can be the windiest time of all. Avoid the wind by getting out early or mov-

ing to a sheltered location, such as the bottom of a wooded valley, where the birds may also have aggregated. If your weather app predicts winds of more than 15 miles per hour, you may wish to reschedule your birding trip to another day.

If you are in search of ducks in winter, think about the presence or absence of ice on the waters you are visiting. Areas that ice over send ducks elsewhere, so try to visit sites where you know there will be open water, such as inlets, larger rivers, sewage outlets, waterfalls, or large public parks with active fountains. This is probably where the ducks will be concentrated. For shorebirding, don't forget about the tide's effect on tidal flats.

Heavy fog can also make birdwatching almost impossible, although it tends to burn off as the day matures.

After wind, rain is probably the second-biggest enemy of bird-watchers. Rain fogs your binoculars and eyeglasses, it stops you using your smart phone, it makes you miserable, and it severely curtails the activity of small birds. However, there are some birds who seem blissfully unaware of all but the heaviest rain (e.g., ducks, seabirds, and shorebirds), and these can still be enjoyed provided you are watching them from a sheltered location, such as below a bridge or building, or inside a car or bird blind. Some of the larger reserves have bird blinds or similar sites where you can watch birds from shelter—check their websites before you go. That being said, some birds seem to enjoy a shower and remain very active in light rain, especially if it is sunny and warm (e.g., wood warblers in May).

Know the times of sunrise and sunset. If you are planning an all-day trip, it is best to do your traveling before dawn so that you arrive at the first birding site shortly before dawn, which is the sweetest time of day and often the best for birding, because that's when birds like to sing.

Google Maps it! Take some time the night before to familiarize yourself with your route by visiting Google Maps. Also use a GPS in the car when on the move. GPSs are great for getting you to obscure destinations off the beaten track.

Listen to the voices of your target birds in advance. If you are looking to locate a Golden-winged Warbler in a scrubby clearing in the Allegheny Highlands, listen in advance to the voice of the species from a smartphone app or online from the Cornell Lab website.

Take extra clothing for wind, cold, and rain. From the comfort of our homes, we tend to forget how different things can be out in the field. Prepare for the unexpected by taking extra layers, a windbreaker, a raincoat, a down vest, gloves, and maybe even a spare set of dry socks. These can be kept in the car, ready for use if you find conditions are more extreme than expected.

Take sunglasses, sunscreen, insect repellent, and a hat with a visor. Be aware of the threat of Lyme disease, Rocky Mountain spotted fever, and other tick-borne diseases. This merits some detail. The tiny deer ticks that carry these bacterial diseases are present year-round, anywhere deer are abundant—which is just about any outdoor location in the Lower 48. The best way to prevent the ticks from attaching to you and transmitting the

A male Ruddy Duck displays to a nearby female.

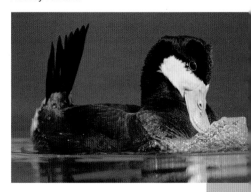

disease is to wear boots and long pants and to spray both before and after going into the field. Also, it is advisable to stay out of long grass and brushy areas frequented by deer. We like to wear those tall rubber pull-on boots that come up to the shin. These are a good tick deterrent, especially when sprayed with repellent. Also spray the inside and outside of the boots, and spray pants from top of the boots to the waist. That said, after a day in the field, it is best, upon return home, to deposit all field clothing in a hamper, take a hot shower, and do a body search for these insidious little ectoparasites. It pays to be careful on this front, as Lyme and similar diseases can cause chronic, debilitating impacts on health. If you start to feel joint pain several days after a possible exposure to ticks, check your body for the telltale bull's-eye rash signifying a bite from an infected tick; if you find one of these, visit your local clinic as soon as possible. Fortunately, doctors in the Lower 48 are now well aware of the symptoms of tick-borne diseases and will prescribe you a course of antibiotics if they suspect you are infected.

Take a friend or colleague. Birding is fun alone, but it usually is more productive in the company of a fellow birder—more birds get seen or heard by a duo. It is also safer. This is especially so if you plan to be deep in the woods or mountains. If you do go alone, let someone know about your plans so they can follow up in an emergency or if you don't return home by a certain time. Keep your cell phone charged and with you at all times.

Stop and ask. If you get lost, stop and ask directions. Also, if you see birders on the side of the road using binoculars or a telescope, definitely stop and find out what they are looking at (but turn off your engine when doing so). Maybe they have a bird in the scope that is a species you have never seen (we call that a "life bird")! Also query them about other interesting sightings of the day. Other birders are a huge aid to finding the birds you are hunting for. In most cases, they have done the work in advance of you. If you get out of your car to speak to them, be sure to close your door carefully—if you slam it and that rarity flies off, you'll be very unpopular!

Call in advance or visit a website. If you are planning a visit a wildlife refuge that is a drive of an hour or two away, it pays to check things out before departure (perhaps the afternoon in advance). Call the refuge headquarters to inquire about road or area closures or to find out about sightings of rarities.

For a week-long birding excursion, it is worth taking some extra steps. One should spend at least a full evening planning the trip. Make all of your bookings well in advance, especially if you are visiting popular birding spots during the migration high season. Lay out your gear and equipment in a place where you can review your needs.

Create an itinerary of birding sites. Using eBird and websites, make a short list of the best birding localities in the region you are visiting. Make a rough plan of what sites you will visit on which mornings or afternoons and in which sequence. Remember that time is short and everything takes more time than you think. The farther you are traveling, the more days you should plan to spend at your destination. Always leave some time to be

In this historic photograph, a party of birders led by Guy McCaskie (in red shirt) searches a wetland in northern California for the elusive Yellow Rail. This is a task best done in a group.

extemporaneous—after all, you may get an alert of a megararity in the area that forces you to change your plan.

Print out maps of the parks you are visiting. Most protected areas have websites, and most of these websites offer downloadable maps of the park. Print these out in advance, and stick them in your backpack or pocket. These can be valuable when in the field and someone you meet in the field tells you about a rare species "up the Canyon Trail, which is just south of the River Trail and east of the Mountain Trail." Also, it pays to pick up state highway maps when you cross a border into a new state. These can be obtained for free at welcome centers or ordered online for no cost. Maps are fun to study in the evening or during a meal in transit, and they can generate backup options when an original plan or route breaks down. The handheld GPS and cell phone are handy gizmos, but a map is a physical entity that is a nice conversation piece to spread out at your table in a restaurant, and it can eventually become a trip souvenir if you take time to annotate it with the locations of specific sightings of rare birds seen.

Consider hiring a local guide. With birding, local knowledge is everything. Some bird species have very narrow habitat requirements, and only experienced locals know their locations. Having a local guide take you out can make a huge difference in what you see. The problem is, only major birding hotspots (such as Cape May, New Jersey) have year-round local guides available. You might have to track down a local expert birder through the American Birding Association. An alternative is to send out a message to the local birding listserv of the state you plan to visit: say where and when you are going, what your target species are, and ask for advice. Birders are generally friendly, and people may either recommend some sites or, even better, offer to take you around.

A White Ibis forages in the sunset of a Florida wildlife refuge.

Consider having a bicycle with you. There are many birding sites that cover extensive territory. These can be more easily covered if you use a bicycle. Bicycling is a great way to bird by ear—traveling until you hear something interesting. Pack a bicycle on the car rack, and use it when needed. Another option is to do the whole birding day by bicycle. Being in a car makes it harder to hear birds, and it is not as friendly to the environment. Cape Henlopen State Park, in Delaware, for instance, has an excellent biking trail, and bicycles can be rented from the nature center.

Create an action list specifically for the trip with supplies, equipment, important phone numbers, and other reminders. Keep a clipboard in the car with lists, maps, reminders, shopping needs, and the like.

IMPORTANT INSTITUTIONS FOR BIRDS AND BIRDING

Here we provide an annotated listing of institutions, both national and continental, that can help further your birding, bird appreciation, and bird conservation. Quite a few of these are membership organizations, and we encourage readers to consider joining these. Many are volunteer-run and depend upon membership dues to continue their mission.

A Black Tern wings over its nesting marsh in North Dakota.

American Bird Conservancy (ABC). With a mission to conserve wild birds and their habitats across the Americas, ABC takes on the greatest problems facing birds today, innovating and building on rapid advancements in science to halt extinctions, conserve habitats, eliminate threats, and build capacity for bird conservation. Website: abcbirds.org.

The American Birding Association (ABA) is North America's continent-wide recreational birding organization. Its focus is to promote the hobby of bird-watching. It also seeks to encourage birders to work to conserve birds, teach others, and build a bird-friendly North America. ABA website: aba.org.

Christmas Bird Counts are managed by the National Audubon Society across North America. These all-volunteer winter bird surveys are carried out from mid-December to early January each year. Each count surveys birds on a single day within a fixed circle 15 miles in diameter. The 2022–2023 counts were the 123rd year of this historic winter birding activity. Each year, more than 2,000 counts are made across the Continent. Sign up to participate in a Christmas Bird Count near your home. To find the nearest count, visit the website: audubon.org/conservation/science/christmas-bird-count.

The Great Backyard Bird Count is an annual backyard feeder count conducted over a few days in mid-February, though the term "backyard" is defined loosely. These citizen-science data are used for long-term analysis of winter bird numbers and distribution of populations. Hosted by the Cornell Lab of Ornithology and the National Audubon Society. Website: gbbc.birdcount.org.

The Association of Field Ornithologists (AFO) was founded in 1922 as the New England Bird Banding Association. Today, the AFO is a society of professional and amateur ornithologists dedicated to bird-banding and bird population studies through trapping and banding. All bird-banders or aspiring bird-banders should be members of the AFO. The AFO is also an important source of bird-banding supplies and equipment. Website: afonet.org.

The Nature Conservancy (TNC), as its mission, conserves "the lands and waters on which all life depends." The TNC "vision is a world where the diversity of life thrives, and people act to conserve nature for its own sake and its ability to enrich our lives." TNC achieves this vision "through the dedicated efforts of [its] diverse staff of more than 400 scientists, all of whom work to impact conservation in 72 countries and territories." TNC deploys a nonconfrontational and collaborative approach. There are also local TNC programs across the United States and Canada. Website: nature.org.

The National Audubon Society works to conserve birds and their habitats. Founded in 1905 in the United States, Audubon is one of the original bird conservation organizations, supporting more than 450 local and regional chapters. The society's two headquarters are in New York City and Washington, DC, and it has 23 state offices. It owns a number of

nature centers open to the public. Audubon helps to forge lifelong connections between people and nature. Website: audubon.org.

The Cornell Lab of Ornithology is a research program of Cornell University in Ithaca, New York, that focuses on the study and conservation of birds of the world. The Lab includes more than 200 faculty, staff, and students working together to better understand and protect the Earth's birdlife. It is member-supported and publishes *Living Bird* magazine and a newsletter. It also manages several educational websites (such as eBird) and bird-focused programs mentioned elsewhere in this book. Website: birds.cornell.edu.

The American Ornithological Society (AOS) is a US-based scholarly organization representing the professional ornithologists of the United States, although membership is open to interested people from around the world. The AOS publishes the scholarly journals *Ornithology* (formerly the *Auk*) and *Ornithological Applications* (formerly the *Condor*), as well as the AOS Classification Committee's checklist of North American birds. Website: americanornithology.org.

BIRDS AT HOME

An excellent place to watch birds is your own backyard. We should all take steps to attract more birds to our yards. By factoring in birds and their needs to a home landscaping plan, we can improve our property's value while making it more bird friendly. And by making it better for birds, we make it more pleasant for our families. Having Pileated Woodpeckers visit the backyard to feed on the suet you have provided makes your yard more interesting. It's just a matter of thinking about what birds need and keeping birds in mind when drafting that yard improvement plan, which is probably worth doing every few years.

Yard beautification is no small task, but it pays benefits for those who do it. There are various ways in which we can beautify the yard. Just as we plant certain flowers to bring color, beauty, and diversity, we can actively attract desirable birds into our yard to add color, song, and the opportunity to witness their fascinating behaviors. Although the flowers have to be bought at the store, the birds are supplied for free by nature, requiring just a few thoughtful tweaks of our backyard environment to bring them our way. It's just a matter of providing food, water, safe shelter, and nesting sites.

The home environment is a human environment, a manufactured environment, not wild nature. The homeowner should manage the home environment, including the yard, to ensure the safety, health, pleasure, and satisfaction of the homeowner, family, and pets. Birds are then added to the mix to bring pleasure. For most homeowners, the objective is not to create a personal wildlife sanctuary or to enhance local bird populations but to attract birds so we can enjoy their presence. That said, most of us want to help protect populations of our favorite birds, and this can help.

Just about any improvement homeowners make to green up and beautify their yards will attract birds. Thus it is not necessary to sweat the details of major yard improvement. The smart way forward is to create a plan, usually by mapping the yard and the proposed improvements on a piece of paper. Having a long-term vision is a useful way to ensure your reworked yard will be a success. It pays to think from big to small in terms of

additions. First, map out the main walking routes, play areas, ponds, patios, and outdoor furniture placement. Next, think about the placement of canopy trees, understory trees, and shrubs, and then herbs and annuals. Once the big stuff is in place, the smaller items can be fit in around them, perhaps even blended in several years down the line.

A few mature canopy trees can offer the most substantial improvements to a yard. A big oak or hickory can cast wonderful shade and give the yard a pleasant rural aspect. Because trees take decades to mature, and because they impact sightlines and shade, selecting and situating these canopy trees is a major decision that is not to be taken lightly. Work with a landscaper or arborist to achieve the proper tree-planting scheme. With regard to canopy trees, fewer is usually better. The initial temptation is to plant lots of saplings because they are small. This can provide some fast satisfaction. But as the trees grow, they require more and more space. Better to think in the long term and allow space for trees to grow and seek the sun and spread their branches. Visit the website of the Arbor Day Foundation (arborday.org) to find out the requirements of mature canopy trees.

It is also good to keep the seasons in mind when deciding what to plant. What will the selection of plantings look like in spring, summer, fall, and winter? Include a diversity of plantings that can provide color, fruit, or green leafy growth in each season. It is also important to think about colors and what will best accent your yard. What autumn colors are produced by a shrub or tree, and are they right for your yard? There are lots of potential pitfalls associated with planting certain tree saplings that do not arise until several years later when the tree matures. For instance, a female Ginkgo may have nice yellow leaves in autumn, but it will also produce stinky and messy fruits that the homeowner will have to deal with. Sweet Gum is a wonderful canopy tree that produces many spikey fruits whose seeds are popular with small seed-eating birds, but the spiny pods are a big nuisance to homeowners. In the same manner, a female American Ash produces tens of thousands of wind-borne seeds that lodge in gutters and in all manner of nooks and crannies—for instance, filling the small narrow wells that hold the windshield wipers of cars. And such an ash could fall prey to the Emerald Ash Borer beetle. Be smart and do research on the trees you are thinking of planting—this is a long-term investment.

In general, for landscape plantings, it is better to plant native species. There are plenty of bird-friendly native species that can beautify your yard and likely host more native insects than non-native plants. There are already thousands of exotic invasive plant species lurking in our local environments. We will be spending billions of dollars in decades to come to remove these exotics from the local flora. Better to not risk adding to this expensive environmental problem.

Try to plant a suite of species that will provide seasonal foods for the birds year-round. This will ensure some nutrition for the birds in every month, and it will provide added pleasure because the birds will be present more months of the year. American Holly produces red fruits that provide additional color in winter and also provide food for Pileated Woodpeckers, American Robins, and Northern Mockingbirds in winter.

Be careful with pesticides and herbicides! For instance, the use of neonicotinoid insecticides can be devastating to birdlife. Better to avoid standard store-bought toxins altogether. Also ensure that anyone you hire to carry out yard work uses only bird-friendly fertilizers and herbicides.

Not everyone has space to plant new canopy trees, but those who do need to think ahead if they plan to make such a major environmental commitment. The best trees for the birds are ones that grow well in your yard, look good, and also provide something for the birds: a place to forage, a place to roost, or a place to nest. As mentioned earlier, native trees are preferred, mainly because they serve as favored habitat for all sorts of wild creatures big and small, some of which serve as important prey for a variety of woodland birds. For instance, the White Oak, the Maryland state tree, is very popular with migrant wood warblers in spring because its young leaves harbor tiny caterpillars of native moths. The caterpillars convert the leaf material to fat, protein, and carbohydrates, ideal for hungry migrant birds, which need to keep feeding to have the energy for their flight north. Having a mature White Oak at the edge of the yard can almost guarantee visits by a whole suite of beautiful migrant warblers, plus other attractive species such as Rose-breasted Grosbeak and Scarlet Tanager.

Trees that grow to canopy height are usually purchased when small (six to seven feet tall) with a root ball the size of a large pumpkin. Don't be fooled by their small size. The tree will grow to become a major part of your yard environment, so caution is in order. Most large trees are best planted far from the house and in the corner of the property. This allows for the considerable space this tree will require once mature. For example, that six-foot Norway Spruce at the garden center looks like an adorable little Christmas tree. The temptation is to treat it like a Christmas tree and plant it by the front door or in the entrance to your drive. Don't! In four decades, this tree will be 70 feet tall with branches that reach out 15 feet on each side of the trunk. That's 30 feet from side to side! If you simply must have a conifer, plant it as far from the house as possible, in the woodsiest corner of the yard, and select a native species. Another concern is root invasion. Big trees send out powerful roots in all directions, and these can rupture sidewalks, patios, water pipes, and basements. Some trees are more invasive than others. Do your research. Once you have made a decision on a species, buy a well-formed one, and one as large as you can afford, as larger saplings have greater probability of surviving to maturity. The tree will be in place for many decades. It's worth the investment in the best quality.

Most yards can handle a few additional understory trees. That said, these can also grow large and spread, so you must plan carefully to allow space for growth. Consider planting the back boundary of the yard with several of these small trees to form a hedgerow, interspersed with attractive shrubs. Birds will love this sort of refuge.

Edging your yard with rows of low shrubs that are somewhat open underneath is an ideal refuge for sparrows and other ground birds that tend to be wary of avian predators like Cooper's Hawks. Place feeders close to these protective shrubs so birds have a protected place to escape to when a predator swoops in.

Steer clear of the large and tall broadleaf evergreen shrubs with a thick shell of leaves. Most of these are exotic, such as English Laurel or various commercial hollies, and tend to attract winter roosts of House Sparrows and spring nest sites for Common Grackles, both of which can detract from a pleasing landscape.

Many winter plants can provide food for birds that consume seeds and fruit. Plants like Staghorn Sumac, viburnums, Virginia Creeper, Serviceberry, Winterberry, American Holly, Toyon, and Catalina Cherry provide fruit and berries that birds love. If you have the

A Snow Goose prepares to alight in a farm field to feed on the waste grain left by the mechanized harvester.

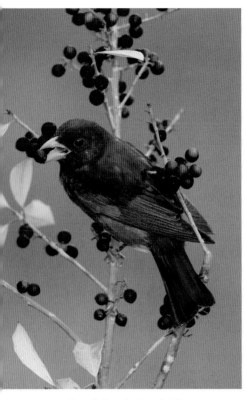

An adult male Scarlet Tanager harvests red berries from a species of holly.

room, evergreen trees can provide seeds from cones. Crab Apple trees can provide both fruit and seeds.

Mowed lawns are fun as play spaces for children but don't do much for the birds. Yes, we see American Robins searching for earthworms on the lawn, but we also see European Starling flocks out on the lawn in search of insect larvae. Most homes could do with less mowed lawn and more permanent vegetation that requires minimal annual work. Think about reducing the lawn space to the center of the yard and building buffers of taller vegetation around the yard's perimeter. This reduces the weekly chore of mowing the lawn and offers a more complex environment for the eye and for the birds. The one good thing we can say about well-tended lawns is they tend to be tick-free, and thus safe for children to play on.

Providing nutrition for birds usually is a combination of smart plantings plus direct feeding. Provide a reliable year-round water source. Also situate and prune plantings so they can offer safe shelter for roosting birds or those escaping predators. Many birds (e.g., Gray Catbirds and American Robins) construct their cup nests in protected shrubbery. Others, such as House Wrens, generally require a nest box of the correct dimensions with a suitably small nest entrance hole. Placement of a water source, food sources, shelter sites, and nest boxes should all be planned, along with the landscaping, to achieve the best effect and most beauty.

Year-round, birds require access to fresh water for drinking and bathing. A heater, bubbler, or other water feature will prevent ice from forming in the birdbath in winter. You can leave this bath up all year and utilize the heating when needed. It is important to change the water frequently to avoid the build-up of algae and microbes from bird droppings. The water source should be placed close to shrubbery and other vegetation so the birds do not have to put themselves at risk when using it. It is safer and more likely to be used by birds if raised off the ground. The bath should have depths varying from half-inch to three inches deep. The surface of the basin should be rough to allow the birds good footing in the water. Finally, it is not a bad idea to put a few stones in the middle so birds can stand on them to drink.

While plants like shrubs and trees that maintain their leaves during the winter can provide birds with cover from the wind, rain, and snow, there are other ways you can offer shelter. When choosing plants for your garden, consider different canopy levels for diverse shelter needs. Brush piles can also provide a safe place for birds to hide or roost overnight, so try making your own from discarded branches and leaf clippings in a hidden, undisturbed corner. Consider offering a roost box for your backyard birds, similar to the one found at the *All About Birds* website (allaboutbirds.org). You can also modify a nest box to make it a temporary roost box. What about birds that don't use cavities? They will seek shelter in an evergreen tree, often huddling together on severe nights. If possible, cluster a few evergreens in a corner of your property.

Nest Boxes and Nesting Birds. It pays to think through your nest-box plan. Many nest boxes sold in stores are not properly constructed or sized to attract the proper target species. Perhaps the most desirable species that use a nest box are wrens, chickadees, and

bluebirds. The wrens are wonderful songsters, the chickadees have loads of personality, and the bluebirds are fun to watch as they look for food and take it back to their young.

There is nothing more frustrating than setting up a nest box in the yard and then seeing it sit empty through the summer. To avoid this, first determine what target species are in the immediate vicinity. Don't put a nest box out for an Eastern Bluebird and expect one to use it if you have never seen the species in your neighborhood. Bluebirds generally require lots of open space and old fields—neither of which is usually found in suburbia. Don't set up an elaborate Purple Martin house unless you are pretty sure your yard is martin friendly (again, martins generally don't inhabit suburban neighborhoods). There are various websites that can assist with carrying out the due diligence on all of this (for bluebirds, for example, sialis.org).

First determine what favored bird species inhabit your yard and come to your feeder. Read up on nesting habits of these selected species at the Cornell Lab's *All About Birds* website (allaboutbirds.org). Then carefully buy or make nesting boxes for these particular species. A variety of websites offer species-specific designs. The most important aspects of the construction include the size of the nest hole and the overall size of the interior of the box. Use untreated and unpainted wood. The best woods are cedar, cypress, and pine. Use galvanized screws, which don't rust. A sloped roof keeps the interior dry. Recess the floor up from the bottom of the box (to keep the bottom dry). Drill ventilation holes on the side walls and maybe a few in the bottom for drainage in case water gets in. Do not put a perch under the entrance hole (it aids predators). To keep out European Starlings, keep the entrance hole smaller than 1.5 inches diameter. Add a metal facing or an extra wooden layer over the main opening to keep predators from enlarging the entrance. The interior and exterior walls of the house are best left rough so the birds can grip them more easily, especially the nestlings as they attempt to leave the box to fledge.

Roost Boxes. Some birds don't mind using last spring's nesting box as this winter's roost box to keep warm during windy, cold nights. Roost boxes and birdhouses both provide shelter for birds, but roost boxes are not intended for building nests or raising young. They are meant to give cavity-dwelling birds protection from cold temperatures, precipitation, and predators. Birds that nest in cavities, such as bluebirds, may crowd together inside a nest box or a natural cavity when temperatures are harsh and food is scarce.

You can repurpose your spring birdhouses by turning them into winter shelters for your backyard birds. First, clean the birdhouse and repair it as necessary. Winter-proof it by sealing the ventilation and drainage holes to keep warm air trapped inside. Some birdhouses are designed with a movable front panel with an entrance hole at the top. If possible, flip this front panel upside down so that the entrance is on the bottom to reduce heat loss (since hot air rises). Remember—any type of shelter, no matter how imperfect, is helpful on a freezing night. Last, place the shelter in a warm and safe location. Choose a spot that has long light exposure—the more sunlight the box sees in the afternoon, the longer it will stay warm in the evening. Position the house so that the entrance is facing away from prevailing winds to prevent gusts from blowing into the shelter. Also, be sure the placement is safe from predators by placing it high off the ground, or on a baffled pole.

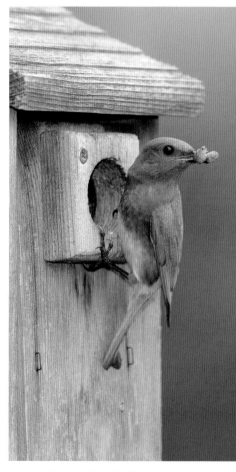

A male Eastern Bluebird brings an insect larva to the nest box.

Don't Forget the Butterflies, Bees, and Bats! When you draft your plan for making your yard into a place for birds, you should consider providing for all four "Bs"—birds, butterflies, bees, and bats. The butterflies and bees will do pollination work in and around your yard. They also add biodiversity to the yard, as well as color and curiosity (just what butterfly is that on the aster?). Just a few strategic plantings of milkweeds, columbines, coneflowers, asters, and goldenrods can make a big difference. Note that the species of butterfly bush are invasive and non-native and probably should be avoided. It is best to plant native species. Most caterpillars of our favorite butterflies require native plants.

Bats frighten people. And some people worry that bats carry disease. Bats, thus, get a bad rap—undeserved. In fact, bats are our friends, ridding our yards of thousands of annoying, whining, and biting insects in the evening. Because of White Nose Syndrome, many of our most familiar bats have been in serious decline. They need help. Put up one or more bat boxes as part of your landscaping plan. Get the details at batcon.org/resources/getting-involved/bat-houses.

Feeding the Birds. Many of us like to feed the birds. There is something very satisfying in attracting beautiful birds into one's backyard. In spite of being a common and year-round resident, a male Northern Cardinal is a lovely addition to anyone's yardscape. Chickadees offer an irresistible bit of personality and fun. And then there are the surprises that appear without warning at the backyard feeder—a glowing male Baltimore Oriole on a snowy December morning, a sprite-like Calliope Hummingbird on a blustery November afternoon, or a Dickcissel taking seed on the ground below the feeder on a frigid January midday. These are just a few of the possible bonus birds that one can attract when feeding the birds.

A 2016 national survey by the U.S. Fish & Wildlife Service reported that 37 million people in the United States feed the birds, spending $4 billion per annum on more than 1 million tons of birdseed, and an additional $900 million on feeders, birdbaths, birdhouses, and other accessories related to backyard birds. For many families, the main connection with birds is through backyard feeding.

Bird feeding, no doubt, arose as a winter activity. Winter is the lean time for birds that do not migrate to the Borderlands or the Tropics. Permanent resident species that subsist largely on insects and other invertebrates during the summer tend to shift to foods that remain available during the cold months—fruit, seeds, hibernating insect larvae, and the like. This shift opens the door to backyard bird feeding. Birds tend to move about more in search of food, and territorial borders break down in winter, so feeding can attract substantial numbers—both of species and of individuals of each species. It is not uncommon to see four or five male Northern Cardinals arrayed in a bush, waiting to collect sunflower seed at a feeder. These birds are looking for high-energy staples that can keep them warm through the long and cold winter nights.

We should place feeders in a location where we can easily see and appreciate the birds that come and forage. That said, there are a couple of caveats. The feeder should be situated away from large windows to avoid bird-window collisions. Also, we may have to protect feeders from marauding squirrels—a difficult prospect. In addition, we need to acknowledge that bird-hunting hawks inhabit our neighborhoods, and it is sometimes

A female Baltimore Oriole sips sugar water from a hummingbird feeder in the back yard.

best to not encourage the smaller birds to put themselves at risk out in the open to obtain proffered seed. The compromise is to situate the feeder in clear view but also not too far from protective vegetation into which the birds can retreat if a hawk appears.

The best feeders are those that dispense the seed to the intended target species (small birds or large birds) without a lot of spillage, while requiring the target species to carefully extract the seed at a limited rate, to avoid gluttony. Many households set out several different feeders that attract different birds: a big feeder with sunflower seed for Northern Cardinals and winter finches, a Nyjer feeder for American Goldfinches and Pine Siskins, and a suet cage for woodpeckers, nuthatches, chickadees, and titmice. "Nyjer," informally called "thistle" is tiny and slim black seed favored by many finches for its high oil content. It may also be worthwhile to put out a table feeder to serve jays, juncos, and sparrows, which cannot access today's standard enclosed feeders.

Most of us feed the birds in the cold of winter. This is clearly the time when local birds are most in need of energy to combat hypothermia or even starvation. Feeding in other seasons is less popular, mainly because food sources are available in the local environment so the birds are less energetically stressed. Times of severe drought are an exception, especially for hummingbirds and insect-eaters. Replenishing hummingbird feeders often and offering mealworms to other kinds of birds can be helpful in extreme dry conditions. Some people feed birds year-round.

The experts say the three preferred commercially available seeds to offer birds are black oil sunflower, Safflower, and the tiny black Nyjer. The less expensive bird feed mixes, which include an array of small seeds such as millet, oats, wheat, flax, buckwheat, and red milo, are popular with Mourning Doves, but they are also popular with flocks of blackbirds and European Starlings, which some households find less desirable. In particular, the aggressiveness of grackles and starlings makes for an unpleasant feeder assemblage. The golden rule of buying bird seed is to never buy it unless you can see what is inside the bag. Many supermarkets and discount stores sell opaque bags of "wild bird mix," which tends to be filled with red milo, which is not favored by the most desired bird species.

It seems most every bird species likes high-fat suet in winter, but especially the woodpeckers, nuthatches, chickadees, titmice, and wrens. Hang suet in a place inaccessible to the squirrels. The best suet feeders can bring in all the different woodpeckers—an achievement no other feeder can accomplish. Easy-to-use plastic-wrapped suet cakes are widely available even in the pet sections of most supermarkets. Suet cakes can be messy to insert into cages; this can be alleviated by storing them in a cool place.

We all love hummingbirds and especially like seeing them at flowers in the backyard. Aside from smart landscaping discussed earlier, one can put out a hummingbird feeder, which provides sugar water to these busy little birds. Feeding hummingbirds is most productive in late summer during the postbreeding dispersal period, and secondarily during the breeding season. Things to remember are that the feeder needs to be cleaned regularly and the sugar-water nectar replaced before it ferments or goes cloudy from algae. Cleaning twice a week is sufficient. The main nuisances are foraging ants and leaky feeders. The best feeders provide nectar ports above the level of the sugar water, not below. Here are two easy nectar recipes: (1) Into four parts hot water, mix in one part white cane sugar (beet sugar is acceptable as well); stir until dissolved and then cool. (2) Into two

cups of water, stir in half a cup of sugar. For details, visit the website of the International Hummingbird Society: hummingbirdsociety.org/feeding-hummingbirds.

Experts say never add red dye to the sugar water, as the chemicals in it may be harmful to the birds. The red and yellow coloration of most feeders should provide enough color to attract hummingbirds. It may also be worth leaving your hummingbird feeders out into late fall, as that is when rare vagrant hummingbirds show up.

Probably everyone who has fed birds can recall hearing the jarring sound of a flying bird crashing into a window that faces the yard. Mortality and injury to birds that strike windows can be substantial. Glass can reflect the landscape and, to birds, looks like a pass-through. Some good remedies include placing feeders either a distance from glass windows and doors or within one and a half feet of them, closing any curtains or shades, covering glass with films or decals (not just one), and using screens or bird-strike tape on the closest bare glass at the very least. These should be applied to the outside of the window for best effect. Visit the website: collidescape.org. Note also that new window and door glass has been developed that looks like opaque to birds but is see-through to us.

Keeping a Yard List. We strongly recommend starting a yard list of birds that visit your feeders and plantings. This can take your bird-feeding experience to the next level of appreciation. For beginners, start with a lined pad and a field guide on a convenient table near a window looking out to the feeder, or use a bird ID app, like Merlin from the Cornell Lab of Ornithology (see p. 519). Spend time identifying the species of every bird that comes to the feeder. Over a year's time, you might expect as many as 15–25 feeder species, which offer a nice start to a yard list. The next step is best taken in spring, when migration and birdsong are in full swing. Try identifying other species of birds coming into the yard or singing close by. Track these down and identify them. Generally, yard-listers agree that it is fair to count any species that can be seen or heard while standing in the yard. Thus, a big adult Bald Eagle soaring high overhead on the way to the reservoir can be counted. Hard-core birders can generate yard lists topping 200 species. Best to start small: work to get 50 species on the list, then go for 100. That might take several years, depending on the location of the yard. Nice yard lists, with special yard birds, provide fun bragging privileges for those who keep them. Keeping a yard list is also a great way to become a full-fledged birder.

BIRD CONSERVATION

The 2022 *State of the Birds* report noted that US bird populations have declined by three billion since 1970 and that one-third of North America's bird species are in need of conservation action. Although our raptors and waterfowl have increased, the groups in decline include birds of oceans, coastlines, grasslands, wetlands, and temperate forests. Fully 432 species—including our Black-billed Cuckoo, Red-headed Woodpecker, Long-eared Owl, and Bobolink—were listed on the 2016 bird conservation *Watch List*, owing to troubling signs such as population loss, range contraction, and threats to habitat.

Below we summarize the main points of the 2022 *State of the Birds* report, along with issues raised in American Bird Conservancy's *Guide to Bird Conservation*. These two publications highlight a range of continental and national threats that are impacting our

birdlife. We begin this chapter discussing these threats. But lest the reader assume that all is lost, we then detail various bird conservation successes of the last half century. There is plenty of good news that, in part, tempers the bad news regarding bird conservation. Finally, we talk about actions needed for the future. We need to keep up the effort for birds, building on our successes, but taking seriously the remaining threats.

Threats. Growing large-scale threats to birds include loss of tropical forests (needed by wintering Neotropical migrants), clear-felling of boreal forests (needed by breeding songbirds), agricultural conversion of bird-rich wetland and grassland habitats, various impacts from urbanization, predation by outdoor cats, window strikes, and more.

More than 350 bird species migrate across North America, living in Canada, the United States, and Mexico over the course of the year. This group of international travelers includes some of our favorite birds—orioles, wood-warblers, flycatchers, cuckoos, hummingbirds, and many others. Conservationists now realize that to protect these seasonally mobile birds it is necessary to conserve habitat for them in all the places they use over the year—wintering forests in the tropics, stopover sites in the middle latitudes, and breeding habitat in the boreal north. These migratory birds need to be protected throughout their full life cycle.

Forests in the eastern and central United States have largely recovered in the 150 years since their decimation during and after the Civil War. That said, the forests of Central America and northern South America are now being cleared and degraded by growing local populations and expanding commercial and subsistence agriculture. Many countries have established conservation areas and parks, but in many instances, these have suffered illegal logging and deforestation. And what of the northern forests where many birds nest? Large tracts of boreal conifer forest in Canada have been clear-felled for pulp. These losses harm populations of many of our popular migrant songbirds that breed in the northern United States and Canada each summer.

Grassland habitats have suffered across the Continent, and grassland birds have declined as a result. Many native grasslands have been converted to commercial agriculture where pesticides and herbicides are used. The widespread introduction of non-native grasses has also produced negative impacts. Our Northern Bobwhite, a favorite game bird, has shown serious declines in the East that are a result of these changes.

Nearly 20% of wetland birds were on the 2016 *Watch List*. Wetland loss accelerated by 140% between 2004 and 2016, according to data from the U.S. Fish & Wildlife Service. This may be the result of declining support for wetlands conservation combined with the growing impacts of climate change, especially sea-level rise in coastal areas. In just a few decades, wetland specialists such as the Black Rail have essentially disappeared across much of their ranges.

Migratory birds face all sorts of threats as they move north and south between their breeding and wintering habitats. Lighted buildings at night attract and disorient nocturnal migrants. Millions of migrating birds strike buildings and perish each year. Various kinds of transmission towers, depending on their lighting, have a similar mortal effect on migrating birds, especially on foggy and rainy nights. Wind energy projects (giant windmills) are often situated atop prominent ridges to catch the wind. These sites are also pas-

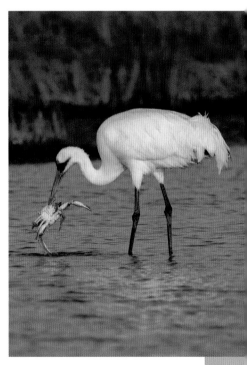

An adult Whooping Crane pulls a large male Blue Crab from the shallows on the coast of southeastern Texas.

sageways for migratory birds and bats, which can be killed both by the moving blades as well as the severe turbulence caused by the blades' rapid rotation. Golden Eagles, migrating along various mountain ridges in the West and East, face this threat each autumn.

Outdoor-ranging and feral cats kill many millions of birds a year in North America. In addition, overabundant native predators such as Raccoons, Coyotes, Virginia Opossums, and Striped Skunks wreak havoc on ground-nesting birds. The affected woodland species include the Wood Thrush and many other songbirds. Grassland species include Bobolink and Eastern Meadowlark, both in decline. Beach-nesting birds include various tern species, American Oystercatchers, Black Skimmers, and Piping Plovers.

Coastal and oceanic fishing industries cause various direct and indirect impacts on seabirds. The direct impact includes bycatch from long-line fisheries, in which a single line may have as many as 30,000 hooks. Every year, many foraging seabirds are caught on baited hooks and, as a result, drown. The industrial overharvest of Horseshoe Crabs in Delaware Bay has impacted Red Knots, because the knots depend on the eggs of the crabs during their spring stopovers there. Red Knots that cannot find adequate food when they stop over in the Mid-Atlantic region subsequently have reduced breeding success in their far northern nesting grounds.

Climate change produces all sorts of impacts on the hemispheric environment that can harm birds. This includes the temporal mismatching of the availability of arthropod prey with the passage of migrant birds in spring, because of the advancing season when the trees leaf out. Migrant songbirds from the Tropics now arrive in the United States too late to encounter the peak of local productivity of caterpillar prey. Without this food resource, these birds will be underweight when they arrive on their breeding grounds in Canada. In another example, climate-driven sea-level rise is seriously impacting marshlands of the Eastern Shore of Maryland. Blackwater National Wildlife Refuge, famous for its productive marshes, has lost thousands of marshland acres in the last several decades.

The aggressive use of new generations of highly bird-toxic pesticides continues to threaten birds, especially various products containing neonicotinoid toxins.

It is thus clear that bird conservationists have their hands full addressing the various threats that face our birdlife across the hemisphere. As we prepare for future conservation battles, we can take hope from past successes in bird conservation, outlined in the next section.

Conservation Successes. Here we mention just a few of the most prominent successes conserving our birdlife. The story of the recovery of the Peregrine Falcon in the East demonstrates the remarkable ingenuity and decades-long effort of the Peregrine Fund and its many partners, both private and governmental. Once extirpated from the eastern United States by the widespread application of the pesticide DDT in the 1960s, today the Peregrine is a common migrant throughout North America, with small breeding populations in most of the East Coast states. The DDT threat is gone, and the captive breeding and targeted release of birds by the Peregrine Fund restored the Peregrine to many places where they formerly bred. One now can take pleasure from watching numbers of

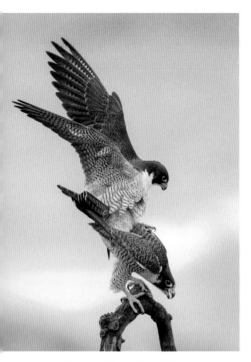

A pair of Peregrine Falcons are demonstrating that these two are a mated pair.

Peregrines pass by the hawk watch platform at Cape May, New Jersey, on a breezy day in October with northeast winds.

The Bald Eagle is another poster child for successful conservation. Just a few short decades ago, seeing a wild eagle in the Lower 48 was a reason for celebration. Today, viewing soaring eagles is all but guaranteed in their former haunts in the United States. The spectacle of scores of eagles at seasonal congregation sites along major rivers from the Mississippi eastward was unimaginable in the 1970s, when DDT ravaged the eastern eagle populations, in part because of their dependence on fish that accumulated the toxic by-products of DDT. The Bald Eagle and the fish-dependent Osprey were afflicted with eggshell-thinning and infertility, mortally threatening populations of both species. Today, the Bald Eagle and Osprey are prospering, thanks to various conservation interventions, not least being the cessation of the application of DDT across the landscape.

The Brown Pelican, because of its fish-eating habit, also suffered population collapse in a manner similar to the two raptors. Today, Brown Pelicans are off the U.S. Fish & Wildlife Service Endangered Species list and are expanding their range northward up the East Coast.

In spite of the local issues facing wetlands and marshlands, at a national level, the waterfowl are among the groups of birds faring well, thanks in large part to the targeted conservation actions supported by the $4 billion generated by the North American Wetlands Conservation Act (NAWCA) over the past two decades. NAWCA has funded conservation projects on 30 million acres of wetlands habitat in Canada, the United States, and Mexico. North America's waterfowl populations are holding steady as a result of NAWCA and the work of Ducks Unlimited and other waterfowl conservation groups.

In the late twentieth century, North American raptor populations were depressed, probably by a combination of widespread "anti-predator" shooting in rural areas and the misuse of pesticides that impacted the raptors and their prey base. Today, raptor populations have recovered in most instances. These regal birds are no longer thought of as "vermin"; they are respected for their high-flying grace and their position atop the food chain. The long-term recovery of waterfowl and raptors proves conservation action works when applied with diligence and intelligence.

Solutions. For every conservation problem there is a solution. The examples of successful conservation cited above prove this. Here we talk a bit about how we must address the pressing conservation threats that today threaten our birdlife.

The three North American treaty nations need to expand their collaboration on behalf of bird conservation. It is essential that the governments and conservation groups of Canada, the United States, and Mexico expand the conservation model that has produced solid results—the NAWCA model. The North American Wetlands Conservation Act has been a boon to waterfowl conservation in North America. The continental populations of many ducks and geese continue to increase. We need to create similar well-funded continent-wide programs for nongame landbirds, seabirds, and shorebirds. One possible new funding source for the conservation of nongame birds comes from a recent proposal to dedicate $1.3 billion of federal energy and minerals development revenue to the Wildlife Conservation Restoration Program. This could be productively matched by

corporations and philanthropic citizens, providing resources to mitigate deforestation, pollution, and threatening structures on behalf of these declining bird groups.

A consortium of local and national institutions is working to address wetlands loss in the Chesapeake Bay through an array of innovative field actions, focusing initial efforts on the greater Blackwater ecosystem in southern Dorchester County, Maryland. Such pilot initiatives need to be strongly supported and, once the interventions are shown to work, expanded to other important estuaries across the Continent.

Programs of American Bird Conservancy and National Audubon Society seek to create safe spaces for beach-nesting birds during the breeding season. These include fencing on mainland beaches, educational programs during periods of intensive human use of beach environments in the spring and summer, and active patrolling by volunteers, as well as the creation of new bird nesting islands from sand and rubble deposited when dredging boating channels in areas rich in waterbirds.

Many of the problems that beset our birdlife are of national, continental, or hemispheric scale. We can best support action to address these large-scale threats by being active and generous members of an array of environmental groups, both nationally and locally. In the United States, we have American Bird Conservancy, National Audubon Society, The Nature Conservancy, and the National Wildlife Federation. Locally, there are state and local bird clubs and state chapters of national organizations, such as The Nature Conservancy. Also, you can participate in our democracy by writing about issues of conservation concern to your representatives in the US Congress and also to state delegates. Our governments are mandated to work on nature conservation as well as economic development. In fact, successful implementation of nature conservation typically leads to improved economies and more jobs.

Within North America, we can support actions that protect critical breeding and wintering habitat, as well as stopover and staging sites for migrants. These are already identified as "Important Bird Areas" by the North American Bird Conservation Initiative (NABCI). That said, such identification does not always indicate full and proper protection. The best thing that many of us can do is to be vigilant about ensuring the protection of our favorite green spaces near where we live. If we all work to protect the best of our nearby wild spots, then we will all benefit, as will our birdlife. We can protect our precious birdlife if we as a society work locally, nationally, and globally on behalf of birds. Groups of dedicated people, working in concert, can make a difference.

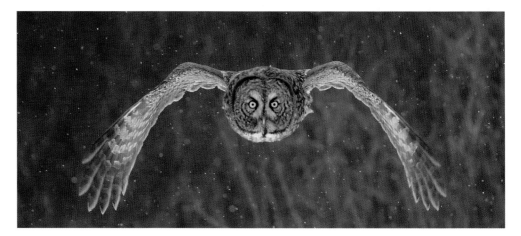

A Great Gray Owl swoops down on a vole that has surfaced through the snow in wintry Minnesota.

Every scholarly book is built upon a foundation of knowledge that includes an assortment of published references that came before it. This book is no exception. The most important sources for this work are marked with an asterisk (*) and include annotations explaining how they informed this work.

*Alderfer, Jonathan, and Jon L. Dunn, eds. 2021. *National Geographic Complete Birds of North America.* Washington, D.C.: National Geographic. Source of up-to-date natural history, conservation status, and range detail for species account texts and maps.

Bailey, Richard S., and Casey B. Rucker, eds. 2021. *The Second Atlas of Breeding Birds in West Virginia.* Pittsburgh, PA: University of Pittsburgh Press.

Beehler, Bruce M. 2019. *Birds of Maryland, Delaware, and the District of Columbia.* Baltimore, MD: Johns Hopkins University Press.

Castrale, John S., Edward M. Hopkins, and Charles E. Keller. 1998. *Atlas of Breeding Birds of Indiana.* Indianapolis, IN: Indiana Department of Natural Resources.

Chipley, Robert M., George H. Fenwick, Michael J. Parr, and David N. Pashley. 2003. *The American Bird Conservancy Guide to the 500 Most Important Bird Areas in the United States.* New York: Random House. Although these "IBAs" are selected for their conservation importance, they also serve as a rich cornucopia of birding destinations across the United States. The book is a gold-mine for birders.

Clark, William S., and Brian K. Wheeler. 2001. *A Field Guide to Hawks of North America.* 2nd ed. Peterson Field Guides. Boston: Houghton Mifflin Harcourt. 316 pages. Field identification of an important, well-watched group of birds, many of which occur in North America the year-round.

Corman, Troy E., and Cathryn Wise-Gervais. 2005. *Arizona Breeding Bird Atlas.* Albuquerque, NM: University of New Mexico Press.

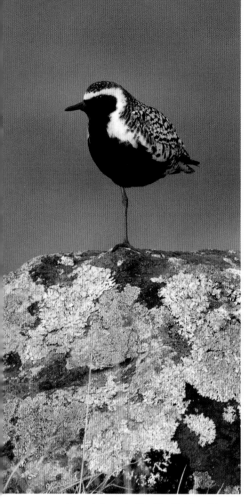

An adult male Pacific Golden-Plover rests atop a lichen-clad boulder in lowland tundra near Nome, Alaska.

Cutright, Noel J., Bettie R. Harriman, and Robert W. Howe, eds. 2006. *Atlas of the Breeding Birds of Wisconsin*. Waukesha, WI: Wisconsin Society for Ornithology.

del Hoyo, Josep, et al., eds. 1992–2011. *Handbook of the Birds of the World*. 16 vols. Barcelona, Spain: Lynx Edicions.

*del Hoyo, Josep, and Nigel Collar. 2014 & 2016. *HBW and BirdLife International Illustrated Checklist of the Birds of the World*. 2 vols. Barcelona, Spain: Lynx Edicions. Important as a source for species and family range details outside of North America.

*Dunn, Jon L., and Jonathan Alderfer. 2017. *The National Geographic Field Guide to the Birds of North America*. 7th ed. Washington, DC: National Geographic. The maps in this field guide served as one of the references for the new maps that appear here. The rare species treatments were important for our treatment of the lesser-known vagrant species. This and *The Sibley Guide to Birds* are the two high-powered birder's guides to North American birds. This one features more rare species and more detail. Weight: 31 ounces.

Dunn, Jon, and Kimball Garrett. 1997. *Warblers*. Peterson Field Guides. Boston: Houghton Mifflin Harcourt. 656 pages. Combining substantial text, paintings, maps, and color photographs, this is a *tour de force* on the subject of North America's wood-warblers.

*eBird. n.d. *"Species Range Maps."* ebird.org/explore. The species-occurrence mapping tool, within the eBird website, allied with the following tool, were the two most useful references for the fine-tuning of the range maps created for this book.

*eBird. n.d. *"eBird Status and Trends."* science.ebird.org/en/status-and-trends. The synthetic species range maps provided in this tool were a critical reference in updating to legacy maps found in the Sibley and National Geographic field guides. The highly detailed maps available from this website in 2019–2021 have been upgraded in 2022.

Ellison, Walter G., ed. 2010. *2nd Atlas of the Breeding Birds of Maryland and the District of Columbia*. Baltimore, MD: Johns Hopkins University Press.

Elphick, Chris, John B. Dunning, and David Allen Sibley. 2001. *The Sibley Guide to Bird Life and Behavior*. New York: Alfred A. Knopf.

Floyd, Ted, Chris S. Elphick, Graham Chisolm, Kevin Mack, Elizabeth Ammon, and John Boone. 2007. *Atlas of Breeding Birds of Nevada*. Las Vegas: Univ. of Nevada Press.

Hess, Gene K., Richard L. West, Maurice V. Barnhill III, and Larraine M. Fleming, eds. 2000. *Birds of Delaware*. Pittsburgh, PA: University of Pittsburgh Press.

Howell, Steve N. G., and Kirk Zufelt. 2019. *Oceanic Birds of the World*. Princeton, NJ: Princeton University Press.

Jacobs, Brad, and James D. Wilson, eds. 1997. *Missouri Breeding Bird Atlas, 1986–1992*. Natural History Series, No. 6. Jefferson City: Missouri Department of Conservation.

Jonsson, Lars. 1999. *Birds of Europe*. London: Christopher Helm. 560 pages. A great guide for identification of European vagrants. The paintings in this volume are large and gorgeous. A great book for learning the birds of Europe; it includes beautiful renderings of many species we see in North America.

*Kaufman, Kenn. 1996. *Lives of North American Birds*. Boston: Houghton Mifflin. An important source for life-history data on North American bird species. Also an important source for our family accounts.

Kaufman, Kenn. 2000. *Birds of North America*. Boston: Houghton Mifflin. 383 pages. For those who prefer color photos over paintings, this will be a useful field guide.

Lebbin, Daniel J., Michael J. Parr, and George H. Fenwick. 2010. *The American Bird Conservancy Guide to Bird Conservation*. Chicago: University of Chicago Press. This is the go-to manual for North American bird conservation.

*Lovette, Irby J., and John W. Fitzpatrick, eds. 2016. *The Cornell Lab of Ornithology Handbook of Bird Biology*. 3rd ed. Chichester, UK: John Wiley & Sons. Served as one of several sources for the bird family accounts. A superb introduction to ornithology.

McGowan, Kevin J., and Kimberley Corwin, eds. 2008. *The Second Breeding Bird Atlas of New York State*. Ithaca, NY: Cornell University Press.

Mollhoff, Wayne J., ed. 2001. *The Nebraska Breeding Bird Atlas, 1984–1989*. Nebraska Technical Series No. 20. Lincoln: Nebraska Game and Parks Commission.

National Audubon Society. *National Audubon Society Birds of North America*. 2021. New York: Alfred A. Knopf. 907 pages. This handsome and well-produced handbook provides accounts, illustrated with photos, of all the birds of North America. This handbook provided useful natural history data on species that filled in gaps not available from the Kaufman reference.

North American Bird Conservation Initiative. 2019. *State of the Birds*. stateofthebirds .org/2019.

North American Bird Conservation Initiative (NABCI). 2022. *State of the Birds 2022*. stateofthebirds.org/2022. The most recent news on the status of our birdlife.

O'Brien, Michael, Richard Crossley, and Kevin Karlson. 2006. *The Shorebird Guide*. 496 pages. Boston: Houghton Mifflin Harcourt. A specialty guide about a favorite group of birds for many birders.

Palmer-Ball, Brainerd. 1993. *The Kentucky Breeding Bird Atlas*. Lexington: University of Kentucky Press.

Peterson, Wayne R., and W. Roger Meservey, eds. 2003. *Massachusetts Breeding Bird Atlas*. Amherst, MA: Massachusetts Audubon Society & University of Massachusetts Press.

Pieplow, Nathan. 2017. *Peterson Field Guide to the Bird Sounds of Eastern North America*. Boston, Massachusetts: Mariner Books. This and the western volume, plus the affiliated website are essential references to North American bird sounds.

*Pratt, H. Douglas, Phillip Bruner, and Delwyn Berrett. 1987. *The Birds of Hawaii and the Tropical Pacific*. Princeton, NJ: Princeton University Press. Served as key source for the Hawaii Birds section.

Reinking, Dan L., ed. 2004. *Oklahoma Breeding Bird Atlas*. Norman: University of Oklahoma Press.

Rodewald, Paul G., Matthew B. Shumar, Aaron T. Boone, David L. Slager, and Jim McCormac. 2016. *The Second Atlas of Breeding Birds in Ohio*. University Park: The Pennsylvania State University Press.

*Sibley, David Allen. 2014. *The Sibley Guide to Birds*. 2nd ed. New York: Alfred A. Knopf. 599 pages. This is a comprehensive and authoritative guide to the birds of North America. A valuable reference for office and car. Weight: 48 ounces. The maps in this field guide served as one of the references for the new maps that appear here.

Sibley, David Allen. 2016. *Sibley Birds East: Field Guide to the Birds of Eastern North America*. 2nd ed. New York: Alfred A. Knopf. 439 pages. This compact field guide to the eastern birds is, hands down, the best identification tool for intermediate or advanced birders to take into the field in the eastern North American region.

Sibley, David Allen. 2016. *Sibley Birds West: Field Guide to the Birds of Western North America*. 2nd ed. New York: Alfred A. Knopf. 504 pages. This compact field guide to the western birds is, hands down, the best identification tool for intermediate or advanced birders to take into the field in the western North American region.

Stephenson, Tom, and Scott Whittle. 2013. *The Warbler Guide*. Princeton, NJ: Princeton University Press. 560 pages. A valuable guide to identifying wood-warblers.

Svensson, Lars. 2010. *Birds of Europe*. 2nd ed. Princeton, NJ: Princeton University Press. 448 pages. This is the best guide for the birds of Europe. A new edition is coming.

Tallamy, Douglas W. 2009. *Bringing Nature Home*. Portland, OR. Timber Press. 360 pages.

Vickery, Peter. 2020. *Birds of Maine*. Princeton, NJ: Princeton University Press.

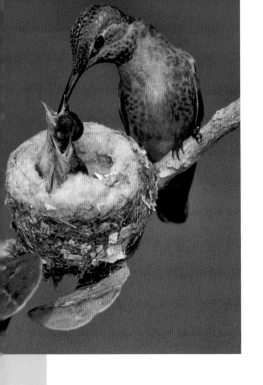

A female Anna's Hummingbird provisions its two tiny nestlings.

CONTRIBUTING PHOTOGRAPHERS AND ILLUSTRATORS

THIS BOOK COULD NOT EXIST without the glorious imagery. Photo editor Brian Small has provided 689 of his own images, and he has gathered up an addition 499 images (some painted, for a number of the extinct species) from a remarkable array of fellow nature photographers (and bird artists) from around the world. I say around the world, because this book includes many Asian, Neotropical, and European species that have only rarely strayed to North America. I tip my hat to these intrepid field photographers who have braved the elements to get that shot, high on a mountain, far out at sea, or in a tropical forest.

Here are the contributing photographers, listed, along with the number of images they have contributed: Brian E. Small (689), Joe Fuhrman (67), Mike Danzenbaker (62), Jack Jeffrey (31), Daniele Occhiato (26), Gerrit Vyn (26), Alan Murphy (23), Bruce Beehler (17), Ralph Martin (17), Bob Steele (14), Markus Varesvuo (13), Saverio Gatto (10), Judd Patterson (10), Eric VanderWerf (10), Glenn Bartley (9), Marc Guyt (9), Greg Homel (9), Dubi Shapiro (8), Vincent Legrand (7), Pete Morris (7), Bob Gress (6), Ian Davies (5), Daniel Garza Tobon (5), Cameron Rutt (4), Ran Schols (4), Aurélien Audevard (3), Harvey van Diek (2), James Eaton (2), Kari Eischer (2), Dick Forsman (2), Tom Friedel (3), Wil Leurs (2), David Monticelli (2), Tomi Muukkonen (2), Jari Peltomäki (3), Helge Sorensen (3), Mathias Putse (2), Daniel Lopez-Velasco (2), Michael McKee (2), Larry Sansone (2), Laurens Steijn (2), Andy & Gill Swash (2), [and one image each from the following]: Arthur A. Allen (courtesy of Cornell Lab of Ornithology), Rafael Armada, Mark Berney, Tom Blackman, Bas van den Boogaard, Hans Bouwmeester, Erik Breden, Scott Clark, Greg & Yvonne Dean, Menno van Duijn, Jacob Garvelink, Hans Gebuis, Alain Ghignone, Jose Hugo Martinez Guerrero, Hugh Harrop, Todd McGrath, Yan Muzika, Arie Ouwerk, Jan Petersson, Stuart Price, Pablo Re, Chris van Rijswijk, Eduard Sangster, Reint Jacob Schut, Arnold Small, Walter Soestbergen, Hiroyuki Tanoi, Alex Vargas, Martijn Verdoes, Fred Visscher, Kathleen Waldron, and See To Yu Wai.

For those bird species for which no photograph was available, painted illustrations were provided by H. Douglas Pratt (32) and John Schmitt (7).

What follows is the list of image credits, by page number, from the front of the book to the back. On pages with more than one image, the images are listed from left to right or top to bottom. Contributors are listed by surname (all listed above), followed by a "/" and the name of the photo agency, when relevant.

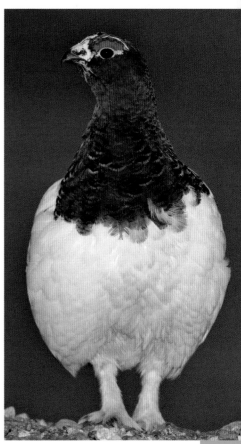

An adult male Willow Ptarmigan stares down the approaching photographer on rocky tundra in Alaska.

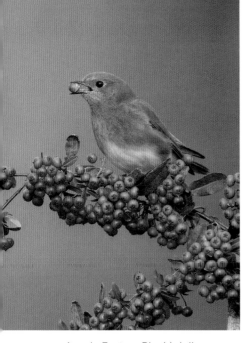

A male Eastern Bluebird dines on the exotic invasive firethorn.

ILLUSTRATION LIST

Front cover, back cover, front endsheet, and all photographs in the front matter of the book and the Introduction (pp. 1-28) are by Small; the map on p. 27 is by Bruce Beehler; the map on p. 29 is by Bill Nelson; pages 31-35: Small; 36: Small, Vyn; 37: Small, Murphy; 38: Fuhrman, Small; 39: Small; 40: Gress/Birds in Focus, Small; 41-46: Small; 47: Fuhrman, Small; 48: Small, Occhiato/AGAMI; 49-63: 64: Fuhrman, Small; 65: Small; 66: Beehler, Small; 67: Small, Vyn; 68-73: Small; 74: Vyn, Small; 75-77 Small; 78: Small, Patterson/Birds in Focus; 79 Fuhrman, Small; 80-88: Small; 89: Danzenbaker, Small; 90: Small; 91: Small, Danzenbaker; 92: Danzenbaker, Small; 93: Small; 94: Bartley, Small; 95: Murphy, Small; 96-101: Small; 102: Fuhrman, Small; 103-107: Small; 108: Small, Beehler; 109-112: Small; 113: Small, Varesvuo/AGAMI; 114: Small, Vyn; 115-118: Small; 119: Beehler, Small; 120-124: Small; 125: Varesvuo/AGAMI, Small; 126-134: Small; 135: Small, Danzenbaker; 136-140: Small; 141: Vyn, Gatto/AGAMI; 142: Small, Vyn; 143: Fuhrman, Small; 144: Vyn; 145: Fuhrman, Murphy; 146: Murphy, Danzenbaker; 147: Danzenbaker, Small; 148: Danzenbaker, McGrath; 149: Danzenbaker, Dudeck; 150: Small; 151: van Diek, Vyn; 152: Steele, Fuhrman; 153: Murphy, Bartley; 154: Small, Steele; 155: Vyn, Small; 156: Small, Murphy; 157: Varesvuo/AGAMI, Danzenbaaker; 158: Small; 159: Small, Beehler; 160: Small; 161: Fuhrman, Small; 162: Small, Forsman/AGAMI; 163: Small; 164: Beehler, Vyn; 165: Fuhrman; 166: Fuhrman; 167: Audevard/AGAMI, Small; 168-170: Small; 171: Steele, Small; 172-173: Small; 174: VanderWerf, Murphy; 175: Murphy; 176: Small, Murphy; 177: Small; 178 Vyn, Small; 179: Small, Steele; 180-183: Danzenbaker; 184: Danzenbaker, Murphy; 185: Danzenbaker; 186: Guyt/AGAMI, Danzenbaker; 187-189: Danzenbaker; 190: Steele, Murphy; 191: Fuhrman, Murphy; 192: Danzenbaker/AGAMI, 193: Murphy, Blackman; 194-195: Small; 196: Danzenbaker, Beehler; 197: Fuhrman, Small; 198-199: Small; 200: Murphy, Small; 201-209: Small; 210: Verdoes/AGAMI, Small; 211: Small, Beehler; 212-216: Small; 217: Small, Varesvuo/AGAMI; 218-219: Small; 220: Small, Murphy; 221-229: Small; 230: Fuhrman, Small; 231: Small, Dudeck; 232-233: Small; 234: Fuhrman; 235-240: Small; 241: Beehler, Small; 242-243: Small; 244: Beehler; 245: Beehler, Small; 246-251: Small; 252: Small, Homel; 253-258: Small; 259: Small, Fuhrman; 260-264: Small; 265: Small, Shapiro/AGAMI; 266-267: Small; 268: Fuhrman, Small; 269-283: Small; 284: Beehler, Small; 285-288: Small; 289: Small, Murphy; 290-294: Small; 295: Fuhrman, Beehler; 296-298: Small; 299: Vyn, Small; 300: Small, Beehler; 301-310: Small; 311: Small, Murphy; 312-326: Small; 327: Beehler, Small; 328-331: Small; 332: Small, Leurs/AGAMI; 333-334: Small; 335: Small, Gatto/AGAMI; 336-337: Small; 338: Beehler, Small; 339: Small, Beehler; 340: Murphy, Davies/AGAMI; 341-344: Small; 345: Small, Fuhrman; 346-357: Small; 358: Clark, Small; 359-368: Small; 369: Small, Shapiro; 370-372: Small; 373: Fuhrman, Small; 374: Small; 375: Fuhrman, Small; 376: Small, Fuhrman; 377-418 Small; 419: Bartley; 420: Eischer/AGAMI, Patterson/Birds in Focus, Friedel/AGAMI, Morris/AGAMI, Patterson/Bids in Focus, Bemey; 421: Danzenbaker, Danzenbaker, Bartley, Tobon, Shapiro/AGAMI, Fuhrman; 422: Morris/AGAMI, Fuhrman, Swash/AGAMI, Homel, Sansone, Steele; 423: Fuhrman, Fuhrman, Lopez-Velasco/AGAMI, Bartley, Small, Fuhrman; 424: Small, Fuhrman, Vyn, Murphy, Danzenbaker, Homel; 425: Homel, Fuhrman, Bartley, Bartley, Vargas/AGAMI, Homel; 426: Tobon, Fuhrman, Fuhrman, Homel, Davies/AGAMI, Re; 427: Breden, Fuhrman, Tobon, Danzenbaker, Bartley, Patterson/Birds in Focus; 428: Gress/Birds in Focus, Fuhrman, Gress/Birds in Focus, Shapiro/AGAMI, Patterson/Birds in Focus; 429: Small, Fuhrman, Gress/Birds in Focus, Leurs/AGAMI, Dean/AGAMI, Danzenbaker; 430: Bartley, Tobon, Monticelli/AGAMI, Small, Homel, Fuhrman; 431: Danzenbaker, Small, Shapiro/AGAMI, Danzenbaker, Tobon, Gress/Birds in Focus; 432: Morris/AGAMI, Homel, Fuhrman, Guerrero, Bartley, Small; 433: Fuhrman, Homel, Small, Fuhrman, Small, Fuhrman; 434: Shapiro/AGAMI, Fuhrman, Shapiro/AGAMI, Small, Patterson/Birds in Focus; 435: Small, Gatto/AGAMI, Steele, Gatto/AGAMI, Legrand/AGAMI, Peltomaki/AGAMI; 436: Small, Gatto/AGAMI, Steele, Gatto/AGAMI, Legrand/AGAMI, Peltomaki/

AGAMI; 437: Jeffrey, Fuhrman, Peltomaki/AGAMI, Vyn, Vyn, Vyn; 438: Murphy, Sorensen/AGAMI, Gatto/AGAMI, Vyn, Varesvuo/AGAMI, Ouwerk/AGAMI; 439: Gatto/AGAMI, Gatto/AGAMI, Occhaito/AGAMI, Furmn, Occhiato/AGAMI, Legrand/AGAMI; 440: Martin/AGAMI, Murphy, Schols/AGAMI, Occhiato/AGAMI, Legrand/AGAMI, Muukkonen/AGAMI; 441: Guyt/AGAMI, Varesvuo/AGAMI, Guyt/AGAMI, Martin/AGAMI, Mcchiato/AGAMI, Martin/AGAMI, Schut/AGAMI; 443: Fuhrman; 444: Peltomaki/AGAMI, Varesvuo/AGAMI, Visscher/AGAMI, Murphy, Fuhrman, Gatto/AGAMI; 445: Small, Fuhrman, Occhiato/AGAMI, Putzel/AGAMI, Soestbergen/AGAMI, van Diek/AGAMI; 446: Occhiato/AGAMI, Martin/AGAMI, Davies/AGAMI, Davies/AGAMI, Schols/AGAMI, Martin/AGAMI; 447: Guyt/AGAMI, Steele, Vyn, Occhiato/AGAMI, Vyn, Small; 448: Vyn, Vyn, Putzel/AGAMI, Vyn, Martin/AGAMI, Vyn; 449: Small, Varesvuo/AGAMI, Audevard/AGAMI, Legrand/AGAMI, Murphy, Vyn; 450: Occhaito/AGAMI, Schols/AGAMI, Vyn, Vyn, Occhiato/AGAMI, Sorensen/AGAMI; 451: Danzenbaker/AGAMI, Small, van den Boogaard/AGAMI, Fuhrman, Occhiato/AGAMI, Guyt/AGAMI; 452: Danzenbaker, Fuhrman, Fuhrman, Fuhrman, Forsman/AGAMI, Varesvuo/AGAMI; 453: Yew Wai, Morris/AGAMI, Danzenbaker, Ghignone/AGAMI, Fuhrman, Muukkonen/AGAMI; 454: Martin/AGAMI, Varesvuo/AGAMI, Occhiato/AAGAMI, Occhiato/AGAMI, Martin/AGAMI, Martin/AGAMI, Danzenbaker; 455: Martin/AGAMI, Legrand/AGAMI, Schols/AGAMI, Martin/AGAMI, Martin/AGAMI, Sorensen/AGAMI; 456: Martin/AGAMI, Occhiato/AGAMI, Martin/AGAMI, Steijn/AGAMI, Martin/AGAMI, Varesvuo/AGAMI; 457: Steijn/AGAMI, Audevard/AGAMI, Occhiato/AGAMI, Eischer/AGAMI, Steele, Occhiato/AGAMI, Steele, Occhiato/AGAMI; 458: Davies/AGAMI, Danzenbaker/AGAMI, Lopez-Velasco/AGAMI, Steele, Martin/AGAMI, Morris/AGAMI; 459: Price/AGAMI, Fuhrman, Veresvuo/AGAMI, Occhiato/AGAMI, van Duijn/AGAMI, Small; 460: Martin/AGAMI, Occhiato/AGAMI, Martin/AGAMI, KcKee/AGAMI, van Rijswijk/AGAMI, Occhiato/AGAMI; 461: Danzenbaker, Bouwmeester/AGAMI, Eaton/AGAMI, Sangster/AGAMI, Occhiato/AGAMI, Occhiato/AGAMI; 462: Occhiato/AGAMI, Occhiato/AGAMI, Occhiato/AGAMI, Occhiato/AGAMI; 463: McKee/AGAMI, Muzika/AGAMI, Danzenbaker, Occhiato/AGAMI; 464: Small; 465: Jeffrey; 466: Small, Rutt, Jeffrey, Small, Patterson/Birds in Focus, Jeffrey; 467: Small, Jeffrey, Jeffrey, Small, Petersson, Steele; 468: Vander-Werf, Fuhrman, Rutt, Gatto/AGAMI, VanderWerf, Fuhrman; 469: Small, Danzenbaker, Danzenbaker, Danzenbaker, Guyt/AGAMI, Danzenbaker; 470: Armada/AGAMI, Danzenbaker, Danzenbaker, Rutt, Jeffrey, Tanoi; 471: Jeffrey, Jeffrey, WanderWerf, Jeffrey, Jeffrey, Jeffrey; 472: Morris/AGAMI, Steele, Steele, Danzenbaker, Steele, Pratt; 473: Jeffrey, Jeffrey, Eaton/AGAMI, Jeffrey, Small, Jeffrey; 474: Jeffrey, Fuhrman, Shapiro/AGAMI, Fuhrman, Jeffrey, Jeffrey; 475: Rutt, VanderWerf, Jeffrey, Jeffrey, Jeffrey, VanderWerf; 476: Vandererf, Jeffrey, Jeffrey, Jeffrey, Jeffrey, Jeffrey, Jeffrey; 477: Jeffrey, Small, VanderWerf, Small, Monticelli/AGAMI, Gress/Birds in Focus; 478: Fuhrman; 479: Danzenbaker; 480: Danzenbaker, Fuhrman, Danzenbaker, Fuhrman, Fuhrman; 481: Fuhrman, Fuhrman, Danzenbaker, Harrop/AGAMI, Guyt/AGAMI, Danzenbaker, Danzenbaker; 482: Danzenbaker, Gatto/AGAMI, Guyt/AGAMI, Danzenbaker, Danzenbaker, Danzenbaker; 483: Varesvuo/AGAMI, Garvelink/AGAMI, Fuhrman, Danzenbaker Morris/AGAMI, Legrand/AGAMI; 484: Guyt/AGAMI, VanderWerf, Small, Fuhrman, Small; 485: Fuhrman; 486: Small, Swash/AGAMI, Monticelli/AGAMI, Small, Legrand, Fuhrman; 487: Small, Small, Small, Sansone, Small, Friedel/AGAMI; 488: Patterson/Birds in Focus, Small, Fuhrman, Fuhrman; 489: VanderWerf, Small, Patterson/Birds in Focus, Fuhrman, Waldron; 490: Murphy, Patterson/Birds in Focus, Small, Friedel/AGAMI; 491: Jeffrey, Fuhrman, Jeffrey, Gatto/AGAMI; 492: Allen; 493: Schmitt; 494: Schmitt, Schmitt, Schmitt, Pratt, Pratt, Gebuis/AGAMI, Schmitt; 495: Schmitt, Allen, Schmitt, Pratt, Pratt, Pratt; 496: Pratt, Pratt, Pratt, Pratt, Pratt, Pratt; 497: Pratt, Pratt, Pratt, Pratt, Pratt, Pratt; 498: Pratt, Pratt, Pratt, Pratt, Pratt, Pratt, Pratt; 499: Pratt, Pratt, Pratt, Pratt, Pratt, Pratt, Pratt, Schmitt; 500-525: Small; 526: Arnold Small; 527-560: Small; back cover: Small; back endsheet: Small.

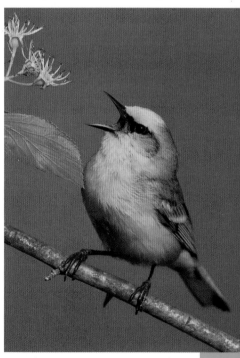

An adult male Blue-winged Warbler sings its spring song from a flowering shrub at the forest edge.

An adult Roseate Spoonbill stretches its strange spatulate bill upward in a courtship display.

THE INDEX THAT FOLLOWS combines and consolidates all entries: the English names of species, the scientific names of species, and the topics, listed alphabetically. Here is how they are organized. The English names are listed by second name. For instance, American Robin will be found in the Rs, as Robin, American. Its scientific name (*Turdus migratorius*) is listed by its first or generic (genus) name, hence in the Ts, as *Turdus migratorius*. And all the other *Turdus* species are indented and listed alphabetically under the genus name *Turdus*.

An adult California Thrasher sings from a desiccated perch in dry California chaparral.

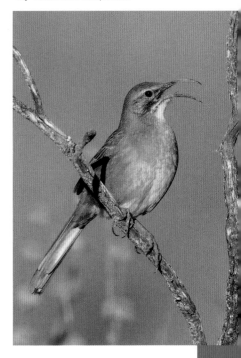

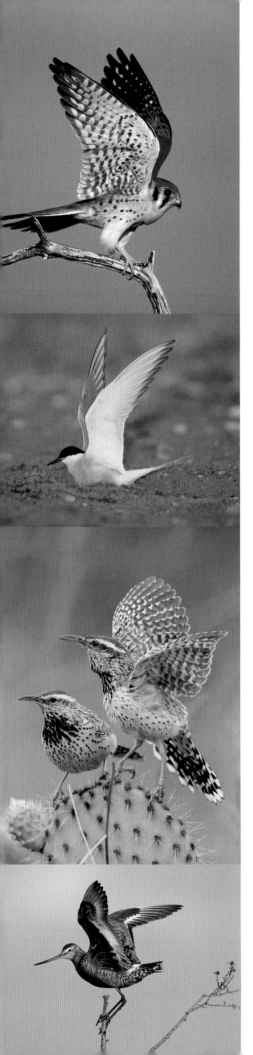

PUBLICATIONS BY THE AUTHOR AND PHOTO EDITOR

Bruce Beehler has authored seventeen books and technical monographs in natural history. Here are some of his recent publications.

New Guinea—Nature and Culture of Earth's Grandest Island
(Princeton University Press, 2020)

Natural Encounters: Biking, Hiking, and Birding Through the Seasons
(Yale University Press, 2019)

Birds of Maryland, Delaware, and the District of Columbia
(Johns Hopkins University Press, 2019)

North on the Wing—Travels with the Songbird Migration of Spring
(Smithsonian Books, 2018)

Lost Worlds: Adventures in the Rainforest.
(Yale University Press, 2008)

Brian E. Small has served as principal photographer for twenty state field guides sponsored by the American Birding Association and published by Scott & Nix, Incorporated, New York, N.Y. They can be seen at the following website: scottandnix.com/collections/american-birding-association-field-guides

In addition, Small has served as principal photographer for the following books:

Birds of Northern California
(R.W. Morse Company, 2015)

Birds of Southern California
(R.W. Morse Company, 2012)

Birds of Eastern North America: A Photographic Guide
(Princeton University Press, 2009)

Birds of Western North America: A Photographic Guide
(Princeton University Press, 2009)

Smithsonian Field Guide to the Birds of North America
(HarperCollins, 2008)

From top to bottom: Adult male American Kestrel; Arctic Tern; pair of Cactus Wrens; adult male Hudsonian Godwit on its nesting territory in Manitoba.

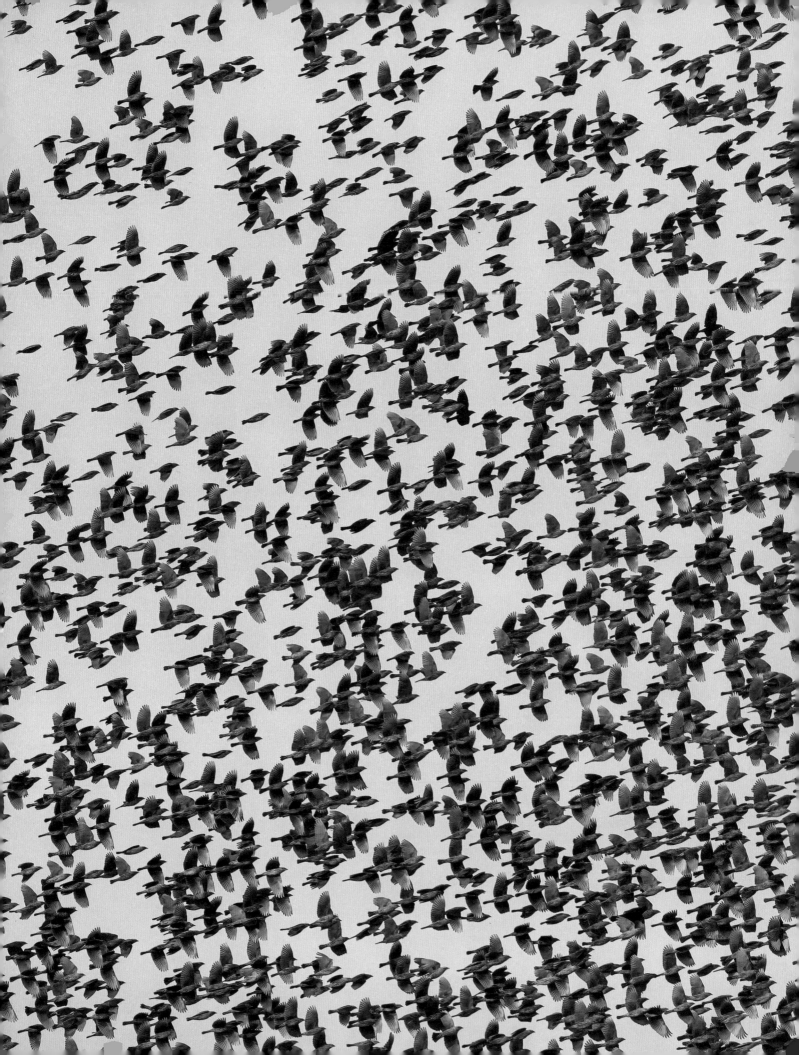